So Rich a Tapestry

So Rich a Tapestry

The Sister Arts
and Cultural Studies

Edited by
Ann Hurley and Kate Greenspan

Lewisburg
Bucknell University Press
London: Associated University Presses

Associated University Presses
440 Forsgate Drive
Cranbury, NJ 08512

Associated University Presses
25 Sicilian Avenue
London WC1A 2QH, England

Associated University Presses
P.O. Box 338, Port Credit
Mississauga, Ontario
Canada L5G 4L8

The paper used in this publication meets the requirements
of the American National Standard for Permanence of Paper
for Printed Library Materials Z39.48-1984.

Library of Congress Cataloging-in-Publication Data

So rich a tapestry : the sister arts and cultural studies / edited by
Ann Hurley and Kate Greenspan.
 p. cm.
 ISBN 0-8387-5282-9 (alk. paper)
 1. English poetry—History and criticism. 2. Art and literature—
Great Britain—History. 3. Ut pictura poesis (Aesthetics)
4. Great Britain—Civilization. 5. Painting, British. I. Hurley,
Ann, 1947– . II. Greenspan, Kate.
PR508.A7S65 1995
821.009'357—dc20

94-35071
CIP

PRINTED IN THE UNITED STATES OF AMERICA

Contents

6

Acknowledgments

The editors would like to thank the Lucius N. Littauer Foundation and Skidmore College's departments of art and art history, English, foreign languages and literatures, the liberal studies program, the dean of faculty's office, the Faculty-Staff Club, and the President's Discretionary Fund for their generous support of the 1990 Sister Arts and Cultural Studies conference, the genesis of this volume.

Our thanks to successive Associate Deans of the Faculty David Seligman and David Burrows, both of whom lavished upon us material support and enthusiasm for the project; we are grateful as well for the several faculty research grants that enabled us to complete the manuscript. Sue Stein gave us her indispensable, incomparable assistance in typing, retyping, and assembling portions of the manuscript. We benefited as well from the advice and encouragement of our colleagues, Terry Diggory and Sarah Webster Goodwin; and we would like to thank Robert Boenig for his right-on-target suggestion of a publisher. The editors at Associated University Presses have been as kind and helpful as we could wish.

Finally, we must acknowledge our greatest debts, repeatedly renewed and never to be repaid, to Rodger Hurley and Steven Epstein.

* * *

Robin Skelton's translation of the epigram by Archias beginning "Apelles surely must have seen," from *Two Hundred Poems from the Greek Anthology* (Seattle: University of Washington Press, 1971), 7. Used with permission of the author.

Paul Engle's poem, "Venus and the Lute Player," from *A Woman Unashamed and Other Poems* (New York: Random House, 1963), 86. Used with permission.

Horace Gregory's poem, "Venus and the Lute Player," from *Collected Poems* (New York: Holt, Rinehart, and Winston, 1964), 116. Used with permission.

Vittoria Colonna's sonnet, "La bella donna, a cui dolente preme," from *Rime,* edited by Alan Bullock (Bari: Laterza, 1982), 162. Used with permission.

James Heffernan's essay was originally published in *Word & Image* 7, no. 3 (July–September 1991), and is reproduced with permission.

Timothy Erwin's essay appeared in shorter form in *Eighteenth-Century Life* 16, no. 3 (November 1992), and is used with permission.

Michael Fried's essay originally appeared in *Critical Inquiry* 17, no. 1 (Autumn 1990). Reproduced by permission of the University of Chicago Press.

W. J. T. Mitchell's essay originally appeared in *Critical Inquiry* 16, no. 4 (Summer 1990). Reproduced by permission of the University of Chicago Press.

Eileen Reeves's essay was originally published in *Word & Image* 9, no. 1 (1993), 51–56, and is used with permission.

Introduction

ANN HURLEY

Over the last decades, the interdisciplinary study of literature and the visual arts has come to take shape as a field in its own right with its own publications and its own vocabulary. Specific topics like *ekphrasis, enargeia,* and the *paragone* have received considerable attention, while a more general engagement with the power of the visual image has fueled a variety of compelling studies. Literary scholars have profited from a more precise knowledge of iconography, while art historians have become increasingly aware of the rhetorical sources of artistic practices. Most recently, cultural historians have begun to probe the conjunction of image and text as a useful means of insight into both contemporary and past thinking, behaviors, and beliefs.

Yet the linking of the sister arts (to use the classical terminology) of painting and poetry is not new. The power of the visual image had played a role in Western literature well before Horace invoked and Plato resisted it. The vocabulary of this tradition—including phrases like "*ut pictura poesis,*" "*Bibilia pauperum,*" "*paragone,*" "Zeitgeist," "pictorial," "the picturesque," or "word and image"—evokes its historical trajectory from ancient Greece and Rome, through Europe of the Middle Ages and Renaissance, into the German and then English romantic and Victorian periods, to the last decades of the twentieth century. A review of this historical background also reveals shifts in perspective—from the rhetorical and philosophical to the spiritually educational, from the scientific and economic to the aesthetic, to, in the twentieth century, the semiotic, psychological, formalist, and structuralist. The most recent shift, from thinking about the image as an object of perception to thinking about the image as a product of culture, provides the occasion of this collection of essays.

Thinking about the image from this perspective offers an advantage to interartistic studies in that scholars like the authors of these essays can now begin to use the intersections of art and literature to examine the activities of that broad mass of assumptions, beliefs, convictions, and behaviors which we normally store under the label of "culture." At least

9

two gains are immediately apparent. A survey of the central historical
events, figures, texts, and core arguments of the ongoing engagement
between the sister arts from a cultural perspective reveals the consistent
role that the visual image has played as a disturbing element—philosophi-
cally, spiritually, politically, and personally—in Western culture. Since
many of the essays here address the powerfully disturbing nature of the
visual image as a key to culture, a brief summary of its historical back-
grounds will serve to introduce this aspect of the collection. A second
gain, this time in the context of theory, lies in these essays in that they
shift the area of discussion away from the post-Lessing concern with
boundaries and limits between the sister arts which has most recently
engaged theorists to a common interest in that property of the sister arts
conjunction which allows us to explore culture. Accordingly, a second
part of this introduction will identify some of the points at issue when
sister arts studies are reoriented in the direction of cultural criticism.

1

Plato objected to the visual image in his ostensibly distanced philo-
sophical critique of representational art as existing at a third remove from
reality. But his objection betrays both the attraction and the danger that
images pose, particularly to the untutored mind which he considered
more receptive to rhetorical persuasion through emotional appeal. In
book 10 of *The Republic,* he comments on "that weakness of the human
mind on which the art of painting in light and shadow, the art of conjuring,
and many other ingenious devices impose, having an effect upon us like
magic."[1] The context which Horace invokes also implies an element of
distrust. "As with the painter's work, so with the poet's: one piece will
take you more if you stand close to it, another at a great distance. This
loves a dark corner, that will desire to be seen in a strong light."[2] "Dark"
corners, like "magic," accompanied by attributing "desire" to the images,
which "take you more" *("te capeat magis"),* suggest a displacement of
human culpability for rhetorical excess onto the no longer inert image.
Such philosophical distrust of the image is even more fully caught in
"The Cratylus," one of Plato's most enigmatic dialogues, the text that
best demonstrates the threat posed by the visual image to classical
rationalism.

The dangerously seductive powers of the image receive renewed em-
phasis, as has been often noted, in the Byzantine empire, particularly in
the eighth century. Here, as evidenced by the piecemeal refutation of the
iconoclast position at the Council of Nicaea in 787, it can be discerned
that the rejection of images was based on a fear of basely materializing

the divine and of contaminating divine things with the actions of human hands. The Iconoclast Council of 754 was explicit. Artists were to be condemned for "having attempted to delineate the incomprehensible and uncircumscribable divine nature of Christ."[3] Such a position, of spiritual and moral distrust, would be articulated again in sixteenth-century Europe during the Protestant Reformation.

By contrast, medieval Europe would appear to have resolved the threat of imagery to the spiritual well-being of the devout. The dominant institution, the Church, acknowledging the potency of images, was skilled in adapting that potency to its own ends. Spiritual instruction was in fact facilitated by linking pictures and text, a linkage which was best illustrated by the *Biblia pauperum* in which biblical origins and patristic development of the critical method of typology served to affirm doctrinal orthodoxy. A similar bonding of image and text would occur later, in the Renaissance, with the circulation of emblem books and meditative manuals like the Ignatian exercises which enhanced moral and religious experience for the spiritually sophisticated. The Second Nicaean Council in the eighth century and the Council of Trent in the sixteenth both addressed the potency of the image by directly asserting that "due honour and veneration is to be given" to images as well as to the Word, "not, however, that any divinity or virtue is believed to be in them by reason of which they are to be venerated . . . but because the honor which is shown them is referred to the prototypes which they represent."[4] The words of the fourteenth-century English mystic Walter Hilton are even more explicitly defensive of images, which are efficacious precisely because they "arouse [the mind] from vain and worldly thoughts to more intent and frequent meditation upon unseen things and the desire for them."[5] And much earlier, in a letter to Charlemagne on the topic of the *Libri Carolini* (a treatise from the court of Charlemagne which, in the wake of the Second Nicaean Council, also attempted to formulate a position on the potency of images), Pope Hadrian I sought to assuage anxieties about the image on the ground that images, like sacred vessels, could be sanctified through consecration. "It was and is the practice of the Catholic and Apostolic Roman Church," he asserted, "that when sacred images and histories are painted, they are first anointed with sacred chrism, and then venerated by the faithful."[6]

Yet the defense of the image as a means of access to the divine— whether it rested on Aristotelian theories, as explained by Aquinas, that knowledge is acquired as an inward image through the senses, particularly sight, or whether it was founded on Augustinian and Neo-platonic arguments as articulated by Italian Renaissance theorists like Lomazzo, that knowledge is inherent in the mind as an image of the divine intellect—

clearly elided rather than addressed some of the most disturbing aspects of the visual image.

As often as the image was seen as efficacious, so was it recurrently seen as dangerous, alarmingly seductive, and misleading for the unwary. The rhetoric of iconoclasm mixed repeatedly, and with biblical precedent, with the language of adultery and fornication in this period, again betraying the fear of materializing the deity, despite the divine precedent of the Incarnation. In the secular world, the disturbing presence of the animate within the inanimate and the recurrence of the desire to possess the image, which reveal the erotic base of such compulsions, were subtexts even to arguments (e.g., Leonardo's) in favor of the powers of the visible image.[7] "Doeth not the worde of GOD call Idolatrie spirituall fornication?" asked an Elizabethan homilist rhetorically,[8] and this same *Homilie against perill of idolatrie* of 1563 charted out the prognosis for the mind infected with diseased images in fascinated detail:

> the nature of man is none otherwise bent to worshipping of Images . . . then it is bent to whoredome and adulterie in the company of harlots. And as unto a man giuen to the lust of the flesh, seeing a wanton harlot, sitting by her, and imbracing her, it profiteth little for one to say, Beware of fornication, GOD will condemne fornicatours and adulterers: for neither will hee, being ouercome with greater inticements of the strumpet giue eare or take heede to such godly admonitions, and when hee is left afterwardes alone with the harlotte, nothing can follow but wickednesse: . . . yee shall in vaine preach and teach them against Idolatry. For a number will notwithstanding fall headlong unto it, what by the nature of Images, and what by the inclination of their owne corrupt nature.[9]

A revival of classical tales about semen-stained statutes of Venus (in, for example, Lucian or *The Greek Anthology*)[10] testifies to a strong undercurrent of belief in the literal, sexual potency of the visual, and Renaissance pornography did not neglect tales of female arousal as one of the stories in Girolamo Morlini's scopophilic novella of 1520 attests. As David Freedberg points out, these fetishizing tales, while clearly designed to be titillating, convey a point more pertinent to the power of imagery. Legends like the most famous one, Ovid's *Pygmalion,* are significant because they adumbrate two deep cultural fears, that of the real body, and, secondly, of artistic creativity, the threat inherent in wishing the image alive. As Freedberg explains, we wish it alive as a testimony to our own creative powers; but we also need it to remain inert as "it is we who should remain masters of what we make, and not have [these images] turn into phantoms that seem dangerously to be like ourselves, and therefore both equal and stronger."[11] The medieval, Renaissance, and Reformation worlds struggled with these issues, and such struggles provide insight into the cultural contexts from which their literary and visual arts emerged and which these, in turn, shaped.

Less dramatically, however, the image was attacked in the pre-modern period on noniconoclastic grounds, and this attack for the first time focuses on the rather different issue of those properties of the visual image which make it both a vehicle for economic exploitation and available for worldly gain. As early as the twelfth century, Bernard of Clairvaux in his *Apologia ad Guillelmum Abbatem* (ca. 1125) offers a medieval example of these attitudes. Written during the early twelfth century, when the greatest artistic controversy over images in the West before the Reformation was taking place, Bernard's *Apologia* attacked the growing monastic practice of using art to attract donations, thereby exposing the economic base of monastic art production. Although Bernard's motives may have been more self-serving than altruistic, his *Apologia,* like Gregory the Great's two letters to Seremus (the authoritative pronouncement on religious art for the Middle Ages), was concerned with distinguishing between the adoration of images and the teaching through images of what should be adored. Unlike Gregory, however, Bernard, in confining his comments to the context of reforms in monastic life, laid bare the economic shift which underlay the concerns with religious images. During the twelfth century, a high point of monastic activity along pilgrimage routes occurred, and Bernard's *Apologia* makes clear that the redirection of monastic investment from agricultural lands to the production of religious art to be marketed to pilgrims reflects the larger economic shift away from the aristocracy as a source of support to diversification of monastic investment, which now also sought to attract the smaller cash offerings of the increasingly free, mobile, and wealthy non-aristocratic social groups. As material and spiritual prosperity thus came to be more closely equated (an equation which Bernard explicitly resisted), the properties of the visual image which he attacked—its materiality, its portability, its potential for sensory excess, its distractive nature, its immediacy— were precisely those which made it vulnerable to such appropriation.[12]

Later, in the Italian Renaissance, conflicts involving these properties of the image would occur again. Because that conflict would no longer be only over the justification of art in the service of (or distraction from) the worship of God, but also over the rival social and economic status of poets versus painters, the iconophilia and iconoclasm displayed then would also have its cultural roots in an economic base. (The first essay of this collection, by James Mirollo, amply documents the cultural and economic base of such arguments from the thirteenth through the sixteenth centuries, and thus no further details need be given here.) For the scholar of culture, it is important to see that in the medieval world of Bernard, in the words of C. Rudolf, "an aesthetics of holiness was obscuring an aesthetics of excess," while in the Italian Renaissance, aesthetic arguments over representational efficacy and scientific discussions about

the relative hierarchy of the senses (seeing vs. hearing; eye vs. ear) obscured significant economic and social motives. In both instances the juxtaposition of word and image in specific social, economic, even political contexts, whether in critical treatises or in actual literary and artistic practices, supplies us with a variety of cultural insights.

By the end of the Renaissance, discussions about the image had taken yet another cultural shift. An increasingly secular orientation, building on first classical and then Renaissance equations of poetry and painting, had so blended the two sister arts that by the late seventeenth century reactions had begun to occur. (The best known discussion of this phase, Rensselaer W. Lee's *Ut Pictura Poesis,* fully explains and documents the conflation of the sister arts during this period.) The reaction to the conflation of the sister arts is, of course, best exemplified by Gotthold Lessing's *Laocoön* (1766). Lessing's famous distinction between literature and the visual arts, whereby poetry was identified as the art concerned with actions taking place over time, and painting was identified as the art concerned with bodies existing in space, initiated a variety of critical discussions about the boundaries between the sister arts which continue today. More pertinently, his comment that "the signs of art must . . . bear a suitable relation to the thing signified" (chap. 16) also reflected the beginnings of what would become a semiotic approach to inter-artistic relations.

<p style="text-align:center">2</p>

Thinking about the image as a sign would seem to be a productive theoretical and methodological move toward using the intersections of literature and art as insights into the activities of culture, but the follow-up, particularly in the twentieth century, on Lessing's first observation about the differences between the sister arts has served instead to undercut that advantage. In reawakening the early Renaissance *paragone* (the war between the signs in which word and image are viewed oppositionally, usually in an effort to determine their relative claims to representation), what Lessing also did was to set in motion an essentialist, or structuralist, movement which has, until recently, deflected attention from the power of the visual image, particularly as supplying an avenue into culture.

It should be quickly acknowledged that few post-Lessing scholars would recognize themselves as structuralists. Nonetheless, the direction of interartistic studies which followed on Lessing's distinction, although usually directed toward specific periods in literary and art history, indeed depended on an unacknowledged prevalorization of certain ostensibly

ahistorical categories which were taken for granted and between which other changing variables endlessly oscillated.

For example, a case in point is offered by Erwin Panofsky in a passage from *Gothic Architecture and Sculpture.*

> The historian cannot help dividing his material into 'periods' . . . To be distinguishable, each of these portions has to have a certain unity, and if the historian wishes to verify this unity instead of merely presupposing it, he must needs try to discover intrinsic analogies between such overtly disparate phenomena as the arts, literature, philosophy, social and political currents, religious movements—[13]

This passage, cited, significantly, by Wylie Sypher, one of Panofsky's followers, reveals itself to have a double, self-cancelling bias. On the one hand is the urge to synthesize; on the other is an explicit need to distinguish. The school of German art historical formalists who preceded Panofsky, scholars like Alois Riegl and Heinrich Wölfflin, had posited a *Zeitgeist* unique to each period which nonetheless manifested itself through certain deep structural principles from which individual art works were generated. Like them, Sypher classified Renaissance art, both verbal and visual, through four categories—"'renaissance,' mannerist, baroque and late-baroque." Although he labeled these the four stages of renaissance style, he nonetheless frequently glanced at what appears to be their transhistorical nature. "A living style," he commented, "often violates the logic of geography and history Like the burning Phoenix, a style can even resurrect itself." The four styles, he continues, "occuring everywhere in the Renaissance arts . . . occur [also] in Picasso's paintings."[14] In another passage, he gestures toward grounding this recurrent cycle in the constant of human biology. "The notion of this sort of analogy is clearer in biology than in the fine arts," he says, and then cites Kant, who "sought to survey the orders of living beings to try to find some traces of a biological system."[15] Such retreats into formalism or structuralism thus seem to have deflected the discussions of the dangerous potency of the visual image to which earlier eras were more sensitive.

A similar inconsistency marks the last wave of scholarship devoted to relations between the sister arts. This generation of scholars, led primarily by Ernst Gombrich, has been less concerned with periodization but more concerned with the distinctions between the sister arts and the grounds for them. Consequently, they have focused largely on the visual image as a product of "pure" perception as one of these grounds. The inconsistency remains, however, because in the concern for locating the grounding of the distinctions between the sister arts, the potential for cultural insight is still being deflected, or, at least, confused. E. H. Gom-

brich, for example, as is implied by the subtitle of his famous work on art and illusion, "A Study in the Psychology of Pictorial Representation," founds his conclusions about our responses to the visual image on certain biological and psychological givens. Ironically, because Gombrich is recognized for his seminal essays establishing the conventional conditions of perception, the very essay in which he announces the limits to those conventions also demonstrates the limits of the perceptual approach.

In "Image and Code: Scope and Limits of Conventionalism in Pictorial Representation," Gombrich examines a variety of instances which mix the conventional with the natural. Some, he points out, like comic books, depend for their recognition on codes, but others, like erotic response to the nude, are largely "natural." And, he concludes, "Western art would not have developed the special tricks of naturalism if it had not been found that the incorporation in the image of all the features which serve us in real life for the discovery and testing of meaning enabled the artist to do with fewer and fewer conventions. This, I know, is the traditional view. I believe it to be correct."[16]

In grounding his conclusions on the physiology of human perception, however, Gombrich has established not the limits of convention but the limits of the perceptual approach. A moment's reflection will verify that responses to the nude are in fact decidedly conventional, specifically because the nude in question is conventionally assumed to be female. Erotic responses, Freud would tell us, are as much learned as are aesthetic ones. The effort to distinguish between the natural and conventional thus collapses, particularly when one realizes that perception is not limited to (or even possible with) the straightforward physiological process whereby the inverted image is cast on the back of the retina and neurologically transmitted to the visual cortex. Instead it becomes culturally complicated when that image is interpreted by the brain. As W. J. T. Mitchell has demonstrated, Gombrich's perceptual approach is as convention-laden as those visual illusions he has so successfully analyzed in perceptual terms.[17]

This does not, of course, in any way diminish the considerable contributions of Gombrich and his contemporaries. In fact, scholars of the image have been slow to react to the current critical emphasis on culture (shared by feminism and the new historicism, for example) precisely because this interdisciplinary field has been so richly explored by theorists like Panofsky and Gombrich.

In recent years, however, it has become increasingly apparent that the very issues which studies in culture might wish to address are not well-handled by a perceptual approach. Indeed the failure to recognize fully that perception is itself culturally conditioned and that cultural assumptions are behind the very act of "seeing" has deflected scholarly attention

from issues like the power of the visual image as an indicator of cultural concerns. It is largely within the last decade that scholars in interartistic studies have begun to emphasize the image as situated in cultural, as opposed to perceptual, contexts. Broadly speaking, they join those who, in a variety of fields, have been taking note of the ways in which communication relies on a matrix of social and cultural norms. From this point of view, cultural setting becomes not merely interesting background but intrinsic to comprehension.

By reorienting sister arts studies in the direction of cultural criticism, scholars have not only begun to give the visual image particular attention, they have also reoriented theoretical discussions. W. J. T. Mitchell, for example, argues that no theory of the image can be isolated from the historically situated politics of iconophilia, iconophobia, idolatry, and iconoclasm in Western culture. By moving our understanding of images from the perceptual domain to the field of cultural recognition, Mitchell has provoked a variety of questions about the nature and function of the image in interart studies that have only recently begun to be explored. Similarly, Norman Bryson, in his introduction to *Calligram: Essays in New Art History from France,* details the way in which art as an "activity of the sign" permits us to take note of the fashion in which our ability to recognize images is "an ability that presupposes competence within . . . socially constructed codes of recognition." By shifting our understanding of image-making and reception from the perceptual domain to the field of social recognition, Bryson identifies the social formation not as something that appropriates or utilizes the image after it has been made; rather, he argues, the image, as an activity of the sign, unfolds within the social formation from the beginning. By redefining and repositioning our understanding of the relationship of art to culture and ideology, Bryson thus refines earlier word/image theory into an instrument for revealing and analyzing cultural activity.

The shift from seeing the image as the result of perception to thinking about the image as a product of culture is thus a gain in that it moves the field of discussion in sister arts studies from issues of boundaries and distinctions between the verbal and visual arts to new areas of consideration for both theorists and practitioners. Among these might be, for example, queries into the extent to which the tension between iconophilia and iconoclasm which scholars like Mitchell see as integral to Western culture is in fact an inevitable by-product of Western fascination with the image, or whether that tension is itself historically specific, more pertinent to Western culture since the Reformation than before. Another set of questions might include explorations of the material nature of the image, in words as well as paint, raising the possibility that the light shed by earlier, formalist scholarship may have left other important insights in obscurity.

More generally, the receptivity of word and image studies to other critical approaches like feminism, neohistoricism, or cultural materialism might clarify more fully the extent to which this shift moves critical discussion away from formalist and structuralist abstractions to a more specific interest in the gendered nature of perception or the racial and/or class bias in what was in the past taken for the "natural" or unquestionably self-evident.

Moving away from even such historically localized abstractions as the vexed notion of periodization, this reorientation in our thinking about the image replaces vague studies of influence or generalized thinking about an elusive *Zeitgeist* with more specific analyses of the ways in which the particular handling of a given visual image or set of images might function as a clue to what cannot be easily said verbally. Thus, rather than resting with such conclusions as the "mute" and hence vulnerable nature of the visual image, for example, these studies can instead investigate the ways in which a given text, either verbal or visual, might make use of that assumption to accomplish its own ideological objectives.

3

Precisely because the new location of the image in cultural contexts does open up such a variety of questions and possibilities for exploration, we have resisted too fine a categorization of the essays collected here. Instead, our selected essays range in chronological scope and methodological variety from the twelfth to the twentieth centuries. They differ widely in substance, emphasis, and method. At the same time, however, they agree in rejecting the Gombrichian privileging of the "natural" over the conventional and in aggressively challenging the essentialist notion of perception as the ground for interdisciplinary study. We have organized them under the simplest headings—the nature of the "text" that each has chosen to address.

Accordingly, the essays of the first section concern themselves in some way with paintings, which serve as a means by which the authors explore other genres, such as drama, poetry, and essays. The second section has as its common element the book as a crossroads of genres, high and low culture, thought and action, addressing questions of gender, religion, and aesthetic value. The essays of the third section collapse the inherent sister arts orientation of the first two into artifacts loosely associated with the traditional distinction between "painting" and "poetry," but more popular or less distinct than these—film, maps, bridges, headstones, architectural elements, even computers.

The first of the essays, "Sibling Rivalry in the Arts Family: The Case

of Poetry vs. Painting in the Italian Renaissance" by James V. Mirollo, surveys a significant portion of the sister arts linkage while at the same time challenging the harmony of that pairing, particularly as it obtains in its alleged "source," the Italian Renaissance. Mirollo's lively reservations about some of the theoretical propositions stated in this preface underscores the point that a cultural approach to interart comparisons is more valuable for its vitality than for any theoretical consensus. The essay which follows his, by Ann Hurley on the politics of John Donne's Lothian portrait, shifts the discussion from the Italian Renaissance to the English Reformation. In so doing it also moves from Mirollo's explication of the general social, psychological, and economic motives involved in the Renaissance sister arts controversies to a specific instance of visual art that offers particular, suggestive cultural clues.

Moving into the eighteenth and nineteenth centuries, the two essays by Timothy Erwin and Michael Wilson use paintings as departure points for cultural analyses of literary theory and drama, respectively. Erwin's essay argues that Annibale Carracci's *Venus Adorned by the Graces* is both "inspiration for and allegory of a visual theory in which the creation of the beautiful is understood as the intersection of an ancient, otherworldly ideal with the human practice of artful design," and then demonstrates how the frontispiece of Pope's *Rape of the Lock* as parody of the Carracci can be seen as the material sign of the loss of that earlier ideal. Wilson's essay also directs attention to a specific painting as a clue to a matrix of values. Sir Joshua Reynolds's famous portrait of the actress Sarah Siddons, he argues, is a complex collaboration between artist and sitter such that the signs of an "ideology of rational discourse" are inscribed for the first time on the body of a female actress. Thus Reynolds's portrait, by invoking and enhancing Siddons's acting style, associates with that actress the entire complex of values summed up for the eighteenth century by the idea of "dignity," while at the same time it implies a nonverbal repertoire of acting gestures to challenge the previous dominance of speech in theatrical performance.

James Heffernan also addresses Reynolds, but this time in the context of Foucault's theory of discursive formation as applied to painting. The discursive system of the *Discourses,* however, as Heffernan points out, was unable to accommodate much of the painting which even Reynolds himself admired, such as landscape. It remained for the artist J. M. W. Turner, instead, to formulate a painted discursive system which would actively confront and displace literature as the legitimating factor in the hierarchy of painterly art, a task which Turner accomplished not through absolute independence of verbal narrative but by the verbal and graphic originality with which he reconstructed his literary sources.

The second section begins with two essays on medieval books. In both,

the images and the texts that surround them are simultaneously narrative and symbolic. The "fragmentation" of medieval verbal and visual images can make even the "merest daubs" difficult to read, yet allows for complex literary evocations that defy easy analysis. When we find ourselves dissatisfied with either text or image from the medieval period, we may well dismiss what we are witnessing as incompetence. But, as these essays demonstrate, where meaning is elevated above execution, and where so many conflicting meanings coexist, we are probably missing the interpretive key. The question is, where do we look for it?

In Robert Boenig's essay, "The Fragmentation of Visionary Iconography in Chaucer's *House of Fame* and the *Cloisters Apocalypse*," the key is a learned, albeit popularized and well-known source, the Book of Revelations. The interpretive problems posed by Chaucer's *House of Fame*, its incomplete state among them, have made satisfactory interpretations difficult. Yet, as Boenig shows, the *Cloisters Apocalypse* (and illuminations in its family) give to the *House of Fame* a base from which to proceed—the known from which or to which to associate the new invention. Boenig demonstrates that images having their source in prior tests are conflated, rearranged, dispersed—fragmented—in the newly constituted text. Similarly, the illuminations fragment the text they illustrate, conflating, rearranging, and dispersing the elements of the text in which they are contained.

The miniatures that resist interpretation in Kate Greenspan's essay, "A Medieval Iconographic Vernacular," seem at first so incompetently drawn that they can be nothing but the result of ignorance of prevailing iconographic tradition and the limner's lack of discrimination and obvious clumsiness with the pen. But it becomes clear that the symbols of the learned culture have not been misunderstood or misrepresented. Rather, they have been appropriated, "vulgarized" in the same sense as Latin literature was vulgarized by translation into local vernaculars; their meaning has been enhanced by the arrangement of traditional symbols into configurations that reflect the lessons taught by a locally venerated holy woman, the author of the surrounding text. Thus both the "House of Fame" and the miniatures of the "Erklärung des Vaterunsers" rely upon their readers'/viewers' familiarity with an extratextual source for coherence and memorability.

Ruth Larson, in "Looking and Learning: Gender, Image and Text and the Genealogy of the Textbook," argues that, like the earlier miniatures, seventeenth-century book illustrations had a greater purpose than merely clarifying the text. They were to reach out, in particular to women, emplanting powerful images in the memory and supplanting those of the weak feminine imagination. As she lucidly demonstrates, the illustrations were meant to control to a precise degree the quality of the moral lesson

to be drawn from the text by the female reader. The textbooks and their illustrations complement each other, creating especially memorable images to shape the personal lives of the women for whom they were designed.

The last essay in this section, Michael Fried's "Almayer's Face: On 'Impressionism' in Conrad, Crane and Norris" makes a rather different argument. As he persuasively argues, the three authors he treats all grappled with the relationship between the book as artifact, as paper, ink, words written upon a page, and the book as ideas, story, narrative. The images of "disfigured faces" are the sheets of writing paper overwritten. The materiality of the writing implements opposes the writer, becomes, in a sense, his victim: writing is an act of mutilation, the physical act of writing that overwhelms the intellectual act of thinking or reading. That fruitful relationship in the fiction of Conrad, Crane, and Norris takes us from images in the book to images of the book.

The essays in the third section of this collection begin with Eileen Reeves's discussion of "Reading Maps," an intriguing resurrection of the graphic map's early association with the printed word and its eventual denial of that association. Maps today are thought of as properly classified with visual artifacts, yet the map only attained graphic status after viewers learned to approach it as a legible text.

James Kettlewell is also concerned with interpreting as a legible symbol another artifact usually thought of as primarily graphic, the Puritan headboard. Like the graphic forms which signify essential information on a map, the ornamental patterns from these headboards were originally abstracted from forms in the real world and then modified. Puritan iconoclasts, the last to have countenanced the "frivolity of mere visual enjoyment," created these forms with serious purpose, Kettlewell suggests. Indeed, the symbols of the headboards functioned as sermons on the relationship between love and death, he argues, and their extreme modification of the natural object was an essential precaution for the Puritan believers in their sensitivity to the dangers of idolatry.

The essay by John Erwin on Henry James's *Golden Bowl,* in offering a challenge to some modern theoretical positions, turns the focus of investigation toward the use of architecture. By conflating textual and architectural succession, James circumvents the nihilistic tendencies of deconstruction, Erwin argues, and thus his novel "articulates the fuller incarnation of reading which buildings propose." Ernest Gilman's essay, "Milton and the Mac," accomplishes a similarly startling juxtaposition of the modern with the past. Here the issues of the sister arts tradition in regard to verbal and visual space are revisited in support of Gilman's thesis that "with hypertext we come round again to a conception of the text as spatiotemporal, as written and graphic, as dimensional and archi-

tectural," an ample conception of text and one which once was the medium of delineation for Milton.

"Wrapping Presence and Bridging the Cultural Gap: The Case of the Pont-Neuf" by Constance Sherak brings us to a new architecture and a renewed artifact: the oldest bridge in Paris transformed, made truly new by art. Sherak shows us how, by wrapping the Pont-Neuf in 440,000 square feet of cloth, Cyril Christo made the old stone bridge ephemeral, endowing it with a new iconic function. The bridge's accumulated meanings, as well as temporarily its function, abridged, it turns from object into sign, challenging cultural codes, causing onlookers to question what they understand by what they see.

The collection concludes with an essay by W. J. T. Mitchell on film, like the Mac another modern site of word and image convergence. In his analysis of Spike Lee's *Do the Right Thing,* Mitchell addresses the topic of cultural violence in public art and explores the oppositions and ironies involved along the borders of public art and private viewing space, actual violence and symbolic violence, commercial appeal and cultural consumption, and the expression and suppression of sex and violence in modern American culture. By placing Lee's analysis of racial tension against this densely complex background, Mitchell is able to demonstrate the ways in which Lee's concerns turn on issues of space and cultural identity as well as on race and property.

Finally, our collection takes its title from Sir Philip Sidney's observation, in his *Apologie for Poetrie,* that "Nature never set forth the earth in so rich tapestry as divers poets have done." Sidney's affirmation of poetry, expressed in the vocabulary of its sibling, the visual, invites an exploration of the complex interaction of verbal and visual as an index to Western culture. These essays are offered as a beginning to that exploration.

NOTES

1. Plato, "*The Republic,* Book X," in *Critical Theory Since Plato,* ed. Hazard Adams (New York: Harcourt, Brace, Jovanovich, 1971), 37.

2. Horace, "Art of Poetry," *Critical Theory Since Plato,* ed. Hazard Adams (New York: Harcourt, Brace, Jovanovich, 1971), 73.

3. J. D. Mansi, ed., *Sacrorum conciliorum nova et amplissima collectio,* vol. 13, col. 256A (Florence and Venice, 1759–98). Cited by David Freedberg, *The Power of Images* (Chicago: University of Chicago Press, 1989), 403.

4. *Canons and Decrees of the Council of Trent,* 25th session, December 1563, original texts and translation by H. J. Schroeder, O.P. (St. Louis, Mo.: B. Herder, 1941), 214–15. Cited by Ernest Gilman, *Iconoclasm and Poetry in the English Reformation* (Chicago: University of Chicago Press, 1986), 32.

5. Cited by Ernest Gilman, *Iconoclasm and Poetry in the English Reformation* (Chicago: University of Chicago Press, 1986), 33.

6. J. Migne, ed., *Patrologia Latina,* 162 vols. (Paris, 1844–64, vol. 118, col. 1265). Cited by David Freedberg, *The Power of Images* (Chicago: University of Chicago Press, 1989), 92.

7. David Freedberg, *The Power of Images* (Chicago: University of Chicago Press, 1989), 317–344.

8. Ernest Gilman, *Iconoclasm and Poetry in the English Reformation* (Chicago: University of Chicago Press, 1986), 132.

9. "Homilie against perill of Idolatrie," in *Certain Sermons or Homilies* (London, 1623; facs. Gainesville, Fla.: Scholars Facsimiles & Reprints, 1968), 61.

10. David Freedberg, *The Power of Images* (Chicago: University of Chicago Press, 1989), 331.

11. Ibid., 344.

12. Conrad Rudolph, *The "Things of Greater Importance": Bernard of Clairvaux's Apologia and the Medieval Attitude Toward Art* (Philadelphia: University of Pennsylvania Press, 1990), 8–23; 80–88.

13. Wylie Sypher, *Four Stages of Renaissance Style* (reprint, Gloucester, Mass.: Peter Smith, 1978), 1.

14. Ibid., 32–33.

15. Ibid., 9–10.

16. Ernst H. Gombrich, "Image and Code: Scope and Limits of Conventionalism in Pictorial Representation," in *Image and Code,* ed. Wendy Steiner (Ann Arbor: University of Michigan Press, 1981), 40–41.

17. See *Iconology,* where Mitchell argues that "the 'nature' implicit in Gombrich's theory of the image is . . . far from universal, but is a particular historical formation," 90.

WORKS CITED

Bryson, Norman, ed. *Calligram: Essays in New Art History from France.* Cambridge: Cambridge University Press, 1988.

Da Vinci, Leonardo. *Leonardo on Painting.* Edited and translated by Martin Kemp. New Haven: Yale University Press, 1989.

Freedberg, David. *The Power of Images.* Chicago: University of Chicago Press, 1989.

Gilman, Ernest. *Iconoclasm and Poetry in the English Reformation.* Chicago: University of Chicago Press, 1986.

Gombrich, Ernst H. "Image and Code: Scope and Limits of Conventionalism in Pictorial Representation." In *Image and Code,* edited by Wendy Steiner. Ann Arbor: University of Michigan Press, 1981.

"Homilie against perill of Idolatrie." In *Certain Sermons or Homilies* London, 1623. Facs. Gainesville, Fla.: Scholars Facsimiles & Reprints, 1968.

Horace. "Art of Poetry." In *Critical Theory Since Plato,* edited by Hazard Adams, 68–75. New York: Harcourt, Brace, Jovanovich, 1971.

Lee, Rensselaer W. *Ut Pictura Poesis: The Humanistic Theory of Painting.* New York: Norton, 1967.

Lessing, Gotthold Ephraim. *Laocoön: An Essay on the Limits of Painting and*

Poetry. Translated by Edward Allen McCormick. Baltimore: The Johns Hopkins University Press, 1984.

Mansi, J. D., ed. *Sacrorum conciliorum nova et amplissima collectio.* Vol. 13, col. 256A Florence and Venice, 1759–98.

Migne, J., ed. *Patrologia Latina.* Vol. 118, col. 1265. Paris, 1844–64.

Mitchell, W. J. T. *Iconology: Image, Text, Ideology.* Chicago: University of Chicago Press, 1986.

Plato. *The Republic,* Book X. *Critical Theory Since Plato.* Edited by Hazard Adams. New York: Harcourt, Brace, Jovanovich, 1971.

Rudolph, Conrad. *The "Things of Greater Importance": Bernard of Clairvaux's Apologia and the Medieval Attitude Toward Art.* Philadelphia: University of Pennsylvania Press, 1990.

Schroeder, H. J., O. P. trans. *Canons and Decrees of the Council of Trent,* original texts. 25th session, December 1563. St. Louis, Mo.: B. Herder, 1941.

Sypher, Wylie. *Four Stages of Renaissance Style.* Reprint, Gloucester, Mass.: Peter Smith, 1978.

So Rich a Tapestry

Part I
The Painting as the Material Text

Sibling Rivalry in the Arts Family: The Case of Poetry vs. Painting in the Italian Renaissance

JAMES V. MIROLLO

But many other things have the power of persuasion . . . even some sight unsupported by language according to the general opinion Phryne was saved not by the eloquence of Hyperides, admirable as it was, but by the sight of her exquisite body, which she further revealed by drawing aside her tunic
Still I would not for this reason go so far as to approve a practice of which I have read, and which indeed I have occasionally witnessed, of bringing into court a picture of the crime painted on wood or canvas, that the judge might be stirred to fury by the horror of the sight. For the pleader who prefers a voiceless picture to speak for him in place of his own eloquence must be singularly incompetent.

<div align="right">

—Quintilian, *Institutio Oratoria,*
2.15.6–9; 6.1.32–33.

</div>

If you [poet] assert that painting is dumb poetry, then the painter may call poetry blind painting
Music is not to be regarded as other than the sister of painting
. . . the poet remains far behind the painter with respect to the representation of corporeal things, and with respect to invisible things, he remains behind the musician.

<div align="right">

—Leonardo, *On Painting*

</div>

If painting claims to be the younger sister of poetry, at least she should not be a jealous sister and should not deny the older one all those ornaments unbecoming to herself.

<div align="right">

—Lessing, *Laocoön*

</div>

. . . the metaphysical poet wishes to seem as independent of the painter as possible. The two arts are often quarreling sisters, a fact that may be no more than a later manifestation of the Renaissance contest between the arts but seems rather to arise from a tendency latent in this type of verse, a tendency to be unpictorial, conversational, and witty.

<div align="right">

—Hagstrum, *The Sister Arts*

</div>

Musica e Poesia son due sorelle

 —Marino, *Adone,* 7.1

A glance at an old tradition dating back as far as Homer's de-
scription of Achilles' shield will easily convince us that poetry
and painting have constantly proceeded hand in hand, in a sis-
terly emulation of aims and means of expression.

 —Praz, *Mnemosyne*

The poet, through the medium of words, characteristically imi-
tates not only what presents itself to the eye, but also what
presents itself to the intellect. The two arts differ, therefore, in
this respect; but they are similar in so many other respects that
one can almost call them brother arts.

 —Aretino in Dolce's *Dialogue on Painting*

 Painter yo' are come, but may be gone,
 Now I have better thought thereon,
 This worke I can performe alone:
 And give you reasons more then one.

 —Jonson, *Eupheme*

This essay departs from the conviction that the Italian Renaissance chap-
ter in the history of sister arts theory and practice is in need of revision,
or at least considerable refinement. To that end, after some preliminary
comment by which I situate my interest and approach in relation to cur-
rent interart inquiry, I devote the first part of my argument to the complex
and contradictory deployment of the consanguinity trope in classical and
Italian Renaissance interart commentary. To epitomize the social and
psychological motives involved, I label them sibling rivalry, and iconin-
vidia, or image envy. In the second part I turn from theory to the specific
confrontation of some Renaissance poets and paintings, poets and paint-
ers, including attention to how painting resists its appropriation by *let-
terati.* A painting by Titian is featured as the site of convergence of many
of the issues raised in my discussion, if not indeed in the essays from
the Skidmore conference that make up this volume. By also adducing
a few modern poetic responses to the Titian painting, I raise the ques-
tion, finally, whether my conclusions are culture-specific or have post-
Renaissance continuities.

 For my own convenience I like to label the spurt of recent interart
studies mentioned above as the post-Lessing or post-*Laocoön* movement,
even though it is actually an activity rather than a movement, a variety
of critical methods and approaches rather than an organized assault on
the past. Its practitioners, several of whom are represented in this volume,
tend to see fluid borders between the arts or dialectical confrontations

between word and image in such conventions as ekphrasis or between word and image when viewed from the perspective of recent literary theory and/or culture studies. It scrutinizes the formal, perceptual, and signifying features that are alleged to link or distinguish word and image, poem and painting, reading and viewing; it has challenged the venerable distinction between the allegedly conventional and temporal word, and the natural, spatial image. It has also ventured into what Murray Roston has called "that waif of literary scholarship," synchronic intermedia interpretation.[1] Examples from the prolific production of the past decade include essays in such journals as *Style, New Literary History, Representations,* and *Critical Inquiry;* W. J. T. Mitchell's investigations of iconology; anthologies such as *The Female Body in Western Culture,* edited by Susan Suleiman, *Calligram,* edited by Norman Bryson, *Space, Time, Image, Sign,* edited by James Heffernan; and the establishment of a new publication series entitled *Literature and the Visual Arts,* appropriately subtitled *New Foundations,* edited by Ernest Gilman. Among the journals devoted wholly to our topic, *Word & Image* began publication in 1985, and in 1989 Wendy Steiner edited a double issue of *Poetics Today* devoted to art and literature. The MLA published a year later a collection of essays on *Teaching Literature and Other Arts,* which is interesting not only for the contributions by members of the movement I am describing but also for its revelation of continuing traditional approaches in many college classrooms. Also, in 1990, there was in addition to the Skidmore conference another held at Indiana on the topic "Intertextuality: German Literature and the Arts," which is in its way an additional rebuke to Lessing. Indeed, as one contributor to the *Poetics Today* issue put it, "Now Lessing's voice should be heard no longer as a source of great anxiety or unchallengeable authority."[2] If that is so, and I believe it is, that authority has been challenged not only by scholars and critics such as those mentioned above but also by influential border-crossers from art history, philosophy, and psychology who have helped to make this that rare academic bird, a truly interdisciplinary enterprise.

I conclude this brief survey by singling out four interart critics whose work has confirmed some long simmering intuitions and entrenched convictions of my own, or severely tested them. Of the Renaissance studies of Giancarlo Maiorino, Clark Hulse, and Paul Barolsky I will have some things to say below, although I might draw attention here to Barolsky's exuberant and wide-ranging book on Pater as a recent example of defiant border-crossing. Or to Clark Hulse's Foucauldian geneology of Renaissance interart discourse, which curiously ends up replicating the period's own propaganda about interart harmony and cooperation.[3] The work of W. J. T. Mitchell has obviously had an impact on the conflictual model I will be discussing, and indeed has clearly inspired the announced theme

of this conference. I find especially provocative Mitchell's positing of a semiomachia, a war of the signs, a less than holy strife, with the word bullying the image as the powerful oppress the weak in the political and social arena, though occasionally *she* fights back. But Mitchell's relationship to the post-Lessing movement is a unique one: on the one hand, he has deconstructed Lessing's argument to powerful effect, but on the other, as his most recent statement in the MLA essay confirms, he is wary of juxtaposing poems and paintings, especially for the purpose of illustrating period style. His work clearly privileges sites of direct image-word confluence, whether in Blake or *Sunset Boulevard*.[4]

As a scarred veteran of the interart wars, bred on Mario Praz and Wylie Sypher, and used to skulking around English departments clutching hidden slide trays, I must admit that I find the interart activity I have been summarizing quite exhilirating. So much so, indeed, that it may seem ungrateful of me to suggest now some reservations I have about "the movement," but I do so because they underpin what follows.

First, the majority of the post-Lessingites are specialists in post-Renaissance literature, hence they tend to privilege later works and their cultural contexts in critical discussion, witness, to name but a few, Charles Altieri, Regina Barreca, Norman Bryson, Wendy Steiner, and Marianna Torgovnick. There are obvious exceptions, such as the work of Ernest Gilman and the occasional foray of a Wendy Steiner, and everybody else, into the paintings of Brueghel. Given the exigencies of specialization, it is understandable that the Renaissance period and its classical antecedents are usually taken up as "background," drawing heavily, as well they should, on such exemplary texts as Hagstrum's *The Sister Arts* and Lee's *Ut Pictura Poesis*. Given, too, that interart study is and must be a collective effort, I am aware that I am as much lamenting the preoccupation of so many young Renaissance scholars with early modern *verbal* texts as I am regretting the dominance of post-Renaissance and modern texts and issues in current interart criticism. Even such recent studies as David Evett's *Literature and the Visual Arts in Tudor England* (1990) and Patricia Fumerton's *Cultural Aesthetics: Renaissance Literature and the Practice of Social Ornament* (1991) are more concerned with historicist juxtapositions of verbal and visual evidence than post-Lessingite theory.[5]

Still, if in their *Poetics Today* essays, Marianna Torgorvnick can advocate "a return to the impulses behind the idea of a zeitgeist," (301), and Charles Altieri can urge the need for "an aesthetic idealism," (375), I may be forgiven if I trot out some residual positivism from my past and draw attention to the need for historical "evidence." If we cannot fully recover the Renaissance, yet want to invoke supporting or confirming sources and continuities, we should wish to do so on the basis of an informed and

informing archeology of historical particulars. Though no guarantee against the invention as opposed to the recuperation of the past, such particulars may serve at least as useful stumbling blocks.

In a more theoretical vein, it will be apparent in what follows that I am not entirely comfortable with some critical assumptions that underlie the work of several interart critics. One such assumption is that verbal and visual works are texts, autonomous codes or assemblages of signs and signifiers. I prefer, and not just for heuristic purposes, to imagine Renaissance creations as complex, to see poems and paintings as both texts *and* works, as both signifying systems or sign types *and* objects made in a particular historical moment and context by someone, author or artist, whom I hold responsible, at least provisionally, for what he and she made or said. It may well be that Renaissance artists and their creations are necessarily passive reflectors and transmitters of cultural ideologies; but I like to test them for deviation, transgression, and opposition as well as reflection. I allow for the possibility that the artist can, as Albert Cook might put it, change the signs. Nor do I rule out an intentionality that may range from the relatively innocent if boring desire to express lofty sentiments and ideals to the most abject appeal for patronage, from the satiric urge to reform society to the most mundane concern with accumulating wealth. If not a commodity in the Marxist sense, the Renaissance work is certainly for sale. In good old Aristotelian terms, poems and paintings have material, efficient, and final causes as well as formal causes or meanings. Obviously, then, I am a card-carrying eclectic who cheerfully pilfers from various methods and approaches, trying to get all the help I can, while keeping a wary eye on post-Renaissance, post-fabricated paradigms.

1

Broadly conceived, Italian Renaissance interart theory and praxis include more than the sister arts discourse and sibling rivalry I am focusing upon here. It is well known, for example, that there was a good deal of speculation upon such sites of confluence of word and image as the emblem and *impresa*. And in the wake of Protestant iconoclasm, a new preoccupation with the image in post-Tridentine disquisitions on the decorum of sacred art. But although the English Reformation attitudes and practices have been studied, most recently by Ernest Gilman, there has not been similar attention paid to the Catholic side.[6] From this perspective, one might study a work such as Cardinal Gabriele Paleotti's 1582 *Discourse on Sacred and Profane Images,* the first two books of which constitute an iconology and an iconography.[7] In the first, Paleotti takes

up the ontology and history of the image as well as its uses and abuses. In the second, his concern is with the painted and sculpted image, with particular attention to every kind of depiction, from sacred theme to *imprese* to decorative grotesques, all duly approved or censured. Paleotti's distinction between the theoretical *imagine* and the problematic *pittura* is a crucial one for counter-Reformation apologists, and finds a curious echo in the admonition of King James I to his grumbling Scottish subjects that they should distinguish between "pictures intended for Ornament and Decoration, and Images erected for Worship and Adoration."[8]

Again, broadly conceived, Italian interart theory would comprehend the mythography that underlies the iconographic imagery of the time as it comes to be summarized in such works as Ripa's dictionary of personifications entitled *Iconologia* (1593). And interart praxis would embrace not only such familiar composite forms as the illustrated book but also such joint efforts as the infamous *I Modi* (The Sixteen Sexual Positions), which featured engravings by Marcantonio Raimondi of Giulio Romano's images, each of which is accompanied by a sonnet composed for them by Pietro Aretino. Now made available by Lynne Lawner, this long surpressed work was easily the most scandalous interart project of the sixteenth century.[9]

Given so broad and rich a spectrum of interart theory and practice, one might question my focus on sister arts chatter, what Galileo, writing in 1612, characterized as "an exercise of wit and ingenuity" on the part of those who are not artists.[10] With due apologies to the great astronomer, I would reply as I would to any charge of "mere rhetoric," that in the Renaissance everything is mere rhetoric—and nothing is. Besides, the sheer, overwhelming quantity of interart commentary, ranging from brief tags to extended *paragoni* arouses speculation, just as the considerable complexity and inconsistency of the commentary invites interpretation. Nor can one rely on modern scholars, who tend to read back into the Renaissance scene a coherence it did not possess, as when Praz, quoted above, posits a sisterly harmony that was at best an ideal, and Hagstrum, also quoted above, recognizes an antagonism between the sisters but suggests this may be "a later manifestation" of an earlier peaceful coexistence. In this regard, my epigraph quoting Lessing, while it deploys the venerable sister trope, at least acknowledges differences in age, *and* jealousy. Note, too, the quotations from Leonardo and Ben Jonson, the former obviously spoiling for a fight and the latter contemptuously dismissing one. Nor is it clear just who the sisters are, Marino claiming (along with Ronsard, whom he is translating here) that they are poetry and music, Leonardo that they are painting and music. To complicate matters further, Dolce has Aretino switch siblings and make poetry and painting "quasi" brothers. And then Francisco de Hollanda, Lomazzo,

and Marino (in another place) argue that poetry and painting are *twin* sisters, to stress their identity and convertibility.[11] But it is always two arts that are singled out, rather than all of them being identified as siblings. If this sounds like a family squabble, we shall see that in a significant sense it is just that.[12]

Now since Renaissance rhetoric is often meaningful as a metarhetoric, utilizing, by commenting upon, classical sources, we had best glance at those sources to see if they can help account for the complexity and incoherence I have been describing.

If Plato and Aristotle, in their comment upon the arts as modes of representation, inaugurated the idea of their being related,[13] it is Cicero who made them blood relatives by his use of the consanguinity trope.[14] Although his claim that "omnes artes" (all of the arts) were linked by a "quasi cognatione" (a kind of consanguinity) hovers between analogy and metaphor, and as we have seen that "quasi" will be remembered, it is the trope that will surface in later associations of any two of the arts. For poetry and painting, the misunderstood passage in Horace *(ut pictura poesis)*[15] was essential, but also, as Nelson Goodman points out, "metaphors become more literal as their novelty wanes," hence tend to be stated as facts.[16] He also suggests that "where there is a metaphor there is conflict" (69), and conflict is indeed present in the Plutarch quotation of Simonides, which was to be resented by Italian Renaissance painters and defenders of painting because of its imputation of silence or dumbness to their art. That this could have a gender implication is made clear when Francisco de Hollanda, challenged to defend painting against poetry, asks sarcastically how he can do so, being the disciple of a dumb and voiceless lady (41–42).

The Simonides tag also proposes the equally influential notion that the two arts are convertible as well as similar, and this, too, was to prove an ideal that also irritated with its implication that the two arts are not uniquely different. Unfortunately, the presence of the Simonides quotation has distracted attention from the rest of the passage in Plutarch where it occurs as part of a eulogy of Athens as "mother and kindly nurse" of the arts.[17] This is significant not only because it proposes the arts as children of a single mother but also because the context of the remark, a discussion of mimetic fidelity in visual and verbal art, argues that the aim of the children is to imitate their mother, Nature. Hardly less significant is the more overtly political point that the arts are nourished by and should therefore be in the service of, or at least glorify, the state.

What might be called the politics of the sister arts emerges in the use of the maternal trope in classical and Renaissance city eulogies. These so-called rhetorical exercises could have real political purposes, as Hans Baron has shown in the case of Leonardo Bruni's early fifteenth-century

laudatio of Florence, which was a weapon in the struggle with the Milanese.[18] Bruni adapted the orator Aristides' praise of Athens, which included the nourishing-of-the-arts topos, and thereby transmitted it to later apologists for city-state and principality. It became a cliché also in the praise of Italy as a region, especially useful to visitors like Francisco de Hollanda, who deployed it in his 1548 dialogues on painting, already cited, as a way of ingratiating himself with his hosts (19). The pursuit of patronage, as the etymology of the word reminds us, involved not just maternally nourishing art activity but the courting of paternal power and support.

Whether the children of Mother Nature or of the state as mother and nurse, the arts obviously had to scramble for the attention of powers with other preoccupations. The dominant gendering of the arts as sisters, though not specifically stated in classical sources, may have become a cliché in the Renaissance because of this subordinate status. Granted the impetus of grammatical gender (all of the arts being feminine) and visual and verbal conventions such as the depiction of the classical Muses as female; yet, as we have seen, Dolce could have Aretino speak of *brothers* and the late Renaissance painter-academician Federico Zuccari could change the visual signs in a 1599 ceiling fresco of his own palace. Following Vasari's earlier assumption in the 1568 edition of the *Lives* that *disegno* or design was the *father* of the visual arts, Zuccari depicted it as a *male* figure surrounded by the conventional female representatives of these arts, thereby displacing Mother Nature. For him, as for Vasari earlier, *disegno,* as a mental image or power, could not be represented as female since this would weaken the claim being made for painting as an intellectual activity. Interestingly enough, Vasari himself had changed the verbal signs in 1568, for two decades earlier he had referred to *disegno* as *madre* (mother) of the arts.[19]

Politically, however, harmonious sisters were a more plausible idea to promote the several arts than the notion of harmonious brothers, it being well and painfully known that the rivalry between brothers had caused upheaval, violence, and bloodshed throughout the peninsula, whereas sisterly conflict occurred rarely, and to any effect only at the highest levels of state, and in any event in far off places like England, where they were foolish enough to have ruling queens. The Goneril-Regan folktale motif of quarreling sisters or mean stepsisters was not widespread in the Italian Renaissance, as the Lessing epigraph quoted above might suggest. The sisterly ideal was exemplified by those two celebrated patronesses of the arts, Isabella and Beatrice d'Este, the fraternal obverse by their murderous male relatives.[20]

The resonance and mutual reflectivity of the consanguinity metaphor and the realities of actual family life—ideals of harmony threatened by discord—account for the reception of the classical sources. The ancient

pedigree confirmed and authorized existing models of patriarchal hier-
archy and power, at all levels. The ideal of a family-of-the-arts as well as
the contradictory actuality of bitter conflict are well illustrated in three
mid-sixteenth-century documents. In his *Lives* of the artists, Vasari uses
many myths in the interest of bolstering the social and economic status,
and therefore the prestige, of his fellow *artefici* (artificers). As a recent
study by Paul Barolsky shows, chief among these is the fiction of family,
a vision of the artists as members of a Florentine family writ large, in
fact. As often happens in Renaissance discourse, the proposed ideal is
hortatory rather than descriptive, so that here Vasari is urging harmony
and cooperation so that all may acquire honor and profit.[21] Honor and
profit are also the leitmotifs of Benvenuto Cellini's *Vita,* but in contrast
to Vasari, he does not bother to conceal the real tensions in his world
between the ideal of solidarity and the demands of an art market. Turn
to almost any page of Cellini and you will find, hyperbole aside, vivid
examples of striving for upward mobility, of cut-throat competition, liter-
ally, and of no-holds-barred scrambling for patronage, but also of artists
as a group or as practitioners of a single art drawing up the wagons around
themselves against a common enemy.[22]

Family dynamics and sibling rivalry, whether psychological or eco-
nomic, are evident also in my third document, the invitation sent out in
1547 by the Florentine *letterato* (man of letters) Benedetto Varchi asking
a group of sculptors and painters for their views on which of their two
arts was preeminent. I will consider the replies below in my discussion
of the *paragone,* but here I want to draw attention to the word Varchi
uses, *maggioranza,* which I have translated as preeminence.[23] The word
also meant *majority* and is related to *maggiorasco,* which is the term for
entail, estate inheritance by the eldest son. The conflictual implications
of Varchi's usage are obvious.

But even a model of family discord does not fully explain the particu-
larly fierce rivalry between poetry and painting, which as I see it has
hitherto been seriously underestimated. To try to account for it, I adduce
two causes, one psychological, the other professional, mutually reinforc-
ing each other. What I referred to earlier as iconinvidia, or image envy,
has to do with the range of antagonistic feeling, from discomfort to hostil-
ity, experienced by practitioners of the word in the presence of the painted
(or sculpted) image. It may be that this hostility has a gender basis, and
that it involves rivalry for the attention and approval of the mother as
well. We all know that pictures *are* worth a thousand words because of
their instant appeal as iconic reflection of reality. But for all of these
reasons they also threaten to dominate the art market as the preferred
investment. My epigraph from Quintilian, juxtaposing two separate pas-
sages from the *Institutio Oratoria,* is a particularly relevant classical

source because of the centrality of oratory as a profession in the cultural life of antiquity, and the centrality of Quintilian in Renaissance humanistic discourse. The first passage very grudgingly acknowledges that a *sight* may persuade apart from words, the chief vehicle of persuasion, but the example given is a cheap erotic ploy by a sexy female. In the second passage, the gloves come off and Quintilian cannot hide his irritation at the threat "voiceless" pictures pose to the rhetorical establishment, with its domination of education, law, politics, and state ceremony. Particularly frustrating is the instant appeal of the picture to the audience, which invalidates the whole elaborate system of training in language that prepares the rhetor to be eloquent and, if effective, justifies his class status and prestige.

The various motives I have been discussing—sibling rivalry, image envy, social status, and economic well-being—underlie the tentative typology of appropriative techniques I would now like to propose and illustrate from classical and Renaissance examples. I focus on the ways writers appropriate visual works because it is they who, being most distressed and having most to lose, respond with obvious defensiveness. I also will suggest some ways in which painting specifically may react, especially in the Renaissance.

The first technique, aptly illustrated by Quintilian in the quotations just taken up, is to confront the visual theoretically and argue its inferior status, as determined by sanctioned cultural values. The second is to treat visual works as verbal texts needing interpretation—indeed, poets claim exclusive rights to their interpretation. The claim to interpretation rights is especially ironic insofar as the poets and rhetoricians, by their own admission, find the painting or statue notable for its mimetic accuracy, its utterly faithful notation of reality, not to mention their citing a source in a literary text such as Homer—all of which would seem to indicate that the work needed no interpretation at all! Still, the contradiction did not prevent the wordsmiths from exploiting their skills for honor and/or profit.

The third way of appropriating visual texts, closely allied to the second, is deliberately to misread the visual work in order to incorporate it into the literary system and the prevailing literary culture, thus reducing it to an illustration.

The fourth technique is to engage the visual work as an opportunity for the virtuoso display of literary skills in describing it—commonly known as *ecphrasis* or *ekphrasis*. This topic of interart inquiry has been pursued recently with a good deal of critical energy: witness the spate of journal articles in the past decade and now the full-length study by Murray Krieger entitled *Ekphrasis: The Illusion of the Natural Sign* (1991) and the book, *Museum of Words,* also combining diachronic and syn-

chronic approaches, general survey, and overarching theory, by James Heffernan.[24] These and other contemporary critics (Grant F. Scott, Marianne Shapiro, Wendy Steiner, Bryan Wolf among them) tend to heady theorizing about issues of aesthetics, ontology, and semiotics even as they deploy political concepts and terms (imperialism, power, dominance, ideology, and so on). Krieger, for example, referring to the current "spreading semiotic interest in texts," argues this phenomenon to be "the ultimate imperialistic move by literature and literary criticism to subject to its terms all the arts and all the arts of discourse alike" (26). On the whole, however, what prevails among recent critics is a rather benign view of ekphrasis as a means by which poetry tests its own limits and especially its mimetic potential. The ekphrastic poem thus, as a sign about a sign, discusses its own ontological status. My emphasis, of course, is not on this kind of usefulness for the poet but on how and why ekphrasis requires a put-down of the painter. For the classical period, and certainly for the Renaissance, the cultural "realities" indicate that ekphrasis involves image envy, turf-guarding, and job security.

A pertinent classical example would be the ekphrases of the sophist Philostratus, which are addressed to a young boy whose ignorance can justify the elaborate account of the painting while the larger audience of young men appreciate the rhetorician's encomiastic power. Philostratus regularly points out the painter's mimetic accuracy and the miraculous sensuous appeal of his work; but he also unfolds the narrative compacted therein, what he calls the painting's "story," delights in emphasizing any psychological or emotional elements depicted, and, though all of this should make the painting fairly accessible to even a boy, deliberately mystifies it by insisting, as a climax to his reading, that he will render its "meaning," often allegorically:

6. Cupids (Gathering Apples)
See, Cupids are gathering apples; . . .But listen carefully; for along with my description of the garden the fragrance of the apples also will come to you It is a beautiful riddle; come, let us perchance see if I can guess the painter's meaning. This is friendship, my boy, and the yearning of one for another.[25]

In his discourse on slander or calumny, Lucian says he wishes to show in words, "as if in a painting," what the nature of that vice is. But of course Apelles, he points out, had already done so in a famous painting, which he proceeds to describe in detail, thereby leaving us a famous and influential ekphrasis. Having done so, however, he then feels obliged to portray the characteristics of slander in words, obviously to show the superiority of the verbal description not tied to a picture.[26] In another place, Lucian tells some friends that he is concerned about his lectures being praised for their novelty rather than their more solid virtues. He

then instances a similar dilemma experienced by the painter Zeuxis, whose viewers appreciated his novel subject matter more than his craftsmanship. Thus Lucian not only aligns himself with the famous painter but also asserts that his is in a sense a superior art: he has an understanding audience of connoiseurs, the friends he addresses in this piece. Their learned appreciation makes up for and allows him to continue addressing that other, vulgar audience to which Zeuxis is limited.[27]

We have already noted the importance of the voicelessness motif, deriving from the Simonides formula, and here I want to adduce some examples of the poets' ventriloquism, their attributing speech to the dumb painting or statue as an appropriative gesture—what Bryan Wolf calls "mute-ilation" of them (n. 24). When they do so, mainly in the epigram or inscription, their purpose is to reveal its meaning through comment or interpretation; by such interpretation via the gift of speech, they enhance the visual work's future fame through having the poem as a pendant. Nothing is said, of course, about how the statue or painting might enhance the reputation of the poem so appended. When the poet creates epigrams that are *not* related to a visual work, he is declaring independence, and the existence of a literary genre unto itself. In the same mood of declared independence, Anacreon and his followers, in and out of the *Greek Anthology,* established such a genre, actually a variety of ekphrasis, when they order painters and sculptors to create works that do not yet exist, according to their specific instructions. This genre, sometimes euphemistically characterized and entitled "advice to the painter," implies, apart from other obvious interart tensions and meanings, that the visual artist needs the help of the verbal specialist, even though the former is apparently not asked!

Among the many examples of these techniques, there is one anonymous epigram from the *Anthology* that is particularly apt: Says Niobe: "From a woman, the gods turned me into stone. / From stone, Praxiteles gave me life again."[28] And, she should have added, "the poet provided the final touch of restoring my voice."

Another is the epigram by Árchias that offers pithy praise of a painter's mimetic skill:

> Apelles surely must have seen
> the nursing sea deliver Cypris
> to draw her thus, with newmade hands
> still wringing water from her tresses.[29]

But in others, like the inscription for a painting of Leda and the Swan attributed to Antíphilos of Byzantium, the visual work, if it indeed existed, or even if it did not, serves to foreground the speaker's own wittily

expressed erotic situation, so that the ekphrasis is appropriated for love-complaint:

> This is Eurotas, the Lakonian river, and this
> is Leda, nearly naked, and the Swan you see
> Conceals great Zeus.
> > O little Loves,
> You that lead me so unwillingly to love,
> What bird can I be?
> > If Zeus is a Swan,
> I must be, I suppose, a Goose.[30]

The Anacreontic instruction poems have had an astonishing progeny considering that there are but a few of them and their motif of ordering the creation of a landscape, a drinking cup, or a portrait of a beloved are fairly trivial. The implication of the genre is significant, however; the visual artist needs to have his work programmed for him by the *letterato*. There are even some jibes at the mimetic implications of painting, as when Anacreon, ordering a portrait of a female beloved, urges the painter, *if* he can, to have her hair smell of perfume, her glance be real fire. Or, as in another example, invoke the two-dimensionality of painting as an impediment to the full fleshly realization of its subject, in this instance a male beloved whose back the painter cannot show.[31] This taunting is not as remote as it might seem at first glance from, say, the Instruction poems of Herrick, Waller, and Marvell, but it survives in Crashaw's bawling out of a painter of St. Teresa's transverberation for not getting it right![32]

To conclude this part of my essay I will adduce some Italian Renaissance examples of the continuation and elaboration of the appropriative gestures deployed by classical critics, with focus upon the *paragone*. It should be noted that neither the term *paragone* nor the term *ekphrasis* was used in the Renaissance, as Hulse implies (8); they are modern designations, but I use *paragone* rather than *maggioranza* because the former is firmly entrenched in scholarship and criticism.

I would define the *paragone* as a brief or extended comparison and contrast of the arts or any two of them, either for the purpose of demonstrating that despite differences they are equal in value, *or* to argue that one of them is superior to, has the *maggioranza* over another or all others. The tone is polite, rarely betraying the tensions that exploded at the practical level, as in the bitter quarrels between a Ben Jonson and an Inigo Jones, or between a Calderón and a Cosmé Lotti.[33] There is obviously a desire and a need to promote harmony in the larger family against outsiders, but this is countered by an equally powerful urge to acquire *maggioranza,* as I have suggested above.

In all of these respects, Leonardo's early fifteenth-century effort is

utterly untypical of the genre in its grumpiness. The hostile tone reflects his discomfort with the status accorded painting, which he calls "daughter of nature," at the time he is writing (197). As a study by Giancarlo Maiorino shows, Leonardo objected to the humanist emphasis on theoretical knowledge apart from *esperienza,* hence he chafed at Alberti's insistence that painters needed to rely on *letterati* instead of nature for their subjects. One can sense, too, a resistance to Alberti's invocation of Ciceronian rhetorical norms and of narrative discursivity, seen as impinging upon painting's own goals, be they iconic or pictorial. As Michael Baxandall, and more recently Jacqueline Lichtenstein have discussed, the association of rhetoric and painting involved the imposition of available linguistic models and philosophical assumptions on visual works, thereby directing both creation and response during, and well beyond, the Renaissance.[34]

Leonardo's use of music as a weapon against poetry also reflects the superior status of that discipline, long listed with the liberal arts thanks to its mathematical basis. Poetry could sneak into the select company of the liberal arts via grammar and logic, but painting, having declined in prestige during the Middle Ages, was considered a mechanical art. Indeed, at the very beginning of his handbook for craftsmen, written in the last decade of the fourteenth century, Cennino Cennini makes a desperate attempt to prove that painting is theoretical, not just the work of the hand, by associating it with poetry in imaginative freedom of creation.[35]

Although there is a lull after Leonardo until mid-century, when *paragoni* sprout everywhere, and the polemical tone will rarely be heard, later writers will echo his strategic use of music as a sister or counterart. Paradoxically music enjoyed prestige, hence could be courted by the other arts, especially poetry, with which it had an ancient linkage, but it is not considered a rival or threat. Painting, on the other hand, was resurgent, newly commanding admiration and patronage, and doing so by exploiting literary culture. No wonder envious poets felt they had a lien on it.

The later sixteenth-century *paragone* was largely promoted by *letterati.* No major painter or sculptor, from Raphael to Tintoretto, got involved. Of those who responded with letters to Varchi's summons, mentioned above—and including Bronzino, Pontormo, Cellini, and Michelangelo—most either declined to choose between painting and sculpture or politely gave one of these arts the edge over the other, as Cellini does for sculpture. But Pontormo can barely conceal his ironic amusement with the whole business, and Michelangelo almost says outright that such disputes are a waste of time.[36] The painters who did become involved with lengthy defenses of painting that took up the *paragone* with poetry were either painter-academicians like Zuccari or painter-*letterati*

like Lomazzo; but they and others who defended painting in treatise and dialogue were reacting to the claims of *letterati* like Vincenzo Borghini, who insisted that only philosophers and rhetoricians could or should talk about the arts, not their makers. Nor did the makers follow the same line of defense: Zuccari, for example, says that painting appeals to both the eyes and the mind, and is superior to poetry in being understood by the simple as well as the learned.[37] The contradiction here is only apparent. Everybody in the Renaissance loved to quote Pliny's anecdotes about lifelike painted horses and grapes, but the argument from mimetic fidelity had been used against painting as dealing only with externals, therefore appealing only to the senses. It had also been claimed against painting that it appealed to the vulgar, clearly a class argument. Zuccari replies by giving painting mental impact and turning the class argument on its head—it is superior to poetry because everyone can understand it! On the other hand, Lomazzo, himself a poet, insists that one cannot be a painter without a "spirito di poesia," since both poets and painters share creative *furor*—thereby taking refuge in a Platonic cliché in order to decline a fight.

In addition to the *letterati* like Varchi, Dolce, and Aretino, who established themselves as experts on painting, most of the major literary critics of the century—including Castelvetro, Mazzoni, and Tasso—put in a word or two in favor of the *maggioranza* of poetry.[38] Writing as both a poet and an amateur collector in the early decades of the seventeenth century, and therefore in a position to recapitulate *cinquecento* sister arts discourse, Marino insisted on their equality, both aiming to delight and console. As to differences, he says painting imitates, with colors rather than words, the externals rather than the inner emotions of the soul, the latter reserved to poetry. Whereas painting causes us to understand with the senses, poetry makes us feel with the intellect (a formulation Hagstrum found surprisingly anticipatory of T. S. Eliot on metaphysical poetry).[39] Finally, painting is understandable to everyone, poetry only to those of learning and wisdom. While seemingly evenhanded, there is no doubt that Marino is boosting poetry by assigning to it higher values, as revealed in words like "inner," "intellect," "soul," and "learning."[40] A similar ploy had been used earlier by Varchi in a 1548 lecture on poetry and painting that was part of the *maggioranza* debate. Ever the diplomat and cultural arbiter, Varchi concluded that poetry and painting both needed each other, but then instanced Michelangelo's *Last Judgment* in the Sistine Chapel, insisting flatly that the painter not only imitated Dante in his poetry but had the *Comedy* "sempre dinanzi agli occhi" (ever before his eyes) as he worked.[41] Here was no mutually fecundating relationship but the utter dependence of a visual artist on a literary source.

Michelangelo's painting reminds us that it was an object of controversy

in the ascetic atmosphere of Catholic reform because of its nudity. At a time when a Jesuit critic of the arts could propose an index of forbidden pictures to match the existing list of books, it was serious business to bring up the matter of obscenity, but the *letterati* did not hesitate to do so.[42] Bernardo Tasso, for example, in a 1562 discourse on poetry, rebuts charges against the lasciviousness of that art by asking his readers why it, rather than the lascivious poet, is blamed. How about the great Titian's paintings of satyrs violating virgins or Venus and Adonis fornicating, he asks—would you blame the art of painting or the lascivious invention of the painter?[43] We shall see how and why Aretino, of all people, attacked Michelangelo and his *Last Judgment* on similar grounds, but suffice it to note here that such mischievous misreadings were still another assertion of interpretative rights.

In this as in other ways excluded from participation in Italian intellectual life, women poets and painters are not to be found among the *paragonisti*. Indeed, I know of only two examples of women taking part in sister arts talk. One is the poet Tullia d'Aragona, whose appearance in a dialogue by Speroni I will refer to below; the other is the poet Vittoria Colonna, Roman aristocrat and friend of Michelangelo, who appears with him in De Hollanda's dialogues already mentioned. But she is present in the first two dialogues only, says very little, and serves mainly to cue in the male disputants.[44] Nor did she directly engage Michelangelo's art in her poetry. Indeed, apart from the exception to be noticed shortly, she avoided even the indirect theorizing that ekphrastic poems can embody. Similarly, Italian women painters kept a low theoretical profile. And so, for example, the painter and academician Artemesia Gentilleschi did not directly engage the theorizing of the leading interart personality of her time, Marino, though they shared a fascination with the art of Caravaggio and, though differently motivated, an interest in the female heroes who are the subjects of her paintings and his ekphrastic poems. Indirectly, however, her revisionist depictions of those heroes may be her response to his theory and practice.[45]

2

La bella donna, a cui dolente preme
quel gran desio che sgombra ogni paura,
di notte, sola, inerme, umile e pura,
armata sol di viva ardente speme,
entra dentro 'l sepolcro, e piange e geme;
gli angeli lascia e più di sé non cura,
ma a' piedi del Signor cade sicura,
ché 'l cor, ch'arde d'amor, di nulla teme.

> Ed agli uomini, eletti a grazie tante,
> forti, insieme richiusi, il Lume vero
> per timor parve nudo spirto ed ombra;
> onde, se 'l ver dal falso non s'adombra,
> convien dar a le donne il preggio intero
> d'aver il cor più acceso e più constante.[46]

[The beautiful woman, who in her grief is moved by that great desire that dispels every fear, arrives at night, alone, defenseless, humble and poor, armed only with living, burning hope, and enters the sepulcher, and weeps and sighs; turning from the angels and careless of herself, she falls with confidence at the feet of the Lord, her heart, glowing with love, fearing nothing. Now to those men, chosen to receive such grace, strong yet fearfully enclosing themselves, the true Light seemed a ghost or shadow; therefore, if the truth is not blotted out by falsehood, it is fitting to give women all due credit for having more ardent and more constant hearts than men.]

I begin this second part of my essay, concerned with direct confrontations of poets and painters, with a sonnet by Vittoria Colonna that is an ekphrasis of a painting on the *Noli Me Tangere* theme, possibly by Titian, and proposes a feminist interpretation of the conventional depiction of Mary Magdalen at the empty tomb of Christ. Her reading, culminating in a defense of women, should be contrasted to Marino's reading of Allori's depiction of another famous biblical heroine, Judith:

> Di Betulia la bella
> vedovetta feroce
> non ha lingua nè voce, eppur favella;
> e par seco si glori e voglia dire:
> Vedi s'io so ferire!
> e di stral e di spada,
> di due morti, fellon, vo' che tu cada;
> da me pria col bel viso,
> poi con la forte man due volte ucciso!

[The beautiful and fierce Bethulian widow has neither tongue nor voice yet speaks; and seems to glory in herself and want to say: Look and see how I can wound! From both dart and sword, from two deaths I wanted you to perish, wretch: you have been murdered twice by me, first by my beautiful visage, then by my strong hand!]

Marino's epigram on Allori's *Judith Holding the Head of Holofernes* is but one of hundreds of such ekphrastic poems from his collection entitled *La Galeria* (1620). Here he evinces considerable strain in dealing with the motif of voicelessness. He says Judith is silent yet speaks. The poet will resolve the paradox by telling us what she wants to say as she stares out at us. Her message, however, is to Holofernes, not us, and turns out to be an amatory cliché. By turning Judith into a Hebrew Laura, Marino

has appropriated her legend *and* the painting for the literary system or code known as Petrarchism, of which the figure of the amorous female homicide is a staple. He is also recapturing the motif from the painter, who in another version of this same subject had visualized the Petrarchan cruelty conceit by depicting his mistress as Judith and himself as Holofernes.[47]

My next two examples illustrate the direct confrontation of poet and painter: one a mere four-line Latin epigram, the other a famous letter to Titian from Aretino. First, Nicolas Bourbon's pendant to a portrait done of him by Hans Holbein:

> In Hansum Ulbium pictorem incomparabilem
> Dum divina meos vultus mens exprimit, Hansi,
> per tabulam docta praecipitante manu,
> ipsum et ego interea sic uno carmine pinxi:
> Hansius me pingens maior Apelle fuit.[48]

> [To Hans Holbein incomparable painter
> While your divine mind expressed my features, Hans,
> And your skilled hand hastened over the canvas,
> I painted you thus meanwhile in one line of poetry:
> Hans as he painted me was greater than Apelles.]

Written by a French poet in the international idiom of neo-Latin, Bourbon's epigram may serve to exemplify the spread of Italian interart theory and practice. Typical is the attempt to equate sketch and poem, painter and poet, and to imply the need of verbal praise to promote and assure the painter's fame. It also reminds us that, if we put aside our knowledge of the reputation subsequently attained by Renaissance artists, we can realize that they might indeed have needed and courted the praise of such minor figures as Bourbon, or have found it necessary to exploit or at least tolerate the attachment of an Aretino. Hence we should examine, however briefly, the background of Aretino's letter to Titian and then interpret it in that light.

It is difficult to approach Titian without bumping into the poet, polemicist, and publicist Pietro Aretino. Although everyone knows of his physical bulk, barely contained within the frame of the famous portrait by his friend Titian, it is not as well known how large he loomed on the interart scene of his day as the quintessential *letterato* bent on appropriating painting and painters in order to secure a piece of the visual action. We have already noted his part in the most infamous interart project of the century, to which he contributed in the form of sonnet subtexts for Giulio Romano's coital images. By penning sonnets that are strident voiceovers for those images, he makes the traditional gesture of giving speech to silent painting. Another way of affirming the dependency of painting on

letters was through scholarship and connoisseurship, promoting the need for consultation and advice on subject matter, or whole iconographic programs, or describing, evaluating, and publicizing works of art.[49] Aretino engaged in all of these practices, especially in his hundreds of letters on art written to artists and patrons. A frustrated painter himself, and hungry for social and economic benefits as well as political clout, he was able to satisfy several urges by becoming an arbiter of art production and marketing.

His success is attested to in the 1557 dialogue on painting published by the *letterato* Lodovico Dolce, entitled "L'Aretino" after its chief interlocutor. We have already seen his assertion of fraternal relations between the arts, but his other remarks and indeed the dialogue as a whole demands scrutiny as an interart effort. Published as a kind of memorial to Aretino, who had died a year earlier, the book bears a title page that says it will offer a discourse on the dignity of painting and on those qualities that are essential to the perfect painter, with ancient and modern examples, and concluding with attention to the virtues of the divine painter Titian.[50] But its author was not an expert on painting; he was an undistinguished literary hack who orbited about Aretino in the bustling world of Venetian arts and letters. Yet the enusing dialogue involves himself, Aretino, and a third *letterato* who serves as a foil to the others. There is disagreement among these *letterati* about the relative merits of Raphael and Michelangelo, of Florentine *disegno* and Venetian *colorito,* with Titian being proposed as supreme reconciler of these opposing aesthetic values, which is hardly surprising. We then detect another discourse when it becomes clear that the dialogue is really about the relations between poetry and painting, and the superiority of the former. This is obvious not only in the usual insistence upon the appeal to eye and mind, but also Aretino's testy reply to a question that is very revealing. When asked whether a *letterato* who has never touched a brush can "ragionar della pittura" (100–101: discourse on painting), which some painters find laughable, Aretino avers that any really smart painter would know writers are painters, and that, "any composition by a man of learning is painting" (101).

In his letters Aretino portrays himself as an adviser to and an intimate of celebrated painters, though only his link with Titian validates the claim. He also tried to extract from them portraits of himself, and other works, from drawings to completed paintings, for his private collection. Yet we know, for example, that Michelangelo did *not* send him a drawing and ignored his advice about the *Last Judgment,* the penalty for which was Aretino's later criticism of its decorum. On another occasion, Titian himself did not follow his friend's advice about a portrait of Charles V. But because Aretino could be dangerous, a known bully with the pen, yet

also useful, he was tolerated and even flattered by artists, and this may give a false or at least distorted idea of his literary power vis à vis the burgeoning prestige and authority of visual production. Thus, in another dialogue, this one by the *letterato* Sperone Speroni, an interlocutor, the poet Tullia d'Aragona comments on the mutuality and comprehensiveness of a painting by Titian and a related poem by Aretino, probably having in mind the many sonnets the latter wrote to accompany Titian portraits. She declares: "to be painted by Titian and praised by Aretino signifies new life for humankind."[51]

True mutuality, of course, would require that if a painting cannot do without a poem, or needs its half self, a poem or verbal text would need to be complemented by a visual text, and certainly not stand alone. But in a famous letter written to Titian in May 1544, Aretino manages to create a verbal painting fully on his own, imitating and interpreting nature without any help from or even the presence of his painter friend, whose absence is ostensibly lamented, but whose presence would in fact have deprived the *letterato* of an opportunity to assert the power of a verbal text, directly confronting nature, to produce a better rendition of her than could a painting alone:

> -Having against my wont dined alone, sir crony, or better, in the company of those annoyances from the fever that no longer allows me to enjoy the taste of any food whatsoever, I rose from the table, sated with the desperation I felt when first sitting down. And so, leaning my arms on the window sill, and letting my chest and almost all the rest of my body sink into it, I gave myself to looking at the marvelous spectacle made by the infinite number of boats, which were as full of foreigners as natives, and amused not only the onlookers but the Grand Canal itself, the recreation of everyone who sails it. No sooner afforded the diversion of two gondolas rowed in a race by as many distinguished oarsmen, I found much pleasure in the crowds that, in order to see the regatta, had paused at the Rialto bridge, the river bank of the Bursars, at the Fish Market, the ferry at Santa Sofia, and at Must House. And while these various crowds were applauding happily and going on their different ways, you could behold me, like a man who hating himself doesn't know what to do with his mind and his thoughts, turn my eyes to the sky, which ever since God created it, had never been so embellished by such a lovely painting of shades and lights. As a result the air was such that they would want to depict it who are envious of you because they cannot be you. See, as I describe it, first the houses, which though made of real stone seemed to be made of artificial material. And then notice the air, which I perceived to be in some places pure and vibrant, in others turbid and bleak. Imagine too the wonder I felt at the clouds composed of condensed moisture, which in the principal vista were half of them near the roofs of buildings, and half in the distance, while on the right there hung over everything a shading of greyish black. I was certainly astonished by the varied colors they displayed; the closest ones glowed with the flames of solar fire; and the more distant ones blushed with the ardor of not fully burnt vermilion. Oh with what beautiful touches Nature's brushes pushed back the air there,

separating it from the palaces in the way Titian does when painting landscapes. There appeared in some places a green-blue, and in others a blue-green, mixed by the whimsicality of Nature, mistress of masters. With the lights and shades she gave depth and relief in such manner to what she wished to foreground and distance that I, who know how your brush is inspired by her spirit, exclaimed three and four times, "Oh Titian, where are you now?" By my faith, if you had painted what I am narrating, you would have aroused in men the same stupor that overcame me; for as I contemplate what I have described to you, I nourished my soul with it, since the wonder of such a picture was not to last.[52]

The letter begins with Aretino alone, ill, and dejected. He goes to his window to gaze at the spectacle of the Grand Canal and its human traffic. Note that he slumps in the window and thereby creates a framed portrait of himself looking at the *veduta* or prospect that he is about to paint in words. First come the gondolas and the busy crowds, then, because he is not in the mood for such sheer human energy and movement, he turns to the sky above. Not to heaven, be it noted, but to a painter's sky. There never was such a sky, he says, never such an ideal atmosphere, the kind envious painters would like to paint in order to equal Titian. But of course it was nature, not Titian, who painted this sky, and Aretino's ekphrasis of nature's painting emphasizes that fact by his choice of such technical terms as *ombre, lumi, artificiata, veduta, sfumato, tratteggiature, pennelli, paesi, chiari, scuri,* and so on.

Given the sheer variety, vividness, and scope of nature's artistry, as Aretino proclaims it, what are we to make of the passage beginning "Oh with what beautiful touches Nature's brushes," in which Aretino first says that nature imitated Titian's way of painting landscapes, then implies that no human could imitate nature in her mixing of colors, her *bizarrie,* because she is *maestra dei maestri,* the latter group of *maestri* including Titian, of course. Does art then imitate nature but never equal it, or does art improve upon and surpass nature? Does nature imitate Titian because he has surpassed her, or is it the case that no matter how great his imitative talent he can never equal her? Knowing that he has painted himself into this familiar theoretical corner, Aretino now cries out for his friend's presence, but with obvious bad faith. On the one hand, only Titian could do justice to such a scene, but he could never hope to equal it. On the other hand, *if* he could have painted it, it would have enhanced his reputation beyond measure. *But* he wasn't present and the scene is now gone forever. Aretino pretends he has complimented his friend by asserting in this open letter that only he could have painted the spectacular *veduta,* and the reader is certainly supposed to grasp and applaud the compliment. In fact, as matters turned out, *only Aretino saw the scene,* and it was preserved only in the text of this letter.

Furthermore, there is even a suggestion that were Titian actually pres-

ent, the visual scene changed so rapidly that he might not have captured it fully or in time, whereas Aretino absorbed it immediately into his mind for transfer to and preservation by a verbal text. In the ambiguous "wish you were here to see this" mode of greeting cards, which as we all know is never fully sincere, Aretino both compliments Titian and reminds him of his limitations as a visual artist. At the same time, by stressing that the only record of that moment of beauty is "quel ch'io vi conto" [what I am narrating to you], he asserts both the autonomy of literature and the dependency upon it of the proud, newly flourishing art of painting and its overly coddled practitioners.

In a second letter that includes an ekphrasis of a now lost *Annunciation* by Titian, Aretino revives and continues the ancient rhetorical *topoi,* for we are told that we can *hear* the beating of the angel's wings; *see* a rainbow more vivid than a real one, as well as a lifelike Gabriel just as he appeared to Mary; and *smell* the lily he is holding! And, of course, we can almost hear the angel uttering his AVE. Then, after rendering the Virgin's image in similar terms, Aretino closes with the remarkable reference to another painting, equally a virtuoso performance, which he says proves, and reproves those who would deny, Titian's genius and his own, as if it were not clear to everyone that they are both great artists! As ekphrastic models and as opportunities for advancing literary claims, such letters were undoubtedly influential on the late sixteenth-century tendency to describe or analyze individual works in theoretical writing, whether paintings by Titian or other prominent artists.[53]

There were two ways painters could fight back. One was to oppose the literary establishment on its own turf of scholarship and criticism, fueled by humanist learning and practices. The other was to resist interpretation by taking refuge in enigmatic meaning, ironically that very silence with which poetry had charged painting and had exploited as a means of domination through ventriloquism. Since the semantic content of a sixteenth-century painting might be conveyed by narrative *(istoria),* iconographic signs, and rhetorical gestures, an obvious way to deflect "reading" was to make these clues illegible. As we know, there was a tradition going back to antiquity, and continued from Alberti thorough Poussin, that put an interpretive premium on rhetorical legibility, on actions and gestures, or body speech. This "muta eloquenza," as the Renaissance called it, has recently been studied by Andre Chastel as "the rhetoric of non-verbal communication."[54] By blurring or obscuring the signification of such gestures, along with narrative and iconographic clues, one could frustrate the ekphrastic impulse and baffle interpretive legibility.

In the first of my illustrations, we have an apt example of the first kind of opposition painters could adopt. It is the title page of Vasari's 1568 edition of the *Lives* of the artists. In an age of literary criticism and

scholarship such as the later decades of sixteenth century were in Italy, Vasari declares by his work that he intends to do for visual art what *letterati* had done for literature through history and criticism. Classical authority is recalled by the very title, a variant of *de viris illustribus,* and such precedents as Varro's biographies of Greek and Roman celebrities, accompanied, like Vasari's, by portraits—not to mention Petrarch's modern collection of such *Lives.*[55] Note how Vasari presents himself as a scholar in the reference to a new edition, revised and enlarged, and in the scholarly apparatus of a text based on research, collation of data, and indexing. And he proudly proclaims himself to be "Giorgio Vasari, pittore et architetto." Visually, the title page has conventional classical decorative figures adorning a tabernacle frame, with its pious overtones and double representations of the implements of the arts. Supporting the title (and therefore the artists, even though not all are Florentines) is the Medici arms. Below, Vasari's efforts are approved by the licensing and privileging afforded by church and state, the Pope and the Duke of Florence and Siena. At the very bottom, sustaining the whole is a *veduta* of Florence, mother and nurse of the arts. And below even that, the identity of the printer, the art of printing making possible the wide dissemination of Vasari's enterprise.

My second illustration offers an example, appropriately enough, of painting's resistance to interpretation as embodied in a work by Titian. *Venus and the Lute Player* exists in two versions dating from the 1560s. The one in Cambridge, in the Fitzwilliam Museum, is the more finished of the two, whereas the New York version we have before us, and which I am using because it was seen by the two poets I will be quoting shortly, is incomplete, in all likelihood a studio record of the composition. This should remind us, along with the fact that it is an oil on canvas measuring approximately five by six feet, that it was a work motivated by a particular occasion, most likely contractual, though details are lacking; and that it was certainly produced in the highly competitive atmosphere of the art market.[56] We would be more aware of its being such a commodity rather than a disconnected image if my slide and other reproductions of it showed its frame, whether the original or not. I bring up the material nature and historical circumstances of the painting, even though the latter are not fully known, because I think these should figure in, though not circumscribe, any attempt to determine its semantic content. Among the historical circumstances would be the rivalry between poetry and painting, and the question arises whether Titian might freely adapt a literary source while fulfilling an explicit commission, especially with mythological as opposed to biblical themes. We know that the *letterato* Raffaelle Borghini rebuked Titian for depicting a reluctant Adonis in his painting of *Venus and Adonis* (now in the Prado), for its deviation from Ovid—a

LE VITE
DE' PIV ECCELLENTI PITTORI,
SCVLTORI, E ARCHITETTORI

Scritte
DA M. GIORGIO VASARI PITTORE
ET ARCHITETTO ARETINO,
*Di Nuouo dal Medesimo Riuiste
Et Ampliate*
CON I RITRATTI LORO
Et con l'aggiunta delle Vite de'viui, & de'morti
Dall'anno 1550. infino al 1567.

Prima, e Seconda Parte.

*Con le Tauole in ciafcun volume, Delle cofe piu Notabili,
De' Ritratti, De lle Vite degli Artefici, Et
Luoghi doue fono l'opere loro.*

CON LICENZA E PRIVILEGIO DI N. S. PIO
DEL DVCA DI FIORENZA E SIENA.

IN FIORENZA, Apprefso i Giunti 1568.

Vasari. Title page of *Lives of the Artists,* **1568. (Avery Library, Columbia University.)**

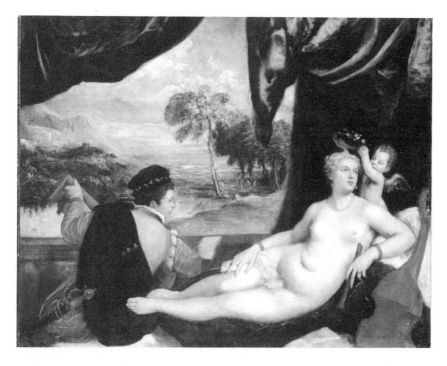

Titian. *Venus and the Lute Player.* (The Metropolitan Museum of Art Munsey Fund, 1936 (36.29).

sin also committed by Shakespeare.[57] This kind of transgression was a matter of debate at the time.[58] Still, assuming patrons would have been happy to have *any* Titian, even with a free treatment of a specified or unspecified theme, I would argue that in the case of *Venus and the Lute Player* there is a basis for suspecting resistence to literary interpretation or legibility.

The painting has no known literary source, itself an interesting deviation. It does involve a familiar Renaissance juxtaposition of mythical and earthly beings, with their representatives on a horizontal axis in the same room, but with definite focus on a recumbent Venus, a conventional motif recalling many visual intertexts and their verbal sources. The "unreal" juxtaposition should encourage us to read the painting not primarily as a narrative "pregnant moment," but as a synchronic cluster of symbolic meanings. To get at these, however, we have to contend with the anomalies and ambiguities that immediately present themselves to us in polar contrasts: indoors and/or outdoors; male and female; richly clad musician and bejewelled but nude goddess; disconnected rather than mutual gazing, or better, perhaps, lustful glance versus decarnalized gaze, in

Bryson's terms; looking *at* versus looking *away*, implicating both the pro-
tagonists and the viewer; *disegno* versus *colorito;* and of course, music
and silence.[59] The silence of the two glancing and gazing protagonists
cries out for the kind of speech poets bestow, their patented ventrilo-
quism, *but* what are they thinking that you could make them say?

More complex issues arise as *we* scan and gaze. For example, the
sensuous reality of the goddess of love and beauty is not defused by her
symbolic significance, so that she is a more erotic presence than the
supposedly "real," fashionably attired sixteenth-century musician who is
serenading or accompanying her. Yet he is glancing furtively at her body,
as though he had just noticed it, and while his eyes are not directed there,
the downward diagonal line of lute-neck and shoulders leads to her *mons
veneris,* which is after all the original, but is inaccessible except to the
eye or mind of the musician *and* viewer. I detect, too, an allusion to the
conventional motif in paintings of the *Annunciation* whereby a beam of
light is directed from a dovelike holy spirit to Mary's womb, with results
far more significant than the sterile glance depicted here! For despite the
suggestiveness, erotic contact is blocked by, in Mario Perniola's terms,
the impossibility of transit between clothing and nudity.[60] Also, the im-
plied male view is obviously invited into and then discomfited by a scene
that surprises and puzzles him. The viola in the lower right-hand corner,
David Rosand reminds us, is an invitation to join the concert since it
extends into viewer space; and it is the only instrument unused at the
moment.[61] Note, too, that there are open part books on the floor nearby
to supplement the one on the sill being used by the lutenist. Panofsky
points out that in the Cambridge version one of the two part books is
clearly marked TENOR.[62] Assuming he could enter the picture space to
pick up either viola or part book, and not from an awkward upper stage
left, where Venus is gazing, the viewer would be as puzzled as we are in
our viewing space as to what is happening.

Why has Venus paused in playing the recorder she holds in her left
hand (or has she not yet begun?). The lutenist is momentarily distracted
from his music by Venus herself (or is he still playing though not singing?).
Why is Venus looking up and seemingly far away? Why is Cupid crowning
her with a garland of flowers, thus turning an intimate bedchamber scene
into a triumphal tableau? And what, finally, are we to make of the pastoral
vista seen through the framing curtains, with its swans visible just below
the lute neck, and, to the right, peasants dancing in a nearby wood—a
veduta that is overdetermined in the many visual and verbal intertexts it
evokes. Still, as Turner found when he tried valiantly to give it equal
viewer time, the landscape cannot distract us for very long from the
provocative indoor scene in the foreground (Ziff, 136).

Has Titian put together his own code, or is the painting a free play of

signifiers? In one sense, if I am right about its resistance to interpretation by *letterati,* its refusal to be "read," the painting *has* to be a fluid assemblage of signs. But as a literary historian, a modern *letterato* lured by the familiarity of some of the signs, I am compelled to go hunting for verbal sources and intertexts, convinced that these *must* figure in somehow if only as ironic allusions. So I remember how, at the beginning of Lucretius's *De Rerum Natura* there is an invocation of Venus, asking that she subdue Mars or war, so peace may come to Rome.[63] I then think of a visual text, Botticelli's celebrated painting of the conquest of Mars by Venus—as you recall, in that work a semi-clothed Mars, deep in a post-coital sleep, reclines opposite a fully clothed and imperial Venus, cooly aware of her power to tame and placate him. There also comes to mind Ficino's *Commentary* on Plato's *Symposium,* adduced by Panofsky:

> There are three kinds of beauty, that of the souls, that of the bodies and that of sounds: that of the souls is perceived by the mind, that of the bodies we perceive through the eyes, that of the sounds through the ears. (120)

Even though I have a nagging suspicion that Titian wanted me to think of that quotation, and therefore I am uneasy about it, I am ready to hazard that the painting at least points to, though it may not affirm or be wholly about, a Renaissance commonplace. That is, the power and triumph of love and beauty embodied in the figure of crowned Venus. As a composite figure she combines the two Venuses, earthly and heavenly, sacred and profane. She stands for personal and social harmony prevailing over inner and outer strife. She both activates and rules our world, and stands for the divine principles that move the cosmos. She both defines and refines our human nature and goals. She is both naked and nude, nudity being the idealization of nakedness but also the perpetual reminder of its material stratum. And she is staring into space because she is waiting for Mars in order to Triumph over and subdue him again, warlike TENOR that he is, so that she may renew flesh and spirit. The musician, then, may represent the implied male viewer and us insofar as we can approach this mystery, join this concert, through sight and sound but not fully apprehend it unless we gaze more deeply with the eyes of the mind and listen to that other music with the ears of the soul. In sum, we must look both *at* and *away.*

With apologies to Titian I advance these interpretative claims, but with little confidence that they are exhaustive or even satisfactory. What is missing from my interpretation is a full account of the motifs of the misreading by the lutenist of the sensuousness of Venus, of the pervasive silence, of the many allusions to poetry and painting in the pastoral landscape, of the framing curtains that neither fully reveal nor fully conceal the scene. And most important, it does not answer the question why

Titian should have gone to so much trouble to mystify a commonplace. Granted the need to defamiliarize the conventional, it would be self-defeating to erect such formal and semantic barriers. I conclude, then, that Titian has chosen to thematize sibling rivalry and image envy by painting a defense of painting—both in the sense that it erects barriers to appropriation and, especially in its privileging of sensuous color over rhetorical action, asserts the superiority of its own painterliness to discursivity. Thus it resists encroachment, flaunts its silence as a profound mystery, and rebukes those who see only its sensous surface but do not look away to hear its transcendent harmony.

A final irony is that Titian himself referred to his paintings of Ovidian myths as *poesie,* a term appropriated from literature to designate the depiction of pagan (untrue) *istorie* (Rosand, 38–43). Although not a *poesia* in the strict sense, our painting is linked to the genre by the figure of Venus. The conflation in *Venus and the Lute Player* of the contemporary and the fantastic, then, is a deliberately baffling provocation precisely because it is *not* a poesia and therefore resists legibility. At the same time, by designating the poetic as the unreal but locating its representative, Venus, in the contemporary world, Titian deflects interpretation from another perspective, that of mimetic realism. Painting is declared to be its unique, independent self.

CONCLUSION

Venus and the Lute Player

Far in the background a blue mountain waits
To echo back the song.
The note-necked swan, while it reverberates,
Paddles the tune along.

The Player is a young man richly dressed,
His hand is never mute.
But quick in motion as if it had caressed
Both lady and the lute.

Nude as the sunlit air the lady rests.
She does not listen with her dainty ear,
But trembles at the love song as her breasts
Turn pink to hear.

She does not rise up at his voice's fall,
But takes that music in,
By pointed leg and searching hand, with all
Her naked skin.

Out of that scene, far off, her hot eyes fall,
Hoping they will take in
The nearing lover, whom she can give all
Her naked skin.[64]

—*Paul Engle, 1963*

Venus and the Lute Player

That young man—
Thin face, dark eyes in shadow, the blue Venetian
Skies and water below the balcony,
Seen where horizon
Falls into distance over his left shoulder—
Makes music with an art that angels sing.
Such songs have power to wake the moon,
Unveil her sleep and draw her from the skies
To walk with him as though she were his bride,
Her light glancing loggia, stairway, stone,
Floating, reflected beneath waters of the canals.
Madrigals,
Songs are flames of Monteverdi
Within the lute, golden in fire as darkness
Turns to day, and rain to fountains
Dancing in the sun.
And one might think
Such vernal arts would capture Venus,
But there is no likeness to his music in her eyes;
She stares and beckons as though her radiance
Alone were summer's noon, as though she said:
"My hairs are golden wires, and what I am
Has been compared to fruits, flowers, vines,
Jewels in the earth,
And the silver motion of the sea—I have no need
Of music nor music's art. I am eternal
Even beyond the sight of artful men.
My presence wakes or sleeps, silent, unsought
Within a darkened room; I need not rise or speak.
I, the world's mistress, remain indifferent
To strings that tremble, to reeds that blow.
I am what you seek,
And all you need to know."[65]

—*Horace Gregory, 1964*

Since I have given the poets a hard time, I would not want to close
this discussion with my own rather than their interpretation, and so I
quote two modern poems that are ekphrases of the Titian painting, now
perceived as a venerable classic. I probe them briefly to determine if
there are continuities between older and more recent quarrels of poetry
and painting—or do Renaissance sibling rivalry and image envy, with
their historically specific social, economic, gender, and psychological

bases, belong to the past? Both my examples evince a peculiarly modern psychic attachment to the painting they describe, a personal need to find comfort or consolation in a revered visual classic, yet also an apparent discomfort with its temporal distance and alleged aloofness of theme. As might be expected, Titian's Renaissance ideas about the harmony of flesh and spirit, and their convertibility into a defense of visual art, are not fully grasped. There is also an urge to sympathize with the assumed loser, the lutenist, as both a deprived male and frustrated artist, and here rivalry and envy begin to stir.

In the first poem, the lutenist's lust is not contained or defused—in fact the speaker can't wait to get his hands on Venus! She, in turn, offering a splendid example of what Kristeva has called "the eroticization of hearing," *listens* with her naked flesh.[66] Although characterized first as *nude,* she seems more like Manet's *Olympia* and behaves more like Boucher's *Miss O'Murphy,* except that even Miss O'Murphy does not tremble, and flush, or extend her limbs achingly, or look for her approaching lover with "hot" eyes. Titian would have understood and approved Engle's insistence on the flesh, but hardly the demystification of Venus, or the failure to note the ambiguities of passion, and the conjunction of disparate worlds of experience. As it turns out Titian is more alert than Engle to the importance of the cultural representation of the female body and the semiotics of the nude, at least as the Renaissance understood them. Nor is his sexism as overt. And whereas the painter had insisted on silence, stillness, and thematic obscurity, the modern poet hears music, sees motion, and proposes a meaning—to wit, the lutenist, or the artist, or the modern poet doesn't get the girl or the public's approval because she and they are going to give themselves to a higher bidder who probably doesn't play the lute and can't write poetry. Are these attitudes and interpretations not convertible into the familiar ones that regard the painted image as silent, merely sensuous, and seductively aloof unless interpreted?

To be fair, we must remember that since the Renaissance there has been a division of *letterati* into scholar/critics and poets, as a general rule, and therefore we may be asking too much learning of modern poets if we find them confronting Renaissance paintings in an intensely personal rather than scholarly fashion. And we have noted that Titian forestalls literary interpretation or exploitation by avoidance of an obvious literary source and, I would add, by eschewing such obvious aids to legibility as powerful rhetorical gestures, especially with the hands. As Lessing pointed out, even a mobile face is not emotionally effective unless accompanied by action of the hands (36). We saw also that Titian does not have his protagonists engage in mutual erotic gazing, which would have been an easy literary and visual pointer to the conventions of traditional love poetry.[67] Facing a similar female figure, Judith, also silent and gazing

outside of the painting at the viewer instead of at her murdered lover, the poet Marino, as we noted above, had recourse to literary Petrarchism. By misreading and so converting that gaze into a mutually erotic one, the alleged past smuggled into the depicted present, Marino imposed on the painting his version of what Lessing would have called its "single moment" (79).

But why, then, does Engle not practice that traditional ventriloquism of the poet and have Venus speak, as Gregory bestows speech on his Venus? The answer is, he does. Lacking the cues that might have been provided by rhetorical gestures, and uncertain as to what Venus might say, he chooses to have her speak body language. Although certainly a misreading of Titian, his imposition of body speech on the protagonist would have been understood as that "muta eloquenza" or nonverbal rhetoric referred to above.

It is perhaps more clear than in Engle's poem that the envied object of Gregory's reading is painting or the painting itself. Drawing our attention to "that young man," who it turns out is a wonderful artist who can stir the universe but not Venus, Gregory's learned poem then shifts to the speech granted her. She says she is beyond our world and us, even artists, and especially poets who tend to idealize her as Petrarchan beloved or transcendent Muse. In the teeth of his evocations of Canaletto and Monteverdi (painting and music), the cultured Venus flings back allusions to Shakespeare and Keats—which sounds like a reversal of interests until we grasp that hers is a ventriloquist echo of the poet's mind and speech. Thus she insists or is made to insist that she is both necessary and inexplicable, both present and absent, needed by but not needing men who are full of art. Although certainly, therefore, the modern poet's favorite deity, a *dea abscondita,* a hidden goddess, it is significant that she is found in a painting, moreover in the female protagonist of that painting. Is there not an echo here of that old rivalry with the younger sister who won't keep her place, and though dumb, still draws the crowds?

NOTES

1. Murray Roston, *Renaissance Perspectives in Literature and the Visual Arts* (Princeton: Princeton University Press, 1987), 3. See also his *Changing Perspectives in Literature and the Visual Arts, 1650–1820,* published by the same press in 1990. On ekphrasis, see fn. 24 below.

2. Marianna Torgovnick, "Making Primitive Art High Art," *Poetics Today,* Art and Literature 2, no. 10 (1989): 300. Other works referred to in the above paragraph not specifically cited below: Norman Bryson, "Intertextuality and Visual Poetics," *Style* 22 (1988): 183–93; his edited collection of essays, *Calligram: Essays in New Art History from France* (Cambridge: Cambridge University Press, 1988) includes essays by Kristeva, Barthes, Foucault, Baudrillard, and others.

3. Paul Barolsky, *Walter Pater's Renaissance* (University Park and London: Pennsylvania State University Press, 1987), 93–111; Clark Hulse, *The Rule of Art: Literature and Painting in the Renaissance* (Chicago and London: University of Chicago Press, 1990), 16–25.

4. W. J. T. Mitchell, *Iconology* (Chicago and London: University of Chicago Press, 1986), 42–43, 47, 50, 102–3, 107; "Going Too Far with the Sister Arts," *Space, Time, Image, Sign,* ed. James W. Heffernan (New York: Peter Lang, 1987), 1–17; "Against Comparison: Teaching Literature and the Visual Arts," *Teaching Literature and Other Arts,* ed. Jean Pierre Baricelli, Joseph Gibaldi, and Estella Lauter (New York: The Modern Language Association of America, 1990), 30–37.

5. Charles Altieri, *Painterly Abstraction in Modernist American Poetry: Infinite Incantations of Ourselves* (New York: Cambridge University Press, 1989); Regina Barreca, ed., *Sex and Death in Victorian Literature* (Bloomington: Indiana University Press, 1990); Norman Bryson, *Tradition and Desire: From David to Delacroix* (Cambridge: Cambridge University Press, 1984); David Evett, *Literature and the Visual Arts in Tudor England* (Athens and London: The University of Georgia Press, 1990); Patricia Fumerton, *Cultural Aesthetics: Renaissance Literature and the Practice of Social Ornament* (Chicago and London: University of Chicago Press, 1991); Wendy Steiner, *Pictures of Romance: Form Against Context in Painting and Literature* (Chicago and London: University of Chicago Press, 1988); Marianna Torgovnick, *Gone Primitive: Savage Intellects, Modern Lives* (Chicago and London: University of Chicago Press, 1990). For Hagstrum and Lee, see Works Cited.

6. Ernest B. Gilman, *Iconoclasm and Poetry in the English Reformation* (Chicago and London: University of Chicago Press, 1986).

7. Gabriele Paleotti, *Discorso Intorno alle Imagini Sacre e Profane,* in *Trattati d'arte del cinquecento,* 2, ed. Paola Barocchi (Bari: Laterza, 1961), 117–510.

8. Quoted in Leah S. Marcus, *The Politics of Mirth* (Chicago and London: University of Chicago Press, 1989), 109.

9. Lynne Lawner, ed., *I Modi* (Milan: Longanesi, 1984), Engl. ed. *I Modi. The Sixteen Pleasures* (Evanston, Ill.: Northwestern University Press, 1988).

10. Erwin Panofsky, *Galileo as a Critic of the Arts* (The Hague: Martinus Nijhoff, 1954), 34.

11. Francisco de Hollanda, *Four Dialogues on Painting,* trans. Aubrey F. G. Bell (Oxford: Oxford University Press, 1928), 39; G. P. Lomazzo, *Trattato dell'arte della pittura, scoltura et architettura* (1584) in *Scritti d'arte del cinquecento,* 3 vols., ed. Paola Barocchi (Milan and Naples: Riccardo Ricciardi Editore, 1971), 1:357; Giambattist Marino, *Dicerie sacre e La Strage degl'Innocenti,* ed. Giovanni Pozzi (Turin: Einaudi Editore, 1960), 151.

12. For the background, see P. O. Kristeller, "The Modern System of the Arts," *Renaissance Thought and the Arts: Collected Essays* (Princeton: Princeton University Press, 1980), 163–227.

13. Jean H. Hagstrum, *The Sister Arts,* 3–36, for the classical tradition. See also Moshe Barasch, *Theories of Art from Plato to Winckelman* (New York and London: New York University Press, 1985), 1–44.

14. Cicero, *Pro Archia Poeta,* trans. N. H. Watts, vol. 9 of Loeb Library (Cambridge: Harvard University Press, 1979), 8–9. Hulse, 114, discusses this statement, which he also uses as an epigraph to his book. But without indicating a source he substitutes for *cognatione* the word *communitatem,* out of which in a sense a key theme of his book exfoliates.

15. The two crucial passages in Horace's *Ars poetica* are 11.361ff. and 11.1–9

(Hagstrum, 9–10, treats them thoroughly). See also Henryk Mankiewicz, "Ut Pictura Poesis: A History of the Topos and the Problem," *New Literary History* 18 (1987): 535–58.

16. Nelson Goodman, *Languages of Art* (New York: Hackett Publishing, 1976), 68–69. See also, Robert R. Wark, "The Weak Sister's View of the Sister Arts," *Articulate Images: The Sister Arts from Hogarth to Tennyson,* ed. Richard Wendorf (Minneapolis: University of Minnesota Press, 1983), 26–35.

17. Plutarch, *De Gloria Atheniensium, Moralia* 4, trans. Frank C. Babbitt (Cambridge: Harvard University Press, 1972), 495–501.

18. Hans Baron, *The Crisis of the Early Italian Renaissance* (Princeton: Princeton University Press, 1966), 192–98; Aristides, *Panathenaic Oration* and *In Defense of Oratory,* trans. C. A. Behr (Cambridge: Harvard University Press, 1973), 247, 251.

19. The Zuccari fresco is discussed and reproduced in David Summers, *The Judgment of Sense: Renaissance Naturalism and the Rise of Aesthetics* (New York: Cambridge University Press, 1990), 285–87, 298–99. Vasari first introduced the idea of *disegno* and of *disegno* as *father* of the visual arts in the 1568 preface on painting to his *Lives,* in the very first sentence, in fact. Earlier, in his response to Varchi, he had indicated that *disegno* was the *mother* of the three arts of painting, sculpture, and architecture (Barocchi, *Scritti d'arte,* 1:497). Hulse, 108, argues that Dolce has Aretino refer to "brother" arts because of "the persistent humanist conception of . . . imitation as a form of male control over the alluringly female." I would give greater emphasis to the gendering of *disegno.* On the connection between *disegno* and *concetto* or conceit, see Françoise Graziani, "L'Image comme verbe divin chez Zuccaro et Marino," in *Art et littérature.* Actes du Congrès de la Société Française de Littérature Générale et Comparée, 1986, foreword by André-M. Rousseau (Aix-en-Provence: Université de Provence, 1988), 263–70.

20. The affair of the conspiracy of Giulio and Ferrante d'Este against their brothers Alfonso and Ippolito, which occurred in 1506, was told by Ariosto obliquely in *Orlando Furioso,* 3, octaves 60–62. It is said that the conspiracy started when Cardinal Ippolito had Giulio's eyes put out in a fit of jealousy because they had been praised by his mistress! In Giambattista Della Porta's play *Gli duoi fratelli rivali (The Two Rival Brothers)* the clash of brothers is called a "misero spettacolo" (act 5, scene 2), ed. and trans. Louise G. Clubb (Berkeley, Los Angeles, London: University of California Press, 1980), 264.

21. The study by Barolsky is *Giotto's Father and the Family of Vasari's "Lives"* (University Park: Pennsylvania State University Press, 1992). This completes a trilogy of Vasari studies, the first being *Michelangelo's Nose: A Myth and Its Maker* (1990) and the second *Why Mona Lisa Smiles* (1991), also published by the same press. Barolsky's argument tends to confirm my theme of rivalry, as opposed to Hulse's view that "At a superficial level, Vasari expresses the resentment of the painter at the encroachment of the literati" (74). While Hulse is arguing here about the relationship of Vasari to Alberti, I would put greater emphasis on Vasari's resistance to the "textualization" of the picture as a social and economic threat.

22. See the chapter entitled "The Mannerisms of Benvenuto Cellini," in my *Mannerism and Renaissance Poetry* (New Haven and London: Yale University Press, 1984), 73–98.

23. Benedetto Varchi, "Lezione della maggioranza delle arti," in *Trattati d'arte del cinquecento,* 3–57.

24. Murray Krieger, *Ekphrasis: The Illusion of the Natural Sign* (Baltimore: Johns Hopkins University Press, 1991). James Heffernan, *Museum of Words* (Chicago: University of Chicago Press, 1993). Wendy Steiner, *The Colors of Rhetoric* (Chicago: University of Chicago Press, 1982), 41–42. See also her "The Causes of Effect: Edith Wharton and the Economics of Ekphrasis," *Poetics Today* 10 (1989): 279–97. Marianne Shapiro, "Ecphrasis in Virgil and Dante," *Comparative Literature* 42 (1990): 108, 113. See also John Hollander, "The Poetics of Ekphrasis," *Word & Image* 4 (1988): 209–19, and "Words on Pictures: Ekphrasis," *Art and Antiques* (March 1984): 80–91; Mary Ann Caws, *The Art of Interference: Stressed Readings in Verbal and Visual Texts* (Princeton: Princeton University Press, 1990); Jennifer Pap, "Apollinaire's Ekphrastic 'Poésie-Critique'," *Word & Image* 8 (1992): 206–14. Lee Patterson, "'Rapt with Pleasaunce': Vision and Narration in the Epic," *English Literary History* 48 (1981): 455–75; Grant F. Scott, "The Rhetoric of Dilation: Ekphrasis and Ideology," *Word & Image* 7 (1991): 301–10; Werner Senn, "Speaking the Silence: Contemporary Poems on Paintings," *Word & Image* 5 (1989): 181–97; Bryan Wolf, "Confessions of a Closet Ekphrastic: Literature, Painting, and Other Unnatural Relations," *Yale Journal of Criticism* 3 (1990): 181–204. Among these critics, opinions range from Senn's view that ekphrastic poems "draw our attention to our way of seeing and thus help us to know what to see" (197) to Wolf's notion that such poems "mute-ilate" paintings (185). Scott tries to have it both ways with his claim that "In truth, ekphrasis may be both a selfless, generous project, and a self-serving diabolical one. It is a gift which writing bestows on images, a way of helping the statue say that which it can only suggest . . . as well as a way of demonstrating dominance and power" (302).

25. Philostratus, *Imagines*, trans. Arthur Fairbanks (Cambridge: Harvard University Press, 1979), 21–29.

26. Lucian, *Slander*, trans. K. Kilburn, in *Works*, 8 vols. (Cambridge: Harvard University Press, 1979), 1:361–67.

27. Lucian, *Zeuxis or Antiochus, ibid.*, 6 (1968): 155–63.

28. Peter Jay, trans. in *The Greek Anthology*, ed. Peter Jay (Harmondsworth, Middlesex, England: Penguin Books, 1981), 334.

29. Robin Skelton, trans., *Two Hundred Poems from the Greek Anthology* (Seattle: University of Washington Press, 1971), 7.

30. Dudley Fitts, trans., *Poems from the Greek Anthology* (New York: New Directions, 1956), 61.

31. *Anacreontea*, trans. J. M. Edmonds (Cambridge: Harvard University Press, 1979), 41–45. See also Mary T. Osborne, *Advice to Painter Poems, 1633–1856: An Annotated Finding List* (Austin: University of Texas Press, 1949), 9–22.

32. Richard Crashaw, "The Flaming Heart," 11.13–42, *The Poems English Latin and Greek of Richard Crashaw*, ed. L. C. Martin (Oxford: Clarendon Press, 1957), 324–25.

33. Walter Cohen, *Drama of a Nation: Public Theatre in Renaissance England and Spain* (Ithaca and London: Cornell University Press, 1988), 272–73. See also D. J. Gordon, "The Quarrel between Ben Jonson and Inigo Jones," *The Renaissance Imagination*, ed. Stephen Orgel (Berkeley: University of California Press, 1980), 77–97, and John Peacock, "Inigo Jones as a Figurative Artist," *Renaissance Bodies*, ed. Lucy Gent and Nigel Llewellyn (London: Reaktion Books, 1990), 154–79.

34. Giancarlo Maiorino, *Leonardo Da Vinci, The Daedelian Myth-Maker* (University Park: The Pennsylvania State University Press, 1992), See Alberti, *On*

Painting, trans. John R. Spencer (New Haven and London: Yale University Press, 1976), 90–91; Michael Baxandall, *Giotto and the Orators: Humanist Observers of Painting in Italy and the Discovery of Pictorial Composition, 1350–1450* (Oxford: At the Clarendon Press, 1971), 121–39; Jacqueline Lichtenstein, *La Couleur éloquente. Rhetorique et peinture a l'âge classique* (Paris: Flammarion, 1989), 153–82. An English translation by Emily McVarish has been published by the University of California Press as *The Eloquence of Color: Rhetoric and Painting in the French Classical Age* in the series entitled The New Historicism (1992). Lichtenstein argues that Roger de Piles and other seventeenth-century defenders of *coloris* against *dessin* renew the ancient quarrel between philosophy and rhetoric, and that by shifting the argument from sign theory based on linguistic models to a theory of pictorial perception, de Piles freed the painted image from referentiality and argued its basis as a rhetoric of illusion (194–95 of the French edition).

35. Cennino d'Andrea Cennini, *The Craftsman's Handbook,* trans. Daniel V. Thompson, Jr. (New York: Dover Publications, 1960), 1–2. Kristeller (above, n. 12) has pointed out, however, that the status of painting in antiquity was *not* high, but for the Renaissance this was obscured by extant rhetorical encomia of ancient artists and works.

36. *Trattati d'arte del cinquecento,* 1 (1960): 3–82. For Michelangelo's reply see also David Summers, *Michelangelo and the Language of Art* (Princeton: Princeton University Press, 1981), 269–78; on the *paragone* see also Lettrice Mendelsohn-Martone, *Benedetto Varchi's "Due Lezzioni": "Paragoni" and Cinquecento Art Theory,* 2 vols. (Ann Arbor, Mich.: University Microfilms International, 1982); Barasch, *Theories of Art,* 164–74, believes the *paragone* of poetry and painting "always" was intended to promote the status of painting (173), but I argue it also defended poetry. I would also contest the claim made by Graziani, anticipating Hulse, that "à la fin de la Renaissance, les théoriciens de l'art et les poètes mènent une action commune de défense et de valorisation de l'art" ("L'Image comme verbe divin chez Zuccaro et Marino," 265).

37. Federico Zuccari, *Idea de'pittori, scultori et architetti* (1607) in *Scritti d'arte del cinquecento,* 1:1047. Barasch, 207, drew my attention to Vincenzo Borghini's claim that only critics, not artists, should theorize about art! See also Larry Silvers, "Step-Sister of the Muses: Painting as Liberal Art and Sister Art," *Articulate Images,* 36–69. Silvers instances Hans von Aachen's 1600 *Athena Introducing Painting to the Liberal Arts* as visual evidence of his theme.

38. Allan H. Gilbert, ed., *Literary Criticism from Plato to Dryden* (Detroit, Mich.: Wayne State University Press, 1962), 306–7; 362–63, 476–77; Baxter Hathaway, *The Age of Criticism: The Late Renaissance in Italy* (Ithaca, N.Y.: Cornell University Press, 1962), 349–52; Bernard Weinberg, *A History of Literary Criticism in the Italian Renaissance,* 2 vols. (Chicago: University of Chicago Press, 1961), passim. For the role of print, see Elizabeth L. Eisenstein, *The Printing Revolution in Early Modern Europe* (New York: Cambridge University Press, 1984), 91–107.

39. Marino, *Dicerie sacre,* 151, Hagstrum, *The Sister Arts,* 103–4. See also Roger Simon, "Vision Picturale et création poètique chez G. B. Marino," *Art et littérature* (above, n. 19), 579–92.

40. See my *The Poet of the Marvelous: Giambattista Marino* (New York and London: Columbia University Press, 1963), 198–202.

41. *Trattati d'arte del cinquecento,* 2:53–58: "In che siano simili e in che differenti i poeti et i pittori"; the point about Michelangelo and Dante is made at the conclusion of the lecture (57–58).

42. For the letter of the Jesuit Francesco Panicarola (1576) proposing censorship of painting and sculpture, see Weinberg, *A History of Literary Criticism in the Italian Renaissance,* 1:309.

43. Bernardo Tasso, *Ragionamento della poesia* (1562) in *Trattati d'arte del cinquecento,* 2:570, 577.

44. *Four Dialogues on Painting,* 1:6–10, 26–27, especially show her in the combined roles of Castiglione's Duchess and her surrogate Emilia Pia, indicating a strong influence from *The Courtier.* The absence of Vittoria from the third and fourth dialogues is explained in pious terms that are to her credit, but the real reason may be the topics discussed, including warfare, niggardly patrons, and so on.

45. The most recent study of Artemesia's art, Mary D. Garrard's *Artemesia Gentileschi: The Image of the Female Hero in Italian Baroque Art* (Princeton: Princeton University Press, 1989), does not refer to such an engagement with Marino as theorist but suggests the painter's acquaintance with *La Galeria* (148, 172, 230), which would support my hypothesis of indirect response.

46. Vittoria Colonna, *Rime,* ed. Alan Bullock (Bari: Laterza, 1982), 162. In surviving letters there are references to two paintings of the Magdalen, one apparently by Titian, that this poem could be describing, but solid evidence is lacking: *Carteggio,* ed. Ermanno Ferrero, Giuseppe Müller (Turin: Loescher, 1884), 64–67, 70–72; see also Maude F. Jerrold, *Vittoria Colonna* (Freeport, N.Y.: Books for Libraries Press, 1969), 57–61; Joseph Gibaldi has an excellent essay on the poet, including translations of this and other sonnets in *Women Writers of the Renaissance and Reformation,* ed. Katharina M. Wilson (Athens and London: University of Georgia Press, 1987), 22–46. The translation here is my own.

47. Marino, *La Galeria* (Venice, Ciotti, 1635), 59. The painter Allori is Cristoforo Bronzino (1577–1621), a Florentine painter related to Agnolo Bronzino through his father, who had been adopted by Agnolo and taken his name. Marino may have owned a copy of the painting of Judith, which he requested in a letter of 1620, although he had seen it or a copy earlier (*Lettere,* ed. Marziano Guglielminetti [Turin: Einaudi, 1966], 275). I wrote the present paragraph before reading Garrard's argument that Judith represents a universal "mankiller" type, confirmed by Marino's poem (299–300), and learning that other painters of this theme represented themselves as Holofernes. I would add that the amorous homicide is a venerable Petrarchan theme, and is therefore not totally reliable as an index to gender attitudes. On Allori and his paintings of Judith, see *Cristofano Allori 1577–1621. Catalogo a cura di Miles L. Chappell* (Florence: Palazzo Pitti, 1984), 78–81.

48. Quoted from *Renaissance Latin Poetry,* ed. I. D. McFarlane (New York: Barnes & Noble Books, 1980), 32–33. My translation.

49. See Lora Anne Palladino, *Pietro Aretino: Orator and Art Theorist* (Ann Arbor, Mich.: University Microfilms International, 1982), 1–28. Also, Luba Freedman, "Bartolomeo Maranta on a Painting by Titian," *Hebrew University Studies in Literature and the Arts* 13 (1985): 175–201.

50. Roskill, *Dolce's "Aretino" and Venetian Art Theory,* reproduces the title page, 83; see also his introduction, 5–61.

51. Quoted by Palladino, *Pietro Aretino,* 271, from Speroni's 1542 *Dialogo d'amore.*

52. Quoted from *Lettere sull'arte di Pietro Aretino,* 3 vols., ed. Fidenzio Pertile, Ettore Camesasca (Milan: Edizioni del Milione, 1957–1960), Letter 179, 3:16–18, my translation. The original Italian text is as follows:

Avendo io, signor compare, con ingiuria de la mia usanza cenato solo o, per dir meglio, in compagnia dei fastidi di quella quartana che più non mi lascia gustar sapore di cibo veruno, mi levai da tavola sazio de la disperazione con la quale mi ci posi. E così, appoggiate le braccia in sul piano de la cornice de la finestra, e sopra lui abbandonato il petto e quasi il resto di tutta la persona, mi diedi a riguardare il mirabile spettacolo che facevano le barche infinite, le quali piene non men di forestieri che di terrazzani, ricreavano non pur i riguardanti ma esso Canal Grande, ricreatore di ciascun che il solca. E subito che fornì lo spasso di due gondole, che con altrettanti barcaiuoli famosi fecero a gara nel vogare, trassi molto piacere de la moltitudine che, per vedere la rigatta, si era fermata nel ponte del Rialto, ne la riva dei Camerlinghi, ne la Pescaria, nel traghetto di Santa Sofia e ne la casa da Mosto. E mentre queste turbe e quelle con lieto applauso se ne andavano a le sue vie, ecco ch'io, quasi uomo che fatto noioso a se stesso non sa che farsi de la mente non che dei pensieri, rivolgo gli occhi al cielo; il quale, da che Iddio lo creò, non fu mai abbellito da così vaga pittura di ombre e di lumi. Onde l'aria era tale quale vorrebbono espirmerla coloro che hanno invidia a voi per non poter esser voi. Che vedete, nel raccontarlo io, in prima i casamenti, che benché sien pietre vere, parevano di materia artificiata. E di poi scorgete l'aria, ch'io compresi in alcun luogo pura e viva, in altre parte torbida e smorta. Considerate anco la maraviglia ch'io ebb dei nuvoli composti d'umidità condensa; i quali in la principal veduta mezzi si stavano vicino ai tetti degli edificii, e mezzi ne la penultima, peroché la diritta era tutta d'uno sfumato pendente in bigio nero. Mi stupii certo del color vario di cui essi si dimostrano; i più vicini ardevano con le fiamme del foco solare; e i più lontani rosseggiavano d'uno ardore di minio non così bene acceso. Oh con che belle tratteggiature i pennelli naturali spingevano l'aria in là, discostandola dai palazzi con il modo che la discosta il Vecellio nel far dei paesi! Appariva in certi latti un verde-azzurro, e in alcun altri un azzurro-verde veramente composto da le bizarrie de la natura, maestra dei maestri. Ella con i chiari e con gli scuri sfondava e rilevava in maniera ciò che le pareva di rilevare e di sfondare, che io, che so come il vostro pennello è spirito dei suoi spiriti, e tre e quattre volte esclamai: "Oh Tiziano, dove sète mo?"

Per mia fè, che se voi aveste ritratto ciò ch'io vi conto, indurreste gli uomini ne lo stupore che confuse me; che nel contemplare quel che v'ho incontrato, ne nutrii l'animo, che più non durò la maraviglia di si fatta pittura.

53. Letter 48, 1:78–79: ". . . e per accorar quegli che, non potendo negar l'ingegno nostro, danno il primo luogo a voi nei ritratti, e a me nel dir male: come non si vedessero per il mondo le vostre e le mie opere." Translation mine. On the influence of Aretino's ekphrases of Titian paintings, see Freedman, above, n. 49.

54. André Chastel, "Gesture in Painting: Problems in Semiology," *Renaissance and Reformation* 10 (1986): 1–22. Chastel instances Giovanni Bonifacio's *L'arte di cenni* (The Art of Gestures), whose long title proposes that the treatise will take up *favella visibile* (visual speech) and *muta eloquenza* or *facondo silenzio* (garrulous silence), 9. See also Poussin's letter to Chantelou in E. G. Holt, ed., *A Documentary History of Art*, II (Princeton: Princeton University Press, 1982), 154–57, and Barasch, *Theories,* 328–29.

55. Hagstrum, *The Sister Arts,* 29, points out that Varro called his biographies *imagines,* an interesting trope which is quite revealing. On Vasari's *Lives* as a print phenomenon, see Eisenstein, *The Printing Revolution,* 128–31. Petrarch's *Lives,* planned to include biblical, Greek, and Roman heroes, inspired the decoration of the palace of Francesco Carrara at Padua, where a *sala* was devoted to portraits of them; see T. E. Mommsen, "Petrarch and the Decoration of the Sala Virorum Illustrium in Padua," *Medieval and Renaissance Studies* (Ithaca, N.Y.: Cornell University Press, 1959), 106–29.

56. The Cambridge and Metropolitan versions of the painting are juxtaposed

by Erwin Panofsky as illustrations 138, 139 in his *Problems in Titian Mostly Iconographic* (New York: New York University Press, 1969).

57. Rafaelle Borghini's 1584 dialogue *Il riposo* is quoted by Rensselaer W. Lee, *Ut Pictura Poesis: The Humanistic Theory of Painting* (New York: W. W. Norton, 1967), 44.

58. See Giovanni Andrea Giglio's 1564 dialogue *Degli errori e degli abusi de' pittori* in *Trattati d'arte del cinquecento*, 2:1–115; in *Scritti d'arte del cinquecento*, vol. 1, the extracts from Borghini, 340–47.

59. Norman Bryson, *Vision and Painting. The Logic of the Gaze* (New Haven and London: Yale University Press, 1985), 87–132. See also his *Word and Image: French Painting of the Ancien Régime* (Cambridge: Cambridge University Press, 1981). James Heffernan has kindly drawn my attention to the remarks of no less a viewer of our painting than J. M. W. Turner, who brought it up in a lecture he gave to the Academy on landscape painting in 1811. See Jerrold Ziff, "'Backgrounds, Introduction of Architecture and Landscape': A Lecture by J. M. W. Turner," *Journal of the Warbourg and Courtauld Institutes* 26 (1963): 124–47. See esp. 135–36 for Turner's reference to the landscape background. On the male gaze, see also Edward Stone, "Theorizing the Male Gaze: Some Problems," *Representations* 25 (1989): 30–41. Stone takes up "the convention that justifies male voyeuristic desire by aligning it with female narcissistic self-involvement" 38.

60. Mario Perniola, "Between Clothing and Nudity," *Fragments for a History of the Human Body*, Pt. 1, ed. Michael Feher with Ramona Nadoff and Nadia Tazi (New York: Zone, 1989), 236–65.

61. David Rosand, *Titian* (New York: Harry N. Abrams, 1978), 140.

62. Erwin Panofsky, *Problems in Titian Mostly Iconographic* (New York: New York University Press, 1969), 125. On the series of paintings dealing with a musician and a nude, see 121–38.

63. Lucretius, *On the Nature of the Universe,* trans. R. E. Latham (Harmondsworth, Middlesex, England: Penguin Books, 1951), 27.

64. Paul Engle, *A Woman Unashamed and other Poems* (New York: Random House, 1963), 86.

65. Horace Gregory, *Collected Poems* (New York: Holt, Rinehart, Winston, 1964), 116.

66. Julia Kristeva, "Stabat Mater," ed. Susan R. Suleiman *The Female Body in Western Culture,* (Cambridge: Harvard University Press, 1986), 108.

67. Robert Baldwin, "'Gates Pure and Shining Serene': Mutual Gazing as an Amatory Motif in Western Literature and Art," *Renaissance and Reformation* 10 (1986): 23–48. On the issue of legibility and resistance to legibility, there are several important articles not yet cited which should be noted: Svetlana Alpers, "Describe or Narrate? A Problem in Realistic Representation," *New Literary History* 8 (1976): 16–42; Donald Kuspit, "Traditional Art History's Complaint Against the Linguistic Analysis of Visual Art," *Journal of Aesthetics and Art Criticism* 45 (1987): 345–49; in a later issue of the same journal (47, 1989), Ann Hurley replies to Alpers via Kuspit's argument in her "Ut Pictura Poesis: Vermeer's Challenge to Some Renaissance Literary Assumptions," 350–57; Werner Senn, "Speaking the Silence: Contemporary Poems on Paintings," *Word & Image* 5 (1989): 181–97, takes up the issue of the provocative silence of painting; David Rosand, "Ut Pictor Poeta: Meaning in Titian's *Poesie*," *New Literary History* 3 (1972): 527–46.

WORKS CITED

Alberti. *On Painting*. Translated by John R. Spencer. New Haven and London: Yale University Press, 1976.

Alpers, Svetlana. "Describe or Narrate? A Problem in Realistic Representation." *New Literary History* 8 (1976).

Altieri, Charles. "Ponderation in Cézanne and Williams." *Poetics Today* 10 (1989).

Aristides. *Panathenaic Oration* and *In Defense of Oratory*. Translated by C. A. Behr. Cambridge: Harvard University Press, 1973.

Baldwin, Robert. "'Gates Pure and Shining Serene': Mutual Gazing as an Amatory Motif in Western Literature and Art." *Renaissance and Reformation* 10 (1986).

Barasch, Moshe. *Theories of Art from Plato to Winckelman*. New York and London: New York University Press, 1985.

Barolsky, Paul. *Giotto's Father and the Family of Vasari's "Lives."* University Park and London: Pennsylvania State University Press. 1992.

———. *Walter Pater's Renaissance*. University Park and London: Pennsylvania State University Press, 1987.

Baron, Hans. *The Crisis of the Early Italian Renaissance*. Princeton: Princeton University Press, 1966.

Barricelli, Jean Pierre, Joseph Gibaldi, and Estella Lauter, eds. *Teaching Literature and Other Arts*. New York: The Modern Language Association of America, 1990.

Baxandall, Michael. *Giotto and the Orators: Humanist Observations of Painting in Italy and the Discovery of Pictorial Composition, 1350–1450*. Oxford: Clarendon Press, 1971.

Bryson, Norman. *Vision and Painting: The Logic of the Gaze*. New Haven and London: Yale University Press, 1985.

———. *Word and Image: French Painting of the Ancien Régime*. Cambridge: Cambridge University Press, 1981.

Chastel, André. "Gesture in Painting: Problems in Semiology." *Renaissance and Reformation,* vol. 10 (1986).

Cicero, *Pro Archia Poeta*. Translated by N. H. Watts, vol. 9 of Loeb Library. Cambridge: Harvard University Press, 1979.

Cohen, Walter. *Drama of a Nation: Public Theatre in Renaissance England and Spain*. Ithaca and London: Cornell University Press, 1988.

Colonna, Vittoria. *Rime*. Edited by Alan Bullock. Bari: Laterza, 1982.

Crashaw, Richard. "The Flaming Heart." In *The Poems English Latin and Greek of Richard Crashaw*. Edited by L. C. Martin. Oxford: Clarendon Press, 1957.

Cristofano Allori 1577–1621: Catalogo a cura di Miles L. Chappell. Florence: Palazzo Pitti, 1984.

d'Andrea Cennini, Cennino. *The Craftsman's Handbook*. Translated by Daniel V. Thompson, Jr. New York: Dover Publications, 1960.

de Hollanda, Francisco. *Four Diaglogues on Painting*. Translated by Aubrey F. G. Bell. Oxford: Oxford University Press, 1928.

Della Porta, Giambattista. *Gli duoi fratelli rivali (The Two Rival Brothers)*. Edited and translated by Louise G. Clubb. Berkeley, Los Angeles, London: University of California Press, 1980.

Edmonds, J. M., trans. *Anacreontea.* Cambridge: Harvard University Press, 1979.

Eisenstein, Elizabeth L. *The Printing Revolution in Early Modern Europe.* New York: Cambridge University Press, 1984.

Engle, Paul. *A Woman Unashamed and other Poems.* New York: Random House, 1963.

Ferrero, Ermanno, and Giuseppe Müller, ed. *Vittoria Colomma: Carteggio.* Turin: Loescher, 1884.

Fitts, Dudley, trans. *Poems from the Greek Anthology.* New York: New Directions, 1956.

Freedman, Luba. "Bartolomeo Maranta on a Painting by Titian." *Hebrew University Studies in Literature and the Arts* 13 (1985).

Garrard, Marry D. *Artemesia Gentileschi: The Image of the Female Hero in Italian Baroque Art.* Princeton: Princeton University Press, 1989.

Giglio, Giovanni Andrea. *Degli errori e degli abusi de' pittori* (1564) in *Trattati d'arte del cinquecento* vol. 2.

Gilbert, Allan H., ed. *Literary Criticism from Plato to Dryden.* Detroit, Mich.: Wayne State University Press, 1962.

Gilman, Ernest B. *Iconoclasm and Poetry in the English Reformation.* Chicago and London: University of Chicago Press, 1986.

Goodman, Nelson. *Languages of Art.* New York: Hackett Publishing, 1976.

Gordon, D. J. "The Quarrel between Ben Jonson and Inago Jones." In *The Renaissance Imagination,* edited by Stephen Orgel. Berkeley: University of California Press, 1980.

Graziani, François. "L'Image comme verbe divin chez Zuccaro et Marino." *Art et littérature.* Actes du Congrès de la Société Française de Littérature Générale et Comparée, 1986.

Gregory, Horace. *Collected Poems.* New York: Holt, Rinehart, Winston, 1964.

Guglielminetti, Marziano, ed. *Giambattista Marino: Lettere.* Turin: Einaudi, 1966.

Hagstrum, Jean H. *The Sister Arts.* Chicago and London: University of Chicago Press, 1987.

Hathaway, Baxter. *The Age of Criticism: The Late Renaissance in Italy.* Ithaca, N.Y.: Cornell University Press, 1962.

Heffernan, James A. W., ed. *Space, Time, Image, Sign.* New York: Peter Lang, 1987.

Hollander, John. "The Poetics of Ekphrasis." *Word & Image* 4 (1988).

Holt, E. G., ed. *A Documentary History of Art* 2. Princeton: Princeton University Press, 1982.

Hulse, Clark. *The Rule of Art: Literature and Painting in the Renaissance.* Chicago and London: University of Chicago Press, 1990.

Hunter, William B., ed. *The Complete Poetry of Ben Jonson.* Garden City, N.Y.: Anchor Books, 1963.

Hurley, Ann. "Ut Pictura Poesis: Vermeer's Challenge to Some Renaissance Literary Assumptions." *Journal of Aesthetics and Art Criticism* 47 (1989).

Jay, Peter, ed. *The Greek Anthology.* Harmondsworth, Middlesex, England: Penguin Books, 1981.

Jerrold, Maude F. *Vittoria Colonna.* Freeport, N.Y.: Books for Libraries Press, 1969.

Kemp, Martin, ed. *Leonardo on Painting*. New Haven and London: Yale University Press, 1989.

Kristeller, P. O. "The Modern System of the Arts." In *Renaissance Thought and the Arts: Collected Essays*. Princeton: Princeton University Press, 1980.

Kristeva, Julia. "Stabat Mater." In *The Female Body in Western Culture*, edited by Susan R. Suleiman. Cambridge: Harvard University Press, 1986.

Kuspit, Donald. "Traditional Art History's Complaint Against the Linguistic Analysis of Visual Art." *Journal of Aesthetics and Art Criticism* 45 (1987)

Lawner, Lynne, ed. *I Modi*. Milan: Longanesi, 1984. (English edition: *I Modi. The Sixteen Pleasures*. Evanston, Ill.: Northwestern University Press, 1988)

Lee, Rensselaer W. *Ut Pictura Poesis: The Humanistic Theory of the Painting*. New York: W. W. Norton, 1967.

Lessing, G. E. *Laocoön*. Translated by Edward A. McCormick. Baltimore and London: Johns Hopkins University Press, 1989.

Lichtenstein, Jacqueline. *La Couleur éloquente: Rhétorique et peinture à l'âge classique*. Paris: Flammarion, 1989.

Lomazzo, G. P. *Trattato dell'arte della pittura, scoltura et architettura (1584)*. In *Scritti d'arte del cinquecento*. 3 vols. Edited by Paola Barocchi. Milan and Naples: Riccardo Ricciardi Editore, 1971.

Lucian. *Slander*. In *Works,* vol. 1, translated by K. Kilburn. Cambridge: Harvard University Press, 1979.

———. *Zeuxis or Antiochus*. In *Works,* vol. 6, translated by K. Kilburn. Cambridge: Harvard University Press, 1979.

Lucretius. *On the Nature of the Universe*. Translated by R. E. Latham. Hammondsworth, Middlesex, England: Penguin Books, 1951.

McFarlane, I. D., ed. *Renaissance Latin Poetry*. New York: Barnes & Noble Books, 1980.

Maiorino, Giancarlo. *Leonardo de Vinci: The Daedelian Myth-Maker*. University Park: Pennsylvania State University Press, 1992.

Mankiewicz, Henryk. "Ut Pictura Poesis: A History of the Topos and the Problem." *New Literary History* 18 (1987).

Marcus, Leah S. *The Politics of Mirth*. Chicago and London: University of Chicago Press, 1989.

Marino, Giambattista. *Dicerie sacre e La Strage delg'Innocenti*. Edited by Giovanni Pozzi. Turin: Einaudi Editore, 1960.

———. *L'Adone*. Edited by Giovanni Pozzi. Milan: Arnaldo Mondadori Editore, 1976.

Mendelsohn-Martone, Lettrice. *Benedetto Varchi's "Due Lezzione": "Paragoni" and Cinquecento Art Theory*. 2 vols. Ann Arbor, Mich.: University Microfilms International, 1982.

Mirollo, James V. *Mannerism and Renaissance Poetry*. New Haven and London: Yale University Press, 1984.

———. *The Poet of the Marvelous: Giambattista Marino*. New York and London: Columbia University Press, 1963.

Mitchell, W. J. T. *Iconology*. Chicago and London: University of Chicago Press, 1986.

Mommsen, T. E. "Petrarch and the Decoration of the Sala Virorum Illustrium in

Padua." In *Medieval and Renaissance Studies*. Ithaca, N.Y.: Cornell University Press, 1959.

Osborne, Mary T. *Advice to Painter Poems, 1633–1856: An Annotated Finding List*. Austin: University of Texas Press, 1949.

Paleotti, Gabriele. *Discorso Intorno alle Imagini Sacre e Profane*. In *Trattati d'arte del cinquecento*, 2, edited by Paola Barocchi. Bari: Laterza, 1961.

Palladino, Lora Anne. *Pietro Aretino: Orator and Art Theorist*. Ann Arbor, Mich.: University Microfilms International, 1982.

Panofsky, Erwin. *Galileo as a Critic of the Arts*. The Hague: Martinus Nijhoff, 1954.

———. *Problems in Titian Mostly Iconographic*. New York: New York University Press, 1969.

Peacock, John. "Inago Jones as a Figurative Artist." In *Renaissance Bodies*, edited by Lucy Gent and Nigel Llewellyn. London: Reaktion Books, 1990.

Perniola, Mario. "Between Clothing and Nudity." In *Fragments for a History of the Human Body*, Pt. 1, edited by Michael Feher with Ramona Nadoff and Nadia Taza. New York: Zone, 1989.

Pertile, Fidenzio and Ettore Camesasca, eds. *Lettere sull'arte di Pietro Aretino*, 3 vols. Milan: Edizioni del Milione, 1957–1960.

Philostratus. *Imagines*. Translated by Arthur Fairbanks. Cambridge: Harvard University Press, 1979.

Plutarch. *De Gloria Atheniensium, Moralia* 4. Translated by Frank C. Babbitt. Cambridge: Harvard University Press, 1972.

Praz, Mario. *Mnemosyne*. Princeton: Princeton University Press, 1970.

Quintilian. *The Instituto Oratoria*. Translated by H. E. Butler. 4 vols. New York: G. P. Putnam's Sons, 1921–1922.

Rosand, David. *Titian*. New York: Harry N. Abrams, 1978.

———. *"Ut Pictor Poeta:* Meaning in Titan's *Poesis." New Literary History* 3 (1972).

Roskill, Mark W. *Dolce's "Aretino" and Venetian Art Theory of the Cinquecento*. New York: New York University Press, 1968.

Roston, Murray. *Renaissance Perspectives in Literature and the Visual Arts*. Princeton: Princeton University Press, 1987.

Senn, Werner. "Speaking the Silence: Contemporary Poems on Paintings." *Word & Image* 5 (1989).

Shapiro, Marianne. "Ecphrasis in Virgil and Dante." *Comparative Literature* 42 (1990).

Silvers, Larry. "Step-Sister of the Muses: Painting as Liberal Art and Sister Art." In *Articulate Images: The Sister Arts from Hogarth to Tennyson*, edited by Richard Wendorf. Minneapolis: University of Minnesota Press, 1983.

Simon, Roger. "Vision Picturale at création poètique chez G. B. Marino." *Art et littérature* Actes du Congrès de la Société Française de Littérature Générale et Comparée, 1986.

Skelton, Robin, trans. *Two Hundred Poems from the Greek Anthology*. Seattle: University of Washington Press, 1971.

Steiner, Wendy. "The Causes of Effect: Edith Wharton and the Economics of Ekphrasis." *Poetics Today* 10 (1989): 279–97.

———. *The Colors of Rhetoric.* Chicago University of Chicago Press, 1982.

Stone, Edward. "Theorizing the Male Gaze: Some Problems." *Representations* 25 (1989).

Suleiman, Susan R., ed. *The Female Body in Western Culture.* Cambridge and London: Harvard University Press, 1986.

Summers, David. *Michelangelo and the Language of Art.* Princeton: Princeton University Press, 1981.

———. *The Judgment of Sense: Renaissance Naturalism and the Rise of Aesthetics.* New York: Cambridge University Press, 1990.

Tasso, Bernardo. *Ragionamento della poesia* (1562). In *Trattati d'arte del cinquecento* 2, edited by Paola Barocchi. Bari: Laterza, 1961.

Torgovnick, Marianna. "Making Primitive Art High Art." *Poetics Today,* Art and Literature 2:10 (1989).

Varchi, Benedetto. "Lezione della maggioranza delle arti." In *Trattati d'arte del cinquecento,* 1, edited by Paola Barocchi. Bari: Laterza, 1960.

Wark, Robert R. "The Weak Sister's View of the Sister Arts." In *Articulate Images: The Sister Arts from Hogarth to Tennyson,* edited by Richard Wendorf. Minneapolis: University of Minnesota Press, 1983.

Weinberg, Bernard. *A History of Literary Criticism in the Italian Renaissance.* 2 vols. Chicago: University of Chicago Press, 1961.

Wilson, Katharina M., ed. *Women Writers of the Renaissance and Reformation.* Athens and London: University of Georgia Press, 1987.

Ziff, Jerrold. "'Backgrounds, Introduction of Architecture and Landscape': A Lecture by J. M. W. Turner." *Journal of the Warbourg and Courtauld Institutes* 26 (1963).

Zuccari, Federico. *Idea de'pittori, scultori et architetti* (1607). In *Scritti d'arte del cinquecento* I, edited by Paola Barocchi. Milan and Naples: Riccardo Ricciardi Editore, 1971.

More Foolery from More?: John Donne's Lothian Portrait as a Clue to His Politics

ANN HURLEY

In the middle of the 1590s, that decade in which so much of English poetry suddenly came into its own, a young poet, already beginning to establish his reputation and facilitate his social and occupational interests through his literary talents, suddenly switched media and commissioned the painting of his own portrait. This was not the first time John Donne had arranged for the recording of his own image. An earlier, less flattering depiction of the poet at age eighteen exists, and other portraits were to follow, concluding with the famous effigy of the Dean of St. Paul's in his shroud.[1]

The existence of this set of portraits has long engaged at least passing critical attention since, as is often noted, it is of some curiosity that Donne, a poet whose verse is not usually associated with pictorial imagery, should have been so fascinated with the reproduction of his own image. Scholars have generally been unified in resolving this apparent contradiction by attributing it to the literary themes of self-preoccupation and self-dramatization that resonate through Donne's verse. Louis Martz, for example, sees the portraits as corroborating "Donne's lifelong practice of adopting dramatic postures, in many different attitudes, his way of constantly creating fictional roles out of aspects of his personality."[2] Ernest Gilman comments that "the surviving portraits offer a series of shifting, carefully contrived poses that vividly reflect the several different selves that Donne would fashion for himself,"[3] and Helen Gardner, less charitably, attributes them in part to "egoism and devouring interest in his own personality."[4]

While it is true that some of these critics do go on to acknowledge with Gardner that Donne's interest in portraiture is also a product of his "discriminating interest in the fine arts," and Ernest Gilman, in particular, has written an impressive study of Donne's sensitivity to the image in the political context of Reformation iconoclasm, the portraits themselves have received attention only as evidence of Donne's visual erudition in

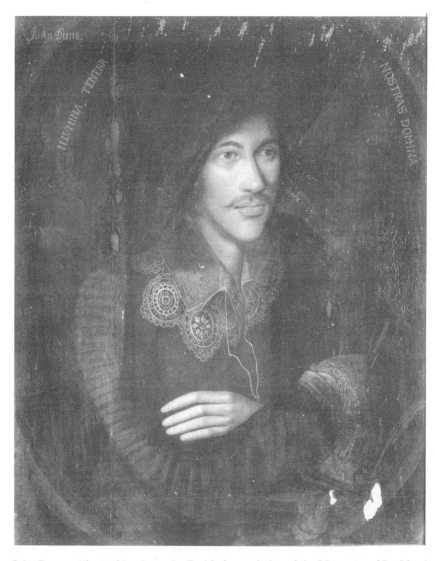

John Donne. *The Lothian Portrait.* **(By kind permission of the Marquess of Lothian.)**

the context of references to the small but astutely selected art collection
that he amassed as Dean of St. Paul's.[5] It might be profitable, therefore,
to pause for a moment, to suggest that Donne's portraits link literature
and the visual arts not simply in the pleasing confirmation that a poet in
possession of the tough intellect that we associate with Donne's verse is
also well read in the subtleties of picture, but also insofar as these visible

links between the sister arts also testify to the thorough political and cultural saturation of English Renaissance art in all its forms.

My starting point is an interest in the ways in which Donne's handling of the visual elements of his culture functions as an index of his response to the social, political, and ideological pressures of his age and social place, and my assumptions here rest, in part, on the previous work of two sets of scholars: that of Stephen Orgel and Roy Strong who in their many publications have convincingly documented the ways in which Renaissance visual experience is culturally saturated and politically shaped; and equally important, the work of theorists in word/image studies, specifically W. J. T. Mitchell and Norman Bryson, who have skillfully demonstrated the ways in which cultural assumptions can be analyzed through word/image conflations and oppositions.

Bryson, for example, analyzes the way in which visual art can be seen as an "activity of the sign"[6] through which ideology is both reflected and produced, while Mitchell's detailing of the ways in which references to the image in Western culture reflect both fear and reverence provides an explanation for why in Western culture the visual image is frequently connected with the marginalized and/or politically subversive. Thus, while Orgel and Strong have analyzed the ways in which Renaissance centers of power appropriated visual imagery as a political instrument through which to consolidate and articulate that power, Bryson and Mitchell offer a means whereby we might also take note of how a specific individual, particularly if he were a practicing poet actively engaged in shaping his future, might articulate his own emerging relation to power.

What I propose to investigate is not Donne's verse but some of its political origins as both revealed and effaced in a specifically visual medium, the Lothian portrait.[7] This famous portrait, described by Donne in his will as "taken in Shaddowes," is frequently correlated, given that description coupled with the verbal inscription which surrounds the poet's head (*"illumina tenebras nostras Domina,"* note the feminine ending), with the literary tradition of the melancholic lover. Yet, while it certainly invites such a reading, one might also conjecture, given Mitchell's discussion of the role of the image in Western culture, that that same verbal inscription effects a double effacement of the image: that is, it draws attention to the witty blasphemy involved in its parody of the third Collect for Evening Prayer (*"Illumina quaesumus Domine Deus tenebras nostras"*), thus rewarding the perceptive viewer with its accepted subversion of state religion. In so doing, however, it also deflects that viewer's attention from visual associations which might be more politically dangerous, and not so easily dismissed as the playful mockery of a recent graduate of the Inns of Court. In short, in this portrait I suggest that words and text are used as they have been traditionally in Western culture—to

tame or even erase the potency of the visual. Properly "read," Donne's portrait in its visual allusions and more complex iconography tells a rather different narrative from what has been discerned in his verse.

Because the kind of analysis I am proposing here necessarily involves rather lengthy detours into the theoretical questions pertinent to any interdisciplinary undertaking, in addition to a consideration of the detail necessary to establishing the iconographic tradition in which Donne's Lothian portrait exists, it might be useful at this point to indicate the sections of the exploration to follow. In short, because discussions of the Lothian portrait have always taken place in the context of literary criticism, that portrait has never been seen as participating in a specifically visual tradition. Thus, in the first section of my essay I will be arguing that such a tradition does exist, and that Donne's selection of the details of his portrait were deliberate choices made with that tradition in mind. Second, because Donne's portrait, as I see it, uses a literary tradition which has been depoliticized to deflect visual allusions which are highly political, a second section of the essay will look briefly at the theoretical questions involved in such a move, particularly with respect to Erwin Panofsky's implication of the verbal in his iconological "readings" of the visual, an implication which has plagued the borders between literature and the visual arts and their cross-borrowings by scholars in their respective fields. Finally, a concluding section will look at the way in which Donne's Lothian portrait does indeed function as an index to his political affiliations in the religious and political climates of England in the 1590s.

The usual reading of this portrait cites textual evidence for its participation in a specifically literary culture. Roy Strong, for example, in a seminal essay on melancholy in Elizabethan and Jacobean portraiture, situates this genre in literary texts like Robert Burton's *Anatomy of Melancholy* (1577–1640) or the passage from *Love's Labour's Lost* (ca. early 1590s) in which the lover, Don Armado, is advised to "sigh a note and sing a note . . . with your hat penthouse-like o'er the shop of your eyes, with your arms crossed on your thin-belly doublet" (3.1). Less well-known are the lines from Samuel Rowland in which the speaker sees

> . . . a well-shaped man,
> His body formed comely as I thought. . . .
> His face being masked with his hat pulled downe,
> And in french doublet without gowne or cloake,
>
>
>
> His head held downe, his armes were held acrosse,
> And in his hat a cole-blacke feather stucke,
> His melancholy argued some great losse,
> He stood so like the picture of ill-lucke.
>
> ("The Melancholie Knight")[8]

Such passages are sufficiently familiar to support Douglas Chambers's conclusion that the Lothian portrait presents Donne "as a literary melancholic with all the black trappings of fashionable melancholy about him."[9]

Among these "trappings," however, is the specific pose of the sitter's arms, "held acrosse" in keeping with the posture of the melancholic lover to be sure, but in this particular instance exaggeratedly so, with mannerist attention to the finely elongated left hand and rich fur of the glove on the right. The crossed arms, although repeatedly mentioned in literary texts, are infrequently duplicated in Renaissance secular art, particularly portraiture. Roy Strong finds only two instances in the portrait tradition associated with the melancholic lover; other related examples which he cites, coming later in the century, take the form of frontispieces or costume sketches, and almost all of these involved full-length portraits. Moreover, only the two portraits, which duplicate Donne's crossed arms position, combine that pose with the half-figure position of the Lothian portrait. Lorne Campbell in his recent study of Renaissance portraiture explains, from a technical point of view, why this pose, the selection of the crossed arms, particularly as combined with the half-figure, is so unusual:

> When composing a full-length portrait, the painter and patron can freely exercise their inventive talents. In a portrait in which the sitter is seen at less than full length, as in other half-length images, the principle compositional problem is to justify the cutting of the figure.[10]

One solution, Campbell continues, was to depict the sitter with hands resting on a parapet or the corner of a table. This solution in turn provoked another problem, however, as the artist was then forced to attend to the depiction of hands which were not only notoriously difficult to draw but which, because they were the same size and tone as the face, could distract attention from that usually preferred focus of interest. Artists thus were inclined to avoid poses like the crossed-arms posture for portraiture.

I would like to suggest, however, that the use of the crossed arms pose in English Protestant portraiture might have been inhibited for another, nontechnical, reason: namely, its complex iconography associated with the angelic figures of the religious art of the fourteenth century and occasionally invoked as an attitude of religious zeal appropriate for veneration of the saints or for militantly devout members of the Roman Catholic ecclesiastical hierarchy.

The crossed-arms posture adopted by Donne for his portrait can be seen, for example, in the rows of fourteenth-century angels depicted by Pietro and Ambrogio Lorenzetti in Siena where what appears to be a localized Roman Catholic tradition of veneration evidently originated. I find it again in depictions by Fra Angelico (e.g., the familiar *Madonna and*

Child Enthroned with Eight Angels, ca. 1425–26, Fiesole, San Dominico), suggesting an early expansion from the Sienese point of origin. It reappears, tellingly, given one portrait which I intend to discuss at the end of this essay, in the work of the French artist, Jean Fouquet, who was active in Italy in the fifteenth century and influenced by Fra Angelico. It then moves north, emerging in sixteenth century Bavaria where it is aggressively assumed by one of the most vigorous opponents of the Protestant Reformation, Chancellor Leonard von Eck, in a 1527 portrait by Barthel Beham. Finally, as we have seen, it arrives in England to appear in the portraits cited above and in Donne's Lothian portrait.

The pose needs to be distinguished from some slightly similar postures to clarify its full implications. It is not quite the same as the standard annunciation pose taken by the Virgin Mary who holds her hands higher and flat across her breasts rather than folded into the sleeves of her robe. Nor is it exactly equivalent to Northern European genre paintings like Frans Hals's Fisherboys who, although holding their hands in poses almost identical to Donne's, are nonetheless situated through landscape, expression, class, and the accompanying accoutrements of their trade in an iconography of idleness associated with verbal texts like *Proverbs* (e.g., "a slothful man hideth his hand in his bosom" 10:4) or folk sayings (e.g., "idle hands are the Devil's workshop.")[11]

Instead the pose appears to have been seen not only as significant of religious zeal but more specifically as the pose of a follower or worshipper. Possibly associated with such emblematic usages as Ripa's image of Pertinacity which shows a woman in the crossed-arms posture (*Iconologia,* Padua, 1618), the pose appears to denote the more positive synonym for pertinacity, "steadfastness." The portrait of Chancellor von Eck, referred to above, is one such instance. Von Eck, a member of the Bavarian nobility and trained in the law, who became chancellor in 1519 and thereafter aggressively served Counter-Reformation interests by vigorous attacks on Protestant Reformers, is depicted by the portraitist Barthel Beham in 1527, at age 47, with arms tensely folded, hands tucked into his sleeves, and an inflexibility determined look in his eyes, the very image of a zealot.

The earlier Sienese angels and those depicted by Fouquet, by contrast, seem devout rather than zealous in their assumption of this pose, but that devotion is still clearly invoked in the larger context of signifying a "follower." Jean Fouquet's fourteenth-century miniature of the death of the Virgin, for example, shows ranks of angels receding into the background while the central figure of Mary, held in the arms of God, is further encircled by angelic figures with elongated wings and similarly folded arms. The other miniature from the same manuscript *The Ascension of Christ* depicts both saints and angels in a similar posture, while the rendition by Fra Angelico mentioned above, of the *Madonna and Child En-*

Chancellor Leonard von Eck. Barthel Beham, 1527. (The Metropolitan Museum of Art.)

throned with Eight Angels and Saints, also suggest the connotations of devotion.

What is intriguing about these examples in the context of discussion of Donne's portraits, however, is not simply that they establish an iconographic tradition for the pose but, more pertinently, that this tradition, unlike that of the melancholic lover or even the idle fisherboys, appears to have been entirely visual. And such a visual allusion, unvalidated by an established literary tradition which in appropriating other aspects of saint-like devotion for the melancholic lover had thereby depoliticized them, thus poses some intriguing theoretical implications for the "readings" of portraiture, particularly as those readings have been described by Erwin Panofsky.

The professional literature on the sister arts of painting and poetry has, since Simonides, both acknowledged and occasionally lamented the point that even the most ostensibly disinterested accounts of their disputed claims tend to resolve in a bias in favor of verbal art. Simonides' distinction between poetry as a "speaking" picture and paintings as "mute" poetry, and Lessing's assertion that although each of the sister arts has its proper sphere, that of poetry is "wider," are only the most famous of a variety of accounts which in spite of a claim to respect the integrity of disciplinary boundaries nonetheless further what the art world sees as the "imperialist" encroachment of linguistic systems on visual art. "Reading" pictures, "narrating" allegorical depictions, even "titling" the framed visual experience are activities in our everyday engagement with visual art which would seem to support the inference that painting will always be the dependent sibling in the rivalry between the sister arts.

Defense of the weaker sister, in turn, can be invoked, however. One of the most recent is that posed by scholars like Michael Baxandall and Svetlana Alpers who see the special properties of painting as activated in the context of specific visual cultures. Alpers, for example, argues that late Renaissance Dutch culture allowed certain paintings to exist simply as descriptions of the physical world rather than as textualized commentaries on it. The advantage of such approaches is their departure from the methods so powerfully instituted by Panofsky that now dominate the procedures of a majority of art historians. Panofsky, as his critics like Alpers have noted, from the start complicates, even as he facilitates, the art historian's approach to visual art with linguistic procedures by founding art historical work on documentation which is often verbal and by directing the scholar's attention toward "imagistic themes" rather than to the image.[12] A visual tradition which invokes images significantly lacking the support of textual reference would then seem to be a gain from the art historian's point of view precisely because it would escape the Panofskian dependence of visual art on the verbal.

Jean Fouquet. "The Ascension of Christ" from *The Hours of Etienne Chevalier*. (Le Muséé Condé.)

What I have been calling the iconographic tradition of the crossed-arms pose invoked by Donne's Lothian portrait, however, does not simply escape dependence on the verbal. Rather, it converts dependence into advantage by activating the verbal culture of sixteenth-and seventeenth-century England as a screen for, or a deflection of, the potent political implications of the visual. As such it offers an instance of interaction between the sister arts in which the weaker sister is thus not only free from dependence on the traditionally stronger sibling, but gains its own potency from a witty manipulation of that traditional dependence. Taking advantage of the coincidence that one gesture, the crossed-arms posture, exists independently in two traditions, painting and poetry, Donne's Lothian portrait thus uses the verbal tradition of the melancholic lover to deflect the dangerous implications of its visual associations with Roman Catholic devotion. Because Protestant England was amused at the time-sanctioned mockery of saint-like devotion of the melancholic lover in the verbal tradition of the sonnet sequences, and thus could be counted on to respond to an echo of that in portraiture, it could easily miss the secular appropriation of a more obscure visual tradition of genuine devotion apparent only to those, like Donne, whose shared religious background was non-Protestant. To support that point, we need to return to the commissioning of the portrait and Donne's probable role in the selection of this pose, not, however, without first noting that border raids between disciplines need not always be evidence of linguistic imperialism; as instances of graphic guerrilla maneuvre, they can, as the Lothian portrait demonstrates, sometimes originate from the visual side.

We know that Donne played an active role in selecting the details of at least two of the "portraits" he commissioned: the marble effigy of his wife, no longer extant but recorded in the notebooks of its sculptor, Nicholas Stone; and the more famous, or infamous, effigy of himself which he posed for in his shroud (by Walton's account so concerned with the correct nature of its depiction that he posed standing on his own funeral urn in order that the drapery would fall accurately). It would be safe then, I think, to assume that the young Donne would have been no less concerned with details of his portraiture, and that the mannerist pose in its self-conscious exaggeration was not chosen by the artist but was selected by the sitter, Donne himself.

Moreover, what I would like to conjecture is that, for the technical reasons described above, this pose was not selected for its aesthetic possibilities but as a visual clue chosen by Donne precisely for its reference to the body of art just summarized as readily associated with the Roman Catholic hierarchy of saints and angelic orders and with postures of veneration adopted by the followers of that religion.

That such a visual allusion might indeed have been considerably risky

in the Protestant England of the 1590s (the same decade in which Donne's brother died as an indirect consequence of harboring a Catholic priest) is exemplified in the action taken by Richard Haydocke, for example, who, when translating Lomazzo's treatise on painting, would be sufficiently concerned as he adapted this Italian Catholic material for an English Protestant audience, with the depiction of such Catholic-tainted images as the angelic orders that he would omit that section of Lomazzo's treatise entirely from his translation.

One possible reading of the pose, were the viewer able to correctly identify its visual, nonliterary associations, then, might imply a covert affiliation of the sitter with the religion of those most closely associated with that pose, and perhaps even a devotional posture correlative with it. Donne would recast the love melancholy of his portrait in just such a fashion in "La Corona" when he offered to God "this crown of prayer and praise / Weav'd in my low *devout* melancholy" (italics mine). Moreover, one of the two other English portraits to use this pose (and missing the mannerist exaggeration as visual clue) is of a particularly suspect individual, politically speaking, Christopher Marlowe.

This is not to suggest that in the 1590s Donne *was* politically suspect. Indeed, he was to be appointed secretary to Thomas Egerton, Lord Keeper of the Great Seal, shortly after this portrait was most probably painted. But this way of looking at Donne's handling of those posed arms in the context of Catholic religious gesture does fill out in interesting ways a version of Donne's Catholicism in its "familial historical" context that is currently being pursued by one of his biographers, Dennis Flynn.

The question of Donne's Catholicism, Flynn points out, is complicated by our failure to realize that although Donne's formative period coincided with the most dramatic and dangerous period for English Catholics, the Catholicism practiced by Donne's family was not the militant Tridentine Catholicism imported into England by Jesuit missionaries from the continent.[13] Instead, Donne's family evidently practiced what was known as "the old religion," which had descended to Donne through his mother's family, the Heywoods, directly from Sir Thomas More. Donne himself, Flynn notes, was "self-consciously a descendent of More," and our recollection of Donne's comments about his famous ancestor (which Flynn cites) support this statement.

What it meant to be a Catholic in England in the 1590s, practicing the "old religion" of the Heywoods and More, had more to do with attitude than with doctrine. Indeed, such a variant included deep distrust of doctrinal dogmatism. Instead the Erasmian Catholicism practiced by Donne's family, even by Jasper Heywood, his Jesuit uncle, was a variant inclined to express itself through humor and controversy. Jasper Heywood, for example, expressed his growing discomfort with his Jesuit peers

by making a "farce" of his own doctrinal dissertation at Dilligen and by cultivating what Flynn describes as "a maverick tendency in the Erasmian vein."[14] Ellis More, his brother, commemorated his famous uncle in 1556 with a dialogue titled "Il Moro" which celebrated, according to Flynn, "Thomas More's rededication to humanist spirituality and persuasion in the last days before his arrest."[15]

That the pose adopted by Donne for his 1590s portrait fits into the mode of Erasmian Catholicism expressed through a kind of witty learned humor might be substantiated by one last piece of iconic reference well in keeping with the foolery of More and his circle. This is a portrait of the court fool, Gonella, from the court of Nicholas III of Ferrara, probably completed in the 1440s and attributed by some to Jean Fouquet. Like Donne's portrait, that of Gonella adopts the unusual crossed-arms angelic pose of devotion, a pose which in Catholic Italy of the fifteenth century might only have been permitted to a licensed fool.

It is tempting to connect this portrait with Donne's. And, given that the portrait of Gonella ends up in the collection of Charles I, perhaps obtained for or donated to the king by Donne's friend, Henry Wotton, it may indeed have been discussed in England in the 1590s or possibly called to Donne's attention during his Italian travels (if these took place as his biographers conjecture) which immediately preceded the commissioning of the Lothian portrait. The Gonella portrait appears to have been something of a cult portrait; at least one might infer that, given that a copy exists, perhaps commissioned by someone other than the original patron.[16] Thus it might well have been described in circles of art collectors or simply those interested in painting, which could easily have included Donne.

In the absence of specific evidence, however, some less dramatic conclusions can be drawn from the coincidence of pose between the Lothian and the Gonella portraits. First, Donne's selection of the Catholic pose of devotion for his Lothian portrait, as seen from the perspective of a visual rather than a verbal tradition, implies that he was considerably more visually erudite than has heretofore been acknowledged by Donne scholars. Even if he had never heard of or seen the Gonella portrait, the fact that its artist (or patron) used the devotional pose for similar witty commentary substantiates the point that the pose might be used in this fashion. Thus the Lothian portrait might be persuasively added to the two effigies as instances where Donne's fascination with images extended to such technical matters as the selection of pose and its implications. Moreover, taken together, the conscious handling of these three "portraits" locates Donne in English visual culture in ways which are fully consistent with his friendships with artists like Inigo Jones and Nicholas

Jean Fouquet. *Le Gonella.* **(Kunsthistorisches Museum.)**

Stone or the collectors of art like Dudley Carleton, Sir Thomas Roe, and Endymion Porter.

Second, the fashion in which the verbal tradition of the melancholy lover, invoked by the witty text encircling the head of the poet, is used to deflect the more politically dangerous visual allusions of the pose, while admittedly only a selective sample, does call into question current critical assumptions about linguistic dominance in Renaissance conjunctions of word and image. Freed from a Panofskian dependence on verbal documentation, art critics may well be able to find other instances in which visual traditions, like that of the Catholic pose of devotion used here, manipulate text to assert their own independent iconographic authority.[17]

Third, and most pertinently for my own interests here, establishing Donne's connections with the visual culture of his time in this instance does indeed provide a clue to his political and cultural circumstances with a specificity that confirms some of the conjectures of his recent biographers like Flynn. Donne's early Catholicism has never been in doubt, but the variation that it took and his own attitude toward it can be explored further if visual as well as verbal sources are consulted. Finally, moreover, the existence of the Gonella portrait corroborates the conjecture that the pose itself has a history of association with politically risky but witty foolery in the context of sacred things, a history well in keeping with both the ancestry and the literary career of John Donne.

NOTES

1. There are seven portraits extant: a 1591 engraving by William Marshall, probably after an original by Nicolas Hilliard, prefixed to the 1635 edition of Donne's *Poems,* the Lothian portrait to be discussed here; a miniature by Isaac Oliver, now at Windsor Castle; a portrait in the Deanery of St. Paul's Cathedral; a copy of that same portrait, now in the Victoria and Albert Museum; the frontispiece for *Death's Duel* (1632) from an engraving by Martin Droeshout; and the effigy by Nicholas Stone in St. Paul's Cathedral.

2. Louis Martz, *The Wit of Love: Donne, Carew, Crashaw, Marvell* (Notre Dame, Ind.: University of Notre Dame Press, 1969), 26.

3. Ernest Gilman, *Iconoclasm and Poetry in the English Reformation: Down Went Dagon* (Chicago: University of Chicago Press, 1986), 120.

4. Helen Gardner, ed., *John Donne: The Elegies and The Songs and Sonnets* (Oxford: The Clarendon Press, 1965), 270.

5. See Wesley Milgate, "Dr. Donne's Art Gallery," *Notes and Queries* 23 (July 1949): 318–19.

6. Norman Bryson, ed., *Calligram: Essays in New Art History from France* (Cambridge: Cambridge University Press, 1988), xxi.

7. Reproductions of this portrait vary in quality, and the original is in need of cleaning. According to Geoffrey Keynes, *A Bibliography of Dr. John Donne* (Ox-

ford, 1973), 373–74, it is a three-quarter profile in an oval on an oak panel 30½ × 24½ in., inscribed above the head of the sitter, *"ILLUMINA TENEBR NOSTRAS DOMINA."* The artist is unknown, and the date of 1595 is conjectural. Donne makes mention of the portrait in his will, describing it as "that Picture of myne wch is taken in Shaddowes." He bequeathed it to his close friend, Robert Kerr. The portrait disappeared from history until it was discovered in Newbattle Abbey among the possessions of Kerr's descendants, the Marquesses of Lothian, by John Bryson as described in the London *Times* (13 October 1959). Donne is wearing a huge black hat turned up from his face and is posed in three fourths profile to the right. His arms are folded, his left hand with fingers bare and his right wearing a fur-lined glove and, according to Keynes and Bryson, holding a book, "the rough edges of which suggest that it is a manuscript,": the "lower edge of the volume rests on a pewter standish with an inkpot and quill pen" (Keynes 374). The latter details are not evident in reproductions which I have seen, and recently, in an entry in *Notes & Queries* (December 1994), Keynes was challenged by Kate Frost, who saw the painting when it was removed for cleaning and has verified that these details are indeed non-existent. Donne is wearing an open-necked doublet, dark, with an embroidered collar and underlying lace; a thin cord hangs from beneath the collar. The picture has been exhibited at the National Portrait Gallery and remains in the keeping of the 11th Marquess of Lothian.

8. Samuel Rowlands, "The Melancholie Knight," Hungarian Club, 24, 1874.

9. Douglas Chambers, "'A Speaking Picture': Some Ways of Proceeding in Literature and the Fine Arts in the Late-Sixteenth and Early-Seventeenth Centuries," in *Encounters: Essays on Literature and the Visual Arts,* ed. John Dixon Hunt (New York: W. W. Norton, 1971), 30.

10. Lorne Cambell, *Renaissance Portraits* (New Haven: Yale University Press, 1990), 69.

11. Susan Koslow, "Frans Hals's *Fisherboys*: Exemplars of Idleness," *Art Bulletin* 67 (1975): 418–43.

12. Ernest Gilman, "Interart Studies and the "Imperialism" of Language," *Poetics Today* 10, no. 1 (1989): 10.

13. Dennis Flynn, "The 'Annales School' and the Catholicism of Donne's Family," *The John Donne Journal* 2 (1983): 2.

14. Ibid., 7.

15. Ibid., 6.

16. Details of the Gonella portrait are to be found in Pacht as well as in essays by R. J. M. Begeer ("Le Bouffon Gonella," *Oud Holland* 67 [1952]: 25–42) and Detlov Kreidl ("Le dessin sous-jacent dans le tableau de Gonella," *Gazette des Beaux Arts* 97 [1981]: 5–8). In the same issue Pacht recapitulates his discussion of 1974, adding that "un ritratto di Gonella est mentionné dans l'inventairé de la galerie des Gonzaga (1627) vendues au roi Charles I d'Angleterre . . . Il est plus que probable . . . que l'archiduc Leopold Wilhelm l'a acquis en Angleterrre comme plusieurs autres pieces de la collection Charles" (4). The painting has a twentieth century history as well in its mention by William Carlos Williams in his "Pictures of Breughel" sequence, as the poet evidently felt that the painting was by that artist rather than Fouquet; see the footnote to this poem in the recent edition of Williams's poetry, edited by Christopher MacGowan. I am indebted to Penny Jolly of the department of art history at Skidmore College for originally calling the Gonella portrait to my attention.

17. Leo Steinberg's essay, "The Sexuality of Christ in Renaissance Art and in Modern Oblivion," originally published in *October* 25 (1983): 1–198 and now in

book form, describes an extreme example of such visual authority operating completely independent of text.

WORKS CITED

Baxandall, Michael. *Patterns of Intention: On the Historical Explanation of Pictures.* New Haven: Yale University Press, 1985.

Bryson, Norman, ed. *Calligram: Essays in New Art History from France.* Cambridge: Cambridge University Press, 1988.

Campbell, Lorne. *Renaissance Portraits: European Portrait-painting in the 14th, 15th, and 16th Centuries* New Haven: Yale University Press, 1990.

Chambers, Douglas. "'A Speaking Picture': Some Ways of Proceeding in Literature and the Fine Arts in the Late-Sixteenth and Early-Seventeenth Centuries." In *Encounters: Essays on Literature and the Visual Arts,* edited by John Dixon Hunt. New York: W. W. Norton, 1971.

Flynn, Dennis. "The 'Annales School' and the Catholicism of Donne's Family." *The John Donne Journal* 2 (1983): 1–9.

Gardner, Helen, ed. *John Donne: The Elegies and The Songs and Sonnets.* Oxford: The Clarendon Press, 1965.

Gilman, Ernest. *Iconoclasm and Poetry in the English Reformation: Down Went Dagon.* Chicago: University of Chicago Press, 1986.

———. "Interart Studies and the "Imperialism" of Language." *Poetics Today* 10 no. 1 (1989): 5–30.

Koslow, Susan. "Frans Hals's *Fisherboys:* Exemplars of Idleness." *Art Bulletin* 67 (1975): 418–43.

Lessing, Gotthold Ephraim. *Laocoön.* Translated by Edward A. McCormick. Indianapolis and New York: Bobbs Merrill, 1962.

Martz, Louis. *The Wit of Love: Donne, Carew, Crashaw, Marvell.* Notre Dame, Ind.: University of Notre Dame Press, 1969.

Milgate, Wesley. "Dr. Donne's Art Gallery." *Notes and Queries* 23 (July 1949): 318–19.

Mitchell, W. J. T. *Iconology: Image, Text, Ideology.* Chicago: University of Chicago Press, 1986.

Orgel, Stephen, and Roy Strong. *The Theater of the Stuart Court,* 2 vols. Berkeley: University of California Press, 1973.

Pacht, Otto. "Die Autorshaft des Gonella-Bildnisses." *Jahrbuch der Kunsthistorischen Sammlungen in Wein,* n.f. xxxiv, vol. 70 (1974): 39–88.

Panofsky, Erwin. "Iconography and Iconology: An Introduction to the Study of Renaissance Art." In *Meaning in the Visual Arts: Papers in and on Art History.* Garden City, N.Y.: Doubleday, 1955, 26–54.

Steinberg, Leo. *The Sexuality of Christ in Renaissance Art and in Modern Oblivion.* New York: Pantheon Press, 1984.

Stone, Nicholas. *The Notebooks and Account Books of Nicholas Stone.* Publications of the Walpole Society, 7 (1919): 50–51.

Strong, Roy. "The Elizabethan Malady." *Apollo* 79 (1964): 264–69.

Walton, Izaak. "The Life of Dr. John Donne." In *Seventeenth-Century Prose and Poetry,* edited by Alexander Witherspoon and Frank J. Warnke, 250–71. New York: Harcourt, Brace & World, 1963.

Alexander Pope and the Disappearance
of the Beautiful

TIMOTHY ERWIN

> I'th' *Lombard Academy*'s plainly taught
> The Principles and Mysteries of *Draught:*
> How to direct and manage ev'ry *Line,*
> Shews when to make a *full stroke,* when a *fine:*
> How to proportion ev'ry thing aright,
> Not by the Compass, but by *simple Sight:*
> What *Airs* become the Young, and what the Old;
> Where to be *Nice,* where *Negligent and Bold:*
> How to give ev'ry Figure its true Station,
> And make them firm by *AEquiponderation:*
> .
> For this the three *Caratts* we are to thank,
> *Andrea Sacchi, Albano Lanfrank,*
> *Dominiquin, Corregio, Guido Rheni,*
> *Spagniolet, Caravagio,* and *Guercini.*
> > —John Elsum, "Reflections on the
> > Several Schools," from *Epigrams Upon*
> > *Paintings* (1700)

In reading the ideology of civic humanism into the discourse of painting, John Barrell points out that while both nations take a strong interest in the welfare of the body politic, English commentary tends to value the moral usefulness of art, French commentary the pleasure it provides. Contrasting Shaftesbury's *Characteristicks* (1711) to Du Fresnoy's *Art of Painting* (1668), Barrell argues that English art honors a republican, and French art an absolutist, concept of civic virtue. Barrell also differentiates a second strand of civic humanism in Jonathan Richardson on artistic theory, where a discourse of political economy seeks to make the public values of civic humanism amenable to the individualism of a mercantile class.[1] Over the course of the century the second strand develops into a separate economic discourse altogether, according to Joyce Oldham Appleby, a Lockean discourse of liberty where ideals of public virtue

give way to a principle of moral choice understood as the individual selection of competing goods on the model of the marketplace.[2] One may see the different discourses at work in two later eighteenth-century redepictions by Angelica Kauffman and Henry Fuseli of a seated Venus dating to the late sixteenth century, from the hand of Annibale Carracci (1560–1609). Their contrasting treatments of the subject in turn bear on the ideology of the aesthetic in Alexander Pope, an approach that appropriates the material practice and theory of painting, and especially of linear design, to the spiritualization of the image. In brief, I shall argue that Pope values the cultural role of the beautiful in painting much more highly than is usually thought, and that his best-known poem recounts nothing so much as the impossibility of fully communicating a public sense of the beautiful in the face of the divisive self-interest of modernism.[3]

Annibale Carracci was an influential artist revered for restoring the art of painting to the Renaissance standards set by Raphael. Extending from the late sixteenth to the early eighteenth century, the *scuola Carracci* included, in addition to Annibale, his brother Agostino (1557–1602) and their cousin Lodovico Carracci (1555–1619), Guido Reni (1575–1642), Giovanni Lanfranco (1582–1647), Domenichino (1581–1641), Francesco Albani (1578–1660), Il Guercino (1591–1666), Andrea Sacchi (1599–1661), Nicholas Poussin (1594–1665), and Carlo Maratta (1625–1713). Theirs was the practice through which the theory of painting redefined its terms, theirs the manner codified by Du Fresnoy, and theirs the taste admired by artists and connoisseurs close to Alexander Pope.[4] Sir Godfrey Kneller studied with Maratta in Rome; Charles Jervas also "studied and imitated" Maratta, more than any other artist according to Horace Walpole; and the Jonathan Richardsons viewed Annibale as the master who self-consciously formed from other artists his own manner, excellent in both thought and execution.[5] Annibale Carracci painted the *Venus Adorned by the Graces* ca. 1594–95, before leaving Bologna for Rome to undertake his great labors in the Farnese Palace. Donald Posner locates the prime narrative source of the painting in the episode from the eighth book of the *Odyssey* where Alcinous hosts Ulysses at a banquet and the guests are entertained with a song about the loves of Venus and Mars.[6] Vulcan catches the goddess of love with the god of war *in flagrante,* so the song goes, and Venus returns to Cyprus—returns in Alexander Pope's translation "To visit *Paphos* and her blooming groves," where

> Conceal'd she bathes in consecrated bow'rs
> The Graces unguents shed, ambrosial show'rs,
> Unguents that charm the Gods! she last assumes
> Her wond'rous robes; and full the Goddess blooms.[7]

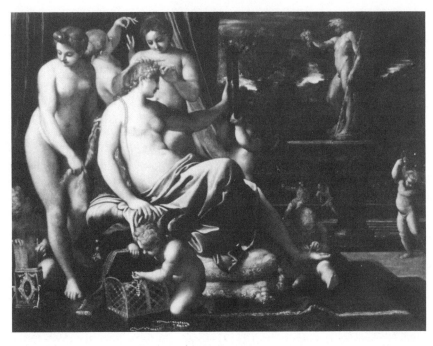

Annibale Carracci. *Venus Adorned by the Graces,* **ca. 1595. (© 1992, Samuel H. Kress Collection, National Gallery of Art, Washington, D.C.)**

In part the painting is a reflexive treatment of the creation of the beautiful, or more accurately of the way a certain idea of the beautiful may be approximated through linear design. In arrangement and argument alike the image suggests that careful preparation is needed. The standing grace at left gently tells the putto offering the comb and hairpin to wait until the braiding is complete, as if the earthly fate of an otherworldly beauty were bound up in an eclectic deliberation, an eclecticism understood as the essence of the aesthetic and long afterward associated with the Carracci tradition.[8] Beginning with the central figure of the goddess, the gaze traces an axis leading from the face of Venus to her reflected but unseen visage, or from the pole of an idealized composite reality to that of an invisible ideal, to the famous *idea* of Giovanni Bellori. The absorption of the goddess is imitated by the graces, and their attention is in turn mimed by the amoretti who hold the mirror, bring in an amphora, and inspect the pearls and other adornments.

The linear seated Venus of Annibale was often interpreted by later artists working the tradition, notably by Domenichino and Francesco Albani, and engravings made after Albani eventually granted the image wide renown (one of a handful of paintings we have from Anne Killigrew,

Etienne Baudet, after Francesco Albani. *Venus Adorned by the Graces.* **(The Metro-politan Museum of Art, Gift of Mr. Giorgio Sangiorgi, 1958 (58.225.2).**

for instance, is a copy after Albani made at the court of James II).[9] A 1672 engraving by Etienne Baudet subtends some Latin verses that describe the proper setting needed for the creation of the beautiful. Michael Baxandall has remarked that the artwork enjoys a real interpretive gain when it engages in dialogue with verbal commentary,[10] and the 1672 verses are worth quoting in full:

> All along the sparkling strand the perfumed earth rejoices
> for Venus has descended and seeks her bright Adonis.
> Neither Cyprus nor beloved Cnidos nor the highest regions
> boast her temple, for she reigns here, happy Sabine,
> Idalian maidens at her side. A devoted Grace curls
> her tresses around a pin, and the goddess beams.
> Another divides them with a comb. A third with jewels
> adorns the snow-white neck. Advised by the glass,
> the goddess blesses their skillful artifice,
> and tender Venus thus adorned waits to please her lover.
> And the swans, unharnessed, drink the divine nectar;
> exhausted, they catch their breath, lifted by Cyprian clouds.
>
> (translation my own)

A 1702 engraving by Bernard Picart depicts an elevated putto celebrating the rebirth of beauty by tossing flower petals onto the goddess. Beneath

Francis Bartolozzi, after Angelica Kauffman. *Venus Attired by the Graces.* **(Yale Center for British Art, Paul Mellon Collection.)**

the scene, verses by Francois Gacon point the primacy of design over coloring, invoking a contemporary quarrel within the French academy between the *poussinistes* and the *rubénistes,* between partisans of design and those of coloring. Beauty, say these verses, arms herself more powerfully with simplicity than with ornament: *"Ces ornements confus qui vous rendent si vaines / Bien loin de retenir les amants dans vos chaines / Les degagent souvent de leur captivité."*

Although connoisseurs always held the Carracci tradition in high regard, in England the linear Venus eventually suffered from the revolution in taste brought about by the Hanoverian court. The "Venus Attired by the Graces" of Angelica Kauffman, engraved in 1784, adopts a nostalgic posture toward civic humanism. Reading from left to right we begin with two amatory motifs, the lovebirds cooing on the balustrade and the mountain sacred to Venus poised above them. Descending to a chest from which the grace at left has drawn a fillet, the gaze traces a lilting dance of delicate pantomime across the activity of her sisters, who bind the tresses of the goddess and bring in flowers. For Erwin Panofsky the meaning of the gesture in art is the historically constituted composite of three things: the formal event, the primary and secondary aspects of the subject, and the symbolic value of the act.[11] Here, in the absence of the mirror and braid, an overdetermined gesture takes us to what Panofsky

calls the realm of the symbolic form. Interestingly, Angelica has transformed the twining of the absent braid into an intertwining gesture of affection and gratitude. The goddess and the putto bringing her a strand of pearls share emotions freely given rather than enter into any commercial exchange of pleasure and ornament. In Kauffman's version of the seated Venus, in other words, the central gesture resembles an exchange only in order to dissociate representation from commerce. The visual rhetoric is appropriate for imagery commodified through the decoration of porcelain vases and the like, and also as answer to a newer discourse of painting that elsewhere sought frankly to admit commercial values. And yet the intrinsic content of the gesture must be seen to be an object of contestation rather than the cultural constant or symbolic form predicted by the iconology of Panofsky.

Fuseli will have none of it, and responds with a handwritten fragment titled "The Dunciad of Painting":

> Where London pours her motley Myriads, Trade
> With fell Luxuriance the Printshop spread.
> There as the wedded elm and tendril'd vine
> Angelica and Bartolozzi twine.
>
> Love without Fire; Smiles without Mirth; bright Tears
> To Grief unknown; and without Beauty, Airs;
> Celestial Harlots; Graces dressed by France.[12]

Fuselli understands the spread of images like Kauffman's to conceal a dangerous profit motive; to indulge such taste, he feels, would be to prostitute art to mere fashion and to transfer English resources abroad. Hence Kauffman and her engraver are characterized as hypocritical conspirators in a meretricious foreign commerce. Fuseli himself is no less implicated in commodification, of course, but merely more candid about it. He lobs his attack on imported tastes from the glass house of book illustration, and his own version of the image, "Flora Attired by the Elements," where beauty spirals upward from a native ground with which she is made one, her image held aloft by a Valkyrie, sponsors the cultural harvest of Burkean empiricism in the triumph of the sublime over the beautiful. His seated goddess represents the full flowering of a mercantile and nationalistic sentiment in the visual arts and forms a keen parody of the entire Carracci tradition. And so an image that begins as the cynosure of a serene and disinterested beauty is subjected during the course of two centuries to the push and pull of controversy, its eloquent outlines and learned iconography serving here to promote a linear academic program and there the aims of commerce, serving now the interests of public-spirited virtue and again of Lockean individualism.

**Anker Smith, after Henry Fuseli. "Flora Attired by the Elements." Frontispiece,
Erasmus Darwin, *The Botanic Garden*, 1791. (Huntington Library.)**

A similar contest is visible in the competing pictorial metaphors of Pope and Joseph Addison during the early decades of the century. In the formal metaphor of Pope, good sense always travels in the vehicle of firm outline, nonsense and loss in the less reliable vehicle of fading colors. *The Rape of the Lock* (1714) staunchly upholds the figural difference, as we shall see, and at the same time brings the pleasures of the beautiful to bear on moral usefulness. So pervasive is the formal discourse of painting in Pope that many readers will doubtless already have several passages in mind. There is the complaint that while the verbal coloring of Crashaw entertains the sight, the "*Lines* and *Life* of the Picture are not to be inspected too narrowly," for example. Or Pope will say that the trouble with metaphysical verse is that it's all trope and no story. Design he calls the soul of verse, and fable or emplotment its body (*Corr.,* 1.109–10). Or he names the aporia of never being able to say quite what one means as the predicament of a formless *phua* lacking its forming *techne.* "We grasp some more beautiful Idea . . . than our Endeavors to express it can set to the view of others," since "the gay Colouring which Fancy gave to our Design at the first transient glance we had of it, goes off in the Execution." Drifting and separating before our very eyes, he says, the parts decay like images in the gilded clouds (*Corr.,* 1.135). Modest supernal shoptalk like this discloses a large ambition even as the imaginative frustration it describes anticipates the disappointment of *The Rape of the Lock.* Pope hoped to create an international style of pictorial verse in which poetic narrative as well as history painting might embody antique ideals of formal correctness. History badly disappoints Pope, of course. With increasing economic expansion the nation has less and less reason to imitate continental taste. In time it will become second nature for poetry to think of itself as a verbal coloring, while painting, falling under increasing empiricist pressure to wrest the sublime away from the past for the sake of a more muscular present, pushes the analogy back to the heightened invention of Michelangelo. The ambition, moreover, posits a wide cultural gap. To prefer the deep analogy of design and plot to that of color and language is to persist in the older pictorialism of the French academy just as English art commentary is writing design out of its theoretical program, and while English poetry sees the *pictura-poesis* analogy shifting from a formal to a linguistic basis. Where Du Fresnoy follows Annibale in setting the maximum number of figures in a painting at twelve, treating the question under the heading of design, for example, Jonathan Richardson the elder discusses the same question under invention, because as Richardson sees things, design has no place among the parts of painting.[13] Why should Pope pledge allegiance to the party of design at a time so badly out of joint? Ever more dated, the foreign quarrel informs the formal metaphor in Pope virtually whenever it comes

into play, drawing battle lines of representational difference and suggest-
ing displacing structures of feeling.

Two critical passages, one well-known in its pictorial aspect and the
other unknown, put the values on display. Twice Pope commends design
at the expense of color in the *Essay on Criticism* (1711), once briefly
likening coloring to false learning (*TE*, 1.241, 11. 23–25) and again liken-
ing linguistic shift to the fading colors of an old masterpiece. Although
the coloring will fade, if the form is as true to nature as Chaucerian
narrative or the composition of Raphael, then the artwork ought to
endure:

> Our Sons their Fathers' *failing Language* see,
> And such as *Chaucer* is, shall *Dryden* be.
> So when the faithful *Pencil* has design'd
> Some *bright Idea* of the Master's Mind,
> Where a *new World* leaps out at his command,
> And ready Nature waits upon his Hand;
> When the ripe Colours *soften* and *unite*,
> And sweetly *melt* into just Shade and Light,
> When mellowing Years their full Perfection give,
> And each Bold Figure just begins to *Live;*
> the *treach'rous Colours* the fair Art betray,
> And all the bright Creation fades away!
>
> (*TE*, 1.293–94, 11. 482–93)

Far from abandoning the ancients to their dated language, Pope argues,
as Jean Hagstrum has shown, for the lasting superiority of literary form
over linguistic expression. The poem situates the sister-arts analogy at a
formal level far beneath what Hagstrum calls the "superficial ornamen-
talism" of expression (213).

The object lesson turns upon the ambiguity of the *bold figure,* a phrase
which the modern poet is deceived into understanding as lifelike form
but which actually names a lifeless, because unstructured, metaphorical
language. What finally matters in Pope is the natural yet ennobling shape
of the artwork, not the material medium, and the cameo appearances of
Chaucer and Dryden urge the poet to preserve through imitation and
translation a vital formal heritage. As linguistic conservationist the poet
should adopt the practical idealism of the painter's *idea.* By attending to
the mere language of form rather than its pictorial meaning the modern
poet imagines a falsely verbal design, distorts the bright idea of creation,
and is doomed to watch from the timeless vantage of final judgment as
representational life leaves his verse. The anxious hyperbole of the clos-
ing couplet only mocks those who would write with the transient poetic
diction or disappearing ink of modernism. And who would they be? Well,
Addison for one. In his 1704 *Letter from Italy,* Addison had drawn a

colorist creation scene involving a confusion of *figure* as both outline and metaphor where the wish is to mix word and color, trope and shading, in just the way Pope declares futile:

> Fain wou'd I *Raphael's* godlike art rehearse,
> And show th'immortal labours in my verse,
> Where from the mingled strength of shade and light
> A new creation rises to my sight,
> Such heav'nly figures from his pencil flow,
> So warm with life his blended colours glow.[14]

For Pope, whether a poet draws the pictorial analogy between plot and perspective, or between language and color, tells the difference between ancient and modern, cosmopolitan and mercantilist, Tory and Whig values.[15]

A more positive if no less daunting way of saying something of the same thing is related in a brief narrative from the *Essay on Criticism* in which Virgil, surprised to find that nature and criticism have together guided his pen through the composition of the *Aeneid,* rather than nature alone as he intended, reexamines the structure of his epic. The passage also means to inscribe pictorial form throughout the whole of Pope's early verse.

> When first young *Maro* in his boundless Mind
> A Work t'outlast Immortal *Rome* design'd,
> Perhaps he seem'd *above* the Critick's Law,
> And but from *Nature's Fountains* scorn'd to draw:
> But when t'examine ev'ry Part he came,
> *Nature* and *Homer* were, he found, the *same:*
> Convinc'd, amaz'd, he checks the bold Design,
> And Rules as strict his labour'd Work confine,
> As if the *Stagyrite* o'erlooked each Line.
> Learn hence for Ancient *Rules* a just Esteem;
> To copy *Nature* is to copy *Them.*
> (*TE,* 1.254–55, 11. 130–40)

The passage seems unpromising from a pictorialist perspective, its didacticism unleavened. The redundant phrase *labored work* is just the sort of leaden construction that Pope and his fellow Scriblerians would later ridicule in "umbrageous Shadow," "verdant Green," and the like.[16] Pope hides his pictorialism, if you will, by damping it in cliché. On the scale of the verse paragraph the lines twice display the demanding formula more obvious on the level of the individual line in which meaning is vividly enacted as well as described. Pope constructs a miniature epic to Aristotelian measure. The first two couplets constitute the intrigue, the seven lines remaining the discovery. A startling recognition takes place

during the first two lines of the triplet while a humbling reversal is completed in the third. Compression dictates a vertical dimension to the representation of reversal. Like the proto-modernist spider of Swift's *Battle of the Books,* Virgil at first thinks himself above Aristotelian rule; after the recognition scene he instead recognizes that Aristotle has indeed overseen the writing of the *Aeneid.* As soon as one reads a graphic aspect into such diction as "draw," "part," "line," "work," and "copy," one notices that the passage travels from the pole of a mental imagining, an internal design *(disegno interno),* to a measuring by rule, an external design *(disegno esterno).*

In Ripa's emblem *Designing,* internal design is represented by a mirror, external design by a compass. The mirror returns the idea to the mind while the compass ensures accuracy of proportion and perspective; together they represent the creative and critical poles of a theoretical progress from inspiration to critical judgment. The brief narrative also opens onto a larger, rhetorical pattern, moving from invention to design to coloring, where design in Virgilian form is introduced by invention in Homeric originality, on one hand, and is followed by elocutionary graces beyond the rules in Longinian troping on the other. The rhetorical scheme is of a piece with the references to Quintilian in text and notes alike and is part and parcel of the pictorial temper; in effect, the passage is a palimpsest of formal theory based in rhetoric, superimposing the vanishing point of painting upon the turning point of narrative in a dual norm of interartistic unity. Although we tend to reserve the term for a later application of interpretive perspective, *theory* in its root sense names a prior, highly visual dimension of the creative imagination. The emblem literature depicts theory as a female figure uniting the compass of critical measure from male design to the airy abstraction of the female idea, attributes later subtly combined in Sir Joshua Reynolds's eponymous allegory. More might be said about the overlapping of visual and literary theory during the period, because *design* is a prime term not only for art historians but also for those who would seek to understand the French neoclassical formalism of Nicolas Boileau and Rene Rapin so important to Pope. In stressing the creative and critical vector the term retraces, along with its visual origins, I mean to speak not against theory but rather for its closer approximation to the historical structures of creation and reception that it serves to explain, for a more supple and inflected theory. If as Eagleton has argued "theory is just human activity bending back upon itself, constrained into a new kind of self-reflexivity," then a historical theory of poetry appropriated at a double remove, under the foreign dispensation of another art, must suffer redoubled constraint and become a social practice but by fits and starts. More certain of its models than its meanings, the sister-arts analogy shapes itself in Pope in much the way that

the *habitus* of sociologist Pierre Bourdieu enters the social field from which it constitutes meaning, that is, slowly, as a loose and baggy intentionality and the burden of an unacknowledged learning.[17]

Ralph Cohen has suggested offhandedly in a brilliant essay that a series of internal allusions running through the early verse may be understood as a relational *concordia discors,* a verbal patterning that might also reflect a sense of visual design.[18] The line encapsulating Virgil's recognition scene quoted above (136) recalls similar moments in Milton and Dryden and also echoes elsewhere in Pope, in "Force he prepar'd, but check'd the rash Design" (*Vertumnus and Pomona; TE,* 1.382, 1. 118) and "Convinc'd, she now contracts her vast design" (*To Mr. Addison; TE,* 6.203, 1. 23),[19] lines that mark turnings understood by an expanded design, the first a narrative juncture, the second an ironic shift from pictorial space to narrative time. Admittedly, to develop full readings from such small hints may seem as if to bring together assorted sculpture by tracing an odd vein in the marble from which it's hewn, and yet it is equally obvious that some rough idea drives toward significance in Pope, something to be translated from critical rule to lyric example.

From the outset the formal notion transposed from the theory of the *Essay on Criticism* to the practice of the lyric is pictorial as well as plotful. Taken in context the line offers the proposition that all writing or painting inspired by nature is by definition true to critical rule because criticism itself is drawn from the observation of nature. In following critical rule without meaning to, Virgil becomes the limiting case of a general truth about creative expression, that its theoretical bent tends always toward a regulated nature. The same proposition is also invoked at plotful junctures within the *The Rape of the Lock,* first in the baron's sacrifice of canto two, "He saw, he wish'd, and to the Prize aspir'd," (*TE,* 2.161; canto 2, 1. 30) and again during Ariel's recognition scene, "Amaz'd, confus'd, he found his Power expir'd" (*TE,* 2.179; canto 3, 1. 145). The related syntax and diction, along with the vaulting iambic measure, carry a dual design into the main complication and major turning of the mock-epic, while the pacing and placement of the lines add lexical momentum to an idea which in Wittgenstein's phrase was before merely idling. Taken together, the series comprises a language game played out across the semantic field of the moral potential of art, a game in which linear design becomes a synonym for creating and judging rightly. Even the proverbial summary conclusion of Clarissa, "Charms strike the Sight, but Merit wins the Soul" (*TE,* 2.201; canto 5, 1. 34), affirms the morality of firm contour against the slippery appeal of color. Pope threads the formal lifeline of design from turning to marked turning as a way of affirming the universality of the dual norm across generic difference. These marked formal moments

in turn thematize the aesthetic movement of *The Rape of the Lock* as a negative allegory about the disappearance from culture of an improving ideal of beauty. Belinda pauses three times this day to be described: during her toilette (*TE,* 2.155–58; canto 1, 11. 121–48), during her appearance on the Thames (*TE,* 2.159–61; canto 2, 11. 1–28), and during the delivery of Ariel's speech regarding her protection (*TE,* 2.162–64; canto 2, 11. 47–72). Each ekphrasis successively limns one of the creative stages of invention, design, and coloring, as if Belinda were like the linear Venus an object of beauty engaged in a cooperative creative progress.

The frontispiece to the 1714 *The Rape of the Lock* tends to support the notion. The visual arrangement of the engraving looks forward to the narrative of the poem, leading the gaze upward along a vertical axis from the toilette scene of canto one to the game of ombre in canto three to the final apotheosis of the lock in canto five. In both engraving and poem the trajectory of the lock describes not the triumph of the linear but the rescue of a ravaged form from chaos and immaturity. Like parents retrieving a toy not properly enjoyed, the gods take back the lock, and an oblique view of ideal beauty is limited to the dim hope of its return. In historical terms, the iconography of the frontispiece looks backward and forward at once. The subject matter and arrangement proudly recall the school of the Carracci; the crude modernist manner, on the other hand, predicts the sad loss of the linear ideal. Already, something has gone terribly wrong with the creation of the beautiful. The putto at right bearing a diminished amphora is confused about what to do with it. Or again one of the would-be graces, in clear defiance of representational rule, gestures one way while looking another. What is wrong with this picture? the frontispiece asks, and then answers the question by flouting perceptual and painterly convention. The most telling detail appears in the palace facade, where the right cornice of the pediment rises to an angle wider than the horizontal of the image frame. The Wren facade of Hampton Court rises abruptly on the right, the urn pedestal tilts forward on the left, and both open awkwardly onto the spectator, who must shift uncomfortably between them. Because the eye level is somewhat higher on the left than on the right, the vanishing point travels an uncertain axis up and down the distant hillside. By transposing Idalia to the level countryside beyond Hampton Court, the frontispiece hints that England in 1714 still awaits a promised return of beauty. Although it is possible that the frontispiece, engraved by Ludovico du Guernier and Claude du Bosc, found its way into the poem without Pope's direction, more probably the image represents Pope's intentions. Quite apart from his usual solicitousness about the published appearance of his work, Pope was studying the art of painting with Charles Jervas (indeed, was often residing with him) during a good part of the time he spent expanding *The Rape of the Lock*

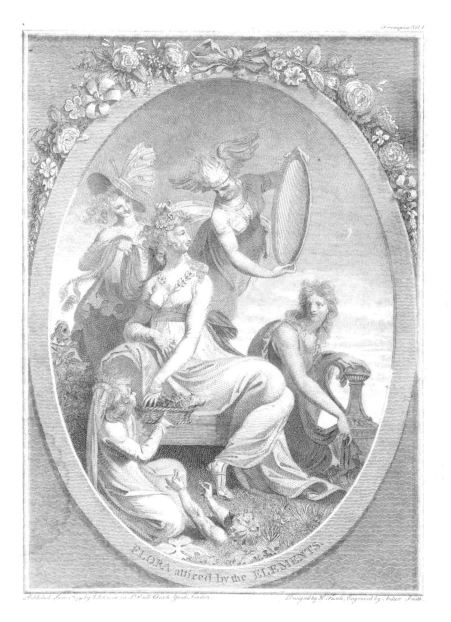

Louis Du Guernier and Claude du Bosc. Frontispiece, *The Rape of the Lock,* **1714. (William Andrews Clark Memorial Library.)**

from the two-canto version of 1712 into the five-canto version published two years later.[20] With so marked an affinity for the Carracci school and with so many of its images close at hand, it seems unlikely that he would allow merely *any* image to stand at the head of his youthful mock-epic, leaving the choice to someone else, and still less likely that anyone else would make a selection so appropriate.[21] When *The Rape of the Lock* was reissued in the 1717 *Works,* moreover, the poem was accompanied by a separate engraved headpiece by another engraver, Simon Gribelin, depicting the same theme in the same setting.[22]

Arguably, as a narrative reenacting both a symbolic abduction and the ravaging of the artwork, the *Rape of the Lock* takes its occasion and the metaphor of its title from the iconoclastic scattering of the royal collections during the protectorate (and doubtless also from the dissolution of the monasteries long before that). Royal patronage for the arts was established on a grand scale in England under Charles I, whose reign also witnessed the unprecedented collections of Arundel. After the Puritan interregnum, another Stuart court restored the royal patronage of art and gave the Carracci tradition pride of place.[23] In reshaping a continental vision to fallen standards, the frontispiece commemorates the Stuart tradition that had sponsored the appreciation, study, and creation of the artwork. The issue for the poem as for English iconoclasm is the use or abuse of the image, or "our Pow'r to use" as Clarissa puts it (the pronoun linking the interests of religion and gender; *TE,* 2.201; canto 5, 1. 29).[24] If virtue were never represented under the aspect of the visual, she asks, and if frivolousness and vanity were not in fact destructive of the beautiful,

> . . . who would learn one earthly Thing of Use?
> To patch, nay ogle, might become a Saint, .
> Nor could it sure be such a Sin to paint.
> <div align="right">(TE, 2.200–201; canto 5, 11. 22–24)</div>

Not everyone will agree with the interpretation outlined here, of course. Ronald Paulson places Pope in a tradition of English iconoclasm that breaks the icon in order to refashion from it something more useful, and generally understands the verse to disclose an aesthetic of ideological accommodation.[25] For other moments in other poems it may well be so. Certainly verse is no less frangible than the cultural will it expresses or opposes. My own view remains that Pope practices an aesthetic of resistance to iconoclasm grounded in a linear theory of painting. His adherence to academic standards of correctness, the repeated preference for the formal rather than the linguistic analogy, together with the marked turns showing readers where the analogy surfaces, all reflect more cosmopolitan commitments. Pope clearly believes the removal of imagery from

worship mistaken and so writes to Ralph Allen: "I can't help thinking (& I know you'l joyn with me, you who have been making an Altar-piece) that the Zeal of the first Reformers was ill peaced, in removing *Pictures* (that is to say Examples) out of Churches" (*Corr.,* 4.13). Tending already toward dullness, the immature creation scene of the frontispiece to *The Rape of the Lock* (1714) is the ruined talisman of that loss.

How are we to regard a poem that refuses the present moment in history for the sake of interartistic unity? First of all, we should probably recognize that literary moments can never be repeated, and that the painful lessons of nostalgia and deferral taught by the failed allegory of *The Rape of the Lock* are nothing new. Every poem is bracketed by cultural conditions long since scattered to the winds; if *The Rape of the Lock* seems uncertain about some things, the poem knows this much. Even as it upholds neoclassical rule, the poem predicts the disappearance of a formal ordering across the arts. Its failed allegory is already inscribed in the break or rupture separating plot from design, or in the language of the early correspondence, separating the body of the poem from the soul or animating spirit needed to bring it to full representational life. In *The Rape of the Lock* time and space must assemble soullessly, as it were, without the significance that they would otherwise convey. Without design the literary work can manage only what Mikhail Bakhtin calls a mechanical whole rather than an aesthetic one. Pope sometimes figures the union of word and image as sexual, likening interartistic meaning to the procreation of progeny; here the action bringing on closure, the convulsive sneeze that starts the lock on its upward journey, is explicitly mock-sexual. And so the mock-epic remains, to borrow another term from Bakhtin, unconsummated by culture.[26]

There are also signs that Pope removes the ravaged lock to an ideal realm in order to preserve, along with other such remnants of eighteenth-century modernism as sedan chairs and snuff, something more important, an alternative social vision. A material critique would surely recognize in the reluctance of the poem to consummate itself a faith in history rather than a withdrawal from politics. The aesthetic realm, it's recently been argued, is always poised between a "secret prototype of subjectivity" on one hand and a "vision of human energies as radical ends in themselves" on the other.[27] The lock which is eventually transformed into a somewhat privatized star likely began as a braid symbolic of communitarian social values as well as of an eclectic artistic practice, and the poem seeks to rescue these values through a formal pictorialism. For French neoclassical theory a lifegiving poetic design is incomplete without some secret turn, and the alternating blushing and breathing of Belinda and company may well be meant to provide the rhetorical design of the sister-arts metaphor with vital signs even as the discourse leaves

the narrative behind. On this view Belinda's blushing is a sign not only of the ambitions and embarrassments of ideal beauty, but also of the imaginative life that pictorialism breathes into narrative, while the sighing that she in turn inspires at crucial junctures in the baron and Ariel may be seen as more subtle evidence, now metaphorical, of formal artifice. To color the expression with a linguistic turn drawn from the mastertrope of design in this way would make the relation of action to image circular nearly to the point of identity. Indeed, yet another way to keep alive the discourse of design would be to create for it a more abstract symbol of narrative return, the circle. The figure is everywhere in the *Rape*, from the "circled Green" and "giddy Circle" of the first canto (*TE*, 2.148, 152; l. 32, 93) to the "Regal Circle" crowning the king of clubs in the third (*TE*, 2:173; l. 71) to the "circling Rays" of the baron's ring in the fourth (*TE*, 2:193; l. 115). (There are still more if Belinda's ringlets [(*TE*, 2.160, 168; canto 2, l. 22, 139; and 197; canto 4, l. 169) and the heavenly spheres (*TE*, 2.208, 211; canto 5, l. 113, 142] also qualify.) And once again, as the spatial form of narrative return, the circle suggests a hopeful if discreet Jacobitism, its geometry firing new scenes of subversive invention even as the poem closes.[28]

As history would have it, the formal discourse of the linear ideal that we have been tracing persists well beyond the reach of either civic human-ism or Lockean liberalism into the high modernism of our own day. Lexi-cal willfulness compels me for coda to turn briefly to the 1920 picture novel by the Belgian artist Frans Masereel called *The Idea: Its Birth, Its Life, Its Death,* represented here by a partial sequence of early pages, and the collaboration of writer Ben Hecht and director Ernst Lubitsch on the 1932 film of Noel Coward's *Design for Living,* represented by a publicity still from the opening scene. Masereel speaks for the power of the aesthetic to propagandize for social change, Hecht and Lutibsch for its ability to remove us to a speculative distance from the world. *The Idea* contains in multiple woodcuts an expressionist narrative of impassioned resistance to early twentieth-century capital. Masereel figures the birth of the idea as a classical dawning, her leavetaking as a saddening dusk. As a female presence, she is all but dismembered by the push and pull of masculine interest. The unadorned truth understood by her nakedness meets with derision until she is captured and brought before the law. When she takes a lover and communicates the idea to him, their love is deemed criminal and her lover is condemned to death. But the idea perseveres, until like a firestorm she is on the lips of everyone. Her task of transmission complete, she returns to her medium the artist, who has been visited meanwhile by yet another idea. In a way that recalls the apotheosis of the lock, the cycle of creation thus begins anew, and the original idea becomes a martyr or idealized exemplar to the successive

A partial sequence of pages from the picture novel, *The Idea: Its Birth, Its Life, Its Death*, by Frans Masereel, 1920; reproduced from Roger Avermaete, *Frans Masereel* (New York: Rizzoli, 1977). (Photo by the author.)

expression of democratic social causes, her self-reflexive message being, of course, that artists must use every technology in spreading the social gospel of an artistic right to free speech.[29]

Film makes of drama what it will, Stanley Cavell remarks,[30] and the screenplay of *Design for Living* promptly asks a question that the play formulates more slowly. What might it mean to live one's life as if it were art, according to the rules of representation? By way of answer the opening scene of the film enacts yet another pantomime of design, showing

Publicity photograph from Noel Coward's *Design for Living*, 1933. (Museum of Modern Art Film Stills Archive.)

how difficult it is for an artist working within a modernist aesthetic to find a muse to represent both Art and Mammon. Commercial artist Gilda Farrell enters a third-class train compartment where two American expatriates, playwright Tom Chambers and painter George Curtis, sit napping. She sketches their caricatures and then drifts off into slumber herself. George is stirred when his hand just brushes the ankle that she has propped between them on the bench opposite. The gesture wakes him— in retrospect we gather that he has awakened from the dream of a pure, uncompromised aesthetic—and it stirs in turn our sense of dramatic anticipation. George and Gilda bicker about the caricatures she has drawn, and in a burlesque of French academic analysis they together inspect the evidence, subjecting the physiognomy of Tom to critical dispute, all the while hurtling toward Paris in the shiny symbol of a modernist movement from the virtual to the actual, of aims swiftly accomplished and ends efficiently met, the railway locomotive.

As their dual muse Gilda challenges both men to profit from culture as well as to interpret it. Play and screenplay alike present her as the critical spirit who gently steers them between impoverished excellence and empty success toward integrity. At the same time, she also leads them into a delicately balanced confusion. Bussing each platonically on the

forehead, Gilda announces that she has become a mother of the arts. As the three pledge to abstain from sex—for if Gilda were to express a preference for one of the men, jealously would drive the other to an unproductive distraction—they also pledge to abstain from commerce, except for Gilda, of course. In terms of our historical allegory, it's as if the formal sisterhood of the arts had always depended upon a moderately mercantile modernism, as if the nostalgia of an Angelica Kauffman, say, were either delusive or had now become so impractical as to amount to the same thing. (In likewise imagining a golden age before conflict got in the way, Coward had brought a linear metaphor to bear: "A single line was in both our minds leading to success—that's what we were planning for," his painter says.[31]) Naturally, the ménage à trois quickly succumbs to sexual competition. Despite their best intentions, Gilda falls alternately in love with Tom and George and they with her, and their mutual desire comes to represent a falling away by the commercial present from the pure aesthetic of a lost past. In the closing scene the three have evidently either resumed some form of their earlier chaste arrangement, or else have come to some unusual terms with the shared profits of desire. Seated together in the back seat of an automobile, they suddenly burst into contagious laughter. What was all the laughing about? critics wanted to know. Coward understandably kept mum. My guess is that their shared laughter means to say that the sisterhood of the arts is wholly compatible with creative labor and its rewards. It tells us that the aesthetic realm cannot be kept apart from considerations of value and commerce, not for very long. And whether it promotes tradition or progress, subtlety or directness, faith or skepticism, the discourse ringing in their laughter reminds us how easily a period vocabulary can be translated into a wide variety of cultural values.[32]

NOTES

The author is grateful to several colleagues for kind advice in composing this essay: to Catherine Puglisi for first pointing me in the right direction, to John Belton for help with some recalcitrant Latin, to William Keach for a thoughtful early critique, and to Cathie Kelly for a timely later one. An abbreviated version of this essay appeared in *Manners of Reading: Essays in Honor of Thomas R. Edwards,* a special issue of *Eighteenth-Century Life* 16 (November 1992): 46–64, © 1992 by the Johns Hopkins University Press and here reprinted by permission.

1. John Barrell, *The Political Theory of Painting from Reynolds to Hazlitt: "The Body of the Public"* (New Haven: Yale University Press, 1986), 2–13, 42–45.

2. Joyce Oldham Appleby, *Economic Thought and Ideology in Seventeenth-Century England* (Princeton: Princeton University Press, 1978). Isaac Kramnick provides a detailed survey of the rival claims for republicanism and liberalism in eighteenth-century Britain in *Republican and Bourgeois Radicalism: Political*

Ideology in Late Eighteenth-Century England and America (Ithaca: Cornell University Press, 1990), 1–40.

3. George Sherburn first commended pictorialism in Pope for study in *The Early Career of Alexander Pope* (Oxford: Clarendon Press, 1934), 102, 103, n.4. On mention of color in the early verse, see Norman Ault, *New Light on Pope* (London: Methuen, 1949), 68–100; on Pope's technical knowledge of the arts, Robert J. Allen, "Pope and the Sister Arts," in *Pope and His Contemporaries: Essays Presented to George Sherburn,* ed. James L. Clifford & Louis A. Landa (Oxford: Clarendon Press, 1949), 78–88; and on the vividness of the pictorial verse, Jean H. Hagstrum, *The Sister Arts: The Tradition of Literary Pictorialism and English Poetry from Dryden to Gray* (Chicago: University of Chicago Press, 1958), 210–42. James Sambrook offers a thorough survey of the poet's taste in painting and gardening in "Pope and the Visual Arts," from *Alexander Pope: Writers and Their Background,* ed. Peter Dixon (Athens: Ohio University Press, 1972), 143–71. For a detailed and informative discussion of Pope's friendship with artists of his own time, see Morris R. Brownell, *Alexander Pope and the Arts of Georgian England* (Oxford: Clarendon Press, 1978), 9–67. The practice of reading individual paintings into the poetry extends back at least as far as Joseph Warton's *An Essay on the Genius and Writings of Pope* (1756). See also Terry Eagleton, *The Ideology of the Aesthetic* (Oxford: Basil Blackwell, 1991), 9.

4. For an overview of the reform in painting brought about through the Bolognese academy of Annibale, Lodovico, and Agostino Carracci, and of Emilian style in general, see the essays by various hands collected in the exhibition catalogue *The Age of Correggio and the Carracci: Emilian Painting of the Sixteenth and Seventeenth Centuries* (New York and Washington: Metropolitan Museum of Art and National Gallery of Art, 1986). The most complete study of the *Art of Painting* is Paul Vitry, *De C. A. Dufresnoy Pictoris Poemate quod 'De arte graphica' Inscribitur* (Paris: G. Rapilly, 1901), valuable on the genesis of the poem, its Roman-school associations, and its relation to earlier art theory (10–19, 14–15, 31–37).

5. See J. Douglas Stewart, *Sir Godfrey Kneller and the English Baroque Portrait* (Oxford: Clarendon Press, 1983), 7–8; Horace Walpole, *Anecdotes of Painting in England,* 3d ed., 4 vols. (London: J. Dodsley, 1786), 4.24; and *An Account of the Statues, Bas-reliefs, Drawings and Pictures in Italy, France, &c. with Remarks,* 2d ed. (London: D. Browne, 1754), 141–42.

Sale catalogs for the Jervas collections bear Walpole out. Jervas was a portraitist and forty-five of his paintings were by or after or his own copies of Van Dyke. According to figures for the first days of sale, he also owned 46 copies after Maratta, 8 after Raphael, 6 after the Carracci, 3 after Albani, and 2 after Sacchi. During the first week, 250 lots of prints and 300 lots of drawings were offered, and although identification is rarely possible at least 500 prints and 1,000 drawings fall within the Carracci tradition, most of them by Maratta or his student Niccolo Berretoni. See *A Catalogue of the Most Valuable Collection of Pictures, Prints, and Drawings . . . late of Charles Jarvis,* 2 parts (London: n.p., 1740).

6. Donald Posner, *Annibale Carracci: A Study in the Reform of Italian Painting around 1590,* 2 vols. (London: Phaidon, 1971), 2.35.

7. Refs. to the poetry are to *The Twickenham Edition of the Works of Alexander Pope,* gen. ed. John Butt, et al., 11 vols. (London: Methuen, 1939–69), 7.279, 11. 396, 399–402, cited as *TE* in the text. Refs. to the correspondence are to *The Correspondence of Alexander Pope,* ed. George Sherburn, 5 vols. (Oxford: Oxford University Press, 1956), cited as *Corr.* in the text.

8. See Charles Dempsey, *Annibale Carracci and the Beginnings of Baroque Style* (Gluckstadt: J. J. Augustin, 1977), 26–36, 43, passim for an account of the way his eclecticism may have developed. Posner discounts the opinion, widespread during the eighteenth century, that Annibale was purposely eclectic (1.91). In *Visual Fact over Verbal Fiction: A Study of the Carracci and the Criticism, Theory, and Practice of Art in Renaissance and Baroque Italy* (Cambridge: Cambridge University Press, 1988), Carl Goldstein moderates the discussion and arrives at a group portrait in which the Carracci appear as "thoughtful artists who consciously chose from among the artistic options available to them" (6).

9. C. H. Collins Baker identifies the image, recorded by Vertue in 1727, as Anne Killigrew's in "Notes on Pictures in the Royal Collection -34 -Anne Killigrew," *Burlington Magazine* 28 (October 1915–March 1916): 112.

10. Michael Baxandall, *Patterns of Intention: On the Historical Explanation of Pictures* (New Haven: Yale University Press, 1985), 8–11.

11. Erwin Panofsky, "Iconography and Iconology: An Introduction to the Study of Renaissance Art," in *Meaning in the Visual Arts* (1955; Chicago: University of Chicago Press, 1982), 26–54. Michael Ann Holly offers an excellent analysis of this influential essay in *Panofsky and the Foundations of Art History* (Ithaca and London: Cornell University Press, 1984), 158–93.

12. Quoted from Henry Fuseli, *Unveroffentlichte Gedichte von Johann Heinrich Fussli*, ed. Eudo C. Mason (Zurich: Neujahrsblatt de Zurcher Kunstgesellschaft, 1951), 57. Because the image has been figured as female and the word as male for so long, pictorialist and feminist criticism usually chart parallel paths in placing images of and by women at a historical center of interest. See Norma Broude and Mary D. Garrard, eds., *Feminism and Art History: Questioning the Litany* (New York: Harper & Row, 1982) for a variety of approaches.

13. *The Works of Mr. Jonathan Richardson* (London: T. Davies, 1773), 34. The notion that design was the soul of painting and plot the soul of tragedy was commonplace. Cf. Isaac Hawkins Browne, *On Design and Beauty* (London: J. Roberts, 1734): "Design, that Particle of heavenly Flame, / Soul of all Beauty, thro' all Arts the same" (1).

14. Joseph Addison, *The Miscellaneous Works of Joseph Addison*, ed. A. C. Guthkelch, 2 vols. (London: G. Bell, 1914), 1.57. The Twickenham editors point out that Addison in his 1694 "Account of the Greatest English Poets," writing of Spenser, anticipates the couplet with which Pope closes his passage (*TE*, 1.294).

15. On Pope's Tory political views, see Howard Erskine-Hill, "Alexander Pope: The Political Poet in His Time," *Eighteenth-Century Studies* 15 (Winter 1981–82): 123–48; rep. in *Modern Essays on Eighteenth-Century Literature*, ed. Leopold Damrosch, Jr. (New York: Oxford University Press, 1988), 123–40.

16. In *The Art of Sinking in Poetry*, ed. Edna Leake Steeves (New York: King's Crown Press, 1952), 58.

17. On Brunelleschi's use of mirror and compass in determining perspective, see Samuel Y. Edgerton, Jr., *The Renaissance Rediscovery of Linear Perspective* (New York: Harper & Row, 1975), 124–52. If Aristotle overlooks the creation of all epic structures then he should also supervise this miniature structure, and select phonemes from the opening couplet may be heard to sound out his name. The words *Maro, his*, and *t'outlast* give us /ariztatl/. The phonemes may conspire as an example of what James Joyce somewhere calls the 'aristmystic unsaid,' but a duly converse sort of verbal play is found in Pope's witty *Verses Occasion'd by an &c. at the End of M. D'Urfy's Name in the Title to one of his Plays* (*TE*, 6.85–90).

See also Terry Eagleton, *The Significance of Theory* (Oxford: Basil Blackwell, 1990), 27, and, for a good survey of the contemporary field also Eagleton's *Literary Theory: An Introduction* (Minneapolis: University of Minnesota Press, 1983). Bourdieu describes the *habitus* as the largely tacit functioning of social principles that generate and organize behaviors and representations, a concept discussed in his *Outline of a Theory of Practice,* trans. Richard Nice (Cambridge: Cambridge University Press, 1977) 72–95; *The Logic of Practice,* trans. Richard Nice (Stanford, Calif.: Stanford University Press, 1990), 52–65; *Distinction: A Social Critique of the Judgement of Taste,* trans. Richard Nice (Cambridge: Harvard University Press, 1984), 437–40 passim; and in *In Other Words: Essays Towards a Reflexive Sociology,* trans. Matthew Adamson (Stanford, Calif.: Stanford University Press, 1990), 10–11 passim. A related essay is Pierre Bourdieu, "The Historical Genesis of a Pure Aesthetic," trans. Channa Newman, *Journal of Aesthetics and Art Criticism* 46 (1987): 201–10.

18. Ralph Cohen, "Pope's Meanings and the Strategies of Interrelation," in *English Literature in the Age of Disguise,* ed. Maximillian E. Novak (Berkeley and Los Angeles: University of California Press, 1977) 101–30.

19. Cf. the moment in *Paradise Lost* when Adam, recognizing Eve's fatal trespass, "amaz'd, / Astonied stood and Blank," quoted from *The Works of John Milton* (New York: Columbia University Press, 1931), 2. 292; bk. 9, ll. 889–90; and Aeneas' response to the apparition of Creusa in the *Aeneid* when in the Dryden translation he is "Aghast, astonish'd, and struck dumb with Fear," quoted from *Poems: The Works of Virgil in English, 1697,* ed. William Frost, text. ed. Vinton A. Dearing, from *The Works of John Dryden,* gen. ed. Alan Roper, text. ed. Vinton A. Dearing (Berkeley & Los Angeles: University Press of California, 1987), 5.413; bk. 2, l. 1050.

20. Maynard Mack, *Alexander Pope: A Life* (New Haven and London: Yale University Press, 1985), 226–31. Robert Halsband, *"The Rape of the Lock" and Its Illustrations, 1714–1896* (Oxford: Clarendon, 1980), 18–21, is particularly informative about the local context of the frontispiece.

21. Pope's *Epistle To Mr. Jervas, with Dryden's Translation of Fresnoy's Art of Painting* testifies to the growing friendship between poet and painter, while it measures the skills of individual painters against their common master, Raphael: "Each heav'nly piece unweary'd we compare, / Match *Raphael*'s grace, with thy lov'd *Guido*'s air, / *Carracci*'s strength, *Correggio*'s softer line, / *Paulo*'s free stroke, / and *Titian*'s warmth divine" (*TE,* 6.157, ll. 35–38). The verse epistle first appeared in *The Art of Painting,* 2d ed. (London: B. Lintot, 1716). Assisted by Pope, Charles Jervas began revising the Dryden translation of Du Fresnoy on returning with Lord Burlington from the grand tour in 1715. Dryden had exaggerated the importance of coloring by following the French version of the colorist Roger de Piles; the second edition restores the sense of the original Latin, again endorsing the arrangement and perspective, the outline and design, of the Carracci tradition. The connoisseur Richard Graham made it plain that unlike de Piles (and also, presumably, Dryden) Jervas had not been misled: "the French translator has frequently mistaken the sense," writes Graham, so "Mr. Jervas . . . has been prevailed upon to correct what was found amiss" (n.p.).

22. Notice of the affinity was not long in coming. In "To Mr. Pope" Walter Harte finds visual precedent for Pope's allusiveness in a wide-arranging design: "So seems some Picture, where exact design, / And curious pains, and strength and sweetness join: / Where the free thought its pleasing grace bestows, / And

each warm stroke with living colour glows: / Soft without weakness, without labour fair: / Wrought up at once with happiness and care!" Another poem from the same collection, "Essay on painting," makes the reference clear: "Each nobler secret others boast alone / By curious toil *Caracci* made his own"; see 101, 35.

Cf., also, the similar iconography of a print by Petrus Aquila after Carlo Maratta titled "Allegory of Annibale Carracci" and the cartouche beneath the portrait engraving of Pope by Jacobus Houbraken in Thomas Birch, *The Heads of Illustrious Persons of Great Britain*, 3 vols. (London: J. and P. Knapton, 1743–47), 3, no. 28. I am grateful to Richard E. Quaintance for the reference to the Houbraken portrait.

23. With the rebuilding of the royal collections under Charles II and James II, the school of the Carracci attains unusual royal sanction. On the royal collection at Whitehall see Oliver Millar, ed., "Abraham Van Der Doort's Catalogue of the Collections of Charles I," *Walpole Society* 37 (1960), and for those of other royal houses his "The Inventories and Valuations of the King's Goods, 1649–51," *Walpole Society* 43 (1972). For the vogue of the Carracci tradition under the later Stuarts, see Oliver Millar, ed., *Tudor, Stuart, and Early Georgian Pictures in the Collection of Her Majesty the Queen*, 2 vols. (London: Phaidon, 1963), 1.20–26.

24. In removing images from the Marian church, iconoclasts distinguished between the idolatrous icon that was worshipped or abused and the commemorative image that properly reminded viewers of human goodness, according to John Phillips, *The Reformation of Images: Destruction of Art in England, 1535–1660* (Berkeley: University Press of California, 1973), 114–17, 202.

25. Ronald Paulson, *Breaking and Remaking: Aesthetic Practice in England, 1700–1820* (New Brunswick, N.J.: Rutgers University Press, 1989), 48–93.

26. Mikhail Bakhtin, *Art and Answerability: Early Philosophical Essays by M. M. Bakhtin*, ed. Michael Holquist and Vadim Liapunov, trans. and notes by Vadim Liapunov (Austin: University of Texas Press, 1990), 257–325, 142–43.

27. Terry Eagleton, *The Ideology of the Aesthetic* (Oxford: Basil Blackwell, 1991), 9.

28. Spatial form harks back to the *dispositio* of history painting by tracking the temporal movement of narrative through representational space, and has attracted renewed commentary. See Joseph Frank, "Spatial Form in Literature," in *The Widening Gyre: Crisis and Mastery in Modern Literature* (New Brunswick, N.J.: Rutgers University Press, 1963), 3–62; W. J. T. Mitchell, "Spatial Form in Literature: Toward a General Theory," in W. J. T. Mitchell, ed. *The Language of Images* (Chicago: University of Chicago Press, 1980), 271–99; and also the essays collected in Jeffrey Smitten and Ann Daghistany, ed., *Spatial Form in Narrative* (Ithaca: Cornell University Press, 1981).

29. Early woodcuts by Masereel were used to illustrate studies published by the Christian Worker Movement in Belgium. Masereel later relocated to Geneva, where he illustrated among other works the novels of Romain Rolland. See Roger Avermaete, *Frans Masereel* (New York: Rizzoli, 1977), 23–25, and also the preface by Maurice Naessens, 9–11.

30. Stanley Cavell, *Pursuits of Happiness: The Hollywood Comedy of Remarriage* (Cambridge: Harvard University Press, 1981), 25.

31. Noel Coward, *Design for Living*, in *Play Parade* (New York: Doubleday, 1933), 52.

32. I've found two biographies helpful in framing these last remarks: William MacAdams, *Ben Hecht: The Man Behind the Legend* (New York: Charles

Scribner's Sons, 1990); and Sheridan Morley, *A Talent to Amuse: A Biography of Noel Coward* (Boston: Little, Brown, 1985).

WORKS CITED

Addison, Joseph. *The Miscellaneous Works of Joseph Addison*. Edited by A. C. Guthkelch, 2 vols. London: G. Bell, 1914.

Allen, Robert J. "Pope and the Sister Arts." In *Pope and His Contemporaries: Essays Presented to George Sherburn*, edited by James L. Clifford and Louis A. Landa. Oxford: Clarendon Press, 1949.

Appleby, Joyce Oldham. *Economic Thought and Ideology in Seventeenth-Century England*. Princeton: Princeton University Press, 1978.

Ault, Norman. *New Light on Pope*. London: Methuen, 1949.

Avermaete, Roger. With a preface by Maurice Naessens. *Frans Masereel*. New York: Rizzoli, 1977.

Baker, C. H. Collins. "Notes on Pictures in the Royal Collection -34 -Anne Killegrew," *Burlington Magazine* 28 (October 1915–March 1916): 112.

Bakhtin, Mikhail. *Art and Answerability: Early Philosophical Essays by M. M. Bakhtin*. Edited by Michael Holquist and Vadim Liapunov, translated and with notes by Vadim Liapunov. Austin: University of Texas Press, 1990.

Barrell, John. *The Political Theory of Painting from Reynolds to Hazlitt: "The Body of the Public."* New Haven: Yale University Press, 1986.

Baxandall, Michael. *Patterns of Intention: On the Historical Explanation of Pictures*. New Haven: Yale University Press, 1985.

Birch, Thomas. *The Heads of Illustrious Persons of Great Britain*, 3 vols. London: J. and P. Knapton, 1743–47.

Bourdieu, Pierre. *Distinction: A Social Critique of the Judgement of Taste*. Translated by Richard Nice. Cambridge: Harvard University Press, 1984.

———. "The Historical Genesis of a Pure Aesthetic." Translated by Channa Newman. *Journal of Aesthetics and Art Criticism* 46 (1987): 201–10.

———. *In Other Words: Essays Towards a Reflexive Sociology*. Translated by Matthew Adamson. Stanford, Calif.: Stanford University Press, 1990.

———. *The Logic of Practice*. Translated by Richard Nice. Stanford, Calif.: Stanford University Press, 1990.

———. *Outline of a Theory of Practice*. Translated by Richard Nice. Cambridge: Cambridge University Press, 1977.

Broude, Norma and Mary D. Garrard, eds. *Feminism and Art History: Questioning the Litany*. New York: Harper & Row, 1982.

Brownell, Morris R. *Alexander Pope and the Arts of Georgian England*. Oxford: Clarendon Press, 1978.

Browne, Isaac Hawkins. *On Design and Beauty*. London: J. Roberts, 1734.

A Catalogue of the Most Valuable Collection of Pictures, Prints, and Drawings . . . late of Charles Jarvis, 2 parts. London: n.p., 1740.

Cavell, Stanley. *Pursuits of Happiness: The Hollywood Comedy of Remarriage*. Cambridge: Harvard University Press, 1981.

Clifford, James L. and Louis A. Landa, eds. *Pope and His Contemporaries: Essays Presented to George Sherburn.* Oxford: Clarendon Press, 1949.

Cohen, Ralph. "Pope's Meanings and the Strategies of Interrelation." In *English Literature in the Age of Disguise,* edited by Maximillian E. Novak. Berkeley and Los Angeles: University of California Press, 1977.

Coward, Noel. *Play Parade.* New York: Doubleday, 1933.

Damrosch, Leopold Jr. ed. *Modern Essays on Eighteenth-Century Literature.* New York: Oxford University Press, 1988.

Dempsey, Charles. *Annibale Carracci and the Beginnings of Baroque Style.* Gluckstadt: J. J. Augustin, 1977.

Dixon, Peter, ed. *Alexander Pope: Writers and Their Background.* Athens: Ohio University Press, 1972.

Dryden, John. *The Works of John Dryden.* General editor Alan Roper, textual editor Vinton A. Dearing. Berkeley and Los Angeles: University of California Press, 1987.

Du Fresnoy, C. A. *The Art of Painting.* 2d ed. Translated by Charles Jervas. London: B. Lintot, 1716.

Eagleton, Terry. *The Ideology of the Aesthetic.* Oxford: Basil Blackwell, 1991.

———. *Literary Theory: An Introduction.* Minneapolis: University of Minnesota Press, 1983.

———. *The Significance of Theory.* Oxford: Basil Blackwell, 1990.

Edgerton, Samuel Y., Jr. *The Renaissance Rediscovery of Linear Perspective.* New York: Harper & Row, 1975.

Erskine-Hill, Howard. "Alexander Pope: The Political Poet in His Time." *Eighteenth-Century Studies* 15 (Winter 1981–82); also in Damrosch.

Frank, Joseph. *The Widening Gyre: Crisis and Mastery in Modern Literature.* New Brunswick, N.J.: Rutgers University Press, 1963.

Fuseli, Henry. *Unveroffentlichte Gedichte von Johann Heinrich Fussli.* Edited by Eudo C. Mason. Zurich: Neujahrsblatt de Zurcher Kunstgesellschaft, 1951.

Goldstein, Carl. *Visual Fact over Verbal Fiction: A Study of the Carracci and the Criticism, Theory, and Practice of Art in Renaissance and Baroque Italy.* Cambridge: Cambridge University Press, 1988.

Hagstrum, Jean H. *The Sister Arts: The Tradition of Literary Pictorialism and English Poetry from Dryden to Gray.* Chicago: University of Chicago Press, 1958.

Halsband, Robert. *"The Rape of the Lock" and Its Illustrations, 1714–1896.* Oxford: Clarendon, 1980.

Harte, Walter. *Poems on Several Occasions.* London: B. Lintot, 1727.

Holly, Michael Ann. *Panofsky and the Foundations of Art History.* Ithaca and London: Cornell University Press, 1984.

Kramnick, Isaac. *Republicanism and Bourgeois Radicalism: Political Ideology in Late Eighteenth-Century England and America.* Ithaca: Cornell University Press, 1990.

MacAdams, William. *Ben Hecht: The Man Behind the Legend.* New York: Charles Scribner's Sons, 1990.

Mack, Maynard. *Alexander Pope: A Life.* New Haven and London: Yale University Press, 1985.

Metropolitan Museum and National Gallery of Art. *The Age of Correggio and the Carracci: Emilian Painting of the Sixteenth and Seventeenth Centuries.* New York and Washington: Metropolitan Museum of Art and National Gallery of Art, 1986.

Millar, Oliver, ed. *Tudor, Stuart, and Early Georgian Pictures in the Collection of Her Majesty the Queen.* 2 vols. London: Phaidon, 1963.

———, ed. "Abraham Van Der Doort's Catalogue of the Collections of Charles I." *Walpole Society* 37 (1960).

———, ed. "The Inventories and Valuations of the King's Goods, 1649–51." *Walpole Society* 43 (1972).

Milton, John. *The Works of John Milton.* New York: Columbia University Press, 1931.

Mitchell, W. J. T., ed. *The Language of Images.* Chicago: University of Chicago Press, 1980.

Morley, Sheridan. *A Talent to Amuse: A Biography of Noel Coward.* Boston: Little, Brown, 1985.

Novak, Maximillian E., ed. *English Literature in the Age of Disguise.* Berkeley and Los Angeles: University of California Press, 1977.

Panofsky, Erwin. *Meaning in the Visual Arts.* 1955; Chicago: University of Chicago Press, 1982.

Paulson, Ronald. *Breaking and Remaking: Aesthetic Practice in England, 1700–1820.* New Brunswick, N.J.: Rutgers University Press, 1989.

Phillips, John. *The Reformation of Images: Destruction of Art in England, 1535–1660.* Berkeley: University of California Press, 1973.

Pope, Alexander. *The Twickenham Edition of the Works of Alexander Pope.* General editor John Butt, et al., 11 vols. London: Methuen, 1939–69.

———. *The Correspondence of Alexander Pope.* Edited by George Sherburn, 5 vols. Oxford: Oxford University Press, 1956.

Posner, Donald. *Annibale Carracci: A Study in the Reform of Italian Painting around 1590.* 2 vols. London: Phaidon, 1971.

Richardson, Jonathan. *The Works of Mr. Jonathan Richardson.* London: T. Davies, 1773.

———. *An Account of the Statues, Bas-reliefs, Drawings and Pictures in Italy, France, &c. with Remarks.* 2d ed. London: D. Browne, 1754.

Sambrook, James. "Pope and the Visual Arts." In *Alexander Pope: Writers and Their Background,* edited by Peter Dixon. Athens: Ohio University Press, 1972.

Sherburn, George. *The Early Career of Alexander Pope.* Oxford: Clarendon Press, 1934.

Smitten, Jeffrey, and Ann Daghistany, eds. *Spatial Form in Narrative.* Ithaca: Cornell University Press, 1981.

Steeves, Edna Leake, ed. *The Art of Sinking in Poetry.* New York: King's Crown Press, 1952.

Stewart, J. Douglas. *Sir Godfrey Kneller and the English Baroque Portrait.* Oxford: Clarendon Press, 1983.

Virgil. *Poems: The Works of Virgil in English, 1697*. Translated by John Dryden. Edited by William Frost, textual Editor Vinton A. Dearing. In *The Works of John Dryden,* general editor Alan Roper. Berkeley and Los Angeles: University of California Press, 1987.

Vitry, Paul. *De C. A. Dufresnoy Pictoris Poemate quod 'De arte graphica' Inscribitur.* Paris: G. Rapilly, 1901.

Walpole, Horace. *Anecdotes of Painting in England.* 3rd ed., 4 vols. London: J. Dodsley, 1786.

The "Incomparable" Siddons as Reynolds's Muse: Art and Ideology on the British Stage

MICHAEL S. WILSON

One must step back from the customary purviews of literary criticism to regard the eighteenth century as the age in which the theater first began to free itself from logocentrism, to establish its autonomy as an art form in whose production ensemble language is only one element. This freedom, a fundamental shift from the dominance of speech over movement, verbal over nonverbal gesture, word over image, enfranchised the actor's expressive body. Even after painting and sculpture had shed their onus as mere crafts in Western mimetic hierarchies, the systems of value and interest that have long distinguished liberal from "mechanic" arts regarded all aspects of theatrical spectacle as unworthy of serious consideration as visual arts. The peculiarly tenacious attitude that theater's probity resides in its tradition of dramatic poetry, that the drama's essential qualities are literary, incorporates a mistrust of impersonation and mimicry in the actor's protean body. At the center of an ancient, antitheatrical bias in our culture, this mistrust involves a fear of the persuasive immediacy of all histrionic imitation; its false realities have always been regarded as threats to sociopolitical, moral, and ontological stability.[1]

The actor's traditional claim to professional dignity is through the aristocratic poetry of tragedy in some classical guise, while the ennobling sign of fealty to this tragedy was a "declamatory" style. The body's due homage to text was exhibited in decorous gesture and restrained movement that subordinated corporeal enactment to the instrument of language; the voice privileged the cadences of poetry, distinguishing them from quotidian utterance with a rhythmic, sometimes melodic chant. Endorsed by a ubiquitous values system as "natural," this style endured to one degree or another through the nineteenth century.[2]

Acting's authority to produce extratextual meaning derived from its alliance with painting to promote civic virtue, the great project of philosophy and the arts throughout the eighteenth century. Status in this cause

116

was ascribed to the visual arts according to their capacity to transcend their sensuous, material media with rhetorics whose rational appeal imitated the discursive means of language to arouse the moral faculties and to inculcate altruistic behaviors. Among the interartistic experiments spawned in Britain by the doctrine of *ut pictura poesis,* the analogy of poetic tragedy to history painting was as influential as the relationship between descriptive poetry and landscape painting, and more durable.[3] History painting shared tragedy's status as a liberal art because, authorized by a verbal text, it too created instructive representations of ideal character in actions of universal import. The analogy was further authorized by a common sign system: the passions were at once a visual and a verbal lexicon, as "legible" in the spatial depictions of the painters as they were vividly envisioned referents for interior life in the verbal renderings of poets.[4] As a result, the actor's body validated a particular incarnation of *ut pictura poesis:* just as it brought movement and utterance to the painter's static images, so this body was the source of *enargeia,* of vivid pictorialism, for the dramatic poet.

As it thus appeared to serve the poetic text with a powerful sense of inevitability, the discourse between actor and audience in the dialogue drama of eighteenth-century patent houses reified an ideology which still, vestigially, regards the "legitimacy" of theater as residing in the literary qualities of its declaimed text. At the same time, however, the actor dignified otherwise contemptuous mimicry whenever he assimilated the newly influential rhetoric with which the painters elevated ideal imitation above mechanical copying. As a result of this assimilation, the great divide between declamatory acting and the styles we now recognize as "natural" is commonly acknowledged in David Garrick.[5] While Garrick's iconic style authorized acting to produce nonverbal norms of self-mastery with painterly enactments of ideal civic order, the performer's full enfranchisement required a similar inscription upon a woman's body. The obstacles were formidable: anti-theatrical arguments had long used the paradigm of cross-dressing to link the seductive female body to the innate immorality of theatrical impersonation, while dramatic examples of compromised masculinity and feminine appropriation of male prerogative in the public domain were conventional and unmistakable signs of sociopolitical disorder.[6] This essay will examine how a special matrix of values in one of the most famous portraits of the century bespeaks a stylistic collaboration between Sarah Siddons and Sir Joshua Reynolds, and the role this painting played in establishing the actress's international reputation for "incomparable" acting.[7] A larger purpose is to suggest an alternative to traditional theater historiography, which seldom examines the process by which performers subsume canons of taste to function as "abstract and brief chronicles of the time." So the argument will demonstrate that Sid-

dons's performance style embodied the painter's ideology of the grand style of history painting, endowing the private domains of feminine dramatic character with signs of a rational dignity and moral authority that had been arrogated exclusively to the public realm of male governance.

After a stillborn London debut under Garrick in part of his final 1775–76 season, and six more years of apprenticeship in provincial theaters, Sarah Siddons returned to Drury Lane in 1782 at the invitation of Richard Brinsley Sheridan. Although the twenty-eight-year-old actress did not immediately display the qualities of tragic style which were to be the signs of her preeminence, her ability to paint the tender and pathetic passions of Southerne, Otway, and Rowe's heroines elicited sufficient admiration in her first two seasons to ensure a London career. By 1785, however, audiences began increasingly to acknowledge a powerful will at work in Siddons's style which evinced an unaccustomed authority in feminine dramatic character, even in such powerless victims as Jane Shore and Belvidera. When Siddons's Zara reacted to the cold indifference of Osmyn, her noble fellow captive and lover in Congreve's *The Mourning Bride,* a Dublin patron reported that "she appeared a being of superior nature; there was a . . . sublimity in her passion, that swallowed up in her vortex all other ideas; for, in general, a suppliant in love, and that a female too, is not a very dignified object."[8] While Thomas Davies characterized the effect of this performance in similar terms, as an actor he measured it by a radical change in the customary response of the audience:

> The expressions of anger and resentment, in the captive queen, seldom failed to excite laughter. Mrs. Porter, who was deservedly admired in Zara, and Mrs. Pritchard, her successor in that part, could not, with all their skill, prevent the risibility of the audience in this interview. Mrs. Siddons alone preserves the dignity and truth of character, unmixed with any incitement to mirth, from the countenance, expression, or action.[9]

The emphasis here upon Siddons's nonverbal achievement might remind us that the deathless exit couplet of the play's most charged scene still enables Congreve's text to resound with "hysterical" rant for contemporary readers: "Heav'n has no rage like love to hatred turn'd, / Nor Hell a fury like a woman scorn'd" (3.1.457–58). In an age when audience response to such famous "points" was obligatory, much more than declamatory skill was required for Siddons to transfigure what must have been an unavoidable punch line for Mary Ann Porter's and Hannah Pritchard's amusing "spectacles." A later reviewer again used a term that seemed best to distinguish Siddons's rendering of Zara's "contending passions of love, jealousy, pride, and revenge": "she exhibited all the greatness and dignity of exalted majesty."[10] James Boaden, her first biographer, ob-

served "a male dignity in the understanding of Mrs. Siddons that raised her above the helpless timidity of other women."[11] This succinct formulation drew the attention of two later biographers because "dignity" invoked an ideological matrix that was apparent to the age both in her acting and in the arts of which it became increasingly iconic.[12]

For the visually literate eighteenth-century patron, Sarah Siddons's depictions of the tragic passions were, like those of her male counterparts, emblems of a rational and moral self-mastery which the philosophy of this turbulent age frequently urged the arts to help inculcate:

> In the affective movements in which nature (instinct) acts the first and seeks to do without the will, or to draw it violently by its side, the morality of character cannot but manifest itself but by its resistance. . . .
> The rule over the instincts by moral force is the emancipation of the mind, and the expression by which this emancipation presents itself to the eyes in the world of phenomena is what is called *dignity.*[13]

When Reynolds asserted that it was "necessary to the security of society that the mind should be elevated to the idea of general beauty, and the contemplation of general truth," he was framing in the ideal theory of his *Discourses,* a political ideology which aesthetic philosophers from Shaftesbury to Alison believed could be established as a republic of "correct taste."[14] Because the same powers of reason necessary to abstract general ideals from sensuous particulars were required to perceive the common good of the polity, the taste required to create and to appreciate the universal, moral truths of ideal art affirmed one's right to full citizenship in that republic.[15] The susceptibility of feminine dramatic characters to their own "affective movements" reinforced the common conviction that women were not worthy of—lacked the *dignitas* for—full citizenship in either the republic of taste or the political republic because, like uneducated laborers or those who practiced trades, they did not possess the rational faculties to abstract the general truths that govern public morality.[16] Throughout his *Discourses* Reynolds's association of "dignity" with explicit standards of ideal beauty make the term a locus, and history painting the authorized vehicle, for an ideology of rational taste that would elevate British art to the status it enjoyed in the continental tradition. "The *Great Style, Genius,* and *Taste* among the English, are but different appellations of the same thing," asserts the third discourse. "It is this intellectual dignity, they say, that ennobles the painter's art; that lays the line between him and the mere mechanick; and produces those effects in an instant, which eloquence and poetry, by slow and repeated efforts, are scarcely able to attain" (43). In 1784, a year before London patrons began to comment upon the "male dignity in the understanding of Mrs. Siddons," Reynolds exhibited his famous *Mrs. Siddons as the*

Tragic Muse. Evident in its iconography are both the signs and the process with which this dignity was inscribed on the actress's body.

Recognizable to most educated patrons of the day, Reynolds's borrowings from Michelangelo's Sistine Chapel prophets to characterize the relation between Mrs. Siddons and Melpomene have often been discussed.[17] Ronald Paulson's suggestion that the choice of Isaiah as the primary model for the actress's pose "adds a religious dimension—perhaps of prophecy—to the idea of Tragedy" finds support in the similarities between the gesture of her limp right arm and that of the prophet Daniel, as well as the pose of the allegorical figure Pity on her right hand and the pose of the figure in the same position behind the prophet Jeremiah.[18] The full significance of these allusions, however, is evident only when the painting and its history are examined in light of the relations between Reynolds's theory and the public response to his subject's style of acting following the picture's exhibition. In his final address to British Royal Academy students, the aging President advised them as a "first exercise" in invention to "select every figure, if possible, from the inventions of Michael Angelo" because he was "the great archetype . . . from whom all of his contemporaries and successors have derived whatever they possessed of the dignified and the majestick" (15:279, 271–72). The value of such apparently constraining advice resided in the perceived inherence in Michelangelo's painting of the "formal, regular, and austere" qualities of sculpture, which "disdains all familiar objects, as incompatible with its dignity; and is an enemy to every species of affectation" (10:187).

To follow Reynolds's advice, then, was to ensure "what every artist ought well to remember" about art's duty to affirm the ascendant power of reason to perceive general truth:

> the more we purify [our art] from everything that is gross in sense, in that proportion we advance its use and dignity; and in proportion as we lower it to mere sensuality, we pervert its nature, and degrade it from the rank of liberal art. (9:170–71)

For Reynolds to engraft on a portrait the sculpturesque style of *istoria's* greatest practitioner was to elevate the genre above its mere mechanical purpose of creating a likeness with "the acquired dignity taken from general nature" (4:72). This is only part of the achievement that James Barry, the Academy Professor of Painting, praised when he described Reynolds's portrait of Siddons as "the finest picture of the kind, perhaps in the world."[19] Sir Thomas Lawrence, in his first formal address as president, told academy students that it was "indisputably the finest female portrait in the world."[20] To be sure, Lawrence's opinion may have been colored by a lifelong infatuation with the actress, but by 1823 the pre-

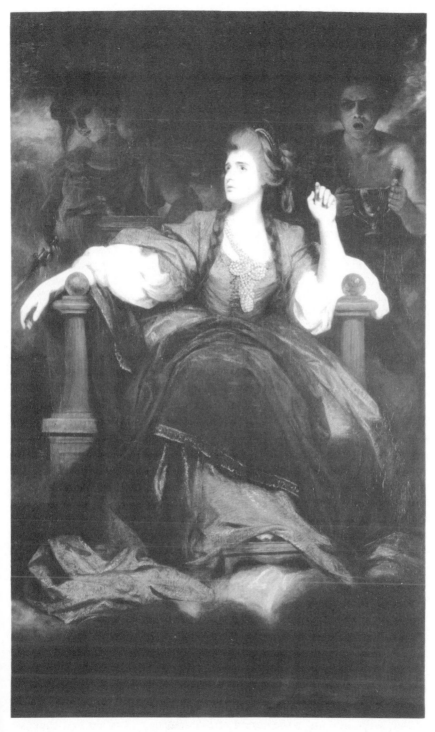

Sir Joshua Reynolds. *Mrs. Siddons as the Tragic Muse,* **1784. (The Huntington Library and Art Gallery.)**

science of Reynolds's iconographic prophecy, and the truth of its representation of the actress's style, had long been widely acknowledged.

This portrait was for Reynolds not merely a flawless demonstration of his ideal theory for Academy colleagues and students; in fact, he painted a manifesto of Academy ideology in order to "advance its use and dignity" through a living enactment, by associating with Sarah Siddons's acting style the entire complex of values invoked for the age by "dignity." Indeed, the combined effect of the portrait and the subsequent development of the actress's style were to prove the truth of the artist's conviction that "we have so far associated personal dignity with the persons represented [by ancient sculpture], and the truth of art to their manner of representation, that it is not in our power any longer to separate them" (8:138).

The expressive quality of Sarah Siddons's style was precisely what William Hazlitt admired in the Elgin marbles in 1801; that is, "their sense of perfect form [which] nearly occupies the whole mind, and hardly suffers it to dwell on any other feeling. It seems enough for them *to be,* without acting or suffering."[21] Without any explicit reference to sculpture, he described the same quality in the actress's

> elevation and magnitude of thought, of which her noble form seemed to be only the natural mould and receptacle. Her nature always seemed to be above the circumstances with which she had to struggle. . . . Grandeur was the cradle in which her genius was rocked: for *her* to be, was to be sublime! (18:278)

Because Hazlitt's sudden emergence in midlife as the most influential theater critic of his day was a natural extension of his experience as a painter and art critic, his admiration for Sarah Siddons and her brother John Philip Kemble was consistently expressed in terms of Reynold's Grand Manner—a doctrine Hazlitt deplored in all other contexts. "The beauty of which we are in quest, is," Reynolds had insisted, ". . . an idea residing in the breast of the artist . . . which he is so far able to communicate, as to raise the thoughts . . . of the spectator" (9:171). When Hazlitt observed a "commanding intellect" and "the perfection of tragedy" in Siddons's "noble form," he was explicitly acknowledging a ubiquitous canon of taste among his educated readers (18:196; 298). The critic was constructing a meaning for the actress's stage deportment that verbally encoded the visual inscription of sculpturesque dignity derived from Reynolds's program for British painting. The origins of this meaning may be traced from the rhetoric of Reynolds's portrait.

Although he characterized the style only as "purely heroic," Edgar Wind was correct to observe that in this portrait Reynolds "emerged as the champion of a new . . . style of acting."[22] When the painter began his sittings with Siddons in the spring of 1783, at the end of her first success-

ful London season, her old rival Mary Anne Yates had moved to Covent Garden and still had exclusive claims to the symbolic role of Tragic Muse which she had created in Garrick's 1769 restaging at Drury Lane of *The Stratford Jubilee*. George Romney, even longer a rival of Reynolds, had painted Yates in this role ten years earlier. Since the identification of London's leading tragedienne with the muse was a convention, the differences between Romney and Reynolds's designs deserve careful scrutiny.[23] Romney portrays Yates in the Aeschylean action of making a libation on a smoking altar. The traditional symbols of secret and open murder that identify her as the muse are suggested by the vessel from which she has poured the offering, and explicit in the dagger held by her other hand. Siddons's contrasting action in Reynolds's depiction seems deliberately vague: her attention seems preoccupied, or absorbed by some object outside the picture frame, evoking no obvious associations with either Melpomene or the theater. Romney emphasizes the theatrical context of Yates's role with the suggestion of a classical stage setting, while Reynolds's muse floats on a vague, cloudy empyrean. The very indefiniteness of this spatial design reinforces both the prophetic import and the sculpturesque allusions of the painting, however, by invoking a sense of the timeless permanence of classical art with which Reynolds sought to lay British painting's claim to worthiness in the continental tradition.

Reynolds's design deliberately simplifies the central image, which places as much emphasis on the presence of the actress as on her "role" as Melpomene. Her cup and dagger have been given to the shadowy personifications of Pity and Terror. That the symbols have been "removed" is pointed by their proximity to Siddons's hands, which are dedicated to more appropriate allusions; that her gestures could readily accommodate the objects, and even suggest their shapes, emphasizes the capacity of the "acquired dignity" of sculpturesque gesture to invoke the ideal grandeur of classical tragedy. Framed by the vertical lines in her throne and Aristotelian attendants, the two stable triangles in the composition of her figure point its ascendancy, as if graphically to underscore the artist's conviction that "the whole beauty and grandeur of the art consists . . . in being able to get above all singular forms, local customs, peculiarities, and details of every kind" (3:44). At the apex of the upper triangle, two strong diagonal lines extend to connect the actress's face with the ideal models of the tragic passions which, we are reminded, are the universal "language" of performer, painter, and dramatic poet.[24] This compelling linear intersection also invites close inspection of the actress's features with a dignified generalization that does not sacrifice likeness as it idealizes, particularly in the careful avoidance of profile for the famous nose so prominently featured in caricatures of the Kembles and in the design of Gainsborough's less flattering portrait.[25] Siddons

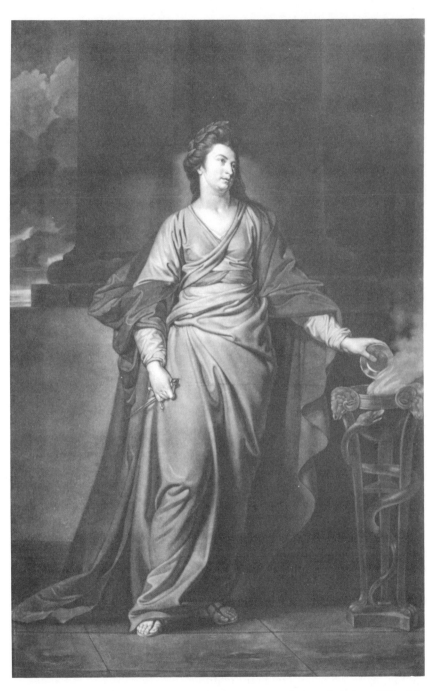

Valentine Green, after George Romney. *Mrs. Yates as the Tragic Muse,* **1772. (The Harvard Theater Collection.)**

must "transcend" her unique, individual qualities in order that the Tragic Muse may appear familiar to the beholder. Reynolds's design draws sharp distinctions both between his own and Romney's rhetorical strategies and between the performance styles of Yates and Siddons, stressing the differences between a "pompous and laboured insolence of grandeur" and simple, unaffected attitudes, "where dignity seeming to be natural and inherent, draws spontaneous reverence, and . . . has the appearance of an inalienable adjunct" (8:149).

An apparent similarity between Romney and Reynolds's portraits reveals the essential difference in their rhetoric. Edgar Wind has observed that Romney's equation of Yates with the muse is a "contamination of two pictorial ideas: the Muse to whom the sacrifice is being made is herself embodied in the sacrificing figure," with "nothing to indicate which goddess is receiving sacrifice." He finds the same unsatisfying ambiguity in Siddons's pose: "the actress is portrayed as if, as an actress, she is being inspired, whereas she should, as a Muse, herself inspire."[26] Wind is correct to seek a significance beyond the Michelangelesque allusions in the pose; particularly in a picture of a performer, Reynolds should be expected to follow his own dictum that "a painter of portraits retains the individual likeness; a painter of history shews the man by shewing his actions" (4:60). It seems unlikely, however, if Reynolds were indeed prophesying Siddons's usurping of her rival, that he would repeat Romney's error; he had deliberately played upon the mock-heroic implications of the same action seventeen years earlier in *Lady Sarah Bunbury Sacrificing to the Graces*.[27] In fact, while Wind correctly identifies the action of Siddons's pose as signifying "inspiration," the ambiguity that he also perceives is the ultimate basis for a unity of diverse iconographic sources which would have been clearest to patrons who brought painterly perceptions to the stage picture.[28] Three different accounts of the origin of the famous pose help to explain how Reynolds transformed Romney's "laboured" equivalence into a subtle and persuasive equivocation, a dual action whose rhetoric specifically fulfilled the artist's own requirement that "there must be something in the action, or in the object, in which men are universally concerned, and which powerfully strikes upon the publick sympathy" (4:57).

In her own *Reminiscences,* the actress credits herself with the "idea" for the pose:

In tribute to [Reynolds's] triumphant Genius I cannot but remark his instantaneous decission [sic] on the attitude and expression. In short, it was in the twinkling of an eye. When I attended him for the first sitting, after many more gratifying encomiums than I dare repeat, he took me by the hand, saying, "Ascend your undisputed throne, and graciously bestow upon me some grand

Idea of the Tragick Muse." I walkd up the steps & seated myself instantly in
the attitude in which she now appears.[29]

Against this implied collaboration stands the account of the painter,
Thomas Phillips, to whom Siddons had earlier explained the pose as "the
production of pure accident:

> Sir Joshua had begun the head and figure in a different view; but while he was
> occupied in the preparation of some colour she changed her position to look
> at a picture on the wall of the room. When he again looked at her, and saw the
> action she had assumed, he requested her not to move; and thus arose the
> beautiful and expressive figure we now see in the picture.[30]

The accidental source of the pose is supported, but attributed to a differ-
ent circumstance in Samuel Rogers's account:

> I was at Sir Joshua's studio when Mrs. Siddons came in, having walked rapidly
> to be in time for her appointment. She threw herself, out of breath, into an
> armchair; having taken off her bonnet and dropped her head on her left hand—
> the other hand drooping over the arm of the chair. Suddenly lifting her head
> she asked, "How shall I sit?" "Just as you are," said Sir Joshua, and so she
> is painted.[31]

At about the midpoint between the sitting in question and the exhibition
of the finished portrait, Reynolds advised Academy students on how,
after one has borrowed a figure or idea from great painting, to work with
a model:

> What is taken from a model, though the first idea may have been suggested by
> another, you have a just right to consider as your own property. And here I
> cannot avoid mentioning a circumstance in placing the model, though to some
> it may appear trifling. It is better to possess the model with the attitude you
> require, than to place him with your own hands; by this means it often happens
> that the model puts himself in an action superior to your own imagination. It
> is a great matter to be in the way of accident, and to be watchful and ready to
> take advantage of it. (12:222–23)

Phillips's and Rogers's accounts appear as confirmations both of Reyn-
olds's ability to discern the "grand idea" in the accidents of nature and,
in any case, of the artist's proprietary rights to whatever notions the
actress may have brought to the pose. Reynolds's essential borrowing
from his living model, however, is more implicit in Siddons's own account
of the sitting. Considering that it was written late in her life for the edifi-
cation of a biographer, as one of a few formative events selected from a
thirty-year career, one is struck by the way in which her emphasis
throughout upon the spontaneous, effortless manner in which painter and
actress cooperated to realize the pose substantiates the very claims that

Reynolds makes in the painting for the "natural" appositeness of actress and allegoric persona.

Ever since her sitting for a crayon portrait as Euphrasia by the adolescent Thomas Lawrence during her final season in Bath, the role Siddons had so often played for painters taught her the reciprocity of expressive devices between the stage and the painters' studios. In the year before her sittings for Reynolds, after one of her many sessions with William Hamilton, the Scots academician who painted at least five portraits of her,

> Mr. Hamilton and his wife were bidding good morning to the famous actress, and accompanying her downstairs, when they pointed out to her her own resemblance to an antique sculpture of Ariadne, that stood on the staircase. Mrs. Siddons was taken by surprise, and her honesty was here a traitor to her vanity. She clasped her hands in delight, and said, "Yes, it is very—" but, immediately recollecting herself, before she got out the word *like* substituted the word, beautiful. She then sat down on the staircase to contemplate the sculpture.[32]

Because in retrospect it was as natural and inevitable to the actress that she be cast as the Tragic Muse in the artist's studio as she had been on the stage, Siddons reconstructs her sitting with Reynolds as a theatrical event that enacts the painting's prophecy: the painter takes the actress by the hand to elevate her in the studio just as he will elevate her on the canvas to the "undisputed throne" that she will subsequently occupy for London theater patrons.

The essential unity of Reynolds's iconography resides in the deliberately equivocal rhetoric of the pose. The most accessible signifier is the inspirational subject of actress-as-Muse, whose ascension, made explicit by the prophetic import of the Michelangelesque allusions, is an "inevitable" consequence of her innate ability to assimilate the sculpturesque dignity of great painting to the nonverbal expressive mode it shares with acting. What Reynolds has "taken from a model" was suggested by her "natural" (because arduously studied) deportment, on and off the stage. Just as educated theater patrons will be inspired by the actress, so connoisseurs will be inspired by the portrait to acknowledge a reciprocal ascendancy of style; embodied in an ideal model of sculpturesque dignity, Academy ideology will hold "a sort of sovereignty over those rules [which regulate good taste]" (2:27).

Another, more esoteric level of signification turns upon the recognition of how Reynolds has appropriated the actress's style. Indeed, Thomas Phillips's account might have served Reynolds's students as a perfect example of "how to possess the model with the attitude you require." When the actress changed the pose in which Reynolds had placed her to observe a painting on the wall, the "accident" of her "free, unrestrained air" of absorption suggested an action from whose rhetoric the iconogra-

phy emerges as if ordained: Mrs. Siddons inspires as if she were Melpomene precisely because she is, like a promising Academy student, capable of *being* inspired by the sculpturesque models of classical art. In the sublime rhetoric of the portrait, Siddons's apotheosis is a direct consequence of manifesting in her acting style an ideology that is extrinsic to customary stage deportment, just as its models are outside the picture's frame, in the studio of the Academy President.[33]

Those capable of "reading" the painting on this level were also aware, from literary theory if not from Reynolds's *Discourses,* that the great artist "did not possess his art from nature [or from mere "enthusiasm"], but by long study" (15:281). For these beholders Siddons's action in the painting bespoke the ennobling results of following the advice of the President's second discourse, a regimen for the aspiring artist to acquire "the habitual dignity" with which "long converse with the greatest minds . . . will display itself in all his attempts" (26–27). Patrons who did not share Phillips's knowledge of the sitting were nevertheless attuned to the competition among leading actresses of the two major houses, and would have been prompted in 1784 to seek evidence in his subject's action, on the stage as well as in the portrait, of Reynolds's rationale for such a striking prediction. Recognition is rewarded by the sense of inevitability with which the iconography serves the proprietary rhetoric of the action; the triumph of Siddons's style will at once verify the power of Academy ideology to inculcate standards of rational taste, even in the mixed audience of the theater, and to reform even the seductive feminine body of the theater into a morally acceptable exemplar of civic virtue. The portrait thus functioned as a multileveled advertisement of official Academy style, its rhetoric veiling ideology in a mystique of ideal beauty, and appropriating the actress as a living endorsement of that style, with their combined authority confirmed by her subsequent success.

Siddons pursued her craft as if she were indeed an Academy student following Reynolds's repeated advice that "attentive survey" and "long, laborious comparison" were "the only price of solid fame" (2:26; 1:18). Although her intimate acquaintances were usually women, her closest friends and most ardent admirers among men were often either the painters whose studios she frequented for sittings—Lawrence, Opie, Hamilton, Haydon—or collectors—Thomas Whalley, Sir George Beaumont, William Fitzhugh. From the end of the century until well after her retirement, she became an arbiter of taste at public exhibitions.[34] When her praise for his *Christ's Entry into Jerusalem* at its solo exhibit in 1820 ensured the picture's success, Haydon ever after solicited her presence when one of his paintings was exhibited.[35] In particular the great sculpture that informed the taste of the age never failed to elicit her most profound admiration.[36] Thomas Gilliland attributed Mrs. Siddons's "classical and perfect posses-

sion of the most beautiful attitudes" to her "knowledge of the antique figure and painting"; she has, he observed, "united with a theoretical knowledge of the arts, the practical art of sculpture, in which she has, on several occasions, greatly distinguished herself. This accounts for her action being so chaste, expressive, and captivating."[37]

Siddons indeed worked closely over thirty years with her good friend Anne Seymour Damer, the only female sculptor in the Royal Academy. The actress performed with the sculptress in amateur theatricals at Strawberry Hill, which Walpole ceded to Damer as a lifetime residence in 1797, while the sculptress made busts of the actress and her now-famous brother. Siddons copied her friend's work and made her own heads, busts, and medallions of herself, her family, and George III, adding studios to her Westbourne farm in 1805 and to her Regent's Park house in 1817.[38] Boaden, who turned to Reynolds's *Discourses* to clarify the principles of the "Kemble style," emphasized the importance of this study in shaping her stage deportment:

> Conspiring with the larger stage to produce some change in her style was her delight in statuary, which directed her attention to the antique, and made a remarkable impression upon her as to simplicity of attire and severity of attitude. The actress had formerly complied with fashion . . . ; she now saw that tragedy was debased by the flutter of light materials.[39]

Boaden echoes Reynolds's remarks in his fourth discourse about "the simplicity and . . . severity, in the grand manner": the painter does not "debase his conceptions with minute attention to the discrimination of drapery. It is the inferior style that marks the variety of stuff" (4:62–63). Whenever a new role invited the practice—as did Desdemona (1784–85), Racine's Hermione (*The Distress'd Mother,* 1785–86), Cleopatra (1787–88), Volumnia (1788–89), Horatia (*The Roman Father,* 1794–95), Dido (*The Queen of Carthage,* 1796–97), and Hermione (1801–2), among others—her choice of costume invariably reflected Reynolds's insistence that the artist's work "shall correspond to those ideas . . . which he knows will regulate the judgment of others; and therefore dresses his figure in something with the general air of the antique for the sake of dignity" (7:140).

Evidence of direct collaboration between painter and actress is meager. Boaden and at least one later biographer claim that Reynolds helped to design her costume for Lady Macbeth in the season following the exhibition of her portrait.[40] In her *Reminiscences,* Siddons recalls with pride the Academy president's approval of her change in stage dress, and describes her reasons for discarding the fashion of elaborate, powdered tresses on stage:

My locks were generally braided into a small compass so as to ascertain the
size and shape of my head, which to a Painter's eye was of course an agreeable
departure from the mode. . . . He [Reynolds] always sat in the Orchestra.[41]

Such a change inevitably evoked in her educated admirers the values that
Reynolds associated with sculpture's "correct out line," which gives "the
most grace and dignity to the human figure" (1:19). An amateur water-
color of Siddons as Lady Macbeth is representative of a series by Mary
Hamilton, who first sketched the actress's attitudes during her 1802–3
performances in Dublin. Unlike Frederick Rehberg's drawings of Lady
Emma Hamilton's attitudes, for instance, the complete absence of facial
or costume detail reflects an interest in a quality that is, Reynolds ex-
plained, "exhibited in Sculpture rather by form and attitude than by the
features."[42] Indeed, no other performer so deliberately exploited the ca-
pacity of Reynolds's grand style to enhance both her own stature and
those of her dramatic characters.

To assimilate the grand style in tragic performance was nonverbally to
endow Siddons's public persona and her dramatic characters with the
masculine moral stature and rational self-mastery for which "dignity" was
the sign. Shakespeare's Queen Katharine was perhaps her most effective
vehicle for this style. Professor George Bell, a student of painting and
close observer of Mrs. Siddons's performances, wrote a precis of his
detailed, firsthand annotation of her nonverbal performance on the flyleaf
of his acting edition of *Henry VIII*:

Mrs. Siddons's Queen Katharine is a perfect picture of a great, dignified, some-
what impatient spirit, conscious of rectitude, and adorned with every generous
and every domestic virtue. Her dignified contempt of Wolsey when comparing
her own royal descent, her place and title as queen, her spotless honor, with
the mean arts and machinations by which this man was driving her into toils
and breaking in upon her happiness; her high spirit and impatient temper; the
energies of a strong and virtuous mind guarding the King at all hazards from
popular discontent and defending her own fame with eloquence and dignity;
her energy subdued, but her queen-like dignity unimpaired by sickness; and
the candor and goodness of her heart in her dying conversation concerning her
great enemy—all this, beautifully painted by Mrs. Siddons, making this one of
the finest female characters in the English drama.[43]

Bell construes the rule of a "strong and virtuous mind" over a "high
spirit and impatient temper" in the "dignifying" terms of the grand style.
Isolated in a world of hostile men, the collected contempt with which the
aging queen confronted such powerful antagonists as Cardinal Wolsey
seemed to ennoble the jeremiads of all wronged womanhood.[44] The roles
for which Mrs. Siddons was most celebrated—Lady Macbeth, Queen
Katharine, Volumnia—were those in which the political context enabled
her style, in Reynolds's terms, to dignify the "genteelness of modern

Mary Hamilton. *Mrs. Siddons as Lady Macbeth: "Hark! Peace!,"* **12 July 1802.**
(Courtesy of the Trustees of the British Museum.)

effeminacy, by uniting it with the simplicity of the ancients and the gran-
deur and simplicity of Michael Angelo" (4:72). Far from subverting the
established social order, however, Siddons's depictions of self-mastery
ultimately reinforced dominant social hierarchies.

With more immediate and persuasive nonverbal powers than the rheto-
ric of easel painting, the stage picture deploys the spatial codes of dress,
gesture, and composition that subordinate bodies in relation to other bod-
ies so as to represent authority and its fixed social relations in the guise
of disinterested ideals of beauty. Joseph Roach observes that "in the

theatre, remote abstractions become physical practices," and "generalities that govern conduct and establish priorities of value—'Taste,' 'Duty,' 'Honor,' 'Beauty'—gain an otherwise unattainable specificity under conditions of precise selection and control." If an alliance with painting enabled the actor's body to generate meanings independent of the dramatic text, the inscription of Reynolds's ideology on an actress's body rendered her lack of social autonomy perspicuous in the context of dramatic situation. The "male dignity" of Siddons's Queen Katharine was summoned, it must be remembered, without defiance of the husband who wrongs her, who in fact must praise her "wifelike government, / Obeying in commanding" (2.4.136–37), and was expressed in courageous opposition only to those who would "shake degree" in the ordained polity. In her descent from Queen to Princess Dowager, Katharine's unjust misfortune taught an explicit moral lesson: when it is born of unshakable conjugal loyalty, the intrepid self-mastery that places "private affections" in service to the commonwealth is the sign of innate *dignitas,* of worthiness to wield a consort's authority. Acting style is, as Roach has elsewhere shrewdly observed, "social order as lived in the body."[45]

The response to Siddons's "male dignity" was an idealization which distinguished her from other actresses as "incomparable" and has served to endow her with an enduring ontological status in the history of the stage. Reynolds's portrait abetted the actress's own studied deportment to reify both an ideology of "right taste," of "dignity," and the mystifying legitimacy of a sculpturesque style as inimitably natural, universal, even timeless; at the same time her very idealization separated the actress's body and dramatic personae in order to subject them to a morality that operated only within the constraints of fixed proprietary bonds. Only out of dramatic context, as if it were a portrait, could the controlled behavior that turned Katharine's "drops of tears" to "sparks of fire" appear as a displacement of feminine "instinct" rather than as merely its disciplined employment (2.4.70–71).[46] The evidence is that Siddons's depictions effected just such dramatic sublimations, eliciting admiration like Gilliland's for "chaste" and "captivating" qualities which were perceived to inhere in a specific code of aesthetic values (n. 37 above). Indeed, the moral stature invoked by her performances "visually banished the notion of frailty" even in the characters of such fallen women as Jane Shore and Mrs. Haller, and paradoxically enhanced the sympathy of the polite audience with nonverbal deportment that obviated any inherent inclinations to adultery.[47]

That Reynolds's portrait legitimated the meanings which George Bell and so many other educated patrons constructed for Siddons's performances is beyond doubt. Even offstage and out of costume, when she "sat on a chair raised on a small platform" for her tragic readings, Bell could

not but see her elevated just as she had been in Reynolds's studio: "Sir Joshua Reynolds's picture . . . gives a perfect conception of the general effect of her look and figure."[48] Another manifestation of such idealization is the cultural ritual of courtesy to women, characterized by Siddons's proud recollection in her *Reminiscences* of Reynolds's famous remark about the placement of his signature on the picture: "I have resolved to go down to posterity on the hem of your Garment."[49] Although the retired actress represents the famous remark as a compliment to her own gifts, it also implicitly affirms the importance of her representation by the Academy president, reminding us of the relations between the painting's rhetoric and the social rewards for willing participation in rituals of courtesy which reinforce dominant social orders.

Such inquiries beg the question of Sarah Siddons's personal "worthiness" for Reynolds's proprietary rhetoric, particularly since the function of performers as social metaphors whets a public appetite for incongruities between their dramatic personae and the micropolitics of their personal lives. Siddons's resistance to the social demands of celebrity status helped to establish her reputation as a devoted mother to the five (of seven) children who lived past early childhood. And although she was the sole provider for her family, her husband (a supporting actor who quit his undistinguished provincial career to manage his wife's) was the legal possessor of her vast earnings, from which he meted her an allowance. Sarah Siddons played her supporting roles in the patriarchal order so well that her reputation was never seriously tarnished by marital discord, sexual scandal, maternal irresponsibility, or even by rivalry with her younger brother John Philip Kemble, under whose authority she worked for most of her career. Fanny Burney's description of her first social impression of the famous actress is characteristic of her offstage persona:

> She is a woman of excellent character, and therefore I am very glad she is thus patronised, since Mrs. Abington, and so many fair frail ones, have been thus noticed by the great. She behaved with great propriety; very calm, modest, quiet, and unaffected. . . . She has, however, a steadiness in her manner and deportment by no means engaging. Mrs. Thrale, who was there, said: "Why, this is a leaden goddess we are all worshipping!"[50]

While other gifted performers also sought similar ennobling associations with the visual arts, no other actress so effectively suppressed her personal identity in a careful enactment of propriety on London's social stage. Similarly acute, but less constrained social sensibilities were the basis for Reynolds's success as a fashionable painter of portraits; Siddons's unexceptional performance in her private life was an essential concomitant of the "dignity taken from general nature" for Reynolds's

representation of her public, "aesthetic transcendence" of individuality, for his idealizing imprimatur as "incomparable."

From this point of view Reynolds's picture seems designed to test the conflation of moral legitimacy with the specific aesthetic program by which Academy ideology

> by a succession of art, may be so far diffused, that its effects may extend themselves imperceptibly into publick benefits, and be among the means of bestowing on whole nations refinements of taste; which, if it does not lead directly to purity of manners, obviates at least their greatest depravation, by disentangling the mind from appetite, and conducting the thoughts through successive stages of excellence, till that contemplation of universal rectitude and harmony which began by Taste, may, as it is exalted and refined, conclude in Virtue. (9:171)

This expectation is perhaps less astonishing when we consider that inexpensive prints were a ubiquitous vehicle for disseminating standards of taste, and that the theater wielded the authority of our cinema and television combined. This was an age in which the House of Commons, on a motion by Pitt, adjourned to see Master Betty play Hamlet. Burke, Gibbon, Fox, Walpole, Windham, and Sheridan were usually in attendance on Siddons's opening nights. When the press could with little exaggeration report that "on a Siddons night, Drury Lane looked more like a meeting of the House of Lords than a theatre," and her benefit book was referred to as "the Court Guide," we must recognize that the actress was an integral part of the national life Reynolds sought to shape with his fledgling Academy.[51] If the riotous denizens of the gallery were irredeemable, the tastes most susceptible to elevation were, the artist recognized, those most debased—and empowered—by the selfish pursuit of "Trade and its consequent riches" (9:169). The irony is that the performer who could best assimilate an ideology that was as masculine as it was aristocratic also represented by her sex the most disenfranchised citizens of the republic.

In this light Reynolds's own attitude toward the picture deserves further conjecture. His contributions to the annual Academy exhibition had declined seriously following a paralytic stroke in 1782, and both his notoriously poor hearing and his eyesight were deteriorating. For the exhibition of 1784 the sixty-one-year-old president made a massive effort, however, and the centerpiece of his seventeen contributions, the portrait of Mrs. Siddons, "kept him in a fever," his disciple James Northcote observed.[52] It was not painted on commission, and the artist priced it so high—five times his normal fee for a full-length portrait—that it remained in his own studio until 1790, when virtual blindness ended his painting career. Robert Wark has reasonably conjectured that Reynolds painted the portrait "for

his own satisfaction and as an object for public exhibition," as the center-piece of a panoply intended to demonstrate that his powers were not failing.[53] One is tempted further to attribute the artist's reluctance to consign the picture to the relative obscurity of a private collection to a desire personally to test the reciprocal influence of its rhetoric and Mrs. Siddons's style upon public taste.

By 1784 the commercial success of landscape and ordinary face-painting were already calling into question the capacity of history painting to achieve Reynolds's ambitious ends. The rhetoric of Siddons's portrait shrewdly allied the artist's conservative ideology to the most public of art forms, ensuring its widespread dissemination with living *istoria,* and using the persuasive immediacy of the stage to demonstrate the instrumental relation between correct taste and ideal virtue. In 1790 Reynolds reminded the Academy that

> as this great style is itself artificial in the highest degree, it presupposes in the spectator, a cultivated and prepared artificial state of mind. It is an absurdity therefore to suppose that we are born with this taste, though we are with the seeds of it, which, by the heat and kindly influence of [Michelangelo's] genius, may be ripened in us. (15:277)

By the very nature of her craft, Siddons demonstrated how this taste could be acquired even as she inculcated it with her performances. Current theory held that the actor's ability to invoke her own—and thus the audience's—belief in her character's feelings, follows from accurately imitating the external manifestations of emotion in the universal language of the passions. In the next passage of the same discourse Reynolds quoted with approval Thomas Harris's conviction that *"we are on no account to expect that fine things should descend to us,—*our taste, if possible, must be made to ascend to them. [Harris] recommends to us *even to feign a relish, till we find a relish come; and feel, that what began in fiction, terminates in reality"* (Reynolds's italics). So in Reynolds's view not only were the actor and the painter's arts of imitation and borrowing close parallels, but the "artificial" taste necessary fully to appreciate them required a determined cultivation of intellect. These insights are not only implicit in the rhetoric of the portrait, but in fact seem to be its test: "the highest state of refinement in either of these arts will not be relished without a long and industrious attention" (15:277–78).[54] In the hurly burly of Covent Garden theater, Siddons nightly faced a more rigorous test: she was confronted by mixed audiences for whom performance tradition had reinforced convictions about feminine character, and constrained by roles that with few exceptions were characterized by an "instinctual" susceptibility to "personal" feelings.

In the Drury Lane season that corresponded with the portrait's public

display, by intriguing coincidence Siddons matched Reynolds's effort with seventeen different roles, eight of which were new to London audiences. Her centerpiece was Lady Macbeth, the role for which she would be most celebrated. Because their actions so violated ideals of feminine decorum, Shakespeare's Cleopatra at one extreme and Medea and Lady Macbeth at another were the tragic characters Siddons had been most reluctant to undertake.[55] *Macbeth* was by mid-century firmly established in the tragic repertory, however, and if Siddons were to justify the claim of Reynolds's portrait, she was obliged to invite comparison in the character in whom her competitors had depicted ruling passions utterly alien to her own sense of feminine propriety. The performance tradition that governed the conjugal relationship in *Macbeth* provoked an ongoing critical debate in a moralizing age about the very possibility of such an unwomanly creature.[56] The fundamental terms of this debate were elicited by the susceptibility of Garrick's virtuously reluctant Macbeth to Hannah Pritchard's monstrous virago, whose "consummate intrepidity in mischief" so inverted gender-specific norms of behavior that Garrick was criticized for depicting a hero in whom sensibility and conscience seemed more prominent than masculine courage, projecting a character "not worthy of our esteem, yet an object not entirely unmeriting our pity."[57]

Despite this tradition and the dictates of Shakespeare's dramatic character, Siddons's sense of propriety required an image of Lady Macbeth as "captivating in feminine loveliness," a woman "fair, feminine, nay, perhaps even fragile," and a wife devoted "entirely to the effort of supporting [her husband]."[58] George Bell verified that in performance this version of Lady Macbeth became "the affectionate aider of her husband's ambition."[59] Particularly after John Philip Kemble took over Macbeth in 1788, Siddons's Lady Macbeth appeared incapable of moral apathy, for her dignity converted the accustomed pathos of mental disintegration into a sympathetic version of a dramatic character that for more than forty years had served as a demeaning moral lesson for women. Nowhere is the effect of her performance clearer than in the public response to the "letter scene" (1.5), which George Henry Harlowe celebrated in a portrait. Rather than "unsex me here" (41), "Come to my woman's breasts" (47), or any other visually dramatic attitude in which the character strips herself of "womanly frailty" or perverts her "feminine instincts," Harlowe chose "Glamis thou art, and Cawdor, and shalt be / What thou art promised" (15–16). Ignoring the clear textual significance for motivation, relationship, and ensuing central action of the two infamous soliloquies that follow this line, the artist depicted the "hit" which best characterized the overall impact of Siddons's Lady Macbeth for an audience who would purchase engraved reproductions of the portrait to commemorate their experience in the theater. In his detailed glossing of Siddons's delivery,

C. Rolls, after George Henry Harlowe. *Mrs. Siddons as Lady Macbeth.* **(The Harvard Theater Collection.)**

Bell testifies that in the phrase "and *shalt* be what thou art promised," her emphasis on the verb was uttered in an "exalted prophetic tone, as if the whole future were present to her soul."[60] Particularly given the taut emotional build over fifty lines, from her recognition of his timorous scruples to her fierce resolve "to catch the nearest way," to invoke "murd'ring ministers" and even to use her husband as a "keen knife" for regicide, that Siddons's Lady Macbeth should be represented by her initial response to the letter suggests the combined authority of dramatic and social personae if not to convert evil to virtue, at least to subordinate a dramatic archetype of seductive feminine disorder to an extra-textual, freestanding emblem of spousal magnanimity.

In response to his famous sister's characterization, Kemble created a Macbeth who, however tormented by conscience, displayed "masculine" qualities of rational self-mastery and physical courage which, if they were not engendered, were clearly elicited by the strength of his wife's devotion. For the first time in the century, a balanced relationship made of the tragedy a fable of mutual moral disintegration. Moreover, by placing feminine appetence in service to the ideal of conjugal loyalty, Siddons's inscriptions of dignity authorized the female body to participate—within acceptable boundaries of duty—in the pictorial process by which the theater established its autonomous, extraliterary authority to instruct citizens in the reciprocal ideals of rational morality and good taste.

The banquet scene was central to the Siddons-Kemble production, for rather than merely foreshadowing Macbeth's fall, the moral significance of Lady Macbeth's madness was complicated by a worthy strength of purpose that seemed in this scene to grow in proportion to Macbeth's remorseful vacillation. The staging of the banquet placed Siddons in an elevated and relatively stationary position upstage, while her character— whom she claimed was "dying with fear"[61]—appeared to the audience to be powerfully torn by a "conflict of courtesy and inquietude" between the guests and Kemble, who frantically traversed the downstage area as if entrapped.[62] The effect was an apparent inversion of gendered behavior, with Macbeth's irrational susceptibility to his own feelings literally foregrounded by the queen's struggle in dangerous political circumstances to compensate with the authority of her own composure. Kemble's managerial innovation was to eliminate the actor in whiteface who had traditionally played Banquo's ghost; Siddons's innovation was to play a Lady Macbeth who *also* saw the imaginary spectre,[63] intensifying the contrast between Macbeth's irrationality and the queen's heroic struggle for selfmastery, which her "mute acting impressed on the audience with an unusual degree of power."[64] George Bell even suspended his customary reverence for Shakespearean text when he testified that "her words are the accompaniments of her thoughts, scarcely necessary, you would imag-

ine, to the expression."[65] Praised by Hazlitt for their effect of "sustained dignity" (18:227), this succession of "hits" prepared the way for the final "flagging of her spirit" which, Bell avowed, was "one of the finest lessons of the drama":

> Of Lady Macbeth there is not a great deal in this play, but the wonderful genius of Mrs. Siddons makes it the whole. She makes it tell the whole story of the ambitious project. . . . Macbeth in Kemble's hand is only a cooperating part. I can conceive Garrick to have sunk Lady Macbeth as much as Mrs. Siddons does Macbeth, yet when you see Mrs. Siddons play this part you scarcely can believe that any acting would make her part subordinate.[66]

For the actress's adoring audience, this was the tragedy of *Lady* Macbeth: after the character's exit in Siddons's farewell performance of 1812, they refused to allow the play to continue.

From her first performance as Lady Macbeth, Boaden said, Siddons's "dominion over the passions was undisputed," and the prophecy of Reynolds's portrait was fulfilled: in Sheridan's re-staging of Garrick's *Stratford Jubilee* of the next season she was "drawn in state as the Muse of Tragedy, and, as well as mere mechanism and motion could compensate the want of background, resembling Sir Joshua's sublime portrait of her."[67] In two popular engravings of Yates and Siddons as Medea, a role the latter never played because the character was too unnatural, Edgar Wind has discovered not only palpable evidence of Siddons's absolute accession to her old rival's throne, but indirect evidence of the role of Reynolds's portrait in the eviction. The designs of the two engravings are similar in almost every respect, except that the plagiarist who replaced Yates with Siddons for John Bell's British Theatre series simply substituted the head from Reynolds's portrait, complete with coiffure and crown.[68] Apparently it was no exaggeration for Hazlitt to observe that "the enthusiasm she excited had something idolatrous about it" (5:312). Siddons's embodiment of the grand style so justified the rhetoric of Reynolds's portrait that their combined effect created a generation of idolaters, with Hazlitt as their unwitting high priest.

The most transparent of Hazlitt's gratuitous eulogies for "the stately pillar of Tragedy" appeared sixteen years after her retirement in an 1828 weekly review of the theater:

> We understand that not long ago Sir Walter Scott and Mrs. Siddons met in the same room before Mr. Martin's picture of the Fall of Nineveh—two such spectators the world cannot match again, the one by common consent of mankind the foremost writer of his age, the other in the eyes of all who saw her prime or her maturity, the queen and mistress of the tragic stage. Forgive us . . . if we should have turned from . . . him . . . *to bow the knee and kiss the hem of the garment of her who . . . was the Muse of Tragedy personified.* [my

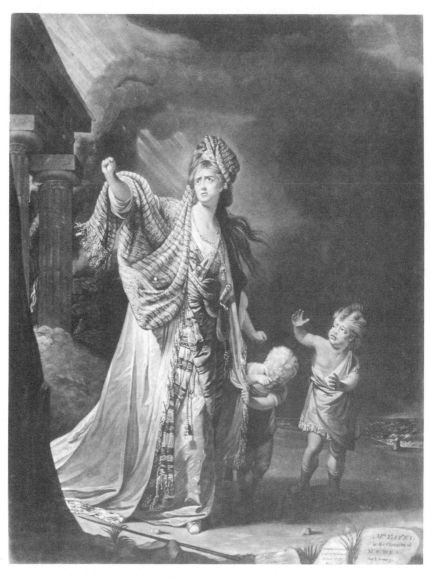

M. Dickinson, after Robert Edge Pine. *Mrs. Yates in the Character of Medea,* **1771.**
(The Harvard Theater Collection.)

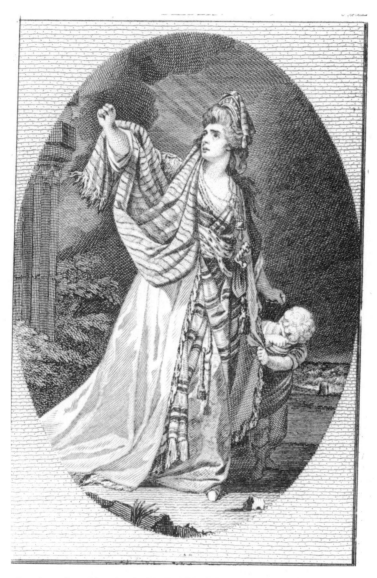

Thornthwaite, after Pine for Bell's British Library. *Mrs. Siddons as Medea.* (The Harvard Theater Collection.)

italics]. . . . We declare that Mrs. Siddons appears to us the more masculine spirit of the two. Sir Walter (when all's said and done) is an inspired butler, a "Yes and No, my Lord" fellow in a noble family—Mrs. Siddons is like a cast from the antique, or rather like the original, divine or more than human, from which it was taken. . . . [She] seemed to command every source of terror and pity, and to rule over their wildest elements with inborn ease and dignity. . . . She wore a crown. She looked as if descended from a higher sphere, and walked the earth in majesty and pride. She . . . touched all chords of passion, they thrilled through her, and yet she preserved an elevation of thought and character above them. (18:407–8)

In his art criticism and philosophy Hazlitt is profoundly at odds with Reynolds's theory, decrying the practice of copying from sculpturesque models for its "cold abstraction of nature," and even criticizing the "bastard style" of his portrait of Mrs. Siddons (10:163, 26). Yet merely to imagine the actress at an exhibition was for him sufficient to conjure the ethos of Reynolds's portrait—replete with all the ideological import of its iconography and rhetoric—as a suitable characterization of "Tragedy personified, . . . the stateliest ornament of the public mind" (5:312). The irony is that a critic of Hazlitt's fierce independence should attach his review to its subject with an imagined gesture of reverence that is an apparently unwitting echo of Reynolds's remark about the placement of his signature on the portrait (n. 49 above).

While eighteenth-century acting established its authority to generate meanings independent of the dramatic text, the logocentric ideology to which the visual arts remained in thrall still sustains a tendency in theater histories to equate the paucity of drama of autonomous literary merit for which the century is notorious with the rise of scenic spectacle, as if they were in some way corollaries.[69] But just as the greatest achievements of British painting were in landscape and portraiture rather than history painting, so the theater's best accomplishment was the unity of the stage picture, to which the paralinguistic and proxemic codes of acting became so integral that nonverbal *mise en scéne* could displace language as the primary agent of dramatic action by the closing decades of the century.[70] Indeed, a better understanding of how the actor's "just delineation of the passions" enabled powerful nonverbal constructions of class, gender, ethnicity, and race promises to explain the alienation of most readers from Augustan drama in part as a result of their inability to read implied stage directions. Theatrical portraiture is an essential record of the actor's nonverbal means, and to reassess its importance is more fully to appreciate how the theater has served as a cultural locus for enduring ideological debates. Certainly it has long been an arena for contests between verbal and visual arts, and the actor's body remains a particularly ephemeral, neglected history of Western iconophobia since Plato. As the cultural semiosis of the actor's nonverbal means is recovered and inter-

preted, it will surely help us better to understand how the figures of difference historically attributed to words and to images have served to produce—and upon occasion to subvert—hegemonic cultural orders.

NOTES

This essay was written in part with the support of a fellowship from the National Endowment for the Humanities.

1. See Jonas Barish, *The Antitheatrical Prejudice* (Berkeley and Los Angeles: University of California Press, 1981), 80–190, 221–55, 277–82.

2. E.g., see Maarten van Dijk, "The Kembles and Vocal Technique," *Theatre Research International* 8 (1983): 23–42.

3. For a more detailed discussion of this thesis, see Michael S. Wilson, "Ut Pictura Tragoedia: An Extrinsic Approach to British Neoclassic and Romantic Theatre," *Theatre Research International* 12 (1987): 201–20.

4. See Alan T. McKenzie, "The Countenance You Show Me: Reading the Passions in the Eighteenth Century," *The Georgia Review* 32 (1978): 758–73; and *Certain, Lively Episodes: The Articulation of Passion in Eighteenth-Century Prose* (Athens: University of Georgia Press, 1990).

5. See Michael S. Wilson, "Garrick, Iconic Acting, and the Ideologies of Theatrical Portraiture," *Word & Image* 6 (1990): 368–94.

6. E.g., see Jill Campbell, "When Men Women Turn': Gender Reversals in Fielding's Plays," in *The New Eighteenth Century: Theory, Politics, English Literature,* ed. Felicity Nussbaum and Laura Brown (New York and London: Methuen, 1987), 62–83.

7. Even while Sarah Bernhardt and Eleanora Duse's reputations were still bright, a century after Siddons's retirement Brander Matthews believed that she "was probably the greatest actress the world has even seen." Introduction to H. C. Fleeming Jenkin, *Mrs. Siddons as Lady Macbeth and Queen Katharine,* 2d ser: Papers on Acting III (New York: Dramatic Museum of Columbia University, 1915), 10. This editing of and commentary by Jenkin on G. J. Bell's firsthand performance notes is subsequently cited under Bell's name.

8. "Mrs. Siddons' Departure from the Stage," a review bound into *The Beauties of Mrs. Siddons* (London, 1786), 15, a series of anonymous, undated letters giving accounts of her characters during her Dublin performances in 1785, TS 193.4 in Harvard University Theatre Collection.

9. Quoted in Mrs. Clement Parsons, *The Incomparable Siddons* (London: Methuen, 1909), 230.

10. *Beauties,* "Letter 2: Zara" (n.p.).

11. James Boaden, *Memoirs of Mrs. Siddons* (London, 1831), 297.

12. Quoted in Parsons, *Incomparable,* 230 and Roger Manvell, *Sarah Siddons: Portrait of an Actress* (New York: Putnam's, 1971), 114.

13. Friedrich Schiller, *Aesthetic and Philosophical Essays,* 2 vols. (Boston: Niccolls, 1902), 1:215 and 217. For representative, but more discursive associations of dignity and moral virtue in British philosophy, see Anthony Ashley Cooper, Earl of Shaftesbury, *Characteristics,* 5th ed., 3 vol. (Birmingham, 1773), 1:28–45, 91–98; Henry Home, Lord Kames, *Elements of Criticism* (1762; rpt.

London and New York: Johnson Rpt., 1967), 2:28–29; and Archibald Alison, *Essays on the Nature and Principles of Taste,* 5th ed. (Edinburgh, 1817), 305–6.

14. *Discourses on Art,* ed. R. R. Wark (San Marino, Calif.: Huntington Library, 1959), 9:170. Subsequent quotations of Reynolds are given parenthetically in the text.

15. See John Barrell, *The Political Theory of Painting from Reynolds to Hazlitt* (New Haven and London: Yale University Press, 1986), 10–33, 65–68, 79. Shaftesburg, *Characteristics,* 2:5–76 represents the ideology in his conviction that the duty of the highest art was its capacity rationally to abstract the "Natural Affections" from "Private" and "Unnatural Affections," which leads inevitably to "the Good of the Publick." Also see Kames, *Elements,* 1:58–65.

16. Mary Wollstonecraft, *A Vindication of the Rights of Women,* ed. Carol Poston (1792; New York: Norton, 1975), 54; quoted in Barrell (cited n. 15), 66.

17. James Boaden, *Memoirs of the Life of John Philip Kemble, Esq.,* 2 vols. (London, 1825), 2:155–56 recognized both the portrait's Michelangelesque allusions and their idealizing effects; also see Parsons (cited n. 9), 254. For contemporary discussions of the theatrical implications of the portrait's iconography, see Edgar Wind, *Hume and the Heroic Portrait,* ed. Jaynie Anderson (Oxford: Clarendon, 1986), 44–46; Robert R. Wark, *Ten British Pictures, 1740–1840* (San Marino: Huntington Library, 1971), 43–57; and Ronald Paulson, *Emblem and Expression: Meaning in English Art of the Eighteenth Century* (Cambridge: Harvard University Press, 1975), 83–85.

18. Paulson, *Emblem,* 85, figs. 40 and 41. Also see Wind, *Hume,* 45, figs. 47 and 48; and Wark, *Ten,* 46–47, figs. 34 and 35.

19. *The Works of James Barry, Esq.,* 2 vols. (London, 1809), 1:553.

20. D. E. Williams, ed., *The Life and Correspondence of Sir Thomas Lawrence,* 2 vols. (London, 1831), 1:430.

21. *Complete Works,* 21 vols., ed. P. P. Howe (London: J. M. Dent, 1930–34), 5:312. Subsequent quotations of Hazlitt are given parenthetically in the text.

22. Wind, *Hume,* 45.

23. Wind builds upon important information about the theatrical tradition of the muse and its representations that was probably gleaned in large part from Parsons, *Incomparable,* 253. Nicholas Penny, ed., *Reynolds* (New York: Abrams, 1986), 325 and Wark, *Ten,* 46 have both suggested that Reynolds's most likely source was William Russell's "The Tragic Muse: A Poem Addressed to Mrs. Siddons" (1783), because of its *ekphrasis* of the actress enthroned as Melpomene. Given the theatrical tradition and the common practice of elevating subjects in the painters' studios, however, the rivalry between Reynolds and Romney is a more compelling basis for comparison.

24. The visual lexicon of the passions served writers, painters, and actors as a potent rhetorical vehicle for defining standards of moral behavior. McKenzie, "Countenance," provides the best general discussion of their ubiquity, and Wark, *Ten,* 49–52 traces their derivation in Reynolds's portrait from the painters' traditional taxonomy. For specific reciprocities between painting and the stage, see Brewster Rogerson, "The Art of Painting the Passions," *Journal of the History of Ideas* 14 (1953): 68–94, and Alastair Smart, "Dramatic Gesture and Expression in the Age of Hogarth and Reynolds," *Apollo* n.s. 82 (1965): 90–97. Joseph R. Roach, "Power's Body: The Inscription of Morality as Style" in *Interpreting the Theatrical Past: Essays in the Historiography of Performance,* ed. Thomas Post-

lewait and Bruce A. McConachie (Iowa City: University of Iowa Press, 1989), 99–118, considers the passions as understood "glosses" to dramatic texts.

25. See Paulson, *Emblem*, 209–10.

26. Wind, *Hume*, 44.

27. Robert E. Moore, "Reynolds and the Art of Characterization" in *Studies in Criticism and Aesthetics, 1660–1800*, ed. Howard P. Anderson and John S. Shea (Minneapolis: University of Minnesota Press, 1967), 332–57, refers to this dictum on p. 345 as the "central problem" Reynolds confronted in mediating the disparate demands of characterization in the two genres. On 350–51, he and Penny (*Reynolds*, 224) both address the social import of such mock-heroic actions.

28. Wark's important essay on the portrait explains in formal terms how the "disparate elements have all . . . emerged as a unit . . . [that] seems not only correct but inevitable" (*Ten*, 52). Wind, however, is the only art historian who has considered the theatrical basis for this unity.

29. *The Reminiscences of Sarah Kemble Siddons*, ed. William Van Lennep (Cambridge, Mass.: Widener Library, 1942), 17.

30. Claude Phillips, *Sir Joshua Reynolds* (London, 1891), 320; quoted in Joel Weinsheimer, "Mrs. Siddons, The Tragic Muse, and the Problem of 'As,'" *Journal of Aesthetics and Art Criticism* 36 (1978): 317–28, on p. 321. For Rogers's account see W. T. Whitley, *Artists & Their Friends in England, 1700–1799*, 2 vols. (Boston and London: Medici Society, 1928), 2:4; also quoted in Wark, *Ten*, 46.

31. Quoted in Richard Wendorf, *The Elements of Life: Biography and Portrait-Painting in Stuart and Georgian England* (Oxford: Clarendon, 1990), 247, whose discussion of the three accounts of the sitting, generously shared in ms. form, helped to shape this argument.

32. Quoted in Parsons, *Incomparable*, 64; and Manvell, *Sarah Siddons*, 84. In her *Reminiscences* (Van Lennep, ed., 16–17) the actress bemoans among the many demands on her time that which "was employ'd in sitting for various Pictures." The notoriety of the actress's sittings with Reynolds—if not her relation with the studio—is reflected in an undistinguished conversation piece by fellow academician W. Q. Orchardson, *Mrs. Siddons in the Artist's Studio* (178?), in which the actress strikes a declamatory pose before a small audience of connoisseurs, with the beginning of Reynolds's pose on a canvas in the background (reproduced in Parsons, *Incomparable*, facing 62).

33. Schiller, *Aesthetic*, 219 explained that "dignity relates to the form and not to the nature of the affection" which, "as soon as it testifies by its form to the empire of the mind over the senses, changes often its character and approaches even toward the sublime."

34. See W. T. Whitley, *Art in England, 1800–1820* (Cambridge: Cambridge University Press, 1928), 110, 314.

35. B. R. Haydon, *The Autobiography and Journals*, ed. M. Elwin (1853; rpt. London: MacDonald, 1950), 333.

36. See Thomas Campbell, *The Life of Mrs. Siddons*, 2 vols. (London, 1834), 2:355–57.

37. Thomas Gilliland, *The Dramatic Mirror*, 2 vols. (London, 1808), 2:972.

38. See Parsons, *Incomparable*, 241, 256–57; and Manvell, *Sarah Siddons*, 185, 298.

39. Boaden, *Siddons*, 402; *Kemble*, 1:425–26. See *Kemble*, 1:170–73 and 178–79

for Boaden's use of Reynolds's sculpturesque ideology to characterize the "Kemble style."

40. Boaden, *Siddons,* 315 and Parsons, *Incomparable,* 63, whose 1909 study Manvell, a contemporary biographer, characterized as "well-researched but somewhat untidy" (*Sarah Siddons,* 318).

41. Siddons, *Reminiscences,* 19.

42. Focusing exclusively on Mary Hamilton's *Mrs. Siddons as Hermione,* the classical attitude in which was a convention widely imitated in celebrity portraiture, Wind, *Hume,* 47, fig. 56 attributes her composition to a "purely social" interest in pose and costume arising from the popular entertainment of *tableaux vivants.* But a familiarity with Lady Emma Hamilton's career as George Romney's model, when she was Emma Hart, and her widely imitated practice of "attitudes" under the tutelage of the connoisseur Sir William Hamilton, leads to the recognition of dissolving boundaries between artist's studio, parlor, and stage, and between painting, sculpture, and theater. In any case, in 47–50 Wind himself offers convincing evidence from portraiture for "an antiquarian interest that influences even the stage and leads actors to mould grand gestures on ancient models; and it is at root a theatrical interest in the classical gestures that leads to such imitations." See Wilson, *"Ut Pictura,"* 211–12, and Frederick Rehberg, *Emma Hamilton's Attitudes: Drawings Faithfully Copied from Nature at Naples* (1794; Cambridge: The Houghton Library, 1990).

43. Bell, in Jenkin, *Mrs. Siddons,* 78–79. Bell's brother Sir Charles, a physician, gifted amateur painter, and also an avid theater patron, linked the scientific study of expression directly to the theater by encouraging painters to supplement traditional sculpturesque models with direct study of the actors' stage expressions in his influential *Essays on the Anatomy and Physiology of Expression* (London, 1806), 8, 18.

44. See Manvell, *Sarah Siddons,* 82–83, 122–23.

45. Roach, "Power's Body," 115. I am indebted to Roach's discussion of inscription and idealization in this essay and in "Theatre History and the Ideology of the Aesthetic," *Theatre Journal* 41 (1989): 155–68, from which the previous quotation was drawn (157).

46. See Wilson, "Garrick," 21ff, for a full discussion of the pictorial conventions by which actors' "hits" privileged the spatial mode of painting in order to accommodate the kinetic imperative of theater to ideals of moral and ontological stasis. Also see Bell, *Mrs. Siddons,* 39, for a detailed glossing of the Siddons's hit in Queen Katharine's "Lord Cardinal, / To you I speak" (2.4.67–68), celebrated by George Henry Harlowe as a dramatic portrait of the Kemble family. Erika Fischer-Lichte, "Theatre and the Civilizing Process: An Approach to the History of Acting," in *Interpreting the Theatrical Past,* provides a valuable discussion of acting history as the increasingly rigorous subjection of the body to forms expressive of internal self-mastery.

47. See Parsons, *Incomparable,* 55, and Manvell, *Sarah Siddons,* 203–4.

48. See Bell, *Mrs. Siddons,* 94–95.

49. Siddons, *Reminiscences,* 17–18.

50. Quoted in Manvell, *Sarah Siddons,* 79–80.

51. E.g., see Parsons, *Incomparable,* 250–52.

52. Quoted in ibid., 253.

53. Wark, *Ten,* 45–46, 56.

54. Though Reynolds's comparison in this passage is to music, Wind, *Hume,* 21–22 has observed its greater relevance to acting.

55. See Parsons, *Incomparable,* 127 and Manvell, *Sarah Siddons,* 75.

56. See Joseph W. Donohue, Jr., *Dramatic Character in the English Romantic Age* (Princeton: Princeton University Press, 1970), 189–215, 233–42 for a useful discussion of this performance and its critical tradition.

57. Thomas Davies, *Dramatic Miscellanies,* 3 vols. (Dublin, 1784), 2:188–89, 191. As distinct from love, desire, and other affinities, "esteem" was specifically linked to "dignity" by way of reason, the "social passions," and public duty (see Schiller, *Aesthetics,* 225–26, Kames, *Elements,* 2:28–39, and Alison, *Essays,* 305–410).

58. See Sarah Siddons, "Remarks on the Character of Lady Macbeth" in Thomas Campbell *Life of Mrs. Siddons,* 2:10–34 and Parsons, *Incomparable,* 119–20. Also quoted in Manvell, 120–21, Siddons's "Remarks" were addressed to Mrs. William Fitzhugh, and later included in Campbell's biography (see Parsons, 217). They have long disconcerted critics seeking to reconcile them with ample testimony to a quite different character in Siddons's many performances. My interpretation is indebted to the careful research of Joseph W. Donohue, Jr., first presented in "Kemble and Mrs. Siddons in *Macbeth:* The Romantic Approach to Tragic Character," *Theatre Notebook* 22 (1967–68): 65–86. Donohue sensibly resolves the dilemma by explaining Siddons's "Remarks" as a "concept of the character *against* which she could play," and infers "two complementary aspects" of interpretation: "she establishes a dramatic tension between impulsive, masculine strength of purpose and qualities more naturally feminine, even maternal" (*Incomparable,* 255, 259). "Playing against" a quality or emotional state is a standard acting technique which Siddons perforce practiced daily, whenever she played a Zara or Volumnia on one evening against a Jane Shore or Mrs. Beverly the next, or sought to balance the conflicts between her public and private personas.

59. Bell, *Mrs. Siddons,* 39; quoted in Donohue, "Kemble and Mrs. Siddons," 259.

60. Bell, *Mrs. Siddons,* 38, 39. When Rolls's popular reproduction is compared to Harlowe's original (reproduced in Donohue, *Dramatic Character,* plate 37), it is apparent that the engraver has softened the actress's expression, perhaps displacing the more determined expression of the original to the emblem of an embossed shield he added on the wall to the right of her face.

61. Quoted in Manvell, *Sarah Siddons,* 121.

62. Quoted in Donohue, *Dramatic Character,* 263.

63. See Thomas Campbell, *Life of Mrs. Siddons,* 2:10–34, and Parsons, *Incomparable,* 119–20.

64. Review in *Daily Advertiser,* 31 October 1785; quoted in Donohue, *Dramatic Character,* 263.

65. Bell, *Mrs. Siddons,* 38.

66. Ibid., 35–36.

67. Boaden, *Siddons,* 340.

68. Wind, *Hume,* 45–46, figs. 42, 43.

69. Among theater historians who hold to this equation are Allardyce Nicoll, *A History of English Drama, 1660–1900,* 5 vols. (Cambridge University Press, 1952–59), and Leo Hughes, *The Drama's Patrons: A Study of the Eighteenth-Century London Audience* (Austin: University of Texas Press, 1971). For a representative parallel among literary critics, see J. Paul Hunter, "The World as Stage and Closet," in *British Theatre and the Other Arts, 1660–1800,* ed. Shirley Strum Kenney (Washington: Folger Shakespeare Library, 1984), 271–87.

70. See Wilson, "Columbine's Picturesque Passage: The Demise of Dramatic Action in the Evolution of Spectacle on the London Stage," *The Eighteenth Century: Theory and Interpretation* 31 (1990): 191–210.

WORKS CITED

Alison, Archibald. *Essays on the Nature and Principles of Taste* 5th ed. Edinburgh, 1817.

Barish, Jonas. *The Antitheatrical Prejudice.* Berkeley and Los Angeles: University of California Press, 1981.

Barrell, John. *The Political Theory of Painting from Reynolds to Hazlitt.* New Haven and London: Yale University Press, 1986.

Barry, James. *The Works of James Barry, Esq.* 2 vols. London, 1809.

The Beauties of Mrs. Siddons. London, 1786. A series of anonymous letters and reviews giving accounts of her characters during her Dublin performances in 1785. TS 193.4 in Harvard University Theatre Collection.

Boaden, James. *Memoirs of the Life of John Philip Kemble, Esq.* 2 vols. London, 1825.

——. *Memoirs of Mrs. Siddons.* London, 1831.

Campbell, Jill. "When Men Women Turn': Gender Reversals in Fielding's Plays." In *The New Eighteenth Century: Theory, Politics, English Literature,* edited by Felicity Nussbaum and Laura Brown, 62–83. New York and London: Methuen, 1987.

Campbell, Thomas. *The Life of Mrs. Siddons.* 2 vols. London, 1834.

Davies, Thomas. *Dramatic Miscellanies.* 3 vols. Dublin, 1784.

Dickinson, M. *Mrs. Yates in the Character of Medea.* 1771. Engraving after Robert Edge Pine. Harvard Theatre Collection.

Donohue, Joseph W., Jr. *Dramatic Character in the English Romantic Age.* Princeton: Princeton University Press, 1970.

——. "Kemble and Siddons in *Macbeth:* The Romantic Approach to Tragic Character." *Theatre Notebook* 22 (1967–68): 65–86.

Fischer-Lichte, Erika. "Theatre and the Civilizing Process: An Approach to the History of Acting." In *Interpreting the Theatrical Past: Essays in the Historiography of Performance,* edited by Thomas Postlewait and Bruce A. McConachie, 19–36. Iowa City: University of Iowa Press, 1989.

Gilliland, Thomas. *The Dramatic Mirror.* 2 vols. London, 1808.

Green, Valentine. *Mrs. Yates as the Tragic Muse.* 1772. Engraving after George Romney. The Harvard Theatre Collection.

Hamilton, Mary. *Mrs. Siddons as Lady Macbeth: "Hark! Peace!"* (12 July 1802). The British Museum, London.

Haydon, B. R. *The Autobiography and Journals.* Edited by M. Elwin. 1853. London: MacDonald, 1950.

Hazlitt, William. *Complete Works.* Edited by P. P. Howe. 21 vols. London: J. M. Dent, 1930–34.

Hughes, Leo. *The Drama's Patrons: A Study of the Eighteenth-Century London Audience.* Austin: University of Texas Press, 1971.

Hunter, J. Paul. "The World as Stage and Closet." In *British Theatre and the Other Arts, 1660–1800,* edited by Shirley Strum Kenney, 271–87. Washington: Folger Shakespeare Library, 1984.

Jenkin, H. C. Fleeming. *Mrs. Siddons as Lady Macbeth and Queen Katharine.* Introduction by Brander Matthews. 2d ser.: Papers on Acting III. New York: Dramatic Museum of Columbia University, 1915. An editing of and commentary by Jenkin on G. J. Bell's firsthand performance notes.

Kames, Henry Home, Lord. *Elements of Criticism.* London, 1762; rpt. London and New York: Johnson Rpt., 1967.

McKenzie, Alan T. "The Countenance You Show Me: Reading the Passions in the Eighteenth Century." *The Georgia Review* 32 (1978): 758–73.

———. *Certain, Lively Episodes: The Articulation of Passion in Eighteenth Century Prose.* Athens: University of Georgia Press, 1990.

Manvell, Roger. *Sarah Siddons: Portrait of an Actress.* New York: Putnam's, 1971.

Moore, Robert E. "Reynolds and the Art of Characterization." In *Studies in Criticism and Aesthetics, 1660–1800,* edited by Howard P. Anderson and John S. Shea, 332–57. Minneapolis: University of Minnesota Press, 1967.

Nicoll, Allardyce. *A History of English Drama, 1660–1900.* 5 vols. Cambridge University Press, 1952–59.

Parsons, Mrs. Clement. *The Incomparable Siddons.* London: Methuen, 1909.

Paulson, Ronald. *Emblem and Expression: Meaning in English Art of the Eighteenth Century.* Cambridge: Harvard University Press, 1975.

Penny, Nicholas. *Reynolds.* New York: Abrams, 1986.

Phillips, Claude. *Sir Joshua Reynolds.* London, 1891.

Rehberg, Frederick. *Emma Hamilton's Attitudes: Drawings Faithfully Copied from Nature at Naples.* 1794. Cambridge: The Houghton Library, 1990.

Reynolds, Sir Joshua. *Discourses on Art.* Edited by R. R. Wark. San Marino, Calif.: Huntington Library, 1959.

———. *Mrs. Siddons as the Tragic Muse.* 1784. San Marino, Calif.: Huntington Library and Art Gallery.

Roach, Joseph R. "Power's Body: The Inscription of Morality as Style." In *Interpreting the Theatrical Past: Essays in the Historiography of Performance,* edited by Thomas Postlewait and Bruce A. McConachie, 99–118 Iowa City: University of Iowa Press, 1989.

———. "Theatre History and the Ideology of the Aesthetic." *Theatre Journal* 41 (1989): 155–68.

Rogerson, Brewster. "The Art of Painting the Passions." *Journal of the History of Ideas* 14 (1953): 68–94.

Rolls, C. *Mrs. Siddons as Lady Macbeth.* Engraving after George Henry Harlowe. The Harvard Theatre Collection.

Schiller, Friedrich. *Aesthetic and Philosophical Essays.* 2 vols. Boston: Niccolls, 1902.

Shaftesbury, Anthony Ashley Cooper, Earl of. *Characteristics.* 5th ed. 3 vols. Birmingham, 1773.

Siddons, Sarah. *The Reminiscences of Sarah Kemble Siddons.* Edited by William Van Lennep. Cambridge: Widener Library, 1942.

Smart, Alastair. "Dramatic Gesture and Expression in the Age of Hogarth and Reynolds." *Apollo* n.s. 82 (1965): 90–97.

Thornthwaite, R. *Mrs. Siddons as Medea.* Engraving after Robert Edge Pine. Bell's British Library. Harvard Theatre Collection.

van Dijk, Maarten. "The Kembles and Vocal Technique." *Theatre Research International* 8 (1983): 23–42.

Wark, Robert R. *Ten British Pictures, 1740–1840.* San Marino, Calif.: Huntington Library, 1971.

Weinsheimer, Joel. "Mrs. Siddons, the Tragic Muse, and the Problem of 'As'." *Journal of Aesthetics and Art Criticism* 36 (1978): 317–28.

Wendorf, Richard. *The Elements of Life: Biography and Portrait-Painting in Stuart and Georgian England.* Oxford: Clarendon, 1990.

Whitley, W. T. *Art in England, 1800–1820.* Cambridge University Press, 1928.

———. *Artists and Their Friends in England, 1700–1799.* 2 vols. Boston and London: Medici Society, 1928.

Williams, D. E., ed. *The Life and Correspondence of Sir Thomas Lawrence.* 2 vols. London, 1831.

Wilson, Michael S. "*Ut Pictura Tragoedia:* An Extrinsic Approach to British Neoclassic and Romantic Theatre." *Theatre Research International* 12 (1987): 201–20.

———. "Columbine's Picturesque Passage: The Demise of Dramatic Action in the Evolution of Spectacle on the London Stage." *The Eighteenth Century: Theory and Interpretation* 31 (1990): 191–210.

———. "Garrick, Iconic Acting, and the Ideologies of Theatrical Portraiture." *Word & Image* 6 (1990): 368–94.

Wind, Edgar. *Hume and the Heroic Portrait.* Edited by Jaynie Anderson. Oxford: Clarendon, 1986.

Wollstonecraft, Mary. *A Vindication of the Rights of Women.* Edited by Carol Poston. 1792. New York: Norton, 1975.

Painting against Poetry: Reynolds's *Discourses* and the Discourse of Turner's Art

JAMES A. W. HEFFERNAN

In *The Archaeology of Knowledge,* Michel Foucault defines the various sciences as so many kinds of discourse resulting from what he calls "discursive formation." Every branch of scientific knowledge, he argues, is the product of a historically definable process, beginning with "the moment at which a single system for the formation of statements is put into operation" and culminating in formalization, when a particular scientific discourse can define the axioms it needs, the elements it uses, and the propositional structures it recognizes as legitimate.[1] It is not at all clear how well this model will explain the literature, literary criticism, or literary theory of any one historical period, and it is still less clear that this model will accommodate the unwieldy collection of things that have been written about works of art. There is no such thing as a coherent discourse about art. In its place we find a bewildering variety of discursive practices that diverge and proliferate: art history, art criticism, art theory, interart theory, interart criticism, iconography, iconology, ekphrasis. Of all these, only art history approaches what Foucault calls the threshold of formalization as a discourse; those who write the kinds of things that might be classified by one of the other terms have not yet even agreed on just how to categorize their writings, and perhaps never will. Nevertheless, in a brief passage that comes near the end of his book, Foucault suggests that an archeological analysis might be applied to painting itself. This analysis, he argues, would aim to show not that painting is a way of speaking or meaning without using words, but rather that it embodies discursive practice in techniques and effects, that "it is shot through . . . with the positivity of knowledge."[2]

In support of Foucault, a history of the process by which Alberti and the artists of the Renaissance developed and refined the techniques of perspective could undoubtedly be used to show that perspective is a discursive formation, an *episteme* or way of knowing comparable to the

ways of knowing generated by the sciences that began to emerge in the same period. But this is not my project. Instead, I wish to apply Foucault's theory of discursive formation to the condition of painting—and more precisely to the condition of discourse about art—at the turn of the eighteenth century in England. Consider first the *Discourses on Art* that were regularly delivered from 1769 to 1790 by Joshua Reynolds in his capacity as founder and first president of the Royal Academy. In these discourses, Reynolds sought to establish the terms in which painting in England would henceforth be conceived: not as a mechanical trade, but as a liberal art whose intellectual dignity made it worthy to rank with poetry. As Reynolds defined it, however, the "intellectual dignity" of painting depended on a vertical system that ranked paintings according to their subject matter and assigned the highest place to paintings that represented "history" in the sense of canonical narrative, whether scriptural, literary, or factual. Reynolds valued most the kind of painting that took its subject matter from "the Poet or Historian" rather than from the mind of the artist himself.[3]

As their full title indicates, Reynolds's *Discourses* constitute not a discourse *of* art but a discourse *on* art, a would-be systematic structure of statements *about* painting. If painting speaks for itself anywhere in the *Discourses,* it is only in Discourse 14, where the "powerful impression of nature" made by the landscapes of Gainsborough (Reynolds 1959, 249) threatens to undermine all that Reynolds has said about the supremacy of history painting, and where the striking sense of resemblance uncannily generated by the "unfinished manner" of Gainsborough's portraits threatens to overturn the "indispensable rule" Reynolds has formulated earlier: the rule that painting must express precisely the painter's "knowledge of the exact form which every part of nature ought to have" (164, 52). The discursive system formulated and codified by the *Discourses,* in fact, cannot accommodate a powerfully impressive painter of "unfinished" landscapes and portraits. Even after placing Gainsborough "among the very first" of the rising English School that will take its place in the history of art (248), Reynolds ends Discourse 14 by warning his students that there is no excuse for Gainsborough's defects—"want of precision and finishing"—in the painting of history, "in that style which this academy teaches, and which ought to be the object of your pursuit" (261).

The fractures and fissures discernable in the discursive formation that Reynolds left behind him strongly suggest that a new discourse—a discourse truly *of* art—was struggling to be born. It emerged with J. M. W. Turner, who began his studies at the Royal Academy in the very last year of Reynolds's presidency. Although he admired Reynolds, Turner radically revised the central premise of the *Discourses,* which is that painting of the highest kind must take its subject matter from poetry and

history, or in other words, that poetic and historical discourse should largely set the terms in which painting is judged. Turner reconstructed this premise in two ways. First, in his own lectures as professor of perspective at the Royal Academy, he repeatedly insisted that landscape painting could be "equal in power" to history painting, and that elements of landscape—such as trees—could even overpower historical figures in works that combined the two.[4] Secondly, he set out to liberate painting from anything like a filial dependence on poetry. In the notes he made about 1809 while preparing his lectures, he carefully explained the problems generated by any attempt to produce the graphic equivalent of a poetic passage, and then concluded that the painter "should be allowed or considered equal [to the poet] in his merits and having conceived his differences of method should be allowed to have produced what is exclusively his own."[5]

Why then, we may ask, were so many of Turner's pictures exhibited with lines of poetry quoted beneath their titles in exhibition catalogues? In the spring of 1798, when painters exhibiting at the Royal Academy were first allowed to put into the catalogue "descriptions" of their works, the twenty-three-year-old Turner was among the very few who quoted poetry under his titles, and the only landscape painter to do so.[6] Five of the ten oils and watercolors he exhibited in 1798 were listed with passages from Milton and Thomson, and eight more passages of poetry—including two by Turner himself—appeared beneath the titles of works he exhibited during the next two years. He kept this practice up for the rest of his life. In the course of his long career, which lasted virtually to his death in 1851, Turner linked the titles of about one-fourth of his exhibited oils to poetry of some kind, to verses either quoted from others or composed by himself.[7] Turner thus asks us to read a substantial body of his work in light of the poetry that he placed against it.

But "against" has a double meaning here. The spirit in which Turner juxtaposed so many of his paintings with lines of poetry is essentially the same as the spirit in which he stipulated that two of his paintings would permanently hang in the National Gallery "by the side of" and at the "same height from the ground" as two works by Claude.[8] Turner sets painting beside poetry to make the two compete before our eyes. When he quotes the poetry of others with the titles of his pictures, he typically prompts us to see how his pictures reconstruct the poetry and thus generate new meanings of their own. When he quotes his own verse, he displaces the literature from which painting was traditionally expected to take its subject and creates a rival text that independently authorizes the painting.

The rivalry between painting and poetry in Turner's art springs from a relentlessly contentious temperament.[9] His legendary performances on

varnishing days at the Royal Academy, when he would labor from dawn to dark on his paintings in full view of other artists, were calculated to show that he could "outwork and kill" every one of them.[10] When the young David Wilkie won acclaim with a painting called *The Village Politicians* in 1806, the first year he exhibited at the Royal Academy, Turner painted for the next year's exhibition a genre piece of his own—*A Country Blacksmith Disputing upon the Price of Iron*—and hung it beside Wilkie's *Blind Fiddler;* together with *Sun Rising Through Vapour,* which he also exhibited in 1807, the "overpowering brightness" of *A Country Blacksmith* is said to have eclipsed Wilkie's *Fiddler,* and Turner's two paintings together reportedly "'killed' every picture within range of their effects" (B&J 1984, 52). Turner thrived on emulation. Writing to a print-publisher in 1822, he proposed that a set of engravings be made from his own works to compete with the set that William Woollett had some years earlier made from four of Richard Wilson's historical landscapes. Eager to show that he could "contend with such powerful antagonists as Wilson and Woollett," he declares: "to succeed would perhaps form another epoch in the English school; and, if we fall, we fall by contending with giant strength."[11]

The giant strength with which Turner spent most of his professional life contending, however, belonged not to Wilson but to Claude. After seeing Claude's *Sacrifice to Apollo* for the first time in 1799, when he was twenty-three, Turner reportedly said that "he was both pleased and unhappy while he viewed it, it seemed to be beyond the power of imitation."[12] Yet for the rest of his long life Turner repeatedly aimed to show that he could match Claude's achievement. The seventy engravings that he commissioned and published in periodical sets from 1807 to 1819 under the title of *Liber Studiorum* were meant to exhibit a variety of "Landscape Compositions" equal in power to the sketches of Claude's *Liber Studiorum*—a graphic record of all Claude's works that had been engraved by Richard Earlom two years after Turner's birth and that appeared, like Turner's *Liber,* right up to 1819.[13] Furthermore, as I have already noted, Turner's will ensured that two of his paintings would hang permanently right by two of Claude's works in the National Gallery (B&J 1984, 96). So Turner could hardly be more explicit about his determination to make us see that he could stand—and indefinitely withstand—comparison with one of the greatest of his European precursors.

To see how Turner's lifelong insistence on measuring himself against Claude intersects with his equally persistent habit of setting painting against poetry, consider *Apullia in Search of Appulus vide Ovid* (ex. 1814, Butlin and Joll #128), which virtually repeats the composition of Claude's *Jacob with Laban and his Daughters* (repr. B&J plate 567). Although nearly forty and well-established when he painted this picture in 1814,

Turner entered it—with typical idiosyncrasy—in a competition designed by the British Institution for artists just launching their careers (B&J 1984, 92). Whether or not the rules of the competition required a painting "proper in Point of Subject and Manner to be a Companion" to a work by Poussin or Claude, as Finberg says (1961, 208–9), Turner deliberately mimics Claude in a picture about mimicry: the tree marked "Appulus" is the wild olive into which, in the *Metamorphosis,* an Apulian shepherd was turned when he mockingly imitated the dancing of nymphs (*Met.* 14. 519–28). Kathleen Nicholson argues that this picture of mimicry and mockery chastised was probably Turner's way of mocking the British Institution, which expected young artists to mimic the old masters.[14] But also embedded in Turner's picture and accentuated by its title is mockery of the old poetic master it ostensibly salutes. If we "see Ovid," as the title directs, we find in his story of the Apulian shepherd no mention of "Apullia." Turner has invented her—or plucked her from the 1709 London edition of Cesare Ripa's *Iconologia* and then graphically composed the story of her doomed quest for the dendrified Appulus.[15] Ostensibly illustrating Ovid's verbal text, Turner creates a visual text of his own. Thus, even as he mocks the expectation that modern painters should dutifully follow the example set by the old masters, he likewise subverts the traditional doctrine that painters should take their subject matter from "the Poet or Historian," in Reynolds's words (57) rather than inventing it themselves.

Turner's challenge to the authority of poetry actually begins with the very first of his poetic quotations. Because all of the poetry he quoted with the pictures he exhibited in 1798–99 stresses atmospheric effects, Jerrold Ziff says that what he quoted in those years was "the verbal equivalent" of what he painted (1982, 8). But consider the relation between *Buttermere Lake* and the verses he linked to it in the exhibition of 1798. For *Buttermere* he quoted the phrases I have underlined in this passage from Thomson's *Seasons:*

> Thus all day long the full-distended clouds
> Indulge their genial stores, and well-showered earth
> Is deep enriched with vegetable life;
> <u>Till in the western sky the downward sun</u>
> <u>Looks out effulgent</u> from amid the flush
> Of broken clouds, gay-shifting to his beam.
> <u>The rapid radiance instantaneous strikes</u>
> <u>The illumined mountains,</u> through the forest streams,
> Shakes on the floods, and in a yellow mist,
> Far smoking o'er the interminable plain,
> In twinkling myriads lights the dewy gems. . . .
> Meantime, refracted from yon eastern cloud,
> Bestriding earth, <u>the grand ethereal bow</u>

> Shoots up immense; and every hue unfolds,
> In fair proportion running from the red
> To where the violet fades into the sky.
> Here awful Newton, the dissolving clouds
> Form, fronting on the sun, thy showery prism;
> And to the sage-instructed eye unfold
> The various twine of light, by thee disclosed
> From the white mingling maze.[16]

Like Thomson's passage, Turner's painting represents radiance, mist, an illuminated mountain, and a rainbow. But Turner's rainbow differs radically from Thomson's, which—as we learn from the full passage—is explicitly Newtonian. As a true product of the Enlightenment, it no longer signifies the Covenant in which God promised never again to flood the earth (Gen. 9:12–17). Although this typological meaning is pointedly recalled in *Paradise Lost,* one of Thomson's sources,[17] Thomson treats the rainbow as a purely scientific phenomenon. It has become the property of Newton—"*thy* showery prism," in Thomson's apostrophe to him—because Newton explained in his *Opticks* (1704) how the white light of the sun is broken up or refracted into various colors as it passes through moisture. To the "sage-instructed eye," the rainbow is no longer an object of wonder, a "white mingling maze." Unfolding "every hue," it is neatly divided into the seven colors of the spectrum from red to violet. In William Kent's illustration for the 1730 edition of *Spring,* the rainbow appears as a broad ribbon subdivided into narrow, well-defined bands of light and dark. Working in black and white, the engraver shows what Thomson does to the rainbow: he makes it a sign of Newton's analytic power.

Turner's rainbow is altogether different. Although he quotes Thomson's phrase "every hue unfolds," he depicts only the upper end of the spectrum, where delicate strands of yellow are interwoven with various degrees of white. While Thomson's rainbow runs in "fair proportion . . . from the red / To where the violet fades into the sky," this early picture already begins to reveal what Norman Bryson finds in Turner's later work: an *"absence of the gamut"* in the rendering of light and color, with enhanced discrimination of the extremes.[18] Turner's bow is an arc of light set between wedges of shadow that are nearly black. Primordial in its structure as well as in the simplicity of its coloring, the arc of the bow is extended by its reflection in the water, so that the two figures in the fishing boat seem to be caught in an uncompleted circle of light. Turner thus subtly revives the biblical typology that Thomson suppresses. The fishing boat prefigures the ark that will later play such a conspicuous part in *Light and Colour: Morning after the Deluge,* and the arc of light itself prefigures the full circle that encloses the later work. In the words Turner quoted from Akenside's *Pleasures of Imagination* at the end of his first

lecture at the Royal Academy in 1811, *Buttermere* shows how the artist draws from "matter's mouldering structures, the pure forms / Of Triangle, or Circle, Cube, or Cone."[19]

To see further how the pictures Turner exhibited in 1798 resist appropriation by the poetry he linked to them, compare the watercolor called *Norham Castle on the Tweed, Summer's Morn* with the lines Turner quoted from this passage of Thomson's "Summer":

> *But yonder comes the powerful King of Day,*
> *Rejoicing in the East: the lessening cloud,*
> *The kindling azure, and the mountain's brow*
> *Illumed* with fluid gold, *his near approach*
> *Betoken glad.* Lo! now, apparent all,
> Aslant the dew-bright earth and coloured air,
> He looks in boundless majesty abroad,
> And sheds the shining day, that burnished plays
> On rocks, and hills, and towers, and wandering streams
> High-gleaming from afar.
>
> (81–90)

For *Norham Castle* Turner quoted just the lines I have italicized and in the fourth line he squeezed "Illumed with fluid gold" down to the one word "Illumin'd." What struck him most in the passage was clearly Thomson's evocation of light spreading everywhere and transforming everything it touched. Yet in the watercolor—insofar as I can judge from a black-and-white reproduction of it (I haven't seen the original, which is in Bedford, England)—light contends with considerable shadow. In the castled cliff that dominates the background and partially occludes the sun rising behind it, Turner establishes a powerful blocking agent that casts its heavy shadow on the river. Some things emerge from this shadow, such as the house and the rock on the left, but except for them and the watery circle of reflected light in the center, the lower half of the picture is wrapped in darkness.

Turner must have known that what he produced was hardly the equivalent of Thomson's passage. While Thomson enumerates a variety of objects touched by light, Turner concentrates on the light of the sky and its reflection in the water. Some years later, in a lecture that he first delivered at the Royal Academy in 1812, he specifically cited Thomson's passage as an example of poetry that could not be made to form a pictorial whole. "The lessening cloud," he said, "displays the most elevated power of delineation; and the kindling azure resembles Shakespeare's beautiful ballad that fancy, when established, dies." (He's thinking of "Tell me where is fancy bred" from *The Merchant of Venice* 3.2: "It is engendered in the eyes, / With gazing fed, and fancy dies / In the cradle where it lies.") "The difficulty," Turner continues, "is the poetic truth: the towers

and hills and streams high gleaming from afar admit the means of pro-
ducing a picture; [but only] by evading the superior elegance and truth
of the foregoing lines and [sic] create a picture of *Morning*."[20]

Turner greatly admires Thomson's poetry, and he expresses his admira-
tion with a literary sensitivity that is too often overlooked. But what
fascinates him most is Thomson's representation of visible objects as both
revealed and consumed by light: the lessening cloud and the kindling
azure. Significantly, Turner ignores Thomson's regal metaphor for the
sun—"the powerful King of Day" as well as the anthropomorphism of
the whole passage. What he finds in Thomson's lines, or interpretively
distills from them, is "the utmost purity of glowing colour" (Gage 1969,
201): a purity that would be evaded or compromised by a picture materi-
ally furnished with rocks, hills, towers, and wandering streams. In linking
Thomson's lines to the 1798 *Norham Castle,* Turner must have felt the
disparity between Thomson's purity and the solidity of his own shadowed
forms. Yet he was beginning to find his own way of representing the power
of light. By setting a dark, mounded castle against a rising sun whose
rays filter through the castle windows, he establishes the permeable mate-
riality that light must overcome.

Over the next fifty years, Turner produced more than fifteen versions of
Norham Castle in various media, culminating in the oil known as *Norham
Castle, Sunrise,* now dated to the late 1840s.[21] By this time Turner had
radically purified his conception of his subject. In the 1798 watercolor,
he gives us not only the castle but a number of other details: a line of
hills in the distance, a wooded hill at left with a white cottage on the
shore, a rowboat by the cottage, a sailboat drifting under the castle, a
group of three cows drinking in the center foreground, and at right a
rocky bank with more cows on it. In the late oil version, most of these
details have disappeared. We no longer see with any certainty the hills in
the background, the cottage, the sailboat, the rowboat, the rocky banks,
or even the castle itself, which has become virtually indistinguishable
from the blocky blue mass on which it rests in the middle distance. The
cows at right have also disappeared, and the three in the center have
dwindled to one. What remains are chiefly light and color, which efface
or transform everything they touch. The deep shadows of the earlier
version have given way to reflections—most especially the reflection of
the sun, whose yellow light shining from above and behind the castle is
repeated in the yellow rays that reach to the bottom of the picture. Unlike
Thomson's "shining day, that burnished plays / On rocks, and hills, and
towers," the light is no longer scattered, no longer distributed to a variety
of separate objects picked out of the shadows, but is rather diffused and
pervasive. The only distinguishable object left in the foreground is a single

cow whose attenuated form is designed to signify not so much the cow itself as—in Hazlitt's words—"the medium through which [it] is seen."[22]

Because the late *Norham Castle* was never exhibited, let alone exhibited with lines from Thomson, we cannot be sure just how much Turner meant it to compete with Thomson's sunrise, or whether—in the last years of his life—he was any longer thinking of Thomson at all. But if we turn from the late 1840s back to the late 1790s, we find him repeatedly testing the power of painting against the poetry he quotes, and then—in 1800—starting to use verses of his own. Turner's verses have generally provoked reactions ranging from condescension to contempt. "Not particularly brilliant," which is what Ruskin called one piece of Turner's verse (B&J 1984, 100), is about the most generous assessment that any piece of Turner's verse has ever received. So far from being great poetry, Turner's verses are not even—in any obvious way—distinctively ekphrastic. He could powerfully describe the work of other painters, as when he salutes the "veil of matchless colour" that Rembrandt displays in *The Mill:* "that lucid interval of Morning dawn and dewy light on which the Eye dwells so completely enthrall'd" that it dares not "pierce the mystic shell of colour in search of form" (Ziff 1963, 145). But Turner never wrote this way about his own art. The verses he linked to *Slavers throwing Overboard the Dead and Dying,* for instance, are not nearly so vivid and evocative as Ruskin's prose account of "its thin masts written upon the sky, in lines of blood, girded with condemnation in that fearful hue which signs the sky with horror" (B&J 1984, 236). Yet Ruskin's declamatory prose threatens to displace the painting itself, which may partly explain why he sold it after owning it for twenty-eight years.[23] With language as fiery and tumid as Ruskin's, who needs pigment? By contrast, Turner's verses must be read beside the paintings to which he linked them. They serve us only insofar as they help us to understand the discourse of his art.

When Turner first linked an exhibited picture to verses of his own in 1800, he identified a political meaning that had been latent in his work up to then. As Jerrold Ziff has noted, all the passages he quoted with the pictures he exhibited in 1798–99 stress atmospheric moments (1982, 8). For pictures such as *Norham Castle* of 1798 and *Caernarvon Castle* of 1799, the verses Turner quotes make no mention of the castle, which plays—or at first sight seems to play—a purely formal role in blocking or framing the light. For *Caernarvon Castle,* for instance, Turner quotes David Mallet's description of the setting sun hovering "o'er this nether firmament, / Whose broad cerulean mirror, calmly bright, / Gave back his beamy visage to the sky / With splendor undiminish'd."[24] Turner's watercolor seems to illustrate these lines perfectly, representing the reflection of the orange sunset with a brilliance that "evokes," as Wilton

notes, "the heroic sunset harbors of Claude Lorrain" (Wilton 1980, 57).
But in this picture as in the 1798 *Norham Castle,* the sun and its reflection
are confronted by the castle and its shadow, and the latent political mean-
ing of this confrontation becomes manifest in the verses he wrote for
Doldabern Castle in 1800:

> How awful is the silence of the waste,
> Where nature lifts her mountains to the sky.
> Majestic solitude, behold the tower
> Where hopeless Owen, long imprison'd pin'd.
> And wrung his hands for liberty, in vain.[25]

Here the verses clearly elicit the political meaning of the picture, which
represents the mountains as a vast shadowy enclosure dwarfing the figures
in the foreground. Sublime in its darkness and isolation, forbiddingly
steep and thus blocking any attempt to see beyond it, to liberate the eye,
the massive enclosure is a like a dungeon sited beneath the tower where
Owen was imprisoned.

When Turner links his exhibited pictures to verses of his own, then,
he is no longer seeking simply to show that he can rival in his own art a
specimen of poetry, that his images can hold their own against someone
else's words. Emulation now becomes appropriation. Seizing the role of
poet, appropriating the art from which the painter was traditionally urged
to take his subject matter, Turner makes words serve images by exposing
their latent meaning and thus revealing their power. Viewed in light of the
verses that Turner wrote for it, *Doldabern* decisively refutes Burke's
contention that painting cannot match the sublimity of poetry because
description will always be more obscure—hence more evocative—than
depiction.[26] (Burke 60–63). Challenging the exclusionary claims made
for the sublimity of words, Turner's verses let us see the sublimity of
his picture.

Turner's challenge to the supremacy of poetic discourse becomes still
more explicit in *The Garreteer's Petition,* which he linked with these
verses of his own:

> Aid me, ye Powers! O bid my thoughts to roll
> In quick succession, animate my soul;
> Descend, my Muse, and every thought refine,
> And finish well my long, my *long-sought* line.
>
> (B&J 1984, 71)

Instead of taking his subject or seeking his inspiration from a poem,
Turner writes words *for* the poet in his picture, a poet who needs inspira-
tion and who ends his request with a phrase that could apply just as well
to a graphic composition as to a verbal one: "finish well my long, my

long-sought line." In articulating the garreteer's petition, in saying just what he is asking for, Turner also prompts us to see that this picture represents painting and poetry as equally entangled in derivation. The picture itself has several sources. Its subject comes from Hogarth's engraving, *The Distressed Poet* (1736–37), which shows a man struggling to write in a cluttered, crowded room; scratching his head and clutching his pen in midair, he illustrates the hopeless quest for inspiration described in the lines from Pope's *Dunciad* (1. 111) that served as a caption for the engraving: "Studious he sate, with all his books around, / Sinking from thought to thought, a vast profound! / Plung'd for his sense, but found no bottom there; / Then writ, and flounder'd on, in mere despair" (*Dunciad* 1. 111–14). Butlin and Joll say that Turner's picture "somewhat ennobles" its Hogarthian source, and it does indeed remove some of Hogarth's clutter as well as reduce the figures to just one man engaged in solemn invocation. But the would-be poet sits in a glow of light surrounded by the Rembrandtian gloom of a humble interior derived—at least in part— from the genre paintings of Wilkie, whom Turner had already begun to emulate in *A Country Blacksmith*. These obviously derivative graphic features of the *Petition* reinforce the garreteer's dependence on a variety of literary sources: he holds a pamphlet in an outstretched hand, rests an elbow on a pile of books, and sits beside a tub of further publications that he will use to make up his poem: the "Translations &c.," "Hints for an Epic Poem," and "Coll. of Odds and Ends"—as Turner calls them in a note on a sketch for the picture (B&J 1984, 71). Altogether, then, the poet of this picture is no more original than the amateur artist of the picture that Turner apparently conceived to accompany it, though he made only a sketch of a figure working with what he calls in an inscription "stolen hints from celebrated Pictures."[27]

A further challenge to the cultural supremacy of poetry in the picture is that Turner may be wryly representing himself as a poet-in-hiding, asking for the inspiration with which to write the poem that he would shortly begin to quote in exhibition catalogues: *The Fallacies of Hope*.[28] Yet the verbal ambiguity of the garreteer's appeal, with its exhortation to finish a line that may be graphic or literary, anticipates the visual ambiguity of another writing figure who appears many years later in one of Turner's most celebrated works: *Light and Colour (Goethe's Theory)— The Morning After the Deluge—Moses Writing the Book of Genesis*.

W. J. T. Mitchell views this picture as both "a history painting that reflects on the writing of history, and an abstract study in visual phenomena that reflects on the science of vision."[29] As its full title indicates, the painting has three subjects: light and color, a biblical event, and the verbal representation of that event. Since our ultimate source for the story of the deluge is the Book of Genesis, Turner makes the author of that book

an integral part of the event itself. Yet in spite of this apparent homage to writing—to the poetry of Scripture—Turner checks the flow of authority from author to painter, from word to image. The very name "Moses" calls verbal authority into question, for as Lawrence Gowing notes, it evokes not only the author of Genesis but also an eighteenth-century color theorist named Moses Harris, who devised a color circle that Turner revised drastically while developing his own color theory.[30] In this picture, therefore, the figure holding what could be a pen or paintbrush and placed just above a doubly turned serpent can signify the author of Genesis or Turner himself, the prophet who re-writes Scripture in color and light. And also in his own words. Instead of quoting Scripture as his source in the exhibition catalogue, he quoted from his own *Fallacies of Hope:*

> The ark stood firm on Ararat; th' returning Sun
> Exhaled earth's humid bubbles, and emulous of light,
> Reflected her lost forms, each in prismatic guise
> Hope's harbinger, ephemeral as the summer fly
> Which rises, flits, expands, and dies.
>
> (B&J 1984, 253)

Verbally as well as graphically, Turner writes a language of light, color, and emulation. "Emulous" of the sun's primordial light, earth's humid bubbles reflect her lost forms even as Turner—a painter emulous of Scripture's poetic light—reflects them on the prismatic vortex of his canvas. Each bubble-head thrown up by the receding waters at lower right is ephemeral, caught up in the swirl of the vortex, but the ark stands firm, and like it the painter holds firm, fixing his mosaic surrogate just above the center of the canvas—the still point of the turning wheel.

If Turner could reconstruct Scripture in his painting, implicitly representing himself as a prophet writing in pigment, he was equally revisionary in his treatment of the other main source on which "history painting" traditionally drew: classical epic. His most remarkable response to classical epic is his lifelong rewriting of Virgil's *Aeneid:* a project that begins with the unexhibited *Aeneas and the Sibyl* of about 1798 and continues right up to 1850, when the very last group of works he exhibited at the Royal Academy included no less than four paintings of Aeneas's sojourn with Dido.

Turner rewrote Virgil not just figuratively in paint but literally in words. Whenever he exhibited pictures of Aeneas or Dido with verse, the verse was his own, and one of his last four pictures of the pair represents an event that Turner simply imagined with no authorization from Virgil. In *The Visit to the Tomb,* Aeneas and Dido visit the tomb of her late husband while—in Turner's line—"the sun went down in wrath at such deceit."[31]

As his source for the line that he linked to this picture, Turner cited *The Fallacies of Hope,* a manuscript poem of his own that he first cited in 1812 with the verses he linked to *Hannibal and his Army Crossing the Alps.*[32] Two things about *The Fallacies* are notable. One is that from the very beginning, Turner cited it in place of the classical, canonized texts we would expect him to cite—such as Livy for the Hannibal picture or Virgil for any picture of Dido and Aeneas. The other notable thing is that Turner's poem exists only in the passages he "quoted" from it. While some of these passages look genuinely fragmentary—they occasionally begin with words such as "or"—we have no access to the whole. Turner's *Fallacies* was in fact a mental construct, an *imaginary* source created to displace and supersede the canonical ones. This is nowhere more evident than in the verses he linked to the second of the two great Carthaginian pictures with which he aimed to rival Claude: *Dido Building Carthage* and *The Decline of the Carthaginian Empire.*

Originally willed to be hung on either side of Claude's *Seaport,* these two pictures also ask to be set beside Virgil's epic. The full title of the first, in fact, is *Dido Building Carthage; or the Rise of the Carthaginian Empire—1st Book of Virgil's Aeneid.* To set this picture beside the *Aeneid* is to see the picture as a profoundly ironic commentary on the empire building that Virgil's whole poem is calculated to glorify and justify. As Karl Kroeber has noted, *Dido Building Carthage* reenacts the creation of Carthage in terms of a literary work written long after the city was destroyed and in celebration of an Imperial Rome that was itself destroyed long before Turner painted his picture.[33] *The Decline* completes this ironic commentary on Virgil's poem, which adumbrates the fall of Carthage when the abandoned Dido calls for endless war between her race and Aeneas's (4.610–30), but which can hardly suggest what the fall of Carthage itself might come to adumbrate. By contrast, the title of Turner's picture—*The Decline of the Carthaginian Empire*—is at once echoic and prophetic. Echoing Gibbons's title, it makes the decline and fall of Carthage prefigure the decline and fall of Rome, and beyond that the ultimate decline of all empires—including the one that Britain herself was building at the very time this picture was first exhibited.

To see just how Turner creates his own vision of Carthage in this picture, we need its elaborately full subtitle as well as the verses he wrote to accompany it. The subtitle defines the historical context of the moment depicted: *Rome being determined on the overthrow of her hated rival, demanded from her such terms as might either force her into war or ruin her by compliance: the enervated Carthaginians, in their anxiety for peace, consented to give up even their arms and their children.* Using these historical circumstances, Turner's verses define the moral meaning of the sunset in the picture:

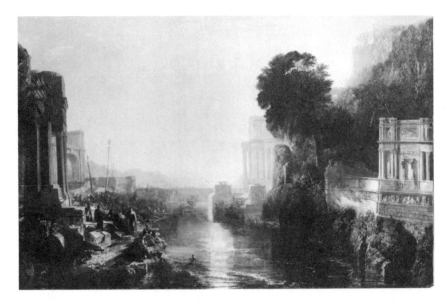

J. M. W. Turner. *Dido Building Carthage*, 1815. (London, National Gallery.)

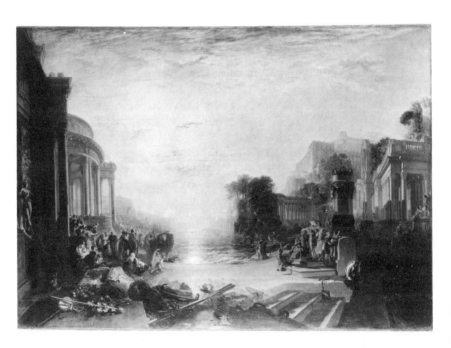

J. M. W. Turner. *Decline of the Carthaginian Empire*, *ex.* 1817. (The Tate Gallery.)

At Hope's delusive smile,
The chieftain's safety and the mother's pride,
Were to the insidious conqu'ror's grasp resigned;
While o'er the western wave th'ensanguin'd sun,
In gathering haze a stormy signal spread,
And set portentous.

(B&J 1984, 100)

Although title and verses together seem to overdetermine the meaning of the picture, it can hardly be said to illustrate the words that accompany it, for it does not show us the Carthaginians giving up their arms and children to the Romans. What we do see can best be understood by comparing this picture with David's *Oath of the Horatii*.

David's picture, which Turner may well have known,[34] commemorates an oath of allegiance to Rome taken by the Horatii brothers before going into battle against their cousins, the Curiatii. But the firmly triangulated stance of the men, the brandishing of phallic swords, and the rigidly extended arms all signify an aggressive male bonding that could serve as a model for any nation threatened by Rome itself—especially since one of the precursors of David's *Oath* is a painting Turner certainly knew: Benjamin West's *Hannibal Taking the Oath*, which shows the young Carthaginian at the altar of Jupiter swearing eternal hatred of Rome at the behest of his father Hamilcar. Although no swords are raised in this picture, the outstretched arms of David's *Horatii* are anticipated by the paralleled upraised forearms of father and son and the pointing arm of the figure at lower right. Strengthening the link between these two pictures and Turner's *Decline* is the fact that Turner's picture explicitly recalls the oath of Hannibal: the architrave of the farther portico on the left is inscribed AMILCAR, and at the top of the altar on the right are the letters HANN. Thus Turner evokes a moment of Carthaginian defiance even as he shows how luxury and decadence have nearly obliterated the record of that moment.

Read against the paintings of West and David, Turner's picture clearly reveals a people ready to surrender everything to Rome. The anchor, the oar, and the flowered staff strewn across the marble steps in the foreground prefigure the casting down of swords—the antithesis of the sword brandishing in the *Horatii*. Further, the sunken, languid, flaccid poses of all the figures in Turner's picture strikingly recall the postures of the women in David's *Oath:* the women whose collapsing figures are so clearly subordinated to and overpowered by the militaristically erect men.

The acquiescence signified by the flaccidity of Turner's figures becomes still more evident when we consider the relation between the figures and the architecture that surrounds them. While *Dido Building Carthage* depicts a city in the making, this picture represents the city complete—but

Jacques Louis David. *Oath of the Horatii*, 1784. (Musée du Louvre, © photo R. M. N.)

Benjamin West. *Hannibal Taking the Oath*, 1771. (London, St. James Palace. Reproduced by gracious permission of H.M. Queen Elizabeth II.)

J. M. W. Turner. *Snowstorm: Hannibal and His Army Crossing the Alps,* **ex. 1812.** (The Tate Gallery.)

only too complete, overly finished, overripe for a fall. And in place of the strong and simple Doric columns that frame the gesture of David's militant males and reinforce their powerfully erect stances, we find elaborate cornices, ornate Corinthean capitols, and a multitude of fluted columns that seem more decorative than structural.[35] This overwrought architecture fittingly encloses a people exhausted and enervated by their own decadence, unable to stand—in any sense—against the Romans.

Reinforcing these graphic signs of imminent surrender and impending disaster, Turner's verses gloss the "ensanguin'd sun" as a stormy signal, and its setting a portent of doom. This is an overstatement. Although Turner clearly does use the setting sun to signify the decline of empire—something that had become a literary cliché by Turner's time—the delicate flush of his sunset resists any simple iconographic equation with blood and destruction.[36] Instead of the fire and blood that will later rage and burn in the sunset of *The Slavers* (1840), the setting sun of *Decline* exudes a delicately pink and yellow light that gilds the waves and turns white marble to rose. What we see in the light of this picture is not a menacing portent but the graphic irony of "Hope's delusive smile."

Decline of the Carthaginian Empire, then, is not only a pendant to *Dido Building Carthage* but a sequel to *Snowstorm: Hannibal and his Army Crossing the Alps,* with which Turner linked these verses from the *Fallacies of Hope:*

Craft, Treachery, and fraud—Salassian force.
Hung on the fainting rear! then Plunder seized
The victor and the captive,—Saguntum's spoil,
Alike, became their prey; still the chief advanc'd,
Look'd on the sun with hope:—low, broad, and wan;
While the fierce archer of the downward year
Stains Italy's blanch'd barrier with storms.
In vain each pass, ensanguin'd deep with dead,
Or rocky fragments, wide destruction roll'd.
Still on Campania's fertile plains—he thought,
But the loud breeze sob'd, "Capua's joys beware!"

(B&J 1984, 89)

Turner draws on Thomson's description of a winter sun turned "weak, wan, and broad" when—in the sequence of zodiacal signs—Saggitarius (the Centaur-Archer) yields to Capricorn "and fierce Aquarius stains the inverted year" ("Winter" 41–49). But Turner has his own way of expressing Hannibal's determination. In spite of the "fierce archer of the downward year" and all the other impediments to his progress, Hannibal advanced and "look'd on the sun with hope." Representing that hope, this picture tempts us to see the beautiful beyond the sublime: to see the sunlit plains of Campania beckoning Hannibal as he struggles to make his way around the jagged rocks hurled down upon his army, past hostile mountaineers, and through the great black Brobdignagian jaws of the snowstorm. These destructive forces work "in vain" against Hannibal's advance. But as the last words reveal, the advance itself is vain, for the sunlit plains in the distance lead only to the luxuries of Capua, where Hannibal's soldiers dissipated their energies in idleness and pleasure and thus anticipated the fatal decadence shown in the setting sun of the *Decline*.[37] It is the *Decline,* in fact, that finally reveals just how cruelly fallacious was Hannibal's hope.

Having re-created the epic story and history of Carthage in just three paintings of its rise and fall, Turner went on to demonstrate that he could rewrite a classical story in a single painting: *The Vision of Medea.* In verses for the painting that are once again said to be drawn from *Fallacies of Hope,* Turner tersely recapitulates Ovid's version of the Medea story—with one striking innovation:

Or Medea, who in the full tide of witchery
Had lured the dragon, gained her Jason's love,
Had filled the spell-bound bowl with Aeson's life,
Yet dashed it to the ground, and raised the poisonous snake
High in the jaundiced sky to wreathe its murderous coil,
Infuriate in the wreck of hope, withdrew
And in the fired palace her twin offspring threw.

J. M. W. Turner. *Vision of Medea*, **1828. (The Tate Gallery.)**

Verbally and graphically, Turner depicts Medea at the height of her rage. Like Dido, she is a woman abandoned by her lover. But unlike Dido, she turns murderous rather than suicidal, killing her own children to punish their father Jason, who has led her to sacrifice everything for him and who is now marrying another woman. Around her are graphic signs of her story. At lower right is the cave of the dragon drugged by Medea's magic so that Jason could obtain the golden fleece. At lower left is the spellbound bowl in which she rejuvenated Aeson, Jason's father, by boiling him in medicinal herbs. But also at lower left (as well as upper left) is the most conspicuous sign that Ovid's story of Medea undergoes a radical metamorphosis in this picture. In Ovid's version, which was almost certainly Turner's source, Medea flees to Athens after killing her children, marries Aegeus, and brews a cup of poison for Aegeus's son Theseus, who is saved from death only when Aegeus dashes the cup from his lips.[38] In Turner's hands, the cup of poison becomes a cup of rejuvenation that Medea herself dashes to the ground so that she—a Medea turned Medusa—can raise "the poisonous snake / High in the jaundiced sky to wreathe its murderous coil." Wielding what treacherously resembles the serpent rod of Aesculapius, god of medicine, she brandishes it over scenes of destruction. At her feet below the oversized bubbles in the center of the picture is the caldron in which she drowned Pelias after promising his daughters that she would rejuvenate him with

a boiling potion. Above, to the right of the bubbles, is the dragon-drawn chariot in which she leaves with her children; and against the cloud at upper left she stretches out her arms to fling her children down.

The points about the chariot and the tiny figure have been made by Cecelia Powell, who also reads the three women on the ground in the center of the picture as the fates, with the one at right paying out the thread, the one in the middle measuring it, and the one at left cutting it.[39] But these three women signify something more specific than fate. The many signs of Medea's past and present elsewhere in the picture authorize us to read all three women as figures in a narrative about Medea, especially since the two fair-haired women in white look like the standing figure—minus her saffron skirt. The woman lying on the ground and facing upwards, I believe, is Medea herself, telling stories of how her magic conquered the dragon on her left and rejuvenated the father of Jason. According to Ovid, Medea told these stories to the daughters of Pelias in order to make them believe that she could rejuvenate their father by boiling him in herbs. The black haired woman in the middle, therefore, is a daughter of Pelias listening to Medea's treacherous words, and to her right is Medea again, this time necromantically directing the same black-haired daughter as she boils the would-be rejuvenating potion. The murderous coil of the snake brandished by the infuriated Medea, then, is a coil of narrative circling the lives of all she has met. Like the dragons of Medea's chariot, who are (says Ovid) "sleek and shining / In Bright new skins" when they return with her from an herb-gathering journey,[40] the snake held aloft by Medea signifies a story of promised renewal and ultimate destruction. She masters the fates that she herself has impersonated, literally taking in her own hands the serpentine thread of life and death.

Emulous in all things, Turner takes into his hands the serpentine thread of narrative—the very thing that traditionally distinguishes literature from the visual arts. His picture actually exemplifies what Paul Ricoeur has written of plot: it "draws a configuration out of a simple succession," organizing events into an intelligible totality and furnishing a point of view from which the story can be perceived as forming a whole.[41] Admittedly, Turner's painting cannot tell its story unaided; we cannot read it without some reference to classical texts as well as Turner's own text. But if narrative must be absolutely self-sufficient, then any story that alludes to any other story would have to forfeit its claim to be narrative. The distinctiveness of Turner's discourse comes not from its absolute independence of verbal narrative but from the originality with which it reconstructs its literary sources—first verbally, then graphically.

One more example underscores this point. In 1837, six years after exhibiting *The Vision of Medea*, Turner showed yet another painting of a

J. M. W. Turner. *Parting of Hero and Leander—from the Greek of Musaeus*, ex. 1837. (London, National Gallery.)

classical subject accompanied by verses of his own: *The Parting of Hero and Leander—from the Greek of Musaeus*. Remarkably enough, the verses tell the story of the lovers precisely by describing—ekphrastically—what the painting depicts:

> The morning came too soon, with crimsoned blush
> Chiding the tardy night and Cynthia's warning beam;
> But love yet lingers on the terraced steep,
> Upheld young Hymen's torch and failing lamp,
> The token of departure never to return.
> Wild dashed the Hellespont its straited surge,
> And on the raised spray appeared Leander's fall.

(B&J 1984, 221)

Butlin and Joll suggest that Turner probably got the story of Hero and Leander from Francis Fawkes's translation of Musaeus's ancient poem on the ill-fated pair (221), but what Turner does with the story in the verses and his painting is something exclusively his own—and emphatically graphic. In the center of the sky in the background two luminaries strive for mastery: the rising sun and the setting moon. Because the sun and the moon cannot appear together in the same part of the sky, their conjunction here is astronomically impossible, but at the same time vividly significant. The lingering moon, which should be behind us as the sun rises before us, remains with the tardy night to signify the lovers' desire to stop time, to prolong night indefinitely, and to keep alive and

glowing the torch of Hymen—a third source of light—which hovers over them as they linger on the terraced steep: on the steps leading down to the moonlit water just below the center of the picture. But even as he represents the lovers' resistance to time, Turner reveals the inexorability of its passage. This is shown not just by the rising sun but by what appears in the "raised spray" of the "straited surge" dashed up against the rocks at lower right, where "Leander's fall" is prefigured in phantasmagoric multiple exposure. Ironically mimicking the celebratory gesture of the torch-bearing figure at center left, the upraised arms of the multiple exposure at right signify the desperation of a drowning man. Thus Turner tells the whole story of Hero and Leander in a single picture. Refusing to be unitemporal, refusing to illustrate just one moment from a story written by someone else, Turner rewrites the story himself in words and pigment, generating a narrative of his own.

Like the Carthaginian series, like the *Vision of Medea*, and like so many of Turner's other paintings of "history," *Hero and Leander* reveals Turner's deep indebtedness to poetic and historical narrative. At the same time, the verses he wrote to accompany his pictures in exhibition catalogues show him radically swerving from the literary and historical discourse of canonical texts. In displacing those texts with texts of his own, in moving from the quotation of known and established works to passages gleaned from a poem that existed solely in his mind, he creates a series of verbal pretexts for the graphic texts of his own art. The result is a kind of painting that takes its stand against poetry in a sense both juxtapositional and oppositional, generating a new discourse of art.

NOTES

1. Michel Foucault, *The Archaeology of Knowledge,* trans. A. M. Smith (London: Tavistock Publications, 1972), 186–87.

2. Ibid., 193–94.

3. Joshua Reynolds, *Discourses on Art,* ed. Robert Wark (San Marino, Calif.: Huntington Library, 1959), 43, 57. Subsequent citations are given parenthetically in the text as Reynolds 1959.

4. Jerrold Ziff, "'Backgrounds, Introduction of Architecture, and Landscape': A Lecture by J. M. W. Turner," *Journal of the Warburg and Courtauld Institute* 26 (1963): 133, 135. I should add that Professor Ziff has kindly given me the benefit of his comments on the present essay.

5. Quoted in Jerrold Ziff, "J. M. W. Turner on Poetry and Painting," *Studies in Romanticism* 3 (1964): 197.

6. Jerrold Ziff, "Turner's First Poetic Quotations: an Examination of Intentions," *Turner Studies* 2, no. 1 (Summer 1982): 2.

7. Jerrold Ziff, "William Turner's Last Four Paintings," *Artforum* 2, no. 10 (April 1964): 25.

8. Martin Butlin and Evelyn Joll, *The Paintings of J. M. W. Turner,* rev. ed. 2

vols. (New Haven and London: Yale University Press, 1984), 96—hereafter cited as B&J.

9. It also derives, of course, from the Renaissance tradition of interart disputation epitomized by Leonardo da Vinci's *Paragone*. See Jean H. Hagstrum, *The Sister Arts: The Tradition of Literary Pictorialism from Dryden to Gray* (Chicago: University of Chicago Press, 1958), 66–70; Claire Farago, *A Critical Interpretation of Leonardo da Vinci's "Paragone," with a new edition of the text in the "Codex Urbinas"* (Leiden: E. J. Brill, 1991); and James V. Mirollo, "Sibling Rivalry in the Arts Family: The Case of Poetry vs. Painting in the Italian Renaissance," in this volume.

10. Graham Reynolds, *Turner* (New York: Oxford University Press, 1969), 142.

11. *Collected Correspondence of J. M. W. Turner,* ed. John Gage (Oxford: Clarendon Press, 1980), 86–87.

12. Farington's Diary of 8 May 1799, quoted in A. J. Finberg, *The Life of J. M. W. Turner, R.A.* 2d ed. rev. by Hilda F. Finberg (Oxford: Clarendon Press, 1961), 59—hereafter cited as Finberg.

13. Andrew Wilton, *J. M. W. Turner: His Art and Life* (Secaucus, N.J.: Poplar Books, 1979), 87, 105, n. 2.

14. "Turner's 'Appulia in Search of Appulus' and the Dialectics of Landscape Tradition," *Burlington Magazine* 120 (1980), 679–84.

15. On Turner's use of Ripa see William Chubb, "Minerva Medica and the Tall Tree," *Turner Studies,* 1, no. 2 (1981): 30.

16. "Spring," l.185–212 in *The Complete Poetical Works of James Thomson,* ed. J. Logie Robertson (London: Oxford University Press, 1908). As Turner did, I deleted Thomson's comma after "sky" (l. 189) and I pluralized Thomson's "mountain" (l. 193). All further quotations of Thomson come from this edition.

17. Ralph Cohen, *The Unfolding of the Seasons* (Baltimore: Johns Hopkins University Press, 1970), 92 and *Paradise Lost* 11.879–98.

18. Bryson notes that Turner "altered the whole gamut of tonalities, so that the obvious contrasts observable by any amateur were played down, while the subtler distinctions of tonality, which one had to be Turner to see, were enhanced. There was expansion of tonality's whole middle range." "Enhancement and Displacement in Turner," *Huntington Library Quarterly* 49 (1986): 53–54.

19. British Museum Add. MS. 46151, K, f.23. Turner quotes from *The Pleasures of Imagination,* l. 137–38.

20. Quoted in John Gage, *Colour in Turner: Poetry and Truth* (New York: Praeger, 1969), 202.

21. On the date of this picture see Martin Butlin, "Turner's Late Unfinished Oils: Some New Evidence for their Late Date," *Turner Studies* 1, no. 2 (Winter 1981): 43–45.

22. *Complete Works of William Hazlitt,* ed. P. P. Howe. 21 vols. (London and Toronto: J. M. Dent & Sons, 1930–34), 4: 76n. For a full discussion of Hazlitt's comment, see my *The Re-Creation of Landscape* (Hanover, N.H.: University Press of New England, 1985), 163–69.

23. B&J, text, 236. Ruskin's account of *Slavers* was "a favorite piece of declamation by William Morris during his Oxford days." See *The Sunset Ship: The Poems of J. M. W. Turner,* ed. Jack Lindsay (Lowestoft, Suffolk: Scorpion Press, 1966), 26.

24. From "Amyntor and Theodora," by David Mallet (1705–65), quoted by Wilton, *J. M. W. Turner,* 328. Wilton reproduces the 1799 *Caernarvon Castle* (private collection) on p. 53.

25. B&J text, 10. Lynn Matteson has suggested that Turner may be imitating Thomas Gray's *The Bard* (1757), which he specifically evokes in the lines he wrote for the *Caernarvon Castle* that he exhibited in 1800 ("And now on Arvon's haughty tow'rs / The Bard the song of pity pours"); see "The Poetics and Politics of Alpine Passage: Turner's *Snow-storm: Hannibal and his Army Crossing the Alps*," *Art Bulletin* 62 (1980): 385–98, and also Andrew Wilton, *Painting and Poetry: Turner's 'Verse Book' and his Work of 1804–1812* (London: Tate Gallery, 1990), 22, 115. But while Gray's poem voices the rage of the last Welsh poet doomed to extinction by the army of Edward I, Turner's lines express a somber pity.

I should add that Wilton's *Painting and Poetry,* which came to my attention after this essay was written, is an important contribution to our understanding of what Turner read and wrote.

26. Burke, *A Philosophical Enquiry into the Origin of our Ideas of the Sublime and Beautiful,* ed. James T. Boulton (Notre Dame, Ind.: University of Notre Dame Press, 1968), 60–63.

27. Quoted by Andrew Wilton, *Turner and the Sublime* (London: British Museum Publications, 1980), 140.

28. Turner actually published—in his own fashion—three samples of his verse in 1809. Besides the verses he wrote for *The Garreteer's Petition,* which appeared at the Royal Academy, he also wrote lines for two other oils exhibited at his own gallery: eight pentameter quatrains for *Thomson's Aeolian Harp,* and three pentameter couplets for *London.* See Wilton, *Painting and Poetry,* 134–35.

29. Mitchell, "Metamorphoses of the Vortex: Hogarth, Turner, and Blake," in *Articulate Images: The Sister Arts from Hogarth to Tennyson,* ed. Richard Wendorf (Minnesota: University of Minnesota Press, 1983), 146.

30. See Gowing, *Turner: Imagination and Reality* (New York: Museum of Modern Art, 1966), 23.

31. Quoted B&J text, 275. The deceit is twofold. By visiting the tomb, Aeneas and Dido together pretend that she will keep her vow of fidelity to Sychaeus, and at the same time, Aeneas deceives Dido about his intention to abandon her—an act that will lead Dido to the fiery end prefigured by the setting sun.

32. Turner's title may derive from John Langhorne's *Visions of Fancy,* which includes the phrase "Fallacious Hope"; see Jerrold Ziff, "John Langhorne and Turner's "Fallacies of Hope," *Journal of the Warburg and Courtauld Institutes* 27 (1964): 340–42. But in any case, as Wilton argues (*Painting and Poetry,* 62–63), Turner's title plainly reflects the well-established eighteenth-century notion that insofar as hope focuses on material ends, it may delude and deceive. Behind *The Fallacies of Hope* stands not only Langhorne's poem but also works such as Samuel Johnson's *Vanity of Human Wishes.*

33. Karl Kroeber, "Experience as History: Shelley's Venice, Turner's Carthage." *ELH* 41 (1974): 325.

34. He visited David's studio during his sojourn in Paris in 1802; see Gage, *Colour in Turner,* 100.

35. The human and more precisely sexual significance of the classical architectural orders was a theme Turner drew from his reading of Henry Wotton's *Elements of Architecture* (first published 1624) and developed in verses of 1805–10 as well as in lecture notes of 1811, where he speaks of "Ionice softness Dorice simplicity and Corninthian magnificence." The verses describe the Ionic capital as a "meretricious courtezan" and the Corinthian as "mature and Chaste" but liable to corruption

> like the damsel out of place
> Who fears the thought of bursting lace
> Her full blown beauties float around
> Acanthus leaves and budding horns abound
> With great display above below
> Placed any where . . . to make a show

See Wilton, *Painting and Poetry,* 30–33, 150.

36. On the sunset cliché see Jerrold Ziff, "Turner as Defender of the Art between 1810–20," *Turner Studies* 8, no. 2 (Winter 1988): 22. On Turner's "ensanguin'd" see Ruskin: "The scarlet of the clouds was [Turner's] symbol of destruction. In his mind it was the color of blood. So he used it in the Fall of Carthage. Note his own written words." *Modern Painters* 5, quoted B&J text, 100.

37. Capua, writes Livy, was "destructive of military discipline, through allurements of every kind of pleasure." *The History of Rome,* trans. George Baker, 6 vols. (London: Strahan, 1797), 2:147, cited by Carl Woodring, *Nature into Art: Cultural Transformations in Nineteenth-Century Britain* (Cambridge: Harvard University Press, 1989), 72–74.

38. Turner owned Robert Anderson's thirteen-volume anthology, *British Poets* (1795), which includes (in vol. 6) excerpts from Dryden's translation of the *Metamorphoses;* see Wilton, *Painting and Poetry,* 113. But the story of Medea (from book 7 of the poem) is not among these excerpts, and I do not know which translation he used.

39. See Cecilia Powell, "'Infuriate in the wreck of hope': Turner's 'Vision of Medea,'" *Turner Studies* 2, no. 1 (Summer 1982): 15.

40. Ovid, *Metamorphoses,* trans. Rolfe Humphries (Bloomington: Indiana University Press, 1955), 7.235.

41. Paul Ricoeur, *Time and Narrative,* trans. Kathleen McLaughlin and David Pellauer. 3 vols. (Chicago: University of Chicago Press, 1983–89) 1:65–67.

WORKS CITED

Akenside, Mark. *The Pleasures of Imagination.* London, 1765.

Bryson, Norman. "Enhancement and Displacement in Turner." *Huntington Library Quarterly* 49 (1986): 53–54.

Butlin, Martin. "Turner's Late Unfinished Oils: Some New Evidence for their Late Date." *Turner Studies* 1, no. 2 (Winter 1981): 43–45.

Butlin, Martin, and Evelyn Joll. *The Paintings of J. M. W. Turner.* New Haven and London: Yale University Press, 1984.

Chubb, William. "Minerva Medica and the Tall Tree." *Turner Studies* 1, no. 2 (1981): 30.

Cohen, Ralph. *The Unfolding of the Seasons.* Baltimore: Johns Hopkins University Press, 1970.

Farago, Claire. *A Critical Interpretation of Leonardo da Vinci's "Paragone," with a new edition of the text in the "Codex Urbinas".* Leiden: E. J. Brill, 1991.

Finberg, A. J. *The Life of J. M. W. Turner, R.A.* 2d ed. Revised by Hilda F. Finberg. Oxford: Clarendon Press, 1961.

Gage, John. *Collected Correspondence of J. M. W. Turner.* Oxford: Clarendon Press, 1980.

———. *Colour in Turner: Poetry and Truth.* New York: Praeger, 1969.

Gowing, Lawrence. *Turner: Imagination and Reality.* New York: Museum of Modern Art, 1966.

Hagstrum, Jean H. *The Sister Arts: The Tradition of Literary Pictorialism from Dryden to Gray.* Chicago: University of Chicago Press, 1958.

Heffernan, James A. W. *The Re-Creation of Landscape.* Hanover, N.H.: University Press of New England, 1985.

Howe, P. P., ed. *Complete Works of William Hazlitt.* London and Toronto: J. M. Dent & Sons, 1930–34.

Humphries, Rolfe, trans. *Ovid: Metamorphoses.* Bloomington: Indiana University Press, 1955.

Kroeber, Karl. "Experience as History: Shelley's Venice, Turner's Carthage," *ELH,* vol. 41 (1974).

Lindsay, Jack, ed. *The Sunset Ship: The Poems of J. M. W. Turner.* Lowestoft, Suffolk: Scorpion Press, 1966.

McLaughlin, Kathleen, and David Pellauer, trans. *Time and Narrative.* Chicago: University of Chicago Press, 1983–89.

Matteson, Lynn. "The Poetics and Politics of Alpine Passage: Turner's *Snowstorm: Hannibal and his Army Crossing the Alps.*" *Art Bulletin* 62 (1980): 385–98.

Mirollo, James V. "Sibling Rivalry in the Arts Family: The Case of Poetry vs. Painting in the Italian Renaissance." In this volume.

Nicholson, Kathleen. "Turner's 'Apulia in Search of Appulus' and the Dialectics of Landscape Tradition." *Burlington Magazine* 120 (1980): 679–84.

Powell, Cecilia. "'Infuriate in the wreck of hope': Turner's 'Vision of Medea.'" *Turner Studies* 2, no. 1 (Summer 1982): 15.

Reynolds, Graham. *Turner.* New York: Oxford University Press, 1969.

Reynolds, Joshua. *Discourses on Art.* Edited by Robert Work. San Marino, Calif.: Huntington Library, 1959.

Robertson, J. Logie, ed. "Spring." *The Complete Poetical Works of James Thomson.* London: Oxford University Press, 1908.

Wilton, Andrew. *J. M. W. Turner: His Art and Life.* Secaucus, N.J.: Poplar Books, 1979.

———. *Painting and Poetry: Turner's 'Verse Book' and his Work of 1804–1812.* London: Tate Gallery, 1990.

———. *Turner and the Sublime.* London: British Museum Publications, 1980.

Woodring, Carl. *Nature into Art: Cultural Transformations in Nineteenth-Century Britain.* Cambridge: Harvard University Press, 1989.

Ziff, Jerrold. "'Backgrounds, Introduction of Architecture, and Landscape': A Lecture by J. M. W. Turner." *Journal of the Warburg and Courtauld Institute* 26 (1963): 124–47.

———. "John Langhorne and Turner's 'Fallacies of Hope.'" *Journal of the Warburg and Courtauld Institutes,* vol. 27 (1964).

———. "J. M. W. Turner on Poetry and Painting." *Studies in Romanticism* 3 (1964): 193–215.

————. "Turner as Defender of the Art between 1810–20." *Turner Studies* 8, no. 1 (Winter 1988): 22

————. "Turner's First Poetic Quotations: an Examination of Intentions." *Turner Studies* 2, no. 1 (Summer 1982): 2

————. "William Turner's Last Four Paintings." *Artforum* 2, no. 10 (April 1964): 25.

Part II
The Book as the Material Text

The Fragmentation of Visionary Iconography in Chaucer's *House of Fame* and the *Cloisters Apocalypse*

ROBERT BOENIG

The fourteenth-century English illuminated manuscript now known as the *Cloisters Apocalypse*[1] and Chaucer's roughly contemporaneous *House of Fame*[2] both depict the Day of Judgment, one the biblical event capping off all history in a riot of grotesque imagery and theological allegory, the other a parody of the first, in which the Goddess Fame, no less grotesque than St. John's visionary beasts and monsters, dispenses her own madcap version of judgment.[3] I have elsewhere explicated the connections between Chaucer's poem and St. John's vision[4]; now I wish to narrow my focus by examining the similar ways a literary and a visual artist use and therefore interpret apocalyptic imagery. Both Chaucer and the anonymous Cloisters-Artist select, rearrange, and fragment the biblical text in their attempts to reinvest it with meaning for their own audiences. Their fragmentation of apocalyptic iconography moreover has, I would argue, interesting implications for literary and iconological theory.

On folio 5v of the *Cloisters Apocalypse,* St. John stands in the frame of a large miniature depicting, even dwarfing, the text of Apocalypse 4:1–8, holding his book and peering through a shuttered window on the dramatic events occurring within:

> Then, in my vision, I saw a door open in heaven and heard the same voice speaking to me, the voice like a trumpet, saying, "Come up here: I will show you what is to come in the future." With that, the Spirit possessed me and I saw a throne standing in heaven, and the One who was sitting on the throne, and the Person sitting there looked like a diamond and a ruby. There was a rainbow encircling the throne, and this looked like an emerald. Round the throne in a circle were twenty-four thrones, and on them I saw twenty-four elders sitting dressed in white robes with golden crowns on their heads. Flashes of lightening were coming from the throne, and the sound of peals of thunder, and in front of the throne there were seven flaming lamps burning, the seven Spirits of God. Between the throne and myself was a sea that seemed to be made of glass, like crystal. In the centre, grouped round the throne itself, were

181

Cloisters Apocalypse, **folio 5v. (The Metropolitan Museum of Art, The Cloisters Collection, 1968.)**

four animals with many eyes, in front and behind. The first animal was like a lion, the second like a bull, the third animal had a human face, and the fourth animal was like a flying eagle. Each of the four animals had six wings and had eyes all the way round as well as inside; and day and night they never stopped singing: "Holy, Holy, Holy is the Lord God, the Almighty; he was, he is and he is to come."[5]

Chaucer's poem shares some of the same iconography with this miniature from the *Cloisters Apocalypse,* as we see by scanning it while reading passages from the poem. In the central mandorla, we see the glorified Christ enthroned among the lamps that represent the Seven Churches of Asia (see Apoc., chaps. 2 and 3), holding in his left hand the seven-sealed book of judgment. Left here is perhaps significant, a detail left out of the prior apocalyptic text the artist is illuminating, for as Christ's *sinister* hand, it is the direction he will send the damned "goats" of Matthew 25:33.

In Chaucer's poem, of course, the central figure is Lady Fame, who passes judgment on groups of suppliants who come before her throne. Chaucer is explicit about her apocalyptic connections:

> But in this lusty and ryche place,
> That Fames halle called was,
> . . . al on hye, above a dees,
> Sitte in a see imperiall . . .
> Y saugh, perpetually ystalled
> A femynyne creature,
> That never formed by Nature
> Nas such another thing yseye.
> For alther-first, soth for to seye,
> Me thoughte that she was so lyte
> That the lengthe of a cubite
> Was lengere than she semed be.
> But thus sone, in a whyle, she
> Hir tho so wonderliche streighte
> That with hir fet she erthe reighte,
> And with hir hed she touched hevene,
> Ther as shynen sterres sevene.
> And therto eke, as to my wit
> I saugh a gretter wonder yit,
> Upon her eyen to beholde;
> But certeyn y hem never tolde.
> For as feele eyen hadde she
> As fetheres upon foules be,
> Or weren on the bestes foure
> That Goddis trone gunne honoure,
> As John writ in th'Apocalips.

(1356–57, 60–61, 64–85)

The apocalyptic details are all here—except for the musical instruments the Cloisters-artist adds to the apocalyptic text—but they are arranged oddly, almost as if Chaucer had cut them out and put the fragments together in the wrong way. The diamond, ruby, and emerald diminish to just a ruby and its alternate name, carbuncle; the eyes that belong to the four beasts now belong to the one sitting on the throne; and the seven lamps become the seven stars, displaced from Apocalypse 1:16, where the glorified Christ is holding them. The four beasts, symbols of the evangelists, are also in place here, but two of them, at least, later scatter to different corners of the poem. The eagle, of course, dominates book 2, occasioning more than one critic to connect it to St. John,[6] while the man, perhaps, shows up at the very end, where the poem ends a fragment:

> Atte last y saugh a man,
> Which that y [nevene] nat ne kan;
> But he semed for to be
> A man of gret auctoritee.[7]

(2155–58)

The implication too tempting not to make is that the unwritten conclusion of the *House of Fame* is the proper pasturage for a calf, the proper wilderness for a lion.

In the lower right portion of the Cloisters miniature, we see the first of the apocalyptic trumpets that so much dominate the biblical text and the manuscript's subsequent miniatures. It edges out of the picture, almost leading the viewer on into the rest of the manuscript, where the seven apocalyptic trumpets will bring destruction to the world, judging it and overthrowing its old order. A trumpet calling people to judgment also dominates the last half of Chaucer's poem. There Eolus, the classical god of the winds, wields it, not an elder or an angel, and it, like the trumpet of Apocalypse 9:1–2, generates smoke as well as sound:

Then the fifth angel blew his trumpet, and I saw a star that had fallen from heaven on to the earth, and he was given the key to the shaft leading down to the Abyss. When he unlocked the shaft of the Abyss, smoke poured up out of the Abyss like the smoke from a huge furnace so that the sun and the sky were darkened by it.

When Eolus blows his trumpet, the smoke and abyss are both there, but again the fragments are rearranged, for the fumes emit directly from the instrument without the agency of the star, keys, and angel:

> What dide this Eolus, but he
> Tok out hys blake trumpe of bras,
> That fouler than the devel was,

And gan this trumpe for to blowe,
As al the world shulde overthrowe,
That thrughout every regioun
Wente this foule trumpes soun,
As swifte as pelet out of gonne,
Whan fyr is in the poudre ronne.
And such a smoke gan out wende
Out of his foule trumpes ende,
Black, bloo, grenyssh, swartish red,
As dooth where that men melte led,
Loo, al on high fro the tuel.
And therto oo thing saugh I wel,
That the ferther that hit ran,
The gretter wexen hit began,
As dooth the ryver from a welle,
And hyt stank as the pit of helle.

<div align="right">(1636–54)</div>

Eolus blows his trumpet, as the apocalyptic angels do, repeatedly, bringing judgment to those seeking recognition from the Goddess Fame.

Analyses of other miniatures from the *Cloisters Apocalypse* and passages from the *House of Fame* reveal this same interpretive methodology, if you will, of fragmentation of apocalyptic iconography. In folio 7r, for instance, we find a depiction of Apocalypse 5:7–14, the opening of the Book of God's Judgment. The text under the miniature reads:

The Lamb came forward to take the scroll from the right hand of the one sitting on the throne, and when he took it, the four animals prostrated themselves before him and with them the twenty-four elders; each one of them was holding a harp and had a golden bowl full of incense made of the prayers of the saints. They sang a new hymn: "You are worthy to take the scroll and break the seals of it, because you were sacrificed, and with your blood you bought men for God of every race, language, people and nation and made them a line of kings and priests, to serve our God and to rule the world." In my vision, I heard the sound of an immense number of angels gathered round the throne and the animals and the elders; there were ten thousand times ten thousand of them and thousands upon thousands, shouting, "The Lamb that was sacrificed is worthy to be given power, riches, wisdom, strength, honour, glory and blessing." Then I heard all the living things in creation—everything that lives in the air, and on the ground, and under the ground, and in the sea, crying "To the One who is sitting on the throne and to the Lamb, be all praise, honour, glory and power, for ever and ever." And the four animals said, "Amen"; and the elders prostrated themselves to worship.

Some things, of course, are of necessity missing, interpreted out—the thousands of angels, everything in all creation—but we do see the same elders as in the earlier miniature now bowing down to worship God, throwing down their musical instruments, which, except for the harp the elder in the lower right is holding, are missing from the Apocalypse and

i ntet. et acepie de decia cedicas in tho
no libum. Et cui apuiller libru. qmor
imlia et iiii. cemoces ceadit cou aguo hu ccs
sugili cichans. et phialas auceis plenas ado
camecou. q luc ouoncs scou. Et aniuabuc canal
nouii diecnes. digno es duc acceipe libiu t
soluic sigiuacta cuis qui occisus es. t ceduuisti
nos dio in sunguinc tuo er onini tibu et linguia
er popino er nacione. et fecash nos dio nro regui
regui er sacdoics et ingnabe scr cam . Et iudi et
nudum uocem angloum inuliou in cecuicu thio

ni et aniuualui t scniocs. cc ccuc nios coum
nulia niliuni . uoce maguia dicchu . digni.c
aguus q occisus est accipce uiccucem et dinuiten
cem et supicnaam . t foccicudincm et honocem
et glamu t biidictoc et oinne creacucu que
ni celo e. et que supce ccam . t sub cccu . et que in
nau . et que in eo sunc . omis audun diccbs
sedeu ui ccono t aguo. Benedictio et honoc
t gla et pocelas in scla selouum . et quaccuoc
aialia diccbane amen . Et uigui senioces fecu
oics ceadec t isouce sunc t adouauecc cl.

Cloisters Apocalypse, folio 7r.

thus added by the artist. Again, as in many of the miniatures, the unengaged narrator holding a book gazes thoughtfully on the actions he will narrate.

More important, there are two other details significant because of analogues in Chaucer's poem. The first is the confusion about who is sitting on the throne. As we have seen, the Lady Fame has the multiple eyes of those worshipping, not, as she is in Chaucer's poem, the one worshiped. Here in this miniature we have another displacement from the throne of worship involving multiple eyes. In the prior apocalyptic text the one sitting on the throne is God the Father, *qui erat, et qui est, et qui venturus est* (Apoc. 4:8), or as Chaucer translates in the *House of Fame,* "And he that mover ys of al / That is and was and ever shal" (81–82). In the text illuminated by this miniature, the song of praise is: "To the One who is sitting on the throne and to the Lamb, be all praise, honour, glory and power, for ever and ever." And Chaucer applies this same song to the Lady Fame: "Thus fond y syttynge this goddesse / In nobley, honour, and rychesse" (1415–16). Yet in the miniature the one sitting on the throne should not, like the Lady Fame, in the strictest sense be there. It is the second, not the first, Person of the Trinity upon the throne, as we can tell from the cruciform halo about him, one reserved in iconography almost entirely for Jesus. And the Lamb with the many eyes who reaches up to accept the book with the seven seals is also, through the alchemy of biblical allegory, Christ himself, the Lamb who was slain. It is a different displacement from the throne than that in Chaucer yet a curious one nevertheless—a theological and iconographical redundancy.

The second notable aspect of this miniature is the grouping of the elders. They separate into six equal groups of four as they bow down in Christ's praise, casting down their phials and musical instruments. The Apocalypse makes no mention, of course, of this grouping, this, as it were, serial posturing as suppliants. But Chaucer's *House of Fame* does. There nine groups of suppliants come before Fame's throne seeking either the praise or blame she will or will not grant. As with Chaucer's poem, the groups in the miniature do the same thing with slight yet significant variation. In Chaucer, the first group seeks good fame but gets none, the second seeks good fame but gets bad, the third gets better fame than the good they deserve, the fourth seeks no fame, even though they deserve it, and so on. In the miniature four of the groups offer up different musical instruments missing from the Apocalypse while two, an admitted redundancy not in Chaucer, offer their phials.

Another miniature in the *Cloisters Apocalypse* involving musical instruments shares this tendency for grouping with the last. On folio 29v, we find the text of Apocalypse 15:1–4 and its accompanying miniature. the text reads:

erudi aliud signum in celo magni
et mirabile. Angelos septem habentes
plagas septem nouissimas. quoniam
sunt in illis consummata est ira dei. Et uidi tan
quam mare uitreum mixtum igne. et eos qui
uicerunt bestiam et ymaginem eius. et nume
rum nominis eius stantes super mare uitreum

num. habentes citharas dei. et cantantes canticum
moysi serui dei. et cantantes dicentes. Magnus
et mirabilia opera tua domine deus omnipotens. iuste et uere vi
e rex seculorum. Quis non timebit te domine et magni
ficabit nomen tuum? Quia solus pius es. quo
niam omnes gentes uenient et adorabunt in conspe
ctu tuo. quoniam iudicia tua manifesta sunt.

Cloisters Apocalypse, folio 29v.

What I saw next, in heaven, was a great and wonderful sign: seven angels were bringing the seven plagues that are the last of all, because they exhaust the anger of God. I seemed to see a glass lake suffused with fire, and standing by the lake of glass, those who had fought against the beast and won, and against his stature and the number which is his name. They all had harps from God, and they were singing the hymn of Moses, the servant of God, and of the Lamb: "How great and wonderful are all your works, Lord God Almighty; just and true are all your ways, King of nations. Who would not revere and praise your name, O Lord? You alone are holy, and all the pagans will come and adore you for the many acts of justice you have shown."

As with the previous miniature and Chaucer's poem, the worshipers/suppliants gather together in separate groups, this time in four, each facing in slightly different directions. This tendency to group, absent in the Apocalypse yet present in apocalyptic iconography, has perhaps as much to do with Chaucer's literary iconography as the necessities of his plot.

But the miniature does more in the way of illustrating Chaucer than this. In lines 1201–26 of the *House of Fame*, there is an analogous crowd of harpers:

> Ther herd I pleyen on an harpe
> That sowned bothe wel and sharpe,
> Orpheus ful craftely,
> And on his syde, faste by,
> Sat the harper Orion,
> And Eacides Chiron,
> And other harpers many oon,
> And the Bret Glascurion;
> And smale harpers with her glees
> Sate under hem in dyvers sees,
> And gunne on hem upward to gape,
> And countrefete hem as an ape,
> Or as craft countrefeteth kynde.
> Tho saugh I stonden hem behynde,
> Afer for hem, al be hemselve,
> Many thousand tymes twelve,
> That maden lowde mynstralcies
> In cornemuse and shalemyes,
> And many other maner pipe,
> Bothe in doucet and in rede,
> That ben at festes with the brede;
> And many flowte and liltyng horn,
> And pipes made of grene corn,
> As han thise lytel herde-gromes,
> That kepen bestis in the bromes.

Like the harpers from Apocalypse 15, Chaucer's are also in groups. Many of those in the miniature gaze upwards, as do many in Chaucer's poem. The minstrels who follow these harpers (and play mostly woodwinds) are

the apocalyptic 144,000 saved souls,[8] just as are those in Apocalypse 15, for they are the same group introduced in chapter 14, verse 1–2:

> Next in my vision I saw Mount Zion, and standing on it a Lamb who had with him a hundred and forty-four thousand people, all with his name and his Father's name written on their foreheads. I heard a sound coming out of the sky like the sound of the ocean or the roar of thunder; it seemed to be the sound of harpists playing their harps.

Here we see the same fragmentation of visionary iconography as in the previous miniatures we have discussed. The harpists separate off into groups: the 144,000 break off from these harpists and turn into minstrels playing all sorts of other instruments. The two sounds in this biblical passage, that of thunder and of the sea, turn up in far-flung corners of Chaucer's poem, for when Geoffrey first sees the eagle, likewise "coming out of the sky," he comments:

> But never was ther dynt of thonder,
> Ne that thyng that men calle fouder,[9]
> That smot somtyme a tour to pouder,
> And in his swifte comynge brende,
> That so swithe gan descende
> As this foul.
>
> (534–39)

And when this eagle later carries him to the House of Fame, the two have this exchange, with the eagle speaking first:

> "Maistow not heren that I do?"
> "What?" quod I. "The grete soun,"
> Quod he, "that rumbleth up and doun."
>
> "Yis, parde!" quod y, "wel ynogh."
> "And what soun is it lyk?" quod hee.
> "Peter! lyk betynge of the see."
>
> (1024–26, 32–34)

As with miniature 5r and 7v, in short, the apocalyptic elements of 29r are all there, but they are jumbled, separated, altered, and dispersed.

We may now come to a preliminary conclusion about the relationship of the apocalyptic iconography and the fragmentary *House of Fame*. The attempts by various critics to make sense of the poem's fragmentation have so far focused almost exclusively on the poem's end, where it breaks off in mid-sentence directly after the appearance of the man of great authority.[10] I suggest that if the fragmentation and dispersal of apocalyptic imagery into the far-flung corners of the poem are any indication, then Chaucer's fragmentation is not merely a characteristic of the poem's end

but of the very fabric of the whole. It is not, in other words, the poem's *accident* but its *substance*. Therefore, we might do better to explicate this and other Chaucerian works as fragmentary in their very essence rather than as would-be completions that never, for one reason or another, quite made it.

There are, however, even more important theoretical implications of this fragmentation involving authorial involvement in the text, as two other miniatures from the *Cloisters Apocalypse* make clear. Folio 3r and 16v both are an artist's attempt to depict authorial intentionality and have curious analogues in Chaucer's *House of Fame*.

Folio 3r illustrates the opening verses of St. John's Apocalypse. The miniature looms over the prior text, dwarfing even it, the longest passage among the miniatures we are discussing. The miniature illustrates the text, certainly, but also interprets it. We have again a self-interpreting text, which we, as critics, reinterpret:

The revelation of Jesus Christ which God gave him, to make known to his servants the things that must shortly come to pass; and he sent and signified them through his angel to his servant John; who bore witness to the word of God and to the testimony of Jesus Christ, to whatever he saw. Blessed is he who reads and those who hear the words of this prophecy, and keeps the things that are written therein; for the time is at hand. John to the seven churches that are in Asia: grace be to you and peace from him who is and who was and who is coming, from the seven spirits who are before his throne, and from Jesus Christ, who is the faithful witness, the firstborn of the dead, and the ruler of the kings of the earth. To him who has loved us, and washed us from our sins in his own blood, and made us to be a kingdom, and priests to God his Father—to him belong glory and dominion for ever and ever. Amen. Behold, he comes with the clouds, and every eye shall see him, and they also who pierced him. And all the tribes of the earth shall wail over him. Even so. Amen. "I am the Alpha and the Omega, the beginning and the end," says the Lord God, "who is and who was and who is coming, the Almighty." I John, your brother and partner in the tribulation and kingdom and patience that are in Jesus, was on the island which is called Patmos, because of the word of God and the testimony of Jesus. I was in the spirit on the Lord's day, and I heard behind me a great voice, as of a trumpet, saying, "What you see, write in a book, and send it to the seven churches—to Ephesus, and to Smyrna, and to Pergamum, and to Thyatira, and to Sardis, and to Philadelphia, and to Laodicea."

(Apoc. 1:1–11)

Note what the Cloister-artist does to the prior apocalyptic text: First, for him St. John's vision is a dream.[11] John's eyes are closed and his hand up to support his head—the usual posture of sleepers in medieval manuscript illuminations.[12] Second, the Cloisters-artist must be selective, choosing to illuminate the last third of this prior text—John in ecstasy on the isle of Patmos. The middle section about Christ the Alpha and Omega coming

pcalipfis ihu xpi qua deds illi de
us palam hicat seruis suis que opor
ten deo, z signiscauit uuttes p age
lum suum suo sco ioshi qui tcstimon
plabuit uso dei · et testimonium ihu e
in huis quecuqz uidet · Beatus
qui legit et qui audit uba pphe
tie huius · et seruat ea que i ea septa sut · Tem
pus euum prop e · Tobannes septem ectesus q sut
in asia. Oratia uobis z pax ab eo qui est et qui e
tur · et qui uentuus est · Et a septem spuabz q
conspctu throni eius sut · et d ihesu xpisto qui est te
stis sidetis primogenitus mortuorum et princeps re

gum tc, Qui dilexit nos et lauit nos a pentis
nostris in sanguie suo · et secit nos regnum et sa
certes deo et patri suo, Ipi gla z uperium · in sect
la seculorum Am, ecce uenit cu nubibz et uidebit
eu ois oaulus et qui eum pupugert · et planget se
se cum omes tibus te · etiam amen Ego su alpha z w.
pncipium z sinis · dicit dominus de, qi est qui erat et q
uentur est omips · ego ioses frat vr z ptceps i tbulate
z regno z patcia i thu · sui in insula q apellat path
nos pp ubu dei z tcstimoui ihu. Sui in spu diem do · z au
diui p me uoce magna tanq tube dicens, Quod uides
scribe z mitte septe eclus, ephelo, z smirne · et
pgamo · z thiatire · z sardis · z philadelphie · et laotroe.

Cloisters Apocalypse, folio 3r.

with the clouds, visual as it may be, is gone entirely, and the first section, which significantly is about the act of reading, at first glance also is gone. But maybe not, for sleeping John holds a book in his hand. An angel breaks through the diapered background and holds a scroll stating, *Quod vides in libro, scribe,* "Write what you see in a book." Is this the book in John's hand? If so, it is doubtless blank, waiting to be filled with John's narrative of the coming visions.

The artist thus selects details from the prior text and also conflates them. This selectivity and conflation, a methodology that, as we have seen, Chaucer shares with the Cloisters-artist, is by its very nature fragmentary. Things are gone, the rest pieced together according to an intentionality subsequent to that of the prior text.

Yet there is the possibility that the book St. John holds is not the blank one but itself a prior text. The Apocalypse, as all New Testament scholars know, is itself in one sense a pastiche of prior texts. As the United Bible Society's standard New Testament text[13] so conclusively shows by printing in boldface all quotations in the Apocalypse from earlier apocalyptic literature, large portions of the book are quotations from the prophets Ezekiel, Daniel, and Isaiah. The prior text emerges in the newly constituted one conflated, rearranged, and dispersed—in other words, fragmented. Perhaps the book St. John holds is a florilegium of apocalyptic quotations from the Greek Septuagent translation of the Hebrew Bible which in the course of the succeeding miniatures he will fragment and rearrange into his own new text.

Scholars attentive to Chaucer, like their biblically oriented colleagues, also know the centrality of the prior text to the newly constituted one. Each of Chaucer's early Dream Visions—the *Book of the Duchess,* the *House of Fame,* and the *Parliament of Fowls*—begins somehow with Chaucer's summarizing evocation of a prior text, and many individual lines are lifted from previous works, particularly the courtly poems of Guillaume de Machaut, and placed in new contexts.[14] The *House of Fame,* for instance, begins with the evocation of a prior text—the story of Dido and Aneas.

In the *Book of the Duchess,* the insomniac Chaucer reads himself to sleep with the *Ovide Moraliseé* and thus begins his dream with the story of Ceyx and Halcyon in mind—which of course functions as a kind of prior gloss to the events about love and marriage that form the matter of the rest of the poem. It is easy to envision Chaucer, in fact, in the earlier lines of the *Book of the Duchess* in the same posture of St. John—asleep, book in hand, about to dream.

The *Parliament of Fowls* likewise begins with an evocation of a prior text—Macrobius's commentary on the *Dream of Scipio.* In the opening lines of that poem, Chaucer sets down better than anywhere else a state-

ment of the text as reconstitution of the prior text, the text as the already always written:

> The lyf so short, the craft so long to lerne. . . .
>
> Not yoore
> Agon it happed me for to beholde
> Upon a bok, was write with lettres olde,
> And therupon, a certeyn thing to lerne,
> The longe day ful faste I redde and yerne.
>
>
> For out of olde feldes, as men seyth,
> Cometh al this newe corn from yer to yere,
> And out of olde bokes, in good feyth,
> Cometh al this newe science that men lere.
>
> (*PF* 1, 17–25)

In the miniature from the *Cloisters Apocalypse,* then, we have an analogous situation to that in Chaucer's Dream Visions—a dreamer asleep with old book in hand commanded to write a new one.

The very liminality of this command in the miniature is worth comment. There the patterned, diapered background is itself an iconographical gesture in the direction of selectivity and thus fragmentation, for the "realistic" sky to complement the island and sea is interpreted out in favor of an artificial background. Then this diapering is broken by the angel in the upper left, at whose back we can discern the skies of heaven, where doubtless his scrolled command has originated. We are, in other words, on the very borders in this miniature between separate realms—heaven and earth, earth and sky, terra firma and sea, wakefulness and sleep, text and life. In this liminal environment the author receives his command to write.

Chaucer treats the iconographical details this miniature shares with the text it illuminates in a similar way to the other iconographical details we have considered earlier—by fragmenting them and dispersing them to the far flung corners of his poem. Specifically, the dream with prior text in hand is separated from the desert island by almost one full book of Chaucer's poem.

Note first the selectivity of the Cloister-artist about John's desert island. Nothing else is on it except the ecstatic, recumbent visionary: no houses, harbors, other people. Even the seagull who might, without offense to the stark realism of John's exile, be expected to coinhabit Patmos with the apostle is perched on a smaller neighboring island.[15] The artist as interpreter, of course, is at work.

Geoffrey is likewise isolated in the *House of Fame,* but not in the act of dreaming the subsequent narrative events. It is only after he recounts

the illuminations of the prior text of Dido and Aeneas on the walls of the Temple of Venus that the fully Patmosian nature of his exile becomes clear:

> When I out at the dores cam,
> I faste about me beheld.
> Then sawgh I but a large feld,
> As fer as that I myghte see,
> Withouten toun, or hous, or tree,
> Or bush, or grass, or eryd lond;
> For al the feld nas but of sond.

(480–86)

The locus of vision is thus fragmented from the locus of narrative.

On folio 16v of the *Cloisters Apocalypse* we see an even more significant miniature for understanding, the fragmentary nature of the authorial process. In it St. John, fully now a character in his own vision, one who has doggedly been carrying his book throughout the intervening miniatures, is commanded to eat it by one of the angels he encounters. The text below the miniature, much shorter than that under folio 3r, is in even greater danger than the earlier text of being gobbled up by its interpretive illumination. It reads:

> And I took the book from the angel's hand, and ate it, and it was in my mouth sweet as honey, and when I had eaten it my stomach was made bitter. And they said to me, "You must prophesy again to many nations and peoples and tongues and kings."

(Apoc. 10:10–11)

Note again the liminal nature of the activity: the angel stands, one foot on the sea and one on the earth. The Cloisters-artist catches St. John in the very act of consuming his book, for its upper right corner is already gone. The text is on the threshold between the externally visible and the internally reified.

The implication here of the text as not so much always already written but as always already eaten—consumed, internalized, reified, understood—is certainly important. The consumption of a text is, of course, its ultimate fragmentation, analogous in many ways to the sacrament of the Eucharist: Christ the Word broken by the teeth of the faithful, internalized and reified for salvation. But more than that, it is an icon, I would suggest, for both the act of reading/interpretation and also for the author who cannot distance her or himself from the text she or he creates. After eating his text, in other words, St. John becomes it: he prophesies, speaking, doubtless, the words he has written. The author thus becomes his own text. He is eaten by it, that is, becomes a character in it, in the act of eating it—a cannibalism of the most literary sort.

Et accepi librum de manu angeli: et
devoravi eum. et erat in ore meo tanqu
mel dulce. Et cum devorassem eum. a

maricatus est venter meus. Et dixit michi.
Oportet te iterum prophetare populis et
gentibus. et linguis. et regibus multis.

Cloisters Apocalypse, folio 16v.

Near the end of the Apocalypse, St. John warns his readers thus:

> This is my solemn warning to all who hear the prophecies in this book: if anyone adds anything to them, God will add to him every plague mentioned in the book; if anyone cuts anything out of the prophecies in this book, God will cut off his share of the tree of life and of the holy city, which are described in the book.
>
> (Apoc. 22:18–19)

The threat is, in simple terms, that of blurring the distinctions between readers and characters, between "real life" and "fiction." The reader who adds or subtracts—in other words selects, rearranges, fragments the necessary stuff of interpretation as a discipline and reading as an avocation—will become the text's characters who suffer the plagues it describes. St. John himself is already a character in his own text; in this final miniature he is now fully inside the frame, not outside as in the others, looking in. When we read/interpret/fragment, we join him, and it is a terrible curse.

Near the beginning of the *House of Fame* Chaucer levels at us, his readers, a similar curse, one likely derived from St. John's:

> And whoso throgh presumpcion,
> Or hate, or skorn, or thorgh envye,
> Dispit, or jape, or vilanye,
> Mysdeme hyt,[16] pray I Jesus God
> That (dreme he barefot, dreme he shod),
> That every harm that any man
> Hath had syth the world began
> Befalle hym therof or he sterve.
>
> (94–101)

Reading, that is interpretation, that is fragmentation, is not only a post-lapsarian activity, it is postdamnation—an icon of the Fall, in which we all set ourselves up as authors, as critics, as gods. Disturbing as this may be, the act of interpretation/fragmentation that has called us here is still exhilarating. The texts taste sweet in our mouths in the damnable, sacramental act of fragmentation—the ground of interpretation, criticism, reading.

NOTES

1. See Florens Deuchler, Jeffrey M. Hoffeld, and Helmut Nickel, eds., *The Cloisters Apocalypse* (New York: The Metropolitan Museum of Art, 1971).

2. The edition of Chaucer I use is that of F. N. Robinson, *The Works of Geoffrey Chaucer,* 2d ed. (Boston: Houghton, Mifflin, 1957).

3. Critics have often noted the similarities between the *House of Fame* and the Apocalypse. J. A. W. Bennett in *Chaucer's Book of Fame* (Oxford: Clarendon

Press, 1968), 151, n. 2, sees a similarity between the trumpet Eolus blows to execute Fame's judgment and the trumpets angels blow to execute God's, but he states that Chaucer has no conscious intention behind his creation of this similarity. B. G. Koonce, in *Chaucer and the Tradition of Fame* (Princeton: Princeton University Press, 1966), 181, on the other hand, recognizes that there is conscious intention; he speaks of how "the Apocalyptic symbolism . . . acquires an increasingly important function" in the poem, but he does not discuss Chaucer's sometimes surprising fragmentation of the material.

4 See Robert Boenig, "Chaucer's *House of Fame,* the Apocalypse, and Bede," *American Benedictine Review* 36 (1985): 263–77.

5. The edition of the Bible I use is that of Alexander Jones, et al., eds., *The Jerusalem Bible* (Garden City, N.Y.: Doubleday, 1966).

6. See, for instance, John Leyerle, "Chaucer's Windy Eagle," *University of Toronto Quarterly* 40 (1971): 253.

7. This man of great authority has been the subject of much critical speculation. Paul G. Ruggiers, for instance, in his article "The Unity of Chaucer's *House of Fame,*" reprinted in Richard J. Schoeck and Jerome Taylor, eds., *Chaucer Criticism,* vol. 1 (London: University of Notre Dame Press, 1961), 271, suggests Boethius for his identity, and Koonce, *Chaucer and the Tradition of Fame,* 275, interprets the poem as a Dantean allegory of the soul's progress from hell through purgatory to heaven with this man of great authority Christ himself (see also 266–67).

8. See Boenig, "Chaucer's *House of Fame,* the Apocalypse, and Bede," 271–72.

9. That is, a "thunder-bolt."

10. See, for instance, Donald K. Fry, "The Ending of the *House of Fame,*" in *Chaucer at Albany,* ed. Rossell Hope Robbins (New York: Burt Franklin, 1975) 27–40; Boenig, "Chaucer's *House of Fame,* the Apocalypse, and Bede," 275; compare Florence H. Ridley, "Questions Without Answers—Yet or Ever? New Critical Modes and Chaucer," *Chaucer Review* 16 (1981): 104; and Larry M. Sklute, "The Inconclusive Form of the *Parliament of Fowls,*" *Chaucer Review* 16 (1981): 128.

11. Chaucer gets most of his information about medieval dream theories from Macrobius's *Commentary on the Dream of Scipio.* See William Harris Stahl, trans., *Macrobius: Commentary on the Dream of Scipio* (New York: Columbia University Press, 1952), 87–92. For explications of Chaucer's adaptation of Macrobius, see Stahl, 52–55; Walter Clyde Curry, *Chaucer and the Mediaeval Sciences* 2d ed. (New York: Barnes & Noble, 1960) and C. S. Lewis, *The Discarded Image* (Cambridge: Cambridge University Press, 1964), 60–69.

12. One further example of this sleeping posture among many is found on folio 2 of King René's *Le Cueur d'Amours Espris.* See F. Unterkircher, ed., *King René's Book of Love* (New York: George Braziller, 1975), plate 1.

13. See Kurt Aland, et al., eds., *The Greek New Testament,* 2d ed. (New York: United Bible Societies, 1966, 1968), 836–95.

14. See James I. Wimsatt and William W. Kibler, eds., *Guillaume de Machaut: Le Jugement du roy de Behaigne and Remede de Fortune* (Athens: University of Georgia Press, 1988), 27–31, 48–52.

15. See Deuchler, Hoffeld, and Nickel, *Cloisters Apocalypse,* 34.

16. That is, the ensuing poem.

Works Cited

Aland, Kurt, et. al., eds. *The Greek New Testament*. 2d ed. New York: United Bible Societies, 1966, 1968.

Bennett, J. A. W. *Chaucer's Book of Fame*. Oxford: Clarendon Press, 1968.

Boenig, Robert. "Chaucer's *House of Fame*, the Apocalypse, and Bede." *American Benedictine Review* 36 (1985): 263–77.

Curry, Walter Clyde. *Chaucer and the Mediaeval Sciences*. 2d ed. New York: Barnes & Noble, 1960.

Deuchler, Florens, Jeffrey M. Hoffeld, and Helmut Nickel, eds. *The Cloisters Apocalypse*. New York: The Metropolitan Museum of Art, 1971.

Fry, Donald K. "The Ending of the *House of Fame*." In *Chaucer at Albany*, Rossell Hope Robbins, ed. New York: Burt Franklin, 1975.

Jones, Alexander, et al., eds. *The Jerusalem Bible*. Garden City, N.Y.: Doubleday, 1966.

Koonce, B. G. *Chaucer and the Tradition of Fame*. Princeton: Princeton University Press, 1966.

Lewis, C. S. *The Discarded Image*. Cambridge: Cambridge University Press, 1964.

Leyerle, John. "Chaucer's Windy Eagle." *University of Toronto Quarterly* 40 (1971): 253.

Ridley, Florence H. "Questions Without Answers—Yet or Ever? New Critical Modes and Chaucer." *Chaucer Review* 16 (1981): 101–6.

Robinson, F. N., ed. *The Works of Geoffrey Chaucer*, 2d ed. Boston: Houghton, Mifflin, 1957.

Ruggiers, Paul G. "The Unity of Chaucer's *House of Fame*." Reprinted in Richard J. Schoeck and Jerome Taylor, eds. *Chaucer Criticism*, vol. 1. London: University of Notre Dame Press, 1961.

Sklute, Larry M. "The Inconclusive Form of the *Parliament of Fowls*." *Chaucer Review* 16 (1981): 119–28.

Stahl, William Harris, trans. *Macrobius: Commentary on the Dream of Scipio*. New York: Columbia University Press, 1952.

Unterkircher, F., ed. *King René's Book of Love*. New York: George Braziller, 1975.

Wimsatt, James I. and William W. Kibler, eds. *Guillaume de Machaut: Le Jugement du roy de Behaigne and Remede de Fortune*. Athens: University of Georgia Press, 1988.

A Medieval Iconographic Vernacular

KATE GREENSPAN

The well-known late medieval devotion to the humanity of Christ was attended by a remarkable efflorescence of mystical literature and art. As early as the twelfth century, images of the divine infant and the suffering Savior began to grip the imagination of learned and simple alike.[1] Passion for the Passion intensified during the fourteenth and fifteenth centuries, sweeping the Low Countries and Germany and generating quantities of vernacular devotional manuals, formulae, handbooks, and meditational guides. Late medieval vernacular accounts of Christ's life went far beyond Gospel sources in their minute concentration on the physical aspects of the Nativity and Crucifixion, adding gruesome or pathetic details to excite tenderness, love, guilt, compassion and tears in the reader. (Marrow 1979, 8) Through their lively verbal and visual imagery, guides to meditation, like the Pseudo-Bonaventuran *Meditationes vitae Christi* or Magdalena of Freiburg's *Erklärung des Vaterunsers,* offered readers a personal means through which they might drawn near to the Son of God.[2]

Popular devotional works of this kind used conventional Christian images, understood by all to contain many levels of significance. Verbal and iconographic imagery served common functions: to inform and inspire. To that end, they utilized, each in its own way, expressive commonplaces—a vocabulary—presented within appropriate syntax.[3] These vocabularies, though they depended upon formal Latin elements, acquired a new immediacy when translated into a vernacular idiom. (Graber 1968, 13–14) Because medieval Christians judged the success of an image not by its elegance of expression or grace of execution, but by its symbolic density, vernacular texts and iconography succeeded by adding extra layers of meaning to traditional images—at least for those who understood the dialect.

Just as the vocabulary and syntax of the author's mother tongue—derived to some degree from liturgical Latin—determined the text's readership, so the artist's local iconographic language—based upon traditional Christian imagery—determine the viewership of its miniatures.[4] What I shall call vernacular iconographies, the visual equivalent of linguistic

vernaculars or dialects, invested traditional Christian symbols with personal or local significance, drawing heavily upon Scripture and upon the lives of saints.[5] Often, though, their source was closer to home, in the life of a resident spiritual prodigy, for example, or in the *vita* of the author in whose text the miniatures appear, or in events important to the spiritual and temporal history of the community for whom the text was produced. Vernacular iconographies usually derived their images from a textual source, either the accompanying text or some other.

Miniaturists working in a vernacular tradition at times deployed conventional vocabularies in unconventional ways. By combining universal Christian ideas with symbols that had significance only within a particular religious foundation and its immediate neighborhood, they tailored the garment of faith to the local fashion. Their iconographies cast up new, compelling meanings out of the old symbols.

The practice might cast up confusion and ambiguity as well, especially when the manuscripts circulated beyond their native ground. Modern viewers tend to dismiss vernacular iconography as "bad art," the product of confused thinking, inadequate education, or naive and perverse religiosity.[6] The imagery would probably have puzzled most contemporaries as well, for its telling iconographic keys were taken, not from the great storehouse of Christian symbol, but from the garrets and bins of local lore. Yet, where it is possible to uncover the symbolic system operating behind the puzzling arrangement of conventional but oddly altered images, a remarkably sophisticated synthesis emerges, a synthesis of universal Christian forms and individual spirituality.

The same principle may be at work, of course, in a secular setting. Many marginal grotesques, for example, combine conventional images with wildly frivolous imaginings, unreadable today, though to contemporaries they were as meaningful, no doubt, as a political cartoon is to us. Where their metaphor depends upon irrecoverable local knowledge—the unusual wen on a magistrate's nose, the abbot's taste for leverett, or the sartorial preferences of the merchant's wife—they remain forever obscure. Yet we cannot doubt that many of these grotesque figures embody sophisticated ideas.[7]

Miniatures containing vernacular iconography were produced for an audience in the know, often by untrained limners who regarded the *vita* of the text's author as an important part of their community's spiritual and temporal history. When the text was copied for wider circulation, the miniatures were usually omitted, in tacit acknowledgment of their inability to communicate to a broader audience. Nevertheless, the images' limited appeal should not be understood as a failure; what they lacked in general significance, they made up for in depth and immediacy. But their power depends upon knowledge of the context in which they were generated;

without it, they may seem meaningless, or at best ambiguous.[8] With the text they are meant to accompany, they reveal as many layers of meaning as the finest art of the period.

* * *

In German and Dutch devotional works intended for private use, clumsily drawn images of startling eccentricity sometimes appear. Seeming to bungle the very conventions we expect them to manipulate best, the images use familiar Christian iconography in ways that confound interpretation. In the case of the popular fifteenth-century meditation on the Paternoster by Magdalena of Freiburg,[9] the *Erklärung des Vaterunsers*,[10] the miniatures were omitted from copies intended for wider circulation. Excerpts of the treatise, originally composed for the edification of Poor Clares in a south German convent, circulated for at least one hundred years in German-speaking areas in both manuscript and printed collections of devotional works. But the awkward execution and unusual iconography of the manuscript's two miniatures made them poor candidates for reproduction with the text. Recently, one of the miniatures has been studied without any reference to the text at all, with bizarre results.[11]

The *Erklärung* is a copy of at least one manuscript written, or perhaps dictated, by Magdalena herself to sisters in her convent. The surviving copy was made in her convent, near or shortly after her death in 1456. Written in the local Allenmanic dialect, the *Erklärung* contains 505 repetitions of the Paternoster, divided into eleven sections of one to 101 repetitions. The work is structured as an antiphon, each line of each repetition of the Paternoster followed by an original prayer, meditation, or explication.

Like the popular sermons, tracts, and miracle plays of its time, the *Erklärung* addressed an audience literate only in their vernacular. Unlike David of Augsburg's *Paternoster,* though, the *Erklärung* is neither a didactic paraphrase of the prayer, nor, as the title might suggest, a theological discourse. Rather, it is a model for mystical meditation, written to encourage a lively and vivid spirituality in those who had no mystical inclinations themselves. Its themes (among them the Eucharist, the humanity of Christ, and the acceptance of illness as a sign of grace) reflect those of the *devotio moderna* and of the Franciscan Observant reformers with whom Magdalena identified herself. Magdalena sets out to provide spiritual models that foster an intimate, unmediated relationship between the individual soul and God.

Although her *vitae* praise her ability to read Latin, Magdalena uses little in her work. Instead, her ecstatic outpourings are in German—as are the repetitions of the Paternoster itself. Only a few repetitions of the Ave Maria and the Credo, their original petitions extended and elaborated

like the Paternoster, and a few liturgical fragments are retained in Latin. Magdalena fills the *Erklärung* with biblical allusions, often quoting the Psalms and the Gospels of Matthew and John from memory, as she had read or heard them in German. She draws as well upon tracts and sermon literature, combining their ideas with her own in original but orthodox ways. By these means, she lends the formal superstructure of Latin prayer an informal, vernacular freedom of expression in order to emphasize the intimate, filial relationship with each member of the Trinity her meditations encourage.

She prefaces four of the many sets of repetitions with passages that explain how the paternosters came to be written. In them, the Holy Spirit commands Magdalena to write down a certain number of Paternosters so that she may serve God properly (f. 3r) or so that those who repeat them may be released from guilt (f. 52v). She must "work the words of the Paternoster [she finds] in the psalter into a form that God will hear with pleasure" (f. 64v); and in answer to her desire to know if her efforts have pleased God, the Spirit tells her that he will give "rich gifts" to those who repeat her Paternoster as she has written it (f. 193r). These passages juxtapose and conflate the voices of Magdalena, the Holy Spirit, and Christ, blurring the distinction between the human and the divine, the low and the high, in ways we recognize as characteristic of medieval popular culture.[12]

The first of these typifies the *Erklärung's* tendency to blur the identity of persons speaking, spoken to, and alluded to.

Der herr sprach zuo minen geist: Schrib mir lxxvii pater noster als ich dir gen und helfen wil, und mir sol do mit biss an dz end der welt gedienet werden und als dick si min. Gebettet werden ze eren, so wil ich es minen vatter loben als ein aller liebsten dienst und nutzen, und heilige zit vor mir sol dis gennent werden. Und ich wil den menschen in dz ebend buoch schriben, der mir si all wuchen bettet. Der si aber teglich mag gebetten, den wil ich selb heiligen vor minem vatter. Und ich hilf dir nit sorg, sprach min herz lieber und getruwer vatter. Deo gratias. (f. 3r–3v)

[The Lord spoke to my soul: Write me 77 pater nosters, which I shall give to you and help you with, and with them you shall serve me unto the end of the world and be my own. Prayer turns to honor, so I wish to praise my father as a loving service and duty, and this shall be called on account of me a holy hour. And I wish to write those people in the book of life who pray to me every week. But those who pray daily, them shall I myself sanctify before my father. And I will help you not to worry, said my beloved and faithful father. Thanks be to God.][13]

At first, two discernible personae speak: Magdalena, who repeats the dialogue, and the Lord, who is the first speaker. But in the second sentence, the *ich* who desires *minen vatter loben*, whom we first assume

to be Magdalena, blends with a persona in the following lines who has
intercessory powers, is worthy of veneration, and who refers to *der herr*
as *min* (not *unser*) *vatter*. In this third *ich* Magdalena seems to merge
with Christ; at any rate, it is no longer clear who is speaking. As Magda-
lena's fame rested in part on her successful public practice of *imitatio
Christi*, confusion of voices may also suggest her own double voice, as
Christusbild and mystic. Ambiguous passages like this communicated two
important points to readers: first, assurance that the work is indeed di-
vinely inspired, the instrument and the author having become one; and
second, that such union is the fruit of the kind of meditation the text tries
to teach.[14]

The text of Magdalena's *Erklärung* operates by means of such allu-
sions, juxtapositions, and conflations of ideas, voices, levels of diction,
of subject and object, of states of consciousness.[15] A vernacular style in
every sense, it owes little to formal rhetoric or learned convention. It
operates, in fact, in "conscious contrast to the language of the learned,"
as Curtius tells us the term was originally applied (1973, 3). Like hagio-
graphic *exempla* and popular sermons, to which it is related, the *Erklä-
rung* shows no concern for unities of time and place; the past, present
and future are one and the same context; no separation of the sublime
from the low and the everyday, all indissoluably connected in Christ's
life and suffering. In a similar fashion, the miniatures bring together in
informal but informative ways familiar images that acquire new dimen-
sions by means of the same techniques of conflation, juxtaposition, and
allusion. The strategies Magdalena uses in the text to encourage imitation
of and identification with Christ find a visual counterpart in the minia-
tures, which draw upon both the text of the meditation and the personal
history of the author to encourage her sisters' ecstatic apprehension of
the divine.

The first miniature depicts a common configuration in medieval German
religious art, the *Gnadenstuhl* or the seat of Grace. In most *Gnadenstühle*,
the Father displays the Crucified full length on the cross with the dove
poised between them. In some cases, the Father holds the dead Christ,
shown half-length, over his arm. Sometimes, instead of the Crucified
Christ, he holds the *Schmerzensmann* (the *imago pietatis* or Man of Sor-
rows), pictured on his feet and alive, arms crossed across the breast or
displaying the wound in his side, perhaps pouring his blood into a chalice.
Often represented as a Child, the *Schmerzensmann* is a eucharistic image,
a particularly potent one for medieval women visionaries who frequently
witnessed the transformation of the host into a baby or a young child.[16]

The three important elements in a *Gnadenstuhl*, all present in this
miniature, are the outstretched hands of the Father, the presence of the
Crucified, and the Dove. On the literal level, then, it is a picture of the

Gnadenstuhl, Erklärung des Vaterunsers. Donaueschingen, Fürstl.-Fürstenberg. Hofbibliothek 298, f. 64r.

Real Presence in the Eucharist: the Trinity at the altar, with the Christ Child as *Schmerzensmann* (though shown only half-length) wrapped in a shroud and leaning over a chalice. The miniature departs from tradition by showing us a living Christ at half-length while the Father spreads his hands to suggest the Cross. (The structure I am calling an altar may be the holy sepulchre—in which case the artist may have assimilated to the *Gnadenstuhl* another kind of image, an angel lowering the dead Christ into the tomb.)

But the *Erklärung's* artist has taken liberties beyond these. Instead of the sorrow traditionally manifest in the Father's face, both the Father and the Son are smiling—as convention permits in south German medieval art. Roses decorate both the altar (or sepulchre) and the background of the miniature—a powerful image to whose significance I will return later. Of greatest significance, though, is the setting: the scene takes place in a heart-shaped monstrance.

This miniature accompanies a single repetition of the Paternoster addressed to the Trinity.

(f. 62v) Lieht und bluomen.
i. Unser vatter der du bist in d himeln. Ich danck dir, gott, vatter, sun, (f. 63r) und heilger geist, aller dinr gueti. Geheilget wert din namm. Ich danck dir aller dinr gueti und erbermd. Zuo kum uns din rich. Jesus Christus, ich danck dir alles dins lidens, dz du litt vir uns. Din will werd und in erd als in himeln, Jesus Christus, ich danck dir aller dinr pin und marter. Gib uns hutt unser teglich brot. Jesus Christus, ich danck dir aller dinr wunden. Und vergib uns unser schuld und wir also vergebent unserren schuldnern. Jesus Christus, ich danck dir dins heiligen bluot vergiessens. Und in leit uns nit in bekorung sunder loes uns von ubel. Jesus Christus, ich danck dir dins bitteren todes, den du litt vir unser sund. Ich danck dir ewiklich, und lob und vergih din on end, min gott und herz lieber, worer, einiger, trivaltiger, wirdiger gott und vatter min und mir alle ding (f. 63v) Ich lob und anbett dich, gott, vatter, sun, heilger geist, die ein worer gott sint, heiliger, rehter, gewaltiger gott und einiger aller hoehster gott, und enkein anderer gott, won du trivaltiger, einiger gott. Din heiliger namen muoss iemer on end gesegnet sin. Gedenck min in din rich, alles lobes und eren wirdiger gott, biss alle zit bi mir in min hertzen und erbarm dich uber uns, amen. Deo gratias. Omnis spiritus laudet dominum.

[Light and flowers.
Our Father who art in heaven. I thank thee, God, Father, Son, and Holy Spirit for all thy goodness. Blessed be thy name. I thank thee for all thy goodness and mercy. Thy kingdom come. Jesus Christ, I thank thee for all thy pains that thou suffered for us. Thy will be done on earth as it is in heaven. Jesus Christ, I thank thee for all thy pain and martyrdom. Give us this day our daily bread. Jesus Christ, I thank thee for all thy wounds. And forgive us our debts as we forgive our debtors. Jesus Christ, I thank thee for the outpouring of thy holy blood. And lead us not into temptation, but deliver us from evil. Jesus Christ I thank thee for thy bitter death, which thou suffered for our sins. I thank thee eternally and praise and confess thee without end, my God and dearest, truest,

only, threefold, worthy God and Father mine, [who art] all things to me. I praise
and pray thee, Father, Son, Holy Spirit, who are a true God, holy, just, powerful
God and only all-highest God, [for] there is no other God than thee, threefold
only God. Thy holy name must ever be blessed without end. Provide for me
in thy kingdom, all praise– and honorworthy God. Be thou at all times with
me in my heart; and have mercy upon us, amen. Thanks be to God. Let every-
thing that hath breath praise the Lord.]

How closely does this passage reflect the imagery of the miniature?
First, the images of blood, martyrdom, bitter death, and thanksgiving that
suggest eucharistic devotion and the proper approach to the seat of grace
find an echo in the symbolism of the roses that decorate the miniature.
The roses, appearing in the rubric as *bluomen,* traditionally symbolize
(among other things) martyrdom, blood, or wounds; here they also allude
to Paternoster prayer itself, as I will explain in due course.

By far the most interesting and idiosyncratic aspect of the miniature's
interpretation of the text comes from the petitioner's cry, *"biss alle zit bi
mir in min hertzen"* (be thou art at all times with me in my heart). The
meditator's heart bears God within it—that is, her heart has become one
with Christ's. But where does the very odd image of the heart-shaped
monstrance come from? Real monstrances do not come in the shape of
the heart and, to my knowledge, they are not so represented in art. Most
likely, it comes from Magdalena's *vitae,*[17] which contain an account of a
vision her mother had while pregnant. She saw a golden monstrance, so
bright that it lit up all the world, sent from Heaven into her womb. That
monstrance, of course, turned out to be Magdalena, renowned for her
inward and outward conformity with Christ. I suggest that the sister who
drew the miniature knew the story of the convent's most famous member
and chose to represent the statement "thou art at all times in my heart"
as a metaphor drawn from the life of the *Erklärung's* author. We are meant
to see the heart of the meditator who identifies through Magdalena with
Christ, as the transformation from earthly to divine substance takes place
within her. Furthermore, devotion to the sacred heart of Jesus, popular
in Magdalena's region and repeatedly expressed in the *Erklärung,*
strengthens the identity of the heart as simultaneously Christ's and
Magdalena's.

The clumsiness and obscurity of the second miniature have given rise,
as I mentioned earlier, to bizarre modern speculations. The chubby little
naked figure on the right, the supposedly coy glances the figures cast at
one another, the mysterious object seeming to poke out of the angel's
robe, suggest to some that this miniature is somehow off-color—in fact,
it has recently been published as an "obscene Annunciation."[18] But icono-
graphic conventions, flexible and idiosyncratic as they can be, rule out
that possibility. The figure on the right is not Mary, the *sine qua non* of

Paradise Garden with Christ Child and Angel, *Erklärung des Vaterunsers.* Donaueschingen, Fürstl.-Fürstenberg. Hofbibliothek 298. f. 64v.

any Annunciation, obscene or otherwise. It is instead the Christ Child, as his pudgy figure, short hair, and crossed nimbus inform us. Nor is the angel an angel of the Annunciation: it bears no spray of lilies, no olive branch, no herald's staff; neither does it make an announcing gesture or offer a greeting scroll. But if this is not an Annunciation, what is it?

On the literal level, it represents a Paradise garden. The infant Christ and an angel sit in a landscape encircled by a crenellated garden wall in the back– and foreground. The Child wears a garland of roses and holds another in his hand. The angel plays upon an instrument—possibly a portatif organ or a psaltery. Although the scene contains symbols that are often used in other contexts to refer to Mary, Mary herself is not present.

To a large extent, the images here are conventional. In the fifteenth century, the Christ Child is often pictured naked in a garden, sometimes with the orb of the world in his outstretched hand, or surrounded by fruit, or playing with animals. He is often accompanied by angels, who entertain him with music and games. Although Mary is usually present, she is not always engaged with him.[19] Sometimes she sits apart while he frolics on the ground.

As I have mentioned, the Christ Child had a special meaning for medieval visionaries: seeing him transformed in the Host, they responded to him as mothers, sometimes nursing him or even giving birth to him in visions.[20] In art, as in visionary literature, mystical marriage most often occurs between an adult visionary and an infant Christ, handed over to his bride by his Mother.[21] Erotic love may inform such images, but it remains subordinated to maternal ecstasies. Through an *imitatio Mariae,* visionaries could attain mystical union with a God not as distinctly male as the adult Christ.[22] Identification, first with the mother, then with the androgynous infant who has no beard and no obvious secondary sexual characteristics, made union possible through love rather than suffering. In this miniature, his innocence and vulnerability are stressed by imagery often, though not exclusively associated with Mary: the *hortus conclusus* (the enclosed garden) and the garlands of roses.

The enclosed garden (Song of Songs 4, 12: *Hortus conclusus soror mea sponsa* [a garden enclosed is my sister, my spouse]), represented conventionally here by the crenellated walls, refers most commonly to Mary's sorrows, motherhood, and virginity, but allude as well to the blood (red) and suffering (thorns) of the Passion. In this picture, the Christ Child enclosed within the walls of the garden, as if within Mary's womb, is innocent, protected. But the roses in his hand remind us of his inevitable sacrifice.

Gathered together into a garland, roses acquire an additional set of meanings. Iconographically, the garland has associations with the crown of thorns; in some representations of the Man of Sorrows, the wound in

Christ's side is surrounded by a garland of roses. Here, though no wound mars his infant flesh, Christ holds the garland up to his side with one hand; with the other, he gestures toward the space where the wound will be. Even as he sports innocently with an angel in a pleasure garden, his sacrifice is kept before our eyes. In addition to the eucharistic symbolism of the wound in the side—having to do with Christ's motherhood and nurturing capacities—Christ traditionally displays his wound or his bleeding heart to invite the viewer in.[23] In this miniature, the roses serve as the gateway to Christ's heart: the inverse of the previous miniature, in which we see the Trinity within the human heart.

The garland Christ holds is a rosary; the word originally meant a garland or bouquet of roses. Real rosaries, though, are strings of beads used for keeping track of repetitions of prayers. Before Magdalena's time, rosaries were also known as paternosters, since they were principally used to count repetitions of the Lord's Prayer. Not until the fifteenth century were they used extensively for the Ave Maria. Even then, a Paternoster was recited between each of fifteen decades of Ave Marias. Here too, then, the apparently Marian reference of the rose garland has another, closer relationship to the text in which it appears: the garland is intended to help us keep track of the repetitions in the *Erklärung*.

When once we observe how the miniature conflates, juxtaposes, and alludes to Marian, christological, eucharistic, and paternoster symbolism, we must ask how it relates to the surrounding text. Above the miniature, the scribe has written:

Dominus dicit. Der geist des heiligen gottes ret zuo minen geist und sprach: Schrib mir dz pater noster in dz selterli und verwirck die selben wort in dz pater noster und ich hoer si als gern als die engelschen zit und lob gesang. Deo Gratias. (F. 64v)

[The Lord says: The spirit of holy God spoke to my spirit and said: Write for me the paternoster in the psalter and elaborate those same words of the paternoster and I will hear them as gladly as the angelic hours and songs of praise. Thanks be to God.]

The miniature's musical angel illustrates the text's *"engelschen zit und lob gesang,"* while the Child's rosary represents the elaborated repetitions of the paternoster. Why a Child in an enclosed garden? A clue to that choice of images can be found in the following repetitions (f. 65r ff.). In these, the petitioner represents herself as a weeping child asking for protection and comfort. She addresses Christ as a parent into whose protecting arms she wishes to flee. She refers often to infants at the breast *(sugenden),* to children, and in one especially eloquent repetition, to her own birth that transfers her from her mother's body to God's maternal

care. The image of the Christ Child in the miniature, then, is one to which the viewer can assimilate herself: she is the vulnerable child who repeats the paternoster many times, praying for her Father's protection. We are presented with a chain of equivalences: the enclosed garden = Mary's womb = rosary = Christ's wound = nursing breast = Mary = mediatrix = Magdalena = *Christusbild* = Christ.

Magdalena Beutler's *vitae* tell us that she practiced the imitation of Christ in a strikingly literal and public fashion. The notion that others might be saved by imitating her, who had herself become a type of Christ, prompted Magdalena to compose her *Erklärung*—for outward imitation was thought to work inward changes, making the practitioner Christlike almost in spite of herself.[24] The abandonment of her own persona in ecstatic utterance, the assimilation of her voice to Christ's and, as represented in the miniatures, of her heart to his, emphasize Magdalena's intention that meditators identify through her with God, so that their names might be written in *"dz lebend buoch"* (f. 65r ff).

In the miniatures, the limner has set the images from the text side by side with images drawn from the author's biography, adding further layers of meaning drawn from mother mysticism and devotion to the rosary, the sacred heart, and the eucharist. She thereby created a vernacular iconography whose symbols do not merely coexist on different interpretive planes: instead, they modify each other, casting up new meanings out of the arrangement of old symbols. Like the text, the miniatures invite the viewer to participate, to allow herself to be worked upon by the images, to be herself transformed by them.

* * *

Like hundreds of other late medieval devotional works in the vernacular, Magdalena of Freiburg's *Erklärung* was originally composed for the use of a particular community. While its themes and images reflected those of the widely practiced *devotio moderna,* a full appreciation of the work required specialized local knowledge—linguistic, visual, and biographical. As such works were copied and sent forth to a broader public, they necessarily surrendered some of their native complexity, including their miniatures, for the sake of general utility. But despite their limited appeal and graphic clumsiness, works like the *Erklärung* should not be taken to lack complex ideas. Working together, text and image inform, enlighten, and inspire, providing models for imitation and methods for practicing it. They also offer incentive to medieval Christians, who, like the rest of us, were more likely to be moved by things close to them than by things foreign and remote. Thus vernacular language and image, together with homegrown spiritual virtuosi, moved readers and viewers toward divine union more surely than incomprehensible, if elevat-

ing, Latin Christian and classical works. Although their power to move us is almost entirely gone, they nevertheless offered complex and sophisticated symbolic meanings to those for whom they were intended.

NOTES

1. This devotional subject predates the twelfth century. As James Marrow stresses, "devotion to the humanity and Passion of Christ is not, as is sometimes thought, an invention of the late Middle Ages; [they] . . . are emphasized in texts from the Greek East from at least the second century, and in western Europe texts from the sixth century and thereafter." *Passion Iconography in Northern European Art of the Late Middle Ages and Early Renaissance* (Kortrijk, Belgium: Van Ghemmert Publishing, 1979), 7. But in the earlier periods, Christ's humanity served as the object of elite, that is, monastic and theological, devotion, rather than the popular focus it became later on.

2. "Devotional programs with differing levels of intellectual appeal, low as well as high, were created, providing a set of practices and a corpus of literature capable of edifying a wide spectrum of the faithful" (Marrow, *Passion,* 10) See also Jeffrey Hamburger, "The Visual and the Visionary: The Image in Late Medieval Monastic Devotions" in *Viator* 20 (1989): 161–83, and "The Use of Images in the Pastoral Care of Nuns" in *Art Bulletin* 71, no. 1 (March 1989): 20–46.

3. For a persuasive discussion of Christian iconography as a language, see André Grabar, *Christian Iconography. A Study of Its Origins,* Bollingen Series 35, 10 (Princeton: Princeton University Press, 1968), xli–l.

4. Grabar argues that "iconography is an important and constant means of diffusing knowledge of the most diverse facts; and this is why it is entirely justifiable to consider this informative iconography a language . . ." (xlv). He notes that "one must . . . recognize what linguists call the semantic fields, that is, the sum of words (for language) or subjects (for iconography) that form semantic families, that is, families of words or subjects that are related to each other by their meaning" (xlvii).

5. Grabar prefers to consider them "one of those special or technical languages that linguists call parasitic. Such incomplete languages with a special and limited vocabulary are parasitic because . . . they depend on another language . . . and take from it those terms which are needed for the special area involved" (xlvi). James H. Stubblebine, *Assisi and the Rise of Vernacular Art* (New York: Harper & Row, 1985), in coining the term "vernacular art," does not consider the linguistic analogy.

6. Grabar acknowledges the ability of such images to communicate, but denies them the status of art: "It is an abuse to include among works of art all those painted, drawn, or sculpted images which in large part are really only signs that stand for a human figure, an object, or an idea, whether those signs are of a descriptive or a symbolic character . . . Iconography is, after all, the aspect of the image that informs, the aspect that is addressed to the intellect of the spectator, and in common to prosaic informative images and to images that rise to poetry, that is, to art" (xliv, xlv). David Freedberg, in *The Power of Images: Studies in the History and Theory of Response* (Chicago: University of Chicago Press, 1989), asserts more convincingly that the image's ability to move a viewer is more important than whether we call it art: "We must consider . . . the effec-

tiveness, efficacy, and vitality of images themselves . . . what images appear to do . . . what [people] expect an imaged form to achieve, and why they have such expectations at all" (xxii).

7. See, for example, Lilian M. C. Randall, *Images in the Margins of Gothic Manuscripts* (Berkeley and Los Angeles: University of California Press, 1966).

8. "[T]aken in isolation, apart from specific context, an image can be understood in many different ways; but its religious meaning becomes clear when it is considered as a part of a series of religious images, all serving the same purpose" (Grabar, *Christian*, xlix).

9. Magdalena Beutler of Freiburg (1407–58), a popular writer in the Franciscan mystical tradition, was well known in her locality for her dramatic public "mystical death" and for her part in bringing about the Observant reform of her convent.

10. Donaueschingen, Fürstlich-Fürstenbergische Hofbibliothek, HS 298 (Die *Erklärung des Vaterunsers* von Magdalena von Kenzingen). See K. Greenspan, "*Erklärung des Vaterunsers.* A Critical Edition of a Fifteenth-Century Mystical Treatise by Magdalena Beutler of Freiburg" (Ph.D. diss., University of Massachusetts, Amherst, 1984). The extraordinary number of copies of the *Goldene Litanei,* an excerpted version of the *Erklärung,* attests to it popularity: it exists in more than forty manuscript copies and eleven incunabula. Compared with the works of some of the best-known and influential writers of the Middle Ages, these numbers are impressive: 171 extant copies of Thomas à Kempis's *Imitatio Christi,* 133 copies of the *extendit-manum* tract ascribed to Heinrich of St. Gall, and 80 copies of Chaucer's *Canterbury Tales;* but only four copies of Julian of Norwich's *Showings* and Hadewijch of Brabant's works.

11. See below, n. 18.

12. Aron Gurevitch, among others, describes the "paradoxical" interpenetration of high and low as fundamental to medieval culture. See *Medieval Popular Culture, Problems of Belief and Perception* (Cambridge: Cambridge Univesity Press, 1988), esp. chap. 6, pp. 176–210.

13. All translations are mine.

14. On the role of images in the imitation of Christ, see Freedberg, *Power of Images,* 174. While he refers chiefly to visual images here—"real" ones, as he puts it—the mystic herself, if known personally or by reputation to the meditator, offers a "real" model for imitation as well.

15. On the importance of juxtaposition and allusion, see Grabar, preface and chapter 6.

16. The works of Angela of Foligno, Margetha Ebner, Christine Ebner, and Agnes of Montepulciano, among many others, recount such visions.

17. Mainzer Stadtbibliothek MS 15 and Freiburger Universitätsbibliothek MS 185.

18. John Friedman, "Nicholas's 'Angelus ad Virginem' and the Mocking of Noah," *Yearbook of English Studies* 22 (1992); 162–80. Friedman bases his identification of the miniature on the "penis" poking out of the angel's robe (174, n. 34). But while *something* pokes out, nothing about it but the wish to see a penis makes it so. While the number of toes on the Child's right foot and the oddness of its fingers persuade us that this limner knew little and cared less about anatomy, a rectangular penis covered with leaves and flowers (evident in the manuscript, if not in photographs of it) is perhaps too clumsy even for her. Friedman gives the limner too much credit as a draughtswoman in seeing *louche* glances, feminine "breasts," and, of course, a four-square penis in her drawing. Nevertheless, the object remains a mystery. I believe it to be something like a basket of flowers left

over from an early sketch, like the figure of the Child and the face and hands of the Angel, but no longer a part of the design. A close examination of the manuscript suggests that the limner tried to scratch it out. For a sounder, if less sensational, account of obscene figures in devotional contexts, see Karl P. Wentersdorf, "The Symbolic Significance of *Figurae Scatalogicae* in Gothic Manuscripts," in *Word, Picture, and Spectacle,* ed. Clifford Davidson, Early Drama, Art, and Music Monograph Series, 5 (Kalamazoo: Medieval Institute Publications, Western Michigan University, 1984), 1–19.

19. One example of the Christ Child alone in a Paradise garden setting appears in a 1482 miniature, Salzburger Missale Bd. 1, Bayerische Staatsbibl. München, Clm 15708 f. 28v., *Christkind im Weidenkörbchen.* I am grateful to Anne Winston Allen for her kindness in pointing it out to me.

20. See, for example, Rosemary Hale, "*Imitatio Mariae:* Motherhood Motifs in Devotional Memoirs," in *Medieval German Literature: Proceedings from the 23rd International Congress on Medieval Studies, Kalamazoo, Michigan, May 5–8, 1988,* ed. Albrecht Classen (Göppingen: Kummerle, 1989).

21. See Kate Greenspan, "*Matre Donante:* The Embrace of Christ as the Virgin's Gift in the Visions of Thirteenth-Century Italian Women," in *Studia Mystica* 13, no. 2&3 (1990): 26–37.

22. As Caroline Bynum points out, "[W]omen's most elaborate self-images were either female ("mother" to spiritual children, "bride" of Christ) or androgynous ("child" to a God who was a mother as well as a father, "judge" and "nurse" to the souls in their keeping)." *Holy Feast and Holy Fast: The Religious Significance of Food to Medieval Women* (Berkeley and Los Angeles: University of California Press, 1987), 28.

23. Ibid., 94, 116, 118, 122, 142, 155, 166–67, passim.

24. See Kurt Ruh, "Zur Theologie des mittelalterlichen Passionstraktats," in *Theologische Zeitschrift* 6 (1950): 27.

WORKS CITED

Bynum, Caroline Walker, *Holy Feast, Holy Fast: The Religious Significance of Food to Medieval Women.* Berkeley and Los Angeles: University of California Press, 1987.

Curtius, E. R. *European Literature and the Latin Middle Ages.* Translated by W. R. Trask. Bollingen Series 36. Princeton: Princeton University Press, [1963] 1973.

Freedberg, David. *The Power of Images. Studies in the History and Theory of Response.* Chicago and London: University of Chicago Press, 1989.

Friedman, John. "Nicholas's 'Angelus ad Virginem' and the Mocking of Noah." *Yearbook of English Studies* 22 (1992): 162–80.

Grabar, André. *Christian Iconography. A Study of Its Origins.* Bollingen Series 35, 10. Princeton: Princeton University Press, 1968.

Greenspan, Kate. "*Matre Donante:* The Embrace of Christ as the Virgin's Gift in the Visions of Thirteenth-Century Italian Women." *Studia Mystica* 13, no. 2&3 (1990): 26–37.

———. "*Erklärung des Vaterunsers.* A Critical Edition of a Fifteenth-Century Mystical Treatise by Magdalena Beutler of Freiburg." Ph.D. diss., University of Massachusetts, Amherst, 1984.

Gurevitch, Aron. *Medieval Popular Culture. Problems of Belief and Perception.* Translated by János M. Bak and Paul A. Hollingsworth. Cambridge Studies in Oral and Literate Culture 14. Cambridge: Cambridge University Press, 1988.

Hale, Rosemary. "Imitatio Mariae: Motherhood Motifs in Devotional Memoirs." In *Medieval German Literature: Proceedings from the 23rd International Congress on Medieval Studies, Kalamazoo, Michigan, May 5–8, 1988,* edited by Albrecht Classen. Göppingen: Kummerle, 1989.

Hamburger, Jeffrey. "The Visual and the Visionary: The Image in Late Medieval Monastic Devotions." *Viator* 20 (1989): 161–83.

———. "The Use of Images in the Pastoral Care of Nuns." *Art Bulletin* 71, no. 1 (March 1989): 20–46.

Magdalena of Freiburg. *Erklärung des Vaterunsers.* Unpublished manuscript. Donaueschingen: Fürstliche-Fürstenbergische Hofbibliothek, Hs. 298.

Marrow, James H. *Passion Iconography in Northern European Art of the Late Middle Ages and Early Renaissance.* Kortrijk, Belgium: Van Ghemmert Publishing, 1979.

Pickering, F. P. *Literatur und darstellende Kunst im Mittelalter.* Grundlagen der Germanistik, 4. Berlin: E. Schmidt, 1966.

Pseudo-Bonaventure. *Meditationes vitae Christi.* In *S. Bonaventurae Opera omnia,* xii. Edited by A. C. Peltier. Paris: 1868.

Randall, Lilian M. C. *Images in the Margins of Gothic Manuscripts.* Berkeley and Los Angeles: University of California Press, 1966.

Ruh, Kurt. "Zur Theologie des mittelalterlichen Passionstraktats." In *Theologische Zeitschrift* 6 (1950): 17–39.

Schwab, Frances Mary. *David of Augsburg's "Paternoster" and the Authenticity of his German Works.* Munich: Beck, 1971.

Schweiker, William. "Beyond Imitation: Mimesis in Understanding, Action, Text, and Language." *Journal of Religion* 68 (1988): 21–38.

Wentersdorf, Karl P. "The Symbolic Significance of *Figurae Scatalogicae* in Gothic Manuscripts." In *Word, Picture and Spectacle,* edited by Clifford Davidson. Kalamazoo: Medieval Institute Publications, Western Michigan University, 1984.

Looking and Learning: Gender, Image, and Text and the Genealogy of the Textbook

RUTH LARSON

Toward the end of Jean-Paul Sartre's novel *La nausée*, Anny, the female protagonist, describes how as a child she used to climb to the attic to look through an enormous edition of Michelet's illustrated *Histoire de France*. From these childhood experiences she developed certain notions about the relationship between narrative and illustration which she then used to structure her own conduct well into her adult life. The physical aspect of the book, that is, the book as object, intrigued her. Along with the size of the edition and the arrangement of the pages Anny was particularly concerned with the quality of the illustrations and their relationship to the accompanying text:

> There were very few pictures in them, maybe three or four in each volume. But each one had a big page all to itself, and the other side of the page was blank. . . . I had an extraordinary love for those engravings; I knew them all by heart, and whenever I read one of Michelet's books, I'd wait for them fifty pages in advance; it always seemed a miracle to find them again. And then there was something in particular: the scene they showed never had any relation to the text on the next page, you had to go looking for the event thirty pages farther on.
> . . . I'm talking about privileged situations. They were what was represented in the engravings. I called them privileged, I told myself they must have been terribly important to be made the subject of such rare images.[1]

Anny would attempt to reproduce in her own life the "grandeur" of the moments which she found singled out for illustration in Michelet. In so doing this twentieth-century fictional character conforms to a seventeenth-century pedagogical ideal of female readership. The relationship articulated in *La nausée* between images, text, and women readers of didactic books can be traced back to strategies of feminine education developed in the beginning of the seventeenth century. In the first part of this article I will explore the genealogy of text-image relations in the early-modern textbook or instructional manual, and in Jesuit educational technique. I will then study the role of early feminine and religious peda-

"Jeanne, be a good and wise child; go often to church." Michelet, "La Pucelle d'Orléans," *Histoire de France.*

gogical theory in this development. I am primarily interested in what seventeenth-century pedagogues have to say about the education of women. But, in as much as their views reflect profound changes in the way education, in general, was conceived and implemented, I will begin with a consideration of the important transformations in educational theory wrought by perhaps the two most influential of Renaissance secular and religious pedagogues, Petrus Ramus and St. Ignatius Loyola.

Pierre de la Ramée, or Ramus, best known as a reformer of logic or dialectic, was appointed Regius Professor of Eloquence and Philosophy

at what would later be called the Collège de France in 1551. As Walter
Ong points out in his 1958 study of the pedagogue,[2] Ramus's logic was a
residual one, a sampling of elements from an earlier more complicated
curriculum, pared down and, in the process, distorted, in order to be
easily taught to youngsters. His reform of logic was the product of his
insistence on "method" coupled with a concern for pedagogical efficiency,
a concern inherited from the Middle Ages when the University was con-
ceived of as a teachers' guild, and its mission was to teach how to teach.

The newest feature and most prominent characteristic of Ramus's peda-
gogical method was its emphasis on visual aids. His books are filled with
charts, brackets, and text split into dichotomies that bifurcate again and
again forming the famous Ramist trees. While the use of visuals in educa-
tion was not new (medieval scholastics had used simple diagrams and later
pedagogues invented some very complicated and ingenious mnemonic
devices), the visual aid took on a new significance with Ramism. Ramus
believed his tables and diagrams made visible the geometric and spatial
relations between terms—relations which discourse could only awk-
wardly represent. Visible, these terms were thus supposedly easier for
students to memorize. Indeed, the pinning of words to the page, the plac-
ing of terms in a spatial relationship, introduced into the lecture hall a
new teacher's aid whose governing principle implied a radical transforma-
tion of educational technique including, first and foremost, the retirement
of the teacher from his position as speaker, inculcator of knowledge. Still
stationed at the front of the class, the Ramist pedagogue conducts the
attention of his pupils now, no longer to himself, but through his pointing
finger to the true and objective authority, object of the collective gaze—
the textbook (of which each student now has a copy sitting open on
his desk).

The amplification of the textbook's role in education is especially well
illustrated in Christofle de Savigny's 1587 *Tableaux Accomplis de tous
les arts liberaux contenans brievement et clerement par singuliere meth-
ode de doctrine, une generale et sommaire partition des dicts arts, amas-
sez et reducts en ordre pour le soulagement et profit de la jeunesse.* This
is a folio volume of which the right-hand page is an enormous dichoto-
mized table, the left-hand page a prose discourse which teaches one how
to "read" the table. Occasionally the tables contain a figurative represen-
tation such as a globe for geography or a cube for geometry. The table
entitled "Dialectique" places the first definition—"Dialectique ou Logique
a deux parties"—*inside* the figure of an open book, the implication being
that dialectic is *found in* and is *taught by* books.[3]

One consequence of this insistence on the use of text and spatial dis-
plays in the teaching of university curriculum subjects was that knowl-
edge came to be looked upon as a thing,—a thing which existed outside

De Savigny. "Dialectique." 1587.

the individual, which no longer had to be passed from person to person as in a philosophical dialogue but which could be *contained* in books, *opened up* by methodical analysis. According to Ong, knowledge became a commodity, something that the university could "traffic in"; it became quantifiable and "measurable" through university examinations. Finally, this new conception of knowledge produced a new "textbook" or "manual" literature. Ong writes:

> an epistemology based on the notion of truth as "content" begins to appear. Out of the twin notions of content and analysis is bred the vast idea–, system–, method-literature of the seventeenth and eighteenth centuries. This literature consists of treatises on practically all conceivable forms of knowledge . . . conceived of as box-like units laid hold of by the mind in such a way that they are fully and adequately treated by being "opened" in an analysis.[4]

Manipulable, knowledge leaves the potentially volatile realm of sound to fix itself on the printed page. Ong points out that Ramus's concept of method is conceived, not as the arrangement of his university lectures or orations but as an arrangement of material in a book. In his lifetime his own books go through a steady progression in typographic technique, from a manuscript-based print, which reproduces the uninterrupted stream of voice in a text where line follows line forming an invariable linear organization, to a print which is self-consciously visual and makes more and more complicated arrangements of headings, subheadings, fonts, and spatial display. The arrangement of his books does not simply reflect Ramus's thinking but organizes it in turn. This is a pedagogics of layout, in which the very structure of the subject treated develops according to its successive arrangements in print.

The influence of Ramus and Ramism in European universities was enormous. Between 1550 and 1650 there were approximately 1,100 separate printings of his works.[5] Seventeenth-century pedagogues, whether they were in agreement with him or not, were necessarily affected by Ramist method because Ramism was not an isolated and individual innovation, but the characteristic product of trends in pedagogy, printing, and university organization begun in the Middle Ages.

This coordination of printing techniques with pedagogy had a similar, if not more profound, effect on religious education: the growth of Protestantism and its relationship to the availability of vernacular versions of the Bible is the most famous example.[6] But there were other consequences for the Catholic church caused by the development of printing, consequences that, by the beginning of the seventeenth century, it had learned to put to its own advantage.

The clergy had always considered the religious education of the faithful to be one of its prime objectives. To this end it relied upon an extremely

rich and sometimes complex sculptural and painted imagery to relate biblical events.[7] But the publication of St. Ignatius Loyola's *Spiritual Exercises* in 1548 and its subsequent popularization (translation from Spanish into Latin and then into other languages, its use by laymen as opposed to spiritual directors) would result in profound changes in the Church's practice of visual pedagogy. On the one hand the careful methodical approach of the *Exercises* offered religious leaders of the Counter-Reformation a badly needed spiritual program to counter allegations of laxism in the Church; thus it served as an arm against and an indictment of the intellectualism of both Protestantism and, later, Jansenism. More specifically, the *Exercises* shaped Jesuit educational technique which, in the first half of the seventeenth century, combined visual imagery in the form of illustration with its development of a highly figurative rhetoric, producing a text-image collaboration that was evangelically unsurpassable.[8]

The *Exercises* are a series of spiritual meditations meant to be practiced over a period of a month and under the direction of a guide. They describe several interesting practices, the Ignatian style of which would have a profound effect on seventeenth-century spiritual life: chiefly, the retreat, self-examination, and the use of a spiritual guide.[9] These practices were not new but had been synthesized by Loyola into what could become a widely implemented method of meditation.[10] I would like to examine in particular the method of meditation itself, performed five times daily for an hour, and in which the exercitant is told, after a preparatory prayer, to make a "composition of place, seeing the spot". This is called the "first prelude," and it is the visualization of the thing to be contemplated, for example the length, width, and depth of hell, or Mary's voyage to Bethlehem. According to Loyola, "the first prelude is a certain way of organizing space." One finds here, as in Ramus, the reference to space as an organizing principle of understanding. Loyola continues:

> Here it is to be observed that, in any contemplation or meditation on a physical reality, for example Christ, we must represent to ourselves, with the eye of the imagination, a corporeal place representing the thing we are contemplating, like a temple or a mountain, a place in which we might find Jesus Christ. If, on the other hand we are contemplating an incorporeal thing like sins. . . , the composition of place will be to imagine that we see our soul locked up in this corruptible body as in a prison. (First Week, First Exercise)[11]

Marc Fumaroli believes the Ignatian "composition de lieu" is a mnemonic device derived from Renaissance *ars memoria*.[12] The insistence on space, place, and visualization which Loyola's *Spiritual Exercises* share with Ramist pedagogy certainly relates them both to contemporary Renaissance memory systems based on topics or places. Indeed, no edu-

cational program from the period could avoid addressing the issue of memory development. But Ramus's pedagogy, believing that its spatial diagrams adequately represented the "true" relations between terms, tended to substitute memorization for understanding. And, as Fumaroli points out, the psychagogic strategy of the *Exercises* was to appeal to the will by means of the imagination; the search for truth had no place in this program: "Il ne s'agit pas de trouver Dieu, mais d'y croire, ni de connaitre la vérité de la religion, par la raison ou par le coeur, mais d'y ajouter foi."[13] In fact, Loyola's use of visual memory aids to enhance religious resolve or "autopersuasion" is illustrated in the very first pages of the *Exercises,* which contain a drawing and explanation of a self-examination device on which penitents are to tabulate their sins from one day to the next. The drawing serves as more than a simple tally sheet: the amount of space available for sins of the last day is considerably less than that for the first, and this partitioning of space on the page is a reminder, yes, but also a visible incentive, to reform oneself through the *Exercises.*

Ramus's diagrams differed from earlier mnemonic devices because they were supposed to represent the "true" relations between terms and, in so doing, make those relations easier to learn and to remember. As well, the Ignatian method used a highly developed visual register to spark memory, but, perhaps more importantly, it used spatial analogy in order to *reform behavior.*

Whether or not it was acknowledged as such by its earliest proponents, the use of visuals as memory aids in education gained wide acceptance and, by the beginning of the seventeenth century, in conjunction with the humanist literary imperative to *"instruire et plaire"* (instruct and please), resulted in a proliferation of visually aided texts and self-educational manuals. Alongside manuals claiming to simplify the most abstract and complicated of subjects came an explosion of educational visual aids— illustrated books, card games, maps, "realia"—which claimed "method" as their governing principle and which reduced the role of, or simply replaced, the teacher.

There was De Condren's "Nouvelle Methode" of 1640—an innovative Latin grammar book which used four colors to teach the principle parts of speech, gender, and tenses. The most famous and perhaps the first illustrated European schoolbook was the bilingual (Latin/German) *Orbis Sensualium Pictus* of 1654,[14] by the Czech pedagogue and theorist Johann Amos Comenius, a disciple of the German Ramist Johann Heinrich Alsted. Comenius's textbook is illustrated with woodcuts beneath which are several columns of text containing numerical references to the items in the illustration. The columns contain discussions of the picture in Latin and the vernacular; one of the columns contains a gloss of important

Orbis Sensualium Pictus, 1685.

words and a guide to their declension and genders. The novel educational design of the *Orbis Pictus* lies in its combination of illustration with a breakup and manipulation of the printed page. Paradoxically, the depiction of a schoolmaster in the introductory woodcut only makes more apparent the function of the little book as replacement of the human pedagogue: the inadequacy of auricular education is pointed up by the very helpful column of gloss on the master's voice; the deficiency of the voice is in turn accused by the master's raised finger which is pointing to the objects in the illustration, his visual aids.

Louis de Lesclache's *La Philosophie en Tables*, first published in 1651, is another case in point. In it the pedagogue has been replaced by a table which "presents" matter and "teaches" ideas. The approach is explained in a "Key to the Tables":

La perfection d'une Methode consiste à contenir plusieurs choses, & à les enseigner en peu de mots, & avec ordre; en sorte que de cette seule veuë l'on

y puisse remarquer non seulement cet ordre, mais la raison que l'établit . . .
Tous ces avantages se trouvent visiblement dans la Methode des Tables . . .
car une Table bien faite embrasse toutes les notions de la matiere qu'elle en-
seigne, & les dispose en sorte devant les yeux de l'Esprit & du corps, qu'on y
void les plus Generales à part, servir de point de convenance aux autres &
puis se diviser & se rependre comme une source en plusieurs ruisseaux, ou
un Tronc en plusieurs branches sensiblement separées; les sens & l'imagination
servant en cela notablement à l'esprit, aussi bien que l'ordre à la Memoire.[15]

Lesclache's pedagogical theory and the production of his tables are the
unquestionable result of Ramist influence. His description of dichotomy
as a branching tree takes up the favorite Ramist emblem which links
Ramus personally to his method (ramus-i = branch). He echoes Ramus's
insistence on the immediacy of understanding which a visual representa-
tion supposedly offers: one sees and understands "all at once," "at a
glance" by means of the senses and the imagination. This peculiar notion
is one which seems to have been quite influential though no pedagogue
manages to explain convincingly (1) that it is true; and (2) why learning
something "at a glance" is better or more thorough. The appeal of the
"at a glance" method certainly had much to do with its direct opposition
to old-style scholasticism and its accessibility to a scholastically undisci-
plined readership. The Jesuit pedagogue Pierre LeMoyne, to whom I will
return later, makes this clear in a discussion of the educational expedience
of the device—a popular visual motto similar to a corporate logo:

Quoy qu'il en soit, on ne se pouvoit aviser d'un moyen d'instruire, plus court
et plus efficace que celuy-là. . . . Par la voye des Devises, on arrive en un
moment & d'une veuë, avec plaisir mesme & comme en jouant, où l'on n'iroit
pas en six journées de travail et de chagrin, par les chemins de l'Ecole.[16]

Pierre Nicole, a Port-Royal teacher, writer, and polemicist, advocates,
in his 1679 *Essais de Morale,* the use of visual aids in educational practice
in terms which reveal the tendency shared by many teachers to think
of reasoning as something associated with the nonvisual, the visual as
associated with the pleasant; this entertaining, nonreasoning, and sensual
frequentation of visuals is used to "fix" ideas in the heads of children who
lack the faculty to reason. For example, Nicole claims that geography is
especially suited to children because "it is largely a matter of the
senses"—which is to say, a matter of vision; "outre qu'elle est assez
divertissante, ce qui est encore fort nécessaire pour ne les pas rebuter
d'abord; qu'elle a peu besoin de raisonnement, ce qui leur manque le plus
en cet age."[17]
Despite the seriousness of the Ramist philosophical program with its
talk of "natural schemes," "true relations," and "methodical order," most
seventeenth-century pedagogues, like Nicole, LeMoyne, and Lesclache,

regarded visual materials as something especially suited to unserious students. For the latter, spatial organization would not only simplify the curriculum, it also could be counted upon to carefully control a student's apprehension of the material. Charts, tables, and images left no room in the student's mind for errors based on badly taken lecture notes.[18]

The humanist preoccupation with developing a "disciplinary approach" to education, that is, one rooted in imitative and reproductive practices, was shared by religious educators of the seventeenth century. Indeed, Loyola's spatial device for recording sins during the *Exercises* was ingeniously modified and expanded in the mid-seventeenth century in a little confessional manual by Christofle Leutbreuver called *La confession coupée*. First printed in Paris in 1650, it saw a fourth edition in 1655 and at least two others in 1677 and 1682. The book claims to contain a list of "all the mortal and venial sins which can be committed against God." Each sin is printed between two black lines on a horizontal slice of the page, bound into the spine at the left and freely moving on the right. The "sin" is held down in place on the page when it is slipped under a fold of paper at the right-hand margin. To prepare for a complete confession, and in order to remember all the sins one has to confess without having to write anything down, the penitent is told to read through the sins and, with the help of a pointy device such as a pin, to "lift up" from between its black lines each sin which needs to be confessed. During the confession, all the sins which are raised up outside of their lines are those one should accuse oneself of. After the confession, all these slices of the page can be slipped back between the lines and anchored under the folds, so that no one else can see what was confessed.

The *confession coupée* is supposedly a memory aid. Like other confessional manuals in the vernacular, it presented people with a list of sins to read through, thereby reminding them of sins they may have forgotten, and defining as sinful certain activities they may not have recognized as such. More important, it seems to me, is the activity which this highly spatialized little manual forces the penitent to perform. The procedure of stabbing and manipulating slices of paper requires dexterity and mental concentration. Far from "expediting" or "cutting" the confession, the book requires that individuals confront their sins at least three times: first, in meticulously prying the "sins" out of their linear order; then, in confessing them; and finally, in carefully reinserting them into the page. The whole process tends to transform sin into a textually defined and spatialized "thing"—manipulable, repressable, and, most importantly, identifiable as something which transgresses, ever so slightly, the lines of printed space.

The spatialization of the educational curriculum in the textbook and spiritual method may have served the interests of a larger disciplinary

practice of so-called moral reform, whose ultimate goal was behavioral control. One thing is certain, and that is that women and children were the privileged objects of these new pedagogical techniques: Ramus's innovations came out of a need to simplify logic for schoolboys; and, as I will demonstrate later, the moral, and, more precisely, sexual, edification of women was one of the crucial aims of Counter-Reformation Jesuit pedagogy.

If Jansenists like Nicole guardedly acknowledged the pedagogical utility of imagery, the Jesuits, in light of the continuing success of Loyola's *Exercises,* had been given a veritable mandate to make illustration *a,* if not *the,* key element of Counter-Reformation religious education. The first step for the Jesuits was to illustrate the *Exercises* themselves: Father Jerome Nadal's *Adnotationes et meditationes in evangelia (Meditations on the Gospel)* appeared in 1594 in two parts. The first part contains 153 engravings representing the life and teachings of Christ; the second part is text, each section of which refers, by lettered references, to various parts of an illustration. The text begins with a scriptural passage followed by remarks and a meditation. This is a popularized, illustrated version of Loyola's *Exercises* meant to reach a public, including the *sexe dévot,* who had less religious education and therefore a limited scriptural imagination upon which to draw for the "composition of place." The illustrations are provided to fill the mental void, and they fill it with an even more controlled spiritual program than that of Loyola. Nadal's illustrations offer a ready-made memory—that imagined by the author-guide who increasingly comes to replace the personal spiritual director.

The mnemonic devices of the *Adnotationes* were taken up by the elaborately illustrated French translation of Philostrate's *Tableaux* in 1614 and set the style for seventeenth-century illustrated religious texts of which the Jesuits were the principal producers. As Father Louis Richeome had claimed in his illustrated *Tableaux sacrées des figures mystiques du très auguste sacrifice et sacrement de l'Eucharistie,* "Il n'y a rien qui plus délecte et qui fasse plus suavement glisser une chose dans l'ame que la peinture, ni qui plus profondément la grave en la mémoire, ni qui plus efficacement pousse la volonté pour lui donner branle et l'émouvoir avec énergie."[19]

The idea that images slip knowledge into the soul, engrave it into the memory, or imprint it on the mind is an ancient topos repopularized in the sixteenth and seventeenth centuries by several developments: the printing press, Renaissance preoccupation with memory systems, the substitution of copper engraving for woodcuts in Paris (the new European center for engraving), and the 1575 publication of a book by a Spanish doctor, Jean Huarte, called *Examen de Ingenios para las ciencias* [Examination of temperaments for the sciences]. In what follows I would like to

examine certain of Huarte's theories of education and their influence on French pedagogues, feminists, and anti-feminists.

Huarte's extremely popular work was a kind of medico-scientific treatise which, drawing on Aristotle, Hippocrates, and Galen, offered an interpretation of the various temperaments of human beings and a guide, for parents and educators, to the intellectual talents and weaknesses occasioned by these temperaments. Huarte, in his preface, claims: "L'intention donc de ce Livre, c'est d'apprendre à distinguer & à connoistre toutes ces differences naturelles de l'esprit humain, & d'appliquer avec art à chacune, la science où elle doit faire plus de profit."[20]

According to Huarte there are three active temperaments—hot, dry, and moist—which affect differently the faculties of memory, imagination, and judgment. Hot and dry temperaments have good imagination and judgment but weak memory. Moist temperaments have good memory but no imagination or judgment. In Huarte's classification, cold has only a negative role: it acts as a hindrance to the mental faculties—memory, imagination, and judgment.

Memory furnishes the imagination and judgment with the images necessary to reason; the job of memory is to conserve these images. Huarte cites Galen: "la memoire renferme & conserve les choses, qui ont esté connues par les sens & par l'esprit, comme quelque coffre & reservoir . . ." From this Huarte concludes that memory depends on moisture, which makes the brain softer and more susceptible to impression: "Nous avons dit aussi que pour avoir bonne memoire, il falloit que le cerveau fust moû, dautant que les figures s'y doivent imprimer comme en les pressant, & que si il est dur, elles ne pourront pas facilement se graver." Imagination and judgment require hot and dry temperaments.[21]

Men are ideally hot and dry; women are cold and moist. Interestingly, it is the assumed difference in aptitude between the sexes which Huarte uses as the prime example and proof of the validity of his theory of temperamental diversity.

> La verité de cette doctrine paroistra clairement, si nous considerons l'esprit de la première femme qui fut au monde . . . c'est un point decidé qu'elle en sçavoit bien moins qu'Adam. . . . La raison donc pourquoy la première femme n'eut pas tant d'esprit, c'est que Dieu l'avoit faite froide et humide, qui est le temperament necessaire pour estre foeconde & avoir des enfans, & celuy qui contredit à la science & à la sagesse.[22]

He uses the same assumption (his "point decidé") of the intellectual inferiority of women to refute Aristotle's equation of judgment with soft skin:

> considerons la chair des femmes & des enfans, & nous trouverons qu'elle est plus douce et plus delicate que celle des hommes, & neantmoins les hommes

pour l'ordinaire ont meilleur esprit que les femmes . . . si [la peau] est molle
& delicate, elle denote . . . bonne memoire, peu d'entendement & moins
d'imagination.[23]

From this discussion it becomes clear that the one aptitude Huarte
believes women do have is an aptitude for memory. Because women are
moist, he concludes that their brains are more susceptible to impression.
A good memory is like a smooth white sheet of paper awaiting an inscrip-
tion: "la memoire n'est qu'une mollesse & douceur du cerveau, disposée
par certaine sorte d'humidité à recevoir & à garder ce que l'imagination
conçoit, avec le mesme rapport qu'il y a entre le papier blanc & poly, &
la personne qui doit écrire."

It is the cold, humid complexion of women, Huarte reminds us, that
caused St. Paul to declare "Que la femme n'enseigne pas, mais qu'elle se
taise & apprenne, & soit subjette à son mary."[24] In other words, women
should act in accordance with their natural moistness and passivity, offer-
ing themselves as a sticky memory upon which to record the lessons of
God and men.

Huarte recognizes that there are some extreme cases of women who
possess God-given talent; he cites Judith and Deborah, biblical heroines,
as examples of women who should speak and teach; in doing so he opens
a small window of opportunity for early feminists to espouse what is
otherwise a theory which comprehensively condemns feminine intellect.
As will become evident below, this is precisely what occurred. Moralist
educators turned Huarte's advocation of individualized education into a
pedagogical program to meet their idea of the specific and different needs
of women, whose intellectual reputation they attempted to redeem using
the very theories which Huarte had constructed against them.

* * *

As I suggested earlier, for Counter-Reformation educators the possibil-
ity of feminine moral education and reformation was an especially im-
portant goal in the solidification of ecclesiastical and state control of the
populace.[25] In France at the beginning of the seventeenth century, sex,
marriage, and reproduction in the laity were a central concern of religious
leaders as evidenced by their reiterations of the Church's opposition to
birth control and by the writings of devout humanists like François de
Sales. In his *Introduction à la vie dévote,* de Sales insisted on the spiritual
duty of wives to engage in procreative sex "qui est si saint, si juste, si
recommandable, si utile à la république."[26]

Jesuit pedagogues were particularly vehement in their assertions that
the best way for women to attain moral perfection was through a moral
education, and in particular through the moral education of books. Since
Counter-Reformation strategies depended upon the positing of a "per-

fectable" feminine moral nature, Jesuit pedagogues, in their books written toward that end, took up the "feminist" side of the medieval and Renaissance "Querelle des femmes." Drawing on and expanding this topos which addressed feminine merits and imperfections, sixteenth- and seventeenth-century educators in France and Italy turned the topos toward the issue of feminine education. Interestingly, writers on both sides of the debate invoked Jean Huarte's theory of the cold moistness of women to support opposing claims about women's intellectual abilities.

The Jesuit pedagogue Pierre LeMoyen (who favored women's education), in his *La Gallerie des femmes fortes* of 1647, answers the moral question "Si les femmes sont capables de la vraye Philosophie." He writes:

> On leur reproche l'humidité de leur complexion: mais on ne la leur reprochera point, quand on se souviendra que l'humidité est la matière dont se forment les images qui servent aux Sciences: qu'elle est le propre Temperament de la memoire, qui en est la depositaire et la nourrice.

LeMoyne resurrects the Aristotelian argument about soft skin (or *delicatesse*) which Huarte had attempted to refute:

> Quant à la delicatesse, apparemment ceux qui leur en font un sujet d'accusation, n'ont pas pris l'avis d'Aristote. Ils sçauroient que le temperament le plus delicat est le moins chargé de matiere: le plus net et le plus propre à estre penetré des lumières de l'Esprit; le mieux preparè aux belles images et à l'impression des sciences.[27]

The anonymous author of *La femme genereuse* (1643), a virulent proto-feminist tract from the period, expressed a similar idea in more graphic terms: here one reads of "imprinting" and "engraving" images onto women who "retain" and "conserve" the engraving better than men due to their softer, colder nature.[28]

But the image of the engraveable woman remains highly ambivalent: on the other side of the debate, a misogynist writer de Ferville, *La méchanceté des femmes* (1618), evokes it to prove women's lack of moral worth: "L'esprit de la femme est comme la toile d'un Peintre, qui reçoit indifferemment l'impression de toutes couleurs, et n'en a jamais d'asseurée que le noir qui une fois couché ne s'efface jamais."[29]

The passages cited above illustrate the influence of Huarte's theory of the temperaments with respect to the susceptibility of women to images, that is, their ability to have things impressed upon them. LeMoyne saw clearly the means of exploiting such an idea: joining theory with practice, he sumptuously illustrated his books for women in an attempt to gain greater influence over their impressionable minds. In 1640 he published

Les peintures morales, où les passions sont représentées par tableaux, par caractères, et par questions nouvelles et curieuses. This book is an illustrated series of philosophical discussions punctuated by poems and descriptive prose; it was designed to teach its readers to control their passions.[30] His later book *La gallerie des femmes fortes* which I mentioned earlier, is a collection of portraits of heroic women of history—Deborah, Judith, Joan of Arc, Mary Stuart—in prose, verse, and engravings. Dedicated to Anne of Austria, the book provided examples of feminine virtue both for the edification of women and in order to contradict antifeminist claims of feminine vanity, cowardliness, and lubricity.[31]

Believing women highly susceptible to images, LeMoyne filled his *Gallerie* with figurative and rhetorical imagery meant to entice women away from their fascination with novels and toward a more chaste reading diet. The illustrations are in no way merely ornamental: the book sets up an interactive relationship between text and image; the reader is frequently directed to the illustration, asked to consider this or that detail. This is a manual for feminine moral behavior, with pictures to aid in the comprehension of the text. Indeed, *La gallerie des femmes fortes*, with its combination of illustrations, moral lessons for women, and feminine heroism effectively theorizes, for a generation of seventeenth-century educators, the gender specificity of Anny's fascination with illustration in *La nausée*.[32]

One interesting permutation of the topos of the engraveable woman is that of the engraved woman, the woman as book. Devotional literature of the period counseling women on the development of their spiritual interior had a tendency to refer to this space as if it were the pages of a book, that is, as if it might ideally come to resemble the pages of a book of devotional literature. Jean Aumont's *Abbregé de l'agneau occis, ou methode d'oraison* of 1664 advises women each day to "feuilleter votre livre intérieur où on apprend la parolle incarnée."[33] The Jesuit Pierre Coton's 1609 *Interieure occupation d'une ame devote* provides prayers for women faced with temptation, domestic responsibilities, and everyday events such as "Quand on flaire un bouquet" [When sniffing a bouquet]; the preconfession prayer which it recommends makes abundantly clear its conception of woman's soul as an inscription of sins and virtues to be spread out like so many sheets of paper and carefully read through:

> Imprimez à mon entendement une parfaite cognoissance de la beauté des vertus, & de la deformité des vices, afin que distinctement et avec science j'estale ma conscience devant [mon directeur] . . . gravez en mon ame la haine du peché & le vray desplaisir de ma vie passée . . . aidez moy en l'exacte recherche de mon interieur, en l'entiere accusation & confession de mes fautes.[34]

LA Pucelle envoyée de Dieu au secours de la France, entre dans Orleans assiegé par les Anglois: et par la liberté de cette Ville donne commencement à la delivrance de l'Estat. *Annales Gallie.*

Vignon invent. *Mariette excud. cum privil. Regis*

LeMoyne. Jeanne d'Arc, *La Gallerie des femme fortes.*

Both of these meditational manuals are, like Nadal's meditations, illustrated: *Abbregé de l'agneau occis* has fold-out illustrations, which, in their flection, suggest the ideal state of the reader's self-reflective soul and reinforce the sense of intimacy and interiority which the book attempts to convey.

In Jacques DuBosc's conduct manual of 1632, *L'honneste femme*, this Jesuit educator takes up the misogynist side of Huarte's theories when he counsels women on conversation. Women are advised to talk little and choose their companions carefully: uneducated women will have sterile conversation but educated women are sometimes confused and tiresome. They haven't enough "heat" in their temperament to digest what they read. They are slaves to their memory and have no use of judgment. They speak in "common places." These memory-women have become the books they are discussing: "elles en veulent dire tout jusques aux marges, aux feuillets, aux dattes, & d'autres circonstances superfluës . . . depuis qu'elles ont commencé un discours, il faut qu'elles vuident leur chapître, elles ne cessent de parler."[35] The image of the woman "emptying her chapter," of the woman turned book, is mirrored in the book itself: Du-Bosc has suppressed his name from the title page and develops, in his dedication, the metaphoric value of the title—*L'honneste femme*—into a figure of the book as an accomplished, *honnête* woman come to offer her polite and helpful advice to the (female) dedicatee. The quintessential figure of the engraved woman, DuBosc's woman-book incarnates the pedagogical strategy and ultimate goal of seventeenth-century "gyne-gogues": educate a woman to conduct herself appropriately, present her with images of feminine virtue upon which to model herself, and teach her to regulate her passions by imprinting upon the pages of her insides a moral agenda written (and illustrated) by men.

In the half-century during which Descartes officially theorized for scientific inquiry the privileged status of sight and observation, feminine educators still espoused the essentially Aristotelian medieval and Renaissance concept of the scientific image. Not only did they espouse it, but the most vocal among them argued its special communicative significance for women. Susceptible to its impression, women were the perfect passive medium into which the scientific image would lay itself. It is perhaps in this educational context, that is, the increasing "feminization" of the Aristotelian image, that we should consider Descartes's "revolution" of scientific method, and in particular, the new sciences' very different conception of the scientific image. Given that the Aristotelian image, as its influence waned, had been deemed appropriate for feminine intellect, is it at all surprising that the new, classical model of scientific inquiry in the developing sciences should be defined in opposite terms? that it should privilege the active over the passive, the gaze over the image; that it

should be an invasive form of investigation of the object, viril, penetrating, and provocative?

Anny's relationship to illustration in *La nausée*—that is, her recognition of it as a privileging of certain mystical and transcendent moments and her attempt to fashion her life in conformity with that transcendence—echoes Renaissance and Counter-Reformation educators' claims about women and images. Her remarks confirm the persistence, to this day, of a gendering of scientific and educational practice which began in the early seventeenth century and which attributed to the image a communicative power of moral influence over women.

NOTES

1. Jean-Paul Sartre, *La nausée,* trans. Lloyd Alexander (New York: New Directions, 1964), 146, translation modified.

> Ils avaient très peu d'images, peut-être trois ou quatre par volume. Mais chacune occupait une grande page à elle toute seule, une page dont le verso était resté blanc . . . J'avais pour ces gravures un amour extraordinaire; je les connaissais toutes par coeur, et quand je relisais un livre de Michelet, je les attendais cinquante pages à l'avance . . .
> Je te parle des situations privilégiées. C'étaient celles qu'on représentait sur les gravures. C'est moi qui les appelais privilégiées, je me disais qu'elles devaient avoir un importance bien considérable pour qu'on eût consenti à en faire le sujet de ces images si rares. (Paris: Editions Galliamard, 1938), 205.

2. My discussion of Ramus is based primarily on this book—Walter Ong, *Ramus, Method, and the Decay of Dialogue* (Cambridge and London: Harvard University Press, 1958)—along with Frances Yates's *The Art of Memory* (London: Routledge & Kegan Paul, 1966).

3. Christofle de Savigny, *Tableaux accomplis de tous les arts liberaux contenans brievement et clerement par singuliere methode de doctrine, une generale et sommaire partition des dicts arts, amassez et reduicts en ordre pour le soulagement et profit de la jeunesse,* 2 vols. (Paris, 1587), vol 1.

4. Ong, *Ramus, Method,* 315.

5. See Walter Ong, *Ramus and Talon Inventory* (Cambridge and London: Harvard University Press, 1958).

6. See Lucien Febvre and Henri-Jean Martin, *L'Apparition du livre* (Paris: Editions Albin Michel, 1958). Translated as *The Coming of the Book: The Impact of Printing 1450–1800* (London: Verso Editions, 1984).

7. See Emile Mâle, *L'Art religieux de la fin du moyen âge en France* (Paris: A. Colin, 1922); and *L'Art religieux après le concile de Trente* (Paris: A. Colin, 1932).

8. See Marc Fumaroli, *L'Age de l'eloquence: rhétorique et "res literaria" de la Renaissance au seuil de l'époque classique* (Genève: Droz, 1980), 421, 673–85. See also Henri-Jean Martin, *Livre, pouvoirs et sociètè à Paris au XVII siècle (1598–1701),* 2 vols. (Geneva: Droz, 1969), 1:168–69.

9. The guide's role would become increasingly ambiguous, in large part as a result of publication of the *Exercises* and especially of its seventeenth-century imitations. See below, discussion of Nadal. But the *Exercises* were not intended to replace the personal spiritual guide, and in an attempt to thwart this inevitable

occurrence, the book was originally published "off the market." Copies could only be obtained from Loyola by those who had undergone the "exercises" and intended to use the book to help others to experience them.

10. See H. Watrigant S. J., "La Genèse des exercises spirituels de Saint Ignace de Loyola," *Etudes* 71 (1897): 506–29.

11. This is my own translation from the Latin vulgate in the edition Monumenta Historica Societatis Jesu, *Sancti Ignatii de Loyola Exercitia Spiritualia* (Rome: Institutum Historicum Societatis Jesu, 1969).

12. Fumaroli, *L'Age,* 421. Fumaroli cites Frances Yates, *The Art of Memory,* as the basis for his analysis.

13. Fumaroli, *L'Age,* 679. "The point is not to find God, but to believe in him, not to know the truth of religion, through reason or the heart, but to increase one's faith" [my translation].

14. Johann Amos Comenius, *Orbis Sensualium Pictus* (Nuremberg: Wolfgang Endter, 1654).

15. Louis de Lesclache, *La Philosophie en Tables, Divisée en Cinq Parties, à Sçavoir La Logique . . . La Science Generale . . . La Physique . . . La Morale . . . La Theologie Naturelle par Monsieur de Lesclache. Avec l'Abregé des mesmes en trente-deux autres Tables, par le mesme Auteur* (Marseille: Claude Garcin, 1675), 1st ed. 1651. Lesclache made his reputation outside the university offering lectures of popularized philosophy for women and the court.

The perfection of a method consists in its containing several things, and in teaching them in few words and with order; so that with one glance one can notice not only the order, but the reasoning which establishes it . . . All these advantages are visibly found in the Tables Method . . . because a well made Table includes all the notions of the matter which it teaches, and arranges them in such a way before the mind's and the body's eye, that one can see the more general notion serve as a point of departure for the others and then divide and split like a river springs into several, or a trunk into several obviously separate branches; the senses and the imagination in all this serve the mind, and order serves the memory. [my translation]

16. Pierre LeMoyne, *De l'Art des devises* (Paris: 1666), 61. The tenacity of this particular pedagogical prejudice can be seen, a century later, in Denis Diderot's aesthetic theory. Diderot claims that the composition of a painting should teach a moral lesson; to that end it should be clear, singular, and simple. It must be capable of being understood in a "coup d'oeil." "Essais sur la peinture," (1766) in Denis Diderot, *Oeuvres Esthétiques* (Paris: Garnier Frères, 1959), 711–15.

No matter what, you couldn't find a better, shorter, or more efficacious way of teaching than this one. . . . By means of the Devise, you arrive in a moment, and at a glance, with pleasure even and as if in play, to a point you couldn't get to after six days of work and chagrin by academic methods. [my translation]

17. Pierre Nicole, *Essais de Morale,* 2 vols. (Paris: Guillaume Despres, 1733), 2:293–98. "Besides which it is entertaining, which is truly necessary to keep from discouraging them; and it [geography] requires little reasoning, which is most lacking in them at their age" [my translation].

18. Richard Halpern's *The Poetics of Primitive Accumulation: English Renaissance Culture and the Genealogy of Capital* (Ithaca and London: Cornell University Press, 1991) analyzes "disciplinary" practices in Tudor education. In an example pertinent to my argument, Halpern demonstrates how, in Renaissance England, the two techniques of penmanship, letter formation and the control of

ink flow, symptomatized the antagonism between sedentarizing and "nomadic" social relations. Letter formation involved a

> sort of bodily orthopedics . . . [in] . . . the control of hand, elbow, and sitting posture. [T]he teaching of handwriting had a noticeably disciplinary character, with an emphasis on exactness and uniformity (of shape, size, and spacing) in the production of letters . . . Cross-hatching on the page was also recommended as an aid for beginning students. Penmanship as copying thus emerged from a striated or "ruled" space (in every sense of the word). (80–81)

By contrast, the practice of line production, based on the control of ink flow, was the special domain, not of the schoolmaster, but of the wandering scrivener whose lessons in the art of creating "rude flourishes" were feared to "draw away the mindes of many of the Schollars from their bookes." (John Brinsley, *Ludus literarius* [1612; facs. rpt. Menston, England: Scholar Press, 1968], sig. Hiv. Cited in Halpern, *Poetics,* 82.)

Halpern's thorough analysis of the disciplinary nature of humanist Tudor education and his specific example of penmanship practices persuasively argues the point that I made earlier with respect to Loyola's *Exercises:* namely, that spatial organization in religious and lay education had, as at least one of its goals, behavior reform.

19. Cited in Henri Bremond, *Histoire littéraire du sentiment religieux en France depuis la fin des guerres de religion jusqu'à nos jours,* 12 vols. (Paris: Librairie Armand Colin, 1967), 1:7. "Nothing delights and more sweetly slips a thing into the soul than painting, and nothing more profoundly engraves it into the memory, or more efficiently pushes the will to stir it and move it with energy" [my translation].

20. Because this work was available almost immediately in French (it was translated as early as 1580 and saw more than 25 French editions in the period 1580–1675) and as I am particularly interested in the French reaction to it, all citations are from the 1645 French translation entitled *L'Examen des Esprits pour les sciences ou se montrent les differences d'Esprits qui se trouvent parmy les hommes, & à quel genre de science chacun est propre en particulier* (Paris, 1645). "Thus the intention of this book is to teach to distinguish and to know all the natural differences of the human mind, and to apply each artfully to the science where it will do most good" [my translation].

21. Huarte, *Examen,* 197–98, 224–25.

> The memory contains and conserves those things which have been known by the senses and the mind, like a coffer and a reservoir.
> We also said that in order to have a good memory it was necessary that the brain be soft, such that the figures can imprint themselves there as if they were pressed in, and that if it is hard, they will not be easily engraved. [my translation]

22. Huarte, *Examen,* 631–32.

> The truth of this doctrine will appear clearly if we consider the mind of the first woman in this world . . . it is a decided fact that she knew a lot less than Adam. The reason, then, why the first woman had less intelligence, is that God had made her cold and moist, which is the temperament necessary to be fertile and have children, and which is contrary to science and wisdom. [my translation]

23. Huarte, *Examen,* 239–40.

Consider the skin of women and children and we will find that it is softer and more
delicate than that of men, and nevertheless men usually have better intelligence than
women . . . if [the skin] is soft and delicate . . . that means . . . good memory, little
understanding and less imagination [my translation]

24. Huarte, *Examen,* 236, 632. "The memory is but a softness of the brain,
disposed by a certain moistness to receive and hold what the imagination con-
ceives, having the same relation as that which exists between white and polished
paper, and the person who must write." "Woman should not teach, but she should
keep still and learn, and be subject to her husband" [my translation].
25. Sandra Cavallo and Simona Cerutti's study of matrimonial lawsuits in Pied-
mont between 1600 and 1800 demonstrates the negative effects for women of
Counter-Reform marriage and sexual policies. According to their study, the
Church's attempt to subordinate community courtship customs to official cere-
mony created a more highly defined concept of moral deviance in sexual matters.
But, as might be expected, the dishonor associated with deviant sexual behavior
did not define the public image of men so unrelentingly as it did that of women.
The authors conclude that the development of the Church's control of heterosex-
ual relations and marriage custom through the eighteenth century marked

an evolutionary process whereby the [community] bonds that guaranteed solidarity and
protection to the woman were weakened, creating in turn a progressive focusing on her
of all responsibility for sexual relations. . . . All these elements unite, in our opinion, in
supporting the hypothesis that the responsibility which once had been broadly shared
was now concentrated on the woman. This dynamic appears reducible to a larger process
of isolating the individual from the protective context of broader relationships; this was
one of the principal effects of the penetration of ecclesiastical institutions into the social
fabric. The means and the language with which this process was affirmed were many. In
the area of relationships between the sexes, the continuous warnings contained either in
manuals of instruction or in the Piedmontese synods had a definite role in discouraging
the most organized forms of socialization among youths, which used to exert a collective
control on such relationships.

Sandra Cavallo and Simona Cerutti, "Female Honor and the Social Control of
Reproduction in Piedmont between 1600 and 1800," *Sex and Gender in Historical
Perspective.* Selections from *Quaderni Storici,* ed. Edward Muir and Guido Rug-
giero, trans. Margaret, Mary and Carole Gallucci (Baltimore: The Johns Hopkins
University Press, 1990), 100, 103. See also Michel Foucault, *L'Usage des plaisirs,
Histoire de la sexualité,* 3 vols. (Paris: Gallimard, 1984) vol. 2, where he makes
at least three references to an idea which, unfortunately, was to have been devel-
oped in the never-published 4th volume *Les Aveux de la chair.* That is, whereas
in the classical period, concepts of virtue and moral health were defined by the
practices of men and exemplified in their relations with young boys, in the Western
Christian tradition these concepts developed around a preoccupation with
women's virtue (virginity, sexual fidelity, motherhood). In the Christian pastoral,
women's virtue became the register of the moral health of society, thus the impor-
tance of a moral education for women as part of Counter-Reform pedagogical
practice.
26. François de Sales, *Introduction à la vie dévote,* 1609, ed. Fabius Henrion
(Paris: J. Calvet, 1929), 269: "which is so sacred, so just, so recommendable, so
useful to the republic" [my translation].
27. Pierre LeMoyne, *La Gallerie des femmes fortes* (Paris: Antoine de Somma-

ville, 1647), 251. Cited in Ian Maclean, *Woman Triumphant: Feminism in French Literature 1620–1652* (Oxford: Clarendon Press, 1977), 48.

They are reproached for the humidity of their complexion: but one will cease to reproach them for this when one remembers that humidity is the matter from which are formed the images which serve the Sciences: that humidity is the true temperament of memory, which is their trustee, and nurse.

As for softness, apparently those who make of it a subject of accusation have not taken the advice of Aristotle into account. They would know that the most delicate temperament is the one least charged with matter: the purest and the most capable of being penetrated with the light of intelligence; the most disposed toward beautiful images and the impression of the sciences. [my translation]

28. Ibid.

29. Ibid. "The mind of a woman is like a painter's canvas which receives indifferently the impression of any color, but is certain to retain only the black, which once laid on can never be erased."

30. Pierre LeMoyne, *Les Peintures morales, où les passions sont representees par tableaux, par characteres, et par questions nouvelles et curieuses* 2 vols. (Paris: Sebastien Cramoisy, 1640–43). According to Fumaroli, *Les Peintures morales* were addressed to the two elite groups of women for whom LeMoyne served as spiritual director: the "grandes dames de famille parlementaire" and the women of the court. Fumaroli, *L'Age*, 251.

31. The regencies of Marie de Médecis and Anne of Austria along with the political activities of aristocratic women during the Fronde inspired many histories of illustrious women during the first half of the seventeenth century. Often illustrated, the heroic women of these books are dressed in armor, a shield in one hand and a sword in the other. Judith holding the head of Holopherne, Hercules and Omphale, and Joan of Arc are some of the legendary women held up as examples of the moral strength of women worthy of emulation. See Hilarion de Coste's *Les eloges et vies des reynes, princesses . . . illustres en pieté*, 1630; François d'Aubignac's *La Pucelle d'Orleans*, 1642; François de Grenaille's *La galerie des dames illustres*, 1643; Jacques DuBosc's *La femme heroïque, ou les heroïnes comparées avec les heros en toute sorte de vertus*, 1645; Antoine Bouvot's *Judith, ou l'amour de la patrie*, 1649; Jean Chapelain's poem *La Pucelle ou la France delivrée*, 1656, to name just a few.

32. There is perhaps also a parallel to be drawn between the early-modern conception of the moist, sticky passivity of memory and de Beauvoir's definition of immanence.

33. Jean Aumont, *Abbregé de l'agneau occis, ou methode d'oraison, Disposé en trois sortes d'entretiens & commerces interieurs à exercer au fond du coeur par trois sortes de moyens & pratiques, conduisans à trois sortes d'unions avec Dieu . . .* (Rennes, 1664), preface.

34. Pierre Coton, *Interieure occupation d'une ame devote*, 2d ed. augmentée (Paris, 1609). According to Bremond, *Histoire Religieux*, vol. 2, the *Interieure occupation* was compiled from letters written by Coton to an influential lady whom he directed spiritually.

Imprint into my understanding a perfect knowledge of the beauty of virtue and of the difformity of vice, so that distinctly and with science I may spread out my conscience before [my director] . . . Engrave into my soul the hatred of sin and a true displeasure

with my past life . . . aid me in the exact investigation of my interior, in the entire
accusation and confession of my faults . . . [my translation]

35. Jacques DuBosc, *L'Honneste femme* (Paris: Pierre Billaine, 1632), 80–81.
"They want to say everything including the margins, notes, dates, and other
superfluous circumstances . . . once they start a discourse they have to empty
their chapter, they never stop talking . . ." [my translation].

Almayer's Face: On "Impressionism" in Conrad, Crane, and Norris

MICHAEL FRIED

1

Consider these passages.

The first, from Stephen Crane's novella *The Monster* (1897), narrates the destruction of the black coachman Henry Johnson's face:

> Johnson had fallen with his head at the base of an old-fashioned desk. There was a row of jars upon the top of this desk. For the most part, they were silent amid this rioting, but there was one which seemed to hold a scintillant and writhing serpent.
>
> Suddenly the glass splintered, and a ruby-red snakelike thing poured its thick length out upon the top of the old desk. It coiled and hesitated, and then began to swim a languorous way down the mahogany slant. At the angle it waved its sizzling molten head to and fro over the closed eyes of the man beneath it. Then, in a moment, with mystic impulse, it moved again, and the red snake flowed directly down into Johnson's upturned face.
>
> Afterward the trail of this creature seemed to reek, and amid flames and low explosions drops like red-hot jewels pattered softly down it at leisurely intervals.[1]

The second is from Joseph Conrad's first novel, *Almayer's Folly* (finished 1894). A dead body has been found by the edge of a river running through the Borneo jungle village of Sambir; Kaspar Almayer, the novel's protagonist, arrives just as his wife, a Malay, "threw her own head-veil over the upturned face of the drowned man."[2] The villager who found the body pleads with Almayer for a reward but is interrupted by an outburst of grief from Mrs. Almayer. "Almayer, bewildered, looked in turn at his wife," the passage runs,

> at Mahmat [the villager], at Babalatchi [a Malay "statesman" who has been plotting against Almayer], and at last arrested his fascinated gaze on the body lying on the mud with covered face in a grotesquely unnatural contortion of mangled and broken limbs, one twisted and lacerated arm, with white bones protruding in many places through the torn flesh, stretched out; the hand with outspread fingers nearly touching his foot.
>
> "Do you know who this is?" he asked of Babalatchi, in a low voice. . . .

"It was fate. Look at your feet, white man. I can see a ring on those torn fingers which I knew well."

Saying this, Babalatchi stepped carelessly forward, putting his foot as if accidentally on the hand of the corpse and pressing it into the soft mud. He swung his staff menacingly towards the crowd, which fell back a little. . . .

"I do not understand what you mean, Babalatchi," said Almayer. "What is the ring you are talking about? Whoever he is, you have trodden the poor fellow's hand right into the mud. Uncover his face," he went on, addressing Mrs. Almayer, who, squatting by the head of the corpse, rocked herself to and fro, shaking from time to time her dishevelled grey locks, and muttering mournfully.

"Hai!" exclaimed Mahmat, who had lingered close by. "Look, Tuan; the logs came together so," and here he pressed the palms of his hands together, "and his head must have been between them, and now there is no face for you to look at. There are his flesh and his bones, the nose, and the lips, and maybe his eyes, but nobody could tell the one from the other. It was written the day he was born that no man could look at him in death and be able to say, 'This is my friend's face.'" (AF, 129–30)

The third and longest passage is from Frank Norris's *Vandover and the Brute* (written in 1895 but not published until 1914). The protagonist, an aspiring painter, is returning by steamer to San Francisco from a brief vacation in southern California. The homeward passage proves a disaster and the steamer founders; in heavy seas Vandover and about forty others board a lifeboat built to hold thirty-five; but just as the boat begins to pull away from the sinking ship, a "little Jew" whom Vandover noticed earlier leaps from the rail of the ship into the water near the boat. A moment later the Jew grasps one of the oar-blades, and someone cries "Draw him in!" but the engineer in charge of the boat refuses:

"It's too late!" he shouted, partly to the Jew and partly to the boat. "One more and we are swamped. Let go there!"

"But you can't let him drown," cried Vandover and the others who sat near. "Oh, take him in anyhow; we must risk it."

"Risk hell!" thundered the engineer. "Look here, you!" he cried to Vandover and the rest. "I'm in command here and am responsible for the lives of all of you. It's a matter of his life or ours; one life or forty. One more and we are swamped. Let go there!"

"Yes, yes," cried some. "It's too late! there's no more room!"

But others still protested. "It's too horrible; don't let him drown; take him in." They threw him their life-preservers and the stumps of the broken oars. But the Jew saw nothing, heard nothing, clinging to the oar-blade, panting and stupid, his eyes wide and staring.

"Shake him off!" commanded the engineer. The sailor at the oar jerked and twisted it, but the Jew still held on, silent and breathing hard. Vandover glanced at the fearfully overloaded boat and saw the necessity of it and held his peace, watching the thing that was being done. The sailor still attempted to tear the oar from the Jew's grip, but the Jew held on, panting, almost exhausted; they could hear his breathing in the boat. "Oh, don't!" he gasped, rolling his eyes.

"Unship that oar and throw it overboard," shouted the engineer.

"Better not, sir," answered the sailor. "Extra oars all broken." The Jew was hindering the progress of the boat and at every moment it threatened to turn broad on to the seas.

"God damn you, let go there!" shouted the engineer, himself wrenching and twisting at the oar. "Let go or I'll shoot!"

But the Jew, deaf and stupid, drew himself along the oar, hand over hand, and in a moment had caught hold of the gunwale of the boat. It careened on the instant. There was a great cry. "Push him off! We're swamping! Push him off!" And one of the women cried to the mate, "Don't let my little girls drown, sir! Push him away! Save my little girls! Let him drown!"

It was the animal in them all that had come to the surface in an instant, the primal instinct of the brute striving for its life and for the life of its young.

The engineer, exasperated, caught up the stump of one of the broken oars and beat on the Jew's hands where they were gripped whitely upon the boat's rim, shouting, "Let go! let go!" But as soon as the Jew relaxed one hand he caught again with the other. He uttered no cry, but his face as it came and went over the gunwale of the boat was white and writhing. When he was at length beaten from the boat he caught again at the oar; it was drawn in, and the engineer clubbed his head and arms and hands till the water near by grew red. The little Jew clung to the end of the oar like a cat, writhing and grunting, his mouth open, and his eyes fixed and staring. When his hands were gone, he tried to embrace the oar with his arms. He slid off in the hollow of a wave, his body turned over twice, and then he sank, his head thrown back, his eyes still open and staring, and a silver chain of bubbles escaping from his mouth.

"Give way, men!" said the engineer.

"Oh, God!" exclaimed Vandover, turning away and vomiting over the side.[3]

All three passages come from novels written within a few years of each other; each describes a violently disfigured face, and two of the three—by Conrad and Norris—depict brutally damaged hands as well. But the affinities between them are more profound than this.

In "Stephen Crane's Upturned Faces"—the second of two chapters in my *Realism, Writing, Disfiguration*—I argue that recurrent images of the disfiguring of upturned faces both of corpses and of living persons in Crane's novels, stories, and sketches are to be read as representing the writer's action of inscribing his text on upward-facing sheets of writing paper.[4] So, for example, in my discussion of the scene in the burning laboratory from *The Monster,* I emphasize that Johnson's head lies face up below a desk; that the burning liquid may be ink; that the gerunds "rioting" and "writhing" (in the sentence "For the most part, they were silent amid this rioting, but there was one which seemed to hold a scintillant and writhing serpent") all but spell out the further gerund "writing"; and that the "ruby-red snakelike thing" itself, like other snakelike forms in Crane's texts, is a figure for his own handwriting, indeed for the movement of his pen across the page.[5] I go on to relate the obsessive thematization of the scene and the action of writing in Crane's prose to the traditional designation of him as an "impressionist," and in this connec-

tion quote Conrad's famous credo from his preface to *The Nigger of the "Narcissus"* (1897): "My task which I am trying to achieve is, by the power of the written word, to make you hear, to make you feel—it is, before all, to make you *see*."[6] (Crane and Conrad became friends in England in 1897, but my bringing Conrad's preface to bear on Crane—like my reading of Conrad later in this essay within a conceptual framework largely determined by my analysis of Crane—has nothing to do with that fact.) I then say:

> By "mak[ing] you see" Conrad of course had in mind making the reader visualize with special acuteness scenes and events which are not literally there on the page but which the letters, words, sentences, and paragraphs that are on the page somehow contrive to evoke. But what if, for reasons that are not entirely clear, Crane's very commitment to a version of the "impressionist" project—his attempt, before all, to make the reader *see*—at least intermittently led Crane himself to see, by which I mean fix his attention upon, and to wish to make the reader see, by which I mean visualize in his imagination, those things that, *before all,* actually lay before Crane's eyes: the written words themselves, the white, lined sheet of paper on which they are inscribed, the marks made by his pen on the surface of the sheet, even perhaps the movement of his hand wielding the pen in the act of inscription? Wouldn't such a development threaten to abort the realization of the "impressionist" project as classically conceived? In fact would it not call into question the very basis of writing as communication—the tendency of the written word at least partly to "efface" itself in favor of its meaning in the acts of writing and reading? But now imagine that instead of recognizing the objects of his attention for what they were—instead of understanding himself to be seeing and representing writing and the production of writing—*Crane unwittingly, obsessionally, and to all intents and purposes automatically metaphorized writing and the production of writing (and the viewing of these) in images, passages, and, in rare instances, entire narratives that hitherto have wholly escaped being read in those terms.* (RWD, 119–20)

Indeed I take this argument several steps further by proposing that not only Crane's recurrent imagery of disfigured upturned faces and snakelike forms but also an entire battery of stylistic devices (pronominal ambiguity, animism, alliteration, onomatopoeia, dialect), signature effects (the prominence of names, words, and phrases beginning with or otherwise conspicuously deploying the letters "s" and "c"), and other characteristic features of his prose (an obsession with numbers and a tendency to depict scenes of representation, usually involving a sharp shift in scale) express a compulsion to declare but also to disguise both the literal circumstances and the material product of his activity as a writer. I find support for this notion in eyewitness accounts of the extraordinary *slowness* (also the sureness) with which Crane formed letters and words in the act of writing, on the grounds that so deliberate a manner of working risked diverting the writer's attention away from the larger flow of meaning in his prose

to both the act of inscription itself and the material product of that act, in which event "the enterprise in question [would have] become *merely* the drawing of letters, which of course [would have meant] that it ceased to be the enterprise of writing. Presumably Crane worked just too quickly for that to happen" (*RWD*, 147). (Note in this connection Crane's insistence on the "languorous" movements of the burning serpent as it makes its way toward Johnson's face.) In sum I argue that in Crane's most characteristic texts

> the materiality of writing [is] simultaneously elicited and repressed: elicited because, under ordinary circumstances, the materiality precisely doesn't call attention to itself . . . in the intimately connected acts of writing and reading; and repressed because, were that materiality allowed to come unimpededly to the surface, not only would the very possibility of narrative continuity be lost, the writing in question would cease to *be* writing and would become mere mark. (*RWD*, xiv)

Now I expressly don't wish to claim that an identical dynamic is operative in the passages from *Almayer's Folly* and *Vandover and the Brute* which I quoted. But I shall argue that two closely related dynamics (or, perhaps better, projects) *are* operative in them, and more broadly that Conrad's and Norris's respective versions of the "impressionist" enterprise are, like Crane's but differently, grounded in a relation to or encounter with the materiality of writing. The same holds for other important writers of the 1890s and early 1900s: Jack London, Harold Frederic, and W. H. Hudson, with Henry James the unresolved borderline case.[7] But my concern in the rest of this essay is less with literary "impressionism" as a global practice than with its specific manifestations in the work of Conrad and Norris; I shall deal with Norris first, as succinctly as possible, before turning to Conrad, whom I shall treat at greater length. Above all I hope to show that a particular fantasmatic relation to the blank page lies at the heart not just of *Almayer's Folly* but of Conrad's fiction generally—though to truly establish the larger claim and pursue its ramifications a book rather than an essay would be required.

2

My basic supposition is that the destruction of the little Jew's face and hands in *Vandover and the Brute* images the irruption of mere (or brute) materiality within the scene of writing—that instead of Crane's double process of eliciting and repressing that materiality, what is figured in the shipwreck scene is a single, unstoppable process of materialization, involving both the act of representation (the beating of the helpless Jew)

and the marking tool and actual page (the stump of the oar, the Jew's "white and writhing" face), the result of which can only be the defeat of the very possibility of writing (as embodied in the chilling phrase, "When his hands were gone").

Here it might be objected that such a reading derives whatever plausibility it has from the comparison with Crane, and in a sense this is true: my claim is precisely that it's only against the background of Crane's seemingly bizarre but, in this regard, normative or centric enterprise that the wider problematic of late nineteenth- and early twentieth-century literary "impressionism" can be made out. In another sense, however, the comparison with Crane involves an appeal to issues—notably that of materialism—which have long been basic to Norris criticism and which the recent work of Walter Benn Michaels has brought to a new level of conceptual sophistication and historical refinement. Specifically, the title essay in Michaels's book, *The Gold Standard and the Logic of Naturalism,* interprets both *McTeague* and *Vandover and the Brute* in terms of a conflict between materiality and representation that found contemporary expression both in the debates over the gold and silver standards versus paper money and in the vogue for trompe l'oeil painting (in which the objects that a given picture represents are as it were directly contrasted with the paint and canvas the picture is made of).[8] In this regard a crucial moment in Vandover's regression from man to beast is his discovery that, as a painter, he has lost the ability to represent nature three-dimensionally; Michaels treats this development as equivalent to "replac-[ing] the painting with nature itself" (that is, with the shallowly three-dimensional canvas), and goes on to remark:

> But this . . . is ultimately a distinction without a difference. Vandover the artist can so easily devolve into Vandover the brute precisely because both artist and brute are already committed to a naturalist ontology—in money, to precious metals; in art, to three-dimensionality. The moral of Vandover's regression, from this standpoint, is that it can only take place because . . . it has already taken place. Discovering that man is a brute, Norris repeats the discovery that paper money is just paper and that a painting of paper money is just paint. (*GS,* 166–67)

My reading of the shipwreck passage would thus be consistent with what Michaels calls Norris's "*trompe l'oeil* materialism" (*GS,* 167), though the nearly sadomasochistic violence of that passage may be taken to imply that materialism's consequences for writing threaten to be even more disastrous than they are for painting. But rather than analyze the role of writing as such in *Vandover,* which would involve an intricate discussion not just of that novel and *McTeague* but also of Michaels's essay, I want to turn to another, lesser-known book by Norris, in which a thematic

of writing plays a conspicuous and more nearly univocal role: *A Man's Woman* (1899).[9]

A Man's Woman is a highly schematic novel that from the start has something of the character of a thought experiment. In effect there are just three characters: the indomitable Arctic explorer Ward Bennett; the woman he loves and eventually marries (the "man's woman" of the title), Lloyd Searight; and Bennett's closest friend and fellow explorer, Richard Ferriss, who also loves Lloyd Searight (and apparently is loved by her until, in an anguished confrontation with Bennett, she realizes that she has been in love with him all along). The novel opens in the Arctic; Bennett's expedition, already in desperate straits, faces

> a wilderness beyond all thought, words, or imagination desolate . . . ice, ice, ice, fields and flows of ice, laying themselves out under that gloomy sky, league after league, endless, sombre, infinitely vast, infinitely formidable. But now it was no longer the smooth ice over which the expedition had for so long been travelling. In every direction, intersecting one another at ten thousand points, crossing and recrossing, weaving a gigantic, bewildering network of gashed, jagged, splintered ice blocks, ran the pressure ridges and hummocks. . . . From horizon to horizon there was no level place, no open water, no pathway. (*MW*, 4)

I see this tormented, impassable landscape, which at first suggests a natural analogy with the white page, as one more image of an overwhelming materiality that defeats the possibility of writing, here figured by the attempt to find a path across it. Moreover, Ferriss soon loses both hands to frostbite; this recalls the mutilation of the little Jew in *Vandover,* while the close resemblance between the names "Ferriss" and "Norris" suggests that the author of *A Man's Woman* is fantasmatically implicated in *its* problematization of writing.[10] (The link between the two names also directs attention back to Vandover's ambivalent relation to the Jew's mutilation and murder, which is what led me to describe the violence of that passage as not simply sadistic but sadomasochistic.) Finally, at a moment when Bennett himself has given up all hope, the surviving members of the expedition are rescued.

Back in the United States, Bennett declares his love to Lloyd as Ferriss lies dying of typhoid; indeed fearing that Lloyd, who has been nursing Ferriss, will contract typhoid, he compels her to abandon her patient at the moment of crisis; this causes a break in their relations, but eventually Bennett and Lloyd marry, and the remainder of *A Man's Woman* describes their joint labors on a book about the ill-fated expedition and Lloyd's efforts to induce Bennett, who, weakened by illness and guilt-ridden because of his role in Ferriss's death, has relinquished all ambition to reach the North Pole, to take up his true work once again (the novel ends with his departure on a new expedition). The account of their

scriptive collaboration is of particular interest. "The task of writing was hateful to him beyond expression," we are told, "but with such determination as he could yet summon to his aid Bennett stuck to it, eight, ten and sometimes fourteen hours each day" (*MW*, 178). Soon, however, Lloyd assumes the role of Bennett's amanuensis:

> "Look at that manuscript," she had exclaimed one day, turning the sheets that Bennett had written; "literally the very worst handwriting I have ever seen. What do you suppose a printer would make out of your 'thes' and 'ands'? It's hieroglyphics, you know," she informed him gravely, nodding her head at him.
> It was quite true. Bennett wrote with amazing rapidity and with ragged, vigorous strokes of the pen, not unfrequently driving the point through the paper itself; his script was pothooks, clumsy, slanting in all directions, all but illegible. In the end Lloyd had almost pushed him from his place at the desk, taking the pen from between his fingers, exclaiming:
> "Get up! Give me your chair—and that pen. Handwriting like that is nothing else but a sin." . . .
> In the end matters adjusted themselves. Daily Lloyd took her place at the desk, pen in hand, the sleeve of her right arm rolled back to the elbow (a habit of hers whenever writing, and which Bennett found to be charming beyond words), her pen travelling steadily from line to line. He on his part paced the floor, a cigar between his teeth, his notes and notebooks in his hand, dictating comments of his own, or quoting from the pages, stained, frayed, and crumpled, written by the light of the auroras, the midnight suns, or the unsteady, flickering of train-oil lanterns and blubber lamps. (*MW*, 215–16)

Bennett's ragged, violent script virtually recreates the wilderness of ice described in chapter 1, as the penstrokes piercing the paper and the clumsy pothooks slanting in all directions (something that seems alien to the nature of handwriting) not only result in a writing that cannot be read but also transform the sheet of paper into an equivalent to the "bewildering network of gashed, jagged, splintered ice blocks" that months before had greeted Bennett's gaze as he sought a possible route for his expedition. Lloyd's mediation is required in order to repair the damage (earlier in the novel she is depicted dressed all in white, doing her correspondence—but nothing more than that—in a white room filled with white furnishings [*MW*, 79]), which is to say that legible writing, writing proper, is here defined as inherently a joint or, better, a *composite* activity; the point is underscored a few pages later when it emerges that, as Bennett's account of the expedition moves toward its climax, "Bennett inserted no comment of his own; but, while Lloyd wrote, read simply and with grim directness from the entries in his journal precisely as they had been written" (*MW*, 218). Lloyd thus merely transcribes what Bennett had previously noted in his "ice journal" (*MW*, 12). Yet the implication seems clear that it is only by virtue of that act of transcription that the journal

entries *become* writing, and this not merely because Lloyd writes a per-spicuous hand and Bennett does not but because the composite *produc-tion* of the scriptive text functions in this context as an equivalent to the internal heterogeneity that distinguishes writing from the mere drawing of letters or making of marks.

What's surprising is that writing is possible at all. For *A Man's Woman* everywhere insists on the primacy of materiality and its related motif, action, over the representation of either. So for example Lloyd herself is characterized in terms that appear to leave no place for writing: "To *do* things had become her creed; to do things, not to think them; to do things, not to talk them; to do things, not to read them. No matter how lofty the thoughts, how brilliant the talk, how beautiful the literature—for her, first, last, and always, were acts, acts, acts—concrete, substantial, material acts" (*MW*, 49). (Independently wealthy, Lloyd earlier founded the nurs-ing agency in which she serves.) And when late in the novel three distin-guished visitors—representatives of "three great and highly developed phases of nineteenth-century intelligence—science, manufactures, and journalism"—invite Bennett to lead a new expedition to the Pole, one of the visitors, Campbell, describes them all as "'men more of action than of art, literature, and the like. Tremlidge is, I know. He wants facts, ac-complished results. When he gives out his money he wants to see the concrete, substantial return—and I am not sure that I am not of the same way of thinking'" (*MW*, 232). More important still, Bennett throughout the book is repeatedly portrayed if not as materialism personified, at any rate as a heroic version of the brute, the one man adequate to a malign materialist universe ("Bennett, his huge jaws clenched, his small, dis-torted eyes twinkling viciously through the apertures of the wind mask, his harsh, black eyebrows lowering under the narrow, contracted fore-head, drove the expedition to its work relentlessly. . . . On that vast frame of bone and muscle fatigue seemed to leave no trace. Upon that inexora-ble bestial determination difficulties beyond belief left no mark" [*MW*, 11].) Indeed, bearing in mind the sense in which writing *to be* writing must be other than its merely material expression, the singleness of Ben-nett's nature would seem to militate against his ever producing that phenomenon:

> Bennett's entire life had been spent in the working out of great ideas in the face of great obstacles; continually he had been called upon to overcome enormous difficulties with enormous strength. For long periods of time he had been isolated from civilization, had been face to face with the simple, crude forces of an elemental world—forces that were to be combated and overthrown by means no less simple and crude than themselves. He had lost the faculty, possessed, no doubt, by smaller minds, of dealing with complicated situ-ations. . . . For him a thing was absolutely right or absolutely wrong, and

between the two there was no gradation. For so long a time had he looked at the larger, broader situations of life that his mental vision had become all deformed and confused. He saw things invariably magnified beyond all proportion, or else dwarfed to a littleness that was beneath consideration. Normal vision was denied him. (*MW*, 124)[11]

The denial of normal vision (Bennett even has a cast in one eye) recalls Vandover in the process of becoming a brute, and in fact *A Man's Woman* may be read as rethinking the relation of bruteness and materiality to writing that is no more than sketched—writing in particular being subordinated to a broader problematic of representation—-in the earlier novel.

More precisely, I interpret *A Man's Woman* as an attempt to imagine the production of a strictly materialist book, one that would be the outcome of wholly "concrete, substantial, material acts." The first point that becomes clear is that such a book will not be the product of the efforts of Norris himself; I take that to be a major implication of Ferriss/Norris's loss of his hands, not to mention his death. (Interestingly, Norris seems to have found writing *A Man's Woman* almost unbearably difficult, as if the necessary gulf between that novel's imaginary project and its actual realization made the latter especially painful.)[12] Instead such a book can only be written by a man like Bennett in collaboration with a woman like Lloyd, whom the novel calls a *man's* woman and denominates with a masculine name. This suggests that she is already in some sense masculinized, whereas Bennett, a "man's man" (*MW*, 34), bears no visible trace of femininity in his makeup. Their relations, in other words, are fundamentally asymmetrical, though exactly how to interpret that asymmetry—above all, what to make of Bennett's attraction to Lloyd's quasimasculinity—remains an open question. (A fortiori, so does Norris's fantasmatic stake in that attraction.)

More immediately pertinent to my argument is the punning relevance of Lloyd Searight's *second* name to the issue of "impressionism," especially in the light of Bennett's lack of normal vision and distaste for the task of writing (Searight = *both* See right *and* See + write). Finally, though, it may be that what the materialist book *A Man's Woman* asks us to envision is not Bennett and Lloyd's composite account of the failed expedition but rather the new expedition Bennett has just embarked on at the novel's end, or rather the material record in the northern ice and snow of the marks of Bennett's passage when and if he succeeds in conquering the Pole. Understood in these terms, *A Man's Woman* resembles what Roland Barthes (citing Thibaudet) has called "a *limit* work, a singular, almost disconcerting text which constitutes at once the secret and the caricature of [a writer's] creation";[13] in it, as nowhere else in Norris's

oeuvre, materiality is imagined not simply as having the last word but also, at least proleptically, as writing the first.[14]

3

Conrad's work bears a different relation to the materiality of writing from both Crane's and Norris's. One sign of that difference can be discerned in the passage from *Almayer's Folly* I quoted at the outset: it is the only one of the three passages that doesn't actually narrate the destruction of a face—that is, the drowned man's obliterated face is revealed to us only at a remove, through the reported speech of Mahmat, the villager who found the corpse. (Later we will learn from Babalatchi's report to the Malay Rajah he serves, Lakamba, that the corpse's face was actually destroyed by Mrs. Almayer, who "'battered the face of the dead with a heavy stone, and . . . pushed him amongst the logs'" [*AF*, 169–70] in order to pass the dead man off as Dain Maroola, a Malay pursued for murder by the Dutch authorities. Here, too, we aren't "shown" that battering but are merely told of it.) I see in the novel's indirection in this regard something akin to Mrs. Almayer's action of "[throwing] her head-veil over the upturned face of the drowned man," which is not to say that the dead man's facelessness has been made less vivid on that account; my point is rather that the effect of vividness is achieved by these particular means, which foreshadow Conradian narrative strategies to come and in particular the emergence of Marlow as an internal narrator who fulfills a similarly dual function. Be this as it may, a relation to writing (and reading) is soon made explicit. Almayer demands that the corpse's face be uncovered, and Mahmat replies (the exact words bear repetition):

> "Look, Tuan; the logs came together so," and here he pressed the palms of his hands together, "and his head must have been between them, and now there is no face for you to look at. There are his flesh and his bones, the nose, and the lips, and maybe his eyes, but nobody could tell the one from the other. It was written the day he was born that no man could look at him in death and be able to say, 'This is my friend's face.'" (*AF*, 130–31)

(Once again the corpse's facelessness is only reported.) Finally, another instance of veiling or covering turns up several pages later when Mrs. Almayer "[covers] the body with a piece of white cotton cloth" (*AF*, 138), an arrangement that prevails until Almayer, who has been led to believe that the drowned man was Dain, defiantly exposes the faceless corpse to the Dutch naval officers who have come to arrest him (*AF*, 188). All this is suggestive as far as it goes, but the full significance of the

juxtaposition of motifs of facelessness, veiling or covering, and writing plus illegibility starts to become clear only later on, toward the end of the eleventh (and next to last) chapter, when another face, Almayer's, becomes the focus of the novel's attention. Almayer has just realized that his beautiful half-caste daughter Nina—the center of his grandiose, unrealistic dreams of becoming rich and escaping together to Amsterdam—is determined to go off with Dain, who has returned to claim her. The scene takes place on an islet in the mouth of the Pantai River; Dain and Nina are waiting for the arrival of a canoe that will carry them to safety; Almayer, who had hoped to persuade Nina to remain with him, has just sat down on the sand by Nina's side:

> "I shall never forgive you, Nina," said Almayer, in a dispassionate voice. "You have torn my heart from me while I dreamt of your happiness. You have deceived me. Your eyes that for me were like truth itself lied to me in every glance—for how long? You know that best. When you were caressing my cheek you were counting the minutes to the sunset that was the signal for your meeting with that man—there!"
>
> He ceased, and they both sat silent side by side, not looking at each other, but gazing at the vast expanse of the sea. Almayer's words had dried Nina's tears, and her look grew hard as she stared before her into the limitless sheet of blue that shone limpid, unwaving, and steady like heaven itself. He looked at it also, but his features had lost all expression, and life in his eyes seemed to have gone out. The face was a blank, without a sign of emotion, feeling, reason, or even knowledge of itself. All passion, regret, grief, hope, or anger— all were gone, erased by the hand of fate, as if after this last stroke everything was over and there was no need for any record. Those few who saw Almayer during the short period of his remaining days were always impressed by the sight of that face that seemed to know nothing of what went on within: like the blank wall of a prison enclosing sin, regrets, and pain, and wasted life, in the cold indifference of mortar and stones. (*AF*, 247–48)

The passage suggests a link between two seemingly unrelated items: Almayer's insistence to Nina that he will never forgive her and the blankness and impassiveness of his face, the absence from it of all signs not just of emotion but of inner life. The nature of that link is clarified as Almayer expands on his resolve not to forgive his daughter. "'I will never forgive you, Nina,'" he repeats, "'and to-morrow I shall forget you!'" In Almayer's confusion and pain, we are told, "only one idea remained clear and definite—not to forgive her; only one vivid desire—to forget her. And this must be made clear to her—and to himself—by frequent repetition" (*AF*, 250–51). But of course the connection between the "idea" of not forgiving Nina and the "desire" to forget her is more than a little problematic. For there is an obvious sense in which not forgiving Nina necessarily will depend on not forgetting what she did, on keeping her and her betrayal constantly in view; while forgetting Nina will involve, not forgiving

her exactly, but relinquishing all awareness of the grievance that motivated the resolve to forget in the first place.

Rather than explore that tension or conflict, the novel in its remaining pages throws all its emphasis on the side of the "desire," or rather it emphasizes a further connection between Almayer's project of hyperbolically forgetting Nina and the blankness and rigidity of his face. After the canoe has arrived and Nina and Dain have begun to leave, Almayer is described in the following terms:

> He stood very straight, his shoulders thrown back, his head held high, and looked at them as they went down the beach to the canoe, walking enlaced in each other's arms. He looked at the line of their footsteps marked in the sand. He followed their figures moving in the crude blaze of the vertical sun, in that light violent and vibrating, like a triumphal flourish of brazen trumpets. He looked at the man's brown shoulders, at the red sarong round his waist; at the tall, slender, dazzling white figure he supported. He looked at the white dress, at the falling masses of the long black hair. He looked at them embarking, and at the canoe growing smaller in the distance, with rage, despair, and regret in his heart, and on his face a peace as that of a carved image of oblivion. Inwardly he felt himself torn to pieces, but [Almayer's servant] Ali—who now aroused—stood close to his master, saw on his features the blank expression of those who live in that hopeless calm which sightless eyes only can give. (*AF*, 253–54)

This, too, isn't without internal tensions: the notion of "a peace [like] that of a carved image of oblivion" is at least potentially discrepant with that of a "hopeless calm," just as the implied sharpness of visual definition of the carved image is at odds with the final figure of blindness. But what I want to stress, what indeed the passage stresses, is the contrast between Almayer's blank expression and the violent emotions raging within him, a contrast that plainly violates the "realistic" convention that facial expression at moments of extreme crisis spontaneously and candidly represents a person's inner condition.

The point is underscored a moment later as Almayer and Ali make their way back to their canoe:

> For all his firmness [Almayer] looked very dejected and feeble as he dragged his feet slowly through the sand on the beach; and by his side—invisible to Ali—stalked that particular fiend whose mission it is to jog the memories of men, lest they should forget the meaning of life. He whispered in Almayer's ear a childish prattle of many years ago. Almayer, his head bent on one side, seemed to listen to his invisible companion, but his face was like the face of a man that had died struck from behind—a face from which all feelings and all expression are suddenly wiped off by the hand of unexpected death. (*AF*, 256)

Such a face, like the one described at the end of the preceding passage, may be imagined to represent the inner state of a person who had succeeded in the project I have called hyperbolic forgetting. And in fact the novel goes on to suggest that Almayer's blank, expressionless face *al-*

ready represents the state of mind and feeling toward which his efforts
at forgetting are directed; put more strongly, it suggests that those efforts
can succeed only by making his inner state accord perfectly with an
outward representation whose uncanniness in the eyes of those who be-
hold it consists in its denial of all evocation of "depths" (what makes the
denial uncanny is that the representation in question is a *face*).

This seems to me the gist of an exchange between Almayer and his
friend Ford, the captain of a steamer, who visits him several times after
his return to Sambir. Immediately after his return Almayer burned down
the house in which he had lived with Nina and moved into another, unfin-
ished one that he had built some time before "for the use of the future
engineers, agents, or settlers" of the larger company he dreamed of estab-
lishing (*AF*, 46). (The second house appropriately came to be called "Al-
mayer's Folly," giving the novel its title.) There he "set himself to wait in
anxiety and pain for that forgetfulness which was so slow to come. He
had done all he could. Every vestige of Nina's existence had been de-
stroyed [among those vestiges was her trunk, the lid of which bore the
large initials "N.A." in brass nails (*AF*, 258)]; and now with every sunrise
he asked himself whether the longed-for oblivion would come before sun-
set, whether it would come before he died" (*AF*, 263). The exchange with
Ford reads as follows:

> One morning Ford found him sitting on the floor of the verandah, his back
> against the wall, his legs stretched stiffly out, his arms hanging by his side. His
> expressionless face, his eyes open wide with immobile pupils, and the rigidly
> of his pose, made him look like an immense man-doll broken and flung there
> out of the way. As Ford came up the steps he turned his head slowly.
> "Ford," he murmured from the floor, "I cannot forget."
> "Can't you?" said Ford, innocently, with an attempt at joviality: "I wish I
> was like you. I am losing my memory—age, I suppose; only the other day
> my mate—"
> He stopped, for Almayer had got up, stumbled, and steadied himself on his
> friend's arm.
> "Hallo! You are better to-day. Soon be all right," said Ford, cheerfully, but
> feeling rather scared.
> Almayer let go his arm and stood very straight with his head up and shoulders
> thrown back, looking stonily at the multitude of suns shining in ripples on the
> river. His jacket and his loose trousers flapped in the breeze on his thin limbs.
> "Let her go!" he whispered in a grating voice. "Let her go. To-morrow I
> shall forget. I am a firm man, . . . firm and as a . . . rock, . . . firm . . ."
> Ford looked at his face—and fled. The skipper was a tolerably firm man
> himself—as those who had sailed with him could testify—but Almayer's firm-
> ness was altogether too much for his fortitude. [*AF*, 266–67]

What makes Almayer's face so disturbing to Ford—the "firmness" of
which the passage speaks—is the absence from it of all expression, and
it is that absence, that expressionlessness, that invites us to think of

Almayer's project of hyperbolic forgetting as seeking above all to make his inner state coincide as if physically with his outward appearance.

It seems obvious that so bizarre a project can't be understood "psychologically," that is, as an instance of plausible though extreme behavior on the part of the character Almayer, if only because it is nowhere implied that Almayer himself is in the least aware of what has happened to his features. Rather, the "long *solo* for Almayer" (Conrad's phrase in a letter to his aunt, Marguerite Poradowska)[15] with which *Almayer's Folly* concludes all but asks to be understood as symbolic or allegorical—but of what? To begin with, of a particular representational project, one that seeks to collapse the distinction between inner and outer (or inner and *outward*) by matching the former to the latter. In the most general terms, this is consistent with my summary account of Crane's "impressionism" in the first part of this essay, and indeed I've already said that I understand the obvious affinities between recurrent images of disfigured faces in Crane and Conrad—specifically, in *Almayer's Folly*—as pointing to the functioning in Conrad as well as in Crane of a distinctively "impressionist" problematic grounded in the writer's relation to the act of writing. But unlike the passage from *The Monster* I cited initially, the quotations from *Almayer's Folly* we have examined neither metaphorize the act of writing as such nor, a fortiori, stage the irruption and repression of the materiality of writing. Rather, they dramatize another relation to the act of writing, a relation I call, following the novel's lead, one of *erasure*. The destruction of the drowned man's face earlier in the novel first announces that relation, not only because the act of destruction invites being read as one of erasure but also by virtue of the indirect narration of that act, of the veiling and then covering of the corpse by Mrs. Almayer, and finally of Mahmat's remark to Almayer, "It was written the day he was born that no man could look at him in death and be able to say, 'This is my friend's face.'" The pertinence of the notion of erasure to the descriptions of Almayer's stricken face we have just considered is even more evident, and in fact those descriptions speak both of "all passion, regret, grief, hope, or anger" having been "erased by the hand of fate" and of "all feelings and all expression" having been "suddenly wiped off by the hand of unexpected death," figures of speech that soon emerge, in arguably the most important scene in the book, as determining for Almayer's project of hyperbolic forgetting as well.

Toward the beginning of the paragraph that describes Almayer watching Nina and Dain embark and leave, we also are told that as the lovers walked down the beach to their canoe, Almayer, standing very straight, "looked at the line of the footsteps marked in the sand" (*AF*, 253). Afterwards Almayer continues to stare out to see "with his eyes fixed on [the canoe's] wake" (*AF*, 254) until Ali points out in the distance the yellow

triangle of a sail, which Almayer follows with his gaze until it disappears. (Earlier Almayer said to Nina, "'It is most important for me to see you go. Both of you. Most important'" [AF, 247]. This turns out to mean literally watching them vanish.) Ali reminds them that they should be returning to Sambir. Then:

> "Wait," whispered Almayer.
> Now she was gone his business was to forget, and he had a strange notion that it should be done systematically and in order. To Ali's great dismay he fell on his hands and knees, and, creeping along the sand, erased carefully with his hand all traces of Nina's footsteps. He piled up small heaps of sand, leaving behind him a line of miniature graves right down to the water. After burying the last slight imprint of Nina's slipper he stood up, and, turning his face towards the headland where he had last seen the prau, he made an effort to shout out loud again his firm resolve to never forgive. Ali watching him uneasily saw only his lips move, but heard no sound. He brought his foot down with a stamp. He was a firm man—firm as a rock. Let her go. He never had a daughter. He would forget. He was forgetting already. (AF, 255–56)

This is a crucial passage. In the first place, Almayer's notion that the "business" of forgetting "should be done systematically and in order" is indeed "strange," not just because the idea of systematicity seems at odds with that of forgetting but also because virtually all this will mean—apart from eradicating the footsteps—is burning down the house he shared with Nina in Sambir. (Note, though, how systematically chapters 11 and 12 develop their double thematic of hyperbolic forgetting and facial blankness.) More important, the passage links Almayer's project of hyperbolic forgetting with a project of erasure, as if not only the imprint of Nina's footsteps in the sand but Almayer's entire store of memories of her, early and late, were so much writing that now had to be undone (to use as neutral a verb as possible). But what of the act of erasure as Conrad describes it? Here one might be tempted to argue that because Almayer's efforts to do away with all traces of Nina's footsteps result, not in the restoration of a perfectly smooth surface, but rather in "small heaps of sand," "a line of miniature graves right down to the water," the passage shows the genuine erasure is impossible. But I think it would be truer to the problematic I have been analyzing to say that the passage *defines* erasure as a visible marking over a preexisting writing—more precisely, as itself a mode of writing that renders irretrievable a prior writing (as the heaps of sand and miniature graves cover up Nina's footprints) but whose own legibility *as* erasure depends on a certain material survival of the original "text" (as the heaps of sand and miniature graves may be seen as inverting the impressions Nina's footsteps made in the sand).

Not that erasure so defined is fundamentally at odds with a thematic of blankness. On the contrary, as we have seen, Almayer's face is repeatedly described as blank and expressionless and is perceived by others in those

terms. But in the first place it has been *made* blank, much as the faceless corpse was earlier covered by a white cloth, and in the second—and equally decisive point—it never ceases to *be* a face, which as I have already implied is why it makes so indelible an impression on those who behold it. (A face can be expressionless but not inexpressive: its capacity for representing "depths" is so to speak ineffaceable, which incidentally is why the various figures Conrad uses to evoke the erasure of all expression from Almayer's face aren't strictly consistent with one another.) More broadly, blankness in *Almayer's Folly* emerges both as the product of the representational act the novel calls erasure and as a particular representation in its own right, *not* as a brute material fact signalling the collapse of representation (as the wilderness of ice—Norris's version of blankness—connotes such a collapse in *A Man's Woman*). At the risk of getting ahead of myself I will go further and suggest that the restoration of an original and in a sense originary blankness *that is never merely a material blankness* functions as a hyperbolic ideal not just in *Almayer's Folly* but throughout Conrad's oeuvre. Indeed a conception of erasure *both* as the disfiguring of a prior representation *and* as the restoration of an originary blankness is implicit in the unexpected image of Almayer's silent shout, which I read as hinting at an analogy between silence and blankness at the same time that it depends for its effect on the contrast between the absence of sound and the sight of Almayer's moving lips.[16] (The same conception is also implicit in the disappearance from view of the sail of the prau carrying Nina and Dain out of Almayer's life.)

It should be emphasized that the blankness in question is "before all" that of the white sheet of paper that confronted Conrad when he sat down to write. A letter from Conrad to Marguerite Poradowska (herself an author), written in late March or early April 1894 when he was nearing the end of *Almayer's Folly,* is illuminating here. The letter is in French, the English translation is as follows:

My very dear Aunt,

Forgive me for not having written sooner, but I am in the midst of struggling with Chapter XI; a struggle to the death, you know! If I let go, I am lost! I am writing to you just as I go out. I must indeed go out sometimes, alas! I begrudge each minute I spend away from the page. I do not say from the pen, for I have written very little, but inspiration comes to me while gazing at the paper. Then there are vistas that extend out of sight; my mind goes wandering through great spaces filled with vague forms. Everything is still chaos, but, slowly, ghosts are transformed into living flesh, floating vapours turn solid, and—who knows?—perhaps something will be born from the collision of indistinct ideas.

I send you the first page (which I have copied) to give you an idea of the appearance of my manuscript. This I owe you, since I have seen yours. I for one like to observe the decencies.

I embrace you warmly. Always yours
J. Conrad (*CL,* 1:150–51)[17]

There could be no more compelling "external" evidence in support of my argument. To begin with, the letter's occasion is significant, by which I mean that it's precisely in chapters 11 and 12 of *Almayer's Folly* that the problematic of blankness and erasure I have been tracing comes at last to the fore. (One has the impression that the main task of the previous chapters was to set the stage for this.) As for the letter's substance, Conrad's distinction between pen and paper and his assertion that inspiration comes to him "while gazing at the paper" can serve to make us aware that *Almayer's Folly,* like Conrad's fiction generally, tends to minimize the role of pen imagery, especially in contrast to Crane's, which continually thematizes instruments of inscription.[18] (That Almayer erases Nina's footprints with his hands is a perfect expression of this tendency.)[19] Moreover, Conrad's emphasis on gazing rather than writing evokes a state of heightened receptivity that, if inspiration were not to arrive, might easily decay into passive fantasizing and anguished conviction of failure.[20] (Commentators on the novel haven't failed to recognize certain affinities between Almayer and his creator.) There is also the suggestion that the vistas and spaces the letter evokes became "visible" to Conrad in the very blankness of the paper, much as if the paper were a crystal ball, then at the height of its popularity as a mediumistic device (see the moment in *Lord Jim* when Marlow, sitting pen in hand over a blank page, literally sees two figures "dodge into view with stride and gestures, as if reproduced in the field of some optical toy").[21] Indeed Conrad's account of the advent of inspiration strongly implies that the field of boundless possibility at which he represents himself gazing was for him the precondition of imaginative vision altogether, which in turn suggests that the continual restoration of blankness with each new sheet of paper but also as a consequence of nonliteral, that is, representational or figurative, acts of erasure was *the* generative—as well as the most anxious—moment in his enterprise. Finally, Conrad's decision to send Marguerite Poradowska an actual page of his writing testifies to a fascination with the *look* of his prose as it filled up (or "blackened") the blank sheet.[22] Not surprisingly, the page in question, which today reposes in the Rosenbach Library in Philadelphia, is heavily revised.[23]

4

> There is no peace and rest in the development of material interests.[24]
>
> —Joseph Conrad, *Nostromo*

I have intimated that I regard the problematic of erasure that lies at the heart of *Almayer's Folly* as fundamental to Conrad's "impressionism."

In the last section of this essay I look briefly at a range of other novels and stories by Conrad in an attempt, first, to justify that claim (or at least to persuade the reader that it *can* be justified); and second, to suggest a few of the larger implications of the argument I have been pursuing.

For the most part I shall restrict my comments to well-known works. I want to begin, however, by considering one of his most obscure stories, "The Black Mate," which holds a privileged position in Conrad's oeuvre by virtue of being, according to his testimony, his first written work (a version of it is thought to have been composed as early as 1886).[25] The story's protagonist is Bunter, first mate on the *Sapphire*. The other mates of the ships then lying in the London Dock are characterized as "a steady, hard-working, staunch, unromantic-looking set of men, belonging to various classes of society, but with the professional stamp obliterating the personal characteristics, which were not very marked anyhow" ("BM," 85). Whereas Bunter, who "was no more black than you or I" ("BM," 86)—in fact the narrator adds, intriguingly from my perspective, that "to call him black was the superficial impressionism of the ignorant" ("BM," 86)—was given his nickname by the dock laborers because of his strikingly black hair, beard, and bushy eyebrows. We are also told at the outset that Bunter has a secret; and by the end of the tale we learn that Bunter's hair in fact is white, and that (at the narrator's suggestion) he dyed it black in order not to be turned down for a post at sea because of his age. The secret is revealed because Bunter's stock of hair coloring is washed away in a gale; brooding about what to do, he falls and knocks himself unconscious one night while on duty; he is put to bed, his hair shaven and his head swathed in white bandages; and while lying there he concocts a tale to the effect that he fell because he saw a ghost (the ship's captain, an argumentative fool who throughout the voyage tries repeatedly to convert Bunter to his spiritualist views, is more than willing to believe his mate's invention). When Bunter's hair begins to grow back white it therefore seems to everyone on board as if the change in color were the result of his terrifying experience. The story ends happily months later as Bunter is reunited with his wife and explains the events of the voyage to her and the narrator.

Those few commentators who have discussed "The Black Mate" have rightly found its prose unremarkable and the narrative not at all deftly managed, while the basic idea has seemed devoid of deeper interest.[26] But considered within the framework of my reading of *Almayer's Folly*, "The Black Mate" may be read as an allegory of different modalities of erasure, starting with "the professional stamp obliterating the personal characteristics" of the other mates, to the white bandages swathing Bunter's shaven head (but leaving exposed his ebony eyebrows, "more sinister than ever amongst all that lot of white linen" ["BM," 109]), and

culminating in the completely white-haired older man—virtually another person—whom the narrator encounters at the end of the voyage:

> Whereas the black mate struck people as deliberate, and strangely stately in his gait for a man in the prime of life, this white-headed chap seemed the most wonderfully alert of old men. I don't suppose Bunter was any quicker on his pins than before. It was the colour of the hair that made all the difference in one's judgment.
>
> The same with his eyes. Those eyes, that looked at you so steely, so fierce, and so fascinating out of a bush of a buccaneer's black hair, now had an innocent, almost boyish expression in their good-humoured brightness under those white eyebrows. ("BM," 116)

Erasure in this last instance is literally a return to an original blankness (Bunter's naturally white hair), but of course that blankness is the product of age (it is something that *happened* to Bunter), and in any case the white-haired mate now seems more youthful in manner and expression than before,which further complicates the metaphorics of youth and age (or originariness and secondariness) and thereby all the more inextricably defines erasure and its effects as matters of representation.

In "The Black Mate" the apparent triviality of the core anecdote, deceptively underscored by the reference to "superficial impressionism," throws the problematic of erasure into allegorical relief. And as we have seen, the "systematic" treatment of Almayer's expressionless face in the last chapter of Conrad's first novel, for all the differences between *Almayer's Folly* and "The Black Mate," produces a not dissimilar effect. But in later works that problematic functions differently: instead of *constituting* meaning, erasure *generates* it, which is to say that on the one hand it is productive of plot, character, and theme, and on the other these cannot be reduced to a thematics of erasure without severely impoverishing our view of Conrad's achievement. There is in this respect a somewhat stark contrast between Conrad and Crane, in whose work, so I have argued, the continual surfacing and repression (or appearance and disappearance) of the materiality of writing tends on the whole to disrupt thematic coherence, destabilize "character," and foreground local effects of often searing brilliance at the expense of overall design.[27] Not that, with respect to the actual texture of his prose, Conrad is to any appreciable degree a less obsessional writer than Crane, or that would-be totalizing interpretations of his novels and stories have been able even remotely to approach their ideal. So, for example, recent discussions of *Heart of Darkness*—perennially a prime focus of academic interest in Conrad—have emphasized its resistance to univocal reading on virtually every level,[28] while *Almayer's Folly* itself teems with vivid, often hallucinatory images of faces and facing that, albeit preparing the ground for the sustained presentation of Almayer's face in chapters 11 and 12, defy ordinary

thematic integration as radically as anything in Crane.[29] My point, how-
ever, is that obsessiveness in Conrad also (and more importantly) takes
the form of recurrent large-scale structures of plot, character, and theme
that have no exact equivalent in Crane, and my further claim is that those
structures reveal a common rationale when they are understood in terms
of Conrad's version of "impressionism" as it has been presented in this
essay.

Here, for example, is André Gide, who knew and admired Conrad, in
his *Journals*: "Much interested by the relationship I discover between
Under Western Eyes and *Lord Jim*. . . . That *irresponsible act* of the
hero, to redeem which his whole life is subsequently engaged. For the
thing that leads to the heaviest responsibility is just the *irresponsibilities*
in a life. How can one efface that fact?"[30] And: "Noteworthy that the
fatal *irresponsible* acts of Conrad's heroes (I am thinking particularly of
Lord Jim and *Under Western Eyes*) are involuntary and immediately stand
seriously in the way of the one who commits them. A whole lifetime,
afterward, is not enough to give them the lie and to efface their mark."[31]
Gide's pioneering insight has been confirmed by later critics, who in turn
have speculated as to the personal reasons behind Conrad's attraction to
the theme of self-betrayal and attempted redemption, but my point is
rather that the plot structure Gide describes is of a project of erasure—
in *Lord Jim* (1900), to speak only of it, Jim's project of ultimately erasing
the appalling shame of his leap from the deck of the *Patna*. In this connec-
tion it's worth noting that that novel, too, is punctuated by an imagery
of faces and facing which, if less relentless than in *Almayer's Folly,* is no
less highly charged. "There was nothing he could not face," we are told
of Jim on the *Patna* shortly before the collision in whose confused after-
math he leaps from the ship. "He was so pleased with the idea that he
smiled, keeping perfunctorily his eyes ahead; and when he happened to
glance back he saw the white streak of the wake drawn as straight by the
ship's keel upon the sea as the black line drawn by the pencil upon the
chart" (*LJ,* 58). (The conjunction of motifs of facing and writing is, of
course, hardly fortuitous.)

Immediately after the accident, while still on board the *Patna,* the light
of Jim's lamp "fell upon an upturned dark face whose eyes entreated him
together with the voice" (*LJ,* 109), whereupon he slings the lamp in that
face and runs off to get at the boats. Subsequently Jim discovers he must
face a hostile world, a world of faces demanding facts (*LJ,* 63), while the
facts themselves seem to him to compose something like a face, "a whole
that had features, shades of expression, a complicated aspect that could
be remembered by the eye, and something else besides, something invisi-
ble, a directing spirit of perdition that dwelt within, like a malevolent soul
in a detestable body" (*LJ,* 65). For his part, Marlow, who first lays eyes

on Jim at the hearing after the disaster, is troubled by Jim's appearance precisely because he appears so sound. "I tell you I ought to know the right kind of looks," Marlow says. "I would have trusted the deck to that youngster on the strength of a single glance, and gone to sleep with both eyes—and, by Jove!—it wouldn't have been safe. There are depths of horror in that thought" (*LJ,* 76). In a sense, Jim's project will be to make the meaning of his life eventually coincide with his appearance as Marlow there describes it (see the last chapters of *Almayer's Folly*); and in fact Marlow's final view of Jim standing all in white on the shore as the black night comes down behind him strongly suggests that, with the narrative's tragic denouement still to come, Jim has largely succeeded.[32]

All this is in line with my argument, but the novel goes still further in the extraordinary scene, extending over three chapters, in which Marlow sits writing letter after letter ("I wrote and wrote; I liquidated all the arrears of my correspondence, and then went on writing to people who had no reason whatever to expect from me a gossipy letter about nothing at all" [*LJ,* 169]), filling page after page, at one point—as was mentioned earlier—even seeing two figures in the blankness of a sheet of notepaper, until at last he brings himself to write recommending Jim to a friend who owns a rice-mill (the friend gives Jim a job and would have made him his heir had Jim not fled from the prospect of some day having to tell him about the *Patna* episode). Marlow hands the letter to Jim, who reads it, thanks him ardently, then stammers: "'I always thought that if a fellow could begin with a clean slate . . . And now you . . . in a measure . . . yes . . . clean slate'" (*LJ,* 179)—in effect transforming the ultimate product of Marlow's labors from a blackened page to a blank one. (Typically, Marlow concludes: "A clean slate, did he say? As if the initial word of each our destiny were not graven in imperishable characters upon the face of a rock" [*LJ,* 179].) The moral/psychological significance of the scene, underscored by its length, is that from this moment on Marlow accepts responsibility for Jim (eventually that will lead to Stein sending Jim to Patusan); but even as we register the point our attention is drawn, as if by Marlow himself, to an act of writing that invites being read as emblematizing the author's project of erasure; and what is distinctively Conradian, too, is the perfect fit, expressive of an unconscious mutual accord, between the two meanings, neither of which can exactly be understood as lying "deeper" than the other.

Another much discussed Conradian structure that bears on the issues we have been tracing is that of the *double,* a structure which, more often than not, leads in the end to the sacrifice or disappearance of one or both members of the featured pair. (Jim and Dain Waris in *Lord Jim* are a case in point.) Whatever else may be at stake in this (and there is every reason to think that Conrad's predilection for doubling, as for the theme of self-

betrayal and redemption, was overdetermined), I read the many varieties of doubling in his work as figures for a two-stage process of inscription and erasure, the respective representations of which are often indistinguishable from one another. Perhaps the key text in this regard is the "Author's Note" to Conrad's first collection of stories, *Tales of Unrest* (published 1898), which begins by stating that the earliest of the stories in the volume, "The Lagoon," was "conceived in the same mood which produced 'Almayer's Folly' and 'An Outcast of the Islands' [Conrad's second novel, also set in Sambir and with a younger Almayer among its leading characters], . . . told in the same breath, . . . seen with the same vision, rendered in the same method—if such a thing as method did exist then in my conscious relation to this new adventure of writing for print." Conrad continues: "I doubt it very much. One does one's work first and theorizes about it afterwards." He then remarks, as if expanding on his *unconscious* relation to that new adventure: "Anybody can see that between the last paragraph of An Outcast and the first of The Lagoon there has been no change of pen, figuratively speaking. It happens also to be literally true. It was the same pen: a common steel pen." And he goes on to say that because he thought the pen had been a good pen and had done enough for him, he put it into his waistcoat pocket as a memento. Later it came to rest among other odds and ends in a wooden bowl, where Conrad would see it from time to time with satisfaction,

> till, one day, I perceived with horror that there were two old pens in there. How the other pen found its way into the bowl instead of the fireplace or wastepaper basket I can't imagine, but there the two were, lying side by side, both encrusted with ink and completely undistinguishable from each other. It was very distressing, but being determined not to share my sentiment between two pens or run the risk of sentimentalizing over a mere stranger, I threw them both out the window into a flower bed—which strikes me now as a poetic grave for the remnants of one's past.[33]

The anecdote itself is most likely an invention (Conrad in an autobiographical mode was notoriously unreliable), but it expresses about as lucidly as can be imagined the figurative truth that not one but two pens, the second for the work of erasure, had been involved in the "impressionist" enterprise of *Almayer's Folly* and the works that immediately followed it.[34]

As for Conrad's actual narratives based on doubling, arguably the most powerful of those, "The Secret Sharer" (1909), ends with the narrator/captain's physically similar "secret self," the inadvertent murderer Leggatt, at last quitting the ship where he has been hiding, with the narrator's connivance, in the latter's cabin, which in turn enables the narrator to get his first voyage as captain under way. Shortly before Leggatt goes

over the side we encounter two mutually reinforcing figures for erasure, the first when Leggatt remarks, "What does the Bible say? 'Driven off the face of the earth.' Very well. I am off the face of the earth now"[35]; and the second when the narrator describes Leggatt studying the map of the region where he will have to swim for it: "He looked thoughtfully at the chart as if surveying chances and distances from a lofty height—and following with his eyes his own figure wandering on the blank land of Cochin-China, and then passing off that piece of paper clean out of sight into unchartered regions" ("SS," 149). But the crucial passage occurs near the end of the story: a moment earlier the narrator impulsively snatched his floppy hat off his own head and placed it on Leggatt's; now the narrator's problem is to bring the ship sufficiently close to shore to give Leggatt a chance to swim to safety without running aground in the windless calm (all this on an utterly black night). The passage reads:

> I swung the mainyard and waited helplessly. She was perhaps stopped, for her very fate hung in the balance, with the black mass of Koh-ring [a mountain] like the gate of the everlasting night towering over her taffrail. What would she do now? . . . I stepped to the side swiftly, and on the shadowy water I could see nothing except a faint phosphorescent flash revealing the glassy smoothness of the sleeping surface. It was impossible to tell—and I had not learned yet the feel of my ship. Was she moving? What I needed was something easily seen, a piece of paper, which I could throw overboard and watch. I had nothing on me. To run down for it I didn't dare. There was no time. All at once my strained, yearning stare distinguished a white object floating within a yard of the ship's side. White on the black water. A phosphorescent flash passed under it. What was that thing? . . . I recognized my own floppy hat. It must have fallen off my head . . . and he didn't bother. Now I had what I wanted—the saving mark for my eyes. ("SS," 157–58)

As Leggatt vanishes from the narrator's life (itself an instance of erasure), the white hat, substituting for a piece of paper, provides the object for the narrator's "strained, yearning stare" (think of Conrad gazing at the page) that enables him to steer his ship to safety. And as if to leave no doubt as to the story's stake in figures of blankness, we are told at the end of the same paragraph that Leggatt not only will be "hidden forever from all friendly faces, to be a fugitive and a vagabond on the earth," but also, unlike Cain, will bear "no brand of the curse on his sane forehead to stay a slaying hand" ("SS," 158).

Once again decisive developments with respect to both the narrative's moral/psychological significance and a problematic of erasure share the same imaginative space without either being reducible to the other. Indeed the mutual autonomy of the two meanings, or rather the *indifference* of the second meaning to the precise moral and/or psychological valences of the imagery that in a sense it generates, is epitomized by the fact that

of the two emblems of blankness the paragraph offers—the floppy hat and Leggatt's unmarked brow—the first is *saving,* the second potentially *dooming* (to the narrator's double if not to the narrator himself). To generalize the point, in its most characteristic manifestations Conrad's problematic of erasure first makes the paper black, then makes it blank, not just once but repeatedly—in one exceptional case, *The Nigger of the "Narcissus,"* on virtually every page—without regard for the internal consistency of the moral, psychological, epistemological, and/or ontological issues that appear to depend on, to have been developed in terms of, an obsessive symbolism of black and white.[36] Even to say this, however, is to impose too rigid a schema upon Conrad's prose, in which *extremes* of blackness and whiteness often produce identical effects of a blankness that simultaneously frustrates and exacerbates vision—think of Nostromo and Decoud adrift on the dark Golfo Placido (*N,* 219–47), of Marlow and his crew enveloped by the blinding white mist as they approach Kurtz's camp[37]—and thereby suggests the primal situation of the writer staring at the unmarked page. (In *The Nigger* a different but equally vertiginous effect is achieved by the sheer rapidity with which images of blackness and whiteness succeed each other, as in the amazing sentence, "On the black sky the stars, coming out, gleamed over an inky sea that, speckled with foam, flashed back at them the evanescent and pale light of a dazzling whiteness born from the black turmoil of the waves" [*NN,* 56]. Or, more succinctly, by the fusion of euphemism and explicitness in the skulking Donkin's exclamation, "blank his black soul!" [*NN,* 39]— said of Jimmy, naturally.)[38] Alternatively, as I came close to suggesting earlier, blankness is sometimes figured by absolute *silence* as in the pages that narrate Decoud's death from solitude near the end of *Nostromo* (*N,* 421–27); the entire section can be read as a barely displaced representation of Conrad's novelistic labors at their most sterile, which partly explains Conrad's heightened concern with auditory as well as visual perception.[39] No wonder, then, that deconstructive critics for whom the task of criticism consists in showing "the existence in works of literature of structures of language which contradict the law of noncontradiction" have found grist for their readings in Conrad's fictions.[40] But their failure to note the basis of those structures in his work in a specific relation to the materiality of writing gives their demonstrations a peculiarly disengaged air.

If space permitted I would analyze as further examples of Conrad's problematic of erasure at least the dual thematic in *Nostromo* of the San Tomé silver, a figure for blankness, and "material interests," a virtual oxymoron in that all such interests are shown to be strongly fantasmatic (or "idealistic")[41]; the climactic encounter between Winnie Verloc and her husband in chapter 11 of *The Secret Agent,* a work relentlessly committed

to an ontology of blank *and therefore unreadable* surfaces (consider Winnie's "tragic suspicion"—the book's leitmotif—"that 'life doesn't stand much looking into'")[42]; toward the beginning of *Under Western Eyes,* the imagery of newly fallen snow "cover[ing] the endless forests, the frozen rivers, the plains of an immense country, obliterating the landmarks, the accidents of the ground, levelling everything under its uniform whiteness, like a monstrous blank page awaiting the record of an inconceivable history," and much later in that novel the deafening of Razumov by the double-named terrorist—himself a double agent—Nikita/Necator[43]; and the last pages of *Victory,* in particular the scene in which Heyst tears off the front of the morally wounded Lena's black dress, sees "the little black hole made by Mr. Jones's bullet under the swelling breast of a dazzling and as it were sacred whiteness," and then, "calm and utterly unlike himself in the face," covers the wound with a wet cloth.[44] Apropos of *Under Western Eyes,* I note in passing that soon after completing that distinctively "Russian" book, Conrad redistributed the semes "snow," "deafness," and "writing" so as to personify Polish (that is, anti-Russian) nationalist purity of motive via a metaphorics of blankness in the heroic protagonist of the short story "Prince Roman."[45] The contrast between novel and story in this regard epitomizes the indifference of Conrad's obsessional procedures to the moral and/or psychological—and in this case the political—meaning of the imagery, characters, and plot in which they issue.[46] But to insist on that indifference is not to deny the specifically political interest of certain of Conrad's narratives (including *Under Western Eyes* and "Prince Roman"), and in the remainder of this essay I want to discuss the relation of the problematic I have been tracing to Conrad's treatment of a topic of urgent concern to recent historicist criticism: imperialism. I shall do this by first citing a familiar passage from *Heart of Darkness* and then moving immediately to consider another, shorter story that has received much less attention than the famous novella, the underrated "Youth."

The passage in *Heart of Darkness* is the one in which Marlow describes how, when he was little, he had a passion for maps.

"I would look for hours at South America, or Africa, or Australia, and lose myself in all the glories of exploration," he remarks to his auditors. "At that time there were many blank spaces on the earth, and when I saw one that looked particularly inviting on a map (but they all look that) I would put my finger on it and say, When I grow up I will go there. The North Pole was one of these places, I remember. Well, I haven't been there yet, and shall not try now. The glamour's off. Other places were scattered about the Equator, and in every sort of latitude all over the two hemispheres. I have been in some of them, and . . . well, we won't talk about that. But there was one yet—the biggest, the most blank, so to speak—that I had a hankering after."

Marlow goes on to say that by the time he grew up "it was not a blank space any more. . . . It had ceased to be a blank space of delightful mystery—a white patch for a boy to dream gloriously over. It had become a place of darkness."[47] As the story unfolds, darkness and blankness turn out to be cognate with one another in innumerable respects, but what I want to emphasize in this context are not the vicissitudes and transformations of that initial image but rather the analogy between the blank page as what I earlier called a field of boundless possibility for the writer seated before it and the white space on the map as a comparable field of imaginative self-realization for the young male European (that is, white) bourgeois subject in the late nineteenth and early twentieth centuries. Understood in this light, maps of the world with their unmarked spaces, color codings, and exotic placenames play a vital role in the technology of imperialism not so much because they give objective expression to the struggle for geopolitical domination as because they help mobilize the youthful energies of an entire class of persons in a seemingly individualist but in fact largely collective undertaking whose economic and political consequences, when not actually occulted, at any rate need never be recognized as such. And the text of Conrad's that dramatizes the efficacy of that technology, more brilliantly and concentratedly that any other, is "Youth" (1898).

Very briefly, "Youth" is Marlow's story of his first voyage to the East as a young man, on a ship named the *Judea* loaded with coal for Bangkok and bearing on her stern, "'below her name in big letters, a lot of scrollwork, with the gilt off, and some sort of a coat of arms, with the motto 'Do or Die' underneath.'"[48] All this, Marlow says, took his fancy immensely, but what more than anything fired his imagination was the ship's destination: "'Bangkok! I thrilled. I had been six years at sea, but had only seen Melbourne and Sydney, very good places, charming places in their way—but Bangkok!'" ("Y," 6). In fact the voyage consisted of nothing more than an unbroken series of false starts and outright disasters, through all of which the youthful Marlow was sustained by the prospect of finally seeing the fabled East; the last disaster, an explosion and fire, eventually sank the ship; and as by now we might expect, the sinking involved an act of erasure. In Marlow's words: "'As we pulled across her stern [Marlow and the crew had transferred to boats] a slim dart of fire shot out viciously at us, and suddenly she went down, head first, in a great hiss of steam. The unconsumed stern was the last to sink; but the paint had gone, had cracked, had peeled off, and there were no letters, there was no word, no stubborn device that was like her soul, to flash at the rising sun her creed and her name'" ("Y," 39). Even then, Marlow explains, his enthusiasm remained undampened: "'I was steering for Java—another blessed name—like Bangkok, you know. I steered many

days'" ("Y," 40). Finally, one night, utterly exhausted, Marlow and his men reached their destination and were joined almost immediately by the other boats from the *Judea*. The captain dispatched Marlow to find out whether a nearby ship in the harbor was English. "'And then,' Marlow reports, 'before I could open my lips, the East spoke to me, but it was in a Western voice. . . . The voice swore and cursed violently; it riddled the solemn peace of the bay by a volley of abuse. It began by calling me Pig, and from that went crescendo into unmentionable adjectives—in English'" ("Y," 43–44). When the bearer of the voice realized that Marlow himself was English its tone changed; a commitment was made to take the crew of the *Judea* on board; whereupon Marlow returned to the jetty and went to sleep.

When he awakened it was broad day; in a flood of light, Marlow opened his eyes and lay without moving. In a long paragraph, which I will quote in its entirety, the story reaches its climax:

"And then I saw the men of the East—they were looking at me. The whole length of the jetty was full of people. I saw brown, bronze, yellow faces, the black eyes, the glitter, the colour of an Eastern crowd. And all these beings stared without a murmur, without a sigh, without a movement. They stared down at the boats, at the sleeping men who at night had come to them from the sea. Nothing moved. The fronds of palms stood still against the sky. Not a branch stirred along the shore, and the brown roofs of hidden houses peeped through the green foliage, through the big leaves that hung shining and still like leaves forged of heavy metal. This was the East of the ancient navigators, so old, so mysterious, resplendent and sombre, living and unchanged, full of danger and promise. And these were the men. I sat up suddenly. A wave of movement passed through the crowd from end to end, passed along the heads, swayed the bodies, ran along the jetty like a ripple on the water, like a breath of wind on a field—and all was still again. I see it now—the wide sweep of the bay, the glittering sands, the wealth of green infinite and varied, the sea blue like the sea of a dream, the crowd of attentive faces, the blaze of vivid colour— the water reflecting it all, the curve of the shore, the jetty, the high-sterned outlandish craft floating still, and the three boats with the tired men from the West sleeping, unconscious of the land and the people and of the violence of sunshine. They slept thrown across the thwarts, curled on bottom-boards, in the careless attitudes of death. The head of the old skipper, leaning back in the stern of the long-boat, had fallen on his breast, and he looked as though he would never wake. Farther out old Mahon's [the first mate's] face was upturned to the sky, with the long white beard spread out on his breast, as though he had been shot where he sat at the tiller; and a man, all in a heap in the bows of the boat, slept with both arms embracing the stem-head and with his cheek laid on the gunwale. The East looked at them without a sound." ("Y," 45–46)

"'For me,'" Marlow sums up, "'all the East is contained in that vision of my youth. It is all in that moment when I opened my young eyes on it. I came upon it from a tussle with the sea—and I was young—and I saw it looking at me'" ("Y," 47).

In this fabulous scene, a problematic of erasure, already thematized in the obliteration of the *Judea's* name and device just before it sank, is further expressed in the autograph Conradian motif of Marlow's two experiences of arrival—the cursing voice and the silent gazes—the second of which effectively cancels (without exactly denying) the first; it perhaps is active as well in the image of the sleeping Mahon's upturned face with his white beard spread out on his breast; but its most powerful manifestation lies in the suggestion that the youthful Marlow was himself a blank page, as if the scene by the jetty were visualized from the position not of the writer staring at the white paper but rather of the paper under his eyes.[49] And this suggests in turn that one of imperialism's fundamental mobilizing strategies was to encourage its younger representatives to imagine, for all their prior formation in European society and the actual economic work they were carrying out, that they were engaged in a strictly personal enterprise of self-realization that cast them in the passive role of blank surfaces on which their experiences of the East (or Africa, or South America) would inscribe the first identity-defining marks.[50] Conrad's singular achievement in "Youth" was, through the medium of erasure, simultaneously to bear eloquent witness to the success of that strategy and to allow the reader to glimpse its merely strategic face.

NOTES

1. Stephen Crane, *The Monster, Tales of Whilomville,* vol. 7 of *The Works of Stephen Crane,* ed. Fredson Bowers (Charlottesville, Va., 1969), 24.

2. Joseph Conrad, *Almayer's Folly: A Story of an Eastern River* (London, 1895), 127; hereafter abbreviated *AF.*

3. Frank Norris, *Vandover and the Brute* (New York, 1914), 138–40; hereafter abbreviated *VB.*

4. Michael Fried, *Realism, Writing, Disfiguration: On Thomas Eakins and Stephen Crane* (Chicago, 1987), 91–161; hereafter abbreviated *RWD.*

5. See ibid., 94–95, 132–44. Let me take this opportunity to add to my discussion of *The Monster* in *RWD* the small point that the child whose party Henry Johnson disrupts in chapter 16 is named Theresa *Page.*

6. Conrad, "Preface," *The Nigger of the "Narcissus,"* ed. Cedric Watts (Harmondsworth, 1988), xlix; hereafter abbreviated *NN.* See Ian Watt's well-known article, "Conrad's Preface to *The Nigger of the 'Narcissus',"* Novel: A Forum on Fiction 7 (Winter 1974): 101–15. As was true of *RWD* (184 n. 21), my use of the concept of literary "impressionism" is heuristic (hence the quotation marks). By this I mean that I am unpersuaded by the many attempts that have been made to define that concept either in relation to French impressionism painting or in terms of a fidelity to or evocation of the "impressions" of one or more characters (including the implied narrator), but that I see no comparably useful designation for the global tendency that Crane, Norris, and Conrad all instantiate. Moreover, the term *impressionism,* understood in relation to a problematic of inscription and (or *as*) erasure, has the virtue of thematizing a certain notion of

pressure or say *imprinting* that it seems important to preserve. (My thanks to Neil Hertz for suggesting this point.) See in this general connection Watt's discussion of "impressionism" in Conrad in his *Conrad in the Nineteenth Century* (Berkeley, 1979), 169–80; Bruce Johnson, "Conrad's Impressionism and Watt's 'Delayed Decoding,'" in *Conrad Revisited: Essays for the Eighties,* ed. Ross C. Murfin (University, Ala., 1983), 51–70; and Donald R. Benson, "Impressionist Painting and the Problem of Conrad's Atmosphere," *Mosaic* 22 (Winter 1989): 29–40.

7. The key text by London is chapter 15 of *Martin Eden,* an account of Martin's hallucinatorily intense recollections of a series of brutal fistfights with his boyhood nemesis, Cheese-Face. "He concentrated upon that face; all else about him was a whirling void," a characteristic passage reads. "There was nothing else in the world but that face, and he would never know rest, blessed rest, until he had beaten that face into a pulp with his bleeding knuckles, or until the bleeding knuckles that somehow belonged to that face had beaten him into a pulp" (Jack London, *Martin Eden* [New York, 1909], 133). Martin's recollections are triggered by his sense of being engaged in an equally fierce battle to publish his manuscripts, which leads me to interpret the chapter as a whole as expressive of a hyperbolic desire to make writing and publication a single continuous act. (This is bound to seem obscure as it stands. See, however, Walter Benn Michaels's discussion of *Martin Eden* in his forthcoming volume of the Cambridge History of American Literature.) The same chapter in *Martin Eden* comments on Martin's "splendid power of vision" by virtue of which he finds himself "both onlooker and participant" in the remembered battles with Cheese-Face, and moreover likens the vividness of the experience to "gazing into a kinetoscope" (ibid., 135). In an altogether different tenor, Harold Frederic's *The Damnation of Theron Ware or Illumination* contains numerous images of upturned *listening* faces (Ware is a preacher), which I relate to the fact that the practice of reading drafts of work in progress aloud to a sympathetic listener, as well as the reverse, having them read aloud to him, played an important role in the composition of his novels. See Stanton Garner, "History of the Text," in Frederick, *The Damnation of Theron Ware or Illumination,* ed. Charlene Dodge, vol. 3 of The Harold Frederic Edition [Lincoln, Nebr., 1985], 367, 373. I was first alerted to this possibility by some remarks in a paper by Maria Farland.

In W. H. Hudson's *Green Mansions: A Romantic of the Tropical Forest* (London, 1904), a work greatly admired in its time and overdue for recognition in ours, the materiality and (especially) the act of writing are not so much repressed as denied by the narrative's insistence on the absolute otherness or "difference" of the jungle girl Rima's beautiful, constantly changing face and enchanting but, to ordinary mortals, unintelligible voice. After she dies, however, both materiality and act are in effect acknowledged—albeit aversively—by the principal narrator's "fancy" that he was accompanied throughout a long journey over open country by "a sinuous mark in the pattern on a huge serpent's head, five or six yards long, always moving deliberately at my side" (311). I prefer not to speculate about the relevance of my general argument to the work of Henry James at the present time.

8. See Walter Benn Michaels, *The Gold Standard and the Logic of Naturalism: American Literature at the Turn of the Century* (Berkeley, 1987), 137–80; hereafter abbreviated *GS.* See also Michaels's insistence in the introduction to that book (entitled "The Writer's Mark") that

the commodity is . . . an example of a thing whose identity involves something more than its physical qualities, but it is by no means the only example. What else, for instance, is money, which (as opposed, say, to gold) cannot be reduced to the thing it is made of and still remain the thing it is? What else is the corporation, which cannot be reduced to the men and women who are its shareholders? Or, to go beyond the economic subjects of texts like *McTeague* and *The Octopus* to their mode of literary expression, what else is that mode of expression, writing? For writing to be writing, it can neither transcend the marks it is made of nor be reduced to those marks. Writing is, in this sense, intrinsically different from itself, neither material nor ideal. (*GS*, 21)

Let me take this opportunity to acknowledge the stimulus I have found in Michaels's writings and conversation in the course of working on this essay.

9. See Norris, *A Man's Woman and Yvernelle*, vol. 6 of the Argonaut Manuscript Limited Edition of Frank Norris's Works (Garden City, N.Y., 1928); hereafter abbreviated *MW*. I note in passing that Christopher Morley in a brief foreword to *A Man's Woman* refers to Norris's "high-tension impressionism" (*MW*, ix).

10. Significantly, Ferriss at one point is described as "drawing figures and vague patterns in the fur of his deerskin coat" with the tip of a tin spoon lashed to one of his stumps (*MW*, 34).

11. See my account in *RWD* of the coexistence in Crane's prose of two opposing tendencies, one toward miniaturization and the other toward a certain monstrosity. There I propose that second tendency may be thought of

as expressing (and repressing) a subliminal awareness of the nearness of the writer's hand, and more broadly of the role of that hand—of the writer as corporeal being—in the production of writing, though alternatively it could be argued that the opposition between miniaturization and monstrosity lines up with the contrast between the relatively minute scale of writing and the unlimited magnitude of writing's representational effects. Perhaps it would be best to say simply that the opposition at once expresses and disguises an unelidable disjunction between the scene of writing and the "space" of representation. (*RWD*, 141)

In any event, the contrast between the double valence of Crane's prose in this regard and Norris's insistence on Bennett's simplicity (or either-or-ness) of vision goes a long way toward disqualifying Bennett as a potential writer. Also, apropos of the passage from *A Man's Woman* just cited, it might be noted that the wilderness of ice that confronts the expedition at the beginning of the novel reads like a description of a piece of paper seen under a microscope.

12. See Franklin Walker, *Frank Norris: A Biography* (Garden City, N.Y., 1932), 212–17.

13. Roland Barthes, "*Will* Burns Us. . . . ," *Critical Essays*, trans. Richard Howard (Evanston, Ill., 1972), 77.

14. The nearest thing to an exception is *Vandover and the Brute*, which begins with a brief account of Vandover's memory (or "memory picture" [*VB*, 5]) of his invalid mother's death. Vandover, then eight years old, and his parents had been travelling by train from Boston to San Francisco; at a depot in a town in Western New York his mother, in a long steamer chair, had been carried from the train and set down on the platform. "By and by she drew a long sigh," the climatic passage reads, "her face became the face of an imbecile, stupid, without expression, her eyes half-closed, her mouth half-open. Her head rolled forward as though she were nodding in her sleep, while a long drip of saliva trailed from her lower lip" (*VB*, 4–5). It's as though the rest of the novel proceeds under the sign of that

face, a motif that returns with a vengeance—whose implicit foregrounding of materiality is in effect unleashed—in the shipwreck scene (note in particular the parallel between the drip of saliva trailing from Vandover's mother's lip and the "silver chain of bubbles escaping from [the Jew's] mouth"). See Mark Seltzer's discussion of the scene of Vandover's mother's death in the context of Norris's "mechanics of fiction" in "The Naturalist Machine," in *Sex, Politics, and Science in the Nineteenth-Century Novel,* ed. Ruth Bernard Yeazell (Baltimore, 1986), 116–47.

15. *The Collected Letters of Joseph Conrad,* ed. Frederick R. Karl and Laurence Davies, 3 vols. (Cambridge, 1983–), 1:156; hereafter abbreviated *CL*.

16. A similar though more highly charged scene takes place toward the end of *The Nigger of the "Narcissus,"* as James Wait, at the end of his strength, rages impotently at Donkin. "Jimmy rallied again," the passage reads.

> He lifted his head and turned bravely at Donkin, who saw a strange face, an unknown face, a fantastic and grimacing mask of despair and fury. Its lips moved rapidly; and hollow, moaning, whistling sounds filled the cabin with a vague mutter full of menace, complaint and desolation, like the far-off murmur of a rising wind. Wait shook his head; rolled his eyes; he denied, cursed, menaced—and not a word had the strength to pass beyond the sorrowful pout of those black lips. It was incomprehensible and disturbing; a gibberish of emotions, a frantic dumb show of speech pleading for impossible things, threatening a shadowy vengeance. It sobered Donkin into a scrutinizing watchfulness. (*NN,* 112).

See in this connection the third from the last paragraph in the preface of *The Nigger,* which begins: "Sometimes, stretched at ease in the shade of a roadside tree, we watch the motions of a labourer in a distant field, and after a time, begin to wonder languidly as to what the fellow may be at" (*NN,* 1). Although Conrad doesn't say so, the perspective the paragraph evokes is not unlike that of a deaf person in a world of sound. In the last section of this essay I comment briefly on Conrad's use of motifs of deafness in *Under Western Eyes* and "Prince Roman."

17. The original reads:

Ma très chère Tante.

Pardonnez-moi de ne pas avoir ecrit plus tot mais je suis en train de lutter avec Chap XI; une lutte a mort Vous savez! Si je me laisse aller je suis perdu! Je Vous ecris au moment de sortir. Il faut bien que je sorte quelquefoi Helas! Je regrette chaque minue que je passe loin du papier. Je ne did pas de la plume car 'ai ecrit fort peu, mais l'inspiration me vient en regardant le papier. Puis ce sont des echappées a perte de vue; la pensée s'en va vagabondant dans des grands éspaces remplis des formes vagues. Tout e[s]t chaos encore mais—lentement—les spectres se changent en chair vivante, les vapeurs flottantes se solidifient et qui sait?—peut-être quelque chose naitra dans le choc des idées indistinctes.—

Je Vous envois la première page (dont j'ai pris copie) pour Vous donner une idée de l'apparence de mon manuscrit. Cela Vous est du puisque j'ai vu le Votre.—J'aime a me conformer a l'etiquette, moi.—

<div align="right">Vous embrasse de tout mon coeur.
Toujours a Vous
Joseph Conrad</div>

18. A case in point is the contrast (also the similarity) between two descriptions of shadow-representations in texts by Conrad and Crane. In chapter 10 of *Al-*

mayer's Folly, Almayer, huddled up in a chair, has fallen asleep on the verandah of his house. "In the increasing light of the moon that had risen now above the night mist," the passage reads, "the objects on the verandah came out strongly outlined in black splashes of shadow with all the uncompromising ugliness of their disorder, and a caricature of the sleeping Almayer appeared on the dirty white-wash of the wall behind him in a grotesquely exaggerated detail of attitude and feature enlarged to a heroic size" (*AF*, 206–7; see my remarks on monstrosity in Crane in n. 11). (The whole of this scene, in which Almayer appears both as a subject of representation and, in his capacity as dreamer, as a surrogate for the writer, is of great interest.) For his part, Crane, in one of his earliest pieces of journalism, describes with relish various "shadow pictures" cast on the canvas walls of Ocean Grove's Camp Meeting Association tents; the last is of a man's vest hung on the tent wall, with a watch chain dangling in full sight; the passage concludes:

> You would think then, that Ocean Grove would be the paradise of thieves.
> All they would have to do is to watch the shadow pictures and see what a family did with its things. Then when the lights were out cut a hole in the canvas and get what they wanted.
> Pretty easy burglary where the only tool required is a sharp knife. What would hinder a clever thief from cutting into a dozen tents in one night and carrying off a dozen vests and watches hung against the canvas wall? (Crane, "Tent Life at Ocean Grove" [1891], reprinted in Thomas A. Gullason, "The 'Lost' Newspaper Writings of Stephen Crane," *Syracuse University Library Associates Courier* 21 [Spring 1986]: 77–78)

Taking the knife as a figure for the writer's pen, we have in this early sketch nothing less than a precocious allegory of Crane's "impressionism."

19. This is as good a place as any to remark that a basic difference between the brutalized hands in the Conrad and Norris passages with which this essay opened is that the faceless dead man's hand on the Sambir riverbank bears an identifying ring (meant to show that the corpse was Dain's, which in fact it isn't). In other words, the ring, and by metonymy the hand, perform a task of (mis)representation; whereas I've read the destruction of the Jew's hands in *Vandover*, like the amputation of Ferriss's hands in *A Man's Woman*, as signifying the impossibility of representation. I need hardly add that identifying rings play a crucial role in other fictions by Conrad.

20. For example, in Conrad's letter to Edward Garnett of 19 June 1896, he writes:

> Since I sent you that part 1st [of the "Rescuer" manuscript] (on the eleventh of the month) I have written one page. Just one page. I went about thinking and forgetting—sitting down before the blank page to find that I could not put one sentence together. To be able to think and unable to express is a fine torture. I am undergoing it—without patience. I don't see the end of it. It's very ridiculous and very awful. Now I've got all my people together I don't know what to do with them. The progressive episodes of the story *will* not emerge from the chaos of my sensations. I feel nothing clearly. And I am frightened when I remember that I have to drag it all out of myself. . . . My task appears to me as sensible as lifting the world without the fulcrum which even that conceited ass, Archimedes, admitted to be necessary. (*CL*, 1:288–89)

21. Conrad, *Lord Jim*, ed. Watts (Harmondsworth, 1988), 171; hereafter abbreviated *LJ*. The passage in *Lord Jim* might in turn be compared with the simile of gazing into a kinetoscope in chapter 15 of *Martin Eden* (see n. 7 above).

22. The metaphor of "blackening" is Conrad's own as, for example, in the following sentence from the most important of his autobiographical writings, *A Personal Record:*

> The conception of a planned book was entirely outside my mental range when I sat down to write [Conrad is recounting the genesis of *Almayer's Folly*]; the ambition of being an author had never turned up amongst these gracious imaginary existences one creates fondly for oneself at times in the stillness and immobility of a daydream; yet it stands clear as the sun at noonday that from the moment I had done blackening over the first manuscript page of "Almayer's Folly" (it contained about two hundred words and this proportion of words to a page has remained with me through the fifteen years of my writing life), from the moment I had, in the simplicity of my heart and the amazing ignorance of my mind, written that page the die was cast. [Conrad, *The Mirror of the Sea and A Personal Record* (1912; Oxford, 1988), 68–69]

A propos of Conrad's fascination with the look of his prose, see, for example, the "Author's Note" to *The Rescue*—a novel begun in the mid-1890s but only completed in 1914—in which Conrad explains that he "dropped *The Rescue* not to give myself up to idleness, regrets or dreaming, but to begin *The Nigger of the 'Narcissus'* and to go on with it without hesitation and without a pause. A comparison of any page of *The Rescue* with any page of *The Nigger* will furnish an ocular demonstration of the nature and the inward meaning of this first crisis of my writing life" (Conrad, *The Rescue* [London, 1950], 10). Perhaps, but how are we to make that comparison? What precisely is the *object* of the "ocular demonstration" to which Conrad alludes?

23. In fact it isn't known for certain that the page in the Rosenbach Library is the one Conrad sent to Poradowska, but several considerations suggest that this is the case: (1) it is one of two versions of chapter 11, p. 1, in the Rosenbach manuscript; (2) of the two it is obviously the "original" version (that is, it's far more heavily revised than the other); (3) it has been folded twice, as if to fit inside an envelope. Exactly when and how it came to rejoin the rest of the manuscript remains an unanswered question. For an interesting discussion of Conrad's revisions of the opening of chapter 11, see John Dozier Gordan, *Joseph Conrad: The Making of a Novelist* (Cambridge, Mass., 1941), 120–21.

24. Words spoken by Dr. Monygham to Mrs. Gould near the end of Conrad's *Nostromo* (London, 1904), 434; hereafter abbreviated *N*.

25. See Conrad, "The Black Mate," *Tales of Hearsay* (Garden City, N.Y., 1925), 85–120; hereafter abbreviated "BM." On the vexed question of the story's dating, see Frederick R. Karl, *Joseph Conrad: The Three Lives* (New York, 1979), 234–36; hereafter abbreviated *JC*.

26. The exception is Aaron Fogel, who, in his ambitious study, *Coercion to Speak: Conrad's Poetics of Dialogue* (Cambridge, Mass., 1985), 252, 254, regards "The Black Mate" as "one of Conrad's key minor pieces." Fogel interestingly relates the scholarly problem of the story's date (what relation does the published version of 1908 bear to an alleged earlier version of 1886?) to the composite age of its protagonist, and suggests that "['The Black Mate'] has a metaphoric fidelity to the author's own servitude," which Fogel defines in terms of the production of "forced dialogues" for a largely uncomprehending public.

27. See *RWD*, 127–28, 142, 160, 187–88 n. 36. In a chapter on literary realism in his forthcoming volume in the Cambridge History of American Literature, Michaels qualifies my argument by emphasizing, first, "realism's attempt to make the reader see writing [as it performs its task of representation, so to speak]," and second, the extent to which "a writing that doubles its formal ambition to

make us see *it* by an ambition to make us see *something else* necessarily alters that formal ambition, providing what are at the same time additional and essential motives for seeing, and making possible scenarios which will link the desire to see with the desire to be seen." Michaels goes on to analyze two such scenarios in *Maggie* and *The Red Badge of Courage,* thereby restoring to those novels a version of the thematic coherence my treatment of them claims to displace. Without subscribing fully to his proposed revision of my account of Crane's "impressionism," I find his readings of *Maggie* and *The Red Badge* largely persuasive. On the other hand, the very terms of those readings militate against traditional notions of character, while Michaels's concentration on a relatively small number of crucial passages minimizes the *anti*totalizing, even athematic, force of the sheer profusion of materiality-effects in Crane's most characteristic texts. In fact the *most* characteristic of all Crane's longer narratives may be *The Monster,* which has always defied thematic recuperation (and perhaps mainly for that reason has remained apart from the select canon of late nineteenth-and early twentieth-century literary masterpieces to which by rights it belongs).

28. See, for example, Peter Brooks, "An Unreadable Report: Conrad's *Heart of Darkness,*" *Reading for the Plot: Design and Intention in Narrative* (New York, 1984), 238–63; James Guetti, *The Limits of Metaphor: A Study of Melville, Conrad, and Faulkner* (Ithaca, N.Y., 1967), 46–68; Christopher L. Miller, "The Discoursing Heart: Conrad's *Heart of Darkness,*" in *Blank Darkness: Africanist Discourse in French* (Chicago, 1985), 169–83; J. Hillis Miller, "*Heart of Darkness* Revisited," in *Conrad Revisited,* ed. Murfin, 31–50; Benita Parry, *Conrad and Imperialism: Ideological Boundaries and Visionary Frontiers* (London, 1983), 20–39; Adena Rosmarin, "Darkening the Reader: Reader-Response Criticism and *Heart of Darkness,*" in Conrad, *Heart of Darkness: A Case Study in Contemporary Criticism,* ed. Murfin (New York, 1989), 148–71; Henry Staten, "Conrad's Mortal Word," *Critical Inquiry* 12 (Summer 1986): 720–40; and Tzvetan Todorov, "Connaissance du vide," *Nouvelle Revue de Psychanalyse,* no. 11 (1975): 145–54. Even Watt, who feels that Todorov goes too far in seeing "*Heart of Darkness* as implying the impossibility of expressing the essential reality of human experience in fiction," acknowledges the obscurity involved in the novella's "quasi-transcendental perspective" (Watt, *Conrad in the Nineteenth Century,* 251–52).

29. For example, near the beginning of chapter 10, Nina, about to leave Sambir to meet Dain, remarks to Mrs. Almayer, "'Mother, I shall return to the house and look once more at my father's face'" (*AF,* 196). Mrs. Almayer, full of hate for her husband, refuses to allow her to go, adding, "'I remember . . . I wanted to look at your face again. He said no! I heard you cry and jumped into the river'" (this when Nina was first sent to Singapore to be educated [*AF,* 196–97]). A bit further on we are told: Mrs. Almayer "could not see her daughter's face," and shortly after that she entreats her daughter, "'Give up your old life! . . . Forget that you ever looked at a white face'" (*AF,* 197–98). We are then informed that "at the bottom of [Nina's] passing desire to look again at her father's face there was no strong affection. She felt no scruples and no remorse at leaving suddenly that man whose sentiment towards herself she could not understand, she could not even see. There was only an instinctive clinging to old life, to old habits, to old faces; that fear of finality which lurks in eery human breast and prevents so many heroisms and so many crimes" (*AF,* 198). (Later, in the encounter on the beach, Almayer will suddenly cry out, for no apparent reason, "'Nina! . . . take your eyes off my face'" [*AF,* 227].) Nor is this all. The chapter continues obsessively both to refer and to describe a variety of faces, reading a crescendo

in its evocation of a tortured dream that visits Almayer as he sits sleeping on his verandah ("How escape from the importunity of lamentable cries and from the look of staring, sad eyes in the faces which pressed round him till he gasped for breath under the crushing weight of worlds that hung over his aching shoulders?" [*AF*, 207].) Almayer is then awakened by the slave-girl Taminah ("He looked at the woman's face under him. A real woman! He knew her. By all that is wonderful! Taminah!" [*AF*, 210].) who, in love with Dain, reveals the lovers' plans. The chapter ends: "Almayer hid his face in his hands as if to shut out a loathsome sight. When, hearing a slight rustle, he uncovered his eyes, the dark heap by the door was gone" (*AF*, 215). This hardly begins to suggest the prevalence of face imagery in the novel as a whole.

30. Quoted in English in *JC*, 709. The original French reads: "Fort intéressé par la parenté que je découvre entre *Sous les Yeux d'Occident* et *Lord Jim.* . . . Cette *inconséquence* du héros, pour le rachat de laquelle toute sa vie, ensuite, est comme mise en gage. Car ce qui tire le plus à conséquence, ce sont précisément les *inconséquences* d'une vie. Comment effacer cela?" (Andre Gide, entry for 23 February 1930, *Journal, 1889–1939* [Paris, 1951], 971.

31. Quoted in English in *JC*, 709. The original French reads: "A remarquer que les fatales *inconséquences* des héros de Conrad (je songe en particulier à *Lord Jim* et à *Under Western Eyes*) sont involontaires et gênent aussitôt grandement l'être qui les commet. Toute la vie, par la suite, ne suffit pas à les démentir et à en effacer les traces" (Gide, *Journal*, 1002).

32. The passage in question reads:

> "He was white from head to foot, and remained persistently visible with the stronghold of the night at his back, the sea at his feet, the opportunity by his side—still veiled. What do you say? Was it still veiled? I don't know. For me that white figure in the stillness of coast and sea seemed to stand at the heart of a vast enigma. The twilight was ebbing fast from the sky above his head, the strip of sand had sunk already under his feet, he himself appeared no bigger than a child—then only a speck, a tiny white speck, that seemed to catch all the light left in a darkened world. . . . And, suddenly, I lost him." (*LJ*, 291)

What has boggled commentary is Marlow's insistence, here as elsewhere, on Jim's *enigmatic* quality as (or as if as) an object to vision. ("'He was not—if I may say so—clear to me,'" Marlow says of him earlier in the book. "'He was not clear'" [*LJ*, 173]). I associate that quality with Conrad's experience of the blank page as a field of boundless possibilities, hence also of radical uncertainty. See his remarks in his letter of 16 September 1899 to Edward Garnett (he was then at work on *Lord Jim*):

> My efforts seem unrelated to anything in heaven and everything under heaven is impalpable to the touch like shapes of mist. Do you see how easy writing must be under such conditions? Do you see? Even writing to a friend—to a person one has heard, touched, drank with, quar[r]elled with—does not give me a sense of reality. All is illusion—the words written, the mind at which they are aimed, the truth they are intended to express, the hands that will hold the paper, the eyes that will glance at the lines. Every image floats vaguely in a sea of doubt—and the doubt itself is lost in an unexpected universe of incertitudes. (*CL*, 2:198)

33. Conrad, "Author's Note," *Tales of Unrest* (1898; Harmondsworth, 1977), 9.

34. Another "Author's Note" of interest in this connection is that to Conrad's second novel, *An Outcast of the Islands* (1896; Harmondsworth, 1975). The "Note" begins: "*An Outcast of the Islands* is my second novel in the absolute

sense of the word; second in conception, second in execution, second as it were in its essence." Conrad explains that after finishing *Almayer's Folly* he remained uncertain whether he "should write another line for print," and that his perplexity was resolved only when his friend Garnett said to him: "'You have the style, you have the temperament: why not write another?'" Conrad continues:

> I believe that as far as one man may wish to influence another man's life Edward Garnett had a great desire that I should go on writing. At that time, and I may say, even afterwards, he was always very patient and gentle with me. What strikes me most however in the phrase quoted above which was offered to me in a tone of detachment is not its gentleness but its effective wisdom. Had he said, "Why not go on writing," it is very probable he would have scared me away from pen and ink for ever; but there was nothing either to frighten one or arouse one's antagonism in the mere suggestion to "write another." And thus a dead point in the revolution of my affairs was insidiously got over. The word "another" did it. (Conrad, "Author's Note," 7–8)

The word "another" did it, I suggest, because it held out the promise of displacing (in that sense erasing) *Almayer's Folly,* which is also why Conrad describes *An Outcast* as "my second novel in the absolute sense of the word." (*An Outcast* is also set in Sambir, and includes a more youthful Almayer, Lingard, and Babalatchi among its dramatis personae. A fuller study of Conrad's "impressionism" would require comparing his first two novels in some detail.)

The association between doubling and erasure (or at least blankness) also emerges in an improbable anecdote that Conrad is supposed to have related in the course of his 1923 visit to the United States. Jessie Conrad, relying on a newspaper cutting from that visit, tells how Conrad spoke of reading cheap editions of Mark Twain on the Congo. "'I recall a remark made to me once when I was paying a call on Arthur Symons,'" the cutting quotes Conrad as having said. "'He had a friend sitting in his room who affected the appearance of Mark Twain. The white flannel suit, the white hair, in fact, the whole appearance was a direct copy of the great American author. I remarked upon the resemblance laughingly and with perfect good-humour the "copy" admitted the intentional likeness, but he insisted, "you see the very name gives me license, 'Mark Twain'"'" (Jessie Conrad, *Joseph Conrad and His Circle* [New York, 1935], 252–53).

35. Conrad, "The Secret Sharer: An Episode from the Coast," *'Twixt Land and Sea* (London, 1912), 146; hereafter abbreviated "SS." There is a large critical literature on this story; see, for example, Albert J. Guerard, *Conrad the Novelist* (Cambridge, Mass., 1958), 21–26; Edward W. Said, *Joseph Conrad and the Fiction of Autobiography* (Cambridge, Mass., 1966), 125–36; and Joan E. Steiner, "Conrad's 'The Secret Sharer': Complexities of the Doubling Relationship," *Conradiana* 12 (1980): 173–86. The notion of "secret sharing" is thematized in Bernard C. Meyer, *Joseph Conrad: A Psychoanalytic Biography* (Princeton, N.J., 1967); see, for example, Meyer's remarks on Conrad's story, 164–67.

36. See Martin Ray, who observes that "the compulsion to write imposed on Conrad by the writing of the first word is yet designed to return him eventually to that blankness from which he began. . . . The work of art appears to exist tentatively, as it were, in parentheses, between the blank page from which it originates and the blank exhaustion which the author must seek." But Ray's concern with the theme of silence leads him away from a problematic of *writing* toward one of *language*. In his summary:

> Conrad's attempt to erect a barrier of language against the impending silence is but one half of his ambiguous attitude to the forces of negation; much of his creative power must

be said to originate in his direct confrontation with those forces, a confrontation which required him to transcend temporarily the barriers of language before retreating again into the shelter which they provide. . . . The medium [of Conrad's style] is itself the record and the reward of Conrad's confrontation with the forces of silence. (Ray, "Language and Silence in the Novels of Joseph Conrad," *Conradiana* 16 [1984]: 27,37)

See also Said: "Writing for Conrad was an activity that constituted negation—of itself, of what it dealt with—and was also oral and repetitive. That is, as an activity Conrad's writing negated and reconstituted itself, negating itself again, and so forth indefinitely; hence the extraordinarily patterned quality of the writing" (Said, "Conrad: The Presentation of Narrative," *The World, the Text, and the Critic* [Cambridge, Mass., 1983], 108). Said's understanding of negation doesn't fully coincide with what I mean by erasure (he is chiefly concerned with the dialectic between visual and oral modes of representation), but Ray's and Said's essays approach more closely than any criticism I know to my argument in these pages. A third commentator who should be mentioned in this connection is Karl, who (before Ray) called attention to Conrad's use of images of blankness, which he associates with "Conrad's immersion in a *symboliste* ideal, the Mallarmé 'absence' and 'blankness'" (*JC*, 365).

37. See Conrad, *Heart of Darkness,* in *Youth: A Narrative and Two Other Stories* (Edinburgh and London, 1902), 115–22. Characteristically, the blinding fog sets in as the sun rises after a night that, in Marlow's words, "'came suddenly, and struck you blind as well'" (ibid., 115). See also the late short story "The Tale," in which, during wartime, a commanding officer has been ordered to take his ship and cruise "'along certain coasts to see—what he could see'" (Conrad, "The Tale," *Tales of Hearsay,* 63); one rocky coast is said to "[stand] out intensely black like an India-ink drawing on gray paper" (ibid., 65); but soon a blinding white fog comes on, and the rest of the narrative (actually an internal narrative, told by a man to a woman) takes place in its grip.

38. Euphemism, in that the verb "blank" in this context reads as a substitute for some other, harsher verb that the conventions of literary discourse disallow from appearance *in propria persona;* and explicitness, in that the seeming invocation of those conventions enables the baldest conceivable expression of Conrad's project of erasure. Note, by the way, how Donkin's exclamation underscores the near-identity of the English words *blank* and *black;* no such situation prevails in French, in which, on the contrary, the word *blanc* (or *blanche*) means both "white" and "blank." To put this slightly differently, the French language offered Conrad no possibility of distinguishing between "white" and "blank"; whereas the English language not only allowed that distinction, the means by which it did so also enabled him to associate blankness with both whiteness and blackness, as his project of erasure (as overwriting, or, in *Lord Jim,* the evocation of a clean slate) implicitly required. I mention this, of course, for its possible bearing on the larger question of Conrad's choice of English as his literary vehicle.

I will add that *The Nigger* ends with a double thematization of blankness: first, Jimmy's dead body, having been wrapped in a white blanket, is sewn into a shroud by a sailmaker who earlier had served on a frigate called the *Blanche* (*NN*, 117); note the French name; could that also be the unnamed name of Kurtz's intended?); and second, the narrator's last view of a "dark knot of seamen" from the *Narcissus* is described as follows: "The sunshine of heaven fell like a gift of grace on the mud of the earth, on the remembering and mute stones, on greed, selfishness; on the anxious faces of forgetful men. And to the right of the dark group the stained front of the Mint, cleansed by the flood of light, stood out for

a moment, dazzling and white, like a marble palace in a fairy tale. The crew of the *Narcissus* drifted out of sight" (*NN*, 128).

39. See the chapter entitled "Silver and Silence: Dependent Currencies in *Nostromo*" in Fogel's *Coercion to Speak*, 94–145. Throughout his book Fogel stresses aurality and in particular what he calls "forced dialogue"; against those critics who believe that Conrad's work is primarily visual, he argues that "in fact is aural, overheard, powerful about experiences of sound and silence, with the visual being more careful, deliberate, and (sometimes unconvincingly) underlined" (ibid., 50). F. R. Leavis suggests that Decoud "had a considerable part in the writing of *Nostromo;* or one might say that *Nostromo* was written by a Decoud who wasn't a complacent dilettante, but was positively drawn towards those capable of 'investing their activities with spiritual value'" (Leavis, *The Great Tradition: George Eliot, Henry James, Joseph Conrad* [1948; New York, 1967], 200).

40. J. Hillis Miller, *Fiction and Repetition: Seven English Novels* (Cambridge, Mass., 1982), 17; hereafter abbreviated *FR*. See Miller's chapter on *Lord Jim* in that book, in which he observes that "a network of light and dark imagery manifestly organizes the novel throughout" (*FR*, 37); compares Marlow's last view of Jim (white against black [see my n. 33]) with another passage that presents Jim "'distinct and black, planted solidly upon the shores of a sea of light'" (*LJ*, 173); and concludes that "the juxtaposition of light and dark offers no better standing ground from which what is equivocal about the rest of the novel may be surveyed and comprehended than any other aspect of the text" (*FR*, 38). "I claim, then," Miller writes, "that from whatever angle it is approached *Lord Jim* reveals itself to be a work which raises questions rather than answering them" (*FR*, 39). In fact, the black-against-white passage Miller cites is taken from the protracted scene of Marlow writing letter after letter that I have just discussed; it's as though Jim himself is there presented as a blackened page, which of course gives the climactic figure of the clean slate even greater force.

41. Some remarks in a letter of 1923 from Conrad to a Swedish professor, Ernst Bendz, are pertinent here:

"*Nostromo* has never been intended for the hero of the Tale of the Seaboard. Silver is the pivot of the moral and material events, affecting the lives of everybody in the tale. That this was my deliberate purpose there can be no doubt. I struck the first note of my intention in the unusual form which I gave to the title of the First Part, by calling it 'The Silver of the Mine,' and by telling the story of the enchanted treasure on Azuera, which, strictly speaking, has nothing to do with the rest of the novel. The word 'silver' occurs almost at the very beginning of the story proper, and I took care to introduce it in the very last paragraph, which would perhaps have been better without the phrase which contains that key-word." (quoted by G. Jean-Aubry, *Joseph Conrad: Life and Letters*, 2 vols. [Garden City, N.Y., 1927], 2:296; cited also by Watt, *Joseph Conrad: Nostromo* [Cambridge, 1988], 18)

The last paragraph in *Nostromo* (480) reads:

Dr. Monygham, pulling round in the policy-galley, heard the name pass over his head. It was another of Nostromo's successes, the greater, the most enviable, the most sinister of all. In that true cry of love and grief that seemed to ring aloud from Punta Mala to Azuera and away to the bright line of the horizon, overhung by a big white cloud shining like a mass of solid silver, the genius of the magnificent Capatax de Cargadores dominated the dark Gulf containing his conquests of treasure and love.

Typically, this final image of erasure follows closely on another, as the aged Giorgio Viola, unaware that the man he has just killed was Nostromo, falls asleep over a book, "his snow-white head rest[ing] upon the open pages" (*N*, 462).

The claim that Charles Gould "'had idealised the existence, the worth, the meaning of the San Tormé mine'" is made by Decoud in conversation with Mrs. Gould (*N*, 179).

42. The phrase occurs in the altogether extraordinary "Author's Note" to the novel (Conrad, *The Secret Agent,* ed. Bruce Harkness and S. W. Reid [1907; Cambridge, 1990], 7; hereafter abbreviated *SA*). In the novel itself Conrad writes of Winnie: "She felt profoundly that things do not stand much looking into" (*SA*, 136), another virtual oxymoron that perhaps emblematizes the "ironic method" Conrad tells us he pursued in that book ("Author's Note," 41). As for the encounter between Winnie and Verloc in chapter 11—in Leavis's view (*The Great Tradition*, 214), "one of the most astonishing triumphs of genius in fiction"—it begins with Winnie's refusal to uncover her face (she has just learned that her much-loved younger brother Stevie has been blown to bits in a plot of Verloc's that misfired), continues with Verloc staring at her back "as if he could read there the effect of his words" (*SA*, 180), and reaches a climax (though not a conclusion) when at last Winnie turns and *almost* faces him: "When he looked up he was startled by the inappropriate character of his wife's stare. It was not a wild stare, and it was not inattentive, but its attention was peculiar and not satisfactory, inasmuch that it seemed concentrated upon some point beyond Mr. Verloc's person. The impression was so strong that Mr. Verloc glanced over his shoulder. There was nothing behind him: there was just the whitewashed wall. The excellent husband of Winnie Verloc saw no writing on the wall" (*SA*, 181). In a fuller study of Conrad's "impressionism" it will be necessary to consider *The Secret Agent* at length; for the moment let it suffice to say that of all his novels it goes farthest toward imagining the triumph of materiality, as figured both by its imagery of unreadable surfaces (often, as in chapter 11, *backs*) and by the mechanical piano in the tavern frequented by the terrorists that periodically bursts into music and then, just as suddenly, stops (*SA*, 52, 56, 64–65, 231). Indeed the attempt to imagine such a triumph—specifically, to imagine a wholly materialist version of agency—but also perhaps the necessary failure of any such attempt—is personified by the fanatic Professor, whose one passion, as he explains to Ossipon, is to "'invent a detonator that would adjust itself to all conditions of action, and even to unexpected changes of conditions. A variable and yet perfectly precise mechanism. A really intelligent detonator'" (also called by him a "'perfect detonator'" [*SA* 56, 57]). (Significantly, *The Secret Agent* also includes a character with a missing hand, the hackney driver with "a hooked iron contrivance protruding from the left sleeve of [his] coat" [*SA*, 121].)

43. Conrad, *Under Western Eyes* (1911; Harmondsworth, 1986), 78, 330. Shortly after the passage describing the snow, Razumov hallucinates the figure of Haldin (whom he will soon betray) lying before him. "Suddenly on the snow," Conrad writes, "stretched on his back right across his path, he saw Haldin, solid, distinct, real, with his inverted hands over his eyes, clad in a brown close-fitting coat and long boots. He was lying out of the way a little, as though he had selected that place on purpose. The snow round him was untrodden." Razumov continues walking; then "after passing he turned his head for a glance, and saw only the unbroken track of his footsteps over the place where the breast of the phantom had been lying" (ibid., 81). The novel's project of erasure may be imagined as seeking to cover up or otherwise undo those footsteps (see the scene on the beach in *Almayer's Folly*). See also Frank Kermode, "Secrets and Narrative Sequence," *The Art of Telling: Essays on Fiction* (Cambridge, Mass., 1983), an essay

that tends somewhat in the direction of my argument but finally opts for a different sort of reading.

44. Conrad, *Victory* (1914; Garden City, N.Y., 1921), 404. The last word in the novel is, of course, "'Nothing!'" And its first sentence reads: "There is, as every schoolboy knows in this scientific age, a very close chemical relation between coal and diamonds"—a relation I see as analogous to that between a page blackened with ink and one that has been (what I mean by) erased. Diamonds thus join ivory *(Heart of Darkness)* and silver *(Nostromo)* as substances of value that figure blankness.

45. See Conrad, "Prince Roman," *Tales of Hearsay,* 29–55. Novel and story are related to one another, not quite on these grounds, by Eloise Knapp Hay, *The Political Novels of Joseph Conrad: A Critical Study* (Chicago, 1963), 311–12.

46. See Conrad's description, in the essay "Autocracy and War," of Russia itself:

> There is an awe-inspiring idea of infinity conveyed in the word *Néant*—and in Russia there is no idea. She is not a *Néant,* she is and has been simply the negation of everything worth living for. She is not an empty void; she is a yawning chasm open between East and West; a bottomless abyss that has swallowed up every hope of mercy, every aspiration towards personal dignity, towards freedom, towards knowledge, every ennobling desire of the heart, every redeeming whisper of conscience. Those that have peered into that abyss, where the dreams of Panslavism, of universal conquest, mingled with the hate and contempt for Western ideas, drift impotently like shapes of mist, know well that it is bottomless. (Conrad, *Notes on Life and Letters* [London, 1921], 133–34; quoted in *JC,* 17–18)

The yawning chasm and bottomless abyss that swallows up everything amounts to a quasi-personification of Conradian erasure, which is to say that, at least in this highly interesting text, Conrad's Russia has much in common with Conrad the writer.

47. Conrad, *Heart of Darkness,* 59. See also the related passage in *A Personal Record* (36–37) in which Conrad describes himself at age nine "looking at a map of Africa of the time and putting my finger on the blank space then representing the unsolved mystery of that continent" and saying "'When I grow up I shall go *there.*'" Conrad explains that "*there* [was] the region of Stanley Falls, which in '68 was the blankest of blank spaces on the earth's figured surface. And the MS. of 'Almayer's Folly,' carried about me as if it were a talisman or a treasure, went *there,* too." My reference here and in note 22 to *A Personal Record* barely hints at its relevance to a fuller understanding of Conrad's "impressionism."

48. Conrad, "Youth: A Narrative," *Youth,* 6; hereafter abbreviated "Y."

49. Such a reading (along with others in this paper) points to the inadequacy of the traditional emphasis—correct as far as it goes—on the Conradian text's exceptional mobility of point of view. What I would stress instead is something like its exceptional mobility of implied subject-positions relative to all aspects of the scene of writing, including both the writer himself and the originary blankness at which or into which we have been imagining the writer staring. (This would be a further difference between Conrad and Crane, in whose texts, for all their profusion of materiality-effects as well as their rampant animism, the implied relation between writer and page remains relatively stable.) An especially interesting passage in this regard is the one in *Heart of Darkness* that begins with the wounding and death of the helmsman during the attack on the steamboat (the dying helmsman's upturned face is a tour de force of its genre), goes on to tell of Marlow's impulsive casting overboard of his blood-soaked shoes (a moment of

distancing or counteridentification), and concludes with Marlow breaking off his narrative to ask for tobacco, whereupon the *primary* narrator reports: "There was a pause of profound stillness, then a match flared, and Marlow's lean face appeared, worn, hollow, with downward folds and dropped eyelids, with an aspect of concentrated attention" (Conrad, *Heart of Darkness,* p. 129)—very much as if the aim (or at least the result) of the passage as a whole were to produce a momentary glimpse of Conrad himself at work on his manuscript.

50. The implication of writing in imperialist or colonialist scenarios of power has been a central topic in cultural analysis since Claude Lévi-Strauss's chapter, "A Writing Lesson," in *Tristes Tropiques* or at least since Jacques Derrida's critique of that chapter in *De la Grammatologie.* In this connection see Jonathan Goldberg's discussion of that confrontation in his impressive study, *Writing Matter: From the Hands of the English Renaissance* (Stanford, Calif., 1990), 1–28; Goldberg's project of "a Derridean cultural graphology" (9)—his attempt, as he puts it, "to write an episode in the history of writing that also attends to the *gramme as such*" (26)—bears a close relation to my enterprise in *RWD* and the present essay (as Goldberg remarks [10]).

WORKS CITED

Barthes, Roland. "*Will* Burns Us . . ." In *Critical Essays,* Translated by Richard Howard. Evanston, Ill.: Northwestern University Press, 1982.

Benson, Donald. "Impressionist Painting and the Problem of Conrad's Atmosphere." *Mosaic* 22 (Winter 1989): 29–40.

Brooks, Peter. "An Unreadable Report: Conrad's *Heart of Darkness.*" In *Reading for the Plot: Design and Intention in Narrative.* New York: A. A. Knopf, 1984.

Conrad, Jessie. *Joseph Conrad and His Circle.* New York: Doubleday, 1935.

Conrad, Joseph. *Almayer's Folly: A Story of an Eastern River.* London: T. Fisher Unwin, 1895.

———. "The Black Mate." In *Tales of Hearsay.* Garden City, N.Y.: Doubleday, 1925.

———. *Heart of Darkness.* In *Youth: A Narrative and Two Other Stories.* Edinburgh and London: Dent, 1902.

———. *Lord Jim.* Edited by Cedric Watts. Harmondsworth: Penguin Books, 1988.

———. *The Mirror of the Sea* and *A Personal Record.* 1912; Oxford, 1988.

———. *The Nigger of the "Narcissus."* Edited by Cedric Watts. Harmondsworth: Penguin Books, 1988.

———. *Nostromo.* New York: Harper, 1904.

———. "Autocracy and War." In *Notes on Life and Letters.* New York: Doubleday, 1921.

———. "Author's Note." In *An Outcast of the Islands.* 1896; Harmondsworth: Penquin Books, 1975.

———. "Prince Roman." In *Tales of Hearsay.*

———. "Author's Note." In *The Rescue.* London: Dent, 1950.

———. "Author's Note." In *The Secret Agent.* Edited by Bruce Harkness and S. W. Reid. 1907; Cambridge: Cambridge University Press, 1990.

————. "The Secret Sharer: An Episode from the Coast." In *'Twixt Land and Sea*. London: Dent, 1912.

————. "The Tale." In *Tales of Hearsay*.

————. "Author's Note." In *Tales of Unrest*. 1898; Harmondsworth: Penguin Books, 1977.

————. *Under Western Eyes*. 1911; Harmondsworth: Penguin Books, 1986.

————. *Victory*. 1914; Garden City, N.Y.: Doubleday, 1921.

————. "Youth: A Narrative." In *Youth: A Narrative and Two Other Stories*.

————. *The Monster, Tales of Whilomville*. In *The Works of Stephen Crane*, vol. 7, edited by Fredson Bowers. Charlottesville: University Press of Virginia, 1969.

————. "Tent Life at Ocean Grove," (1891). Reprinted in Thomas A. Gullason, "The 'Lost' Newspaper Writing of Stephen Crane," *Syracuse University Library Associates Courier* 21 (Spring 1986): 77–78.

Fogel, Aaron. *Coercion to Speak: Conrad's Poetics of Dialogue*. Cambridge: Harvard University Press, 1985.

Fried, Michael. *Realism, Writing, Disfiguration: On Thomas Eakins and Stephen Crane*. Chicago: University of Chicago Press, 1987.

Garner, Stanton. "History of the Text." In Harold Frederic, *The Damnation of Theron Ware or Illumination*, edited by Charlene Dodge, vol. 3 of The Harold Frederic Edition. Lincoln: University of Nebraska Press, 1985.

Gide, André. *Journal, 1889–1939*. 23 February 1930. Paris: Schoenhof, 1951.

Goldberg, Jonathan. *Writing Matter: From the Hands of the English Renaissance*. Stanford, Calif.: Stanford University Press, 1990.

Gordon, John Dozier. *Joseph Conrad: The Making of a Novelist*. Cambridge: Harvard University Press, 1941.

Guerard, Albert J. *Conrad the Novelist*. Cambridge: Harvard University Press, 1958.

Guetti, James. *The Limits of Metaphor: A Study of Melville, Conrad, and Faulkner*. Ithaca, N.Y.: Cornell University Press, 1967.

Hay, Eloise Knapp. *The Political Novels of Joseph Conrad: A Critical Study*. Chicago: University of Chicago Press, 1963.

Hudson, W. H. *Green Mansions: A Romance of the Tropical Forest*. London: Collins, 1904.

Jean-Aubry, G. *Joseph Conrad: Life and Letters*. 2 vols. Garden City, N.Y.: Doubleday, 1927.

Johnson, Bruce. "Conrad's Impressionism and Watt's 'Delayed Decoding.'" In *Conrad Revisited: Essays for the Eighties*, edited by Ross C. Murfin, 51–70. University: University of Alabama Press, 1983.

Karl, Frederick R. *Joseph Conrad: The Three Lives*. New York: Farrar, Straus & Giroux, 1979.

————, and Laurence Davies. *The Collected Letters of Joseph Conrad*. 3 vols. Cambridge: Cambridge University Press, 1983–.

Kermode, Frank. "Secrets and Narrative Sequence." In *The Art of Telling: Essays on Fiction*. Cambridge: Harvard University Press, 1983.

Leavis, F. R. *The Great Tradition: George Eliot, Henry James, Joseph Conrad*. 1948; New York: Biblo and Tanner, 1967.

London, Jack. *Martin Eden*. New York, 1909.

Meyer, Bernard C. *Joseph Conrad: A Psychoanalytic Biography.* Princeton: Princeton University Press, 1967.

Michaels, Walter Benn. Discussion of *Martin Eden.* Cambridge History of American Literature. Forthcoming.

———. *The Gold Standard and the Logic of Naturalism: American Literature at the Turn of the Century.* Berkeley: University of California Press, 1987.

Miller, Christopher. "The Discoursing Heart: Conrad's *Heart of Darkness.*" In *Blank Darkness: Africanist Discourse in French.* Chicago: University of Chicago Press, 1985.

Miller, J. Hillis. *Fiction and Repetition: Seven English Novels.* Cambridge: Harvard University Press, 1982.

———. "*Heart of Darkness* Revisited." In *Conrad Revisited: Essays for the Eighties,* edited by Ross C. Murfin. University: University of Alabama Press, 1983.

Norris, Frank. *A Man's Woman and Yvernelle.* Vol. 6 of the Argonaut Manuscript Limited Edition of Frank Norris's Works. Garden City, N.Y.: Doubleday, 1928.

Norris, Frank. *Vandover and the Brute.* Garden City, N.Y.: Doubleday, 1914.

Parry, Benita. *Conrad and Imperialism: Ideological Boundaries and Vision Frontiers.* London: Macmillan, 1983.

Ray, Martin. "Language and Silence in the Novels of Joseph Conrad." In *Conradiana* 16 (1984): 27, 37.

Rosmarin, Adena. "Darkening the Reader: Reader-Response Criticism and *Heart of Darkness.*" In *Conrad, Heart of Darkness: A Case Study in Contemporary Criticism,* edited by Ross C. Murfin. New York, 1989.

Said, Edward W. "Conrad: The Presentation of Narrative." In *The World, the Text, and the Critic.* Cambridge: Harvard University Press, 1983.

———. *Joseph Conrad and the Fiction of Autobiography.* Cambridge: Harvard University Press, 1966.

Seltzer, Mark. "The Naturalist Machine." In *In Sex, Politics, and Science in the Nineteenth-Century Novel,* edited by Ruth Bernard Yeazell. Baltimore: Johns Hopkins University Press, 1986.

Staten, Henry. "Conrad's Mortal Word." *Critical Inquiry* 12 (Summer 1986): 720–40.

Steiner, Joan E. "Conrad's 'The Secret Sharer'" Complexities of the Doubling Relationship." *Conradiana* 12 (1980): 173–86.

Todorov. Tzvetan. "Connaissance due vide." In *Nouvelle Revue de Psychanalyse,* no. 11 (1975): 145–54.

Walker, Franklin. *Frank Norris: A Biography.* Garden City, N.Y.: Doubleday, 1932.

Watt, Ian. "Conrad's Preface to *The Nigger of the 'Narcissus'.*" *Novel: A Forum on Fiction* 7 (Winter 1974): 101–15.

———. *Conrad in the Nineteenth Century.* Berkeley: University of California Press, 1979.

———. *Joseph Conrad: Nostromo.* Cambridge: Cambridge University Press, 1988.

Part III
The Artifact as the Material Text

Reading Maps

EILEEN REEVES

The relationship between the sister arts of writing and painting is perhaps nowhere so close as within the confines of cartography, the science of map-making. Although the current tendency is to treat maps as a kind of specialized picture,[1] and thus as an odd but entirely authentic representative of the visual arts, the very language we use to discuss cartography denotes its early and stronger alliance with the printed word. While we look at maps as we do images, we say nonetheless that we "read" them, and it was not until the eighteenth century, when cartography's association with the written word was called into question, that a small section of the map was marked off with *legenda,* or "things to be read." Until that time, every feature of the map would have been considered a legible part of a text, albeit one not meant for all readers.

The focus of the present essay will be the reasons for the consistent correlation between map-making and the written word, given that such parallels were invariably drawn at the expense of the visual arts. The period which I will consider most fully stretches from the Renaissance through the 1700s. As I will suggest, moreover, the connection between certain types of maps and literacy also included a gender bias—roughly, men "read" the most abstract of maps, while women merely looked at painted landscapes—and this was most apparent precisely when developments in cartography rendered the original dichotomy between large- and small-scale maps less than valid. The vestiges of the association between certain aspects of cartography and the written word (though perhaps not the insistence on the gender of the mapreader) are present even as late as the middle of the nineteenth century, when the first systematic treatises of geography were being integrated into public education.[2]

OBLIQUE LINES

It is within the context of certain Renaissance translations of Ptolemy's *Geographia* that cartography is first explicitly regarded as a text.[3] The

285

spectacular results of early modern voyages of discovery excited a new interest in Ptolemy's work, for it remained through the sixteenth century the most technically advanced treatise on the business of map-making. Renaissance translations of the *Geographia* were often accompanied by commentaries that updated or sometimes contested the original text, and the novelty and the exoticism which they promised surely explain both the popularity and the variety of the translations. Even as commentators detailed the existence of bizarre peoples on the other side of the globe, however, other and more radical changes were making their way into Ptolemy's work. In the first pages of the *Geographia,* the great Alexandrian scientist had distinguished between the tasks of the two different types of cartographers: that of the geographer, who in "imitating drawings of the whole earth," constructed large maps; and that of the chorographer, who depicted areas as great (or as small) as that occupied by one nation. This difference lay not only in the scale of the task but also in the skills that each required: for as Ptolemy acknowledged, "no one could be a chorographer who was not skilled in the art of painting, but these talents were in no way necessary to the geographer, who used *simple lines and clear symbols* to designate the position and the shape of the earth in space."[4]

The distinction between the undertakings of the two types of mapmakers was based on relative, not absolute, differences. As the Ptolemaic definition suggests, the work of the geographer was associated with the larger field of the cosmographer, while the smaller project of the chorographer was described in terms appropriate to the still more detailed art of topography, or landscape depiction. Some of Ptolemy's Renaissance translators and commentators, eager to exploit what they saw as a fundamental difference and to establish a distinction based on something other than scale, tended to portray geography as a literary art, chorography a visual one. In 1482, for example, the poet Francesco Berlinghieri explicitly referred to geography as *scriptura imitante . . . La terrestre & chonosciuta sphera* ["writing representing the known part of the globe"].[5] In 1564 the drama critic Girolamo Ruscelli noted that geography was "an imitation of a drawing, and not a drawing itself," eschewing likeness for signs composed of dots, squares, circle and place names, and thus at several removes from a picture.[6] In 1598 Leonardo Cernoti and Giovanni Antonio Magini altered the "simple lines and clear symbols" on which the geographer was said to rely to *minute lettere e segni,* ["small letters and signs"] as if the undertaking were wholly textual.[7] In sum, one read a map, but merely looked at a landscape.

It was to some extent natural that maps of the whole world were regarded as texts during the Renaissance, for the similarity between geography and chorography was becoming less and less evident.[8] In the first

place, the familiarity and relative coherence of a landscape had little to do with the novelty and intricacy of the new map-making techniques used by those who depicted the entire globe. Moreover, some of the associations between maps and texts depended, no doubt, on the questionable but pervasive supposition that anyone can "see" images, but not everyone can "read" writing. The connections drawn between large maps and texts, in other words, are an index of the interpretive difficulty which they posed for most early modern men, a difficulty that could only be compared to that of reading.

Other features of Renaissance cartography lent themselves to such interpretation. Consider, for instance, the manner in which the Spanish humanist Fernán Pérez de Oliva, known both as a translator of Sophocles, Euripedes, and Plautus, and as a student of the sciences, compared two Ptolemaic projections. He wrote that they were best used together in the depiction of the globe: "Secundum et tertium planispherium *omnem* tollere videntur *ambiguetatem et translatationis errorem*," ["the second and third planispheres seem to eliminate *all ambiguity and error in translation*,"] as if the project at hand were a linguistic and poetic enterprise, rather than a purely geometrical one. Because the projections were complementary, he added, one had to be read in terms of the other, as would be two different translations of the same text: "the one corrects the flaws of the other."[9] While the term "translation" is as appropriate to cartography as it is to literature, it is telling that Pérez de Oliva chose to describe the geographer's task just as he presented his plays, in which it was also a question of two translations, the one supplementing the other. The titles alone of two of Pérez de Oliva's dramatic works make clear that he saw cartographic "translation" much as he did the literary sort: *Hécuba triste. Tragedia que escribió en Griego el Poeta Euripides; y el Maestro Fernán Pérez de Oliva, tomando el argumento, y mudando muchas cosas, la escribió en Castellano [Sad Hecabe. A Tragedy that the Poet Euripides wrote in Greek, and that Master Fernán Pérez de Oliva, taking up the plot and changing many things, has written in Castilian]*, and *Muestra de la lengua Castellan en el nacimiento de Hércules, o comedia de Amphitrion, tomando el argumento de la Latina de Plauto [A Sample of Castilian in the Birth of Hercules, or the Comedy of Amphytrion, the plot being taken from the Latin of Plautus]*.

The man who introduced the greatest change in cartography, Gerard Mercator, also produced the first important treatise on penmanship,[10] realizing that literacy and the ability to read maps were closely allied. The codification of the kinds of script used on maps[11]—capital letters for large cities and big forests, Roman type for towns and smaller wooded areas, italic letters for villages, a slanted script to show the direction in which a river flows—is a practice that relies not on images or icons, but

rather on conventions associated with the written word to indicate the
nature, size, or civic status of anything on the face of the earth. But it is
the distortion developed by Mercator that provides the most striking
example of the Renaissance perception of the map as a text. This innova-
tion was an interesting revision of previous map-making techniques, and
one that insisted upon the two-dimensional plane in which writing lies,
rather than upon the three-dimensional one in which images are placed.[12]
Although earlier maps generally used foreshortening and other perspec-
tive devices in order to acknowledge that they were merely crude approxi-
mations of the "real" three-dimensional space, Mercator's invention
recognized no such imperfections, and it subscribed to no such spatial
hierarchy. The spherical earth had to conform to the page-like map, and
not vice versa. In order to make all meridians parallel—which they would
be if the earth were two-dimensional—Mercator distorted the size of
regions far from the equator, as if the land there were not curving toward
one or the other pole. His delineation of the globe was further than ever
from both the drawings which one might make of its landscape, and—
more importantly—from any previous map. Here the two-dimensional
status of the medium is, as much as the land masses inscribed on it, the
thing represented, as if Mercator were seeking to copy the plane of a
sheet of paper, as well as distant continents. The result was a map that
all could see but few could read.

The seventeenth century abounds in the association of maps and texts,
and while my earlier examples have all come from cartographical trea-
tises, by this period the theme was a frequent feature of more canonical
works of literature. It is perhaps within the poetry and the sermons of
John Donne that references to the literary dimension of map-making are
the most common and most learned. In his *Valediction: Forbidding
Mourning,* his best-known poem, the enigmatic "I, like the other foot,
shall *obliquely run,*" is a translation of a contemporary issue in both map-
making and navigation, the *cursus obliquus* or *loxodrome,* to which he
also makes reference in the sermons. As I will show, the movement im-
plied by the *cursus obliquus* is one which has long been recognized by
those readers of the poem who chose to emphasize its Neoplatonic
aspects: the spiral path traced by a compass that both "leans" and
"hearkens," the figure for a love neither divine nor bestial, is also that of
the loxodrome.[13]

That the *Valediction: Forbidding Mourning* involves a voyage is in fact
crucial, for it is upon Donne's journey to the continent that the metaphor
of the oblique course—and indeed the whole poem—is based. Navigation
was, as Elizabethan mariners' manuals point out, of three distinct types:
for short distances in familiar waters one sailed along a straight line,

for immense distances one sailed along a Great Circle route, and for intermediate distances one followed an *oblique* or *loxodromic* course.[14] While the first method was primitive and of limited application, the second, which involved tracing the circumference of an imaginary plane passing through the earth's center, was little more than an elegant theory, because it involved considerable mathematical and astronomical knowledge. The third possibility, loxodromic navigation, was generally favored by the Elizabethan mariner because of its relative ease and practicality. Following an oblique course meant crossing the net of longitudes and latitudes at a constant angle, and maps generally showed seven such fixed angles of approach, broken down into increments of 11 degrees and 15 minutes, between the baseline of the latitude and the perpendicular longitude. The constant path which the ship took was called its "course," and the captain's representation of it on his flat map was known as a "rhumb line" or a "loxodrome."

As cartographers had lately recognized, however, a constant diagonal path on a curved earth would become that of an infinite spiral about the pole, because of the converging meridians.[15] The loxodrome, like the oblique course taken by the rational lovers of *A Valediction: Forbidding Mourning,* was a compromise between the impractical routes of limited linear movement and circularity, a path poised between the straight furrow of bestiality and the ceaseless revolutions described by the angels. As should be evident, then, the *cursus obliquus* of the ship that bears the poet away is the visible counterpart of the unseen spiral suggested by the poem's metaphysical tendencies; what is less apparent, and more interesting still, is that Donne's first readers would have seen the serpentine lines traced in this voyage as the analogue of the difficult lines of which the poem itself was composed.

A Valediction: Forbidding Mourning builds on precisely the notion of translation evoked by writers such as Pérez de Oliva, and it celebrates a point that delighted map-makers and infuriated navigators, for this last group referred to the intricate *cursus obliquus* as "paradoxall" and described such oblique routes as "certain crooked winding lines."[16] In writing "I, like the other foot, shall obliquely run," Donne superimposed the paradoxall, oblique, and winding lines of his poetry on those of the *cursus obliquus,* offering what is certainly one of the closest associations of literature with cartography.[17]

Donne's overlay of verse and map inspired Andrew Marvell's *Definition of Love,* though this poem can hardly be said to be devoted to the oblique course of a pair of "rational lovers." The poet complains that he and his beloved are as far apart as the two poles, and that they have no hope of union unless the heavens fall and force the entire globe into a single plane.

fed infinitis gyris circumacta ad illud punctum nunquam
perveniet.

PROPOSITIO XVII.

*Loxodromia est instar basis trianguli plani rectanguli
ad spæræ superficiem applicati, cujus crus unum sit distan-
tia parallelorum inter quos intercipitur.*

INclinatio anguli
quem navium ca-
rina cum meridiano
comprehendit, poft-
quam à perpendi-
culo demutat va-
ria omnino effe po-
teft, & ideo loxodro-
miæ helices infini-
tæ, alium atque ali-
um cum meridianis
angulum compre-
hendentes: angu-
lum autem recto mi-
norem hic inclina-
tionis angulum vo-
camus. Cum autem
fingularum una ea-
demq; fit ad omnes
miridianos inclina-
tio, & per fiugula
puncta etiam vici-

niffima

And therefore [Fate's] decrees of steel
Us as the distant poles have placed,
(Though Love's whole world on us doth wheel)
Not by themselves to be embraced,

Unless the giddy heaven fall,
And the earth some new convulsion tear;
And, us to join, the world should all
Be cramped into a planisphere.

As lines (so loves) oblique may well
Themselves in every angle greet:
But ours so truly parallel,
Though infinite, can never meet.[18]

The term "planisphere" confuses the issue, for it normally indicates a round map on which half the globe's face is imprinted; one would need two of them to accurately represent the entire world. As Nathaniel Carpenter wrote in his *Geography delineated,* "the Planispheare cannot be expressed without two faces or Hemispheares; whereof the one represents the Easterne, the other the Westerne part of the Terrene Globe."[19] On a planisphere of this type, the poles would be just as far apart as they ever are, and the image bespeaks no great intimacy.

There were several other kinds of maps indicated by the word "planisphere," and these usually involved some notion of the earth as a globe whose surface might be peeled off and rearranged onto a plane. There was, for instance, the relatively recent cordiform map, one in which almost all of the polar region and a good part of the northern hemisphere lay in a heart-shaped pattern; as Carpenter acknowledged, however, those who drew up these planispheres were "(perhaps) as Painters . . . more indulgent to fancy then common use."[20] There was also an elliptical figure, one that sacrificed the poles but showed whatever lay between the winter and summer tropics on both sides of the earth; the men who conceived such planispheres were said to "flay the globe and stretch out the skin."[21] Both the dainty cordiform map and this graceless alternative were understood to be wildly inaccurate, and neither resembles the configuration suggested in *The Definition of Love.*

Marvell was, however, drawing on still another type of planisphere. It would have been known, furthermore, to every English schoolboy: in his widely read *Exercises* Thomas Blundeville had written, "The Astrolabe . . . is called of some a Planispheare, because it is both flat and round, representing the Globe or Spheare, having both his Poles clapt flat together."[22]

The astrolabe (or planisphere), a metallic disk offering a two-dimensional picture of the celestial vault above a particular horizon, is

Ptolemy's Third Projection, from his *Geographia*, trans. Girolamo Ruscelli, Venice, Giordano Ziletti, 1564, p. 348. (Courtesy of Special Collections, Van Pelt Library, University of Pennsylvania.

more easily imagined if we bear in mind the popular myth of its invention. This story has some of the violence of both Blundeville's definition of the instrument and Marvell's *Definition of Love:* it was said that the astrolabe was created in a roadside accident when an armillary sphere was damaged. It seems that one day when he was traveling, Ptolemy dropped his armillary sphere, and before he could retrieve it, the animal on which he was riding smashed it, clapping its poles flat together, and forcing all the world into one plane.[23]

The story about the astrolabe or planisphere is interesting for several reasons. Ptolemy himself offered a projection that reduced the armillary sphere to a more traditional planisphere, and the map that he drew featured not the polar regions but the *oikoumene*—the known inhabited part of the earth—surrounded by the rings of the armillary sphere. He described and constructed this projection, his third, in book 7 of his *Geo-*

graphia, alluding briefly to the irrational efforts of others who had tried to produce a map of this sort:

> It will therefore not be out of place (now) to set forth how one can depict on a plane the hemisphere of the earth in which the *oikoumene* is located, surrounded by a ringed [i.e., armillary] sphere. Whereas several persons have made an attempt to give such a demonstration, they seem to have made very unreasonable use of it.[24]

Marvell's map is a crude, almost comic, alternative to Ptolemy's elegant model. The Alexandrian scientist mapped nothing beyond the *oikoumene,* while Marvell was concerned only with the polar regions. Ptolemy used nuanced color and perspective[25] to reduce the metal rings of the armillary sphere to a plane figure or something resembling a traditional planisphere; the poet proposed a thoroughly "unreasonable use" of the projection to convert the armillary sphere to the rare planisphere described by Blundeville, and to thwart not the instrument's rings of brass but Fate's "decrees of steel."

What sense Marvell's beloved would have made of the "oblique lines" written in her honor is only a matter of conjecture; few women in this era would have been familiar with either the refined Ptolemaic projection or the more practical directives offered in Blundeville in his *Exercises.* As regards the latter work, moreover, it is significant that the correct definition of planisphere as astrolabe and the explanation of its construction and use appear in a manual addressed *only* to young men, so that the poem's emphasis upon the explicitly sexual is nicely replicated in the presumed gender-based division of its audience.[26]

GEOGRAPHY AND GENDER

It is the relationship of geography to gender, repeatedly developed in several seventeenth-and eighteenth-century works, that I would now like to consider: I will begin with a somewhat different definition of love, friendship, and cordial esteem. This was Mademoiselle de Scudéry's famous *Carte de Tendre,* an allegorical map showing different routes towards a tender rapport with the *précieuse.* I have noted that the distinction between large maps—where some reference is made to the earth's position in the heavens—and smaller ones—which were closer to

Madelaine de Scudéry. *La Carte de Tendre,* **1653, from an English translation of** *Clélie,* **London: H. Herringman, 1678. (Courtesy of Special Collections, Van Pelt Library, University of Pennsylvania.)**

landscapes—was usually presented in terms of the difference between writing and painting, geography and the correlative science of cosmography being associated with literate practices, and chorography and the ancillary discipline of topography with the visual arts. Not only does Mademoiselle de Scudéry's *Carte de Tendre* preserve the distinction; the novel in which it appears, *Clélie,* thematizes the difference and aligns it with other gender-specific issues. The "masculine" way of looking at the world, according to this rather primitive schema, would be more global, more abstract, and less concerned with the niceties of detail: in brief, closer to what was considered the more abstruse and difficult of the sister arts of writing and painting.[27] The feminine, even in the favorable context of *roman précieux,* was allied with painting as if by default, as the following examination will show.

When, in the course of Mademoiselle de Scudéry's lengthy novel, the heroine Clélie is asked to account for her various friendships, she explains that these different relationships are by no means equal. There are first of all "pleasant acquaintances," then there are "new friendships," followed by friendships maintained from childhood, and then "solid friendships," "special friendships," and finally a few "tender friendships," beyond which, Clélie warns, one cannot go.[28] She also admonishes the

eager young men who surround her that the route from the new friend-
ships that they presumably enjoy with her to something more "tender"
involves a particularly long and arduous journey, and the final destination
may be reached by three paths alone, by her Esteem of the friend in
question, or by her Gratitude to him or her, or by the natural and largely
inexplicable Inclination which the *précieuse* may have toward that
person.

Clélie's friends are intrigued rather than checked by her admonitions,
and they ask for a "Carte de Tendre" in which these and other rules might
find codification. What they expect is in fact a written description,[29] most
probably in the form of the letters that Clélie liked to write, for at that
point the word *Carte* was used to indicate both verbal depictions and
maps. Clélie surprises them by producing instead the famous (or infa-
mous) landscape known as the *Carte de Tendre,* a detailed map of the
inroads one might attempt in establishing a tender friendship with her.
While in itself a coherent depiction of a landscape,[30] its radical circum-
scription is difficult to overlook: beyond the River of Inclination is a sea
which Clélie characterizes as "particularly dangerous for women," and
beyond that various "Unknown Countries," the perils of which *les pré-
cieuses* cannot even imagine. Although Clélie presents the map as an
index of the immense distances that lie between new and tender friend-
ships, it also is clear that the kingdom portrayed there is meant to seem
restrained and even miniscule to the roving masculine eye, for greater
geographical knowledge is associated with the more ample sexual experi-
ence of men.

It is not particularly surprising to note that the *Carte de Tendre* was
soon parodied: the topographical features of these other and less delicate
maps showed how easy it was for a man to reach the coveted "tender
friendship" and its wild hinterland.[31] The point which I would like to
make, however, is elsewhere; as I will show, the novel itself, in addition
to latterday parodies, envisages this "alternative" way of reading the
Carte de Tendre and portrays it, moreover, in terms of two traditional
distinctions—that commonly drawn between chorography and geography,
and that opposing visual and literary arts. The fact that cartography
seemed to have its feminine and masculine aspects—the former generally
featuring defense and the latter territorial conquest—tells us more, I
think, about the development of the discipline than it does about the
ongoing war of the sexes. It was because small and large maps of the
earth were seen as *qualitatively,* and not quantitatively, dissimilar that the
distinction was first stated in terms of gender, as if this were the best
index of an essential and lasting difference. What I would like to indicate
in the following discussion is the presence of a map that rivals the *Carte*

de Tendre, and one in which the masculine and textual associations of geography are explicitly recognized.

It is significant that the *Carte de Tendre* was, as the final edition of the novel acknowledges, passed around everywhere, meaning that the map of Clélie's heart enjoyed a circulation which that young lady surely did not.[32] The discrepancy between the world-wide distribution of the map and the restrained landscape which the *Carte de Tendre* actually represents is a mirror, of course, of the paradoxical disjunction between geography and chorography. At stake here is the chorographer's inability to integrate the circumscribed space of landscape into the larger panorama of geographical knowledge, and Mademoiselle de Scudéry portrays this kind of cartographical ignorance as the analogue of the innocence of the *précieuse.*

Although Clélie intended the map for her friends alone, the novelist notes that "a certain constellation" caused it to be exposed throughout the world.[33] This appeal to astronomy, and specifically to a group of stars in the zodiac, serves two distinct purposes: for the feminine reader, it is a way of pointing out "fatal forces" presumed beyond her control, and regions as remote to her as the lands lying on the far side of the "Dangerous Sea."[34] For the masculine reader, however, the point is less the dainty map provided by Clélie than its widespread and even global dissemination. Such a reader would have effected a neat reversal, substituting a map of the entire earth for the restrained landscape of the *Carte de Tendre,* and by implication shrinking the vast distances which the *précieuses* saw between new and tender friendships to nothing at all, a threshold crossed quickly and often with any manner of man.

This new global map, a textlike one which effectively displaces the drawing of the *Carte de Tendre* in the novel, is marked, as would be most world maps through the next century, with the zodiac, for geographies always began with a description of the earth's place in space.[35] The mention of the "certain constellation" that led to the wanton display and virtual undoing of Clélie's landscape is, then, a way of evoking the textlike map to which the masculine reader would have been drawn, and the one which he first expected, in fact, when the heroine promised a *Carte.*

That Clélie and the other *précieuses* would have remained largely ignorant of the world map that their male counterparts would read into the expression "a certain constellation" goes without saying, for a variety of reasons. Their girlish innocence, of course, precludes such knowledge, just as their status as chorographers implies their unfamiliarity with geography. This particular detail is not surprising, because chorography, the less complex of the two arts, was traditionally defined in terms of its technical shortcomings. What *is* noteworthy is the unusual suggestion that those skilled in the more difficult discipline might not be competent

Nicholas de Fer, *L'Atlas Curieux*, Paris, chez l'auteur, 1705, f. 6. (Courtesy of the Fine Arts Library, University of Pennsylvania.)

in what was generally seen as the less demanding one. When Clélie fears that certain people, "incapable of understanding this novel *galanterie,*"[36] would end up discussing it as their whim or vulgarity permitted, she insists upon the value of her map, *la préciosité,* and by implication, the discipline of chorography of which she is the representative. At the same time, her reference to the vulgarity, or *grossiereté,* of her potential detractors serves as a subtle criticism of the vaster horizons of geography; she suggests that those who can see and chart the entire earth lose something valuable through their neglect of detail.

This emphasis upon the relationship of gender to map-reading has its echoes in the eighteenth century as well. The primitive distinction between geography and chorography began to break down, almost certainly as a result of the increased use of large-scale maps in the many foreign military campaigns that animated the period.[37] Clearly, the long and exclusive association of pictorial detail with the feminine was no longer entirely valid, but there were nonetheless ways of designating these new map-reading skills that managed to imply that the abstraction and interpretation involved were distinctly masculine arts. A striking example of this traditional bias is Philippe Mercier's *Sense of Sight,* painted between 1744 and 1748.[38] This work, part of a series celebrating the five senses, shows various forms of vision: in the background, one young woman stares into a mirror and another looks through a telescope, while three individuals in the foreground examine two different maps. The area depicted in the upright map is at first difficult to identify, because even though the larger island off the coast is labeled "Majorca," neither Majorca nor Minorca ought to be portrayed as so large and so close to the Spanish mainland. On the other hand, the other parts of the map are passably accurate: the way the three rivers Ebro, Cinca, and Segre flow together and empty themselves into the sea at Cape Tortosa is a telling and fairly reliable detail, and the distinctive shape of the land mass at the very bottom looks quite like Cape Nao. Mercier's painting is doubtless an allusion to the support which France gave to Spain in 1744 in her ongoing war with the British, who controlled the strategically important island of Minorca from 1713 to 1756.[39] This recent and initially popular military alliance would also explain the presence of the dark young man in the cape who appears absorbed in the second map, for he is surely a Spanish "friend" of the other personnages in the painting.

What is not explained, however, is the manner in which the young woman in the foreground inspects the map before her, and less still the reason for her foray into this particular science. There is, in the first place, an odd replication of cartographical features in her own attributes: the pearls on her head, that symmetrical and right-angled arrangement of dark and light dots, mirror, both in their position and in their tonality,

Philippe Mercier, *The Sense of Sight,* **1744. (Courtesy of the Yale Center for British Art, Paul Mellon Collection.)**

the border that surrounds this problematic map, the device by which the longitude and latitude of these land masses might be known. A second instance of this pattern of replication lies in the similarity between the depiction of Port Mahon and the right sleeve of the woman's dress. This Minorcan port, which was judged by contemporaries to "have the finest harbour in the Mediterranean,"[40] featured an extended and easily defended inlet, the length of which is nonetheless grotesquely, even obscenely, exaggerated on this map. The key to taking the island was, of course, this port, and the optimism of the French painter is conveyed by the suggestively unbuttoned sleeve of the young map-reader. As in the case of the woman's headdress and the map's border, the opening in the sleeve and the inlet on the chart run across the painting in parallel lines. The lighted portion of the sleeve, moreover, resembles the outline of the island of Minorca itself, with, of course, the crucial difference in the contours of the impregnable port and its more accessible sartorial correlative.

While this latter detail is not without its erotic dimension, I do not
wish to insist upon the inevitable similarities between the conquest of
women and of territories. It is certain that such unfortunate metaphors
did and do flourish, but I believe that the first similarity which I have
described somewhat complicates the issue. The fact that it is not just
another land mass but an abstract portion of the map—the borderline
marking showing latitude and longitude—that is mirrored in the arrange-
ment of the woman's hair implies less, I think, about masculine notions
of conquest than about their prevailing sense of women's ability to read
maps. It is significant that the woman appears to be gauging the distance
of the island of Majorca from the Spanish mainland with her right hand,
for this particular maneuvre suggests that she is not using the coordinate
system that appears at the border of the map, nor measuring off the
distance with a pair of compasses and comparing it to a scale, but re-
sorting to a rather more primitive, and almost child-like, system of reck-
oning. The device that would help her evaluate the position and relative
size of the two islands is transferred—and thus trivialized—to her ornate
hairstyle, where points of light and darkness form the same right-angled
pattern.

In other words, the particulars of the latitude and longitude markers
find a dainty reflection in the woman's headdress precisely because they
serve her not at all on the map. Mercier's depiction of his female map-
reader mirrors, in sum, directives offered some sixty years earlier in the
popular *L'Art de plaire dans la conversation,* where it was noted that

> Women should not, in using terms that are a bit too rough for them, try to
> sound like geographers. I yield to them the terms 'climate,' 'zone,' and 'inlet'
> [*détroit*], and perhaps other words still, but under no circumstances do I want
> them to shock me with expressions like 'longitude' and 'latitude.'[41]

While the more abstract conventions of cartography are forbidden her,
the female speaker, like Mercier's map-reader, does have some acquain-
tance with less technical terminology. All three of the acceptable expres-
sions, moreover, have a troubling relevance to the woman's sexuality and
figure, the climate exerting a notorious influence over her passions, a
"zone" being a type of belt or girdle,[42] and a *détroit* describing an inlet
like the one at Port Mahon, here suggestively reproduced in the pattern
of her sleeve, and offering a crude index of her gender.

There is also the issue of the woman's gesture. As I have suggested,
it seems to be a way of measuring distances, though one not nearly as
sophisticated as the map itself might require. A typical early modern
guide to hand signals, the *Chironomia, or the Art of Manuall Rhetorique,*
does in fact describe a gesture used "to denote amplitude,"[43] and it corre-
sponds to that depicted, with one crucial difference: it is the thumb, and

not the index finger, that would be extended by one who wanted to indicate width. More interesting still is the meaning attributed in the *Chironomia* to the sign that the woman is actually making: when "the two Middle-Fingers are bent forward, and their extremes presented in a fork, [the hand] doth object a scosse, and doth contumeliously reproach."[44] The gesture on which the *Sense of Sight* centers would have, therefore, a moral significance: the lady in question offers a commentary on the military ventures which her countrymen and their Spanish allies have undertaken. Whether she condemns the enterprise itself or, as is more likely, the English enemy against whom warfare is directed, it would appear that she has little to do with the technical aspects of the map that lies before her. Interpretation based upon manuals such as the *Chironomia* suggest, then, that whatever it is that the woman sees in the *Sense of Sight,* it does not involve accurate map reading, nor even a crude form of reckoning, but a moral vision at some remove from the tools she handles.

What is most pertinent, then, about Mercier's depiction of the woman with the map is its insistence upon her inability to read the document that she displays to all onlookers. The *Sense of Sight* also suggests that male observers, whether within or without the picture frame, can read both the map and the various indices of the woman's ignorance, given that the latter—the arrangement of the pearls and the suggestive configuration of the sleeve—involve some knowledge of the former. The question that I would pose at this point is about the woman's own attitude toward her incompetence, for it is one thing not to be able to read a map, but it is another to want to learn to do so. If she happily accepts her ignorance as a natural attribute of femininity, then the gesture retains its moral significance: women may not be able to read maps, but they can interpret and convey the ethical lessons derived from these wartime documents. It might, however, be argued that the woman's gesture is the clumsy first step of beginner, and that she is genuinely interested in learning a discipline normally mastered by men alone. It is upon this more complex (and attractive) possibility that I will focus, noting in passing that the larger island toward which she points, Majorca, was known as a leading center of cartography.[45]

Although women were not generally encouraged to take up cartography, related studies were at times recommended to them.[46] In 1765, for instance, a Mr. Demarville published a manual of geography which he dedicated to Queen Charlotte and expressly designed for the education of the weaker sex.[47] In his preface, Demarville promoted this discipline as an antidote to more pernicious past-times, ones which tell as much about the anxieties of the author as about the practices of idle ladies. *The Young Lady's Geography* presented itself as an "endeavor to entice from

the hands of the Fair, obscene and ridiculous novels, (which serve only
to vitiate their morals, inflame their passions, and eradicate the very
seeds of virtue) by persuading them to the study of a science both useful
and amusing." After a brief introduction to the technical aspects of geog-
raphy, a chapter in which abstract notions such as the figure and the
motion of the earth, and the pattern of its seasons, were discussed, this
primer devoted itself to verbal descriptions of one country after another:
those young ladies who had the sense to abandon their novels for the
bracing regimen of geography would acquire a smattering of history and
anthropology. The author recognized, however, that even this kind of
information was not always suitable for his impressionable readers. One
instance of his censorship is particularly pertinent to our discussion of
Minorca: Port Mahon, he wrote, "was taken from [the English] by the
French at the beginning of the late war; but in such a manner, as is better
to be forgotten than repeated here."[48]

A little knowledge, apparently, was a dangerous thing, and what shame-
ful passions the story of this capture—where the timorous Admiral John
Byng lost his nerve, was charged with neglect of duty, and eventually
executed[49]—would have excited in the young lady can only be imagined.
What is significant, however, in the reticence that Demarville shows be-
fore his audience is the way it mirrors yet another contemporary refer-
ence to Minorca. In 1752 John Armstrong decided to tell an uninformed
world about the island around which so many military ventures had been
planned. Minorcans were generally uneducated, he acknowledged, and
especially so the women, but there were reasons for their ignorance.

> There is scarce a woman in the country that writes or reads, which does not
> proceed from their want of capacity, but is the consequence of the jealous
> nature of the Men, who are not willing to furnish them with the means of
> intriguing, to which the heat of the climate does not a little incline them, in
> which however they are extremely cautious and secret.[50]

The underlying premises of these two passages are crucial. Literate Mi-
norcan women, like a young lady who knew too much about the cowardly
behavior of the otherwise worthy Admiral Byng, would be more than
ever likely to give in to their passions. What little the torrid climate and
obscene novels had not already done, this knowledge might do. However
dissimilar the Minorcan matron and Demarville's maiden, both groups of
women, if privy to the wrong kind of information, would yield themselves
entirely to men for whom they were not destined.

There is an interesting cultural gradient in these analogous preoccupa-
tions, and one which will suggest much about Mercier's tableau. The
Minorcan woman is already so uncontrollable that literacy would destroy
what little tendency toward marital fidelity she has: even without the art

of letters she manages regularly to betray her husband. Demarville's young lady, presumably a more civilized creature, can learn to read without necessarily putting her virtue into danger; she is even encouraged to study geographies in order to undo the harm previously done by novels. The story of masculine inadequacy, however, would drive her into the arms of someone other than the husband for whom she is being schooled, as if something in the sad tale of Admiral Byng's failure to protect the valuable inlet entrusted to him would persuade her, too, to abandon all defenses. The Frenchwoman of Mercier's painting is more sophisticated still: it is probable that she can read, possible that she can read what she likes, and conceivable that she wants to learn to read a map, one which features the torrid zone where both the riotous island of Minorca and the cartographical center Majorca are to be found. No matter what it is that she is doing with her hand, it lies well within that dangerous area of the globe, as if she can at least locate the theater of such passion and learning.

Finally, there is another meaning assigned to her gesture, one which would not have figured in treatises of manual rhetoric such as the *Chironomia,* but is still recognized by modern viewers: that of cuckholdry. This is not to suggest that the *Sense of Sight* is an actual depiction of marital infidelity, for there is no indication that the young woman is even married, much less betraying anyone with anyone else. But it does seem likely, given the association of female insubordination with both Minorca itself and written works about the island, that map literacy, emblematized by Majorca, would be the last in a series of implied threats. The young woman's open sleeve would then denote less about the anticipated victory of the French and Spanish at Fort Mahon than about the burgeoning passions attributed to the novice map-reader, desires which her older companion would perhaps be unable to satisfy.

I would not like to suggest that all references to women's inability to read maps were in fact men's elaborately disguised fears of sexual inadequacy, though more than one late twentieth-century joke reaches just that conclusion. I would argue, however, that the reductive association of men with map literacy and women with ignorance of the same was most frequent precisely when those notions were imperilled. By way of example I refer to an incident in Laurence Sterne's *Tristam Shandy,* published about twenty-five years after Mercier completed his painting. Again, cartography is portrayed as a valuable tool for the soldier, and thus as a science somewhat outside the realm of feminine talents. When the lustful Widow Wadman decides to pursue the wounded veteran Captain Toby Shandy, she persuades him to show his various military maps to her. It is he who reads the maps, of course, while she is chiefly engaged in following his forefinger with hers over terrains that interest her not at all. In one of its most celebrated chapters, the novel emphasizes Captain

Shandy's tendency toward the abstraction required of a map-reader and
the Widow Wadman's preference for the more concrete details of exis-
tence. The greatest preoccupation of that worthy lady being the nature
of the wound from which Captain Shandy is still recovering, she sets
about making relevant inquiries.

> And whereabouts, dear Sir, quoth Mrs. Wadman, a little categorically, did you
> receive this sad blow? In asking this question, Mrs. Wadman gave a slight
> glance towards the waistband of my uncle Toby's red plush breeches, expecting
> naturally, as the shortest reply to it, that my uncle Toby would lay his forefinger
> on the place.—It fell out otherwise—for my uncle Toby having got his wound
> before the gate of St. Nicholas, in one of the traverses of the trench, opposite
> to the salient angle of the demi-bastion of St. Rich; he could at any time stick
> a pin upon the identical spot of ground where he was standing when the stone
> struck him: this struck instantly upon my uncle Toby's sensorium—and with
> it, struck his large map of the town and citadel of Namur and its environs,
> which he had purchased and pasted down upon a board by the Corporal's aid,
> during his long illness—and it had lain with other military lumber in the garrett
> ever since, and accordingly the Corporal was detached to the garrett to fetch it.
>
> My uncle Toby measured off thirty toises, with Mrs. Wadman's scissors, from
> the returning angle before the gate of St. Nicholas; and with such virgin mod-
> esty laid her finger on the place that the goddess of Decency forbid her to
> explain the mistake.
> Unhappy Mrs. Wadman![51]

What might have been a humiliating—not to say emasculating—situ-
ation is happily averted, for Uncle Toby has no trouble showing the place
where he was wounded: this portion of the long discussed map, in fact,
is so large[52] that it has to be measured off with the inquisitive woman's
scissors. At issue here, of course, is the masculinity of Captain Toby
Shandy, and though he fails to assert it in the fashion that Mrs. Wadman
desires, he does so in a more oblique manner by his interpretation of her
question, that is, by his manly tendency towards abstraction, his inclina-
tion to *read maps* rather than to follow her glance toward his red plush
breeches and merely *look* at the supposed site of his wound. In sum, this
particular scene between Mrs. Wadman and Captain Toby would be a
latterday version of the Renaissance emblem of Geometria, where a
woman representing this liberal art measured off distances on a globe with
a pair of compasses while her male companion consulted an open book.[53]
 It should be apparent, then, that even the detailed and picturelike maps
used in military campaigns constituted a kind of text, a representational
system whose abstract meaning women preferred to ignore when faced
with more tangible possibilities. Again, while implications of this tradition
are offensive, it is more significant that when the distinction between
geography and chorography, or large and small maps, threatened to break

Cornelius Drebbel, after Hendrik Goltzius, *Geometry*. (Courtesy of the Prentenkabinet, Rijksuniversiteit, Leiden.)

down, as indeed it did in the face of eighteenth-century military campaigns, what was formerly the feminine domain of cartography developed its "masculine" aspects, and that these involved precisely the same skills that were normally associated with reading.

Consider, finally, a last example from the eighteenth century, this one less concerned with a particular battle than with the ongoing war between

the sexes, and entailing the more general issue of perspective. In *Jacques le Fataliste,* Diderot tells the story of a daughter of Jean Pigeon, "that talented artist who made those beautiful relief maps of the world," a young lady who insisted on learning a bit of geometry herself. "Mademoiselle Pigeon used to go [to the Academy of Sciences] every morning with her briefcase under her arm and her box of mathematical instruments in her muff." Unfortunately, her teacher, a certain Pierre-André Prémontval, "fell in love with his student, and somehow by way of propositions concerning solids inscribed in spheres, a child was begotten."[54] Diderot recounts that the lovers were fearful of M. Pigeon's anger, and they fled the country, though it was well known that in fact Prémontval, author of a certain number of anti-Catholic tracts, left France for religious reasons, and perhaps to escape his creditors as well.[55] His companion's alleged pregnancy, in other words, would have only been the third factor in his departure for Switzerland.

However amusing Diderot's presentation of the story of Prémontval and Mlle. Pigeon, it is disturbing in its resemblance to an older tale, the infamous encounter of two baroque artists, Artemisia Gentileschi and Agostino Tassi. Tassi, an associate of Artemisia's father Orazio Gentileschi, also a painter, had come to the Gentileschi household to give the accomplished eighteen-year-old girl lessons in perspective, since she would not have been permitted to study this discipline in an academy for painters. Early in 1612 Orazio Gentileschi denounced Tassi for raping Artemisia and misleading her with promises of marriage; the celebrated trial that followed forced the accused to spend eight months in prison, and firmly established Artemisia'a reputation as a sexual adventuress for the next few centuries.[56]

In both the story of Artemisia Gentileschi and of Mlle. Pigeon, the desire to study some aspect of geometry is the occasion for illicit sexual activity. Artemisia, though unable to preserve her good name through marriage to her so-called preceptor, soon managed to overshadow the paintings both of Tassi and of her father (who may have begun to work together again after the trial)[57] through her own brilliant artistic production. Mlle. Pigeon, on the other hand, may or may not have returned to the study of perspective after her marriage, but she is known today for her biography and edition of her father's work, having published the *Mécaniste philosophe. Mémoire contenant plusieurs particularités de la vie & des ouvrages de Jean Pigeon, mathématicien* in 1750. In summary, given that various elements of the Prémontval-Pigeon episode were Diderot's own invention, and that their story bears a generic resemblance to the true and less pleasant incidents between Gentileschi and Tassi, it seems likely that the author saw it as a kind of cautionary tale. His audience would have understood it as yet another injunction against fe-

male map-readers, those women foolish enough to go about with carto-graphical features inscribed in their hairdress and "mathematical instruments" enclosed in their garments.

ORTHOGRAPHY

By the nineteenth century the integration of small-and large-scale maps was nearly complete, a development due to more accurate methods of surveying, ones in which the curvature of even the smallest part of the earth was reflected in chorographical and topographical maps. This trans-fer of techniques meant that the differences between the two areas of cartography might be minimized, and the need for the old oppositions of writing and painting, or of masculine and feminine interpretations, might be finally abandoned. The association of maps and literary activity is something curious and outmoded, and while it is ironized in a narrative context such as Edgar Allan Poe's *Unparalleled Adventure of One Hans Pfaall,* it is neglected in contemporaneous treatises on geography itself.

Poe's story, first published in 1835, involves the hoax perpetrated by Hans Pfaall, a penniless Dutchman who escaped his creditors by leaving town, and who after an interval of several years sent a dwarf in a hot-air balloon with a letter detailing his alleged journey to the moon. The body of Poe's tale is thus the letter of Hans Pfaall, an epistle that the frame of the story undercuts. Among the most interesting of the many details provided by Pfaall is his insistence upon the appearance of both the earth and the moon from the air: they look, he notes with unnecessary empha-sis, "like a chart orthographically projected."[58] Bodies seen from above are, however, virtually identical to an orthographic projection: this means no more than that their curved surfaces are foreshortened, as we would expect them to be.[59] The negligible quality of his cartographic information conceals, on the other hand, a point that is rather more pertinent to our understanding of the story: "orthographic" also means "to write straight or correctly," which Hans Pfaall would have us believe he is doing. In this instance, then, the map-reading that we are asked to do is meant to prevent us from the real reading that threatens to undo the whole story.

Conrad Malte-Brun's well-known *System of Universal Geography,* originally published in the first decades of the nineteenth century as the *Précis de la géographie universelle,*[60] does not so actively oppose the two kinds of reading. The author appears embarrassed, rather than intrigued, by activities once considered so similar. As with Poe's work, it is the treatment of the word "orthography" that is most significant. Malte-Brun offers a discussion of the orthographical projection in an early chapter, noting that it might also be called a "planetary projection, since [its]

principal object is to show the direct image of half the globe."[61] Several pages later he turns to the question of "orthography" itself, which was understood in that era to mean, as I have noted, "correct writing," and by extension, proper spelling and penmanship.[62] He deplores the disregard among map-makers for standardized spelling and labeling techniques, and emphasizes the illegibility of many of the names on contemporary maps. Yet the connections between the two sorts of orthography are not drawn, and the common denominator of text-like objects no longer evoked, for the relationship which the early modern world considered so evident was no longer apparent. The irony of the association of maps and writing, of course, was that it was bound to break down and give way to the more obvious correlation with the visual arts, because once we had all learned to read maps, they looked more like pictures.

NOTES

I am grateful to the John Carter Brown Library for supporting my research with the Jeanette D. Black Memorial Fellowship for the History of Cartography. I also thank the staff of the John Hay Library for their help in locating pertinent materials.

1. Recent studies on the relationship of the map to the visual arts include the opposed views of Samuel Y. Edgerton, Jr. "From Mental Matrix to Mappamundi" and Svetlana Alpers, "The Mapping Impulse in Dutch Art"; both essays are in David Woodward, ed., *Art and Cartography* (Chicago: University of Chicago Press, 1987), 10–50, 51–96, respectively. "Art and Cartography" was also the focus of two concurrent exhibitions sponsored by the Hermon Dunlap Smith Center for the History of Cartography and the Art Institute of Chicago in 1980–1981 and presented in *Mapline* 5 (1980). One of the relatively few studies to focus on the textlike legibility of early modern maps is J. B. Harley's "Meaning and Ambiguity in Tudor Cartography," in Sarah Tyacke, ed., *English Map-Making 1500–1650* (London: British Library, 1983), 22–45. In order to discuss "cartographic semantics" Harley adopts as his methodology Erwin Panofsky's approach to iconography by using the art historian's tripartite analysis of the icon. Finally, a special issue of *Word & Image* devoted to maps and mapping (4, no. 2 [April–June 1988]) offers various examinations of the relationship of cartography to graphic systems. Of particular interest are G. N. G. Clarke, "Taking possession: the cartouche as cultural text in eighteenth-century American maps," 455–74; Lucia Nuti, "The mapped views by Georg Hoefnagel: the merchant's eye, the humanist's eye," 545–70; Sarah Tyacke, "Intersections or disputed territory," 571–79.

2. See in this connection J. B. Harley, "The Map and the Development of the History of Cartography," in J. B. Harley and David Woodward, eds., *The History of Cartography*, vol. 1 (Chicago: University of Chicago Press, 1987), 12. (Hereafter abbreviated as *HC*, 1).

3. For an excellent discussion of Ptolemy's contribution to cartography, see O. A. W. Dilke, "The Culmination of Greek Cartography in Ptolemy," in *HC*, 1:

177–99. For the subsequent influence of the *Geographia* on the Byzantine world, see Dilke, "Cartography in the Byzantine Empire," in *HC*, 1: 267–74. The *Geographia* was translated to Latin in 1406. For bibliographical information on these earliest Latin and vernacular editions, see Carlos Sanz, *La Geographía de Ptolomeo* (Madrid: Librería General Victoriano Suarez, 1959) and Angela Codazzi, *Le Edizioni Quattrocentesche e cinquecentesche della 'Geografia' di Tolomeo* (Milan: La Goliardica, s.d.).

4. In the Latin translation of Bernardo Silvano's edition of the Venice 1511 of the *Geographia*, now in a facsimile edition prepared by R. A. Skelton (Amsterdam: Theatrum Orbis Terrarum, 1969), the phrase is "per puras lineas/ nudas denotationes" ["with clean lines and simple markings."] In 1537 Pedro Nuñes rendered the term "per muy sotis traços y pontos" ["with very fine lines and dots"] in his translation of the first book of Ptolemy's work. See *Tratado da sphera com a theorica do sol e da lua e ho primeiro livro da Geographia de Claudio Ptolomeo* (Lisbon, 1537; facsimile edition Munich: J. B. Obernetter, 1915), 61–62.

5. Ptolemy, *Geographia,* translated by Francesco di Niccoló Berlinghieri, (Florence: Niccolo Todescho, 1482), 1, chap. 2, "In che si discorda la geographia dalla chorographia." Berlinghieri's verse paraphrase of the *Geography* has been republished in a facsimile edition by R. A. Skelton, ed. (Amsterdam: Theatrum Orbis Terrarum, 1966).

6. "Dice [Tolomeo] imitatione del disegno, & non dice disegno proprio, percioche la descrittione, che del mondo si fa in piano, ò in balle, non è propriamente disegno, che si dipingono in essa le città e i paesi, con la propria forma loro, ma si notano solamente con alcuni segnetti, ò terre, ò tondi, ò quadretti piccoli, & col nome di tai luoghi, ò terri, ò fiumi, ò mari, che con tai segni si rappresentano. Et però ella è più tosto veramente imitatione di disegno, che disegno vero." Ptolemy, *La Geografia di Claudio Tolomeo Alessandrino nuovamente tradotta di Greco in Italiano,* translated by Girolamo Ruscelli, and annotated by Giuseppe Moletto, (Venice: Giordano Ziletti, 1564), 3.

7. "Là onde la Corografia ha bisogno del disegno, ò della dipintura de' luoghi, & niuno potrà esser Corografo, che non sappia disegnare ò dipingere. Di che alla Geographia non fa mestiere per niun modo, come quella, che può dimostrar *con sole minute lettre, & segni,* il sito & la figura di tutto il mondo." Ptolemy, *La Geografia,* translated by Leonardo Cernoti and annotated by Giovanni Antonio Magini (Venice: Giovanni Battista & Giogio Galignani Fratelli, 1598), 1.

8. For an interesting survey of the study of mathematical geography, chorography, and the subdiscipline descriptive geography in sixteenth-and seventeenth-century England, see Lesley B. Cormack, "'Good Fences Make Good Neighbors': Geography as Self-Definition in Early Modern England," *Isis* 82 (1991): 639–61.

9. Fernán Pérez de Oliva, *Cosmografía Nueva.* ed. Cirilo Flórez Miguel, Pablo Garcí Castillo, José Luis Fuertes Herreros, and Leonard Sandoval Ramón, Latin and Spanish bilingual edition (Salamanca: Ediciónes Universidad de Salamanca, 1985), 134–35. For Pérez de Oliva's activities as a playwright and translator of classical comedies and tragedies, see esp. 47 and 54.

10. See *Mercator: a monograph on the lettering of maps, etc., in the 16th century Netherlands, with a facsimile and translation of his treatise on the italic hand and a translation of Ghim's Vita Mercatoris,* by A. S. Osley, with a foreword by R. A. Skelton (London: Faber, 1969).

11. For particulars of these changing conventions, see esp. François de Dain-

ville, S.J., *Le Langage des géographes* (Paris: Editions A. et J. Picard, 1964), 59–61, 74–76; and David Woodward, "The Manuscript, Engraved, and Typographic Traditions of Map Lettering," in *Art and Cartography,* ed. David Woodward (Chicago: University of Chicago Press, 1987), 174–212.

12. I am indebted to Michael Fried's discussion of the way in which these same oppositions animate the paintings of Thomas Eakins. See in particular *Realism, Writing, Disfiguration* (Chicago: University of Chicago Press, 1987), 50–54, 76–89.

13. John Freccero, "Donne's *Valediction: Forbidding Mourning,*" *E.L.H.* 30 (1963): 335–76, esp. 337.

14. For the best general discussion see David W. Waters, *The Art of Navigation in England in Elizabethan and Early Stuart Times* (London: Hollis and Carter, 1958).

15. John Dee was even able to give mathematical evidence for this argument. See Waters, *The Art of Navigation,* 209–11, and appendix 8b.

16. John Davys discussed the "paradoxall line" of the loxodromic course in his *Seaman's Secrets* (London: Thomas Dawson, 1595; reprinted in John Davys, *The Voyages and Works of John Davis, the Navigator,* edited, with an introduction and notes, by A. H. Markham (London: printed for the Hakluyt Society, 1880), 240. Robert Hues referred to loxodromes as "certain crooked winding lines" in his *Learned Treatise of Globes,* trans. John Chilmead (London: printed for J. B. for Andrew Kemb, 1659), 157.

17. For a more elaborate version of this argument, see my "John Donne and the Oblique Course," *Renaissance Studies* 7, no. 2 (June 1993) 168–183.

18. Andrew Marvell, *The Complete Poems,* ed. Elizabeth Story Donno (London: Penguin Books, 1987), 50.

19. Nathaniel Carpenter, *Geography delineated* (Oxford: I. Lichfield & W. Turner for H. Cripps, 1625), 174. Toward the end of the century Nicolas Sanson defined the instrument thus: "Planisphère, qui signifie Globe plat, ou Boule platte, ce qui veut dire, une carte qui représente sur une Figure platte le Globe Terrestre comme s'il estoit plat." See his *Introduction à la Géographie* (Paris: chez l'auteur, 1681), 9. For a general discussion of the planisphere, see Dainville, *Le Langage des géographes,* 39–42.

20. Carpenter, *Geography delineated,* 175.

21. Pierre Bourdin, *Le cours de mathématique* (Paris: Benard[?], 1641), cited in Dainville, *Le Langage des géographes,* 41.

22. I have used the following edition of this popular work: Thomas Blundeville, *Blundeville His Exercises,* 7th ed. enlarged by Ro. Hartwell philomathematicus (London: R. Bishop, 1636), 598. Herschel Maurice Margoliouth offers Blundeville's definition of the planisphere in his commentary on Marvell's poem, without, however, discussing the relative obscurity of its connection with the astrolabe, the sexual connotations of this usage, or the context in which readers would have found this association. See Andrew Marvell, *The Poems and Letters of Andrew Marvell,* ed. H. M. Margoliouth, 2d ed. 2 vol. (Oxford: Clarendon Press, 1952), 1: 224.

23. David A. King, "The Origin of the Astrolabe According to the Medieval Islamic Sources," *Journal for the History of Arabic Science* 5 (1981): 43–83, esp. 45 and 55, reprinted in King, *Islamic Astronomical Instruments,* chap. 3.

24. I have used Otto Neugebauer's translation of and commentary on this section of the *Geography;* see Otto Neugebauer, "Ptolemy's *Geography,* Book VII, Chapters 6 and 7," *Isis* 50, no. 1 (March 1959): 22–29, now reprinted in

Otto Neugebauer, *Astronomy and History. Selected Essays* (New York: Springer-Verlag, 1983), 326–33.

25. "One must also take care that the circles are not merely (represented by simple) lines but with an appropriate width and in different colors and also that the arcs across the earth (be given) in a fainter color than those near the eye; and that of apparently intersecting parts, those which are more distant from the eye be interrupted by the nearer ones, corresponding to the true position on the rings and on the earth; and that the zodiac with its southern semicircle which passes through the winter solstice, lies above the earth, while the northern (semicircle) which passes through the summer solstice be interrupted by (the earth)." See Neugebauer, "Ptolemy's *Geography*," 24. As Neugebauer points out (on p. 26 of the same article), the *oikoumene*, unlike the armillary sphere, was not drawn in perspective, but rather as a map preserving latitudes along the central meridian. Renaissance engravings of the third projection (as in Figure 36 of this study) generally ignored this distinction, and presented the *oikoumene* as seen in perspective. On the importance of *Geographia* 7: 6–7 to the development of Renaissance perspective theory, see Samuel Y. Edgerton, "Florentine Interest in Ptolemaic Cartography as Background for Renaissance Painting, Architecture, and the Discovery of America," *Journal of the Society of Architectural Historians* 33 (1974): 275–92, esp. 284–85.

26. For a survey of the instruction which boys in the early modern period would have received in geography and allied fields, see Foster Watson, *The Beginnings of the Teaching of Modern Subjects in England* (London: Sir Isaac Pitman & Sons, 1909), 89–135.

27. On the traditional alliance of details and the feminine, see Naomi Schor, *Reading in Detail: Aesthetics and the Feminine* (New York and Methuen, 1987), esp. 3–41.

28. Madeleine de Scudéry, *Clélie, Histoire Romaine* (Paris: Augustin Courbé, 1660; Geneva: Slatkine Reprints, 1973), 1: 399 ff.

29. "Mais nous fusmes bien estonnez, lors qu'Herminius apres avoir veû ce que Clelie, luy venoit d'envoyer, nous fit voir que c'estoit effectivement une Carte dessignée de sa m[a]in, qui enseignoit par où l'on pouuoit aller de *Nouvelle Amitié* à *Tendre*. . . ." Madeleine de Scudéry, *Clélie*, 1: 396.

30. See Claude Filteau, "Le Pays de Tendre: l'enjeu d'une carte," *Littérature* 36 (1979): 37–60 for an excellent description of the technical and symbolic aspects of the *Carte de Tendre*. For its place in the history of allegorical maps, see E. P. Mayberry Senter, "Les Cartes allégoriques romanesques du XVIIᵉ siècle," *Gazette de Beaux-Arts* (April 1977): 133–44.

31. See, for example, *La Carte du Royaume de Coquetterie* (1654). The suggestive *Royaume d'Amour en L'Isle de Cythère, carte descripte par le S. Tristan Lhermitte* appeared before the *Carte de Tendre*, having been published in 1650. On the relationship of these maps to that of Tendre, see Mayberry Senter, "Les Cartes allégoriques romanesques du XVIIe siècle."

32. "Ce que i'ay fait pour n'estre veu que de cinq ou six Personnes qui ont infiniment de l'esprit, qui l'ont delicat & conoissant, soit veu de deux mille qui n'en ont guere qui l'ont mal tourné, & peu esclairé, & qui entendent fort mal les plus belles choses?" Madeleine de Scudéry, *Clélie*, 1: 408.

33. Ibid., 1: 406.

34. This "fatality," incidentally, would not be unlike the steely "decrees of Fate" which Marvell mentions in his *Definition of Love;* both authors are referring

to zodiacal configurations with which armillary spheres and world maps were then adorned.

35. Augustin Lubin argued in his *Mercure géographique; ou le guide du curieux des cartes géographiques* (Paris: C. Remy, 1678) that the zodiac was becoming an obsolete detail on world maps: "Depuis que l'on a séparé la Géographie de la Cosmographie, on ne trace plus le Zodiaque sur les Planisphères, parce qu'il n'est pas nécessaire pour la description de la Terre." Cited in Dainville, *Le Langage des géographes*, 42. Many world maps published after this date, however, are adorned with the curving line of the ecliptic, and often the zodiacal signs themselves are indicated.

36. de Scudéry, *Clélie* 1:406. See, in this connection, the recent analysis of the *Carte de Tendre* in Joan DeJean's *Tender Geographies*, where the author argues for the centrality of the map, and indeed of the novel itself, in the development of female authorship; the literary project of Madeleine de Scudéry is the revendication of the rights and perspectives of women writers and their audience. See Joan DeJean, *Tender Geographies: Women and the Origin of the Novel in France* (New York: Columbia University Press, 1991), 55–60; 87–93.

37. On the increasing relevance of cartography to military activity in this period, see Gian Paolo Brizzi, *La Formazione della classe dirigente nel Sei-Settecento* (Bologna: Il Mulino, 1976), 244–47.

38. On Philippe Mercier (1689–1760) see Robert Rey, *Quelques satellites de Watteau: Antoine Pesne et Philippe Mercier—Francois Octavien—Bonaventure de Bar—François-Jérome Chantereau* (Paris: Librairie de France, 1931).

39. For a general discussion of the War of the Austrian Succession, see Derek McKay and H. M. Scott, *The Rise of the Great Powers 1648–1815* (New York: Longman, 1983), 162–71. After the Second Family Pact (1743) France agreed to join forces with Spain so that the latter might regain Minorca from the British.

40. Demarville, *The Young Lady's Geography* (London: printed for R. Baldwin and T. Lounds, 1765), 24.

41. "Il ne faut pas que, par des termes qui sont rudes pour leur bouche, les dames affectent de paraître un peu trop géographes. Je leur abandonne *climat, zone, détroit,* et quelques autres mais je ne veux point qu'elles me viennent effrayer par des *longitudes* et des *latitudes.*" F. De Vaumorière, *L'Art de plaire dans la conversation* (1688), cited in François de Dainville, S.J., *La Géographie des humanistes* (Paris: Beauchesne et ses fils, 1940), 476. Dainville's discussion of the way in which women impeded the progress of geography in the seventeenth and eighteenth century (475–477) is itself a latterday version of the traditional bias against female map-readers.

42. See, for instance, William Alingham's definition in *A Short Account of the Nature and Use of Maps* (London: printed by R. Janeway, for B. Barker, 1703²), 41: "A *Zone* signifies a Belt or Girdle; but here is to be understood a certain quantity of Land, included by (one or) two Parallels." In his commentary on Girolamo Ruscelli's translation of the *Geographia*, Giuseppe Moletto displayed a similar punctiliousness, pointing out that the word "armillary," derived from "those bands of gold or silver or other material that women wear on their arms as ornament, and that we call 'bracelet' in Italian." Ptolemy, *Geographia* (Venice: Giordano Ziletti, 1564), 349.

43. J. B. Philochirosophus, *Chironomia, or the Art of Manuall Rhetorique* (London: Thomas Harper, 1644), 76–77.

44. See the *Chironomia,* 76, and the chart on p. 95.

45. Its importance dates to the Middle Ages. See J. B. Harley and David Wood-

ward, *HC*, 1: 431–32, 437–38, where Majorca is noted as a leader in the production and development of the portolan chart.

46. In her *Essay to Revive the Antient Education of Gentlewomen* (1673), Bathsua Makin sees geography as useful because it "puts life into history," but she does not ally it with any lessons in the use of either the map or the globe. Bathsua Makin, *An Essay to Revive the Antient Education of Gentlewomen* (Augustan Reprint Society, Publication no. 202, 1980), 24.

47. The woman who was to become Queen Charlotte Sophia of England married King George III of England in 1761, several years before the publication of this edition of *The Young Lady's Geography*. As Demarville's preface suggests, Charlotte herself was well educated. In later years she devoted great attention to the schooling of her daughters. Demarville's work had previously appeared in a bilingual French and English version, the *Géographie des jeunes demoiselles* (London: De l'imprimerie de J. Haberkorn, 1757).

48. Demarville, *The Young Lady's Geography*, 24.

49. On the incident at Port Mahon, see *An exact copy of a remarkable letter from Admiral Byng to the right Hon. W—-P—-, Esq; Dated March 12, 1757, two days before his execution* (London: J. Reason, 1757); *The Trial of the Honourable Admiral John Byng, at a court martial, as taken by Mr. Charles Fearne, Judge-Advocate of his Majesty's Fleet* (London: for R. Manby, 1757). At his trial it was determined that Byng, who had abandoned the fort in his charge because he was overwhelmed by French forces, had acted "through cowardice, negligence, or disaffection."

50. John Armstrong, *History of the Island of Minorca* (London: C. Davis, 1752), 200.

51. Laurence Sterne, *Tristam Shandy,* ed. Howard Anderson (New York: W. W. Norton, 1980), 450.

52. One toise is about 6.4 feet in length. This unit of measurement was most frequently adopted in military operations.

53. As James A. Welu mentions in a recent study, the emblem was also transferred to Jodocus Hondius's *World Map of 1611,* where it appears on a cartouche discussing measurement. In this case, the individuals portrayed were actually a married couple, Iodocus Hondius and his wife. See James A. Welu, "Sources and Development of Cartographic Ornamentation in the Netherlands," in *Art and Cartography* ed. David Woodward (Chicago: University of Chicago Press, 1987), 160; and Rodney W. Shirley, *The Mapping of the World: Early Printed World Maps: 1472–1700* (London: Holland Press, 1983), 293.

54. Denis Diderot, *Jacques the Fatalist,* trans. Michael Henry, with an introduction and notes by Martin Hall (London: Penguin Books, 1986), 73.

55. Ibid., 256 n. 21.

56. See Mary D. Garrard, *Artemisia Gentileschi: The Image of the Female Hero in Italian Baroque Art* (Princeton: Princeton University Press, 1989), esp. 20–23, 34, 137, 519 n. 243.

57. Ibid., 36, 496–97 n. 46.

58. "The Unparalleled Adventure of One Hans Pfaall," in *The Science Fiction of Edgar Allan Poe,* edited and annotated by Harold Beaver (London: Penguin, 1976), 46, 51.

59. As the author of a standard textbook of cartography points out, "the orthographic projection looks like a perspective view of a globe from a considerable distance, although it is not quite the same. For this reason it might almost be called a visual projection in that the distortion of areas and angles, although great

from the edges, is not particularly apparent to the viewer. On this account it is useful for preparing illustrative maps wherein the sphericity of the globe is of major significance." Arthur H. Robinson, Randall D. Sale, Joel L. Morrison, and Philip C. Muehrcke, *Elements of Cartography,* 5th ed. (New York: John Wiley & Sons, 1984), 101.

60. Conrad Malte-Brun, *Précis de la geographie universelle,* 8 vols. (Paris: F. Buisson, 1810–1829).

61. Conrad Malte-Brun, *A System of Universal Geography,* with additions and corrections by James G. Percival, 3 vols. (Boston: Samuel Walker, 1834), 41. The laws governing this kind of projection are discussed on pp. 37–38.

62. Ibid., 56.

Themes of Love and Death in a Reading of the Carved Ornament of a Puritan Headboard

JAMES K. KETTLEWELL

The carved ornament decorating the Puritan headboard that is the subject of this article is the most that the iconoclastic Puritans could offer in the visual arts. Curiously, there has never been a serious attempt to interpret as legible symbols the ornamental forms painted or carved on the furnishings of Puritan homes. But to see these forms merely as pretty decoration would be to forget who the Puritans were; would be to forget that it would not have been their way to countenance the frivolity of mere visual enjoyment. The symbols here in oak, the most permanent of woods, once functioned as a constant sermon on the divine purpose of earthly marriage and love.

This headboard was part of a bed made for a Puritan, probably by a Puritan, at about the same time, 1667, as the most famous of all Puritan works of art, John Milton's *Paradise Lost,* was first offered for sale in London. The panels were carved from English oak for a marriage bed, known as a "great bed" in its time.[1] Both *Paradise Lost* and the headboard represent the purist strain of puritanism, before its evolution later in the seventeenth century into a religion more remote from the humanism of the Renaissance. In *Paradise Lost* Milton wrote of the first marriage. The bed to which this headboard belonged would have been made on the occasion of a Puritan marriage. These Puritans believed that, in a true marriage, the lives of Adam and Eve were once more replayed, the events of Genesis relived, but with one significant difference: the current of the old story was reversed. Through the ritual of a Christian marriage, played out through a lifetime, the paradise that was lost could be regained.

To interpret the carved symbols of the headboard is not as difficult as it might appear. It is significant that the meaning is largely accessible to simple common sense, aided by a little knowledge of the Bible. At the same time the interpretation offered here can be corroborated by a review of the historical context. Originating in early Christian times, this vocabu-

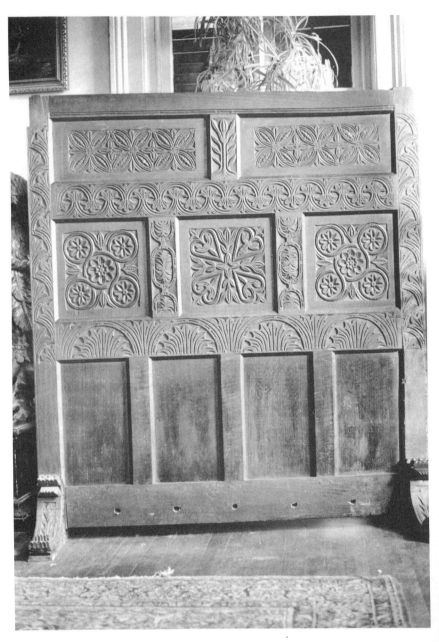

Headboard. (Permission granted by James Kettlewell.)

lary of ornament first became common knowledge in England in the ornament decorating the furnishings of late Gothic English churches. In the sixteenth century, after Protestant influence dampened the ardor for decorated churches, this ornamental vocabulary was resurrected in furniture designed for domestic use. Later in the seventeenth and during the eighteenth century, when the fashion for furniture decorated with these forms died out, they appeared again on the carved gravemarkers of England and America.

The headstone was the headboard of the grave, the bed in which the deceased would sleep until the Second Coming. Much of the symbolic language of gravemarkers actually was taken from the decorated headboard. Because many of the meanings of gravemarker symbols are now understood, they are the starting point for an interpretation of the similar symbols that appear on the furniture of the Puritans.[2] Finally, in the search for the sense behind these signs, the metaphors found in the poetry of the New England clergyman Edward Taylor reflect a common vocabulary of symbolic language, a language that would have been generally understood in the Puritan communities of the seventeenth century.[3]

The great bed of which this headboard was once a part was located in the parlor of the house. Serving both as the master bedroom and as a space of religious ritual, the parlor was the normal place for the sacraments of baptism and marriage, and of the ceremonies that pertained to death.[4] The great bed, constructed like an open box, had a solid roof of oak supported by two carved posts at the foot. Curtains could be closed around the perimeter to protect the occupants from the vapors of the night. The flat surfaces and the posts were commonly decorated with carved or painted symbols. These would have gleamed in candle light, the carvings or the painted forms enhanced by a glaze of linseed oil.

One could say this carved headboard is a visual work of art, a sculpture in low relief. However, being quite flat, it is in some ways like a written text. One reads these forms across a surface as one reads the pages of a book. Still, these signs are not entirely temporal as are words. They are also spacial, since their location across the surface is critical to what they signify. The arrangement is an ascent upward from the mortal to the divine.

Ornament in the decorative arts is an art form not normally included in a consideration of the relationship between words and images. In fact, design patterns in the decorative arts often convey meanings, even though these meanings are rarely read today. However, the language in which ornamental symbols communicate is very different from the language of the arts of painting or writing. Ornamental symbols are like hieroglyphs, pictographs that reflect something of the appearance of forms in the real world, but which have been modified, sometimes almost

beyond recognition, until they have the arbitrary formal quality of words. Sharing factors with both verbal and painted art forms, ornament exists at a median point between the two.

This headboard ornament is symbolism in its purest form. There is a tendency, not entirely incorrect, to designate almost everything that appears in art as "symbolic," a symbol being a form that stands for something other than itself. Thus a simple four-letter word or a full-fleshed image of a human form might be symbols. But would not the term "symbol" first suggest an image something like the highly stylized hieroglyphs of this headboard, abstract but with their sources in real things still recognizable?

Abstracted symbols in the visual arts perform a specific task, more exclusive than the tasks performed by words and sentences, or by the realistic images of the visual arts. The abstracted art symbol captures and makes tangible that which is too subtle or too grand to ever be confined. There are symbols that distill into a concentrated essence things that are vast. A simple circle might mean God. Symbols can represent invisible properties such as love. They may be adjectival and suggest particular ideas about what they represent. While a heart represents love in all its varied senses, when a flower stands for love we learn that love, which begins in beauty, always withers and dies.

True symbols of this sort have extraordinary and special properties. Shaped by inner urges of the human psyche, if what Carl Jung implies is true, such symbols have this marvelous facility of passing unchanged through time, and back and forth across cultural barriers. Hearts, whether from a medieval heraldic shield, from this headboard, or from last year's valentine, would have the same essential form and meaning, a meaning equally discernable to a scholar and a child.

The strangest property of true symbols is that they seem to appear without a narrator. In paintings and poems there is always the artist speaking, but symbols give no sense of a communicator. Rather, they are activated in a more mysterious, transcendent way, as if by no mortal hand. When they convey the commands of God as here, it is only His voice that can be heard.

An art of hieroglyphs was critical to our iconophobic Puritans. If they had not had a symbolic language, they would not have had an art. The second commandment (Ex. 20: 4) was their command: "You shall not make a carved image for yourself nor the likeness of anything in the heavens above, or on the earth below, or in the waters under the earth." But locking critical meanings within the shapes of art is too strong a human urge to ever be suppressed. If it does not come out one way, it will come out another. Following a tradition as old as Christian art itself,

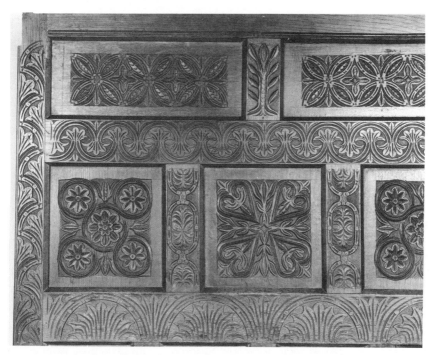

Detail of headboard. (Photo by Joseph Levy.)

the Puritans abstracted the forms of this earth to the point where neither
God nor anyone else would mistake them for the real thing.

In the Puritan parlor the great bed in its entirety signified the "Bower
of Adam." A popular Puritan image, this Bower of Adam is described in
Milton's words:

> The roof
> Of thickset covert was inwoven shade,
> Laurel, and myrtle, and what higher grew
> Of firm and fragrant leaf; on either side
> Acanthus, and each odorous bushy shrub,
> Fenced up the verdant wall; each beauteous flower,
> Iris all hues, roses and jessamine,
> Reared high their flourished heads between, and wrought
> Mosaic . . .
>
> (*Paradise Lost*, bk. 4, l. 692–700)

The plant forms everywhere in the headboard ornament make the general
reference to Adam's Bower clear. However, the powerful ritualistic func-
tion of the marriage bed goes beyond the connotations of a simple bower.

It is the staging platform for the sacramental acts of love and death. (But not for birth. This was relegated to another room, the woman's space, the kitchen.)

The bottom panels of the headboard are plain and unadorned. At this time it was the custom to sleep in a partially upright position against a stack of pillows. The base of the headboard would have been largely covered over. In this lowest zone there are four panels, two for the wife's side, two for the husband's. Each pair resonates a theme of dualities, a possible reference to the mortality and divinity that pervade this symbolic environment. The direction of these panels is vertical, God-aspiring. From here the symbolic text moves upward.

In the panels above this plain beginning the action slows and converges on three squares, then terminates at the top in two horizontals. There is a neat progression, starting fast, then coming to a stop.

Surrounding the panels is a closed structure of vertical stiles and muntins, and horizontal rails, an architecture form corresponding not merely to the controlled structure of the Puritan life on earth, but to their entire seventeenth-century universe as defined by René Descartes, where the divine scheme manifests itself in the strictest kind of order. An order quite superior to the chaos of the earth is visible in the strong pattern of this arrangement of symbolic ornament. Design, the essence of all art, has meaning here as well as aesthetic import. Conceived of in artistic *horror vacui,* without those attributes of the material world empty void and solid mass, this ornament defines a solely spiritual realm.

In this treatment of the marriage bed we encounter the astonishing change the early Puritans wrought on the Christian understanding of sex and the original sin. Unlike Roman Catholics, they found for sex in marriage a high position in God's plan.[5] As a true reading of the Bible had revealed, sex was something ordained before the Fall of Man. Milton's description of Adam and Eve in Eden throbs with erotic power. Satan agonizes with envy as he sees the first man and woman "imparadised in one another's arms" (*Paradise Lost,* bk. 4, l. 506). When the husband and wife of a Puritan marriage slept together and made love, they too became "imparadised," returned to Paradise through the medium of sexual love. Thinking of the Roman Catholic point of view, Milton writes of "hypocrites who austerely talk of purity, defaming as impure what god declares pure"; and further, "Hail wedded love, mysterious law, true source of human offspring, sole propriety in Paradise" (*Paradise Lost,* bk. 4, l. 44–51).

Beginning at the lowest level of ornament we see the kind of symbol that powerfully distills reality. The vastness of the heavens is expressed by a little arc, studded by the faintest suggestion of stars. For the meaning only a single arc would have been necessary; for the harmony and rhythm

necessary to art, four were required. The arc of heaven is an ancient and universal representation of the divine, a meaning that can be traced in a unbroken line from ancient Sumer to the gravestones of New England, to any modern backyard shrine enclosing an image of the Virgin Mary. This particular arc has a modified meaning. It encloses a simple plant form resembling somewhat the acanthus that Milton described as on the sides of Adam's Bower. Together, the arc and the acanthus set the action in an earthly garden of love presided over by the divine. This image of a garden as the appropriate setting for love has pervaded Islamic and Christian imaginations since the time when Eden first entered their sacred texts. Through the force of symbolic reference the great bed re-created Eden, setting the stage for a nightly reenactment of the intimate drama of the first erotic encounter.

A thought comes to mind of how this tough and severe environment of carved oak—hard, dark, flat, and covered with tightly organized form—would have set off in vivid contrast the softness and roundness of the bed's occupants, the softness of heaped up feather beds and pillows, and, finally, the disarray of the bedclothes. The memory of the original context of any work of art contributes to its force.

The second zone of the headboard presents a sermon on earthly love. The entwined flowers in the panels to the right and left of center stand for the love of the husband for the wife, the wife for the husband. Rough, almost crude, the carving is direct and to the point. The flower itself is such a universal and ancient symbol of love it needs no explanation, except to repeat its message about the mortality of earthly love. In the Puritan doctrine of love, the feelings that the husband and wife hold for each other are required to end at the grave, where God's love takes over. It is very clear that, for the Puritans, earthly love, particularly its sexual aspects, is a version of divine love, similar in kind but less in degree. One encounters this in the erotic lines of the Reverend Edward Taylor in writing of his love of God.

> The soul's the womb. Christ the spermodote
> and saving grace the seed cast thereunto . . .

or

> Let him kiss me with his oral kisses.
> Should he but stop such acts of love and Grace
> Making dark clouds mask up his brightsom face.[6]

Many of Taylor's poems directed to God closely resemble love poems written to a woman. The simple idea is that sexual love is the cause of life on earth, while God's love is the cause of eternal life.

In his poetry Edward Taylor continually refers to "true loves knot" which these entwined flowers represent. The entwined form is, of course, erotically suggestive, provoking a specific image of the married couple entwined in bed. At the same time this symbol stands for love in a universal sense. The flowers are arranged in one of the great archetypal patterns of art and religion, the quincunx, forming four corners and a center, that once stood for the four corners of the universe with God in the middle. We might have here the epicurean interpretation of love as a force pervading all reality, as it appears in the *De Rerum Natura* of the Roman poet-philosopher Lucretius. Of pervasive influence in the seventeenth century, this was the book blind Milton most often requested his daughters to read aloud. The quincunx is a variant of Carl Jung's favorite archetype, the mandala. If the form of a mandala appears in a dream, Jung sees it as a yearning for completeness and for unity of self. The very lines that interweave these floral forms are endless, and therefore timeless, signifying the universal. Some of the meaning here may have extruded from the collective unconscious of the Puritans. More likely they were clearly conscious of what these forms could mean.

In the central panel the generalized quincunx/mandala metamorphoses into a very specific form. The converging hearts are a powerful emblem of coitus itself. They focus their energy upon a center where life streams forth in the form of plants. Observe that each heart encloses a small plant form, a bud. The little cross in the center is a soul coming into being. (Equal-armed crosses commonly appear on New England headstones as a symbol of the soul.) The directional heart is a common symbol in the writing of the Puritans. Michael Wigglesworth writes Mrs. Avery to persuade her to marry him: "my thoughts and heart have been toward you ever since."[7] Countless times the Puritans write of someone's heart turning toward God. This evokes the image of the heart as some kind of dial, turning this way and that in the rib cage, pointing at what it desires. The heart symbol itself is like an arrowhead. (Could it have originated in Cupid's arrow?) The two directions in which these hearts point signify the two aspects of earthly love. One aspect, mundane, points toward the earth. The other, God-aspiring, points to heaven. The ornament of this middle zone of the headboard thus becomes a silent but articulate sermon, admonishing the husband and the wife to love each other and to make love. In Puritan theology this was a Christian duty.[8]

Above the central zone a horizontal band of ornament demonstrates the purpose of marital love. Twenty symbolic sheaves like sheaves of wheat but modified to resemble the leafy forms elsewhere on the headboard signify the new lives love brings into existence. It is a variation on an ornamental form common in late Gothic churches, where bound

sheaves of wheat referred to the life-restoring powers of communion bread. But wheat also signified fertility. At this time, it was the custom to shower the bride at a wedding with wheat as a reference to the children she might bear. God's command is to be obeyed: to be fruitful and to multiply the human race. However, bound as sheaves, this multitude seems prepared for the harvest that occurs at death.

In the center above the row of sheaves stands the strongest symbol in the group, the Tree of Life. As trees go, this is a strange species. It combines in a single form connotations both of a tree and of an olive branch. Growing in the center of the Garden of Eden, the Tree of Life was the source of eternal life in Paradise. The olive branch refers to the branch brought by a dove to Noah, signaling the end of the Flood. Here it represents the salvation from death for those chosen by God.

The ornamental carving of this Puritan headboard is a form of nonspacial visual art existing at a halfway point between images and words. Across a flat surface, flat like the page of a book, one follows a direction beginning at the bottom and advancing to the top. At the lowest stage four panels divide the husband and the wife. In three panels above, love exists passively in the entwined flowers to the right and left, then actively as sexual union in the central converging hearts. All the life engendered by this love is arranged neatly in sheaves in a band above, harvested by God in death. In the top-most zone this progression has a happy end in Paradise, presided over by the Tree of Life.

The compass-drawn stars which flank the Tree of Life stand for heaven itself and, in a symbol with an ancient past, signify also the souls who populate the heavens. One can follow this interpretation of the soul as an astral body for at least as far back as the ancient Near Eastern cult of Astarte, goddess of love, fertility, and salvation. (Love and death have always been paired in religious history.) Astarte presided over a sky full of stars representing departed souls. In headstones carved by the early Christian Copts of Egypt and by the Puritans of New England twelve hundred years later, compass-drawn stars convey the same idea. But it is a symbol that lacks any metaphorical sense. Either intuitively or with purpose, the artist chose the opaque pattern of an abstracted star, a form which leaves obscure the nature of the life that follows death. What this life might be remains a mystery to those below and is only signified by a row of stars.

By reading the symbolic language of this headboard we are taught the Puritan doctrine of the role of love and sex within the sacred bond of marriage. With visually powerful forms it would inspire a married couple, lying together as Adam and Eve once did in Eden, to love and to make

love, to multiply and increase. For the Puritans it was conjugal love that opened the way to the ultimate love of God.

NOTES

1. This headboard, found in Brewster, Massachusetts, is in the author's collection. Although common in seventeenth-century inventories of the contents of houses, Puritan great beds, made of deal (pine) or oak with carved or painted headboards, are now extremely rare. To the best of my knowledge no bed or headboard of this sort, with this exception, exists in America, and only one or two in England. There are many more examples in existence of the elaborate great beds made for the Anglican aristocracy.

2. The authoritative account of the symbolic meanings of grave-marker carving is Alan Ludwig's *Graven Images* (Middletown, Conn.: Wesleyan University Press, 1966).

3. *The Poems of Edward Taylor*, ed. Donald E. Stanford (New Haven, Conn.: Yale University Press, 1960.) See particularly "Upon Wedlock and the Death of Children," 468.

4. To the Puritans the only church was the Puritan home itself. In America the typical house plan signified the duality of earthly existence. On one side of the great chimney was the hall, which functioned as the kitchen and workplace and was identified with the life of labor that was a consequence of the original sin. On the other side was the parlor, which, like a church, was both a place of formal worship and a place of rest. The principal items of furniture, the decoration, and the bright colors of the parlor originated in the interior of the English medieval parish church.

5. For the importance of sex in Puritan marriage, see Levin L. Schucking, *The Puritan Family* (New York: Schocken Books, 1970), 37ff.

6. *The Poems of Edward Taylor,* 230, 256. The title of this second poem is "Let Him Kiss Me with the Kisses of His Mouth."

7. Edmund S. Morgan, *The Puritan Family* (Boston, Mass.: Boston Public Library, 1956), 18.

8. Ibid., 12–14.

Henry James Circumvents Lessing and Derrida

JOHN W. ERWIN

1

Two months after the outbreak of World War I, Henry James described his personal battle with illness as "a demonic art of circumvention, of general and particular counterplotting, so long as life is in me."[1] Published ten years earlier, *The Golden Bowl* projects intensely particular, lively circumventions and counterplottings of demonic arts (and would-be sciences) of difference which threaten Western culture even more as this violent century ends.

The novel plays variations on similarities as well as differences in textual and architectural succession. It thereby calls into question not only Lessing's distinction between arts of time and space but also his potentially more dangerous assumption that both visual and verbal texts increase in interest to the degree that they generalize the confusing particulars of historical life in the body—explicitly designated by James as the beneficiary of his general and particular counterplotting. *The Golden Bowl* also, I think, suggests how we might begin to counterplot the suppression of the particular in Jacques Derrida's general, nonhistoricist assertion that there is no outside to text.

The Golden Bowl exhibits particularities of writing and two visual arts in several historical periods. It varies James's practice in earlier novels of alluding to Renaissance and modern painting in ways that in effect take the measure of limitations shared by patriarchal, imperialist prewar Anglo-American culture and his own literary formalism—as well as, we may feel, by the Derridean claim of deconstructive power over verbal and visual texts of whatever period. Responding more often to architecture than to painting, the novel articulates the fuller incarnation of reading which buildings propose. If the eye moves around a painting, the whole body explores a church, house, or garden. Correspondingly, a verbal narrative which takes many cues from the history of architecture can

counter the disembodied abstractions that haunt writing more authoritatively than one—*The Ambassadors,* say, with its climactic parody of an Impressionist boating scene—which refers primarily to the two-dimensional art of post-Renaissance easel painting.

We are also invited to bring more of our bodies to readings of *The Golden Bowl* because the text frequently calls attention to its biohistorical genesis in dictation rather than inscription, an anomaly which the other late novels do not as strongly register. Sometimes subtly colored with French, alliterative and often onomatopoeic passages index the potential for voicing in the *langue* almost as fully as the ebulliently bilingual, pun-studded letters which James addressed to Edith Wharton during the last years of his life. These traces of a verbal performance more directly corporeal than writing suggest that the corresponding physicalization of vision in the novel's many renderings of movement through architectural space may also have larger implications.

Both reminders that the historical as well as biological individual body has many languages of its own may in turn suggest that James's efforts to circumvent limitations of perspective imposed by solitary writing and reading play useful variations on the double turn of that larger body, the great globe itself. The novel has much in common with the ardently artful letters to Wharton, to whom the ailing James attributed the "genius . . . for great globe-adventures and putting girdles round the earth."[2]

Named for a merely gilded parody of the globe's three-hundred-and-sixty-degree round, *The Golden Bowl* may tempt us to try to do more than break the codes which mark it as the secular textual equivalent of that Scripture-derived icon (Eccles. 12:6). This consummately disconcerting performance by the Master of Lamb House can provoke us to sketch any number of alternatives to mastery of many kinds, including the unmasking of authorial pretensions by deconstruction. These alternatives may be global in implication but must also be as responsive to our own personal and cultural histories as James's exuberant word play was to his pain and suffering and to the less tangible but more influential confusions of his culture.

2

An emphatically American Adam apes James's own authorial ambitions in a way that grounds them in the imperialist Anglo-American nineteenth century's parody of the Exodus. Adam Verver plans to build—in American City—the "museum of museums," "a house from whose open doors and windows, open to grateful, to thirsty millions, the higher, the highest knowledge would shine out to bless the land."[3] A monument to the "su-

preme idea" of propagating "the exemplary passion, the passion for perfection at any price" (143), the museum of museums is to display loot accumulated in a double career in which "acquisition of one sort" is obviously a "perfect preliminary to acquisition of another" (142). Both clearly owe as little as possible to the agricultural nurture of the land to which Adam's abstractions are compared—with an inappropriateness that James surely wanted us to note: "the supreme idea all the while growing and striking deep, under everything, in the warm rich earth" (142).

But a visit to a Jewish antique dealer in Brighton by Adam and Charlotte Stant, his fiancée-about-to-be, sets the defiantly secular rubric for James's counterplotting of American monomania with an active respect for differences among persons, cultures, and even species—a respect which every day is emerging more clearly as the condition of continuing life on this round, more than bowl-shaped and, I think, never to be entirely texted globe.

> [Mr. Gutermann-Seuss] stood among his progeny—eleven in all, as he confessed without a sigh, eleven little brown clear faces, yet with such impersonal old eyes astride of such impersonal old noses . . . The handsome frank familiar young lady, presumably Mrs. Verver, noticed the graduated offspring, noticed the fat ear-ringed aunts and the glossy cockneyfied, familiar uncles . . . noticed the place in short, noticed the treasure produced, noticed everything . . . It really came home to her friend on the spot that this free range of observation in her, picking out the frequent funny with extraordinary promptness, would verily henceforth make a different thing for him of such experiences, of the customary hunt for the possible prize, the inquisitive play of his accepted monomania. (190)

> With their return to the room in which they had been received and the renewed encompassment of the tribe, he felt quite merged in the elated circle formed by the girl's free response to the collective caress of all the shining eyes.(192)

Seeing and being seen by a circle of bright eyes, Charlotte anticipates James's frequently funny but very painstaking translation of singleminded mastery into an embrace of mystery and multiplicity which is passionate enough to counterplot even the neoimperialism of late twentieth-century academic deconstructions of imperialism.

There are other outsides to Adam's singleminded script besides the diaspora, and Charlotte seems to have relations with at least two of them. At the start of the Brighton sequence, "the very sea" is de-natured, socialized into a "mere big booming medium for excursions and aquariums" (189). But the sea that sounds French-connected and mothering in "*mere . . . medium*" gets back her natural truth ("very") once Charlotte has focused the—funny—polyglot "wild music of gilded and befrogged bands,

Croatian, Dalmatian, Carpathian, violently exotic and nostalgic" (189) by visiting and enjoying the doubly Semitic inner sanctum where Damascene tiles are shown by a Jew.

Never directly presenting the point of view of the "handsome frank familiar" mediatrix between Adam and the Jews, James mutes her into an intimacy with "the rumble and flutter . . . the rumbling beach and rising tide" (190–91) that helps her free Adam to "wander like one of the vague" (191)—like a French wave *(vague)?*—and in James's likewise multiple linguistic medium: not always booming but often foregrounded by alliteration ("might I so far multiply my metaphors," 330) and therefore able to project circlings of eyes as extravagant, as vaguely wandering, as the sea-dominated globe.

Nothing could be less vague, though, than the choreographic extrapolations from architecture in *The Golden Bowl*. These have to be very precise if they are to rival Adam Verver's project of building the museum of museums.

3

This alternative strategy is initiated at "Matcham": the punnily named great house which permits an adulterous assignation between Charlotte, now Adam's wife, and the Prince, his daughter Maggie's husband. With its "old marble balustrade—so like others that he knew in still more nobly-terraced Italy" (286), Matcham is clearly classical, perhaps Palladian—like spacious, lightsome Fawns, the setting and presumably model for Adam's famous image of the Prince as "a great Palladian church . . . something with a grand architectural front" (135). But the classicism of Matcham is more firmly established because it is countered by an outlook on "the towers of three cathedrals, in different counties" (287), notably flamboyantly Gothic Gloucester.

The architecture of Matcham requires the Prince to approach his meeting with Charlotte through a succession of temporal/spatial moments. Having moved once along the terrace which gives partial views of two of four sides of the multiwindowed house, he sees Charlotte looking down at him from one of the windows. But before she joins him on the terrace

> he came along the terrace again, with pauses during which his eyes rested, as they had already often done, on the brave darker wash of far-away water-colour that represented the most distant of the cathedral towns. (291)

and only then

> Mrs. Verver appeared, afar off, in one of the smaller doorways. She came toward him in silence while he moved to meet her; the great scale of this particular front, at Matcham, multiplied thus, in the golden morning, the stages of their meeting and the successions of their consciousness. (291)

And as the Prince's promenade has been controlled by his wondering which of many windows might frame the intensely singular object of his desire, he focuses on one of the three cathedrals visible from the terrace, the inevitable monomania of sexual desire making him repeat its name.

> This place, with its great church and its high accessibility, its towers that distinguishably signalled, its English history, its appealing type, its acknowledged interest, this place had sounded its name to him half the night through, and its name had become but another name, the pronounceable and convenient one, for that supreme sense of things which now throbbed within him. He had kept saying to himself "Glo'ster, Glo'ster, Glo'ster," quite as if the sharpest meaning of all the years just ended were intensely expressed in it. (291)

Yet the Prince breaks his return along the terrace with pauses that index the regular division of the great house's facade by classically framed windows, and Charlotte follows suit.

The choreography of vision propagated by multieyed, matchmaking Matcham projects a freedom far more authentic than the sense of liberation that the Prince derives from his incantatory repetition. At each stage of their approach to each other past the ranks of windows and larger and smaller doorways, the human protagonists appear larger and larger to each other. "The great scale of this particular front, at Matcham, multiplied . . . in the golden morning, the stages of their meeting and the successions of their consciousness" (291). The many-windowed and multidoored facade counters the Prince's monotonous repetition "Glos'ter, Glos'ter, Glos'ter," suggesting the expressive potential of serial variation. Like Charlotte in the elated circle of eyes at Brighton, "this particular front" brings out the particularity of each moment of interchanged perception.

It remains for another, more elaborate series of variations on serial architecture to suggest that particularity can itself be generated by interchange.

4

Wild—Gothic—in its intensities as well as much of its imagery and rhythm, a sequence at Fawns, Adam's rented country house, questions analogies to the fixed-point perspective of Renaissance painting in architecture that is classical but, because it is three-dimensional, open to very

unclassical performed interpretation. Definitively challenging the pre-
scriptiveness of Adam, at first indifferent to those Goth-like Jews at
Brighton, an interplay of sharp-eyed and sharp-minded bodies yields
what Maggie ultimately pictures as a Gothic haunting of a characteristic
element of Palladian architecture: "a great overarched and over-glazed
rotunda . . . the doors of which opened into sinister circular passages"
(524). It also suggests how to circumvent a tendency toward absolutism
in supposedly antipatriarchal deconstruction.

Fanny Assingham has joined the Prince, Charlotte, and Adam as Mag-
gie's substitute in a game of bridge that plays out the wildly overdeter-
mined coupling of couples, Maggie's "father's wife's lover facing his
mistress" (480), which requires and animates James's whole supremely
elaborate rewriting of narrative as a pretext for ultimately untextable
dialogue. Maggie pretends to read a magazine, but in fact reads the more
densely interactive four-sided text of the bridge game, a strained simula-
tion of normalcy. This doubling of pretexts associates her single point
perspective with the disregard of any environment by the male imperium.

> The facts of the situation . . . upright for her round the green cloth and the
> silver flambeaux . . . erect above all for her was the sharp-edged fact of the
> relation of the whole group, individually and collectively to herself. (486)

The "standard of the house" to which Maggie's reading of the bridge
game conforms is indeed "stiff": it has all the swollen pride of any patriar-
chal demand for perfection. But even in testing and realizing "the prodi-
gious effect that, just as she sat there, she had at her command" (486),
Maggie begins to imitate the Charlotte of Brighton, opening the cult of
perfection at any price to the alternative standards of multiplicity and
dialogue.

"Springing up under her wrong and making them all start, stare and
turn pale, she might sound out their doom in a single sentence." But
Maggie deliberately counterplots the temptation of apocalypse which al-
ways haunts the perspective of a solitary reader. Closing her magazine,
she almost ritualizes the potential for change through interchange in the
four-member game.

> She rose from her place, laying aside her magazine, and moved slowly round
> the room, passing near the card-players and pausing an instant behind the
> chairs in turn. . . . She took from each, across the table, in the common solem-
> nity, an upward recognition which she was to carry away with her on her
> moving out to the terrace a few minutes later. (487)

Circling the square table, Maggie simultaneously identifies with each
player in turn and makes each of the others seated across from him or

her acknowledge her strategic consecration of a flawed status quo. This emphatic choreography attributes absolute authority to the crossed couples' parody of foursquare perfection. Yet it also sets the rubric for a gradual counterpointing of any and all authoritarian prescriptions. It both allows Maggie to see each player in the round, from four successive points of view, and makes her as fully visible as Charlotte was in the elated circle of eyes at Brighton. Counterpart to that secularization of "some mystic rite of old Jewry" (129), this tight, even liturgical multiplication of perspectives opens the way to much larger developments of Charlotte's upstaging of "patriarchal teas" (191) with mutual acknowledgments of personal difference.

At first Maggie focuses the four different recognitions by casting herself as a substitute in turn for the wild surrogate-subject of a painting which, as Patricia Crick notes in the Penguin edition (589), many of James's contemporaries would have known: *The Scapegoat* by Holman Hunt. The four pairs of eyes define

> some relation to be contrived by her, a relation with herself, which would spare the individual the danger, the actual present strain, of the relation with the others . . . she was there, and there just as she was, to lift it off them and take it; to charge herself with it as the scapegoat of old, of whom she had once seen a terrible picture, had been charged with the sins of the people and had gone forth into the desert to sink under his burden and die. (487)

Maggie takes at least a few steps away from prescription here. This scapegoat figures the definition by multiplied metaphor and surrogacy which Maggie's performances will establish as an alternative, inclusive reading of reality. Condoning the conservative impulse to mastery in the immemorial scapegoat economy, Hunt's allegory of Christ as a grotesque—Gothic—wild creature emphasizes the static isolation of its hirsute subject. But James's variations on the four-member bridge game will gradually realize the larger potential for change through exchange which the animal embodies.

Like Matcham, Fawns becomes the stage for a clear articulation of stages of meeting as well as successions of consciousness. "Several of the long windows of the occupied rooms stood open to [the summer night] and the light came out in vague shafts and fell upon the old smooth stones." The house's regular classical geometry allows Maggie to explore the only so far non-negotiable and nonsymbolic wildness which is the other side of the univocal judgment that could have smashed the tenuous order of the bridge game, "that provocation of opportunity which had assaulted her, within on her sofa as a beast might have leaped at her throat" (488). Maggie's first movement out from the exclusively textual order of solitary reading, her circling of the table, has called up only the

equally absolute and impersonal opposite of upstanding power: the victim's total submission to the sacrificial economy. And this expansion of her ceremonial multiplication of perspective only makes the wandering reader reassert her authorial power.

> Her companions, watched by her through one of the windows, actually struck her as almost consciously and gratefully safer . . . they might have been figures rehearsing some play of which she herself was the author. (488)

Yet the Princess is moved into a different relation with her supposed subjects when the larger foursquare mass of the house is further animated by oblique shafts of light, requiring her to take an active part in defining—by animating—a complex, potentially dialogic structure.

> She walked to the end and far out of the light; she returned and saw the others still where she had left them; she passed round the house and looked into the drawing-room, lighted also, but empty now, and seeming to speak the more in its own voice of all the possibilities she controlled. Spacious and splendid, like a stage again awaiting a drama, it was a scene she might people, by the press of her spring, either with serenities and dignities and decencies, or with terrors and shames and ruins, things as ugly as those formless fragments of her golden bowl she was trying so hard to pick up. (488)

First and last, this segment of Maggie's midnight prowl qualifies the prescriptive power served by solitary reading. Having gone "far out of the light," she identifies a radically unorthodox model for authority: the nightlike chaos of fragments of the Golden Bowl, the secular Grail which she has provoked Fanny Assingham to smash. But fragmentation is established as paradoxical guarantor of—compassionate—order only because Maggie defers to the relatively constraining, already multiple, serially articulated authority of classical architecture. One window-articulated linear sequence in her walk is further broken by a ninety-degree turn around one of the house's four corners. Dramatizing the different successions of architecture, James spatializes and in effect choreographs textual narrative; he thereby projects tracings and retracings of common ground by as many distinct and self-conscious interpreters as his provocatively self-critical text can summon.

When Maggie turns back around the corner of the house, she shows how physical as well as mental submission to alignment by a three-dimensional architectural text can not only circumvent but also counterplot the potential for monomania in the writing and reading of print.

> She continued to walk and continued to pause; she stopped afresh for the look into the smoking-room, and by this time . . . she saw as in a picture, with the

temptation she had fled from quite extinct, why it was she had been able to give herself from the first so little to the vulgar heat of her wrong. (488–89)

Maggie's explicit denial of the sacrificial economy of scripture first invoked by her temptation to burst out into apocalyptic judgment precisely counters her mental self-portrait as another player in that order, the scapegoat painted by Hunt. But it is only once Maggie has continued her variously discontinuous walk—broken by her own pauses as well as by one of the house's four right angles—that this partial retracing of architectural lines can encourage us to substitute a radically different, dialogic reading of relationship for the less fertile differentiation permitted by narrative succession.

The different successiveness of architecture having proposed to Maggie's conscious body how to perform, as in a theater, acknowledgments that difference can have positive value, the house gives Charlotte a starring role. She stops Maggie in her tracks, allowing both of them to play generative variations on the sensitivity to particulars that she brought to Brighton.

> She had resumed her walk—stopping here and there, while she rested on the cool smooth balustrade, to draw it out; in the course of which, after a little, she passed again the lights of the empty drawing-room and paused again for what she saw and felt there . . . Charlotte was in the room, launched and erect there in the middle and looking about her . . . she had evidently just come round to it, from her card-table, by one of the passages—with the expectation to all appearance of joining her stepdaughter . . . the splendid shining supple creature was out of the cage, was at large. (490)

As erect and central in the bright room as Maggie's image of her own authority in the counter-room ("erect above all for her was the sharp-edged fact of the relation of the whole group, individually and collectively to herself"), Charlotte figures the adulterous wildness to which her heterodox sense of her own and others' particularity has been driven by Maggie's own efforts to control a situation which is at least four-sided. She "seemed to offer, for meeting her, a new basis and something like a new system" (491): a system of mutual recognition and articulation, of efforts to establish personal predominance that realize the potential suggested by Maggie's walk back along the terrace, around the corner and back again.

> The projected clearness of the smoking-room windows had presently contributed its help. Her friend came slowly into that circle—having also, for herself, by this time, not indistinguishably discovered that Maggie was on the terrace. Maggie, from the end, saw her stop before one of the windows to look at the group within, and then saw her come nearer and pause again, still with a considerable length of the place between them.

> Yes, Charlotte had seen she was watching her from afar, and had stopped now
> to put her further attention to the test. . . . The two women at all events only
> hovered there, for these first minutes, face to face over their interval and ex-
> changing no sign; the intensity of their mutual look might have pierced the
> night. (492)

Two sides of Fawns have multiplied the stages of Maggie's meeting with
a rival reader of choreographed architecture who defines herself exclu-
sively in the nonexclusive terms of meeting: of a continual re-creation of
truth from exchange. Yet James must repeatedly retrace limitations of
textual culture in order to expose and transcend them. Only systematic
deconstructive parody can project an outside to the scriptural, patriar-
chal, sacrificial economy.

Maggie having retraced her steps several times, Charlotte leads her
around the corner into a further retracing that hints at a multiplicity
which can upstage any variant of monotheism—by more insistently, even
violently, imposing it.

> They presently went back the way she had come, but she stopped Maggie again
> within range of the smoking-room window and made her stand where the party
> at cards would be before her. Side by side for three minutes they fixed this
> picture of quiet harmonies, the positive charm of it and, as might have been
> said, the full significance—which, as was now brought home to Maggie, could
> be no more than a matter of interpretation, differing always for a different
> interpreter . . . There was a minute, just a supreme instant, during which there
> burned in her a wild wish that her father would only look up . . . if he would
> but just raise his eyes and catch them, across the larger space, standing in the
> outer dark together . . . he might somehow show a preference—distinguishing
> between them . . . That represented Maggie's one little lapse from consis-
> tency—the sole small deflexion in the whole course of her scheme. (493–96)

When Charlotte shows the group, especially Adam, to Maggie, she forces
her to acknowledge her own equal and not so opposite particularity: to
admit to herself that she is maintaining the arrangement not only for
Adam but also for herself.

Without such an acknowledgment, the self-regard which is the more or
less concealed origin of aestheticism as well as imperialism could not
be parleyed into the basis for a truly new system. Maggie's "sole small
deflexion" is the true wildness, the opening on any number of outsides
to any arrangement which can be achieved by such retracings of retrac-
ing as *The Golden Bowl*. Recognizing many alternative relations among
interpreters, the choreographic complication of reading by rival self-
conscious bodies not only acknowledges the particularity of competing
power plays. It also makes the inevitable competition of every one with
every other the very condition of community. For the entrepreneurial

drive for personal predominance resists any fixed concentration of power in a single entity, whether corporate or individual.

Each of us may be, and feel, very alone when we take the time and make the effort to retrace Maggie's multiplied and successive retracings of her own secular pilgrim's progress. Yet—or perhaps therefore—we can at least partially redeem her parody of Christ's redemption of Father Adam. We can recognize and acknowledge with her—and with her happily never invisible or inaudible and always particular and partial creator—at least two things: not only that readings differ as much as readers, but also that we can never entirely give up wishing that our own partial and particular readings could be definitive, and prevail.

Maggie's momentary but crucial swerve can help us see the paradoxically common desire for personal predominance as sufficient ground for shattering any illusion of Bowl—or *bowl*—like perfection: even for transforming Adam's self-reflexive museum of museums into a community which is at least learning to be somewhat self-critical and thus certainly more open and inclusive than "American City," its projected site. And such is the radically iconoclastic scattering of perspective that *The Golden Bowl* proposes, a multiplication not only of stages of consciousness but also of stages of meeting for which the counterpointing of architectural styles at "Matcham" can stand as the dynamic, provocative model.

NOTES

1. Lyall H. Powers, ed., *Henry James and Edith Wharton, Letters 1900–1915* (New York, 1990), 308.
2. Ibid., 193.
3. Henry James, *The Golden Bowl* (New York: Penguin, 1988), 143.

Milton and the Mac: "Inwrought with figures dim"

ERNEST GILMAN

"The linearity of texts is a bug, not a feature."
—John McDaid

This paper stems from three hitherto separate interests: in Renaissance notions of the sister arts, in Milton, and, more recently, in the uses of the computer in writing instruction—both at the college level and, coincidentally, in my daughter's fifth grade classroom, where her teacher, a former nun, believes that electronic word processing makes it too easy to correct errors and so promotes a lust for instant gratification. These interests have now come together here, for better or worse, in a model of Renaissance textuality. Nor is my title completely frivolous, as I hope to show in the end when I give in to the temptation of the Apple. Under its influence I will argue that electronic representations of textual depth now possible, or glimpsable, in hypertext systems such as those available for the Apple Macintosh computer also offer a congenial environment for plumbing the depths of the poetic text in Milton. Rewriting Milton on the Macintosh is not intended to be, as it may appear, an absurd violation of all historical propriety (not to mention an indecorous comparison of great things with small). Rather, my aim, by way of a brief discussion of "Lycidas," will be to suggest the re-closing of a historical circle. With hypertext we come round again to a Renaissance de-lineation of the poetic text as something like the academic regalia of Milton's river god Camus, a textile weave rather than a linear thread—a medium figured as thick, or deep, or layered, its significance as much "inscrib'd," worked into its depths, as spun out from line to line.[1]

Arguably, this ampler conception of the text will open a new prospect in the history of computer-based writing; however, it always *was* the medium of delineation for Milton. If this joining of future and past seems forced to us, it is because we still tend to take as given a set of question-

able distinctions between words and images, the temporal and the spatial, the sequential and the simultaneous. Finding no such gap in their own more unified experience of electronic media, our children will find no such impediment to reconnecting Milton and the Mac.

<div align="center">1</div>

I have now twice used the word "delineation"—once as "*de*-lineation"—to characterize Milton's writing. In spite of the apparent critical novelty implied by the hyphen, the word will prove useful in an effort to recover an older unified sense of textuality because in the range of its historical meanings it was understood to suggest both writing and drawing (as, indeed, the Greek *graphein* had meant both "to write" and "to paint"). To "delineate" was to portray, trace, sketch an image in outline, as well as to outline or describe a topic in lines of writing. Although we may have trouble conflating these two meanings of "outline," Raleigh engages both senses when he tells us that he takes as his task, in his *History of the World*, to "delineate the region in which God first planted his delightful garden." Milton himself, in a key passage from *Paradise Lost* to which we will return, has the angel Raphael promise to "delineate" the "High matter" about which Adam has expressed his curiosity (5:572); and the method of delineation, "by lik'ning spiritual to corporal forms" (5:573), begins at once in the angel's discourse about body working up to spirit and in the incorporation of that discourse in the form of a plant, its "green stalk" and "bright consummate flow'r" (5:480–81) shedding the same light in the mind as the line of argument from which it springs. An older, double sense of writing that I have been trying to catch in the word "delineation" is, of course, much more broadly current in the Renaissance than just in Milton's poetry—which I take here as typical, though for us revealingly self-conscious about its artistic practice—and its roots, as the Renaissance traced them, were sunk deep in pagan and biblical antiquity.

In the Renaissance poetry and painting are figured as rivals. Which one was "better"? Critical treatises, echoing a tradition of rhetorical debate in which speakers exercised their virtuosity over such topics as the comparative merits of water and wine, baldness and hair, argued both sides of the question with equal facility. In the Protestant north of Europe, the Reformation give this debate a harsher polemical edge. The destruction of devotional statues and paintings by zealous opponents of idolatry was matched in fervor by an iconoclastic theology that insisted on driving a wedge between the Word (of God) and the image (erected in its place by a corrupt church). The secular, aesthetic, version of this cleavage would

be codified in the eighteenth century by Lessing, who reduced the matter to "first principles": painting relies on "figures and colors in space," poetry on "articulated sounds in time."[2] Given such absolute differences in their proper forms and modes of symbolization, any attempt to cross the frontier (by writing a "pictorial" poem, or painting a "narrative" scene) must result in an unnatural contamination of the arts.

Insofar as we still tend to believe that a distinction between "space" and "time" does not merely indicate one, historically conditioned way of thinking about the difference between the visual and verbal arts, but rather specifies *the* necessary difference between them in the nature of things, we remain the heirs if not the prisoners of Lessing's categories, as W. J. T. Mitchell has shown.[3] In fact in the history of critical reflection on the arts, Lessing's positing of a strict difference in kind stands against a long tradition that sees their differences as undergirded by a congenial, even familial, bond. In this tradition poetry and painting are the "sister arts," affectionate rivals striving to outdo each other by emulation. Ben Jonson's commonplace book notes the classical dictum, recorded by Plutarch and tirelessly cited in the Renaissance, that "Painting is mute Poetry, Poetry a speaking Picture." It was Jonson's translation of Horace's "Art of Poetry" that gave the Renaissance its English version of the no less famous phrase *ut pictura poesis*—"As Painting, so is Poesie." With the fundamental bond between the arts so quotably certified by the ancient authorities, the "competition" of the arts, enacted in the sometimes bitter professional rivalries of poets and painters, was nonetheless seen to be based as much on similarity as on difference, on a close affiliation assumed everywhere in English Renaissance discussions. Sidney, extolling the luminous power of the poetic imagination, argues that the poet's words conjure up a "perfect picture," and "image" of that whereof the more prosaic philosopher can offer only a "woordish description."[4]

Painting, correspondingly, would be said to achieve its highest excellence when it aspires to the condition of a literary text—taking its invention from an iconographic program, embodying a rhetoric of gesture and expression drawn from literary sources, subsuming narrative and allegory, offering itself as a pictorial history, or epic, or drama, and fulfilling all the rules of excellence that Aristotle and Quintilian had prescribed for verbal art. The idea of painting was fully permeated by literary expectation and interpretation. Poussin, speaking of his own fidelity to scripture in his handling of the theme of the *Fall of the Manna in the Wilderness*, declares (in a passage made familiar by Rensselaer Lee): "Lisez l'histoire et le tableau" "read the story and the painting", by which he means that we should not merely compare the pictorial image with the chapter in Exodus it illustrates, but read the two as parallel texts.[5] At the limits of

their ambition, the two arts might almost succeed in jumping the gap between them—each outdoing, by becoming, the other.

The European Renaissance at whose latter end Milton appears thrives on the riches of interartistic practice and speculation. However much painters might vie with poets, both were fascinated by the synaesthetic, promiscuous interplay of the arts that in the long history of human representation more often marks their relationship than does the difference based on time and space that we have taken as a critical imperative for only two hundred years. The founding literary text in that history is the delineation of the shield of Achilles in Homer's *Iliad*. That history, however, reaches farther back to the invention of graphic systems in which the distinction between linguistic and pictorial signs had not yet emerged. Renaissance Neoplatonists like Ficino, meditating on Egyptian hieroglyphics, believed that these picture-writings—an amalgam, as they are now understood, of ideogrammatic and phonetic figures—were the archive of primordial wisdom vouchsafed to the Egyptian priests. Could they be the surviving remnants of the language Adam spoke before the fall, when he was able to look at the animals and pronounce the names he saw mystically inscribed in their figures? Or perhaps there was an original, prelapsarian sign language shared by humans and beasts, a faded, silent code whose traces survive no longer understood by us in the gestures of animals and birds. Thus John Bulwer, writing in 1644, notes that a "Naturall Language of the Hand" is a "kinde of knowledge that *Adam* partly lost with his innocency, yet might be repaired in us, by a diligent observation and marking of the outward effects of the inward and secret motions of beasts." Bulwer was a pioneer semiotician, an early and humane advocate of education for the deaf, and a strong supporter of sign language as a "full, and majestique way of expression, present[ing] the *signifying faculties* of the soule and the inward discourse of Reason."[6] Such speculation arose from and strengthened the traditional view of the visible creation as the Book of Nature, a vast significant design in which, as in a text parallel to the book of scripture, God's word could be read out of the very rocks and plants.

Alphabetical writing itself bears the traces of its pictorial origins in the form of its letters and in the faint iconic associations they still convey. In both the sight and sound of the letter, an ancient camel still lumbers somewhere behind the Roman "G" and its older cognates, the Greek "Gamma" and the Hebrew "Gimel." According to the *Zohar*, every letter of the sacred alphabet has seventy "faces." Hebrew scribal art may, as Barbara Kirshenblatt-Gimblett notes, elaborate "the letter *nun sofit* (final 'n') in the form of a fish, because *nun* is both the name of the letter and the generic Biblical Hebrew term for fish." So, on more fanciful grounds, might the long-necked and one-legged letter *lamed* be drawn as a stork.[7]

The arts of calligraphy and graphic design remind us that writing is itself a *concordia discors,* combining a phonetic script for vocal performance with a material artform of considerable expressive range with its own stylistic and iconographic history. Svetlana Alpers, while arguing *contra* Panofsky that seventeenth-century Dutch painting, unlike that of the Italian Renaissance, should not be regarded as the adjunct of a literary tradition, nevertheless calls our attention to the contemporary Dutch genre of *penschilderij* of "pen-painting," in which, she explains, a "board prepared as if for a painting is worked in pen and ink" so as to blur the boundaries of painting, drawing, and writing, and to give us a world "seen as if it were rendered as an inscription."[8]

2

Of all the Renaissance writers working within the view of language briefly sketched here, in England Milton offers perhaps the most instructive example because his own practice rests on two convictions—not entirely his own, to be sure, but developed with his own imaginative force—that serve in the context of such broader influences as that of print culture to embody language in the space and substance of the world.[9] One of Milton's convictions is that the "Discursive" flow of thought and language, temporal and linear as it moves from premises to conclusions, is perfected in the "Intuitive" knowledge of the angels. The "latter most is ours," Raphael tells Adam of this higher knowledge, reassuring him at the same time that the intuitive is not foreclosed to human aspiration, "Differing but in degree, of kind the same" as the discourse Adam knows (PL 5:489–90). The intuitive is the visual, spatial, conspective faculty, that by which the mind is able to perceive all at once. It is that by which Milton's God has always foreseen the history of the world, and that by which Adam learns to see it under the tutelage of the Archangel Michael in the last books, the events to come spread out like a vast panorama on the plain below.

It is also the way the reader comes to see Milton's epic—not, finally, in its linear unfolding but in its overall pattern. *Paradise Lost* moves discursively from the "fruit" of disobedience in the first line to the ripening, by tract of time, of the fruit of Mary's womb in the end. Intuitively, these first and last fruits of the fall are seen at once as bracketing the space of the epic, with all the features of its elaborate interior design—the careful paralleling and counterpointing of episode against episode and book against book—open to view.

The shift from a discursive to an intuitive apprehension of the text corresponds to a shift in the writer's purpose from "delineation" in the

one sense to "delineation" in the other. With all the angels posted as sentries "watching round" the newly created world, whoever of the fallen company dares to approach it, cautions Beelzebub in the council in hell, "had need / All circumspection" (2:413–14). The circumspect reader, appreciating the glancing Latin pun, also appreciates the readerly vigilance of watching round the world of the text even while following its progression line by line. Circumspection—achieving a silent, encompassing view—is the virtue of intuitive reading. At the beginning of *Paradise Lost* we are told in a famous conflation of time and space that the ruined Satan—having fallen from the ethereal sky and, so to speak, into the poem—before rousing himself lay confounded on the burning lake "Nine times the Space that measures Day and Night / To mortal men" (1:50–51). More than merely indicating "nine days," the circumlocution suggests by a kind of multiplication of time and space that the medium of the poem is to be the product of the two.

The second conviction underlying Milton's practice is that "All things proceed," not *ex nihilo,* but as Raphael again explains to Adam, from "one first matter all (5:470–72). Much has been written about Milton's rather heterodox view of creation. Its import here is that, just as the intuitive opens the space of Milton's text, his materialism gives it its substance—since language is both the means by which things come into being in the divine *fiat* and itself a "thing" in the created world. When the angel promises to "delineate" his argument "By lik'ning spiritual to corporal forms / As may express them best" (5:572–73), it is not that "corporal forms" are to be imported as something alien into the purer realm of language for the purpose of accommodation or tangible example of what otherwise "surmounts the reach / of human sense" (5:571–72). Nor is language to be made to strain against its own earthly fetters toward the realm of the uninscribably spiritual where its powers will ultimately fail. Rather than mediating such stark oppositions, language works in the first place, is capable of expression at all, because it exists in a continuum along with the forms it incorporates and the objects it intends to delineate. As the discursive and the intuitive differ but in degree, the lower in Milton's world is purified and enlightened into the higher, "by gradual scale sublim'd" (5:483). All the steps of the scale short of God himself—men and angels, events in heaven and events on earth—are "Each to the other like, more than on Earth is thought" (5:575) because all are embedded in the same material nature.

The space of the text for Milton is thus not to be imagined as a post-Cartesian void, but as something denser and fuller, containing (as we shall see in "Lycidas") "figures" of space and time interfused—figures and prefigurations inscribed together. It is a plenary "corporal form" within which meaning is digested (not to lose sight of the lunch in paradise that

is the occasion of Raphael's conversation with Adam) and articulated. All these implications are caught much more economically in a Miltonic pun on the word "matter": Raphael's task is "hard," says the angel, because he must elucidate the "High matter" of the war in heaven (5:563–64). Yet it is possible to do so because that obdurate "matter," however exalted, shares its being with the "one first matter" of creation. Partaking of "matter" in both senses, the high and the low, language joins the two in the text of the epic. The "hardness" of Raphael's task is both reflected in and eased by the corresponding hardness of a text imagined as possessing durability as well as duration.

3

Although I have so far been drawing on the angelic wisdom revealed in book 5 of *Paradise Lost,* it is "Lycidas" that best illustrates what I mean by a durable text, its firmness resting on an embedded substratum even as its movement is marked by the horizontal movement of its lines. This is not to imply that the linear is unimportant in Milton's elegy. On the contrary, the consecutive thrust of the poem is strongly announced from the very start:

> Yet once more, O ye Laurels, and once more
> Ye Myrtles brown, with Ivy never sere,
> I come to pluck your Berries harsh and crude,
> And with forc'd fingers rude,
> Shatter your leaves before the mellowing year.
>
> (1–5)

"Yet once more . . . and once more": "Lycidas" does not begin at the beginning but stands next in the line of Milton's own poems as the "sad occasion" (6) of Edward King's death forces him to write again, though still before the "mellowing year," and it looks forward to the next poet, some as yet unknown "gentle Muse" whose "words" will "favor" the speaker's own "destin'd Urn" (20) just as his now favor King. The poem also stands self-consciously in the lineage of Greek and Latin pastoral, and finally it stands in the sequence of enunciations longer still that mark the beginnings and endings of sacred history, since Milton's "Yet once more" at the moment of King's death echoes the divine promise of Hebrews 12:26–27, "Yet once more I shake not the earth only, but also heaven," which the scripture takes as signifying the final "removing of those things that are shaken" at the death of the world, so that "those things which cannot be shaken may remain." "Yet once more" and "once more," and finally "Weep no more" (165)—all these beats punctuate the

poem's concern with the dramas, great and small, of beginnings, successions, and endings.

Yet no less strongly from the beginning, where the muses are identified with the "sacred well, / That from beneath the seat of *Jove* doth spring" (15–16), the poem imagines itself as plumbing a rich liquid depth, from which it is in turn sustained and nourished. The imagination of that depth can be momentarily horrific: it is the "remorseless deep" (50), the "bottom of the monstrous world," where "under the whelming tide" Lycidas lies drowned (158–59). But it is at the same time a depth alive with the sources of renewal. Just as Lycidas, "sunk low, but mounted high" is plucked up from death by the "dear might of him that walk'd the waves" (172–73) in his Christian resurrection, so, with equal might, celebrated in "lofty rhyme" (11), he seems to well up from below in the stream of pastoral refreshment. For through these waters flows the history of pastoral poetry in its voyage from the waters of Greece and Rome to the Irish seas where the author's friend lies unfortunately drowned. Arethuse, invoked at line 85, is the nymph who fled the river god Alpheus by diving beneath the seas of her native Arcadian Greece. She bubbled up again as a fountain in Sicily, whence by way of the Greek-speaking Sicilian communities at whose cultural wells the Romans drank, the influence of Theocritus could pour into the "honor'd flood" (85) of Virgil's Latin *Eclogues*—and thence, eventually surface again in the English pastoral of "Lycidas."

When Alpheus is invoked indirectly at line 85 by way of "Fountain *Arethuse*" and then, after a gap of nearly fifty lines, suddenly called back again—"Return *Alpheus* . . . / . . . Return *Sicilian* Muse" (132–33)—the reader might wonder for a brief moment, however absurdly, where Alpheus has been in the interim, while the poet has been attending to the "dread voice" (132) of the Pilot of the Galilean lake. From a temporal point of view, the absurd question has no answer that is not equally absurd, since there is no "where" for Alpheus to be once his name has passed the poet's lips. From the poem's own vantage point over the depths of pastoral history, the answer is clear: Alpheus, like Lycidas, has sunk beneath the waves of the text's surface—the "level brine" (98) that conceals depths both fatal and fecund—where he awaits the summons of the muse to spring up again.

Thus the poem's sense of itself as marking a linear sequence—"once more . . . and once more"—is crossed, as it were at right angles, by the vertical dimension that opens the Miltonic *altitudo* of the text—"sunk low, but mounted high." Along the former vector, the poem situates itself as a moment, articulated "once," along a chain of moments before and after that are finally linked into a single proleptic history. Along the latter, the poem contains that same history within it all at once, beneath the

surface, as its own subtext. Consider only one telling detail occasioned in the poem by the brief appearance of Camus, the god of the river Cam, who takes his place in the procession of mourners as the representative of Cambridge University, and whose gown, the poet notes, is bordered with the crimson color of the hyacinth:

> Next *Camus,* reverend Sire, went footing slow,
> His Mantle hairy, and his Bonnet sedge,
> Inwrought with figures dim, and on the edge
> Like to that sanguine flower inscrib'd with woe.
> "Ah! Who hath reft" (quoth he) "my dearest pledge?"
>
> (103–7)

In the myth the youth Hyacinth, sunk low in death when he was accidentally killed by Apollo, sprang up again in the "sanguine flower" (106) watered with his blood, that would now perpetuate his name in its own. This is the flower once "inscribed with woe" (106) when, according to Ovid, Apollo embedded in its petals the designs which were also to be read as the words "Ai, Ai," the inscription and the expression of his own "cries of grief."[10] It is the same flower that in Milton's poem now appears once more, inscribed on the soggy academic regalia of the river god, who cries out, as Apollo did for Hyacinth, in grief for the death of his own "dearest pledge" (107) Lycidas. Camus and his robe "Inwrought with figures dim" (105) are themselves among the figures worked into Milton's elegy, motifs layered one upon and within the other—all visible, however dimly, wrought within the depths of the text. Thus Camus's "Mantle hairy," which (in another subtextual link) will resurface in fresh colors as the poet's "Mantle blue" (192) at the end of the elegy, may be taken as a figure for the text itself as a medium of regeneration—its own, and that of the pastoral tradition. What Milton hath wrought is *in*wrought with figures dim but, like Lycidas himself, "not dead / Sunk though [they] be beneath the wat'ry floor" (106–7).

<div style="text-align:center">

4

</div>

To speak in this way of the "depths of the text" is, it may be objected, only to speak metaphorically. "Lycidas" cannot literally contain the history of pastoral as its subtext. The objection, both trivial and inescapable, can be met on various grounds.[11] It is useful here insofar as it leads back to the fundamental question of what can be presupposed as being "in" a text at all. To pose the question so as to introduce a distinction crucial to everything that follows: What is the nature of the *text* as a site of representation in relation to the *poem* it represents?

We can, of course, think of the relation of the poem to its textual representation (the manuscript, the printed page, the computer-generated display) in many ways. For the purpose of what I am about to suggest, it is arguably irrelevant whether we think of the poem as having its being in the perfection of the Idea in the poet's mind, in a dialogic confluence of voices, in the realization of the reading experience, in the codes of interpretive communities, or in the refraction of class interests. Indeed, it doesn't matter here if in a deconstructive mood we think of a poem as having no essence at all, and so might wish to argue even more strongly for the constitutive function of the text. In whatever sense the poem may be thought to exist apart from its material representation, we might see the two as subject to the cognitive interplay of the hermeneutic circle—the text both enabling and constraining the representation of the poem, which generates the representation but can itself be known only through the representation it generates. Again, what matters is that the poem, however we conceive of it, is not identical to any particular representation of it, whether a printed text, a manuscript version, or an oral rendition (any more than a dance can be said to be identical to any of the several systems of dance notation in which it can be plotted out, or to any electronic record of its performance, or indeed to any one performance or to an "average" of all performances).

Once we grant this distinction between the literary work and its textual representation, then it might be possible to think of other—more or less satisfactory, but at least different—modes of representing the work than the one in which it conventionally appears, or even other than the one in which it was first embodied historically. We would find it difficult to deny that the printed "standard" version of a Renaissance poem that first existed only in manuscript, a version with the ambiguities of handwriting clarified, variants noted, and spelling regularized, is a more satisfactory textual representation of the poem for most purposes than the original—which, by implication, has been in this process rendered "substandard" for all but antiquarian interests, and this despite its priority. The slight step, or leap, I am urging in the case of "Lycidas" would involve thinking hypothetically about a new mode of textual representation adequate to the poem's verbal depth, to its thickness of implication as well as to the moment by moment unfolding at its surface—and thus, a representation more adequate to the poem than the technology of writing made possible in Milton's time.

I am aware that in speaking, as I have and will again, of the new electronic environment of writing as the recuperation of an older, as yet undepleted, textuality, I risk seeing the history of textuality since Milton as itself a Miltonic drama of fall and redemption. In the most cogent discussion to date of the problem of "spatial form," W. J. T. Mitchell labels this

particular nostalgia a "cliché of historicism," by which a putative "unified sensibility" is said to have "disintegrated sometime between the middle ages and the nineteenth century," usually, Mitchell notes, "in the center of the period in which the critic is a specialist." Mitchell insists to the contrary that "the phenomenon of spatial form is a constant in literary history," and that "our problem is to describe the history and significance of changes in spatial form, not to assign it to one period and temporality to another."[12] Thus the conjunction of time and space that we have observed in Milton preeminently, Mitchell would see as the formal and perceptual ground of all literary texts. The "linear"—imagined necessarily as a line—is actually a form in space; conversely, "space" is never apprehended in art "apart from time and movement." Rather than pose sharp dichotomies between such terms as linear and spatial, or temporal and spatial, or sequential and instantaneous (Milton's "discursive" and "intuitive"), we should instead assume their "complex interaction, interdependence, and interpenetration" in any and every historical period.

My own more circular sense of a historical return does not preclude the "constant" of spatial form in Mitchell's sense. Certainly, as Mitchell has helped to elucidate, Blake's "composite" art challenges all conventional oppositions. In Blake's infernal method of writing the project of Miltonic delineation is continued in the most profound and original way— as it is after Blake, other critics might argue, in the pictorialism of James's narrative, or in the painterly poems of the Victorians, before issuing in the "spatial form" of Joseph Frank's modernism. If we take the long historical view, it is surely more productive to be open to the composite dimensions of textual composition in every period than to work within prescriptive models based upon the presumed aesthetic doctrines of the age. The complex of features Frank identifies as "spatial form" may not be the invention of modernism—the instance of an absolute break with the past required by the ideology of modernism itself—but the foregrounding of possibilities always latent in the history of textuality. From our children's perspective, indeed, the textual experiments of modernism (with randomness, simultaneity, multiple or dislocated narratives, and so on) may come to be seen as a fascinating if local anticipation, at the dawn of the electronic age, of a more general reformatting of the text at the end of the twentieth century.

Nevertheless, it still seems clear that Lessing's *Laocoön* of 1766 marks a key moment of conceptual shift even within such an arguably constant history of artistic practice. Only after Lessing does a distinction between literary time and pictorial space as the proper form of the two "different" arts sound obvious, fundamental, and beyond dispute as an assumption of the discourse of the arts. Mitchell's own subsequent study of the *Laocoön* in *Iconology* only testifies to Lessing's importance in this regard.

In the article on spatial form, as we have seen, Mitchell had urged the formal constancy of literary space as a general rule beyond all local violation—it was impossible for a literary work not to be interpenetrated by spatial form, however it may be (mis)understood by readers at the time or since. In *Iconology,* however, he insists on cutting through the same kinds of argument from general principles when they are made by Lessing, exposing their roots deep in Lessing's prejudices about politics and gender. But to undercut Lessing's supposedly impartial "first principles" by revealing the interests they serve is not necessarily to diminish the historical influence of his pronouncements on aesthetic theory and consequently on our assumptions about the "nature" of the poems we read.

Indeed, were it not for Lessing's enduring influence, neither Joseph Frank in his turn nor Mitchell in his would have had to argue so strenuously, against the reader's skepticism, on behalf of a (seemingly counterintuitive) notion of spatial form in literature. The "linear" may "really" be spatial in the strict geometrical sense in which lines are an extension in space, but in the history of aesthetics since Lessing it has not been "wrong" to align the linear with the temporal and to oppose both to a plastic and holistic sense of space seen as incompatible with the literary. An emphasis on the technical constraints of representation (a line cannot but exist in space) or on the perceptual limits of reading or seeing (no one, except a Miltonic angel, can apprehend a poem or a picture all at once) should not obscure the historical fact that "texts," "images," and the differences" between them, as well as the activities that constitute "reading," "seeing," and "interpretation," are the constructions of culture and so subject to cultural change. We are now at a moment of change when computer-based systems of representation can utterly (re)collapse Lessing's barriers between the textual and the graphic media. That such a reunion may be felt as a threat rather than a promise indicates the power Lessing's rhetoric still exerts over a field of artistic practice that we persist in seeing through his eyes.

5

My interest in hypertext focuses mainly on Mitchell's "literal level," the "physical existence of the text itself." Although this is the lowest of the four tiers in Mitchell's hierarchical model for discriminating the "varieties of spatial form in literature", it is also the most fundamental, and Mitchell cautions against detaching the "ontology of literature from its material incarnation."[13] On the literal level are based all "higher" forms of spatial apperception, whether of the "world" described in the text as

an imagined spatial expanse, or of the patterns of form and meaning "seen" in it at a more abstract level by the reader.

Undeniably a "spatial form" in the most literal sense, a conventional printed text both manifests and conceals its implication in the realm of tangible, perceptual space. On the one hand the dominion of print in the west signaled the triumph of visual over oral culture, of silent reading over speech, of the dissemination of texts into the multitude of private spaces of domestic reading rather than public oratory. It also, among its many other complex effects, encouraged the spread of diagrammatic and illustrated forms of knowledge. On the other hand, the regularity of print only strengthens the tendency noted by Mitchell of "phonetic alphabets to 'background' the spatial dimension, bringing it to the fore only in special experiments like concrete poetry."[14] Effective letterpress is literally designed to remove all impediment to the easy passage of the eye, and so to make the text all the more transparent to perception, all the less tangible as a thing in itself. In the process of unobstructed reading facilitated by the printed text, the lines of type tend to become attenuated, even in a sense evacuated, to perception. The text becomes the smooth channel of fluent reading that may be cadenced but not interrupted by such conventions as punctuation or end-stopped lines of verse.

The material text thus stands in something of a paradoxical relationship to the higher levels of apperception to which it leads. For the reader's freedom to "see" at these higher levels comes at the cost of the visibility— and of what we might call the perceptual density—of the medium itself. It is true that the linear text has available to it a rhetoric of digression that allows for retrospection and anticipation ("as we have seen" or "will see") and even for sidetracking or dead-ending the strong forward directionality of linear reading ("it goes without saying," "space does not permit"). Such gestures arise from the desire, never fully achieved, to overcome the narrowly channeled momentum of linear reading.

What follows here is an attempt to guess at the implications of a writing medium in which space does permit—one in which the means of representation will have given, or restored to, the inscription of the literary work something of the capaciousness of its *ontos* in the minds of writers and readers. One aim of this attempt is to correct a misimpression on the part of software craftspeople about the novelty of the new media. Another is to locate the new technology for students of Milton within a comprehensible history whose lesson is that the new electronic media may augur not a rebellious break in the history of representation but rather a reprise and an opportunity at once.

The term "hypertext," to characterize it briefly, refers generically to computer-based systems for producing nonlinear representations of text.[15] Although the thinking behind hypertext goes back to the pioneer-

ing work of Ted Nelson twenty-five years ago, such systems—or "programming environments"—are still under development and may, indeed, still be in their conceptual infancy. Hypertext takes advantage of the sophisticated graphics now available even on modest personal computers to generate the means for nonsequential or, perhaps more accurately, hypersequential writing. In a hypertext environment, text can be structured and retrieved not only in the familiar linear array of present word-processing programs, but spatially, in three virtual dimensions. Blocks of text or graphics can be freely linked on the face of the screen. But blocks also can be embedded within, or behind, other blocks—one opening at the click of the mouse to reveal the other—and interlinked in depth as well as on, or to, the surface.

One recent hypertext application called *Storyspace* can use these multiple linkages to create not only expository documents (manuals, handbooks) but interactive fictions in which various narrative possibilities open up depending on the reader's choices at a given moment, with no two versions of the resultant story necessarily the same. For example, here is a figure which represents part of the structure of such a fiction written by Stuart Moulthrop of the University of Texas at Austin, appropriately entitled (after the Borges story on which it is based), "forking paths."[16] The diagram shows the criss-cross network of "links" interconnecting a number of textual "nodes," the whole related as an assemblage of subtexts, again along multiple pathways, to text paragraph number 001 isolated at the upper left. Paragraph 001 is thus doubly linked: in a linear, syntagmatic sequence to paragraphs 002, 003, and so forth, and in a spatial network to other paragraphs "later" or, from the point of view of this dimension, "deeper" in the story with which it shares verbal or thematic links that might take the narrative along a myriad of alternative paths. Any one set of choices, of course, issues in a reading path no less linear than the progression of paragraphs in their "normal" order; but the story as a whole—as the matrix of all possible choices—exists as a multidimensional construction in (electronically generated) space.

A much simpler array may be used to chart one element in the structure of "Lycidas," the submerged but upwelling kindred spirits of pastoral renewal, all of them linked as subtexts to the Muses' "sacred well" in line 14: "Fountain *Arethuse*" (85); the Ovidian "sanguine flower" of Hyacinth (106), itself linked both through the Latin to the "smooth-sliding *Mincius*" (86) of Virgil's *Eclogues* (7:12), and through the Greek to Theocritus, who mentions this flower in *Idyl* 10:28, to Alpheus, bidden to return at line 132 and—as an example of a link that could be extended even farther into the mythic depths of the poem—to Orpheus, whose "gory visage" washed "Down the swift *Hebrus*" and then up again on the "*Lesbian* shore," still singing (62–63).

Stuart Moulthrop, "forking paths," detail of structure.

The function of this diagram is merely to indicate the links between a particular passage of text and its subtexts. What appears here on paper as a frozen schematic must be imagined as a set of dynamic interrelations in hypertext, the "sacred well" scrolling across the top of the screen in its proper linear sequence, but as it appears also invoking its subtexts— a process that would then be repeated with other patterns of text and subtext in the following lines. The reader would also be free at any moment to follow alternative passageways—like Alpheus pursuing Arethuse under the sea—from one subtext to another, reconfiguring the poem in multiple patterns along the way. What has been achieved by such a realization? The strong claim for hypertext is that this representation only makes explicit what must remain implicit in a strictly unidirectional linear

John Milton. "Lycidas," detail of structure.

environment—namely, the web of interconnections *in* the poem, between various parts *of* the poem. This representation would then be a more complete "Lycidas," what the material embodiment of the poem would be, or even would have been ideally, if in previous inscriptions it had not been bound by outmoded technical limitations. Its relation to an earlier linear "Lycidas" would be that of a stereophonic to a monaural recording of a classical symphony—or, to take a different and perhaps more provocative analogy, the relation would be that of a digitalized image of an old masters painting to the original, where the computer-based version revealed features of the painting not visible in the oil-based representation.

A weaker claim would be that what has been represented here is not the poem in some better form, indeed not the poem at all but (merely) one interpretation of it, since readers may differ in the patterns of connection they see. Your hypertext transcription of the poem may be different from mine. Rather than set these claims against each other as opposites, I would be tempted to accommodate them both in a term like "activation," or perhaps even "performance," to describe what happens to the poem in the hypertext "Lycidas." Hypertext gives a local material habitation to the activity of making/discovering connections that every reader must engage in if the poem is to exist at all as a structure of meaning for

him or her. As such, hypertext should be regarded as a welcome elec-
tronic enhancement to what we have always already done when—as writ-
ers and readers engaged in the collaborative effort of the text—we bring
a poem into being.

 6

 This document is reformatting itself. The "WAIT" warning blinking on
my screen offers a few moments of enforced self-reflection on the critic's
own medium as a writer. With word processing in a state that will surely
seem primitive in five years, I can still merge text and graphics instantly
into the same working environment. Shifting, deleting, and reshaping
blocks of text electronically feels more like sculpting than "editing" in
the old yellow-pencil sense of the word. The metaphor of "cut and paste,"
as such operations used to be called in the early word processors, seems
an ungainly throwback to an almost medieval *ars scribendi*.
 The next step? Not that "Lycidas" could, or should, actually be retran-
scribed in a hypertext format. I will stop short of claiming that Milton
would have written "Lycidas" on the Macintosh if he had had the chance.
But *Storyspace,* as the model for other, much more sophisticated comput-
erized textual environments, allows us to imagine what such a transcrip-
tion might entail—even to imagine fresh woods and electronic pastures
new for poets yet unborn. Applications now under development will open
a new space for the process of composition.[17] They will enable the writer
to compose a work (all puns intended) by drawing and redrawing connec-
tions among chunks of text or graphic material not only arrayed in a
plane but stacked in a vertical third dimension, and so to see the full
molecular structure of an argument in various configurations (as archi-
tects using computer assisted design technology can now see the struc-
ture of a building-to-be projected in space). Putting together a text will
be more like playing three-dimensional chess or building a model than
running a squiggle across the page. That text might not be bound to the
conventional beginning, middle, and end of linear representation. Instead
it might proceed by prompts or menus, offering alternative pathways in
response to the concern of an individual reader. Indeed, rather than a
conventional printout, its final form might well be an electronic document
that (like a Renaissance memory theater) gives the reader the same plastic
ability to move in a virtual space in and around the girders of the building.
 This new electronic "architexture" (to adapt a term from Mary Ann
Caws) will loosen the hold of the consecutive, the temporal, and the
linear on writing, regarding these categories not as a law of nature but
an outmoded technical constraint.[18] It may not be wildly visionary to

assume that the way our children's children will be taught to write will reconceive the very nature of (what may no longer be called) "writing," as a multisensory, multimedia process of recording the designs of thought. So we may in the end recover something of the primitive hieroglyphic bond of word and picture, of the temporal and the simultaneous, and thus come to regard their enforced critical separation as a brief (if not impoverished) historical interlude between Milton and the Mac.

NOTES

John McDaid, "Hypermedia as an Ecology for Composition" (paper presented at MacAdemia Conference, Rochester, New York, June, 1990). I am grateful to Professor McDaid, as well as to Professors Richard Lanham, Anthony Low, W. J. T. Mitchell, and Stuart Moulthrop for their careful reading of this essay in an earlier form.

1. "Lycidas," line 105, in *John Milton: Complete Poems and Major Prose,* ed. Merritt Y. Hughes (New York: Odyssey, 1957), 123. Subsequent quotations from Milton's work refer to this edition and are cited parenthetically in the text by line number.

2. G. E. Lessing, *Laocoön: An Essay on the Limits of Painting and Poetry,* trans. from the German by Edward A. McCormick (Indianapolis: Bobbs-Merrill, 1962), 78. Subsequent quotations from this work are cited parenthetically in the text.

3. W. J. T. Mitchell, *Iconology: Image, Text, Ideology* (Chicago: University of Chicago Press, 1986), esp. chap. 4.

4. Sir Philip Sidney, "An Apologie for Poetrie," in *Elizabethan Critical Essays,* ed. G. Gregory Smith (Oxford: Oxford University Press, 1904), 1:164.

5. Rensselaer W. Lee, *Ut Pictura Poesis: The Humanistic Theory of Painting* (New York: Norton, 1967), 30.

6. John Bulwer, *Chirologia, or the Naturall Language of the Hand* (London, 1644), 6–7, 2.

7. Barbara Kirshenblatt-Gimblett, "The Cut That Binds: The Western Askenazic Torah Binder as Nexus between Circumcision and Torah," in *Celebration: Studies in Festivity and Ritual,* ed. Victor Turner (Washington, D.C.: Smithsonian Institution Press, 1982), 140–42.

8. Svetlana Alpers, *The Art of Describing* (Chicago: University of Chicago Press, 1986), 180.

9. See Martin Elsky, *Authorizing Words: Speech, Writing, and Print in the English Renaissance* (Ithaca: Cornell University Press, 1989), esp. chap. 4.

10. *Metamorphoses* 10:206–18, trans. Rolfe Humphries (Bloomington: Indiana University Press, 1955).

11. See, for example, W. J. T. Mitchell, "Spatial Form in Literature: Toward a General Theory," in *The Language of Images,* ed. W. J. T. Mitchell (Chicago: University of Chicago Press, 1980), 272 n. 2.s12

12. Ibid., 289–90. The quotations following in this paragraph are from pages 292 and 276 of Mitchell's article.

13. Ibid., 282, 279 n. 18.

14. Ibid., 282.

15. A number of works exploring hypertext and its relation to literary study have appeared in the last several years, testifying to the growing interest in such linkages, and making it possible to refer the reader elsewhere for the kind of detailed explanation of hypertext systems that cannot be attempted here. On the bibliography below, see works by Coover, Lanham, McDaid, and esp. George P. Landow, whose *Hypertext: The Convergence of Contemporary Critical Theory and Technology* (Baltimore: The Johns Hopkins University Press, 1992) appeared after this essay was completed.

16. Stuart Moulthrop, "forking paths," unpublished computer software. See also Moulthrop's "Reading from the Map: Metaphor and Metonomy in the Fiction of Forking Paths," in *Hypermedia and Literary Studies* (Cambridge: MIT Press, 1991), 119–32.

17. Robert Coover reports on his own hypertext fiction writing workshop at Brown University in "The End of Books," *The New York Times Book Review,* 21 June 1992.

18. Mary Ann Caws, *The Eye in the Text: Essays on Perception, Mannerist to Modern* (Princeton: Princeton University Press, 1981), 8–10.

WORKS CITED

Alpers, Svetlana. *The Art of Describing.* Chicago: University of Chicago Press, 1986.

Bulwer, John. *Chirologia, or the Naturall Language of the Hand.* London, 1644.

Caws, Mary Ann. *The Eye in the Text: Essays on Perception, Mannerist to Modern.* Princeton: Princeton University Press, 1981.

Coover, Robert. "The End of Books." *The New York Times Book Review,* 21 June 1992.

Elsky, Martin. *Authorizing Words: Speech, Writing, and Print in the English Renaissance.* Ithaca: Cornell University Press, 1989.

Frank, Joseph. "Spatial Form in Modern Literature." In *The Widening Gyre.* New Brunswick, N.J.: Rutgers University Press, 1963.

Hypermedia and Literary Studies. Edited by Paul Delaney and George P. Landow. Cambridge: M.I.T. Press, 1991.

Joyce, Michael, Jay David Bolter, and John Smith. *Storyspace.* Computer software. Eastgate Systems, 1990.

Kirshenblatt-Gimblett, Barbara. "The Cut That Binds: The Western Askenazic Torah Binder as Nexus between Circumcision and Torah." In *Celebration: Studies in Festivity and Ritual,* edited by Victor Turner, 137–46. Washington, D.C.: Smithsonian Institution Press, 1982.

Landow, George P. *Hypertext: The Convergence of Contemporary Critical Theory and Technology.* Baltimore: The Johns Hopkins University Press, 1992.

Lanham, Richard. "The Electronic Word: Literary Study and the Digital Revolution." *New Literary History* 20 (1989): 268–89.

———. "Twenty years after: Digital Decorum and Bistable Allusions." *Texte* 8/9 (1989): 63–98.

Lee, Rensselaer W. *Ut Pictura Poesis: The Humanistic Theory of Painting.* New York: Norton, 1967.

Lessing, G. E. *Laocoön: An Essay on the Limits of Painting and Poetry.* Trans-

lated from the German by Edward A. McCormick. Indianapolis: Bobbs-Merrill, 1962.

McDaid, John. "Hypermedia as an Ecology for Composition." MacAdemia Conference, Rochester, New York, June 1990. Published as "Toward an Ecology of Hypermedia." In *Evolving Perspectives on Computers and Composition Studies: Questions for the 1990's,* edited by Gail Haywisher and Cynthia Selfe, 203–23. Urbana, Ill.: NCTE Press, 1991.

Milton, John. *John Milton: Complete Poems and Major Prose.* Edited by Merritt Y. Hughes. New York: Odyssey, 1957.

Mitchell, W. J. T. *Iconology: Image, Text, Ideology.* Chicago: University of Chicago Press, 1986.

———. "Spatial Form in Literature: Toward a General Theory." In *The Language of Images,* edited by W. J. T. Mitchell, 271–99. Chicago: University of Chicago Press, 1980.

Ovid. *Metamorphoses.* Translated by Rolfe Humphries. Bloomington: Indiana University Press, 1955.

Sidney, Philip. "An Apologie for Poetrie." In *Elizabethan Critical Essays,* edited by G. Gregory Smith, 1: 148–207. 2 vols. Oxford: Oxford University Press, 1904.

Wrapping Presence and Bridging the Cultural Gap: The Case of the Pont-Neuf

CONSTANCE SHERAK

THE POETICS OF STONE

Veil, shroud, dress, gown.. Such are the attributes of the sacred and the histrionic. They conceal to reveal buried meaning; they imbue their subjects with life. A stone monument draped in cloth no longer represents a petrified, lapidary history but a living and polysemic testimony to the delicate and evanescent contours of the stone; it bespeaks the transformational powers of art.

For fourteen autumn days, from 22 September to 7 October 1985, an estimated three million people witnessed the rapid metamorphosis of stone into sign. Before their very eyes, they observed Christo, wrap-artist par excellence, envelop the Pont-Neuf bridge in 440,000 square feet of sandstone-colored woven polyamide fabric, 42,900 feet of rope, and 12.1 tons of steel chains encircling the base of the bridge's tower three feet under water. And like the goods in the Samaritaine department store just a few steps away, the very concept of bridge was scrutinized, handled, packaged, reproduced, and exchanged to expose its status as artifact, commodity, and material paradox of semiotic transformation.

How could the wrapping in cloth of such a familiar Parisian monument have provoked such a *mise-en-question* of the urban landscape? And how was this miracle of place capable of turning the semiotics of stone on its head by unearthing and jostling such fossilized dualities as past and present, private and public, presence and absence, sacred and profane, to credit the bridge with its rightly owned appellation of New—Bridge (le Pont—Neuf)? In the following pages, I will uncover the event of Christo's wrapped bridge in light of such fundamental dichotomies, sketching out how the very draping in golden cloth endowed the bridge with a newfound iconic function and created fissures in the cultural codes to which Parisians still desperately cling.

Christo's own staging of a theater of the temporary translated the fleet-

ing moment into a cultural eternity as he deposited the two-week event in the bedrock of collective memory. By fashioning an immutable work of memory, he consequently subverted our linear image of eternity so dependent on its representation in stone. And with just a fleeting stroke of the veil, the stone came to stand for its own malleability through time and in space.

In his seminal work of 1903, *The Modern Cult of Monuments,* Aloïs Riegl, the Austrian art historian, outlines a conceptual history of the monument in which he discriminates specifically among artistic value, historical value, and what he calls "age value."[1] Where artistic and historical value may be self-explanatory as an idealizing tendency, "age value" is a criterion defined by its immediate accessibility to perception. So, for those two weeks, the Pont-Neuf assimilated Riegl's conceptualization of the monument by linking the bridge's value as artifact to our perception of the bridge and to its emotional effect. Our sensory perception of the bridge may or may not have depended on scholarly knowledge nor historical education but on a psychological response to the modification of a historical landmark. We made new associations with the stone, became bemused by a new function of bridge, and rescripted the role of the Pont-Neuf in the Parisian landscape. Despite its stoney permanence the bridge resembled more closely the watery Seine below, fluctuating between these three commemorative moments outlined by Riegl. As we come to understand further, Christo's choice of the Pont-Neuf was determined by the bridge's function as a salient Parisian landmark and as a palimpsest for important historical events that have swept through Paris over the ages. The artist did not burn his bridge behind him with the sweep of a veil; on the contrary, he approached his lofty goal of "seek[ing] the involuntary beauty of the ephemeral."[2]

The logic of the veil and its inherent transparency seem to characterize most of Christo's projects. In the case of the Pont-Neuf, Christo did not ask us to dig down into the earth or back into our pasts to exhume stones and events, but instead, as in a reverse archaeology, he buried the stone under a piece of fabric to be resurrected and reanimated through our presence. By subscribing to the Pascalian logic of the *deus abscondius,* he masked beauty in the name of beauty. What is clear is that Christo wanted the public to forget the bridge's built-in anachronism and discover a new, New Bridge which, ironically, happens to be the oldest in Paris yet one which was the most likely candidate for his experiments in urban iconography.

Why was the Pont-Neuf such a good candidate? What is it about the materiality *and* the concept of (the) bridge that attracted Christo's attention? In wrapping the Pont-Neuf, the associations surrounding the Pont-Neuf and the meaning of bridge itself were permanently altered. Bridge

no longer signified as stone or as a concept of stone like a Prometheus bound to the rock of singular images; purged of its matter, the bridge signified in the only sense that remained—its name. Thus Christo made the name alone a signifier.

I am also interested in the inherently paradoxical "museum effect" that was engendered by the wrapping. Christo set about unraveling the institution of museum-going before our very eyes at the same time he revalorized that experienced through his art. The wrapping of the bridge gave rise to a new discourse of specularity. His task as artist was and still is a rhetorical one in that Christo requires the public to constantly interrogate the aesthetic value of his projects and the fundamental meaning of art. He purposely seeks to disturb old notions of institutionalized taste and to arouse and agitate the imagination. No longer can the artist-as-guarantor-of-permanence inscribe a work within codified spatial boundaries. Instead, through a subversion of conventional assumptions about art and its museological setting, he is forced to write a new syntax of the museum. He orchestrates the community in a temporal event and in one that by definition must be improvised.

CHRISTO'S EARLIER PROJECTS

Christo's works have often constituted galleries of the environment, allowing people to interact with nature and art (*Valley Curtain* and *Wrapped Coast,* for example). Because of this invitation to interaction, we can choose our own manner of circulating among art. There is no admission fee, no explanatory notes, no arrows pointing out the sequence of the visit, no opening or closing hours, no identifying labels nor attributions. Instead, we are invited to invent our own way of looking at and thinking about art. In a reciprocal gesture, the public's response to Christo reconfigures his work in a museological setting. By their very presence, his spectators invest the fence, wall, or islands with a newfound discursive meaning. Philip Fisher's notion of the "socialization of the object"[3] based on a community of access chartered by a map of limited rights, demands, and uses for the object addresses the constitution of meaning through community, whether community refers to the presence of spectators or the side-by-side configuration of artifacts in a collective setting. It seems, then, that the "setting" of the bridge is the collective event of the wrapping as well as the bridge's original utilitarian commitment to ferrying the urban community of Paris back and forth from Left to Right Bank and back again.

Thanks to his modified landscapes, Christo has returned unmediated reality back to his spectators and has changed our manner of looking at

the world. He positions himself within and outside of this reality. Christo's landscape pieces,

> enhance the real world, and exist as art in themselves. They point out the varied, amazing, subtle and dramatic beauties of city and country, wilderness and cultivated farm and park, sea and coast, and they are beautiful in themselves. A Christo is both a part of the world, and apart from it.[4]

Most of Christo's earlier projects involve the malleability of boundaries, places where two elements enter into contact with one another. Roads that divide and link (*Wrapped Walkways,* 1977–78), beaches separating water and land (*Wrapped Coast,* 1969 and *Surrounded Islands,* 1983), bridges arching over water (*Le Pont Neuf,* 1985), air (*Air Package 280 Feet High,* 1968) that is omnipresent and knows no boundaries, exemplify his immensely varied oeuvre.[5] The interchangeability of continents is revealed in the surrounding of natural landscapes, as in the case of *Surrounded Islands, Biscayne Bay*[6] and his *Wrapped Coast* (1969). With the *Wrapped Coast,* Christo, in draping a simple piece of fabric over the rocky Australian shore at Little Bay, suggests, through metonymy, a world about to be packaged and removed. In his *Wrapped Painting* from 1968, we are reminded of the material features of the work of art and of its status as exchangeable object.

Since his 1972 construction of the *Valley Curtain* in Rifle Gap, Colorado, Christo has also been interested in the partitioning and compartmentalizing of the world. For instance, the *Running Fence,* built in northern California in 1976, becomes the running frontier. It gives us the phantom appearance of a frontier and thus polarizes the world between past and present, ephemeral and permanent. Christo has constructed several other frontiers in the urban landscape, including the Roman Wall bordering the Villa Borghese on Via Veneto in Rome (*The Wall,* 1974), a wall of oil barrels (*Iron Curtain Wall of Oil Drums, Paris,* 1962), the *Monument to Victor Emmanuel* (1970) in Milan, and has several works in progress that include gates in Central Park and, most currently, the wrapping of the Reichstag in Berlin. This last project is most representative of the notion of politically committed art. We must not forget that Berlin was, until recently, the site of the physical encounter of East and West, of two value systems and ways of life, and representative of one of the most varied textures of European cities. His recent construction of gigantic umbrellas dotting the hillsides of Southern California and in Ibaraki, Japan (*The Umbrellas, Joint Project for Japan and U.S.A.*) seems to be a move away from closed boundaries where the open umbrellas suggest a dialogue both between the two countries and motorists/spectators on the freeway.

Christo himself was born on a border in 1935 in Nazi-occupied territory

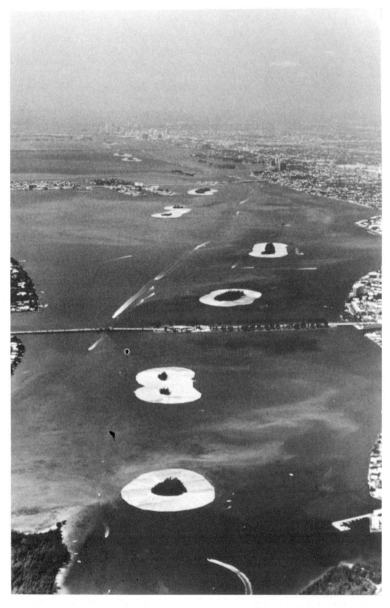

Surrounded Islands, Biscayne Bay, Greater Miami, Florida, 1980–1983. 6,500,000 square feet of floating pink polypropylene fabric. (Photo by Wolfgang Volz). ©️ Christo C.V.J. Corp. 1983.

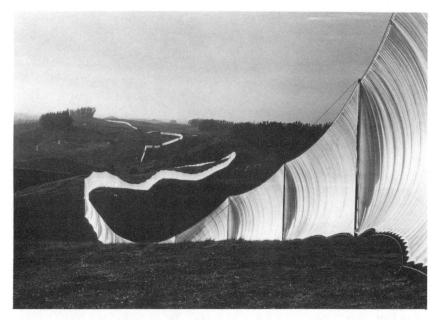

Running Fence, Sonoma and Marin Counties, California, 1972–1976. (Photo by Jeanne-Claude.) © Christo 1976.

and had scarcely turned nine when Soviet forces invaded his native Bulgaria in order to liberate it. One must ask whether the fall of the Berlin Wall has any way altered Christo's notion of free-floating boundaries, of the permanence of stone, and of the liberation of frontiers. It was almost as if the fall of the Wall was a tribute to or re-enactment of Christo's own theater of the temporary. It might be interesting to theorize on the effect of his wrapping of the Wall had he actually done so. We already know of its value as commodity in that it has been fragmented and packaged to be sold in pieces throughout the Western world; yet, we have not been encouraged necessarily to think of the graffitti besmeared Wall as a work of art worthy of our attention.

PARIS AND THE HISTORY OF THE PONT-NEUF

But what of bridges? Christo himself has explained his choice of bridge within the urban landscape:

From 1578 to 1890, the Pont-Neuf underwent continual changes and additions of the most extravagant sort, such as the construction of shops on the bridge under Soufflot and the building, demolition, rebuilding, and once again demoli-

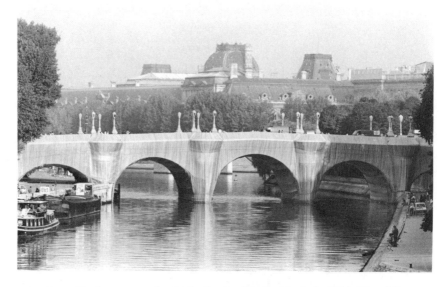

"The Pont Neuf connects the Right Bank with the Ile de la Cité. Six of its seven arches span the Seine while the seventh crosses the Quai de l'Horloge on the island." (Photo by Wolfgang Volz). © Christo Solidus C. V. J., Corp.

tion of the massive rococco structure which housed the Samaritaine's water pump. Wrapping the Pont-Neuf continues this tradition of successive metamorphoses by giving the bridge a new sculptural dimension and transforming it, for fourteen days, into a work of art itself. Ropes held down the fabric to the bridge's surface and maintained the principal shapes, accentuating relief while emphasizing proportions and details of this bridge which joins the left and right banks and the Ile de la Cité, the heart of Paris for over two thousand years. (Laporte, 83)

On 22 September 1985, the very day that Christo's project was finally realized, a consciousness of time began to inhabit the Pont-Neuf. People were forced to discuss the event and to search their memories for the facts; they went about excavating historical strata embedded in the bridge and unearthed similar findings as Christo. What had these "mental archaeologists," so to speak, discovered? In what respects had they instead rediscovered an old, new bridge? And how had history singled out the bridge as Paris's political and geographical epicenter?

The Pont-Neuf is the oldest of Paris's bridges and has a long and eventful history. During the Middle Ages, four wooden footbridges joined the Ile de la Cité to the settlements across the river. These medieval bridges were lined with houses which were not demolished until the eighteenth century. The first stone bridge, built without houses, linked the two banks

of the Seine and dates from the end of the sixteenth century when it was such a novelty that the Parisians called it simply the "new bridge"—le pont neuf. Its two spans rest on what was at the time a small island downstream from the Ile de la Cité. The foundation stone of the Pont-Neuf was laid on 19 February 1578 by Henry III, and Henry IV, who opened it in 1606, filled in the narrow creek which separated the bridge from the royal palace on the Ile de la Cité. A triangular square was laid out on the reclaimed land. Magistrates and judges lived on the square, which was named Place Dauphine in honor of the Dauphin, the heir to the throne, who was at that time the future Louis XIII. One side of the square was destroyed in the nineteenth century, but two houses on Place du Pont-Neuf still look out onto the statue of Henry IV, the man who ordered them to be built. In the seventeenth century, it was the only equestrian statue in Paris, so that people would often arrange to meet "under the horse."[7] The Pont-Neuf and the surrounding area was a bustling public center where peddlars, dentists, animal trainers, and traveling entertainers of all kinds set up their booths. Beneath the status, the garden of the Vert Galant, which also takes its name from the gallant King Henry IV, was once the haunt of tramps.

The original statue was knocked from its pedestal and melted down during the French Revolution. But in 1818, a statue of Henry IV was recast and reinstalled in its original location. During the Restoration, ultraroyalists such as Victor Hugo bemoaned the destruction of their worshipped icon at the hands of the revolutionaries. In the opening strophe of Hugo's sixth *Ode to the Restoration of the Statue of Henry IV* written in February 1819 to commemorate the return of the statue to its rightful owners, the poet laments the fate of the kings, those fragile reminders of the Old Regime and French monarchical rule:

> Je voyais s'élever, dans le lointain des âges,
> Ces monuments, espoir de cent rois glorieux;
> Puis je voyais s'écrouler les fragiles images
> De ces fragiles demi-dieux.

> I saw rise up, in the far-off ages,
> These monuments, hope of a hundred glorious kings;
> Then I saw collapse the fragile images
> Of these fragile demi-gods.[8]

After the return of the Bourbon kings, the bronze effigy of Napoleon on the Vendôme Column came in for the same treatment. Its bronze was melted down and used for the present statue that is found on the Pont-Neuf. A Bonapartist was credited for the cast and is said to have included in the monument a copy of Voltaire's epic poem *La Henriade* on the

"At all hours, passersby came to the bridge to stroll or to stop and interact with the cloth." (Photo by Wolfgang Volz). © Christo 1985.

League and Henry IV, a statuette of Napoleon and various written articles glorifying the emperor. In 1827, Hugo wrote his *Ode to the Vendôme Column (Ode à la Colonne de la Place Vendôme),* a poetic celebration of the famous Parisian monument which stood as a potent reminder of the transfer of power from Rome to Paris. In this poem, Hugo apostrophizes the Vendôme Column and, through an ekphrastic narrative of Napoleonic conquest, he carefully reads the column as a chronicle of military history:

> J'aime à voir sur tes flancs, Colonne étincelante,
> Revivre ces soldats qu'en leur onde sanglante
> Ont roulés le Danube, et le Rhin, et le Pô!
>
> I love to see on your flanks
> Oh sparkling column
> The life of these soldiers re-enacted

 (396)

And later, during the Third Republic, as a subject for Monet, Renoir, Turner, and other artists, the bridge had won the affection of the citizenry. Shortly after the Baron Haussmann's drastic urban updating it came to symbolize old Paris for a public consumed by nostalgia for its picturesque past.

When another footbridge, the Pont des Arts, was built across the Pont-

Neuf in 1803, this early example of iron served as a contrast to the weighty and historically burdened permanence of the stone Pont-Neuf. When Walter Benjamin claimed that "In iron, an artificial building material makes its appearance for the first time in the history of architecture; [I]t undergoes a development that accelerates in the course of the century,"[9] he was explicitly situating modernity in the rhetoric of construction. "Construction fills the role of the unconscious," Benjamin proclaims, and iron emerges as the symbol of progress. Train stations, railroads, arcades, and exhibition halls became the architectonic embodiment and icon of modernity in the second half of the nineteenth century whose apotheosis, of course, was the construction of the Eiffel Tower in 1889 (Benjamin, 147). The bridges of Paris, these bourgeois balconies as Charles Baudelaire would call them, over which *le flâneur* roamed and stopped to observe city dwellers, are still often identified with stone, conceptualized in stone, built in stone. Today, crowds sit beneath the branches of the weeping willow on the sharp prow of land that is the Place Dauphine and peer down the Seine to fix their eyes on the Louvre.

THE BRIDGE AS CULTURAL REFERENT

A bridge is, of course, a bridge. It crosses over water, the natural frontier that symbolizes time. The liquidity of the river serves as a counterpoint to the bridge seeking to defy the passage of time—bridges, castles, ramparts, constructions that define, cross, or defend frontiers, walls that delimit the zones of the possible and the unknown—require our perception of them. A bridge can be perceived as not only providing a spatial link but also playing a temporal role in the formation of community; indeed, the bridge constitutes that link to the past, a temporal separation from bank to bank, ferrying us across human time. The building of a bridge, the crossing of the face of time by a monument of stone, can be made to resonate with the sacred.

Both Plutarch and Varro trace the derivation of the word *pontifex,* or pontiff, from the sacrifices offered up on bridges. In Roman times, the architects and builders of Europe as well as the guardian of religion were called the "builders of bridges," originally a name for the priests who conducted the sacrifices on bridges. Dominique Laporte is interested in sacrificial rituals on bridges as a rhetorical gesture marking the violent contrast between petrification and the ephemeral:

> During the Middle Ages, there were constant allusions made to enemy prisoners, slaves, and serious criminals walled up to ensure the stone's resistance to the passage of time. Later, a coffin, a sacrificial animal, an object—anything

that could be metonymically considered an immolated victim—was a substitute for the human being. (20)

It seems that, for Laporte, immolation of the human body insures the existence of its opposite—the permanence of the inanimate. And this permanence is guaranteed by the permanence of the bridge and its temporal meaning.

What does it mean to drape a cloth over stone? What is Christo doing when he shrouds a monument of stone that in essence defies time and locates the sacred? The bridge does not disappear. It is not abolished. The Pont-Neuf *and* its shroud call attention to the bridge as a work of art. For a moment, Christo erases the stone, covers it in a shroud around the death of the concept of bridge so that the multiplicity of experiences is taken out of a seemingly temporal continuum and its various elements are liberated for new semantic combinations. This operation is not merely a new perception that is created, but one now united with the paradox of the name. In his desire to ignite historical consciousness, Christo buries the image under layers of fabric. He purges the monument of its sacrificial elements. What is really at stake here and what Christo forces us to ask is, how does intervention by fabric as a means of communication enact what W. J. T. Mitchell calls "semiotic fetishism" or "mediolatry" whereby the very act of wrapping allows us to worship the idea of art rather than the work itself?[10] We forget the actual function of bridge, transforming it into an image of the ideal or idea of the art work. The fetishized cloth mediates between the concrete and the ideal as a material emblem of this transformational process. For those two weeks in September 1985, meaning was repeatedly constructed and deconstructed in the eyes of the beholders as crowds of people mingled to make pronouncements on and to interpret the event of the season.

By draping the stone in fabric, Christo unmasked the bridge and the *toile* (the cloth) was metamorphosed into the *voile* (the veil). The fabric accentuated the crisp, rhythmic silhouette of the bridge's contours "glistening like a baroque fantasy, euphoric, exuberant, magnificent" (Vaizey, 8); its lamps projected and sustained a diaphanous glow through the gold-colored cloth. The painterly qualities of Christo's work underscored its plastic features and conjured up associations with antique bronze statuary with its rippling sensual effect. During the two weeks, the public was invited to physically interact with the bridge, to walk on the cloth barefoot, to sit at all points on the bridge and even to write on it. Some people hosted elaborate dinner parties in the alcoves of the bridge while sunbathers lay out on this new public beach to re-enact a return to that nineteenth-century convivial afternoon *A l'Ile de la Grande Jatte*. The fabric suddenly became antithetical to the cold stone and paradoxically

brought people closer to its own materiality through the *toile/voile*. Christo was present during those two weeks, explaining his artistic intent to passers-by and which was printed in *Le Monde* in an article entitled "Pont au suaire ("The Shroud Bridge"):

> Je veux offrir un autre regard et d'autres habitudes au public, accoutumé à un espace immuable depuis des siècles. Il s'agit de redécouvrir l'architecture du pont en soulignant les reliefs grâce à des cordes et une toile couleur de pierre, mais aussi en créant de nouvelles habitudes physiques telle que marcher sur du tissu au lieu de sentir l'asphalte sous ses pieds. Il sera même possible de se coucher sur la toile pour bronzer. En bref, empaqueter, c'est provoquer un impact conceptuel et sensoriel nouveau, mais également accueillant pour le public.

> I want to offer another view and other practices to the public, accustomed to a space that has gone unchanged for centuries. It involves rediscovering the bridge's architecture by emphasizing its reliefs thanks to ropes and stone-colored cloth, but also by creating new physical customs such as walking on fabric instead of feeling asphalt under one's feet. It will even be possible to lay down and tan on the cloth . . . In short, to package [the bridge] is to elicit a newfound conceptual and sensorial impact while making it inviting to the public.[11]

On the banks of the Seine, Christo was doing his best to shake Parisian complacency. The meaning of bridge was tossed around like a game of *pétanque*. Tourists from nearby Champagne or from faraway Champaign reacted to and against the event. It became a meeting place for not only the students and bohemians of Paris's Left Bank but also a museum and curio for the wealthy from NAP—the Neuilly, Auteuil, and Passy districts. The collusion of cultural difference upset what the sociologist Pierre Bourdieu calls one's "cultural competence," or one's educational and experiential background as determined by class.[12] For Bourdieu, all contexts examining a work of art setting provides a perfect arena for distinction in aesthetic judgments and especially those based on class:

> Although art obviously offers the greatest scope to the aesthetic disposition, there is no area of practice in which the aim of purifying, refining and sublimating primary needs and impulses cannot assert itself, no area in which the stylization of life, that is, the primacy of forms over function, of manner over matter, does not produce the same effect. And nothing is more distinctive, more distinguished, than the capacity to confer aesthetic status on objects that are banal or even 'common' . . . (5)

Many people disputed the wrapped bridge, criticizing Christo's pretensions as creator and artist. They opposed the way in which Christo colonized public space by literally signing his name to city property. The bridge now was simply a concept, an image not unlike the one T. J. Clark

uses to designate the notion of spectacle and spectacular society in the late nineteenth century. Referring to the city as the mass-produced image, Clark describes the consumption of public space that was expanded during this same period but which he finds to be an oppressive form of social practice:

> On the face of things, the new image did not look entirely different from the old ones. It still seemed to propose that the city was one place, in some sense belonging to them now simply as an image, something occasionally and casually consumed in space expressly designed for the purpose—promenades, panoramas, outings on Sundays, great exhibitions, and official parades. It could not have been elsewhere, apparently; it was no longer part of those patterns of action and appropriation which made up the spectators' everyday lives.[13]

The spectator at the bridge was perhaps caught in this same ambiguity between image and property, this "marketable mass of images" (Clark, 9) that Clark describes; yet the very presence of the public constituted the bridge as spectacle and for some, as work of art.

The wrapping was, of course, an overwhelming media event. The bridge not only became the cultural center of Paris for two weeks but its wrapping transformed Paris into a Hyde Park where populist sentiment abounded and resounded on street corners and at the bridge. The public was even invited to secure autographed photos from Christo that were subsequently reproduced in Paris's leftist daily, *Libération*. Many came to pontificate on the meaning of art in person and in print. The wrapping riled up journalists, some of whom published satirical articles on the adorned bridge. One journalist wrote a poem entitled *Sur un Pont Veuf,* or, *On a Widowed Bridge,* in which he visited pity on the bewildered tourist who comes to Paris to discover "au lieu du Pont-Neuf attendu, / Un ridicule paquet de linge mal étendu" ["instead of the expected Pont Neuf bridge / (he finds) a ridiculous bundle of poorly-strung laundry"].[14]

Numerous articles and editorials were published daily accompanied by Christo's early sketches detailing the dimensions of the Pont-Neuf project. Photographers were forbidden to photograph the bridge during those two weeks because only Christo and his official photographer Wolfgang Volz had the legal rights to visual reproductions of the bridge. In fact, Christo's selling of his own preparatory sketches and collages of the bridge helped finance the project.[15] Indeed, the very concept of bridge was commodified and circulated in mass quantities through the sale of posters, postcards, and t-shirts (ninety francs or approximately $18 for a rolled and *wrapped* poster!). A swatch of the actual nylon fabric figures on a page of the impressive and captivating chronicle of the Pont-Neuf project, a five-hundred and ninety-two-page collaboration with Volz, and

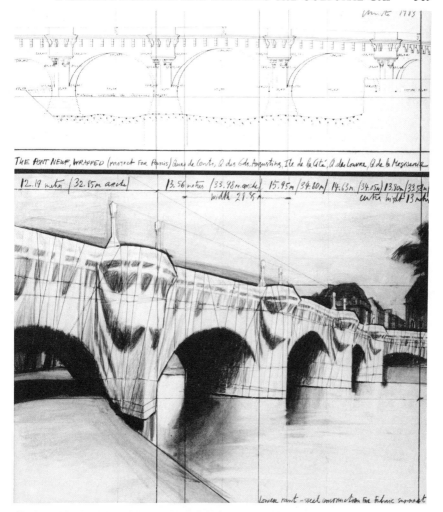

Christo, *The Pont Neuf Wrapped, Project for Paris*, 1983. Collage in two parts (pencil, charcoal, crayon, pastel, and technical data on paper). (Collection, J. Paul Getty Trust, Los Angeles). © Christo 1983.

picture commentary by David Bourdon.[16] It is also important to note that Christo does not receive royalties for this publication.

At the time of the wrapping, the Samaritaine department store hung a banner across its façade, proclaiming "Moi, La Samaritaine m'emballe" [literally, "I'm all wrapped up in the Samaritaine store"], a pun on the verb "to wrap" *(emballer)*. Or the headline of France's satirical daily *Le Canard enchaîné* read "Coût de torchon," playing on the words *coup* and

torchon as a dismissive "swipe with a rag," to underscore the exorbitant cost *(coût)* of the cloth *(torchon)* required for the project's realization.[17]

CONCLUSION

Christo did in fact attain his goal of resuscitating the past; he revived history by making the Pont-Neuf new again. Although the actual wrapping remained for a mere fourteen days, the bridge itself has since become a renewed topos of civic and history redolent with cultural and historical significance for the Parisian public. The bridge locates an important semiotic reversal, a culturally complex teasing out of a familiar chicken-before-egg conundrum. In succeeding to topple such an entrenched hierarchy of form over content, Christo carved out his place in the Parisian art world. As the critic Jonathan Kuhn sums up, "[Y]ears from now one can imagine people pointing to the Pont-Neuf and saying: 'That's the bridge that Christo wrapped.' Thus by making history he becomes part of it."[18] Let us hope that this reversal will remain intact.

NOTES

1. Aloïs Riegl, "The Modern Cult of Monuments: Its Character and Its Origin." *Oppositions* 25 (Fall 1982).

2. Dominique Laporte, *Christo,* trans. Abby Pollak (New York: Pantheon Books, 1986), 26. This is an important study of Christo, focusing on the artist as a master of paradox who seeks to unravel or subvert our arithmetical and linear image of eternity. Subsequent quotations from this work are cited parenthetically in the text.

3. Philip Fisher, *Making and Effacing Art: Modern American Art in a Culture of Museums* (New York: Oxford University Press), 5.

4. Marina Vaizey, *Christo* (New York: Rizzoli, 1990), 8. Subsequent quotations from this work are cited parenthetically in the text.

5. See Vaizey for a comprehensive catalogue of Christo's works.

6. Werner Spies writes of the wrapped islands as a constantly shifting utopia "magnified by the media into the semblance of some gigantic reality [. . .] no one else has linked realization and removal to the extent that Christo has" in the introduction to *Christo: Surrounded Islands* (New York: Harry Abrams, 1985), 8.

7. Patrick Greene, *Paris Observed* (London: Kaye & Ward, 1977), 13.

8. Victor Hugo, *Oeuvres poétiques* (Paris: Gallimard, 1964), 309. Translation is mine. Subsequent quotations from this work are cited parenthetically in the text.

9. Walter Benjamin, *Paris, Capital of the Nineteenth Century,* trans. Edmund Jephcott (New York: Schocken Books, 1986), 147. Subsequent quotations from this work are cited parenthetically in the text.

10. W. J. T. Mitchell, *Iconology: Image, Text, Ideology* (Chicago: University of Chicago Press, 1986), 202.

11. Stéphane Durand-Souffland, "Pont au suaire," *Le Monde* 22–23 September 1985.

12. Pierre Bourdieu, *Distinction: A Social Critique of the Judgement of Taste,* trans. Richard Nice (Cambridge: Harvard University Press, 1984), 2. Subsequent quotations from this work are cited parenthetically in the text.

13. T. J. Clark, *The Painting of Modern Life: Paris in the Art of Manet and His Followers* (Princeton: Princeton University Press, 1984), 9. Subsequent quotations from this work are cited parenthetically in the text.

14. Félix Lévy, "Sur un pont veuf," *Le Monde* 6–7 October 1985. Translation is mine.

15. The CVJ Corporation, of which Christo's wife Jeanne-Claude is president and treasurer, raised four million dollars for the Pont-Neuf project through the sale of Christo's own sketches, collages, and objects.

16. See David Bourdon et al., *The Pont Neuf Wrapped, Project for Paris, 1975–85* (New York: Harry N. Abrams, 1990).

17. Sylvie Castor, "Coût de torchon," *Le Canard enchaîné* 25 September 1985.

18. Jonathan Kuhn, "The Picasso Museum, Christo's Pont Neuf Project, and Pei's Pyramid: Reflections on Artistic Ego and the Artistic Life of Paris," *Arts Magazine* 61:4 (December 1986): 90–93.

The Violence of Public Art:
Do the Right Thing

W. J. T. MITCHELL

In May 1988, I took what may well be the last photograph of the statue
of Mao Tse-tung on the campus of Beijing University. The thirty-foot-
high monolith was enveloped in bamboo scaffolding "to keep off the harsh
desert winds," my hosts told me with knowing smiles. That night, workers
with sledgehammers reduced the statue to a pile of rubble, and rumors
spread throughout Beijing that the same thing was happening to statues
of Mao on university campuses all over China. One year later, most of
the world's newspaper readers scanned the photos of Chinese students
erecting a thirty-foot-high styrofoam and plaster "Goddess of Liberty"
directly facing the disfigured portrait of Mao in Tiananmen Square despite
the warnings from government loudspeakers: "This statue is illegal. It is
not approved by the government. Even in the United States statues need
permission before they can be put up."[1] A few days later the newspaper
accounts told us of army tanks mowing down this statue along with thou-
sands of protesters, reasserting the rule of what was called law over a
public and its art.

The Beijing Massacre, and the confrontation of images at the central
public space in China, is full of instruction for anyone who wants to think
about public art and, more generally, about the whole relation of images,
violence, and the public sphere.[2] "Even in the United States" political
and legal control is exerted, not only over the erection of public statues
and monuments but over the display of a wide range of images, artistic
or otherwise, to actual or potential publics. Even in the United States
the "publicness" of public images goes well beyond their specific sites or
sponsorship: "publicity" has, in a very real sense, made all art into public
art. And even in the United States, art that enters the public sphere is
liable to be received as a provocation to or an act of violence.

Our own historical moment seems especially rich in examples of such
public acts and provocations. Recent art has carried the scandals previ-
ously associated with the cloistered spaces of the art world—the gallery,

The Wrapped statue of Mao Tse-tung, campus of Beijing University. (Photo by the author).

the museum, and the private collection—into the public sphere. And the public, by virtue of governmental patronage of the arts, has taken an interest in what is done with its money, no matter whether it is spent on traditional public art—in a public place as a public commission—or on a private activity in a private space that just happens to receive some public support or publicity.

The controversy over Richard Serra's *Tilted Arc* sculpture in a public plaza in New York City marks one boundary of this phenomenon. Serra's is a traditional work of public art; it provokes another engagement in what Michael North has called the "tiresome battle, repeated in city after city . . . whenever a piece of modern sculpture is installed outdoors."[3] But now the battle has moved indoors, into the spaces of museums and art schools. The privacy of the exhibition site is no longer a protection for art that does symbolic violence to revered public figures like the deceased mayor of Chicago, or to public emblems and icons like the American flag or the crucifix.

The erosion of the boundary between public and private art is accompanied by a collapsing of the distinction between symbolic and actual violence, whether the "official" violence of police, juridical, or legislative power, or "unofficial" violence in the responses of private individuals. Serra's *Tilted Arc* was seen as a violation of public space, was subjected to actual defacement and vandalism by some members of the public, and became the subject of public legal proceedings to determine whether it should be dismantled.[4] The official removal of an art student's caricature of Mayor Harold Washington from the School of the Art Institute of Chicago involved not just the damaging of the offensive picture but a claim that the picture was itself an "incitement to violence" in the black community. A later installation at the same school asking *What is the Proper Way to Display the American Flag?* was construed as an invitation to "trample" on the flag. It immediately attracted threats of unofficial violence against the person of the artist and may ultimately serve as the catalyst not simply for legislative action but for a constitutional amendment protecting the flag against all acts of symbolic or real violence. The recent response to Andres Serrano's crucifix in urine and the closing of the Mapplethorpe show at the Corcoran Gallery indicate the presence of an American public, or at least of some well-entrenched political interests, that is fed up with tolerating symbolic violence against religious and sexual taboos under covers of "art," "privacy," and "free speech," and is determined to fight back with the very real power of financial sanctions. We may not have tanks mowing down students and their statues, but we are experiencing a moment when art and the public (insofar as it is embodied by state power and "public opinion") seem on a collision course.

The association of public art with violence is nothing new. The fall

of every Chinese dynasty since antiquity has been accompanied by the destruction of its public monuments, and the long history of political and religious strife in the West could almost be rewritten as a history of iconoclasm. There is also nothing new about the opposition of art to its public. Artists have been biting the hands that feed them since antiquity,[5] and even the notion of an avant-garde capable of scandalizing the bourgeoisie has been dismissed, by a number of critics, to the dustbin of history. The avant-garde, in Thomas Crow's words, now functions "as a kind of research and development arm of the culture industry."[6] Opposi-tional movements such as surrealism, expressionism, and cubism have been recuperated for entertainment and advertising, and the boldest ges-tures of high modernism become the ornaments of corporate public spaces. If traditional public art identified certain classical styles as appro-priate to the embodiment of public images, contemporary public art has turned to the monumental abstraction as its acceptable icon. What Kate Linker calls the "corporate bauble" in the shopping mall or bank plaza need have no iconic or symbolic relation to the public it serves, the space it occupies, or the figures it reveres.[7] It is enough that it remain an emblem of aesthetic surplus, a token of "art" imported into and adding value to a public space.

The notorious "anti-aesthetic" posture of much postmodern art may be seen, in its flouting of the canons of high modernism, as the latest edition of the iconoclastic public icon, the image that affronts its own public—in this case, the art world as well as the "general" public. The violence associated with this art is inseparable from its *publicness,* espe-cially its exploitation of and by the apparatuses of publicity, reproduction, and commercial distribution.[8] The scandalousness and obtrusive theatri-cality of these images hold up a mirror to the nature of the commodified image, and the public spectator addressed by advertising, television, mov-ies, and "Art" with a capital A. If all images are for sale, it's hardly surprising that artists would invent public images that are difficult (in any sense) to "buy." Postmodern art tries, among other things, to be difficult to own or collect, and much of it succeeds, existing only as ruined frag-ments or photographic "documentation." Much of it also "fails," of course, to be unmarketable and thus "succeeds" quite handsomely as an aesthetic commodity, as Andy Warhol's work demonstrates. The common thread of both the marketable and the unmarketable art work is the more or less explicit awareness of "marketability" and publicity as unavoidable dimensions of any public sphere that art might address. "Co-optation" and "resistance" are thus the ethical-political maxims of this public sphere and the aesthetic it generates.

The violence associated with this art may seem, then, to have a pecu-liarly desperate character and is often directed at the work itself as much

as its beholder. Sometimes a self-destructive violence is built into the work, as in Jean Tinguely's self-destroying machine sculpture, *Homage to New York,* or Rudolf Schwarzkogler's amputation of his own penis, both of which now exist only in photographic documentation.[9] More often, the violence suffered by contemporary art seems simultaneously fateful and accidental, a combination of misunderstanding by local or partial publics and a certain fragility or temporariness in the work itself. The early history of Claes Oldenburg's monumental *Lipstick* at Yale University is one of progressive disfigurement and dismantling. Many of the works of Robert Smithson and Robert Morris are destroyed, existing now only in documents and photographs. The openness of contemporary art to publicity and public destruction has been interpreted by some commentators as a kind of artistic aggression and scandalmongering. A more accurate reading would recognize it as a deliberate vulnerability to violence, a strategy for dramatizing new relations between the traditionally "timeless" work of art and the transient generations, the "publics," that are addressed by it.[10] The defaced and graffiti-laden walls that Jonathan Borofsky installs in museum spaces are a strategy for reconfiguring the whole relation of private and public, legitimate and "transgressive" exhibition spaces. Morris's 1981 proposal to install the casings of nuclear bombs as monumental sculpture at a Florida VA hospital was both a logical extension of a public sculpture tradition (the public display of obsolete weapons) and a deadpan mimicry of the claim that these weapons "saved American lives" in World War II.[11]

The question naturally arises: Is public art inherently violent, or is it a provocation to violence? Is violence built into the monument in its very conception? Or is violence simply an accident that befalls some monuments, a matter of the fortunes of history? The historical record suggests that if violence is simply an accident that happens to public art, it is one that is always waiting to happen. The principal media and materials of public art are stone and metal sculpture not so much by choice as by necessity. "A public sculpture," says Lawrence Alloway, "should be invulnerable or inaccessible. It should have the material strength to resist attack or be easily cleanable, but it also needs a formal structure that is not wrecked by alterations."[12] The violence that surrounds public art is more, however, than simply the ever-present possibility of accident—the natural disaster or random act of vandalism. Much of the world's public art—memorials, monuments, triumphal arches, obelisks, columns, and statues—has a rather direct reference to violence in the form of war or conquest. From Ozymandias to Caesar to Napoleon to Hitler, public art has served as a kind of monumentalizing of violence, and never more powerfully than when it presents the conqueror as a man of peace, imposing a Napoleonic code or a *pax Romana* on the world. Public sculpture

that is too frank or explicit about this monumentalizing of violence, whether the Assyrian palace reliefs of the ninth century B.C., or Morris's bomb sculpture proposal of 1981, is likely to offend the sensibilities of a public committed to the repression of its own complicity in violence.[13] The very notion of public art as we receive it is inseparable from what Jürgen Habermas has called "the liberal model of the public sphere," a dimension distinct from the economic, private, and political. This ideal realm provides the space in which disinterested citizens may contemplate a transparent emblem of their own inclusiveness and solidarity, and deliberate on the general good, free of coercion, violence, or private interests.[14]

The fictional ideal of the classic public sphere is that it includes everyone; the fact is that it can be constituted only by the rigorous exclusion of certain groups—slaves, children, foreigners, those without property, and (most conspicuously) women. The very notion of the "public," it seems, grows out of a conflation of two quite different Latin words, *populus* (the people) and *pubes* (adult men). The word *public* might more properly be written with the "l" in parentheses to remind us that for much of human history political and social authority has derived from a "pubic" sphere, not a public one.[15] This seems to be the case even when the public sphere is personified as a female figure. The famous examples of female monuments to the all-inclusive principle of public civility and rule of law—Athena to represent impartial Athenian justice, the Goddess of Reason epitomizing the rationalization of the public sphere in revolutionary France, the Statue of Liberty welcoming the huddled masses from every shore—all presided over political systems that rigorously excluded women from any public role.[16]

Perhaps some of the power associated with the Vietnam Veterans Memorial in Washington, D.C., comes from its cunning violation and inversion of monumental conventions for expressing and repressing the violence of the pub(l)ic sphere. The VVM is antiheroic, antimonumental, a V-shaped gash or scar, a trace of violence suffered, not of violence wielded in the service of a glorious cause (as in the conventional war memorial).[17] It achieves the universality of the public monument not be rising above its surroundings to transcend the political but by going beneath the political to the shared sense of a wound that will never heal, or (more optimistically) a scar that will never fade. Its legibility is not that of narrative: no heroic episode such as the planting of the American flag on Iwo Jima is memorialized, only the mind-numbing and undifferentiated chronology of violence and death catalogued by the fifty-eight thousand names inscribed on the black marble walls. The only other legibility is that of the giant flat V carved in the earth itself, a mutlivalent monogram or initial that seems uncannily overdetermined. Does the V stand for

Aerial view of the Vietnam Veterans Memorial. (Photo: Richard Hofmeister, Smithsonian Institution's Office of Printing and Photographic Services. From *Reflections on the Wall: The Vietnam Veterans Memorial*, Harrisburg, Pa., 1987.

Vietnam? For a pyrrhic "victory?" For the veterans themselves? For the violence they suffered? Is it possible, finally, to avoid seeing it as a quite literal antitype to the "pubic sphere" signified in the traditional phallic monument, that is, as the vagina of Mother Earth opened to receive her sons, as if the American soil were opening its legs to show the scars inscribed on her private parts? Even the authorship of this polysemous and thoroughly feminized monument seems overdetermined in retrospect. Who would have predicted that the national trauma of the United States' catastrophic adventure in the Far East would be memorialized in a design by a twenty-one-year-old Asian woman?[18]

It should be clear that the violence associated with public art is not simply an undifferentiated abstraction, any more than is the public sphere it addresses. Violence may be in some sense "encoded" in the concept and practice of public art, but the specific role it plays, its political or ethical status, the form in which it is manifested, the identities of those who wield and suffer it, is always nested in particular circumstances. We may distinguish three basic forms of violence in the images of public art, each of which may, in various ways, interact with the other: the image as (1) an *act* or *object* of violence, itself doing violence to beholders, or

"suffering" violence as the target of vandalism, disfigurement, or demolition; (2) a *weapon* of violence, a device for attack, coercion, incitement, or more subtle "dislocations" of public spaces; (3) a *representation* of violence, whether a realistic imitation of a violent act or a monument, trophy, memorial, or other trace of past violence. All three forms are, in principle, independent of one another: an image can be a weapon of violence without representing it; it may become the object of violence without ever being used as a weapon; it may represent violence without ever exerting or suffering it. In fact, however, these three forms of violence are often linked together. Pornography is said to be a representation and a weapon of violence against women, which should be destroyed or at least banned from public distribution.[19] The propaganda image is a weapon of war that obviously engaged with all three forms of violence in various ways, depending on the circumstances. The relation of pornography to propaganda is a kind of allegory for the relation of "private" to "public" art: the former projects fetishistic images that are confined, in theory, to the "private sphere" of sexuality; the latter projects totemistic or idolatrous images that are directed, in theory, at a specific public sphere.[20] In practice, however, private "arousal" and public "mobilization" cannot be confined to their proper spheres: rape and riot are the "surplus" of the economy of violence encoded in public and private images.

These elisions of the boundary between public and private images are what make it possible, perhaps even necessary, to turn from the sphere of public art in its "proper" or traditional sense (works of art installed in public places by public agencies at public expense) to film, a medium of public art in an extended or "improper" sense. Although film is sometimes called the central public art of the twentieth century, we should be clear about the adjustments in both key terms—*public* and *art*—required to make this turn. Film is not a "public art" in the classical sense stipulated by Habermas; it is deeply entangled with the marketplace and the sphere of commercial-industrial publicity that replaces what Habermas calls the "culture-debating" public with a "culture-consuming" public. We need not accept Habermas's historical claim that the classic public sphere (based in the "world of letters") was "replaced by the pseudo-public or sham-private world of culture consumption"[21] to see that its basic distinction between an ideal, utopian public sphere and the real world of commerce and publicity is what underwrites the distinction between public art "proper" and the "improper" turn to film, a medium that is neither public nor art in this proper (utopian) sense.

This juxtaposition of public art and commercial film illuminates a number of contrasting features whose distinctiveness is under considerable pressure, both in contemporary art and recent film practice. An obvious

difference between public art and the movies is the contrast in mobility. Of all forms of art, public art is the most static, stable, and fixed in space: the monument is a fixed, generally rigid object, designed to remain on its site for all time.[22] The movies, by contrast, "move" in every possible way—in their presentation, their circulation and distribution, and in their responsiveness to the fluctuations of contemporary taste. Public art is supposed to occupy a pacified, utopian space, a site held in common by free and equal citizens whose debates, freed of commercial motives, private interest, or violent coercion, will form "public opinion." Movies are beheld in private, commercial theaters that further privatize spectators by isolating and immobilizing them in darkness. Public art stands still and silent while its beholders move in the reciprocal social relations of festivals, mass meetings, parades, and rendezvous. Movies appropriate all motion and sound to themselves, allowing only the furtive, private rendezvous of lovers or of autoeroticism.

The most dramatic contrast between film and public art emerges in the characteristic tendencies of each medium with respect to the representation of sex and violence. Public art tends to repress violence, veiling it with the stasis of monumentalized and pacified spaces, just as it veils gender inequality by representing the masculine public sphere with the monumentalized bodies of women. Film tends to express violence, staging it as a climactic spectacle, just as it foregrounds gender inequality by fetishizing rather than monumentalizing the female body. Sex and violence are strictly forbidden in the public site, and thus the plaza, common, or city square is the favored site for insurrection and symbolic transgression, with disfiguration of the monument a familiar, almost ritual occurrence.[23] The representation of sex and violence is licensed in the cinema, and it is generally presumed (even by the censors) that it is reenacted elsewhere—in streets, alleys, and private places.

I have rehearsed these traditional distinctions between film and public art not to claim their irresistible truth but to sketch the conventional background against which the relations of certain contemporary practices in film and public art may be understood—their common horizon of resistance, as it were. Much recent public art obviously resists and criticizes its own site and the fixed, monumental status conventionally required of it; much of it aspires, quite literally, to the condition of film in the form of photographic or cinematic documentation. I turn now to a film that aspires to the condition of public art, attempting a similar form of resistance within its own medium, and holding up a mirror to the economy of violence encoded in public images.[24]

In May 1989 I tried unsuccessfully to attend an advance screening of Spike Lee's *Do the Right Thing* at the University of Chicago. People from

"Wall of Fame" from *Do the Right Thing*.

the university and its neighborhood had lined up for six hours to get the free tickets, and none of them seemed interested in scalping them at any price. Spike Lee made an appearance at the film's conclusion and stayed until well after midnight answering the questions of the overflow crowd. This event turned out to be a preview not simply of the film but of the film's subsequent reception. Lee spent much of the summer answering questions about the film in television and newspaper interviews; the *New York Times* staged an instant symposium of experts on ethnicity and urban violence; and screenings of the film (especially in urban theaters) took on the character of festivals, with audiences in New York, London, Chicago, and Los Angeles shouting out their approval to the screen and to each other.

The film elicited disapproval from critics and viewers as well. It was denounced as an incitement to violence and even as an *act* of violence by viewers who regarded its representations of ghetto characters as demeaning.[25] The film moved from the familiar commercial public sphere of "culture consumption" into the sphere of public art, the arena of the "culture-debating" public, a shift signalled most dramatically by its exclusion from the "Best Picture" category of the Academy Awards. As the film's early reception subsides into the cultural history of the late eighties

in the United States, we may now be in a position to assess its significance
as something more than a "public sensation" or "popular phenomenon."
Do the Right Thing is rapidly establishing itself not only as a work of
public art (a "monumental achievement" in the trade lingo), but as a film
about public art. The film tells a story of multiple ethnic public spheres,
the violence that circulates among and within these partial publics, and
the tendency of this violence to fixate itself on specific images—symbolic
objects, fetishes, and public icons or idols.

The specific public image at the center of the violence in *Do the Right
Thing* is a collection of photographs, an array of signed publicity photos
of Italian-American stars in sports, movies, and popular music framed
and hung up on the "Wall of Fame" in Sal's Famous Pizzeria at the corner
of Stuyvesant and Lexington in Brooklyn. A bespectacled b-boy and
would-be political activist named Buggin' Out challenges this arrange-
ment, asking Sal why no pictures of African-Americans are on the Wall.
Sal's response is an appeal to the rights of private property: "You want
brothers up on the Wall of Fame, you open up your own business, then
you can do what you wanna do. My pizzeria, Italian-Americans only up
on the wall." When Buggin' Out persists, arguing that blacks should have
some say about the Wall since their money keeps the pizzeria in business,
Sal reaches for an all-too-familiar emblem of both the American way of
life and of racial violence: his baseball bat. Mookie, Sal's black delivery
boy (played by Lee) defuses the situation by hustling Buggin' Out out of
the pizzeria. In retaliation, Buggin' Out tries, quite unsuccessfully, to
organize a neighborhood boycott, and the conflict between the black pub-
lic and the white-owned private business simmers on the back burner
throughout the hot summer day. Smiley, a stammering, semi-articulate
black man who sells copies of a unique photograph showing Martin Lu-
ther King, Jr., and Malcolm X together, tries to sell his photos to Sal
(who seems ready to be accommodating) but is driven off by Sal's son
Pino. Sal is assaulted by another form of "public art" when Radio Raheem
enters the pizzeria with his boom-box blasting out Public Enemy's rap
song, "Fight the Power." Finally, at closing time, Radio Raheem and Bug-
gin' Out reenter Sal's, radio blasting, to demand once again that some
black people go up on the Wall of Fame. Sal smashes the radio with his
baseball bat, Raheem pulls Sal over the counter and begins to choke him.
In the melee that follows, the police kill Radio Raheem and depart with
his body, leaving Sal and his sons to face a neighborhood mob. Mookie
throws a garbage can through the window of the pizzeria, and the mob
loots and burns it. Later, when the fire is burning down, Smiley enters
the ruins and pins his photograph of King and Malcolm to the smoldering
Wall of Fame.

Sal's Wall of Fame exemplifies the central contradictions of public art.

Buggin' Out looks up at the Wall of Fame.

It is located in a place that may be described, with equal force, as a public accommodation and a private business. Like the classic liberal public sphere, it rests on a foundation of private property that comes into the open when its public inclusiveness is challenged. Sal's repeated refrain throughout the film to express both his openness and hospitality to the public and his "right" to reign as a despot in his "own place" is a simple definition of what his "place" is: "This is America." As "art," Sal's wall stands on the threshold between the aesthetic and the rhetorical, functioning simultaneously as ornament and as propaganda, both a private collection and a public statement. The content of the statement occupies a similar threshold, the hyphenated space designated by "Italian-American," a hybrid of particular ethnic identification and general public identity. The Wall is important to Sal not just because it displays famous Italians but because they are famous *Americans* (Frank Sinatra, Joe Di-Maggio, Liza Minelli, Mario Cuomo) who have made it possible for Italians to think of themselves as Americans, full-fledged members of the general public sphere. The Wall is important to Buggin' Out because it signifies exclusion from the public sphere. This may seem odd, since the neighborhood is filled with public representations of African-American heroes on every side: a huge billboard of Mike Tyson looms over Sal's

pizzeria; children's art ornaments the sidewalks, and graffiti streaks subversive messages like "Tawana told the Truth" on the walls; Magic Johnson T-shirts, Air Jordan sneakers, and a variety of jewelry and exotic hairdos make the characters like walking billboards for "black pride"; and the sound-world of the film is suffused with a musical "Wall of Fame," a veritable anthology of great jazz, blues, and popular music emanating from Mister Señor Love Daddy's storefront radio station, just two doors away from Sal's.

Why aren't these tokens of black self-respect enough for Buggin' Out? The answer, I think, is that they are only tokens of self-respect, of black pride, and what Buggin' Out wants is the respect of whites, the acknowledgment that African-Americans are hyphenated Americans, too, just like Italians.[26] The public spaces accessible to blacks are *only* public, and that only in the special way that the sphere of commercial-industrial publicity (a sphere that includes, by the way, movies themselves) is available to blacks. They are, like the public spaces in which black athletes and entertainers appear, rarely owned by blacks themselves; they are reminders that black public figures are by and large the "property" of a white-owned corporation—whether a professional sports franchise, a recording company, or a film distributor. The public spaces in which blacks achieve prominence are thus only sites of publicity, or of marginalized arts of resistance epitomized by graffiti, not of a genuine public sphere they may enter as equal citizens. These spaces, despite their glamour and magnitude, are not as important as the humble little piece of "real America" that is Sal's Pizzeria, the semi-private, semi-public, white-owned space, the threshold space that supports genuine membership in the American public sphere. The one piece of public art "proper" that appears in the film is an allegorical mural across the street from Sal's, and it is conspicuously marginalized; the camera never lingers on it long enough to allow decipherment of its complex images. The mural is a kind of archaic residue of a past moment in the black struggle for equality, when black pride was enough. In *Do the Right Thing* the blacks have plenty of pride; what they want, and cannot get, is the acknowledgment and respect of whites.

The film is not suggesting, however, that integrating the Wall of Fame would solve the problem of racism or allow African-Americans to enter the public sphere as full-fledged Americans. Probably the most fundamental contradiction the film suggests about the whole issue of public art is its simultaneous triviality and monumentality. The Wall of Fame is, in a precise sense, the "cause" of the major violence in the narrative, and yet it is also merely a token or symptom. Buggin' Out's boycott fails to draw any support from the neighborhood, which generally regards his plan as a meaningless gesture. The racial integration of the public symbol, as of

the public accommodation, is merely a token of public acceptance. Real participation in the public sphere involves more than tokenism: it involves full economic participation. As long as blacks do not own private property in this society, they remain in something like the status of public art, mere ornaments to the public place, entertaining statues and abstract caricatures rather than full human beings.

Spike Lee has been accused by some critics of racism for projecting a world of black stereotypes in his film: Tina, the tough, foul-mouthed sexy ghetto "babe"; Radio Raheem, the sullen menace with his ghetto blaster; Da Mayor, the neighborhood wino; Mother Sister, the domineering, disapproving matriarch who sits in her window all day posed like Whistler's mother. Lee even casts himself as a type: a streetwise, lazy, treacherous hustler who hoards his money, neglects his child, and betrays his employer by setting off the mob to destroy the pizzeria. But it is not enough to call these stereotypes "unrealistic"; they are, from another point of view, highly realistic representations of the public *image* of blacks, the caricatures imposed on them and acted out by them. Ruby Dee and Ossie Davis, whom Lee cast as the Matriarch and the Wino, have a long history of participation in the film proliferation of these images, and Dee's comment on the role of black elders is quite self-conscious about this history: "'When you get old in this country, you become a statue, a monument. And what happens to statues? Birds shit on them. There's got to be more to life for an elder than that.'"[27] The film suggests that there's got to be more to life for the younger generation as well, which seems equally in danger of being smothered by the straitjacket of stereotypes. It is as if the film wanted to cast its characters as public statues with human beings imprisoned inside them, struggling to break out of their shells to truly participate in the public space where they are displayed.

This "breaking out" of the public image is what the film dramatizes and what constitutes the violence that pervades it. Much of this violence is merely trivial or irritating, involving the tokens of public display, as when an Irish-American yuppie homesteader steps on Buggin' Out's Air Jordans; some is erotic, as in Tina's dance as a female boxer, which opens the film; some is subtle and poetic, as in the scene when Radio Raheem breaks out of his sullen silence, turns off his blaster, and does a rap directly addressed to the camera, punctuating his lines with punches, his fists clad in massive gold rings that are inscribed with the words LOVE and HATE. Negative reactions to the film tend to focus obsessively on the destruction of the pizzeria, as if the violence against property were the only "real" violence in the film. Radio Raheem's death is regularly passed over as a mere link in the narrative chain that leads to the climactic spectacle of the burning pizzeria. Lee has also been criticized for showing this spectacle at all; the film has routinely been denounced as an incite-

ment to violence, or at least a defense of rioting against white property as an act of justifiable violence in the black community. Commentators have complained that the riot is insufficiently motivated, or that it is just there for the spectacle, or to prove a thesis.[28] In particular, Lee has been criticized for allowing Mookie's character to "break out" of its passive, evasive, uncommitted stance at the crucial moment, when he throws the garbage can through the window.

Mookie's act dramatizes the whole issue of violence and public art by staging an act of vandalism against a public symbol, and specifically by smashing the plate-glass window that marks the boundary between public and private property, the street and the commercial interest. Most of the negative commentary on the film has construed this action as a political statement, a call by Spike Lee to advance African-American interests by trashing white-owned businesses. Lee risks this misinterpretation, of course, in the very act of staging this spectacle for potential monumentalization as a public statement, a clearly legible image readable by all potential publics as a threat or model for imitation. But the fact that this event has emerged as the focus of principal controversy suggests that it is not so legible, not so transparent as it might have seemed. Spike Lee's motives as writer and director—whether to make a political statement, give the audience the spectacle it wants, or fulfill a narrative design—are far from clear. And Mookie's motivation as a character is equally problematic: at the very least, his action seems subject to multiple private determinations—anger at Sal, frustration at his dead-end job, rage at Radio Raheem's murder—that have no political or "public" content. At the most intimate level, Mookie's act hints at the anxieties about sexual violence that we have seen encoded in other public monuments. Sal has, in Mookie's view, attempted to seduce his beloved sister (whom we have seen in a nearly incestuous relation to Mookie in an opening scene), and Mookie has warned his sister never to enter the pizzeria again (this dialogue staged in front of the pizzeria's brick wall, spray-painted with the graffiti message, "Tawana told the Truth," an evocation of another indecipherable case of highly publicized sexual violence). Mookie's private anxieties about his manhood ("Be a man, Mookie!" is his girlfriend Tina's hectoring refrain) are deeply inscribed in his public act of violence against the public symbol of white domination.

But private, psychological explanations do not exhaust the meaning of Mookie's act. An equally compelling account would regard the smashing of the window as an ethical intervention. At the moment of Mookie's decision the mob is wavering between attacking the pizzeria and assaulting its Italian-American owners. Mookie's act directs the violence away from persons and toward property, the only choice available in that moment. Mookie "does the right thing," saving human lives by sacrificing property.[29] Most fundamentally, however, we have to say that Lee himself

"does the right thing" in this moment by breaking the illusion of cinematic realism and intervening as the director of his own work of public art, taking personal responsibility for the decision to portray and perform a public act of violence against private property. This choice breaks the film loose from the *narrative* justification of violence, its legitimation by a law of cause and effect or political justice, and displays it as a pure effect of *this* work of art in this moment and place. The act makes perfect sense as a piece of Brechtian theater, giving the audience what it wants with one hand and taking it back with the other.

We may call *Do the Right Thing* a piece of "violent public art," then, in all the relevant senses—as a representation, an act, and a weapon of violence. But it is a work of *intelligent* violence, to echo the words of Malcolm X that conclude the film. It does not repudiate the alternative of nonviolence articulated by Martin Luther King in the film's other epigraph (this is, after all, a film, a symbolic and not a "real" act of violence); it resituates both violence and nonviolence as strategies within a struggle that is simply an ineradicable fact of American public life. The film may be suffused in violence, but unlike the "black Rambo" films that find such ready acceptance with the American public, it takes the trouble to differentiate this violence with ethically and aesthetically precise images. The film exerts a violence on its viewers, badgering us to "fight the power" and "do the right thing," but it never underestimates the difficulty of rightly locating the power to be fought, or the right strategy for fighting it. A prefabricated propaganda image of political or ethical correctness, a public monument to "legitimate violence" is exactly what the film refuses to be. It is, rather, a monument of resistance, of "intelligent violence," a ready-made assemblage of images that reconfigures a local space—literally, the space of the black ghetto, figuratively, the space of public images of race in the American public sphere. Like the Goddess of Liberty in Tiananmen Square, the film confronts the disfigured public image of legitimate power, holding out the torch of liberty with two hands, one inscribed with HATE, the other with LOVE.

If *Do the Right Thing* has a moral for those who wish to continue the tradition of public art and public sculpture as a utopian venture, a "daring to dream" of a more humane and comprehensive public sphere, it is probably in the opening lines of the film, uttered by the ubiquitous voice of Love Daddy: "Wake up!" Public art has always dared to dream, projecting fantasies of a monolithic, uniform, pacified public sphere. What seems called for now, and what many of our contemporary artists wish to provide, is a *critical* public art that is frank about the contradictions and violence encoded in its own situation, one that dares to awaken a public sphere of resistance, struggle, and dialogue. Exactly how to negotiate the border between struggle and dialogue, between the argument of force and the force of argument, is an open question.

Martin Luther King, Jr. and Malcolm X. (A.P./Wide World Photo). "It resituates both violence and nonviolence as strategies within a struggle that is simply an ineradicable fact of American life."

Violence as a way of achieving racial justice is both impractical and immoral. It is impractical because it is a descending spiral ending in destruction for all. The old law of an eye for an eye leaves everybody blind. It is immoral because it seeks to humiliate the opponent rather than win his understanding; it seeks to annihilate rather than to convert. Violence is immoral because it thrives on hatred rather than love. It destroys community and makes brotherhood impossible. It leaves society in monologue rather than dialogue. Violence ends by defeating itself. It creates bitterness in the survivors and brutality in the destroyers. [Martin Luther King, Jr., "Where Do We Go from Here?" *Stride Toward Freedom: The Montgomery Story* (New York, 1958), p. 213.]

I think there are plenty of good people in America, but there are also plenty of bad people in America and the bad ones are the ones who seem to have all the power and be in these positions to block things that you and I need. Because this is the situation, you and I have to preserve the right to do what is necessary to bring an end to that situation, and it doesn't mean that I advocate violence, but at the same time I am not against using violence is self-defense. I call it intelligence. [Malcolm X, "Communication and Reality," *Malcolm X: The Man and His Times*, ed. John Henrik Clarke (New York, 1969), p. 313.]

NOTES

1. Quoted in Uli Schmetzer, "Torch of China's Lady Liberty Rekindles Fervor," *Chicago Tribune*, 31 May 1989, sec. 1.

2. For an excellent discussion of the way the events in China in June 1989 became a "spectacle for the West," overdetermined by the presence of a massive publicity apparatus, see Rey Chow, "Violence in the Other Country: Preliminary Remarks on the 'China Crisis,' June 1989," *Radical America* 22 (July–August 1988): 23–32.

3. Michael North, *The Final Sculpture: Public Monuments and Modern Poets* (Ithaca, N.Y.: Cornell University Press, 1985), 17. *Tilted Arc* is "traditional" in its legal status as a commission by a public, governmental agency. In other ways (style, form, relation to site, public legibility) it is obviously nontraditional.

4. Serra described his intention "to dislocate or alter the decorative function" of the Federal Building plaza in an interview with Douglas Crimp ("Richard Serra's Urban Sculpture: An Interview," *Arts Magazine* 55 [November 1980]: 118), but he rejects Crimp's suggestion that he was attempting to "block the conventional views" available in the plaza: "the intention is to bring the viewer into the sculpture. . . . After the piece is erected, the space will be understood primarily as a function of the sculpture." For an excellent account of this whole controversy and the ill-considered decision to remove *Tilted Arc*, see *Public Art, Public Controversy: The "Tilted Arc" on Trial*, ed. Sherrill Jordan et at. (New York: American Council of the Arts, 1987).

5. G. E. Lessing notes that beauty in visual art was not simply an aesthetic preference for the ancients but a matter of juridical control. The Greeks had laws against caricature, and the ugly "dirt painters" were subjected to censorship. See Lessing's *Laocoon: An Essay upon the Limits of Painting and Poetry*, trans. Ellen Frothingham (1766; New York: Noonday Press, 1969), 9–10.

6. Thomas Crow, "Modernism and Mass Culture in the Visual Arts," in *Pollock and After: The Critical Debate*, ed. Francis Frascina (New York, 1985), 257.

7. See Kate Linker's important essay, "Public Sculpture: The Pursuit of the Pleasurable and Profitable Paradise," *Artforum* 19 (March 1981): 66.

8. Scott Burton summarizes the "new kind of relationship" between art and its audience: "it might be called public art. Not because it is necessarily located in public places, but because the content is more than the private history of the maker" (quoted in Henry M. Sayer, *The Object of Performance: The American Avant-Garde since 1970* [Chicago: University of Chicago Press, 1989], 6).

9. See Sayer, *The Object of Performance*, 2–3.

10. For a shocking example of an artist's misrepresentation of these issues, see Frederick E. Hart, "The Shocking Truth about Contemporary Art," *The Washington Post*, 28 August–3 September 1989, national weekly edition, op-ed. sec. It hardly comes as a surprise that Hart is the sculptor responsible for the figural "supplement" to the Vietnam Veterans Memorial, the traditional monumental figures of three soldiers erected in the area above and behind the memorial.

11. See Robert Morris, "Fissures," unpublished Ms.

12. Lawrence Alloway, "The Public Sculpture Problem," *Studio International* 184 (October 1972): 124.

13. See Leo Bersani and Ulysse Dutoit, "The Forms of Violence," *October*, no. 8 (Spring 1979): 17–29, for an important critique of the "narrativization" of violence in Western art and an examination of the alternative suggested by the Assyrian palace reliefs.

14. Habermas first introduced this concept in *The Structural Transformation of the Public Sphere: An Inquiry into a Category of Bourgeois Society,* trans. Thomas Burger and Frederick Lawrence (Cambridge, Mass.: MIT Press, 1989). First published in 1962, it has since become the focus of an extensive literature. See also Habermas's short encyclopedia article, "The Public Sphere," trans. Sara Lennox and Frank Lennox, *New German Critique* 1 (Fall 1974): 49–55, and the introduction to it by Peter Hohendahl in the same issue, 45–48. I owe much to the guidance of Miriam Hansen and Lauren Berlant on this complex and crucial topic.

15. See Joan Landes, *Women and the Public Sphere in the Age of the French Revolution* (Ithaca, N.Y.: Cornell University Press, 1988), 13.

16. Chow notes the way the "Goddess of Liberty" in Tiananmen Square replicates the "'*King Kong* syndrome,'" in which the body of the white woman sutures the gap between "enlightened instrumental reason and barbarism-lurking-behind-the Wall," the "white man's production and the monster's destruction" (Chow, "Violence in the Other Country," 26).

17. See Charles L. Griswold, "The Vietnam Veterans Memorial and the Washington Mall: Philosophical Thoughts on Political Iconography," *Critical Inquiry* 12 (Summer 1986): 709. Griswold reads the VVM as a symbol of "honor without glory."

18. Maya Lin, then a twenty-one-year-old Yale University architecture student, submitted the winning design in what may have been the largest competition for a work of public art ever held: 1,421 designs were entered.

19. See Catharine A. MacKinnon, *Feminism Unmodified: Discourses on Life and Law* (Cambridge, Mass.: Harvard University Press, 1987), esp. 172–73, 192–93.

20. For more on the distinction between totemism and fetishism, see my "Tableau and Taboo: The Resistance to Vision in Literary Discourse," *CEA Critic* 51 (Fall 1988):4–10.

21. Habermas, *Structural Transformation,* 160.

22. The removal of *Tilted Arc* is all the more remarkable (and ominous) in view of this strong presumption in favor of permanence.

23. The fate of the Berlin Wall is a perfect illustration of this process of disfiguration as a transformation of a public monument into a host of private fetishes. While the Wall stood it served as a work of public art, both in its official status and its unofficial function as a blank slate for the expression of public resistance. As it is torn to pieces, its fragments are carried away to serve as trophies in private collections. As German reunification proceeds, these fragments may come to signify a nostalgia for the monument that expressed and enforced its division.

24. By the phrase "economy of violence," I mean, quite strictly, a social structure in which violence circulates and is exchanged as a currency of social interaction. The "trading" of insults might be called the barter or "in kind" exchange; body parts (eyes, teeth notably) can also be exchanged, along with blows, glares, hard looks, threats, and first strikes. This economy lends itself to rapid, runaway inflation, so that (under the right circumstances) an injury that would have been trivial (stepping on someone's sneakers, smashing a radio) is drastically overestimated in importance. As a currency, violence is notoriously and appropriately unstable.

25. Murray Kempton's review ("The Pizza Is Burning!" *New York Review of Books,* 28 September 1989, 37–38), is perhaps the most hysterically abusive of the hostile reviews. Kempton condemns Spike Lee as a "hack" who is ignorant of African-American history and guilty of "a low opinion of his own people" (37).

His judgment of Mookie, the character played by Lee in the film, is even more vitriolic: Mookie "is not just an inferior specimen of a great race but beneath the decent minimum for humankind itself" (37).

26. I am indebted to Joel Snyder for suggesting this distinction between self-respect and acknowledgment.

27. Quoted in Spike Lee and Lisa Jones, *Do the Right Thing: A Spike Lee Joint* (New York: Fireside, 1989), caption to pl. 30.

28. Terrence Rafferty ("Open and Shut," review of *Do the Right Thing, The New Yorker*, 24 July 1989, 78–81) makes all three complaints: Rafferty (1) reduces the film to a thesis about "the inevitability of race conflict in America"; (2) suggests that the violent ending comes only from "Lee's sense, as a filmmaker, that he needs a conflagration at the end"; and (3) compares Lee's film unfavorably to Martin Scorsese's *Mean Streets* and *Taxi Driver*, where "the final bursts of violence are generated entirely from within." What Rafferty fails to consider is (1) that the film explicitly articulates theses that are diametrically opposed to his reductive reading (most notably, Love Daddy's concluding call "my people, my people," for peace and harmony, a speech filled with echoes of Zora Neale Hurston's autobiography); (2) that the final conflagration might be deliberately staged *as a stagy, theatrical event* to foreground a certain "requirement" of the medium; (3) that the psychological conventions of Italian-American neorealism with their "inner" motivations for violence are precisely what is in question in *Do the Right Thing*.

29. This interpretation was first suggested to me by Arnold Davidson, who heard it from David Wellbery of the department of comparative literature at Stanford University. It received independent confirmation from audiences to this paper at Harvard, California Institute of the Arts, Williams College, University of Southern California, UCLA, Pasadena Art Center, the University of Chicago's American Studies Workshop, the Chicago Art History Colloquium, and Sculpture Chicago's conference. I wish to thank the participants in these discussions for their many provocative questions and suggestions.

WORKS CITED

Alloway, Lawrence. "The Public Sculpture Problem." *Studio International* 184 (October 1972).

Bersani, Leo and Ulysse Dutoit. "The Forms of Violence." *October* no. 8 (Spring, 1979).

Chow, Rey. "Violence in the Other Country: Preliminary Remarks on the 'China Crisis,' June 1989." *Radical America* 22 (July–August 1988).

Crimp, Douglas. "Richard Serra's Urban Sculpture: An Interview." *Arts Magazine* 55 (November 1980).

Crow, Thomas. "Modernism and Mass Culture in the Visual Arts." *Pollock and After: The Critical Debate*. Edited by Francis Frascina. New York, 1985.

Griswold, Charles L. "The Vietnam Veterans Memorial and the Washington Mall: Philosophical Thoughts on Political Iconography." *Critical Inquiry* 12 (Summer 1986).

Habermas, Jürgen. "The Public Sphere." Translated by Sara Lennox and Frank Lennox. *New German Critique* 1 (Fall 1974).

———. *The Structural Transformation of the Public Sphere: An Inquiry into a*

Category of Bourgeois Society. Translated by Thomas Burger and Frederick Lawrence. Cambridge, Mass.: MIT Press, 1989.

Hart, Frederick E. "The Shocking Truth about Contemporary Art." *The Washington Post*, 28 August–3 September 1989.

Jordan, Sherrill et al. *Public Art, Public Controversy: The "Tilted Arc" on Trial*. New York: American Council of the Arts, 1987.

Kempton, Murray. "The Pizza Is Burning!" *New York Review of Books*, 28 September 1989.

Landes, Joan. *Women and the Public Sphere in the Age of the French Revolution*. Ithaca, N.Y.: Cornell University Press, 1988.

Lee, Spike, and Lisa Jones. *Do the Right Thing: A Spike Lee Joint*. New York Fireside, 1989.

Lessing, G. E. *Laocoön: An Essay upon the Limits of Painting and Poetry*. Translated by Ellen Frothingham. New York: Noonday Press, 1969.

Linker, Kate. "Public Sculpture: The Pursuit of the Pleasurable and Profitable Paradise." *Artforum* 19 (March 1981).

MacKinnon, Catharine A. *Feminism Unmodified: Discourses on Life and Law*. Cambridge, Mass.: Harvard University Press, 1987.

Mitchell, W. J. T. "Tableau and Taboo: The Resistance to Vision in Literary Discourse" *CEA Critic* 51 (Fall 1988).

Morris, Robert. "Fissures." Unpublished MS.

North, Michael. *The Final Sculpture: Public Monuments and Modern Poets*. Ithaca, N.Y.: Cornell University Press 1985.

Rafferty, Terrence. "Open and Shut." *The New Yorker*, 24 July 1989.

Sayer, Henry M. *The Object of Performance: The American Avant-Garde since 1970*. Chicago: University of Chicago Press, 1989.

Schmetzer, Uli. "Torch of China's Lady Liberty Rekindles Fervor." *Chicago Tribune*, 31 May 1989, sec. 1.

Notes on Contributors

ROBERT BOENIG is the author of *Chaucer and the Mystics* and *Saint and Hero: Andreas and Medieval Doctrine,* as well as articles in such journals as *JEGP, The Chaucer Review, English Language Notes,* and *Neophilologus.* He is an editor of *Studia Mystica* and a member of the English Department of Texas A&M University.

JOHN W. ERWIN is President and Executive Director of The Fund for New Performance/Video, a Boston-based not-for-profit organization which he founded in 1990 to produce, document, and interpret new inter-cultural work in the performing and visual arts. Erwin is working on a book which reads phenomenological strategies in the art, architecture, and writing of modern and contemporary Prague in terms of nineteenth-century ecologies by James, Ruskin, Wagner, and Monet. He is the author of *Lyric Apocalypse: Reconstruction in Ancient and Modern Poetry* (1984) and *Annunciations to Anyone: The Disclosure of Authority in Writing and Painting* (1990). He previously served as Director of Programs at the Council for the United States and Italy in New York and Rome, as Chairman of the Program in Comparative Literature and Visiting Associate Professor of English at Carleton College, and as Assistant Professor of Comparative Literature at Yale University, and was a Rhodes Scholar at Balliol College, Oxford University.

TIMOTHY ERWIN teaches eighteenth-century studies and the sister arts at the University of Nevada, Las Vegas. His essay is part of a longer work in progress tentatively titled *Some Augustan Designs.* He took his Ph.D. in English literature at the University of Chicago, where he also edited *Chicago Review.*

MICHAEL FRIED is professor of humanities and the history of art and director of the Humanities Center at the Johns Hopkins University. He has published widely on modern art and criticism and is the author of *Morris Louis, Absorption and Theatricality: Painting and Beholder in the Age of Diderot* (awarded the Louis Gottschalk Prize of the American Society for Eighteenth-Century Studies) and most recently, *Realism, Writing, Disfiguration: On Thomas Eakins and Stephen Crane.*

Ernest B. Gilman, now professor of English at New York University, has taught at Columbia and the University of Virginia. He is the author of two books on the relationships of literature and the visual arts in early modern England, *The Curious Perspective* and *Iconoclasm and Poetry in the English Reformation* (1986), and is currently at work on a study of the pioneering art historian and philologist Francis Junius the Younger in the cultural context of the Stuart Court. Among other honors he has held a Guggenheim Fellowship. He is also the General Editor of the monograph series "Literature and the Visual Arts: New Foundations," with Peter Lang Publishing.

James A. W. Heffernan, Professor of English at Dartmouth College, has published various studies of English romantic poetry and of interart relations. His books include *Wordsworth's Theory of Poetry: The Transforming Imagination* (1969), *The Re-creation of Landscape: A Study of Wordsworth, Coleridge, Constable, and Turner* (1985), and *Museum of Words: The Poetics of Ekphrasis from Homer to Ashbery* (1993). He has also edited two collections of interdisciplinary essays: *Space, Time, Image, Sign: Essays on Literature and the Visual Arts* (1987) and *Representing the French Revolution: Literature, Historiography, and Art* (1992).

James T. Kettlewell, Associate Professor of Art History at Skidmore College, earned his A.B. and A.M. degrees at Harvard University in the History of Art. He has been a Fulbright scholar in advanced research at the Courtauld Institute, University of London, and has taught at Harvard and the University of Toronto. He has served as Director and Vice-Chairman of the Gallery Association of New York State, for whom he produced the award-winning publication *Ornament and the Victorian Style*. As curator of the Hyde Collection, Glens Falls, New York, he published the scholarly *Catalogue of the Hyde Collection*. Most recently, he has published *Saratoga Springs, an Architectural History* (1991). Interested for many years in ornament and the decorative arts, his current research concerns the significance of ornament in the development of abstract art.

Ruth Larson is Assistant Professor of French at Texas A&M University. Her publications include "The Iconography of Feminine Sexual Education in the 17th Century: Molière, Scarron, Chaveau" in *Papers on French Seventeenth-Century Literature* (1993) and "Confession, Dissimulation and Storytelling in the Ur-Text of Classical Eroticism" in *Bulletin de la Société Américaine de Philosophie de Langue Française* (1994). She is currently working on a book on the early-modern "Whore's Tale."

James V. Mirollo is the Parr Professor of English and Comparative Literature at Columbia University, where he teaches his specialty, Renaissance and Baroque literature and art. He has lectured and published widely in his field on such subjects as Mannerism and Baroque poetry and painting. His current project is a study of the representation of the erotic sacred in Baroque verbal and visual texts.

W. J. T. Mitchell is Gaylord Donnelley Distinguished Service Professor of English and Art History at the University of Chicago, and editor of *Critical Inquiry*. His books include *Blake's Composite Art, Iconology,* and *Picture Theory,* and he has edited numerous collections of essays, including *The Language of Images, Art and the Public Sphere,* and *Landscape and Power.*

Eileen Reeves is Assistant Professor of Comparative Literature at Princeton University. She specializes in Renaissance and Baroque culture, and her area of expertise is early modern scientific literature. Her publications are primarily devoted to seventeenth-century astronomy and cartography.

Constance Sherak is Visiting Assistant Professor of French at Connecticut College. She has published articles on cultural memory and the rhetoric of the museum in nineteenth-century France, including "Ouvert au Public: the Musée Napoléon and the Politics of Appropriation" in the *Stanford Literary Review* (1987).

Michael Wilson has taught in several university and college theater departments, held an NEH fellowship, and authored articles on eighteenth- and early nineteenth-century British theater and culture. Currently Associate Director of the Sagamore Institute in the Adirondack region of New York State, he is completing a book on British theater and the visual arts, 1695–1830.

Ann Hurley has been teaching Renaissance literature at Skidmore College. She has published essays on literature and the visual arts, on the poetry of John Donne, and on women writers of the English Renaissance. Her essay here is part of a longer work on reading John Donne's poetry in the context of late Renaissance visual culture.

KATE GREENSPAN teaches medieval studies at Skidmore College. A recipient of Fulbright, AAUW, and ACLS fellowships, she has published translations and studies of medieval German, English, and Italian mystics of the thirteenth through fifteenth centuries. She has recently completed a book on Magdalena of Freiburg and is currently preparing a book on medieval autobiography.

Index

397